# THE ROUTLEDGE COMPANION TO AFRICAN AMERICAN THEATRE AND PERFORMANCE

*The Routledge Companion to African American Theatre and Performance* is an outstanding collection of specially written essays that charts the emergence, development, and diversity of African American Theatre and Performance—from the nineteenth-century African Grove Theatre to Afrofuturism. Alongside chapters from scholars are contributions from theatre makers, including producers, theatre managers, choreographers, directors, designers, and critics. This ambitious *Companion* includes:

- A "Timeline of African American theatre and performance."
- Part I "Seeing ourselves onstage" explores the important experience of Black theatrical self-representation. Analyses of diverse topics including historical dramas, Broadway musicals, and experimental theatre allow readers to discover expansive articulations of Blackness.
- Part II "Institution building" highlights institutions that have nurtured Black people both on stage and behind the scenes. Topics include historically Black colleges and universities (HBCUs), festivals, and Black actor training.
- Part III "Theatre and social change" surveys key moments when Black people harnessed the power of theatre to affirm community realities and posit new representations for themselves and the nation as a whole. Topics include Du Bois and African Muslims, women of the Black Arts Movement, Afro-Latinx theatre, youth theatre, and operatic sustenance for an Afro future.
- Part IV "Expanding the traditional stage" examines Black performance traditions that privilege Black worldviews, sense-making, rituals, and innovation in everyday life. This section explores performances that prefer the space of the kitchen, classroom, club, or field.

This book engages a wide audience of scholars, students, and theatre practitioners with its unprecedented breadth. More than anything, these invaluable insights not only offer a window onto the processes of producing work, but also the labor and economic issues that have shaped and enabled African American theatre.

**Kathy A. Perkins** is Professor Emerita of the University of Illinois (Urbana-Champaign) and University of North Carolina at Chapel Hill. She is a professional lighting designer who has designed throughout the United States and internationally, and as an author has edited six anthologies focusing on African/African Diaspora women.

**Sandra L. Richards** is Professor Emerita in African American Studies and Theatre at Northwestern University. Specializing in African American, African, and African Diaspora drama, she has published articles on a range of playwrights and on tourism to slave sites in the Black Atlantic.

**Renée Alexander Craft** is an Associate Professor at the University of North Carolina at Chapel Hill with a joint appointment in the Department of Communication and Curriculum in Global Studies. She is a performance studies trained Black feminist writer, scholar, and educator.

**Thomas F. DeFrantz** is Professor of African and African American Studies and Theater Studies at Duke University. He directs SLIPPAGE:Performance | Culture | Technology, a research group that explores live processing in theatrical contexts.

# ROUTLEDGE THEATRE AND PERFORMANCE COMPANIONS

For more information about this series, please visit: www.routledge.com/handbooks/products/SCAR30

# THE ROUTLEDGE COMPANION TO AFRICAN AMERICAN THEATRE AND PERFORMANCE

Edited by *Kathy A. Perkins, Sandra L. Richards, Renée Alexander Craft, and Thomas F. DeFrantz*

LONDON AND NEW YORK

First published 2019
by Routledge

2 Park Square, Milton Park, Abingdon, Oxfordshire OX14 4RN
52 Vanderbilt Avenue, New York, NY 10017

*Routledge is an imprint of the Taylor & Francis Group, an informa business*

First issued in paperback 2020

*British Library Cataloguing-in-Publication Data*
A catalogue record for this book is available from the British Library

*Library of Congress Cataloging-in-Publication Data*
Names: DeFrantz, Thomas, editor. | Alexander Craft, Renée, editor. |
Richards, Sandra L., editor. | Perkins, Kathy A., 1954– editor. |
Title: The Routledge companion to African American theatre and performance /
edited by Kathy A. Perkins, Sandra L. Richards,
Renée Alexander Craft, and Thomas F. DeFrantz.
Description: New York, NY : Routledge, 2019. |
Series: Routledge theatre and performance companions | Includes index.
Identifiers: LCCN 2018028249 (print) | LCCN 2018029064 (ebook) |
ISBN 9781315191225 (Master) | ISBN 9781351751445 (Adobe Reader) |
ISBN 9781351751438 (ePub3) | ISBN 9781351751421 (Mobipocket Unencrypted) |
ISBN 9781138726710 (hardback : alk. paper) | ISBN 9781315191225 (ebook)
Subjects: LCSH: African American theater. | African American theatrical producers and directors. |
African American dramatists. | African American actors.
Classification: LCC PN2270.A35 (ebook) | LCC PN2270.A35 R68 2019 (print) |
DDC 792.08996073–dc23
LC record available at https://lccn.loc.gov/2018028249

ISBN: 978-1-138-72671-0 (hbk)
ISBN: 978-0-367-47801-8 (pbk)

Typeset in Bembo
by Out of House Publishing

# CONTENTS

Contents

# Contents

# Contents

# FIGURES

# EDITORS AND CONTRIBUTORS

## Editors

**Renée Alexander Craft** is a performance studies trained Black feminist writer, scholar, and educator. She is an Associate Professor at the University of North Carolina at Chapel Hill with a joint appointment in the Department of Communication and Curriculum in Global Studies. She is the author of *When the Devil Knocks: The Congo Tradition and the Politics of Blackness in Twentieth-Century Panama* and a digital humanities project titled *Digital Portobelo: Art + Scholarship + Cultural Preservation* (digitalportobelo.org).

**Thomas F. DeFrantz** directs SLIPPAGE: Performance, Culture, Technology. His books include: *Dancing Many Drums: Excavations in African American Dance, Dancing Revelations Alvin Ailey's Embodiment of African American Culture, Black Performance Theory* (co-edited with Anita Gonzalez), and *Choreography and Corporeality: Relay in Motion* (co-edited with Philipa Rothfield). He contributed voice-over and content for a permanent installation on Black Social Dance at the Smithsonian Museum of African American Life and Culture.

**Kathy A. Perkins** is editor of six play anthologies including *Black Female Playwrights: An Anthology of Plays before 1950.* As lighting designer she has designed nationally and internationally. She was theatre consultant for the *Taking the Stage* exhibition at the Smithsonian National African American Museum. She is a member of the College of Fellows of the American Theatre, Professor Emerita in theatre at the University of Illinois (Urbana-Champaign) and University of North Carolina at Chapel Hill.

**Sandra L. Richards** is Professor Emerita at Northwestern University, having taught in African American studies and theatre on the home campus and in liberal arts at Northwestern in Qatar. With research specialties in African American, African, and African Diaspora theatres, she has authored *Ancient Songs Set Ablaze: The Theatre of Femi Osofisan* and numerous articles on a range of Black dramatists. Richards is co-editor (with Sandra Shannon) of *Approaches to Teaching the Plays of August Wilson.*

# Contributors

**Sandra Adell** is a Professor in the Department of Afro-American Studies at the University of Wisconsin-Madison. She is the editor of *Contemporary Plays by African American Women: Ten Complete Plays*, and the executive editor of *Continuum: The Journal of African and Diaspora Drama, Theatre and Performance*.

**Leslye Joy Allen** is a historian and dramaturg who specializes in twentieth-century Georgia history and theatre history. She holds Bachelor and Master of Arts degrees from Agnes Scott College and Georgia State University, respectively. She recently completed her Doctor of Philosophy degree in History from Georgia State University (USA).

**Pedro E. Alvarado** has an MA in Religious Studies and a BIS with a concentration in Theatre Performance Studies from Georgia State University. He is happily married to Anastasia Alvarado and proud member of the Iota Phi Theta Fraternity.

**Loyce L. Arthur**, Associate Professor (USA 829) has designed costumes for numerous productions including *Brokenville* and *Welcome to Thebes*. She coordinates the Iowa City Caribbean-style Carnival Community Project, 2012–present. She has studied carnival in New Orleans, Cuba, Canada, Trinidad and Tobago, the Netherlands, and Germany.

**Lori D. Barcliff Baptista**, PhD, is a Senior Lecturer in Performance Studies and Associate Dean for Undergraduate Programs and Advising at the School of Communication, Northwestern University. Her essays have appeared in: *SLIPPAGE: Performance, Culture, Technology, Fashioning Ethnic Culture: Portuguese-American Communities Along the Eastern Seaboard*, and *Text and Performance Quarterly*.

**Nefertiti Burton**, Professor and Chair of Howard University's Department of Theatre Arts, has directed in university, Off-Broadway, and international venues. Her creative work focuses on Yoruba traditions in Africa and the Diaspora. She holds an MFA in Directing from the University of Massachusetts Amherst and a Research Certificate in Media Arts from the Massachusetts Insitute of Technology.

**Rikki Byrd** is a writer, educator, and scholar whose work specializes in fashion and race. She is the co-editor of the Fashion and Race Syllabus and a student in the African American Studies PhD program at Northwestern University.

**Gregory S. Carr** is an instructor of speech and theatre at Harris-Stowe State University. His ten-minute play *Watch Night* was published in *Cosmic Underground: A Grimoire of Black Speculative Discontent*. Two of his essays appear in the SETC *Theatre Symposium Volumes 21 and 26*.

**Tabitha Jamie Mary Chester** is an interdisciplinary scholar. Dr. Chester's research interests include sexuality, religion, gender, and performance. Dr. Chester is currently working on the forthcoming monograph *Always a Preacher's Daughter*, which examines Black women's sexual and gender development in the Black church.

**Elizabeth M. Cizmar** is a Visiting Assistant Professor at Franklin and Marshall College. She holds a PhD in Drama from Tufts University and an MFA in Acting from the Actors Studio

Drama School. She is currently working on her book project on Ernie McClintock's legacy and his Jazz Acting technique.

**Howard L. Craft** is a poet, playwright, arts educator, and columnist. He is the author of two books of poetry and numerous plays. He is currently the Piller Professor of the practice for the Writing for the Stage and Screen program at the University of North Carolina at Chapel Hill.

**J.K. Curry** is an Associate Professor and former Chair of the Department of Theatre and Dance at Wake Forest University. She is the author of *Nineteenth-Century American Women Theatre Managers and John Guare: A Production Sourcebook* and is a past editor of *Theatre Symposium*.

**Phyllisa Smith Deroze** is an Assistant Professor of English Literature at United Arab Emirates University. She writes about American literature, drama, and medical humanities. Her latest publication is "Deconstructing the Urban Circuit: Gospel Musicals, Langston Hughes' Legacy, and Tyler Perry's Contemporary Influence." She received her PhD in English from Pennsylvania State University.

**Margit Edwards** is a doctoral candidate in the Theatre Program at the Graduate Center, CUNY and Adjunct Assistant Professor at John Jay College of Criminal Justice and City College. Her research interests include West African theatre and dance performance, theories of coloniality, and transcultural dance dramaturgy.

**Marta Effinger-Crichlow** is author of *Staging Migrations Toward an American West: From Ida B. Wells to Rhodessa Jones*. This dramaturg and filmmaker is an Associate Professor of African American Studies at New York City College of Technology (CUNY). She received her PhD from Northwestern University.

**Niiamar Felder**, noted fashion and costume designer, is inspired by the brilliance of fashion. His design aesthetic, highlighted in collections by his namesake label, captures the nostalgic beauty of glamour. Niiamar is the Head of Costumes and Adjunct Professor at Pace University School of Performing Arts in New York City.

**La Donna L. Forsgren** is an Assistant Professor of Theatre at the University of Notre Dame. She is the author of *In Search of Our Warrior Mothers: Women Dramatists of the Black Arts Movement*. Her research appears in *Theatre Topics*, *Theatre History Studies*, *Callaloo*, *Frontiers*, and *New England Theatre Journal*.

**Rhone Fraser** is a Lecturer in the Department of English at Howard University and a play-wright. He produced the Philadelphia premiere of Sonia Sanchez's 1971 play *Dirty Hearts* and finished his fifth play *The Original Mrs. Garvey*. He is a member of the Dramatists Guild and studied playwriting with Leslie Lee.

**Nadine George-Graves** is a Professor of Theatre and Dance at UCSD. She is the author and editor of numerous books and articles at the intersections of African American studies, critical gender studies, performance studies, theatre history, and dance history. She is a past-president of the Congress on Research in Dance.

**Freda Scott Giles**, PhD, recently retired from the University of Georgia, where she taught in the Department of Theatre and Film Studies and the Institute for African American Studies. She is founding editor of *Continuum*, an online journal of African American theatre, drama, and performance published by the Black Theatre Network.

**Amoaba Gooden** is an Associate Professor at Kent State University. She is the editor of a special edition of the *Southern Journal of Canadian Studies: Constructing Black Canada*. Some of her publications can be found in the *Journal of Black Studies*, and *Wagadu: Journal of Transnational Women's and Gender Studies*.

**Alexis Pauline Gumbs** is the author of *Spill: Scenes of Black Feminist Fugitivity* and *M Archive: After the End of the World*, and is a co-editor of *Revolutionary Mothering: Love on the Front Lines*. Alexis is currently the visiting Winton Chair of Liberal Arts at University of Minnesota.

**Melanie Greene**, a 2017 Bessie Award recipient, is a writer and movement artist. She has received generous support from New York Live Arts, Gibney Dance, Actors Fund Summer Push Grant, and Dancing While Black Fellowship. www.methodsofperception.com.

**Denise J. Hart** is an Associate Professor of Theatre at Howard University. Dramaturgically, she has worked on: *Jitney, Sweet Charity, Joe Turner's Come and Gone, Day of Absence, Zooman and the Sign, Repairing a Nation, Malcom, Martin, and Medgar*, and *Breath, Boom*. She's a member of ATHE, LMDA, and SAG.

**JaMeeka Holloway-Burrell** is a theatre festival coordinator and freelance director based in North Carolina. She is Founding Artistic Director of Black Ops Theatre Company. Additionally, JaMeeka is Co-Program Manager for the Black Theatre Commons, a national advocacy group and resource sharing network for Black theatres and Black theatre practitioners.

**E. Patrick Johnson** is the Carlos Montezuma Professor of Performance Studies and African American Studies at Northwestern University. He is the author of *Appropriating Blackness: Performance and the Politics of Authenticity* and *Sweet Tea: Black Gay Men of the South* as well as editor or co-editor of several other volumes.

**Jasmine Johnson** is a scholar/practitioner of African diasporic dance. She is an Assistant Professor of Theater Arts and Performance Studies at Brown University. Her work has appeared in *Dance Research Journal, The Drama Review, Africa and Black Diaspora: An International Journal, Colorlines, Gawker*, and elsewhere.

**Kashi Johnson** is a Professor of Theatre at Lehigh University where she teaches performance, hip hop theatre, and directs. She has given video-recorded talks about her cutting-edge hip hop theatre course "Act Like You Know," for TEDx, BlackademicsTV, and published on the topic in *Black Acting Methods: Critical Approaches*.

**Nicole M. Morris Johnson** is an Andrew W. Mellon Teaching Fellow at Morehouse College in Atlanta, Georgia and a PhD candidate in English at Emory University. Her current project examines the impact that Afro-creole cultural practices have upon Black women's literary production during the twentieth century.

**Johnny Jones** is an Assistant Professor and Director of the African American Theatre Program at the University of Louisville where he teaches Black performance studies. His scholarly/creative work focuses on contemporary Black life and identities and has appeared in journals and academic texts nationally and internationally.

**Sascha Just** is a filmmaker, writer, and educator. She holds a PhD in Theatre with a minor in Cinema Studies from the CUNY Graduate Center. She is currently working on a project comprising a book and an oral history web archive of New Orleans performance cultures. She teaches at New York City College of Technology (CUNY).

**Nambi E. Kelley** is a playwright and award-winning actress. She was in residence at the National Black Theatre, a finalist for the Francesca Primus Award, the KSF Award, and is adapting Toni Morrison's *Jazz*. Her play *Native Son* has enjoyed productions across the country. As an actress Kelley has performed regionally, internationally, and on television.

**Baron Kelly** is an internationally recognized critic, historian, practitioner, and scholar. In addition to his long list of acting and directing credits on and Off-Broadway, he is a four-time Fulbright Scholar. He is Full Professor and Head of the Graduate Acting Program at the University of Louisville.

**Sonny Kelly** is a scholar, performer, and storyteller. Sonny has an MA in Communication Studies from St. Mary's University, a BA in International Relations from Stanford University, and is currently pursuing a PhD in Communication at UNC Chapel Hill. His research focuses on critical/performance ethnography, critical pedagogy, and youth empowerment.

**Mario LaMothe** is an Assistant Professor of African American Studies and Anthropology at the University of Illinois at Chicago. His research agenda involves narratives of "home" in the Haitian Diaspora, embodied pedagogies of Afro-Caribbean religious rituals, and the intersections of spectatorship, queerness, and social justice in the African Diaspora.

**Barbara Lewis** heads the William Monroe Trotter Institute for the Study of Black History and Culture at the University of Massachusetts, Boston, where she is an Associate Professor of English, with publications on lynching, the nineteenth-century minstrel stage, the Black arts era of the sixties, and the urban drama of August Wilson.

**Khalid Yaya Long** received his PhD in Theatre and Performance Studies at the University of Maryland, College Park. Khalid's research and creative works center on Black/Diasporic theatre, drama, and performance, with specific attention on the intersection of race, class, gender, and sexuality within marginalized and oppressed communities.

**Sharrell D. Luckett**, PhD is Assistant Professor of English, Drama, and Performance Studies at the University of Cincinnati, and founder of the Black Acting Methods® Studio. She is lead editor of *Black Acting Methods: Critical Approaches* and author of *YoungGiftedandFat: An Autoethnography of Size, Sexuality, and Privilege*.

**Marvin McAllister** is an Assistant Professor of Theatre and Drama at Winthrop University specializing in African American and American theatre, drama, and performance. He has worked

as a dramaturg and literary manager for theatre companies in New York, Washington, DC, Chicago, and Seattle.

**D. Soyini Madison** is a Professor of Performance Studies at Northwestern University with affiliated appointments in African Studies and Anthropology. Madison's latest book, *PerformED Ethnography and Communication: Improvisation and Embodied Technique*, focuses on adaptation, devised performance, symbolic movement, and emergent expressions of ethnographic research and oral history.

**Sandra M. Mayo**, PhD, is a retired Professor of Theatre and administrator at Texas State University in San Marcos. Her publications include *Acting Up and Getting Down: Plays by African American Texans*, and *Stages of Struggle and Celebration: A Production History of Black Theatre in Texas*, both with Dr. Elvin Holt.

**Shondrika Moss-Bouldin** is a Visiting Lecturer at Georgia State University and the co-founder of Soulploitation Creative Works, LLC (www.scworks.tv), a multi-media production company based out of Atlanta and Los Angeles. She earned her degrees (BA, MA, and PhD) from Northwestern University. She is a professional director and a private acting coach.

**Sam O'Connell** is an Associate Professor of Theatre and Interdisciplinary Arts at Worcester State University. His research interests include music as performance, musical theatre history, and media technologies in live performance. He has published in the *Cambridge Companion to African American Theatre*, *Contemporary Theatre Review*, and a number of edited collections.

**Portia Owusu** is a scholar of English and American literature. She studied at the Universities of Kent, York, and the University of London's School of Oriental and African Studies. In 2015–2016, she was a Visiting Fulbright Scholar at the University of Kansas. She currently teaches at the University of Kent.

**Twila L. Perry** is a Professor of Law and the Judge Alexander P. Waugh Sr. Scholar at Rutgers University School of Law-Newark. Her scholarship addresses issues at the intersection of race, gender, and family law and the intersection of race, music, and the law.

**Nicole Hodges Persley** is the Associate Dean of Diversity, Equity, and Inclusion at the University of Kansas and an Associate Professor in the Department of Theatre. She teaches acting, critical race theory, and improvised performance. She is the Artistic Director of the KC Melting Pot Theatre in Kansas City, Missouri.

**Eric Ruffin** co-coordinates the Acting program at Howard University. His regional theatre directing credits include Sarafina! (Kennedy Center) and Black Nativity for Theater Alliance. He is a stage director and choreographer associate, and former Drama League Directing Fellow, Folger Theatre Acting Fellow, and Princess Grace Grant recipient for Dance.

**Sandra Seaton** is a playwright and librettist. *From the Diary of Sally Hemings*, her collaboration with composer William Bolcom, has been performed at the Kennedy Center and Carnegie Hall. Seaton's plays include *The Bridge Party, Music History or A Play About Greeks And SNCC in 1963, Estate Sale*, and *The Will*.

**Paula Marie Seniors**, is an Associate Professor at Virginia Tech, biographer of her family's legacy *Mae Mallory, the Monroe Defense Committee and World Revolutions: African American Women Radical Activists*, and award-winning author of *Beyond Lift Every Voice and Sing: The Culture of Uplift, Identity and Politics in Black Musical Theater*.

**Sandra G. Shannon** is a Professor Emeritus of African American Literature at Howard University. She is the author of *The Dramatic Vision of August Wilson* and *August Wilson's Fences: A Reference Guide*. She was key consultant and interviewee for the 2015 PBS-American Masters documentary *August Wilson: The Ground on Which I Stand*.

**Daphnie Sicre** is an Assistant Professor at Borough of Manhattan Community College/CUNY, where she teaches courses in theatre, social justice, and public speaking. She also teaches Latinx theatre and arts and social justice at Marymount Manhattan College. Focusing on Afro-Latinx performance, she completed her PhD at NYU in Educational Theatre.

**Susan Stone-Lawrence** is a PhD student at Texas Tech University. She often writes about Amiri Baraka, as in her chapter for the Bloomsbury Methuen series, *Decades of Modern American Drama: Playwriting from the 1930s to 2009*, and her essay for *Continuum: The Journal of African Diaspora Drama, Theatre and Performance*.

**K. Zaheerah Sultan** is the treasurer of the Black Theatre Network. She holds a Master of Arts degree in Fine, Performing, and Communication Arts, and a Master of Arts Management degree in Arts, Entertainment, and Media Management. Her expertise includes fundraising, "brandraising," organizational development, strategic planning, and marketing.

**Asantewa Fulani Sunni-Ali** directs the Center of Pan-African Culture and teaches in the Department of Pan-African Studies at Kent State University. Her educational background includes an undergraduate and graduate degree in Africana Studies and a PhD in Theatre for Youth. Dr. Sunni-Ali's research explores Black childhood, performance, agency, and liberation.

**Tezeru Teshome** is currently a PhD student of theatre/dance at UCSD-UCI. Her research is on how representations of Black childhood inform institutional care. After she has established her career in scholarship and performance, she hopes to return to her mother country of Ethiopia and work with young girls.

**Lisa B. Thompson** is an Associate Professor of African and African Diaspora Studies at the University of Texas at Austin and author of *Beyond the Black Lady: Sexuality and the New African American Middle Class*. The scholar/artist is also a playwright whose works include *Single Black Female*, *Underground*, and *The Mamalogues*.

**Cristal Chanelle Truscott**, PhD, is a playwright, director, and creator of *SoulWork* theatre-making method and founder of Progress Theatre. Her works include *PEACHES*, *'MEMBUH*, *The Burnin'* and *Plantation Remix*. Cristal is a Doris Duke Impact Artist Awardee and recipient of NPN Creation Fund, MAP Fund, and NEFA National Theatre Project Grant.

**Beth Turner** taught theatre at New York University for 13 years and is currently an adjunct at Florida A&M and Florida State universities. She has previously written about Pearl Cleage

in *Contemporary African American Playwrights*. She is also the founder of *Black Masks*, a 34-year publication on the Black performing arts.

**Susan Watson Turner** began her theatre career at the Karamu Theatre. Ms. Watson Turner worked at the Negro Ensemble Company 1980–2001. She is a Board Member at New Federal Theatre and a Professor of Multi-Media and African American Theatre at Lehman College— CUNY. For more information visit www.watsonturnerfilms.webs.com.

**Alison Walls** is a PhD candidate in Theatre at the Graduate Center, CUNY, New York. An actor/director from New Zealand, she holds an MA in French and an MFA in Acting. Her current project examines the surrogate mother character in US popular culture 1939–1963.

**Monica White Ndounou**, is Dartmouth College Associate Professor of Theater, Sony Music Fellow, and President of Black Theatre Association of ATHE. She is an actor, director, advocate for inclusive formal training, and award-winning author of *Shaping the Future of African American Film: Color-Coded Economics and the Story Behind the Numbers*.

**Kimmika L.H. Williams-Witherspoon** has a PhD in Cultural Anthropology, an MA in Anthropology, an MFA in Theater, and a BA in Journalism. She is an Associate Professor of Urban Theater and Community Engagement at Temple. She is author of *Through Smiles and Tears: The History of African American Theater* and *The Secret Messages in African American Theater*. She has had over 29 plays produced.

**Katelyn Hale Wood** is an Assistant Professor of Theatre History and Performance Studies at the University of Virginia. Her research engages critical race and queer theory, gender studies, and comedic performance. Wood's writing can be found in *QED: A Journal in GLTBQ Worldmaking*, *Departures in Critical Qualitative Research*, and *Theatre Topics*.

**Isaiah Matthew Wooden** is a director-dramaturg and Assistant Professor of Performing Arts at American University. His articles, chapters, essays, and reviews on contemporary Black art, theatre, and performance have appeared in *Callaloo*, *Journal of Dramatic Theory and Criticism*, *PAJ*, *Theatre Journal*, *Theater*, as well as several edited volumes.

**Katherine Zien** is Assistant Professor at McGill University and researches theatre and performance in the Americas. Her recent book is *Sovereign Acts: Performing Race, Space, and Belonging in Panama and the Canal Zone*. Zien has published in journals such as *Theatre Survey*, *Theatre Research in Canada*, and *Global South*.

# "BLACK ART NOW"

*Nambi E. Kelley*

Black art now.
Not Because.
Black art not in relationship to white narrative
Black art now.
Because
Black art for Black people
About Black narratives
By and for Black people
Black art now because ancestors threw themselves overboard for it
Escaped and ran for it
Survived and thrived for it.
Black art now because I get to stand in now and choose.
Black art now because art now more than ever.
Black art now because without
The African Grove
The Negro Ensemble Company
The New Federal Theatre
The New Lafayette
The National Black Theater
Ex-Bag
Chicago Theatre Company
The Black Ensemble
MPAACT
Without their rich histories
Sacrifice
Without the wear
Tear
Closed doors
Scratching
Clawing for pennies

Without them there is no us.
Without those who paved the way
Kicked down doors
Said what needed to be said
Demanded that people listen.
Without them there is no us.
I AM NOT NEW.

# INTRODUCTION

*Renée Alexander Craft, Thomas F. DeFrantz, Kathy A. Perkins, and Sandra L. Richards*

Ambitious in scope, *The Routledge Companion to African American Theatre and Performance* provides a selected overview from William Henry Brown's foundational nineteenth-century African Grove Theatre in New York City to Toshi Reagon's and Bernice Johnson Reagon's innovative twenty-first-century adaptation of *Octavia E. Butler's Parable of the Sower*, an Afrofuturistic opera. We have created a book that seeks to meet the broad content of theatre and performance as practiced in various African American communities. In this approach, we include a wide range of contributors not often included in books dealing with African American theatre, or theatre in general. The voices represented here reflect those of scholars (who research without practicing theatre to a large degree), scholars (who research and are also out there in the field making theatre), actors, designers, dancers, poets, directors, producers, theatre managers, playwrights, hip hop artists, composers, Black Indian chiefs, storytellers, lawyers, and more. Where the shapers, critics, and brokers of African American theatre and performance have led, we have attempted to follow.

This book also endeavors to highlight often neglected areas and people, such as the role of the historically Black colleges and universities (HBCUs) in the construction of a theatrical landscape or the creative impulses of artists in areas like design, marketing, stage management, or production. In this, we bring Black voicing to the construction of literary history, criticism, and theoretical models of performance analysis.

This Companion is not just multi-generational but also decidedly intergenerational. It not only explores the significance of early plays, actors, and events within their original contexts, but it also examines how newer generations of artists and scholars are revisiting and reimagining their history. One example is the revival of Angelina Grimke's 1916 drama *Rachel* to address political issues of the twenty-first century. Other chapters compare events in theatre regarding race from the early 1900s to the present day. The book also consists of interviews with practitioners that reflect intergenerational pairings. We recognize the importance for younger artists of connection with those of rich professional experience. Likewise, we realize the value for trailblazers of sharing their wisdom directly with those who might pick up the baton and carry it forward, including our student readers.

Now, more than ever, it seems the stories we tell and how we come to tell them help us all understand possibilities for future movements and motions. Our aim is to broaden imaginings about these possibilities by holding a space open to witness the relationship

between past and present circumstances of Black theatre and performance. We feel that such a diversity adds a richness to the Companion. As editors, we come from different regional, generational, and educational locations that shape how we see the world and produce knowledge. These differences are reflected in each of our section introductions. Taken as a whole, the book does not intend to be an encyclopedia, nor a comprehensive work on African American theatre and performance. Rather, it is a vibrant snapshot of how an expansive group of researchers is thinking about possibilities for historiography and documentation now. Note that all of the offerings here are new, created in the crucible of political motion that is the late 2010s.

The generations of scholars and artists represented here have educational and life experiences as varied as the editors. Some are proud graduates of historically Black colleges or universities (HBCUs), while others were among the early cohorts of people of color to enter historically white institutions in numbers larger than one or two. Some understand theatre and performance through the lens of acting or dance, arts management, and set or light design. Others engage it as a dynamic method to study social, political, and cultural life as well as a means of community engagement, collaboration, and social justice. For these reasons, this anthology—unlike other collections—includes the voices of practitioners as well as scholars.

When we started this journey, we had a broad idea of the areas on which we intended to focus. The impressive quantity and quality of abstracts pointed us toward the shape the book would ultimately take. Divided into four sections along with a timeline of important events, the book is organized thus:

- **The Highlights of African American theatre and performance timeline** is not comprehensive. Rather, we intend for the timeline to help the student researcher imagine a context for the innovations always bound up in African American performance.
- **Part I: Seeing ourselves onstage** explores the important experience of Black theatrical self-representation. Analyses of diverse topics including historical dramas, Broadway musicals, and experimental theatre allow readers to discover expansive articulations of Blackness.
- **Part II: Institution building: making a space of our own** highlights institutions that have nurtured Black people both onstage and behind the scenes. Topics include historically Black colleges and universities, festivals, and Black actor training.
- **Part III: Theatre and social change** surveys key moments when Black people harnessed the power of theatre to affirm community realities and posit new representations for themselves and the nation as a whole. Topics include: Du Bois and African Muslims; women of the Black Arts Movement; Afro-Latinx theatre; youth theatre; and operatic sustenance for an Afro future.
- **Part IV: Expanding the traditional stage** focuses on performance traditions that privilege Black worldviews, sense-making, rituals, and innovation in ways that extend the space of "the stage" to include the circus tent, club, movie theatre lobby, street, field, fashion runway, photograph, and classroom. Chapters reflect a range that includes: Black solo performance, stand-up comedy, carnival, staged oral history and field research, and hip hop theatre in the classroom.

There are many topics that we editors realize are not included due to space limitations. One is a definition of African American theatre. Attempting to define it has ignited contentious and ongoing debate since at least the second decade of the twentieth century, when two of the

pre-eminent scholars, philosophers, and champions of the arts, Alain Locke and W.E.B. Du Bois, clashed concerning the objectives of such a theatre. Though Locke's edited collection of writing by African Americans, called *The New Negro: An Interpretation* (1925), was critical in fostering a period of intense arts production known as the Harlem Renaissance (aka the Negro Renaissance), Du Bois' formulation has largely oriented Black theatres throughout the twentieth century.[1] He asserted in 1926, when he founded the Krigwa (*Crisis* Guild of Writers and Artists) Players:

> The plays of a real Negro theatre must be: One: About us. That is, they must have plots which reveal Negro life as it is. Two: By us. That is, they must be written by Negro authors who understand from birth and continual association just what it means to be a Negro today. Three: For us. That is, the theatre must cater primarily to Negro audiences and be supported and sustained by their entertainment and approval. Fourth: Near Us. The theatre must be in a Negro neighborhood near the mass of ordinary Negro people.
>
> (134)

Some readers may perceive in these chapters an unacknowledged conversation occurring around the terms *African Americans* and *Blacks*. The first is the term suggested by our publisher. Some of us prefer it for its historicity within a US context, while others find it constraining because people of African descent—even within the United States—have historically looked beyond the nation for affirmations of their identity and aspirations for fulfilling lives. Some authors use *Black* in a 1960s sense of pride in African heritage and drive for collective self-determination, while others deploy it in its post-colonial valence as a sign of identities that extend beyond the US nation-state to include continental Africans as well as those of African descent living in majority, non-African societies. We remark upon this fluidity of meaning as a way of gently urging readers to reflect upon how they understand these terms and how their understandings may shift, depending upon context.

A new generation of Black people is defining Blackness along with African American theatre in their own voices while recognizing voices from the past. We are excited that a global audience turns its attention to the achievements—often against ridiculous odds—of African American theatre and its practitioners. We are inspired that a new generation of playwrights, directors, and producers are exploring historical time periods as well as reviving earlier plays in order to introduce today's audiences to earlier ways of life. We are delighted to see new companies and projects like the New African Grove Theatre (Atlanta), Congo Square Theatre (Chicago), and others creating their own legacies while extending the legacies of trailblazing progenitors by adopting their names.

Our enthusiasm as editors for the richness of African American theatre and performance is matched by the curiosity and rigor of the many contributors to this volume. Ultimately, our goal in creating this *Companion* is to share the undeniable diversity and bounty of Black creativity with our readers. Black people continue to feed the world with an abundance of imaginative brilliance and theatrical flair. We are shiny and vibrant in our performances, as the chapters of this book attest again and again to the vitality and importance of these explorations.

We end by calling your attention to the poem by actress and playwright (*Native Son, Jazz*) Nambi E. Kelley, featured in the place of a more traditional acknowledgment in the front matter of this book. Kelley's words remind us why we create these literary documents of performance artistry; why African American theatre and performance will always matter; and why we offer this complex work to you, dear reader, to peruse and explore.

We are also grateful for those who assisted with providing resources vital to this text. Archivists at the Moorland–Spingarn Research Center, Howard University Archives; the Schomburg Center for Research in Black Culture; the New York Public Library Digital Collections; and the New York Public Library for the Performing Arts are among the personnel behind the scenes who have facilitated this book. We want to express our special appreciation to Cheryl Odeleye for her keen eye and diligence in helping us polish the final copy and to Marion Wright for expert assistance in helping us manage the process of delivering this project to the publishers. We could not have made it to the finish line without your invaluable editorial support. Thank you also to our communities of support for your understanding and encouragement. We have sought to honor your sacrifice and love here. Finally, to the 80 contributors and interviewees of this *Companion*, thank you for your rigor, artistry, and commitment to this project specifically and to African American theatre and performance more generally. We are honored beyond measure that you chose to take this journey with us. Thank you for the gift of your work.

## Note

1 For a more recent example of this debate, see *Theatre Journal* 57.4 (December 2005) where an intergenerational group of playwrights, performers, and scholars like Anna Deavere Smith, Suzan-Lori Parks, Paul Carter Harrison, Tavia Nyong'O, and James V. Hatch offer a range of definitions of "what is a black play."

## Works cited

Du Bois, W.E.B. "Krigwa Players Little Negro Theatre." *The Crisis*, vol. 32, 1926, pp. 133–134.
Locke, Alain, editor. *The New Negro: An Interpretation*. Simon & Schuster, 1925.

# HIGHLIGHTS OF AFRICAN AMERICAN THEATRE AND PERFORMANCE

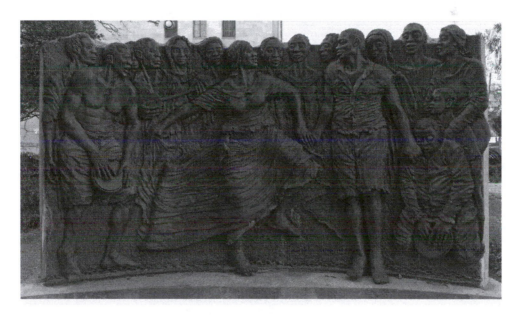

*Figure 0.1*   Congo Square sculpture relief, commemorating the enslaved Africans who participated in the performances in the square during slavery. New Orleans, Louisiana.

*Source*: Photo Kathy A. Perkins.

## 1700s–1800s

**1741**   Congo Square, an open space in New Orleans, becomes an area for enslaved Africans to freely sing, dance, and play music.

**1821**   William Alexander Brown opens in New York City the African Grove Theatre, the first African American theatre in the United States. In 1823 it produces Brown's *The Drama of King Shotaway*.

| 1830 | Thomas D. "Daddy" Rice, a white performer in blackface, introduces America to the character Jim Crow. |
| 1833 | Ira Aldridge performs at Covent Garden in London. |
| 1837 | Cheyney University of Pennsylvania is established as the first institution of higher learning for African Americans. Originally named the African Institute, it went through a series of name changes until 1983. |
| 1856 | Wilberforce University in Ohio is established as the first African American institution of higher learning owned and operated by Blacks. |
| 1858 | William Wells Brown publishes *The Escape; or, a Leap for Freedom*, one of the earliest *written* plays by a Black person. |
| 1865 | Brooker and Clayton's Georgia Minstrels, one of the earliest successful African American blackface minstrel groups, begins touring. |
| 1865 | Atlanta University (now Clark Atlanta University) is founded. |
| 1867 | Howard University is established in Washington, DC. |
| 1871 | Fisk Jubilee Singers is formed at Fisk University in Nashville. |
| 1879 | Pauline Hopkins' musical drama *The Slaves' Escape; or, the Underground Railroad*, believed to be the first play by an African American woman, is performed in Boston. |
| 1879 | The Creole Wild West becomes the first official Mardi Gras Black Indian tribe in New Orleans. |
| 1892 | Matilda Sissieretta Joyner Jones becomes the first Black person to sing at Music Hall (later Carnegie Hall) in New York City. |
| 1894 | Order of Doves, the earliest known Black mystic society or carnival group, is formed in Mobile, AL. |
| 1895 | George Walker and Bert Williams become the first Black performers on Broadway. |
| 1895 | Adrienne Herndon develops a drama club at Atlanta University, the earliest known at an HBCU. |

## 1900s–1940s

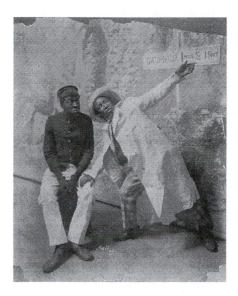

*Figure 0.2*    Bert Williams and George Walker in a scene from unidentified Williams and Walker musical (*c.*1900).

*Source*: Photographer: Hall Schomburg Center for Research in Black Culture, Photographs and Prints Division, New York Public Library Digital Collections. http://digitalcollections.nypl.org/items/7f1c40ac-5088-ff11-e040-e00a180614ed.

| | |
|---|---|
| **1903** | *In Dahomey*, starring George Walker and Bert Williams, premieres as the first full-length musical written and performed by Blacks on Broadway. |
| **1905** | Robert Mott opens the Pekin Theatre in Chicago, the first Black owned theatre space. |
| **1909** | The Zulu Social Aid and Pleasure Club of New Orleans is established. It continues to feature one of the largest Mardi Gras parades each year. |
| **1909** | The National Association for the Advancement of Colored People (NAACP) is formed. |
| **1910** | Bert Williams stars in the *Ziegfeld Follies*, becoming the first African American to receive top billing above white performers. |
| **1913** | W.E.B. Du Bois premieres *Star of Ethiopia* pageant in New York City. |
| **1914** | War World War I begins and, along with it, the start of the Great Migration of Black people from the South to northern cities. |
| **1915** | Anita Bush establishes the Anita Bush Stock Company (later renamed the Lafayette Players), which became the first major professional Black dramatic company in the United States. |
| **1915** | The NAACP forms a Drama Committee. |
| **1915** | Rowena and Russell Jelliffe establish the Playhouse Settlement, later renamed Karamu House, in Cleveland. It is one of the first multi-racial theatres in the country. |
| **1916** | Angelina Weld Grimke's *Rachel* premieres in Washington, DC, as the first full-length dramatic play written, directed, performed, and produced by Black people. |
| **1918** | War World I ends. |

**1919**   The Howard Players is formed by Montgomery T. Gregory and Alain Locke at Howard University.

**1919**   Jackie "Moms" Mabley (aka Loretta Mary Aiken) begins a nearly 60-year career with the "Chitlin Circuit" as one of the most influential stand-up comedians of all times.

**1920**   Eugene O'Neill's *The Emperor Jones* opens on Broadway starring Charles Gilpin.

**1922**   Ethiopian Art Theatre of Chicago opens.

**1922**   Paul Robeson, actor and singer, performs on Broadway in *All God's Chillun Got Wings*, the first of many leading roles over three decades. Others include *Emperor Jones, Othello, Show Boat*, and *John Henry*.

**1923**   Willis Richardson's one-act play *The Chip Woman's Fortune* becomes the first one-act by an African American playwright to open on Broadway.

**1925**   Garland Anderson's *Appearances* opens. It is the first full-length drama on Broadway by an African American.

**1925**   The Hall Johnson Negro Choir is organized to present the authentic beauty of spirituals and Black folk songs in a concert setting.

**1926**   Krigwa Players is established by the NAACP under the leadership of W.E.B. Du Bois.

**1930**   Willis Richardson edits and publishes *Plays and Pageants from the Life of the Negro*, the first anthology of stage plays written exclusively by Black authors.

**1930**   Katherine Dunham establishes the Ballet Nègre, a student troupe that eventually evolves into the Katherine Dunham Company.

**1932**   *Tom Tom: An Epic of Music and the Negro* by Shirley Graham (Du Bois) becomes the first professionally produced opera written by a Black person.

**1934**   Anne Cooke, director of theatre at Spelman College, starts the first major summer theatre for Blacks in the country under the name Atlanta University Summer Theatre.

**1934**   Sierra Leonean Asadata Dafora premieres *Kykunkor*, the first dance drama on an American stage.

**1935**   Langston Hughes' *Mulatto* premieres on Broadway.

**1935**   The Federal Theatre Project is created by the federal government's Works Progress Administration (WPA) and sets up "Negro Units" throughout the country.

**1936**   Dr. Randolph Sheppard Edmonds organizes the Southern Association of Dramatic and Speech Arts (SADSA). He would later develop and head programs at HBCUs including the Department of Speech and Drama at Florida A&M University (FAMU).

**1938**   Langston Hughes and Louise Thompson form the Harlem Suitcase Theatre.

**1939**   World War II begins.

**1939**   Perry Watkins becomes the first Black to design on Broadway for *Mamba's Daughter* and the first Black to gain membership to United Scenic Artists Association (USAA).

**1940**   American Negro Theatre (ANT) is collectively established by Frederick O'Neal, Abram Hill, Austin Briggs-Hall, and others in Harlem.

**1945**   World War II ends.

**1949**   The Howard Players becomes the first American university theatre group invited to perform in Europe.

*Figure 0.3*   Unknown Florida A&M students behind the scenes (*c*.1950s).

*Source*: Courtesy of the Moorland-Spingarn Research Center, Howard University Archives Howard University, Washington DC.

## 1950s–1970s

**1950**   Juanita Hall becomes the first African American to win the Tony Award for Best Performance by an Actress in a Featured Role in a Musical in *South Pacific*.

**1950**   Nick and Edna Stewart establish the Ebony Showcase Theatre in Los Angeles.

**1950**   Evelyn Ellis becomes the first African American to direct a dramatic play on Broadway with *Tobacco Road*. Also known for her acting, Ellis originated the role of Bess in the 1927 Broadway production of *Porgy: A play in Four Acts*.

**1951**   Janet Collins becomes the first Black female ballerina to dance at the Metropolitan Opera in New York City, but because of segregation she could not tour parts of the South.

**1952**   James "Jimmy" Walls becomes the first Black stage manager on Broadway with a revival of *Shuffle Along*.

**1952**   Alice Childress' *Gold Through the Trees* becomes the first play written by an African American female to receive a professional production in New York City.

**1953**   Arena Players is established in Baltimore.

**1954**   Harry Belafonte becomes the first African American to win a Tony Award for Best Performance by an Actor in a Leading Role in a Musical for *John Murray Anderson's Almanac*.

**1954**   *Brown v. Board of Education* declares segregation in public schools unconstitutional.

**1955**   James Baldwin's *The Amen Corner* premieres at Howard University.

**1955**   Marian Anderson becomes the first Black soloist to perform at the Metropolitan Opera in New York.

**1957**   *Jamaica* opens as the first Broadway production to use Black stagehands.

11

*Figure 0.4* Evelyn Ellis (Bess).

*Source*: Billy Rose Theatre Division. New York Public Library Digital Collections (1927). http:// digitalcollections.nypl.org/items/510d47dc-9fef-a3d9-e040-e00a18064a99.

| 1958 | Alvin Ailey establishes the Alvin Ailey American Dance Theatre in New York City. |
|---|---|
| 1959 | Lorraine Hansberry's *A Raisin in the Sun* premieres. It is the first time that a play authored by a Black woman and directed by a Black man (Lloyd Richards) appears on a Broadway stage. Hansberry would have a second Broadway production in 1964 with *The Sign in Sidney Brustein's Window*. In 1979 Lloyd Richards is named dean of the Yale University School of Drama. |
| 1961 | Ellen Stewart opens Cafe La Mama (later La MaMa Experimental Theatre Club) in New York City. |
| 1961 | Leontyne Price becomes the first African American to become a leading artist with New York's Metropolitan Opera. |
| 1962 | Concept East is established in Detroit by Woodie King, Jr., Cliff Frazier, and David Rambeau. |
| 1962 | Diahann Carroll becomes the first African American to win a Tony Award for Best Performance by an Actress in a Leading Role in a Musical with *No Strings*. |
| 1963 | Free Southern Theater is founded in Tougaloo, MS, by John O'Neal, Doris Derby, and Gilbert Moses. |
| 1963 | Richard Pryor begins his career as one of America's greatest stand-up comedians. |
| 1964 | Amiri Baraka (aka Leroi Jones) wins an Obie for Best Play with *Dutchman*. Adrienne Kennedy's *Funnyhouse of a Negro* wins the Obie for Distinguished Play. |
| 1965 | The Black Arts Movement begins. Amiri Baraka opens the Black Arts Repertory Theatre/School in Harlem. |
| 1965 | Clarence Bernard Jackson establishes the Inner City Cultural Center in Los Angeles after the Watts Riots. |
| 1967 | Robert Macbeth establishes the New Lafayette Theatre in Harlem. |
| 1967 | Douglas Turner Ward establishes the Negro Ensemble Company (NEC) in New York. |
| 1968 | Dr. Barbara Ann Teer establishes the National Black Theatre in New York City. |

*Figure 0.5*   Dancer Arthur Mitchell in George Balanchine's *Agon* (1957) with the New York City Ballet.
*Source*: New York Public Library Digital Collections (1957). http://digitalcollections.nypl.org/items/9d2ab180–bda5–0131–0df2–58d385a7b928.

| | |
|---|---|
| **1969** | The Dance Theatre of Harlem is founded by Arthur Mitchell and Karel Shook. |
| **1969** | The first annual West Indian-American Labor Day Carnival is held in Brooklyn, NY. |
| **1969** | James Earl Jones becomes the first African American to win the Tony Award for Best Performance by an Actor in a Leading Role in a Play for *The Great White Hope*. |
| **1970** | Woodie King, Jr. establishes the New Federal Theatre in New York City. |
| **1970** | Joan Myers Brown founds the Philadelphia Dance Company (PHILADANCO). |
| **1970** | Ashton Springer, one of the most influential Black producers, premieres Charles Gordone's *No Place to Be Somebody* on Broadway, and Gordone becomes the first African American playwright to win a Pulitzer Prize. Springer would produce other Broadway hits including *Bubbling Brown Sugar* and *Eubie!* |
| **1970** | Cleavon Little becomes the first African American to win a Tony Award for Best Actor in a Musical for *Purlie* by Ossie Davis. |
| **1970** | Garth Fagan opens his company Garth Fagan Dance, originally called the Bottom of the Bucket, But … Dance Theatre, in Rochester, NY. In 1998, he wins the Tony Award for Best Choreography with *The Lion King*. |
| **1971** | eta Creative Arts Foundation is founded by Abena Joan Brown in Chicago. |
| **1971** | Melvin Van Peebles' *Ain't Supposed to Die a Natural Death* opens on Broadway. |
| **1971** | Oakland Ensemble Theatre opens in California under Ron Stacker Thompson. |
| **1972** | Dianne McIntyre founds Sounds in Motion Dance Company in Harlem. |
| **1972** | Franklin A. Thomas establishes the Billie Holiday Theatre in Brooklyn, NY. |
| **1973** | Micki Grant becomes the first woman to win a Grammy for Best Musical Score Album for the Broadway production *Don't Bother Me, I Can't Cope*, conceived and directed by Vinnette Carroll. |
| **1973** | Vivian Robinson establishes AUDELCO (Audience Development Committee, Inc.) to honor excellence in New York City's Black theatre through the presentation of AUDELCO Awards (aka the Viv Awards). |

**1973**    Shirley Prendergast becomes the first African American female to design lighting on Broadway with *The River Niger*.

**1973**    Garland Lee Thompson establishes The Frank Silvera Writers' Workshop along with Morgan Freeman, Billie Allen Henderson, and Clayton Riley as a living memorial to the late actor, director, teacher, and producer, Frank Silvera (1914–1970).

**1974**    Joseph Walker becomes the first African American to win a Tony Award for Best Play for *The River Niger*.

**1974**    James V. Hatch and Ted Shine publish *Black Theatre USA: 45 Plays by Black Americans: 1847–1974*.

**1975**    Charlie Smalls' *The Wiz* opens on Broadway and wins the Tony Award for Best Musical. The musical wins a total of seven Tony Awards and makes history with a string of firsts: Geoffrey Holder for Best Director and Costume Design, George Faison for Best Chorography, and Ken Harper for Producer.

**1976**    Ntozake Shange's choreopoem *for colored girls who have considered suicide/when the rainbow is enuf* opens on Broadway. The first version of her choreopoem was performed in Berkeley, CA, and transferred to the New Federal Theatre before opening on Broadway.

**1976**    Jackie Taylor opens the Black Ensemble Theater in Chicago.

**1976**    Ron Himes opens the St. Louis (MO) Black Repertory Theatre Company.

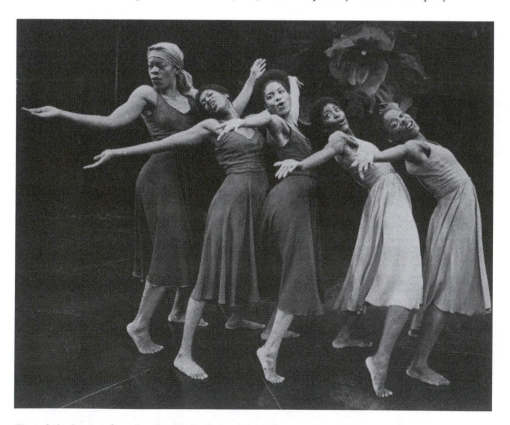

*Figure 0.6*    A scene from *for colored girls who have considered suicide/when the rainbow is enuf* (1976).

*Source*: Photographer Martha Swope. Billy Rose Theatre Division, New York Public Library for the Performing Arts. Astor, Lenox, and Tilden Foundations.

| | |
|---|---|
| **1976** | Lou Bellamy establishes Penumbra Theatre Company in St. Paul, MN. |
| **1976** | George W. Hawkins establishes the Ensemble Theatre in Houston, TX. |
| **1977** | Trazana Beverley becomes the first African American to win the Tony Award for Best Performance by a Featured Actress in a Play for *for colored girls*. |
| **1977** | Chuck Davis, one of the foremost masters of African dance, establishes the annual DanceAfrica festival at the Brooklyn Academy of Music. |
| **1978** | Crossroads Theatre is founded by Ricardo Khan and L. Kenneth Richardson in New Brunswick, NJ. |

## 1980s–1990s

| | |
|---|---|
| **1980** | The Lula Washington Contemporary Dance Foundation opens in Los Angeles. |
| **1981** | *Dreamgirls* opens on Broadway. |
| **1981** | Stanley E. Williams and Quentin Easter establish the Lorraine Hansberry Theatre in San Francisco. |
| **1981** | IATSE (International Alliance of Theatrical Stage Employees) Local 22A in Washington, DC, becomes the last segregated local in the country after merging with local 22. |
| **1982** | Zakes Mokae wins a Tony for Best Performance by an Actor in a Featured Role for *"Master Harold" … and the Boys*, making him the first African-born actor to win. |
| **1982** | Charles Fuller receives Pulitzer Prize for Drama for *A Soldier's Play*. |
| **1984** | Jawole Willa Jo Zollar founds Urban Bush Women performance ensemble. |
| **1984** | Beth Turner launches the magazine *Black Masks*, the oldest continuously published magazine dedicated to Black theatre. |
| **1984** | The Robey Theatre Company is established in Los Angeles by Danny Glover and Ben Guillory. |
| **1985** | Whoopi Goldberg premieres her one-woman show, *Whoopi Goldberg*, on Broadway. |
| **1985** | The Original Gullah Festival is launched in Beaufort, SC. |
| **1985** | August Wilson wins the New York Drama Critics Circle Award for *Ma Rainey's Black Bottom*. This would be the first of many awards for his plays, ten of which are collectively known as the Pittsburgh Cycle. Some 20 years later, a Broadway theatre would be re-named in his honor. |
| **1986** | The Black Theatre Network (BTN) founded. |
| **1986** | *The Colored Museum* by George C. Wolfe premieres at Crossroads Theatre Company in NJ. Over the next two decades Wolfe would garner multiple awards for writing and directing with such plays and musicals as *Angels in America*, *Jelly's Last Jam*, *Bring in 'da Noise, Bring in 'da Funk*, and *Elaine Stritch at Liberty*, in addition to being appointed artistic director of the Public Theater in New York City from 1993 to 2004. |
| **1987** | Lloyd Richards becomes the first Black man to win a Tony for Directing a Play with August Wilson's *Fences*. Wilson wins the Pulitzer Prize for the play. |
| **1988** | Kenny Leon is appointed artistic director of Atlanta's Alliance Theatre. |
| **1989** | Gary Anderson and Michael Garza establish Plowshares Theatre Company in Detroit. |
| **1989** | Larry Leon Hamlin founds the National Black Theatre Festival in Winston-Salem, NC. |
| **1990** | Pomo Afro Homos, a Black gay theatre troupe founded by Djola Bernard Branner, Brian Freeman, and Eric Gupton, opens in San Francisco. |
| **1991** | *Mule Bone: A Comedy of Negro Life* by Zora N. Hurston and Langston Hughes premieres posthumously on Broadway. |

**1994** Audra McDonald wins a Tony Award, Drama Desk Award, and Outer Critics Circle Award for Featured Actress in the musical *Carousel*. This would be the beginning of a series of awards over the next 24 years. In 2014, she would win her sixth Tony for *Lady Day at Emerson's Bar & Grill*. She would also make history as the only actor to win in all four categories: Best Performance by a Featured Actress in a Musical, Best Performance by a Featured Actress in a Play, Best Performance by a Leading Actress in a Musical, and Best Performance by a Leading Actress in a Play

**1996** August Wilson presents "The Ground on Which I Stand," his landmark speech on race and the American theatre, at Princeton University.

**1997** Greg Williams establishes the New Venture Theatre in Baton Rouge, LA.

**1997** Desmond Richardson becomes the first African American male principal dancer for the American Ballet Theatre in New York City.

**1998** Playwright, director, and producer Tyler Perry emerges on the urban theatre circuit, creating 20 plays over the next 20 years, thus making him the richest playwright in the United States.

**1999** Congo Square Theatre is co-founded by Derrick Sanders and Reginald Nelson in Chicago.

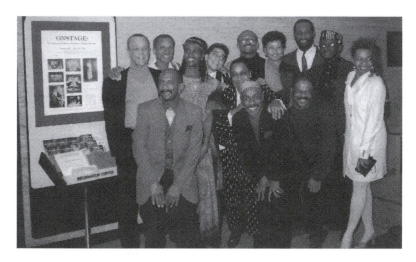

*Figure 0.7* Designers pose during the exhibition *ONSTAGE: A Century of African American Stage Design* at the New York Public Library for the Performing Arts at Lincoln Center (January 1995).

*Source*: Courtesy of Kathy A. Perkins.

## 2000–present

**2000** Kamilah Forbes co-founds the Hip Hop Theatre Festival with Danny Hoch and Clyde Valentin at PS122 in New York City.

**2002** Suzan-Lori Parks becomes the first Black female to receive the Drama Pulitzer Prize for *Topdog/Underdog*.

**2003**    Errol G. Hill and James V. Hatch publish *A History of African American Theatre*.

**2004**    Phylicia Rashad wins the Tony Award for Best Performance by an Actress in a Leading Role in a Play for a revival of *A Raisin in the Sun*.

**2005**    *Margaret Garner*, the opera with libretto by Toni Morrison, premieres at the Detroit Opera House.

**2006**    Ekundayo Bandele establishes Hattiloo Theatre in Memphis, TN.

**2008**    Barack Hussein Obama is elected president of the United States.

**2008**    Mark "Stew" Stewart wins a Tony Award for Best Book of a Musical for *Passing Strange*.

**2008**    Lynn Nottage wins the Pulitzer Prize for Drama for *Ruined*.

**2008**    Stephen C. Byrd, Founder of Front Row Productions, Inc., and Alia Jones-Harvey become the first Black lead producers on Broadway.

**2010**    Daryl Waters becomes the first African American to win a Tony Award for Best Orchestrations for *Memphis*.

**2010**    Tyler Perry produces the film version of Ntozake Shange's *for colored girls who have considered suicide/when the rainbow is enuf*.

**2010**    The New Black Fest is established by Keith Josef Adkins, Jocelyn Prince, and J. Holthan in Brooklyn, NY.

**2011**    The first annual DC Black Theatre and Arts Festival is held.

**2011**    Works by three Black women appear on Broadway: Katori Hall's *The Mountaintop*, Lydia Diamond's *Stick Fly*, and *The Gershwins' Porgy and Bess*, a musical revival adapted by Suzan-Lori Parks.

**2012**    Toni Simmons Henson and Wanda Simmons co-found the Atlanta Black Theatre Festival.

**2014**    Ron Simons wins a Tony Award for Best Musical as producer of *A Gentleman's Guide to Love and Murder*.

**2015**    Misty Copeland becomes the first African American to be a principal dancer with the American Ballet Theatre.

**2016**    Paul Tazewell wins the Tony Award for Best Costume Design for *Hamilton*.

**2016**    *Eclipsed* by Danai Gurira opens with the first-ever all-Black, all-women creative team and cast on Broadway.

**2017**    The National Museum of African American History and Culture opens as part of the Smithsonian Institution in Washington, DC. Its collection includes a permanent exhibition on the performing arts.

**2017**    Lynn Nottage wins a second Pulitzer Prize for Drama for *Sweat*.

**2017**    *Moonlight*, the film based on Tarell Alvin McCraney's semi-autobiographical play *In Moonlight Black Boys Look Blue*, wins the Academy Award (Oscar) for Best Picture.

**2018**    JaMeeka Holloway-Burrell establishes the Bull City Black Theatre Festival in Durham, NC.

**2018**    Poet, playwright, novelist Ntozake Shange—who inspired significant innovations in contemporary Black theatre and performance—rejoins the ancestors.

*Figure 0.8*   Marc Bamuthi Joseph and Dahlak Brathwaite perform *Scourge* in the 2005 Hip Hop Theatre Festival in San Francisco at Yerba Buena Center for the Arts. Directed by Kamilah Forbes.

*Source*: Courtesy of Kathy A. Perkins.

# PART 1

# Seeing ourselves onstage

*Thomas F. DeFrantz*

Alvin Ailey American Dance Theater performance in Indianapolis, IN, 1970s:

> We line up at the theater doors, full of anticipation. Dressed in Sunday clothes, nicer
> than what we usually wear to school, we wonder what sort of adventure this will be,
> inside this huge marble building that stretches toward the sky. We are ten-year-olds on
> an outing, having bounded from the bus under watchful eyes, being directed toward
> our section of seats in the big community theater. The lights dim and we cheer, but
> we are shushed into quiet by our teachers. We hear a curtain rise—we can't see it in
> the dark—and beautiful men and women are revealed, dancing. We hear blues music.
> We witness expression and intense emotion, stories told through bodies in motion.
> We hold our breath. We are amazed. We see ourselves in these dancers of the Ailey
> company, and we straighten our spines, we loosen our hips, we circle our shoulders, we
> snap our fingers. We dance in our seats in response. *We are enlivened.*

Part I explores the important experience of self-actualization through theatrical representation.
As Black people see ourselves working through urgent dramatic and musical/dance expression,
we imagine stronger possibilities for our shared futures, and we better understand our shared
pasts. What we see matters: who is doing the performing, who has created the experience back-
stage, and who is in the audience all contribute to the sense of satisfaction and appreciation for
theatrical expression.

When we see ourselves onstage, we begin the important process of imagining beyond the
everyday stresses and strains of living Black. Those stresses contribute mightily to the ways that
we create and perform. African American approaches to performance value improvisation, wit,
and a ferocious variety of address that create a multi-layered experience. These are tactics of
survival that encourage Black people forward.

Our artistry also emerges in the spaces of unexpected demonstration of excellence made
manifest by believing, deeply, in the power of performance to transform experience. Black
people rely on the arts as a social necessity. We grow together through continuous practice in
the arts. We sing, dance, rhyme, write, and design in creative play that extends through a lifetime

from childhood through elder status, with each generation creating new modes of performance possibility.

The journey to sharing those performances, though, has never been easy. African Americans have always struggled for the chance to express our truths publicly. In the United States, civic legislation, deeply structured traditions of economic disempowerment, and racist social norms have kept Black people from thriving in professional theatre. Historically, the institutions of theatre have shunned Black participation or only allowed for narrow, racist depictions of Black life. As Black people have struggled for basic recognitions in social life outside of the theatre, the place of professional entertainment and its artistry has held even more urgency for African Americans hungry for skillful representations.

But African American artistry will not be denied. Its inventions, burnished in the crucibles of slavery and its afterlives, continuously demonstrate excellence in the face of disavowal. The chapters in this section speak to the inventiveness of artists and theatre professionals who have resisted being placed in any box of respectability, predictability, or some narrow definition of what it means to be involved in professional African American theatre. The authors and their subjects here are an intentionally diverse group: some are queer, some are concerned with bi-racial identity, some are Broadway producers and designers, and others are writing plays about Black families. In each case, these chapters remind us of the essential function of seeing ourselves and our sensibilities in full public view, where we can be surprised and amazed at the capacities of Black life in its infinite variety.

The first four chapters here explore early efforts by Black people committed to the possibilities of professional theatre. In every case, racist disavowals so challenged these artists that they had to nimbly change their approaches to producing theatre or submerge their intentions as authors according to acceptable genres and storylines. Nadine George-Graves (Chapter 1) considers the achievements of Sherman H. Dudley, who began as a versatile vaudeville entertainer, working as a singer, dancer, actor, songwriter, and live horse-act organizer. He went on to manage one of the breakthrough Black entertainment organizations of the early twentieth century, proving a versatility that extended into strong business acumen. Sandra Mayo (Chapter 2) explores the important theatrical genre of Black historical dramas, which demonstrate that African Americans inherit a wide range of legacies worthy of remembering and retelling to new audiences. Marvin McAllister (Chapter 3) reminds us how William Brown's African Company, one of the earliest professional troupes of Black performers, suffered rioting by white marauders envious of its skilled actors and financial success. Alison Walls (Chapter 4) writes of the ways that the important Langston Hughes' play *Mulatto* (1934) aligns the quintessential genre of family drama to the quintessential American concerns with racial mixing, sexual assault, and bi-racial identity.

An interview with legendary producer and director Woodie King, Jr. (Chapter 5) underscores the difficulties of centering Black lives in the circumstances of professional theatre. Black audiences and white audiences tend to experience African American creativity differently, and they often support differing portrayals of Black life onstage. King's expertise and achievement offer beacons of excellence in this difficult, always-shifting landscape. While Broadway audiences have enjoyed King's efforts in several landmark productions, Barbara Lewis (Chapter 6) thinks through the ways that playwrights Alice Childress and Lorraine Hansberry—who worked before King formed his New Federal Theatre—championed possibilities for an emergent Black feminism in their works that supported Black freedom as an ultimate implication of theatrical representation.

We turn to art in order to better understand what happens when people are willing, or forced, to live outside of norms of propriety. Black artists do indeed look toward the edges of

everyday life to imagine transformative visions of lives in motion. Playwright Lynn Nottage follows in the path laid by Childress and Hansberry as an author often produced on Broadway whose plays tease the terms of normative living. Marta Effinger-Crichlow (Chapter 7) recounts the ways in which Nottage's entirely successful play *Intimate Apparel* wonders at sexual and racial transgressions that push at a politics of respectability for Black Americans at the turn of the twentieth century. Baron Kelly (Chapter 8) points out that actor Earle Hyman achieved an unprecedented success performing Shakespeare and O'Neill in two Norwegian languages, confirming Black excellence as a result of his focused intellect and outstanding abilities as an actor. And thinking through the tremendous plays of August Wilson, Pedro E. Alvarado (Chapter 9) helps us to begin to understand an ever-present need for the non-tangible presence of spirituality that permeates Black life.

Black sensibilities on Broadway can also take the form of design and economic production. Interviews with producer Ron Simons and designer Paul Tazewell (Chapters 10 and 11) underscore the important presence of Black visioning that happens out of the direct view of the theatrical audience. Simons and Tazewell have each received Tony Awards for their work in theatre, an accolade of the highest order available to theatre professionals.

*Mama, I Want to Sing!* in New York City, 1980s:

> We line up at the theater doors, smiling and happy to be together at an unusual location. Although we are in Manhattan, we are not at a Broadway theater, but rather a theater inside a museum that has been turned over to the long run of a gospel musical. Most of us are older, and have come with our church groups, decked out in elaborate finery that shows off style without being too flashy. But we are also young artists in New York, hungry for the taste of home back in the Midwest, or down South, or even out West. Now that we've moved to the Big Apple to find our way in theater, we gather to be in the presence of the people at the play. Slipping inside to sit in a small group among the many larger congregations of elders, we disregard the simplistic lighting instruments and the crackling hisses of a sound system in need of an upgrade. The play begins when it needs to—long after the ticketed time—and we pay attention as we will, when the action surprises us into cheering, booing, testifying alongside, or calling out to the characters onstage. We go up when one of the characters reaches into the arm cushion of a sofa and pulls out a microphone connected to a Mr. Microphone amplifier and begins her song. This performer came prepared with her own sound system! We smile, cry a bit, laugh, and enjoy the wholeness of our time together, *entirely delivered* by the end of the show.

Music and dance hold profound influence in Black life, so it should not surprise us that opera and musicals have provided important routes to public expression for scores of professional artists. Opera welcomed outstanding African American singers—especially women—in leading roles originally written for whites long before television or film followed suit. Twila Perry (Chapter 12) helps us understand how opera has expanded its possibilities by including artists of color, even if those artists did not immediately alter the demographic makeup of audiences for opera. Sam O'Connell (Chapter 13) reconsiders the narrative content of *The Wiz* in terms of its connection to African diasporic lives and the construction of a Black "home" that might nourish us in our various migrations.

Chapters 14 and 15 consider the legacies of the important 1921 Broadway production of *Shuffle Along*. That musical brought together an array of accomplished artists in a commercial and creative success the revitalized Black presence in New York professional theatre.

Researchers in this volume explore how calls for Black economic independence intersect with the difficulties of producing resource-intensive Broadway musicals. Paula Seniors (Chapter 14) notes that *Shuffle Along* was revived in an altered version led by outstanding Black artists in 2016, only to succumb to the vicissitudes of economic pressures and close, prematurely. Sandra Seaton (Chapter 15) offers a highly personal account of Black theatre as a family affair that suits the needs of its practitioners, including Black people eager to applaud the raucous comedic efforts of usually respectable community members.

Seaton's chapter provides a pivot toward thinking about how Black people engage theatre to imagine progressive futures and to illuminate the always-necessary, non-normative ways of being in the world. Black people enjoy seeing ourselves in excellence within popular modes of entertainment that are not necessarily of our own making. While we create so many forms of popular music and social dance, African American artists also excel in forms created by others. Experimental dance and theatre have always attracted Black participation, even when the audiences for these exquisite works might be small in size. In Chapter 16, prize-winning dance writer Eva Yaa Asantewaa offers insight into her method that allows her to valorize the achievements of queer artists of color (among others, of course) as she emphasizes the importance of documenting and reflecting upon performance in literary form. Her prescient commentary confirms: if we don't learn to write about our creative exercises, how will future generations know what we have done?

Nappy Grooves Drag Kings performance in Cambridge, MA, 2000s:

> We arrive at the small college theater, glammed out and ready to play. We wear shiny shoes, and sport retro-disco afros next to dreadlocks and fringe. Skin showing: beautiful tones of black, brown, and beige. We nod each to the other, too cool to speak much at first, but basking in the affirmation of being queers of color together. The show, we know, will be dope: the touring drag king company from the Bay Area will headline and some of the local queens and kings will also perform. Inside the theater we greet each other more heartily: hugging and smiling, swaying with bodies close together, admiring bling and snatched-ness. We ask for news of others who haven't come. "Are they good?" The music screams a fanfare, and we holler as one, never bothering to sit in the too-small theater seats. We are ready to be transfixed by the playful illusions of gender shift; and to bear witness to the theatrical monologues about Black Trans lives interpolated throughout the show. We know these stories and we need to hear them told again, amid the technologies of the theater space. Here, *we love ourselves wholly and fiercely*, in our always-shifting gendered and sexualized variety.

The final three chapters in this section explore sexuality as an essential aspect of African American theatricality as well as a crucial aspect of Black being in the world. Beth Turner (Chapter 17) explores the extraordinary work of dramatist Pearl Cleage, whose plays explore an unapologetic Black women's sensual strength. Rhone Fraser (Chapter 18) looks at Leslie Lee's archetypal family drama *First Breeze of Summer* to consider how gender nonconforming Black youth find a way toward maturity within the difficult strictures of acceptable social relations. Finally, Tabitha Chester (Chapter 19) offers an excellent overview of the groundbreaking work of Pomo Afro Homos, the experimental performance group that galvanized Black queer performance in the shadow of the 1980s first-wave AIDS crisis.

Taken together, these chapters confirm what my memories of attending Black theatre imply: that seeing ourselves onstage helps us conjure who we have been, who we are, and who we might want to be.

# 1

# DUDLEY, THE SMART SET, AND THE BEGINNING OF THE BLACK ENTERTAINMENT INDUSTRY

*Nadine George-Graves*

There are, of course, many key figures in the early African American professional entertainment industry. Individual men and women, a generation away from slavery, breaking through the walls that prevented them from earning a living—sometimes by chipping away and sometimes with a sledgehammer—made names for themselves through talent and ambition. On the one hand, singling out one particular figure is a disservice to the many other important individuals of this era. On the other hand, too often histories become blurs, generalized in the pursuit of breadth over depth. There were many shows, venues, and performers that each deserves dedicated essays. And there are many ways to describe these early artists and analyze their significance in American history. One could trace the developments of musical styles or dance steps. One could do close readings of theatrical scripts. One could compare Black vaudeville traditions to white vaudeville traditions. In this chapter, I attempt to lend insight into the Black vaudeville industry as the progenitor of the Black entertainment industry by focusing on the story of one key figure. I did not choose to detail the career of Sherman H. Dudley (Figure 1.1) at random, however. Because Dudley had a long career as an entertainer, stage manager, producer, and entrepreneur, because he became a major player with the Smart Set Company, and because he became an owner of (and the face of) the Theatre Owners Booking Association (TOBA or Toby), the largest management organization of Black talent at the time, his experience allows for a balance of breadth and depth in this short discussion.

Sherman H. Dudley was likely born sometime between 1870 and 1872 (accounts differ) in Dallas, Texas. He started out as a jockey and relied on his equine knowledge when he moved into show business and developed his signature acts with performing horses and mules. Also known as the Lone Star Comedian, he started out in medicine shows as a singer and moved on to tent shows and minstrel shows singing, dancing, composing, giving stump speeches, and developing a comedic style that was minimalist yet clever. The complexity of ethics and aesthetics seen in Dudley's repertoire was emblematic of issues for the enterprise at large. For example, Dudley wrote a number of hit "coon songs," like "Mr. Coon, You'se Too Black for Me"; performed in a number of "coon shows," like *A Holiday in Coonville* (self-produced) and *Coontown Golf Club* produced by Tom Brown and Sam Cousins; and performed with several

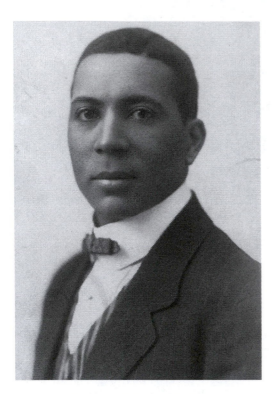

*Figure 1.1*   Sherman H. Dudley (aka Loan Star comedian) African American vaudeville performer and theatre entrepreneur (date unknown).

minstrel companies.[1] He also had his own minstrel troupe for a year—S.H. Dudley's Georgia Minstrels, 1897–1898, based in Galveston, TX. We look back on these activities for their role in perpetuating denigrating stereotypes; at the same time, we recognize the ways in which early Black performers were limited in the scope of representations afforded them onstage. Though he began in minstrelsy and wrote "coon" songs, Dudley went on to abandon blackface, create signature musical comedy routines that were less degrading, and move into the business end of performance. One of his most significant career moves happened in 1904 when he joined the Smart Set Company, starred in its shows, and took over management of its productions.

The actor-manager system of producing a theatrical event was an established business process in Europe (and later the United States) beginning in the sixteenth century and gaining popularity in the nineteenth century. In this system, a leading man of a serious performance genre, like Shakespeare or a "straight" tragedy, would assume responsibility for assembling a cast, booking a venue, publicity, ticket sales, payments, etc. Because the genres of serious, tragic, or Shakespearean performance were largely denied to African American artists, leaving only music and comedy in their many forms (musical-comedy, variety, minstrelsy, vaudeville, tent shows, etc.), the person who usually assumed primary responsibility for organizing a Black performance became the comedian. At that time, Black entertainment (performances by people of African descent for people of African descent) was a burgeoning professional industry, and stage aesthetics were consolidating into a commercial genre. Business-minded performers saw the value in organizing and managing this work. Dudley became one of the most successful comedian-producers in early Black entertainment. The comedian-producer, like the actor-manager, was

often the star of the show and had the most invested in it—if not always in terms of money then certainly in terms of reputation. This person had to have a recognizable name and a popular act that could draw audiences. But to be successful as a comedian-producer the person needed business acumen as well as talent. Administration and artistry went hand in hand, and the most significant accomplishments of the comedian-producer were, first, in establishing the economics of the early Black entertainment industry, and, second, in shifting the aesthetics of the industry away from demeaning stereotypes of the inherited minstrel formulas toward more accurate representations of Black life while maintaining comedic value. Even when the performers continued to use burnt cork or grease paint to darken their skin, reviewers and audiences recognized that the characters they portrayed were more identifiable and that their expressions were less exaggerated and more natural.

As will be discussed below, the difference in responses to this observation between Black and white spectators provides insight into contemporaneous racial politics. The characters and performances of the early Black entertainment industry were aimed primarily at Black audiences, not white ones. And though they had been conditioned to find the stereotypes funny, Black audiences grew to demand more from their performances. More people recognized the stakes at play in the portrayal of Black life and behavior onstage, and with that increased awareness came more vocal opposition to stereotypes. Comedian-producers along with theatre critics in Black newspapers mounted a campaign to maintain and elevate musical comedy standards for performance while doing away with stereotypes that impeded the social progress of the race.

The Smart Set Company, managed by Dudley for a time, is an important example of this push for social progress. First, it was significant that the company was known as the "Smart Set," a term that came into use in the 1890s to refer to fashionable high society. While the use of the term for a Black touring performance company not only evoked Black sophistication, perhaps to the point of dandyism, it also signaled a claiming of high-class status for Black bodies. This negotiation of high and low, authentic and stereotype, poignant and playful was all part of the repertoire of the Smart Set. Though the reviews of individual acts and numbers were mixed, critics made a point of recognizing moments in performances that signaled a broader range in the depiction of African American life, particularly depictions of decorum and grace that encouraged both performers and audiences to value works that moved away from minstrel stereotypes. For example, one reviewer stated that "the ruling stars ... left an impression for good as it concerns the colored people's capacity and aptitude for all lines of theatrical work" and "it sought to put a better front to Negro life" ("Stage" n.p.). Performing class in this public way helped to create a popular glamour as depiction of and rehearsal for life and the success of the Smart Set influenced other Black theatrical endeavors to perform with similar codes of respectability and propriety.

The Smart Set is also noteworthy for having traveled to the South as a non-blackface minstrel theatrical endeavor. Though the performances were generally praised by Black theatregoers, as the tour continued reports of dissatisfaction among white patrons increased with threats of violence and general resistance. The basis for much of these hostilities was the "overstepping" of Black performers both on and offstage. They increasingly refused to perform the docile, happy darky, either as actors or as citizens, resulting in responses ranging from annoyance to anger by many (but not all) white people. One significant example came when they performed in New Orleans, in 1903, at the "mainstream" (read white) Crescent Theater. Previews in *The Daily Picayune* excitedly anticipated "good old colored ragtime and the side-splitting comedy" ("Crescent Theater" n.p.). The balcony was reserved for "colored people" with seats on the lower floors for whites, who usually sat in the balcony. Although this would become the segregation practice of "nigger heaven" (balcony seating), at the time it was seen as a sign of progress

for Blacks since they were actually permitted to enter the door of the theatre in large enough numbers to occupy the whole balcony. However, the very next day, reviewing the opening night's performance, the same newspaper railed against Black bodies in elegant clothes, speaking "proper" multisyllabic English. In other words, the producers of the Smart Set were being "uppity" by pushing against minstrel stereotypes.

> The negroes sing and dance well, but they make an incongruous picture when they wear rich costumes. And it does not sound right to Southern ears to have them dropping off their lips five and six syllable words. Yet for all of this, "The Smart Set" does not descend into vulgarism, and the unpolished fun, uncultivated singing and the natural dancing goes along for three acts with a swing. It is questionable, however, whether a first class theater should darken its stage with such attractions.
>
> ("The Smart Set" n.p.)

Though the critics seemed impressed that the company managed to not be too vulgar, there was clearly a line that it had stepped over. The consequence for its "offense" (daring to eschew the old happy-darky routines) was the complete banning of African American touring companies from booking in any New Orleans theatre for nearly seven years. It was only after a Black-owned theatre, Temple Theatre, opened in 1909 that a Black touring company was allowed to return to the city. However, it is important to note that African American touring performers were allowed to return but only to "their" place, a Black space. The Tutt Whitney Musical Comedy Company (comprising members of the second Smart Set) that opened at the Temple Theatre that year was the first Black company to perform since the Smart Set had "overstepped."

> New Orleans has suffered the want of good, first-class shows for a long time. In fact, ever since the Smart Set played at the Crescent Theater years ago and won the unbounded adoration it did, and cause the envy and jealousy that have barred colored shows out of the white theaters from that time, there has been a popular demand among the colored people of New Orleans for the Smart Set, or shows of that class, to come back. But the coming back of such shows has been out of the question until Messrs. Kilduff and Cheevers opened the Temple Theater.
>
> (Abbott and Seroff 87)

There are a number of ways to look back at this moment in history with our twenty-first-century analytical gaze and sensibilities. First, one is outraged (though maybe not totally surprised) at the systemic racism that prevented African American traveling artists from performing in New Orleans for so long. And one rails against the injustice and feels for the Black citizens of New Orleans who would have wanted to see such shows, particularly since the shows received "unbounded adoration" from the (presumably) Black audience members. Second, one might notice what is entrenched in the loaded compliments of words like "unpolished," "uncultivated," and "natural" that operated to undermine African American performers' talent, training, hard work, and skill. Third, one might think about the impact that banning Black shows had on the economy of the industry, both for Black touring companies as well as for the local New Orleans economy. White theatres could afford to keep these shows out of town. Patrons who wanted to see those shows, who were presumably mostly African American, did not have enough political, social, or economic clout to get this decision overturned. The performers and producers of traveling companies were denied income that would have come from performing in New Orleans.

Widespread adoption of this policy might have meant the end of one of the first viable Black enterprises before it truly began. However, this ban also signaled an important shift in the power dynamics of the entertainment industry. The establishment of the Temple Theatre signaled an increase in both the economic status of Black residents and the entrepreneurial venture of impresarios who moved beyond the itineracy of traveling shows in white venues and ventured into the permanency of real estate. Because African American patrons did not have a venue to see performers who looked like them, savvy business men (gender intentional) increased the number of Black theatre spaces throughout the southern and mid-Atlantic states to cater to this demographic, which had increasing disposable income. This and similar incidents in turn inspired artist-entrepreneurs like S.H. Dudley to later buy up theatres for Black audiences and create Black performing circuits so performers could book tours in a more organized manner than going on their own and dealing with the exploitative practices of white owners. TOBA became the most successful of these endeavors. To be sure, the racism at the root of banning Black performance was unjust, but the result of this and similarly oppressive practices was the development and expansion of an important era in African American theatre.

Dudley joined the third incarnation/season of the Smart Set. This incarnation produced the musical comedies *The Black Politician*, *Dr. Beans from Boston*, and *His Honor the Barber* with large casts that helped create the Black musical comedy structure with more complicated (albeit mainly ridiculous) plots. Dudley's prior training as a jockey allowed him to create unique acts with horses and mules. For example, in *The Black Politician*, Dudley rode a horse onstage, and in *His Honor the Barber* he created what was to be his most famous act in which Patrick,[2] a donkey dressed in blue overalls, engaged in witty repartee with Dudley, appearing to answer his questions. This production was also significant for working to undermine "nigger heaven." Instead of relegating Black patrons to the balcony, this production created a number of sections throughout the house where Black audience members could sit. Although still segregated, this policy contributed to the larger discussion about better treatment for African Americans in US theatres.

When interrogating the significance of these performances it is important to weigh the complexity of audience expectations enmeshed in complicated and often contradictory racial negotiations. While the Smart Set Company received many favorable reviews, it was also criticized for looking "too white" and, at the same time, too stereotypically Black. Dudley's history in minstrelsy both influenced his aesthetic and plagued his image. Blacking-up was moving out of favor as more Black audience members rejected the convention, but it was not yet verboten. Lighter-complexioned dancing girls were preferred due to beauty standards based in colorism. On balance though, its productions were considered a successful trailblazing enterprise, and Dudley was credited with revitalizing the show and making it an important example of American popular performance.

After leaving the Smart Set, Dudley went on to manage TOBA, the Theatre Owners Booking Association. For a Black performing artist, life on the TOBA circuit was certainly better than previous options or going it alone. Toby-time was considered the "big-time" in Black vaudeville. Most of its shows were 45 minutes long and played three times a night, typically featuring about 35 artists (singers, dancers, actors, comedians, and musicians). However, performers with TOBA still complained of mismanagement, ill treatment, subpar pay, and unbearable Southern racism. It soon earned the nicknames Tough on Black Actors and Tough on Black Asses. In the South, performers still had to use service entrances instead of the front doors of theatres, hotels, and restaurants. They had to dress below their station and conduct themselves in a manner that would not attract attention from jealous white (perhaps poorer) townsfolk. Black artists on

TOBA had to navigate thin lines of racial sociability while recognizing that the better guarantee of work and increased demand for Black acts was good for business and their livelihoods. Though it was far from perfect, this kind of organized exposure had not been available prior to the establishment of TOBA.

This brief discussion points not only to the ways in which Africanist aesthetics developed in the United States to create an industry, but also to the ways in which that development was part and parcel of larger national conversations about ability and possibility for the Black race. The national psychic debate around the limits of equality that would be afforded African Americans was borne on the backs of performers in unique ways. The field, which offered more opportunities for African Americans, was also the field in which the seeds of unconscious (and conscious) bias were planted. In other words, Black vaudeville was an important site for both possibility and limitation. Deliberations about blackface, segregated seating, the effects of stereotyping, the prospects of more "respectable" performance styles, the importance of accurate depictions of Black life, uplift, etc. all influenced and were influenced by what took place on an increasing number of stages in front of a growing number of Black audience members who were seeing themselves represented onstage by more Black performers as well as a growing number of white audience members who were seeing more actual Black bodies. From the 1880s to the 1930s there was a grand reckoning taking place on Black vaudeville stages.

## Notes

1 He appeared in Richards and Pringle's Georgia Minstrels (star billing), Rusco and Holland Minstrels, McCabe and Young's Operatic Minstrels, P.T. Wright's Nashville Students (with A.P. Harris), Sam Corker, Will Marion Cook's *Clorindy* company, the production on *King Rastus* with Billy Kersands (a frequent collaborator), and the production of *A Hot Old Time in Dixie* with Tom McIntosh.
2 Some sources say the name of the donkey was Shamus O'Brien.

## Works cited

Abbott, Lynn, and Doug Seroff, *Ragged But Right: Black Traveling Shows, "Coon Songs," and the Dark Pathway to Blues and Jazz*. UP of Mississippi, 2012.
"Crescent Theater." *New Orleans Daily Picayune*, Nov. 15, 1903.
"'The Smart Set' at The Crescent Theater." *New Orleans Daily Picayune*, Nov. 16, 1903.
"Stage," *Indianapolis Freeman*, Mar. 21, 1903.

# 2

# BLACK THEATRE HISTORY PLAYS

## Remembering, recovering, re-envisioning

*Sandra M. Mayo*

The first known Black theatre troupe in America can be traced to William Alexander Brown's African Company (1821–1823) at the African Grove Theatre in New York City. Brown, founder and manager of the African Company, also wrote and produced the earliest known Black play, *The Drama of King Shotaway* (1823), a historical rendering of the Black Carib War in St. Vincent in 1796 (Hill and Hatch 27). In 1858, self-educated former slave William Wells Brown wrote *The Escape; or, a Leap for Freedom,* a historical account of the evils of slavery based on his own experiences. William Easton contributed to the genre with two plays on Haitian emperors, *Dessalines* (1893) and *Henri Christophe* (1912), produced in Chicago and New York City, respectively. Thus, historical recovery and reimagining through drama traversed the first half of the twentieth century in African American theatre. This creative impulse persists in contemporary playwriting with celebrated examples, including Jeff Stetson's *The Meeting* (1990), Carlyle Brown's *The African Company Presents Richard III* (1993), Philip Hayes Dean's *Paul Robeson* (1997), Anna Deavere Smith's *Twilight Los Angeles* (1992), and Katori Hall's *The Mountaintop* (2009). Black historical theatre celebrates and preserves Black culture in the tradition of the African griot (storyteller/oral historian)—remembering, recovering, and re-envisioning historical narratives on the stage. After defining the history play genre, this chapter analyzes the genre in terms of its purpose, theatricality, and themes in the pioneering period from the early 1800s to the 1960s.

## Defining the genre

As a genre, the history play's earliest form harkens back to Aeschylus' *The Persians* written in 472 BCE, an extant work that celebrates a famous Athenian naval victory (Gainor 90). During the Medieval period (*c.*600s CE to mid-1600s), the history genre took the form of re-enactments celebrating the lives of saints and biblical stories. Codification of the genre began to emerge during the Renaissance with the historical renderings of Christopher Marlow's *Edward II* (1594) and William Shakespeare's chronicles of monarchs such as *Richard III* (1597) and *Henry V* (1599) (Ribner, "Marlowe's"; *English History Play*). The *First Folio* (1623) publication of Shakespeare's plays cataloged them as tragedies, comedies, and histories, though the history classification was limited to the lives of monarchs. Historical drama up to that point was mainly a combination of fact and fiction based on historical narratives.

Scholar Gary Dawson notes the emergence of documentary drama with Georg Buchner's *Danton's Death* in 1835 (166). Most of *Danton's Death* features verbatim documentation from primary sources. The word "documentary" enters the lexicon in February 1926 in a review of a British film by John Grierson who defined the documentary as "creative treatment of actuality" (Dawson 224–225). The term, used by Brecht in 1926, came to be associated with German director Erwin Piscator's epic and documentary plays. Dawson notes a principal shift with documentary theatre from the Aristotelian paradigm—exposition, complication, recognition, reversal, complication, and resolution—to a non-Aristotelian one of montage, juxtaposition, historical documentation, distantiation, direct address, audience participation, and total theatre (279).

Although definitions of plays that retell history are fluid and varying among artists and scholars, historical theatre showcasing factual material falls under the generic term *history play*. Three genres come under this term. One coinage for the most prevalent subgenre is *historical drama*, fictionalized drama based primarily on actual events gathered mainly from *secondary* sources. Docudrama, one of its major descriptors, is also used to identify documentary drama, causing some confusion because of the overlap. Historical drama takes the form of prose or verse, straight or musical, myth or realism or combination of these elements. *Documentary drama*, created with facts derived mainly from *primary* sources, is the second key subgenre of history play. Its main descriptors include verbatim theatre and theatre-of-fact (Hammond and Steward). The *historical pageant* is the third key form of the history play. "Too pictorial to be a parade, but not dramatic enough to be a play, pageants—with their music, costume, dance, narration and tableaux—reenacted historical events" (Shine and Hatch 86). For clarity, this chapter uses history play as a general umbrella term and differentiates between the subgenres using the terms historical drama, documentary drama, or historical pageant (except in direct quotes).

African American playwrights up to and through the 1960s and beyond embraced the history play most often in the form of the historical drama (combination of fact and fiction). In the 1930s, Langston Hughes pioneered Black documentary drama (mainly factual) as agitation propaganda with his political plays (Hughes and Duffy). In 1913, W. E. B. Du Bois pioneered the African American historical pageant (panoramic collage).

## Purpose

Theatre historian Udo Hebel notes that, "Historical plays were to serve as sites of memory … display[ing] agency, achievement, and endurance even under the most repressive, dehumanizing circumstances" (54). Former enslaved playwright William Wells Brown used his personal memories of slavery in *The Escape; Or a Leap for Freedom* (1858) to educate Northern sympathizers about the realities of slavery. In 1925, Arthur Schomburg asserted that Black history plays offer "a future oriented, revisionary recognition of the American Negro as an active collaborator, and often a pioneer, in the struggle for his own freedom and advancement" (qtd. in Hebel 54). Carter G. Woodson, founder of the Association for the Study of Negro Life (1915) and other significant history initiatives, promoted Black history in dramatic form for educational purposes. His sponsorship led to the publication of *Plays and Pageants from the Life of the Negro* (1930) and *Negro History in Thirteen Plays* (1935). Woodson's ideas challenged monocultural versions of American history regarding the dramatization of a new America, the symbolic enactment of examples of the New Negro as a maker of civilization in Africa, a contributor to progress in Europe, and a factor in the development of greater America (Hebel 54; Richardson and Miller iv–v).

Social scientist, co-founder of the NAACP, and founding editor of the NAACP's *The Crisis* magazine, W.E.B. Du Bois promoted the theatre as a tool for agitation/propaganda. With his historical pageant, *The Star of Ethiopia* (1913), and other initiatives, including the founding of the Krigwa Players (1929), he significantly shaped the mission of the history genre into self-affirmation and advocacy for equal rights. Charting a different path from Du Bois in the 1920s, Howard University professors Montgomery Gregory and Alain Locke called for an emphasis on the folk drama stories of rural Blacks that document their joys and sorrows. They mentored many Howard University student/playwrights who blended their own goals with those of Du Bois, Gregory, and Locke in writing historical dramas and pageants. In the promotion of the history genre, May Miller and Willis Richardson were Gregory and Locke's best-known disciples.

## Theatricality

The theatrical style of Black history plays varied with each author. Of the 60 history plays documented by this research from the early 1800s to the mid-1960s, the dominant subgenre was the historical drama: fact with fiction embellishment. A few examples include William Easton's *Christophe* (1911), Randolph Sheppard Edmonds' *Denmark Vesey* (1929), Owen Dodson's *Amistad* (1939), and Theodore Ward's *Our Lan'* (1947). Historical dramas, paying homage to Black heroes, often fit the pattern of melodrama with good and evil characters clearly delineated and good triumphing, as in May Miller's *Harriet Tubman*. The hero treatises were also historical tragedies with the hero defeated and killed, though not before demonstrating an undaunted will to fight for freedom and dignity, for example, Randolph Sheppard Edmond's *Nat Turner*. In *Black Heroes* (1989), Errol Hill documents the criteria for the Black hero protagonist:

- He or she should pursue a goal that leads to betterment of mankind.
- The goal should become a passion.
- The hero should not expect to receive material gain.
- [The] hero should be willing to risk life, if need be, in carrying out this self-imposed mission.
- [T]he hero is driven by a superior force that sustains him [or her] in the quest and allows him [or her] to endure whatever hardships are experienced in striving toward the goal.

(viii)

Black historical dramas were often one-acts. Teacher/playwrights found the shorter form best for their young audiences, plays like May Miller's *Christophe's Daughters* and Georgia Douglas Johnson's *Frederick Douglass*. However, representative longer works such as Brown's *Escape*, in five acts, and William Branch's *In Splendid Error*, in three acts, demonstrate the diversity in range.

In the Black historical drama, language indicates the character's education, the verbal creativity of the playwright (poetic dramas), and the political perspectives of writers, editors, and producers. As early as 1858, Brown demonstrated flexibility with dramatic dialogue in *The Escape; or, a Leap for Freedom*. He starts with the dialect of the Black comic character Cato: "I allers knowed I was a doctor, an' now de old boss has put me at it" (Hill and Hatch 39). Then, he switches to the elevated language of Glen, the slave suitor of mulatto slave Melinda: "How slowly the time passes away. I've been waiting here two hours, and Melinda has yet to come. What keeps her I cannot tell" (40). Melinda speaks even more eloquently than Glen: "It is often said that the darkest hour of the night precedes the dawn. It is ever thus with vicissitudes of human suffering" (41). Brown adds a poetic language song in Glen's tribute to the North Star:

Star of the North! Though night winds drift
The fleecy drapery of the sky
Between thy lamp and me, I lift,
Yea, lift with home my sleepless eye,
To the blue heights wherein thou dwellest,
And of a land of freedom tellest.

(Shine and Hatch 55)

Langston Hughes is among the Black playwrights who developed historical plays in verse such as *Don't You Want to Be Free* (1938). This play includes many of his well-known poems. Owen Dodson's *Ballad of Dorie Miller* (1943) is a poetic tribute to the Black hero of World War II.

Dialect or standard English: that was the question. In Richardson's *Plays and Pageants* (1930), he announced that the plays "must for the most part not be written in dialect," [noting] the difficulty because "most plays by Negro authors are written in dialect" (xlv). Indeed, many plays written by Black females before the 1960s employed dialect to represent authentic folk culture. In 1934, Randolph Sheppard Edmonds, a graduate of Oberlin College and Columbia University, prolific playwright, director, and professor defended the use of dialect, stressing its authenticity (Hill and Hatch 264). Edmonds' *Nat Turner* and Miller's *Harriet Tubman* were among the plays written in dialect or a combination of dialect and standard English depending on the character. However, plays by Black authors chronicling the Haitian revolution were dialect free; even the most uneducated ex-slave, Dessalines, who rose to power as a great military leader and emperor, spoke standard English in Langston Hughes' *Emperor of Haiti* (1936). The re-imagining of the Haitian revolution in English was complicated by the fact that the Black Haitians' native language was Kreyòl, with French the forced second. Thus, playwrights avoided the challenge of creating authentic vernacular speech by using standard English dialogue.

Black historical dramas like Hughes' *Troubled Island* (1936) and Pauline Elizabeth Hopkins' *Peculiar Sam, Slaves Escape; or, the Underground Railroad* (1880) often included songs—Black spirituals and gospels. Hughes' *De Organizer: A Blues Opera* (1939), written during the height of the depression, musically charts the labor challenges of the time. Black historical pageants traditionally combined verse, prose, and music, as in Hughes' *Don't You Want to Be?* (1938). African American music enhanced Du Bois' pageant, *Star of Ethiopia*. In its 1915 performance in Washington, DC, the pageant featured 1,200 performers, including 200 singers with J. Rosamond Johnson as the musical director.

## Thematic overview

Though a few historical works explored biblical and military history, the dominant themes have been slavery, Black heroes, and contributions of the race to civilization. Black playwrights returned frequently to the Haitian Revolution (1791–1804), during which self-liberated slaves successfully ousted their colonizers and re-took their freedom and country—Easton's *Dessalines* (1893) and *Christophe* (1911), Hughes' *Emperor of Haiti* (1936), and Miller's *Christophe's Daughters* (1936). Many of the plays chronicling Black heroes celebrated those who courageously fought against slavery—Branch's *In Splendid Error* (1954), Edmonds' *Nat Turner* (1935), and Miller's *Harriet Tubman*. Another popular theme was the fight for equity and justice, as seen in Hughes' *Mulatto* (1935) and his documentary labor plays such as *Scottsboro Limited* (1932). The pageants' themes, like those of Du Bois' *Star of Ethiopia* (1913) and Frances Gunner's *The Light of Women* (1930), often focused on a survey of Black

contributions to civilization and Black freedom and integrity. In 1913, *Star of Ethiopia* had the highest participation and attendance rate of any Black historical production up to the 1960s—more than 14,000 spectators and 350 performers; the 1915 restaging included 1,200 performers (Hill and Hatch 201).

Remembering, recovering, re-envisioning for the sake of education, entertainment, and glorification of Black participation on the world stage—these were the goals and achievements of Black playwrights who transformed historical narratives into history plays from the 1800s through the mid-1960s.

## Works cited

Dawson, Gary F. *Documentary Theatre in the United States: An Historical Survey.* Greenwood Press, 1999.

Gainor, J. Ellen, et al., editors. *The Norton Anthology of Drama*, vol. 1, 2nd ed. W.W. Norton, 2014.

Hammond, Will, and Dan Steward, editors. *Verbatim, Verbatim: Contemporary Documentary Theatre.* Oberon, 2009.

Hebel, Udo J. "'Not a Story to Pass On?' The Pluralization of American Memory in Historical Dramas by Harlem Renaissance Women Playwrights." *American Multiculturalism and Ethnic Survival*, edited by Renate von Bardeleben, et al., Peter Lang, 2012, pp. 51–65.

Hill, Errol G., editor. *Black Heroes: Seven Plays.* Applause, 1989.

Hill, Errol G., and James V. Hatch. *A History of African American Theatre.* Cambridge UP, 2003.

Hughes, Langston. "Troubled Island/Emperor of Haiti." *The Collected Works of Langston Hughes*, vol. 5, U of Missouri P, 2002, pp. 16–51.

Hughes, Langston, and Susan Duffy. *The Political Plays of Langston Hughes.* Southern Illinois UP, 2000.

Ribner, Irving. *The English History Play in the Age of Shakespeare*, Routledge, 2005.

———. "*Marlowe's Edward II and the Tudor History Play.*" *ELH*, no. 4, pp. 243–53.

Richardson, Willis, editor. *Plays and Pageants from the Life of the Negro.* UP of Mississippi, 1993.

Richardson, Willis, and May Miller, editors. *Negro History in Thirteen Plays.* Associated Publishers, 1935.

Shine, Ted, and James V. Hatch, editors. *Black Theatre USA.* Free Press, 1996.

# 3

# "HUNG BE THE HEAVENS WITH BLACK" BODIES

## An analysis of the August 1822 riot at William Brown's Greenwich Village Theatre

*Marvin McAllister*

During the fall of 1821, William A. Brown, a retired ship's steward turned theatrical impresario, relocated his entertainments to an unassuming wood building in the sleepy, farming Village of Greenwich, New York. His new theatre rested at Mercer and Bleecker, one block west of Broadway, which was not yet the theatrical nexus we know today but an emerging leisure destination. Each summer this thoroughfare hosted James West's Broadway Circus, a unique entertainment featuring horseback riders, dancers, and clowns in blackface.

Throughout the summer of 1822, a heated rivalry escalated between these circus performers and Brown's all-Black company. In July, Ira Aldridge, who would later become a renowned Shakespearean actor, was beaten by a circus rider named James Bellmont.[1] A month later, on August 10, more circus workers descended on Brown's theatre. The *New York Spectator* recounted the riot in an article titled "Unmanly Outrage":

> Saturday night a gang of fifteen or twenty ruffians, among whom was arrested and recognized one or more of the Circus riders, made an attack upon the *African Theatre*, in Mercer-street, with full intent, as is understood, to break it up root and branch; and the vigour of their operations is reported to have corresponded fully with their purpose. First entering the house by regular tickets, they proceeded at *quick* time, to extinguish all the lights in the house, and then to demolish and destroy every thing in the shape of furniture, scenery, &c. &c., it contained. The *actors* and *actresses*, it is said, were fairly stripped like so many squirrels, and their glittering apparel torn in pieces over their heads: the intruders thus completely putting an end to the play for the night.[2]

The *Spectator* recounted this violent intrusion as a fully coordinated assault on property. Police records further describe how rioters broke up "the benches and making clubs with them" proceeded to "injure scenery." According to Brown, his new venture was "injured" to the tune of nearly two hundred dollars (Thompson 103). However, the rioters violated more than the material; they humiliated these Black bodies by stripping them from their costumes. According to court documents, manager Brown was seriously beaten by George Bellmont, James Bellmont's

brother (105). Historians Emma Lapsansky and Paul Gilje have examined why Black bodies and institutions became focal points for nineteenth-century white aggression. In her work on Black churches in Philadelphia, Lapsansky found that whites targeted houses of worship because they symbolized African American progress, arrogance, and perhaps moral superiority (62–65). Gilje, concentrating on New York, found that Black churches, mutual aid societies, and theatres were violated for many of the same reasons (153–157). Gilje further disaggregated Brown's rioters to uncover racial, familial, occupational, and even recreational motivations.

In my previous work on Brown's entertainments, I have positioned this rivalry between James West's counterfeit Black performers and real Negro thespians as ground zero for the emergence of blackface minstrelsy (McAllister). This more comprehensive riot analysis examines how Brown's groundbreaking African American theatre emerged as a target for representational *and* physical assault. The August 10 riot was the culmination of a racialization process engineered by white New Yorkers, a representational process that marked Black bodies as political, cultural, and criminal threats. In addition, this physical attack could be attributed to Brown's spatial experiments with class and integration. His egalitarian audience policies failed, which perhaps demonstrated the impossibility of real equality in early national New York.

In August 1821, Mordecai Manuel Noah, editor of the *National Advocate*, began the racialization of these Black entertainments with an editorial on Brown's original pleasure garden, which Noah dubbed the "African Grove." Brown's ambitiously posh garden was located on Thomas Street in the heart of Manhattan and provided open-air entertainments to Afro-New Yorkers denied admission to white pleasure gardens. After a couple of months serving Black social climbers, Noah branded the garden a nuisance: "it appears that some of the neighbors, not relishing its jocund nightly sarabands of these sable fashionables, actually complained to the Police, and the avenues of African Grove were closed by authority"[3] (African Amusements, 2). Noah's paper and Brown's neighbors deemed this colored entertainment a threat to quietude. More importantly, this first representational assault slyly questioned whether Brown's "sable" bodies could ever be legitimately counted among the ranks of Manhattan's fashionables.

Noah's racializing coverage escalated from humorous pieces about African Grove attendees to serious commentary on the political threat posed by Black citizens. In addition to editing a newspaper, Noah was a Republican political operative deeply concerned with the close ties between the Black community and the rival Federalist Party. Theatre historian Samuel Hay has documented how Noah used a fear of the free Black vote to sway an August 1821 New York state constitutional convention (6–9). The convention featured a Republican-Federalist showdown over an amendment that would permit all white males to vote and require Black male voters to own $250 in property. At the end of an article about Brown's upcoming *Richard III*, Noah exposed the political ambitions of Afro-New Yorkers:

> they are determined to have balls and quadrille parties, establish a forum, solicit a seat in the assembly or in the common council, which, if refused, let them look to the elections. They can outvote the whites, as they say.
>
> (September 25, 1821, 2)

Noah's political fear-mongering worked; the suffrage amendment passed in convention, thus disenfranchising most Black New Yorkers.

Post-garden closure, Brown's driving ambition was to transition into theatrical management. The New York media soon linked this more cost-intensive enterprise with criminality through one of Brown's lead actor, Charles Beers. Once the property of a Mr. Hodgkinson, Beers was manumitted because of "his bad conduct," and, in November 1821, he was convicted of grand

larceny for stealing cash and cravats worth nearly two hundred dollars (Thompson 75). The *New York American* and *New York Daily Advertiser* both identified Beers as "lately a principal actor in the African corps dramatique." They also claimed "his passion for his new pursuit led him to the deed for the purpose of obtaining funds to purchase decorations for his theatre" (Thompson 77). Noah's *National Advocate* extended the illegality narrative by adding how Beers "wanted cloathes [*sic*] to dress in the character of Richard the 3rd" (Thompson 78). Noah specifically tied Black bodies and criminality to Shakespearean production, a cultural transgression that went beyond Beers' grand theft for his craft.

As an editor and respected playwright, Noah considered Black Shakespeareans a representational crime against Anglo-American supremacy. Brown, as perpetrator, launched his "heist" in early January 1822, when he rented a room at Hampton's Hotel on Park Row next door to the Park Theatre, Manhattan's premiere playhouse. His plan was to mount a series of competing Shakespearean productions. Noah covered the showdown in an article titled "Hung Be the Heavens with Black." The piece claimed that audiences at the hotel residency were so boisterous that the watch had to be called, and "the sable corps were thrust in one green room together, where for some time, they were loud and theatrical. Their detainment concluded when Brown's company promised to "never to act Shakespeare again"[4] (2). The official reasons offered for the shutdown were "danger from fire" and "civil discord," but the true motive behind this regulatory action was to send a message: Black bodies should not trespass on European cultural property.

Rewinding back to October 1821, Noah's *National Advocate* reported that, for Brown's new "pantheon" at Bleecker and Mercer, he had "graciously made a partition at the back of their house, for the accommodation of the whites" (October 27, 1821, 2). Theatre historian George Odell opined, "This partition, erected by a race so long segregated in the negro gallery of playhouses, strikes me as pathetic and ominous" (36). Perhaps that partition represented Brown's conditioned response to racial bodies in social space. As a manager, Brown labored under a complex perceptual dilemma created by racialization. He designed his Village space as a gentile entertainment for an integrated public; however, his experiments with racial and class integration revealed the impossibility of real equality in Manhattan and created conditions for the August 1822 riot.

When Brown relocated to Greenwich Village, he had to contend not only with assumptions of Black criminality and jealous circus performers, but with this rural region's reputation as a destination for disorder. The Village was technically a part of New York's eighth ward, but, according to municipal records, the then-suburb was often treated as an afterthought by the city's Common Council (*Laws and Ordinances* 159–160). During the late 1810s and early 1820s, the Council considered various requests for greater "structure" in the Village. These petitions included requests to contain roaming swine; construct curbstones, sidewalks, and carriage ways; add more street lamps; curtail colored musicians practicing on public avenues; and increase the number of watchmen (Peterson vol. 10–11).

In laying out his Village venue, Brown intentionally replicated the class divisions of the typical nineteenth-century playhouse with a gallery, pit, and box seats. A correspondent for the *New York Spectator*, writing under the pseudonym Mr. Twaites, visited just before the August riot and described Brown's pit as "a deep hole, whence the sounds of critical damnation, once or twice, during the evening arose to the boxes with a 'fine effect'" (2). Brown's pit conformed to rough, working-class expectations, but Twaites recalled a unique box that defied caste: "the Boxes, or rather Box, there being no partition to impede the circulation of the air, was extremely agreeable, although built upon an entirely different plan from those very convenient benches in the side boxes at the Park" (2). Unlike the Park, Brown's top-tier seats were less exclusive, more open, as spectators were able to access and easily commingle within the box. On August

10, police records show "a number of white persons" entered through the pit, climbed into the box, and violently crashed a circular frame "containing a number of lamps and candle" down into the pit (Thompson 103). It is no coincidence that rioters pulled the candelabra down into the area from which "sounds of critical damnation" emanated, a section in which white patrons predominated.

In the same summer, satirist Simon Snipe published his version of a raucous evening at Brown's establishment. He recalls a "variegated audience" composed "of white, black, copper-colored, and light brown." Contrary to Noah's announcement, Snipe never mentions a partition made for whites in the back of the house. He remembers a pit dominated by white spectators, with only a corner "partitioned off for the 'the gemmen and ladies of color.'" Nineteenth-century historian and physician James McCune Smith, a rare Black informant, characterized Brown's audience as composed "largely of laughter-loving young clerks, who came to see the sport, but invariably paid their quarter for admission" (28). The term "clerks" refers to the growing class of young white males who worked as salespersons in dry goods shops throughout the city (Augst 20). "Sport" suggests the unpredictable nature of Brown's entertainments, a sometimes unruly flavor added to the Black theatrical experience. Historian Paul Gilje legitimated this disorderly reputation when he speculated that two sailors arrested were simply "out for a good time" (157). Unfortunately, this "good time" involved mayhem driven not by Black bodies but by white New Yorkers who enjoyed free reign in Brown's pit—a pit from which they hurled peas, apple cores, and eventually fists to disrupt the proceedings. Brown never perceived his theatre as a disruptive social space, but in the end he could not control the actions and motivations of the white public he attracted.

Cultural historian Saidiya Hartman's interpretation of the *Plessy v. Ferguson* (1896) ruling, although decided over 70 years after the 1822 riot, can help us better understand Brown's dilemma. In arriving at "separate but equal" accommodations as the law of the land, the Supreme Court argued the law had no control over the social. The Court disconnected the state from "the public character of racism" and attributed private matters, like segregation, "to individual prerogative" (201). The "separation and isolation of blacks from the rest of the population" was created by individuals and their "aversive sentiment," not state policy (201). Hartman rejects this familiar individual versus institution argument and concludes that the Court's embrace of legalized segregation demonstrated state collusion with social inequality. She characterizes the *Plessy* ruling as representative of an anxiety that "found expression in an organization of space that arranged, separated, and isolated bodies to forestall this feared and anticipated intrusion" (206). George Odell alludes to the same collusion and fear of intrusion when he references institutions like the Park Theatre, where it was official policy to segregate Black patrons in the gallery. Historian David Roediger suggested Brown's theatre was attacked because he did not follow accepted protocol and encouraged social intermixture among the races (103). More accurately, Brown cultivated an integrated public, but then he capitulated to social convention by creating a segregated area for racially averse white patrons.

So in August 1822, in the Village, who were the actual intruders? Noah and other white writers viewed Afro-New Yorkers as the real political, social, and cultural threats, but Brown's playhouse was engulfed by "laughter-loving white clerks" and brutally attacked by resentful white circus workers. James Bellmont, the circus rider who attacked Aldridge in July, was never charged, and his brother George Bellmont was found guilty of assaulting Brown in August but was never sentenced (Thompson 105). In his memoir, Aldridge conceded, "of course there was no protection or redress to be obtained from the magistracy (for unhappily, they were whites)" (11). Brown's "pathetic" partition attempted to manage an escalating intrusion of white

patrons, but his acceptance of social protocol only demonstrated his conditioned response to the racialization of Black bodies.

## Notes

1 Research librarian George Thompson collected court documents on the riot from the New York County District Attorney Records and the New York City Police Records. See *A Documentary History of the African Theatre* (100–105).
2 I accessed this report in the weekly version of the newspaper, but there was also a daily version titled *The Commercial Advertiser*.
3 Noah's first article about the African Grove appeared August 3, 1821.
4 In his play *The African Company Presents Richard the Third*, Carlyle Brown dramatized the clash between Stephen Price's Park Theatre and Brown's company.

## Works cited

Aldridge, Ira. *Memoir and Theatrical Career of Ira Aldridge, the African Roscius.* J. Onuhyn, 1849.

Augst, Thomas, *The Clerk's Tale: Young Men and Moral Life in Nineteenth-Century America.* U of Chicago P, 2003.

Brown, Carlyle. *The African Company Presents Richard the Third.* Dramatists Play Service, 1994.

Hartman, Saidiya. *Scenes of Subjection: Terror, Slavery, and Self-Making in Nineteenth-Century America.* Oxford UP, 1997.

Hay, Samuel. *African-American Theatre: An Historical and Critical Analysis.* Cambridge UP, 1994.

Gilje, Paul. *The Road to Mobocracy: Popular Disorder in New York City, 1765–1854.* U of North Carolina P, 1987.

Lapsansky, Emma Jones. "Since They Got Those Separate Churches: Afro-Americans and Racism in Jacksonian Philadelphia." *American Quarterly*, vol. 32, no. 1, Spring 1980, pp. 54–78.

*Laws and Ordinances Ordained and Established by the Mayor, Alderman, and Commonalty of the City of New York, in Common Council convened; During the Mayoralties of Cadwallader D. Golden, and Stephen Allen.* G.L. Birch, 1823.

McAllister, Marvin. *White People Do Not Know How To Behave At Entertainments Designed for Ladies and Gentlemen of Colour: William Brown's African and American Theater.* U of North Carolina P, 2003.

Noah, Mordecai Manuel. "African Amusements" *National Advocate*, Sep. 21, 1821, p. 2.

———. "African Amusements" *National Advocate*, Sep. 25, 1821, p. 2.

———. "Fire" *National Advocate*, Oct. 27, 1821, p. 2.

———. "Hung Be the Heavens with Black." *National Advocate*, Jan. 9, 1822, p. 2.

Odell, George. *Annals of the New York Stage*, vol. 2. Columbia UP, 1927.

Peterson, Arthur Everett, editor. *Minutes of the Common Council of the City of New York, 1784–1831.* City of New York, 1917.

Roediger, David R. *The Wages of Whiteness.* Verso, 1991.

Smith, James McCune. "Ira Aldridge." *Anglo-African Magazine*, vol. 2, no. 1, Jan. 1860, pp. 27–32.

Snipe, Simon. *Sports of New York: Containing an Evening at the African Theatre.* Simon Snipe, 1823.

Thompson, George A., Jr. *A Documentary History of the African Theatre.* Northwestern UP, 1998.

Twaites, Mr. "Theatrical Extraordinary." *New York Spectator*, Aug. 13, 1822, p. 2.

"Unmanly Outrage." *New York Spectator*, Aug. 20, 1822, p. 2.

# 4

# MULATTOES, MISTRESSES, AND MAMMIES

## The phantom family in Langston Hughes' *Mulatto*

### *Alison Walls*

The family is perhaps one of the few themes that can lay claim to universality and that can certainly be found at the heart of Western drama as far back as the ancient Greeks through to realism and the bourgeois family dramas of Ibsen and Chekhov. In the popular melodramas of the nineteenth and early twentieth centuries, the domestic family is truly fundamental to the story. This genre, so enthusiastically taken up by US theatres and audiences, has contributed to making it an almost quintessentially US American genre. It could also be said that the US American drama is quintessentially familial. In *Mulatto* (1935), Langston Hughes rewrites the US American family drama as fundamentally interracial and amalgamated. The play draws out the degree to which interracial intimacy—hegemonically imposed and emotionally embedded—is inextricably threaded throughout the US American family and, hence, the American nation. The titular mulatto on the surface seems to refer to Bert, the defiant son of a Black mother and white father, who refuses to accept his subordinated status; but the absence of an article—not *The Mulatto*, but *Mulatto*—implies an all-encompassing theme. It is, moreover, Bert's mother, Cora, who is truly the heart of the play. In Hughes' subtle yet powerful characterization of Cora, which resists the stereotypical "mammification" of the Black mother, the play pushes against the assumptions of the nineteenth-century "tragic mulatto" melodramas and early twentieth-century anti-lynching plays.[1] Cora stands at the end of the play as the voice of resilience for a family that is both too intimate and not intimate enough—a family that is tainted by the realistic threat and the figurative realization of incest, and fractured by racial oppression—a family that is ultimately a model for the nation, and that nation is mulatto.

*Mulatto* takes place on Colonel Norwood's plantation in Georgia and was written in 1935, a period when lynching was at a peak. The drama revolves around the conflict between Colonel Norwood and Bert, who is one of four children that Norwood has had with Cora Lewis since their first meeting when Cora was just 15. It seems evident that Cora's family was once the Norwoods' slaves, but Cora is now Norwood's housekeeper and mistress. Norwood has educated their children but does not publicly acknowledge them, and he expects them to continue to work in the fields and in the "Big House." Returning to the plantation from college, however, Bert refuses to "behave colored" (12–15), and he asserts his identity as Norwood's son.

His fight for recognition ends when he kills Norwood and then commits suicide to avoid the lynchers' rope. With both the Colonel and Bert dead, the other workers depart, leaving Cora the sole occupant of the house.

Despite Norwood's bullying and the intrinsically exploitative nature at the root of the relationship between him and Cora, their connection seems genuine. Norwood implies that it is for Cora's sake that he has shown their children even the slightest preferential treatment by sending them to school (7, 17). Playwright Hughes makes it crystal clear how closely their domestic arrangements resemble those of a conventional, interdependent (if profoundly unequal) marriage; one that seems, moreover, to have eclipsed the potential of a second marriage by Norwood to a white woman. A local politician and friend, Fred Higgins, tells Norwood, for instance, that he should have remarried, "brought a white woman out here on this damn place o' yours," condemning in the same breath Norwood's living situation with Cora (10). Although Cora's memory of the first time she "loved [Norwood] in the dark" should almost certainly be taken as a euphemistic account of rape, when she continues—"I was happy because I liked you, 'cause you was tall and proud, 'cause you said I was sweet to you and called me purty"— the word "loving" takes on a truer sense (22).[2] She also describes loving Bert "like I loved [Norwood]" (22).

Affectionately likening her son to his father, as is her wont, Cora describes Bert to Norwood as "just smart and young and kinder careless, Colonel Tom, like ma mother said you used be when you was eighteen" (7). Another layer of family intimacy is thus revealed. Not only does Cora know Norwood intimately; her mother did, too. More detail emerges in Cora's later soliloquy: "Mama said she nursed you when you was a baby, just like she nursed me" (22). Cora has already revealed an intertwining of the two families that precedes her and Norwood's relationship—"Three of your yellow brothers yo' father had by Aunt Sallie Deal"—yet the reference to nursing exposes another way in which slavery and its aftermath created a conflicted racial intimacy (21). White masters may have fathered Black children, but Black nurses also mothered white children.

The significance of this detail in the wider cultural context of the characterization of the Black nurse, or "mammy," highlights the anxiety surrounding the line between mother and mammy as explored by historian Micki McElya. McElya recounts the 1916 legal furor over a white girl, Marjorie Delbridge, who was removed from her Black adoptive mother, Camilla Jackson, by a Chicago juvenile court judge. The judge and the press consistently referred to Jackson as Delbridge's "mammy" despite Delbridge's assertion that "I don't like the name 'mammy.' I always call my mother, mother" (118). The story demonstrates the process by which the appellation "mammy," of which the original sense is "mother," comes to disavow how close to motherhood that role might be, paradoxically serving to deny the depth of intimacy between Jackson and Marjorie.

Writing only a couple of decades later, Hughes reminds audiences of these intimacies through the memory of Cora's mother nursing Norwood without allowing the stereotype of the mammy, born of racial anxiety, to appear. In some ways, Cora takes her mother's place as both the caretaker of Norwood and as a profoundly maternal figure. Cora is not, however, exclusively maternal. She stands in contrast to the mammy whose intimate physical contact with whites is sanctioned through a reductive sentimentalized and desexualized characterization. Indeed, the ideological pool from which the mammy emerges is inseparable from the "cultural anxieties surrounding miscegenation" (McDaniel 95). Edward Williams Clay's 1839 anti-miscegenist engraving, *The Fruits of Amalgamation*, depicts a white woman nursing a dark-skinned baby, apparently the child of the man standing nearby (Bernstein 2). The image highlights the intimacy essential to nursing while reinforcing the message that amalgamation

would give Black men access to the bodies of white women. The more familiar image of the Black nurse, however, simply reflects the pre-existing self-entitled possession of Black bodies by whites, the nurse's asexualization permitting such close contact and overshadowing the realities of sexual contact between white men and Black women in particular.

This elision of intimacies—sexual and maternal—are challenged by the character of Cora, who establishes continuity between the Black nurse and the Black mistress and thus breaks down the ideological bind between the "mammification" and the sexualization of Black women. It is Cora's mother who encouraged her to welcome Norwood's sexual advances, and the nursing of Norwood by Cora's mother seems tied into Cora's tenderness toward him (and doubtless his toward her). There is a complicated net of love—or actions of love—among mothers and children here: Cora's mother performed a loving act towards the infant Norwood; her child performs a different loving act towards the adult Norwood, and Cora characterizes the love for her own son as replicating that love; the son finally displaces Norwood altogether when Cora envisages Bert taking his father's place in her bed as the white lynching mob storms the house (23). Norwood's "mammy," his lover, and his children share a lineage.

Another strand of this lineage is in the milk shared by Cora and Norwood. Alongside the open secret that white children might grow up alongside their illegitimate Black siblings, the fact that Cora and Norwood, like many Black and white children, were breastfed by the same woman places them in the position of siblings. The concept has its precedent in European literature: in George Sand's *Indiana*, the protagonist, a slave owner's daughter, is nursed by a Black woman as a baby and refers to her non-white maid as her *sœur de lait*, or "milk sister" (Sand 26, 29). The many drops of "black milk" imbibed by white children—paradoxically disregarded by the same anti-miscegenists preoccupied with the mingling of bodily fluids—easily overlay the metaphor of shared blood.[3] The overall implication is that Norwood is part of Cora's family— as a child and sibling as well as father to her children—and thereby in a way "Blackening" him, destabilizing the hegemonic division between unmarked whiteness and "otherness." The undertones of incest that emerge from this image of Cora and Norwood as "milk siblings" are also apparent in Norwood's simultaneously protective and sexualized treatment of his daughter Sallie. His observation of her "womanish" figure as "*he puts his hands on her arms as if feeling her flesh*" (8) echoes Cora's recollection: "Thirty years ago, you put your hands on me to feel my breast, and you say, 'You a pretty little piece of flesh, ain't you?'" (22). In maintaining the status quo of white landowners who treat young Black girls as available sexual objects and then deny any resulting progeny, Norwood risks seeing his own daughter in this light.

This is a reversal of the mammy problematic. Instead of the desexualization that allows a familial dynamic to emerge, a defamiliarization allows a sexual dynamic to emerge. The dual taboos of incest and miscegenation both form part of slavery's legacy, and the former could indeed result from the later.[4] Literary critic Richard King asserts, "the historically specific taboo underlying the Southern family romance is the taboo against miscegenation, the inverse of the incest taboo" (126).[5] When the two taboos are violated the patriarchal institution collapses. I would argue, however, that rather than inversion, *Mulatto* exposes the truth behind the seemingly contradictory conflation of the two taboos in nineteenth-century anti-miscegenation discourse.[6] In the evocation of the literal threat of incest in Norwood's attitude to Sallie and its figurative realization in Norwood and Cora's sibling-like connection, the theme of incest fuses with the central theme of miscegenation. The subtle thematic pairing draws into the open the denial of racial and familial intertwinings that are US America's dirty little ancestral secret.[7]

The ideal of the white family in whom Norwood could have overtly expressed paternal pride, and which he never had with his childless deceased white wife, haunts Cora and Norwood's miscegenated family. Bert momentarily conjures such a family in his "half-playful" embodiment

of "Mr Norwood, Junior," creating a poignant double vision of sons: one vital and unacceptable; the other ideal but non-existent. In the play's final moments, Cora proudly contrasts her own warm maternity with its lack in the "pale beautiful Mrs Norwood" who was "like a slender pine tree in de winter frost," an image that ties the Norwood name (North wood) to chilly sterility (22). Cora accuses Norwood's corpse of "living dead" even while alive from the moment he first beat Bert (22). When Norwood rejected his son he thus instigated his own metaphorical death, choosing to situate himself within the ghost family of his dead white wife and non-existent white children.

The grand Southern house is a symbol of that romanticized family pride. It is significant, then, that Bert returns to the house to take, not surrender, his life—a final assertion of his rightful legacy. But it is significant, too, that it is Cora—the housekeeper who has, after all, always held the keys—who dominates the final moments of the play. Slapped by the overseer, she does not move—"*as though no human hand can touch her again*"—suggesting a permanence to her presence in the house (23). Upon Norwood's death, others re-shroud his mixed family with their assertion that "the colonel didn't have no relatives," but Cora's voice resonates: "White mens and colored womens, and little bastard chillums—that's de old way of de South—but it's ending now ... you got colored relatives scattered all over this country. Them de ways o' de South—mixtries, mixtries" (19, 21). Literary theorist Juda Bennett, comparing Hughes' poem "Curious" to his "Cross," postulates that "Hughes structures identity upon the metaphor of a house as a second skin ... houses represent the unknown, and secrets of racial and sexual identity pervade these structures" (686–687). If the Norwood home is a metaphorical skin, Cora affirms the presence of Blackness under white skin, the "mixtries" hidden but irrevocably present at the heart of the US American family.

## Notes

1 Dion Boucicault's 1859 *The Octoroon* is a famous example of the former, while Angelina Grimké and Georgia Douglas Johnson's anti-lynching plays typify the latter.
2 The play that opened on Broadway on October 24, 1935, was not, in fact, *Mulatto* as Hughes wrote it. White producer Martin Jones optioned and rewrote the play without Hughes' approval and included a gratuitous rape, pushing the play further towards cliché melodrama. As Harry J. Elam, Jr. and Michele Elam point out, "loving" in this bastardized version serves as an "excruciating euphemism for rape" (Elam and Elam 100; Hatch and Shine 7).
3 A "drop of black blood" still carried weight (Harris 737; Sollors 120–121).
4 As Eric Sundquist notes in relation to Charles Chesnutt's story, "The Dumb Witness," "miscegenation was also frequently enough literal incest of just the sort described in Chesnutt's tale, where the ... quadroon slave mistress and her lover are both descended from the same patriarchal ancestral tree" (396).
5 King returns to the question of the family throughout his work, as well as dedicating a chapter to a fuller discussion of family.
6 Even the 1880 Mississippi code against interracial marriages deemed such alliances "incestuous and void" (Sollors 315).
7 The notion of a suppressed national sickness is not entirely synonymous to, but naturally aligns with, W.E.B. Du Bois' famous concept of "double-consciousness" expressed in 1930.

## Works cited

Bennett, Juda. "Multiple Passings and the Double Death of Langston Hughes." *Biography*, vol. 23, no. 4, 2000, pp. 670–693. *Project Muse*, doi: 10.1353/bio.2000.0043.
Bernstein, Robin. *Racial Innocence: Performing American Childhood and Race from Slavery to Civil Rights.* New York UP, 2011.
Du Bois, W.E.B. *The Souls of Black Folk.* Dover, 2015.

Elam, Harry J., Jr., and Michele Elam. "Blood Debt: Reparations in Langston Hughes's Mulatto." *Theatre Journal*, vol. 61, no. 1, 2009, pp. 85–103. *Project Muse*, doi: 10.1353/tj.0.0128.

Harris, Cheryl I. "Whiteness as Property." *Harvard Law Review*, vol. 106, no. 8, 1 June 1993, pp. 1707–1791. *JSTOR*, doi: 10.2307/1341787.

Hatch, James Vernon, and Ted Shine. *Black Theatre USA: Plays by African Americans*. Free Press, 1996.

Hughes, Langston. "Mulatto." *Black Theatre USA: Plays by African Americans. Vol 2: The Recent Period 1935 to Today*, edited by Ted Shine and James Vernon Hatch, Free Press, 1996, pp. 4–23.

King, Richard H. *A Southern Renaissance: The Cultural Awakening of the American South, 1930–1955*. Oxford UP, 1982.

McDaniel, L. Bailey. *(Re)Constructing Maternal Performance in Twentieth-Century American Drama*. Palgrave Macmillan, 2015.

McElya, Micki. *Clinging to Mammy the Faithful Slave in Twentieth-Century America*. Harvard UP, 2007, http://site.ebrary.com/id/10312765.

Sand, George. *Indiana*. M. Levy, 1858.

Sollors, Werner. *Neither Black Nor White Yet Both: Thematic Explorations of Interracial Literature*. Oxford UP, 1997.

Sundquist, Eric J. *To Wake the Nations: Race in the Making of American Literature*. Belknap Press, 1993.

# 5

# INTERVIEW WITH WOODIE KING, JR.

## *Producer and director*

*Interviewed by JaMeeka Holloway-Burrell*
*July 30, 2017*

Often referred to as the King of Black Theatre, Woodie King, Jr. is the founder and producing director of New Federal Theatre (NFT) in New York City (Figure 5.1). Founded in 1970, NFT has presented more than 200 productions, launching the careers of numerous actors, playwrights, directors, designers, and other artists. Additionally, King has produced such Broadway shows as *What the Wine-Sellers Buy*; *for colored girls who have considered suicide/when the rainbow is enuf*; and *Checkmates*. Notable actors who came through NFT include Denzel Washington, Phylicia Rashad, Viola Davis, and Samuel L. Jackson, to name a few. King is the subject of the documentary *King of Stage: The Woodie King, Jr. Documentary* (2017).

JHB: When did you realize that you wanted to be a theatre artist?

WK: Probably 1957 or '58. I saw a movie with Sidney Poitier called *The Defiant Ones*. Then at Wayne State University, I saw a performance by actor Martin Shakar, and that put me into the direction I wanted to go as an actor. After that and doing 15 or 20 plays in Detroit, I saw my possibilities as an actor, and I was working at Ford Motor Company, and I said, "Well, when can I study?" They had classes two days a week at an all-white school and I went, and they gave me a scholarship. And for the next four or five years, I studied there. Later, myself with 11 friends got together, put up the money, $100 each, and rented a bar and converted it into a small 60-seat theatre, and we did plays. We started in downtown Detroit and called it Concept East. We toured and it took us into New York, and I stayed there.

JHB: You grew up in Alabama and moved to Detroit when you were …

WK: Eleven years old.

JHB: Did growing up in the South and then moving to Detroit influence your work in any way?

WK: I was totally lost because the North has this prejudice against schools in Alabama, and I was put back to the first grade. But I went to school every year and beat the system.

JHB: Who were your early influencers?

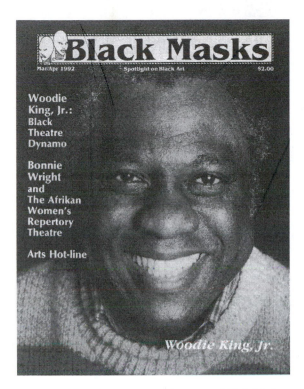

*Figure 5.1* Woodie King, Jr. on the cover of *Black Masks* magazine (March/April 1992).
*Source:* Courtesy of Beth Turner.

W K : Langston Hughes was my influence.

J H B : Which is clear because you did the adaptation of "The Weary Blues."

W K : Yeah, yeah. My influence in school was, at Lehman College, a woman named Shauneille Perry, then at Brooklyn College, where I got my master's, Tom Bullard. But I was already kind of well known when I ran into these people. I had really graduated from Willoway School of Theatre in Bloomfield Hill, Michigan, and that school prepared me, in a sense, for all I needed to be in New York, but I needed those credentials to teach, to work side by side with other [people who had] MFAs. And I had already produced two or three huge hit plays. When I arrived in New York, I was in this play, me and Cliff Frazier, called *Study in Color*, and I was the producer and director, one of them. Cliff was the director or the other. But that only ran six or seven months; then I had to get a job. Robert Hooks introduced me to Mobilization for Youth (MFY), and the people hired me as the cultural arts director for five or six years. Had a huge budget, like $500,000, $600,000. That sort of prepared me to handle budgets, but it was really a prototype of what I was studying at Willoway.

J H B : What were those early days like for you? Coming out of mobilization and getting that $600,000?

W K : You mean before the New Federal?

J H B : Yes.

WK: I was running the training program for young Hispanics, Blacks, and Asians to be filmmakers, theatre artists, actors, and I was paying them out of that $600,000, and that had never been done before. People thought, "Wow, this guy is in his twenties. He don't know how to handle that kind of money." So I hired lawyers, bookkeepers, and accountants, and that sort of like set the tone for anti-poverty programs around America.

JHB: Is that advice that you would give emerging theatre artists when going into business, to begin to think about hiring lawyers and bookkeepers?

WK: The theatre in Detroit taught us to hire lawyers and businesspeople. So coming to New York, it was a natural thing to do. I would encourage that, but you've got to have the kind of budget I had to hire them.

JHB: Now, let's cut to New Federal, the beginning days. You probably were doing a lot of that work on your own. What was day-to-day life like in the very beginning stages of building a company?

WK: Well, I built an organization. In New York, you really don't need a company. Because the poverty program and MFY was so successful, when the head of that agency went to Henry Street Settlement, he asked me to come with him and start that kind of program, and I said, "Yeah, I'll come, but I want to start a theatre as well." So I had this contract, agreement, if you will, something like 15 or 20 years that they would pay my salary, my assistant's salary, and certain other salaries, and we would raise the rest of the money. And that means I would have to give up all the other job-jobs. One of the job-jobs was the Rockefeller Foundation. That's where I worked and traveled and did research and gave grants out. So I left that … [when the foundation] gave the theatre $115,000. We did plays, and I could use the Henry Street facilities, phones, bookkeepers, and all that to look out for me. So the day-to-day operation of that was partially on New Federal and partially on Henry Street.

JHB: And you feel like you were more prepared because of the work you had done previously coming out of Wayne State and the MFY?

WK: Yeah, you're learning as you go. You're learning what mistakes not to make. You never know what *to* do, but you know what *not* to do. So that's what I would advise. Watch what you do and be careful on what you know you should not do. New Federal Theatre was at Henry Street. They supported us until 1989, and then we were pretty much on our own even though we used their space and then [again] from '95 and to 2016.

JHB: So during that time, you were wearing a lot of hats. You were producer, you were directing. You were also talent scouting as well?

WK: No. [Laughs]

JHB: Well, you were able to help launch some of the most brilliant minds we have in American theatre, like Ron Milner, Amiri Baraka, Ntozake Shange.

WK: At New Federal, you've got to understand—this is what I always tell people—in the first two years at New Federal, we produced the kind of plays that you did not see any-where, but everybody in the Black Arts Movement would say, "Whoa!" I had produced the Black Quartet: Baraka, Bullins, Caldwell, and Milner, four one-acts. It didn't make any money, but, my god, we got so much press. People were sending us plays from all over—South Africa, everywhere. Then the following year, we had a play call *Black Girl*, which won a Drama Desk Award, and, my god, no community theatre, so called, had ever combined the professional theatre and community.

JHB: How did you cross over that line?

WK: Because in New York, the Off-Broadway and Off-Off-Broadway, at that time there was no separation. You knew you had to have a press agent, professional director, and have equity actors, and paying a union member was no more than $10 more than paying a regular actor. So when it won all those awards, my god, this young writer J.e. Franklin became the cause célèbre, and I said, "Wow!" It moved [off] Off-Broadway, toured Washington and Baltimore. It had never happened before. So New Federal had all these accolades. Now, an accolade like that brings grants into the theatre, so Henry Street, which was umbrella for New Federal, got all this money. It was amazing.

Then we had Ron Milner's play *What the Wine-Sellers Buy*. That moved to Lincoln Center. It was unique. It had not happened because, I think, I want to say because white artistic directors and white leaders of theatre were so totally different then than now. If you knew your craft, if you knew what you were talking about when you talked about theatre, they would sit and listen. You could make almost any kind of deal you wanted, because they weren't doing Black theatre. They didn't have the plays. So Ron Milner's *Wine-Sellers* broke through, moved to Lincoln Center in '74, '75, and Shange's [play] moved to the same theatre '75 and '76; and '76 to '79, it toured nationally, went to Australia, London, all over. We took it everywhere. So, again, we got all this visibility for these plays … from 1970 through 1979, we virtually had a hit every year and that supported the theatre.

JHB: Why do you think we are not championing Black playwrights the same way you were in the Black Arts Movement? There are only a small few going through to big productions.

WK: Well, the cost of doing it skyrocketed. *colored girls* cost $400,000. *Sweat*, Lynn Nottage's, might have cost $2 million, and it's a big difference.

JHB: And do you think that funders see Black theatre differently now?

WK: Well, funders don't fund Broadway. It's individuals. Now, what happens is if the play flops and [the producer] runs it past the money he got, he's got to pay for it. But he's never going to do that. You understand? It's the knowledge of what happens … it's a game, and … that's why they don't let us in it. You know this play cost $2 million. One person takes it on, but one person doesn't put up $2 million.

JHB: Their job is to go out and find other people?

WK: Friends who he's worked with or she's worked with before, who covers costs for him, for her.

JHB: I want to get to your mission. You specifically mention wanting to move forward the works of women and minorities.

WK: And integrate it into the American theatre.

JHB: Why was that important to you?

WK: Because I grew up in a household of women. I knew and observed the idiosyncrasies, the fun they had, the camaraderie they had—aunties, uncles, cousins. In particular, the women of the household, in many of the cases, was growing up without men in the house. My mother was a single mother.

JHB: You wanted those stories to live on, and, back then, our artists were writing from personal experiences.

WK: Yes. Ron Milner's all through *Wine-Seller*, J.e. Franklin is all through *Black Girl*. Ed Bullins is all through his plays. You see them there and you share their experiences.

JHB: I often wonder will the work of our current writers have the same longevity.

wk: I don't think so. Every college does *Checkmate. colored girls*, you could run it three nights now, you couldn't get a ticket.

jhb: Why is it important that it wasn't just Black people you focused on, but on minorities in general? Because you were the first to produce David Henry Hwang.

wk: Yeah, David Henry Hwang, Genny Lim, Joseph Lizardi, Tisa Chang—all these people, because I was in the Lower East Side, and that was the makeup of the population.

jhb: What was it in Ron Milner's play that you said, "I've got to produce this"? What was it in a Baraka play or what did you see in Debbie Allen that made you say, "I want to work with them"?

wk: Ron Milner and I both came from Detroit. We were writing about people we knew. Debbie Allen, she's a master craftsman. That's how easily she and her sister Phylicia [Rashad] could move from dance to straight acting, and that's why she now produces so much television and directs so much television. She went in and saved that spinoff, *A Different World*, because she said, "Wait a minute. It wasn't like that at the school I went to." When the white woman was producing it, she don't know no Black people. They didn't know Black people from Adam. They were just putting shows together and getting laughs.

jhb: Talk a little bit more about that. We see so many of our stories coming to us through the gaze of whiteness when there are a plethora of Black directors who could actually be directing these.

wk: The cost of doing a half-hour show, the cost of actually doing an hour show, is just so great. The bottom line: ABC, NBC, HBO, and all these shows do not trust Black directors with a million dollars. It's all about that. These guys—Michael Schultz, Oz Scott—all these directors, they are just masters. They know what they're doing, but they only let them do episodics because you've got to come into the studio, you've got to work on the set they built in the studio; therefore, they control the studio.

jhb: You don't have any creative agency.

wk: You can suggest your AD [Assistant Director], but the endgame is they will edit it [the script] with you.

jhb: Do you think the same thing happens in the theatre—that one of the reasons they don't hire as many Black directors as they could is because they don't trust us with the money or trust us with the stories?

wk: Well, in the theatre, they aren't going to hire you because they don't trust you artistically. The reason I can bring so many directors in is because if I've I seen 15 plays here [at the National Black Theatre Festival], and if I see a director I like, I hire him or her. Now I've got to find a product. So when I find a script and hook that writer up with that director, I've got to trust that director.

jhb: What are some of the most notable moments in your career?

wk: I think what's notable is I produced James Brown in Liberia, and a company of 27 dancers, singers, musicians, private planes, and all that. And Liberian Air picked us up in London, brought us into Liberia. Oliver Bright, the prime minister, leaned over to me and he said "Brother King, you made all this happen." You feel good. Another thing, you have a play like *for colored girls*, and opening night on Broadway, women are crying and hugging each other like Ntozake and Laurie Carlos, who passed. Then there was *Wine-Seller*. We realized that touring was ultimately a way of communicating with everybody. If you create characters that are identifiable for the people of

Southside Chicago, Black Bottom, Detroit, Watts, the people say, "Oh, I know them people." Then you know you've found that common denominator in Blackness, you know, and that is the experience that makes people just love the theatre. I know you heard the stories of *A Raisin in the Sun*. Old people, they would come to the theatre at noon and say, "When is that thing going on here?" They had never been to the theatre before. And Lloyd Richards, who directed it, just went, "Why'd you come down here at 12:00 noon?" She said, "I heard my people is doing a play of something and that it was important that I see it." That's the kind of theatre that you want to be involved in.

JHB: I also feel like with predominantly white institutions, it's all about what your academic training has been, and oftentimes, for Black artists it feels like it should be just more visceral and more primal.

WK: But in making it more primal, you're trained. You know there's a system that obviously immediately denigrates an artist if he came from an HBCU, and while I know if I've got an artist that comes into New York, if they come from Howard, I *know* they know who they are. You cannot come from an all-Black school and bullshit. But if you graduated from Carnegie Mellon, NYU, Juilliard, they don't tell you, "Oh, check out Woodie King" if you're Black. I'm the last place you come to. But during the '80s and '90s when I was teaching at those universities, that was where they came to. I'm proud, but I know the pressures these artists are under to get those loans paid off, to go to white theatres … [but] white agents don't send no Black clients to a Black theatre.

JHB: You were also good friends with a lot of the writers whose work you produce and direct, and so I want to check in a little bit about what those relationships were like, such as Milner, Baraka. You directed and produced their work, so how was that relationship sometimes where you had to go direct and produce, but they were friends?

WK: Art is difficult. Ron was difficult. We argued during rehearsal. When the rehearsal was over, we'd go out for coffee and go partying at night. Baraka, he's *not* going to do any rewrites, and some of the best directors have tried to do his work. He's *not* going to do a rewrite.

JHB: So you all kept a healthy collaborative relationship.

WK: Yeah, for 35, 40 years. Because you're not going to hurt the work, even though every artist thinks he knows everything.

JHB: If there is any advice that you could give emerging theatre administrators, directors, producers, and artistic directors on how we can build more sustainability in Black theatres, what would that be?

WK: I would say read more. I would say experience more and put that in the work. You've got to put it in the work. A lot of people just don't put it in the work. I don't know why. They won't put it in the work. Why won't they put it in the work?

# 6

# FREEDOM FORWARD

## Alice Childress and Lorraine Hansberry circling Broadway in the 1950s

*Barbara Lewis*

Alice Childress and Lorraine Hansberry, two African American women playwrights who were young and bursting with ambition in the middle of the twentieth century, advanced the modern phase of Black theatre. They changed its post-World War II access to and recognition on Broadway and Off-Broadway. The war and the sense of self that African Americans took on through major participation in that global effort changed how a community, too often set aside, started to see its members as valuable and worthy of notice and concern. African Americans began to see each other as major players, not just as people in the world destined to perform as supernumerary characters or figures whose roles were to unburden and facilitate the lives of others. They did not have to stay in the shadows, withdraw into corners, hide their faces and feelings. They had energies to cultivate, choices to make, loved ones to remember, futures to build, their own mistakes to forgive, their own freedoms to create and safeguard, their own children to prepare and protect, and their own truths and troubles to understand and proclaim. Childress and Hansberry raised their voices in this era and presented them to a public gathered on Broadway and Off-Broadway, a public open to seeing and understanding novel perspectives spiced with a bit of difference.

Uptown in Harlem in the early 1950s, Childress and Hansberry were journalists together writing for the periodical *Freedom*, published by Harlem Renaissance icon Paul Robeson. The times were rife with activism, and artists both Black and white wanted to widen their world in positive ways. The future was knocking, and African Americans wanted to increase their freedom share. Childress' family was working class. Hansberry was the daughter of highly educated parents, originally from the South, who settled in the Chicago area. Through Robeson, Childress, who had already garnered impressive stage credits as an actress, playwright, and producer, and Hansberry, who was just starting out, tapped more deeply into the pulse of the people uptown, sharpening their sense of the collective—what it was feeling, seeing, doing. And the collective was not only in Harlem; it was in other countries, as well. As a result, Robeson offered Hansberry the chance to travel, representing him abroad at conferences. Childress, during her time at *Freedom*, concentrated on her chosen community: the female worker eager for her own sense of dignity and freedom, and the church sister laboring in the kitchens and bathrooms of others, bursting with her own dreams and voice to which others rarely listened. That social segment, Childress understood. Hansberry saw them, too, but her focus was more on the educationally and economically ambitious who were gaining a wider, even international,

sense of their status and belonging. Childress and Hansberry both pushed for Broadway access and representation, each seeing a positive public image as key to citizenship and freedom.

At *Freedom*, Childress wrote a fictional column about a feisty Harlem domestic worker named Mildred Johnson who defiantly and consistently stands up for herself. That column, which also appeared in the *Baltimore Afro-American*, was later published as a novel (reissued by Beacon Press at the start of 2017). Its ironic title, *Like One of the Family*, references the psychological need of some white employers to believe that the women, and sometimes the men, who work for them in a menial capacity really love them and are happy to be paid little or nothing for the pleasure of being in their presence. Mildred, the independent domestic, has her own mind. She was inspired by a title character in some Langston Hughes stories, Jess B. Simple, who is comfortable with his own homespun, vernacular view of things. Black women who worked as domestics were rarely considered family members, but the reference would surface if the employing family, usually the lady of the house, wanted more done for less.

In 1952 Childress became the first African American woman to have an original play produced Off-Broadway, *Gold Through the Trees* (Wilkerson 136). The title of this Committee on Negro Arts production drew from what Harriet Tubman said when she got past the Mason-Dixon line and knew she and her fellow runaways had reached freedom ground. There, the future seemed brilliant and finally free of angry, accumulated hatreds. But true freedom and the safety and inviolability of home continued to remain off in the distance for many African Americans. More than a hundred years after Tubman worked as a laundress to make the money to finance her freedom trips to the North, freedom was still a vista off in the distance that beamed beautifully from afar. Likewise fleeing segregation's divisions, Hansberry came to New York from the Midwest with two years of college under her belt. Eager to become a playwright, she was hired to assist Robeson, a family friend. Almost immediately, her byline began appearing in *Freedom*, and her early play critiques included a review of Childress' *Gold Through the Trees*.

Childress had established a stellar theatrical resume years before. She had been a regular with the Harlem-based American Negro Theatre (ANT) where Harry Belafonte, Ruby Dee, Ossie Davis, Sidney Poitier, and others got their start. In 1944, ANT gained the theatrical pinnacle, going to Broadway with the drama *Anna Lucasta*. Childress received a Tony nomination for acting in *Lucasta* before the national and international tours began. In fairly short order, she transitioned from actress to playwright. Her debut effort, *Florence*, a one-act play that debuted in Harlem in 1949, looked at the flight north that so many African Americans were taking, hoping to do better for themselves and their children. It emphasized the resolve to speak and choose for themselves despite the limitations that racial prejudice often imposed. After *Florence* opened in Harlem, Childress adapted a series of Hughes' short stories for the stage, which she also successfully produced. That was around the time that Hansberry wandered into a campus rehearsal of a Sean O'Casey play, *Juno and the Paycock*, which tells the story of a mother doing all she can to protect her besieged family. Immediately, Hansberry named her life goal—interpreting the truth of her people's struggle for survival and dignity.

Childress and Hansberry were women artists with a similar agenda. Each wanted to share her story and insights on the national stage, and each succeeded, albeit with some caveats. *A Raisin in the Sun*, a title reinterpreting a Langston Hughes poem, reached Broadway in 1959 and introduced Black theatre to new accolades and audiences. Lloyd Richards, born in Canada and representing, in his heritage, the previously enslaved who had gone all the way north in their trek to freedom, directed it. Several decades later, when he was at Yale, Richards directed the early dramatic explorations of August Wilson, who ended the one-play wonder phenomenon that had been the Great White Way agenda for Black plays until

that point. Childress' *Trouble in Mind* (1955), its setting split between Broadway and the Jim Crow South, comments on the limited history of Blacks on Broadway. Her insights were born in her experience with *Anna Lucasta*, in its World War II Broadway run. *Trouble* was also slated for a Broadway stint, but that never came to pass. Childress would not shape the ending to satisfy the money guys who wanted a more traditional conclusion, one privileging a point of view dwarfing the understanding and insight of the community that had been routinely shut out of Broadway's doors.

The 1950s was a time of transition, when much that was old was trying to renew itself, but realities were shifting. The year that *Trouble in Mind* was produced was when Rosa Parks refused to relinquish the seat on the bus for which she had paid so that a white male could be accommodated and made comfortable. That was also the year that Emmett Till, a handsome teenager born in Chicago, went south for the summer to stay with relatives in Mississippi, where he was disfigured and killed for apparently disobeying the political etiquette of the South which required Blacks to be subservient to whites 24 hours a day, 7 days a week. Till's mutilated body was found at the bottom of a river and then shipped back to Chicago, with instructions from his mother Mamie Till that his casket remain open so that all could see the physical punishment he endured at the hands of an empowered Southern citizen class that could strangle the law in its hands without repercussion.

The decade was highly contentious, and each playwright drew on personal experience. Hansberry shared a vivid childhood memory of when her father, a politician and businessman, moved his family from the inner city to the suburbs. The family's new neighbors, of European heritage, feared a decline in property values, and so they attacked the newcomers, trying to oust them from the property they had purchased. Hansberry's narrative was not isolated. After World War II, middle-class families were bent on improving their circumstances by moving themselves up and out to better neighborhoods, but not everyone was welcome in the color-coded areas. The Younger family featured in Hansberry's drama was a likely designation for a younger generation that saw itself as ready for more than what was on offer in the past. Ultimately, the family manages to integrate an area with greater access to good schools for the next generation. *Trouble*, Childress' play, questions the popular Blackness saga that presents African Americans as voiceless victims, denied political presence and opinion, lacking options to be fully seen or heard, left quarantined outside legitimized spaces, stuck in an instrumental status, consigned to helping others achieve their desires but hardly ever getting good for themselves, which is the situation for Mildred in *Like One of the Family* and for all four Black actors—two men and two women—in *Trouble*, who, as the play's title suggests, keep trying to make the best of being regularly held back under a threatening sky.

Part of the promise package for African Americans risking their lives in World War II included post-war opportunities in housing, jobs, and education, but those promises were empty. Seeing that any improvements would come only through independent efforts, citizens, artists, activists, and writers joined the "freedom war," with women often stepping forward. A few women rose to positions of leadership and voice: Alice Childress, Lorraine Hansberry, Rosa Parks, and Mamie Till prominent among them, the first two in culture and the third and fourth in the political realm. The stage has always been a political space where the nation projects its self-image, its range of ideal members. Childress represented Harlem, where she lived and built her talent, and the South, her birthplace. Hansberry, the daughter of a politically engaged, highly educated family, represented the urban Midwest, a generation or two removed from the sharecropping South. Rosa Parks, a seamstress, was a skilled worker whose labor lineage reached back to the enslavement era when some African American women used their craft status to negotiate greater voice. Mrs. Till, who would not be deflected from honoring her son's memory, showed

the horror of his battered face to the country at his funeral, which united the community in honor of motherhood.

Childress, roughly a decade older than Hansberry, was groomed by her Southern grand-mother to write down what she saw and felt so that the history of what happened and what had been done would not be lost, erased, forgotten. Recognizing the value of the past, Childress knew the importance of the stage in connecting yesterday and today, seeing both as continuous. Her artistic ambitious were also extensive, and she enjoyed success in film, novels, and criticism as well as in acting, producing, and playwriting. She was more than a triple threat, but his-tory and time have not given her the accolades she deserves. Nor was the zeitgeist kind to the northern-born Hansberry, who wanted, more than anything, to portray her community with truth and kindness. Having done that, she soon fell ill and passed, perhaps burdened by opening Broadway's gates to an African American saga and then seeing her subsequent work fare not nearly as well. Her cultural and creative candles were exhausted.

With a longer, much more varied career, Childress built her reputation over time, exploring every artistic door yielding to her efforts. Yet, why did *Raisin* garner longevity while *Trouble* did not? The reason, I believe, is dependent on the mind of whiteness—what it sees as worthy. Sean O'Casey, an early twentieth-century Irish playwright, was Hansberry's dramatic idol, so much so that critics immediately saw links between the two and were happy, even relieved, to have an African American play they could easily equate with what they already understood. Although Childress also admired O'Casey as a playwright and valued the Irish theatrical tradition—even acknowledging it in the character of Henry, the Irish American stage electrician and elderly doorman in *Trouble*—her story, which is autobiographical, is not clearly patterned after the work of a European author (unless we consider her play-within-a-play format as entirely indebted to Shakespeare, who structured several plays in that fashion). Both Childress and Hansberry express much the same concerns, raising the question of who is entitled to have, hold, and benefit from access to property, whether in a residential area or on Broadway.

The plays of both women still speak with strong voices to continuing racial circumstances such as gentrification and public executions acted out, ritualistically, across the country's urban expanse, north and south. African Americans, in the demographically expanded sense of resettled peoples from the vast African Diaspora, with escalating population percentages, are sometimes quarantined from inclusion in upscale urban zip codes. Further, representatives of the Black millennial generation, male and female, are under target while walking, driving, and shopping, with some prematurely terminated from a full lease on life. Hansberry cites lynching, another name for today's white-on-Black killing spree, as an impetus for the exodus north, but Childress gives it greater attention, drawing a causal connection between voting and lynching, indicating that winnowing and attacking the demographic strength of a people can be aided and abetted by the *deus ex machina* hand delivering immediate demise. Since the tendency among many playwrights today is to look back rather than forward, this may be the moment for considering whether Alice Childress and Lorraine Hansberry still have something pertinent to say to the young activists, women included, who find them-selves face-to-face with some of yesteryear's narratives—the argument that Blacks are an inherently criminal people who are lawless and deserve whatever bullets are sent in their direction. Since the very beginning of the nation, when Blacks were the workers making its machinery go, they have been the pain in America's side. Under cover of righteousness, the white forefathers and foremothers found ways to excuse the gigantic eviction or land grab that gave the country its expanse, a reality commemorated in the names of states, streets, and towns. But the blood and gore that enslavement spilled is just as indelible, if not more so, than the Native American names that will not die. And the blood and gore surviving

unwashed since the era of enslavement is still making slippery and red the streets on which we all walk, every day, and sometimes twice on Sunday—which was an extremely popular day for public lynchings. The congregation could leave church and see the al fresco public show without changing clothes or doffing a hat, the latter a reference to the lynching photographs in the book *Without Sanctuary* that reveal a rapt, engaged audience decked out and capped off in its Sunday best (Allen 24).

Childress, who had the longer, more varied career, is enjoying new popularity in the twenty-first century. *Trouble in Mind*, *Wine in the Wilderness*, and *Wedding Band* are regularly revived, and there is a new, 2017 edition of *Like One of the Family: Conversations from a Domestic's Life*, the novel crafted from the journalistic commentaries that Childress published in *Freedom* in the 1950s. A new documentary on Hansberry, *Sighted Eyes/Feeling Heart*, premiered on public television in 2018, and is making a new generation aware of her struggles, significance, and continued relevance, particularly in naming her Chicago family the Youngers—three generations representing past, present, and future and still struggling to find a place of light and sun in urban America where young, green, sturdy stalks of life can thrive. Childress, too, speaks to the public portrayals on Broadway, in film, on television, and on social media that seek to diminish other experiences, contrary voices, and faces. As heralds of a changing status quo, Childress and Hansberry championed the experiences, the perspectives, and insights of strong, outsider individuals who knew what they had experienced and would not deny or gainsay their truth on public stages or screens. Among them were artists, writers, thinkers, making the leap, taking the giant step ahead, learning all they could, studying and writing and writing some more, writing against gender bias, against class and color limitations, remembering the poets, performers, singers, writers, and playwrights before who looked to the future. They shaped and molded stories, fitted them out to honor those who had seen freedom in the distance, in a glint of gold and sun, illuminating a divided landscape that kept morphing and growing, year after year.

## Works cited

Allen, James, et al. *Without Sanctuary: Lynching Photography in America.* Twin Palms, 2000.

Childress, Alice. *Like One of the Family.* Beacon Press, 2017.

Wilkerson, Margaret B. "From Harlem to Broadway: African American Women Playwrights at Mid-Century." *The Cambridge Companion to American Women Playwrights*, edited by Brenda E. Murphy, Cambridge UP, 1999, pp. 134–152.

# 7

# NAVIGATING RESPECTABILITY IN TURN-OF-THE-CENTURY NEW YORK CITY

## *Intimate Apparel* by Lynn Nottage

*Marta Effinger-Crichlow*

Pulitzer Prize-winning playwright Lynn Nottage sets her historically centered drama *Intimate Apparel* in Lower Manhattan in 1905. Nottage's African American female protagonist, Esther Mills, spends long hours working hard at her sewing machine. Through her meticulously designed and sewn intimate apparel, Esther offers her diverse clientele the semblance of physical perfection a mere four years after the Victorian era. Consequently, Nottage's characters embrace and reject guidelines of respectability. The term respectability refers to the state or quality of being respectable; having decency, decorum, morality, or a good reputation. Historian Stephanie Shaw in *What a Woman Ought to Be and Do* even claims that during the Jim Crow era young Black professional women who were respectable were expected to be "polite," to be "morally upright," to possess "self-control" and to have a "clean and neat appearance" (14, 16). Nottage's drama inspires two particular questions: What did it mean to be a respectable Black woman in early twentieth-century New York City? More importantly, how might the play's settings communicate varied messages about respectability or decency for the Black female characters?

Aged 35 and single, Esther is the oldest boarder at Mrs. Dickson's rooming house. Esther grows tired of Mrs. Dickson's meddling and the constant flow of younger boarders and "unattractive" suitors. For instance, in Act 1, Mrs. Dickson declares that marriage should help colored women raise their status in the city. She encourages Esther to welcome the attention of Mr. Charles, a respectable and economically stable Black gentleman. But Esther announces that she does not need Mr. Charles "for his good job and position" (Nottage 25).[1] Here, Esther clearly rejects the older Black female character's values. When Esther begins corresponding with a stranger, George Armstrong, a Bajan laborer working on the Panama Canal, Mrs. Dickson, who behaves as if she is Esther's surrogate mother, confirms that she does not approve. Regardless of the sweet language included in Armstrong's letters, Mrs. Dickson cannot fathom why a respectable and practical girl like Esther would expose herself to a strange laborer thousands of miles away. The intimate apparel helps Esther "escape" Mrs. Dickson's notion of respectability and gain greater access to the city and its occupants.

Esther purchases the most luxurious fabrics from Mr. Marks, a Romanian Orthodox Jewish immigrant on Orchard Street on Manhattan's Lower East Side, where Eastern European immigrants largely dwell. She then carries the amazing fabrics back to her room at Mrs. Dickson's, where she creates divine corsets for clientele like Mayme, an African American prostitute and saloon singer who inhabits the Tenderloin district, and Mrs. Van Buren, a white socialite who feels trapped on the Upper East Side. In Nottage's production notes she remarks, "The set should be spare to allow for fluid movement between the various bedrooms" that Esther enters (5). Esther does not know how to read or write, but her artistry—the intricate beading and fine needlework—sends her into many worlds—the Lower East Side, the Tenderloin district, and the Upper East Side.

Esther navigates her way through the multitude of languages and customs that fill the overcrowded Lower East Side streets in order to reach the gorgeous fabrics in Mr. Marks' tiny tenement. According to the *Historical Atlas of New York City*, these tenements "were usually five stories tall, with four tiny apartments on each floor. Large families and their boarders were squeezed into ill-lit and crowded rooms. With little fresh air and minimal plumbing, sanitation was inadequate and health inevitably suffered" (Homberger 132). When Esther reaches Mr. Marks' apartment to purchase her fabric, Nottage notes the following in the stage directions in Act 1, Scene 3: Another bedroom in a cramped tenement flat. It is small and cluttered with bolts of fabric. Esther stands in the doorway. She notices the bedroll but chooses to ignore it (Nottage 16).

Mr. Marks' professional and private lives exist in the same physical setting. Still, Esther must ignore the bedroll. If she speaks of it, she further exposes an intimate part of the Romanian Orthodox Jew's life. Touching and smelling the fabric is a sensual experience for Esther and Mr. Marks, but their apparent attraction to each other must remain unspoken. They must acknowledge and respect the cultural and religious differences that exist and restrict their relationship to selling and buying fabric. The characters' feelings are literally and figuratively trapped in this small tenement with tradition and respectability.[2]

For several years, Esther stuffs the money she earns from her intimate apparel inside the lining of her crazy quilt. As a migrant from North Carolina, she is enjoying a level of economic independence not experienced by other colored women of her day. Esther dreams of opening a "respectable" beauty parlor where her kind will be pampered. In Act 1, Scene 4, a canopy bed and an upright piano fill Mayme's boudoir. For the first time Esther shares her dream with Mayme:

ESTHER: I own a quaint beauty parlor for colored ladies …

MAYME: Of course.

ESTHER: The smart set. Some place east of Amsterdam, fancy, where you get pampered and treated real nice. 'Cause no one does it for us. We just as soon wash our heads in a bucket and be treated like mules. But what I'm talking about is some place elegant.

MAYME: Go on missy, you too fancy for me.

*(Esther allows herself to get lost in the fantasy.)*

ESTHER: When you come in Miss Mayme, I'll take your coat and ask, "Would you like a cup of tea?"

MAYME: Why, thank you.

ESTHER: Make yourself comfortable; put your feet up, I know they're tired … and in no time flat—for the cost of a ride uptown and back—you got a whole new look.

MAYME: Just like that? I reckon I'd pay someone good money to be treated like a lady. It would be worth two, three days on my back. Yes it would. (Nottage 21)

Esther expresses that she wants to give colored women, at least the ones who can afford it, a "place," and that she plans to use the beauty parlor to accomplish this goal. In part, she associates respectability with a setting like "some place east of Amsterdam, fancy." Where does Esther acquire her notions of respectability? Does Esther secretly desire to create a community for colored women much like the one established by her surrogate mother, Mrs. Dickson? Is Esther channeling Black female entrepreneurs Annie Malone and Madame C.J. Walker, pioneers of the Black beauty industry in the early 1900s? Is Esther proclaiming to potential customers that they will achieve respectability through assimilation like the straightening of their hair in her beauty parlor?

Nottage also centralizes Mayme's voice in this scene. According to Marcy S. Sacks in *Before Harlem: The Black Experience before World War I*, "Facing a life of drudgery that proved to be little better than what they had left behind in the South, some chose prostitution as the best of the meager options available to them" (61). Mayme, a Memphis native, plans to use the beauty parlor to shed the unflattering labels pinned on prostitutes like her. When she steps into Esther's beauty parlor, there will be a place for her. Mayme longs to be "treated like a lady" and secure the economic and social privileges that apparently stifle the white socialite, Mrs. Van Buren. When Esther makes Mayme a pale blue corset with royal glass beads similar to the one Esther has made for Mrs. Van Buren, an elated Mayme says, "Feel it. It feel like Fifth Avenue, does" (Nottage 19). Esther, in essence, brings Fifth Avenue high society to Mayme in the Tenderloin district. New York's colored women may be devalued by the larger society, but, according to Esther, in her shop they are high-class ladies. Historian Darlene Clark Hine says that "these black aristocrats" found ways to "distance themselves from less affluent black and white people" (*African-American* 378). To some extent, the dreamer Esther naively believes that the Black female elite of New York City will patronize the same beauty parlor that Mayme visits.

Although little to nothing is said about what Esther experiences on the streets as she ventures to Mayme's, Scene 4 inspires further queries about the ways in which a seemingly demure character like Esther manages to navigate New York to deliver her undergarments. Sacks writes that, as the Black population increased in the city before and after the turn of the century, "whites rebelled" (47). In 1900, race riots first erupted in the Tenderloin district, which approximately spanned 23rd Street up to 42nd Street, and Fifth to Seventh Avenues. The Tenderloin had largely become African American but also included an Irish population (40, 75). How difficult was it for Esther to navigate the Manhattan streets alone when tensions prevailed between Blacks, Irish, and Italians beyond 1900? Sacks notes that "white police officers regularly presumed black women's engagement in prostitution, causing them to make false arrests on this charge" (61). How did a colored woman like Esther manage to maintain her dignity and self-esteem in public if her movement was always under suspicion?

At the end of Act 1 in Scene 6, Esther prepares to vacate the rooming house as Mrs. Dickson shares her philosophy on marriage:

> [M]y mother wanted me to marry up. She was a washerwoman, and my father was the very-married minister of our mission. He couldn't even look at her there in the church pews, but she'd sit there proudly every Sunday, determined to gain God's favor … I was going to marry up. Love was an entirely impractical thing for a woman in her position. "Look what love done to me," Mama would say … But I would not be a washerwoman if it killed me. And I have absolutely marvelous hands to prove it. (Laughs, displaying her hands.) But you have godly fingers and a means, and you deserve a gentleman. Why gamble it away for a common laborer?
>
> (Nottage 32–33)

The misery experienced by her mother shapes Mrs. Dickson's worldview. Mrs. Dickson's mother sits at the bottom of the Black church's social order. According to Hine, the ministers' wives, historically the "principal agents" within the church, sit in the front pews of this religious institution (*Black Women* 46). This is a seat of prestige, of respectability that translates into a comfortable position within the larger Black community. As the minister's mistress, Mrs. Dickson's mother was forever "confined" to the other pews and to manual labor. Mrs. Dickson asserts respectability like "marrying up" is more important than love (Nottage 39). According to Mrs. Dickson, marrying up will elevate a colored woman's status in society. It will symbolically move the colored woman to the first pew in the Black church.

As a respectable widow, Mrs. Dickson continues to celebrate the values and guidelines of the Victorian era, which ended in 1901. In Shirley J. Carlson's essay, "Black Ideals of Womanhood in the Late Victorian era," she states that "the ideal black woman embodied the genteel behavior of the 'cult of true womanhood,' as espoused by the larger society" (61). Simply stated, respectability coexists with genteel behavior. Carlson adds that, "This ideal woman spent her leisure time in a variety of social activities, including attendance at teas and luncheons, parties and church activities, among others" (62). Mrs. Dickson longs to include Esther in the activities attended by the so-called ideal colored woman.

Once Esther meets and marries handsome George Armstrong, she receives invitations to church socials and ladies' teas. By Act 2, Esther hopes to attend "respectable social activities" with her husband on her arm. Despite the fact that George has yet to secure employment in the city, attendance at these activities with her husband will show that Mrs. Esther Armstrong belongs and is loved. Furthermore, when George attempts to lure Esther's entire savings away from her to purchase draft horses, he uses notions of respectability to do so. In Act 2, Scene 4, George declares in the couple's bedroom:

> GEORGE: …'e know a fella got twelve draft horses and want to sell them quick quick. And 'e buy them, and in two years they'll have enough money for a beauty parlor even. They'll have the finest stable in New York City. People'll tip their hats and pay tribute. They'll call them Mr. and Mrs. Armstrong. The Armstrongs. Them church ladies will clear the front row just for them. And 'e will …
>
> ESTHER: (*Wants to believe him*): He will what?
>
> (*George slowly moves toward Esther.*)
>
> GEORGE: 'E will sit with she and nod graciously to the ladies. 'E will come home for supper every evenin'. (*Seductively*) 'E will lie with she.
>
> (Nottage 50)

George claims that his success with the horses will translate into a good reputation and enormous wealth. George is a recent immigrant who understands the significance of class status in a capitalist society. But here, he fails to display his understanding of the racial fabric of America when he naively expects the Armstrongs to obtain the same kind of wealth and prestige as white elite families like the Vanderbilts and Rockefellers. In order to acquire Esther's savings, he convinces her that he will play the respectable gentleman. With his wealth, he will display some self-control. George and Esther are strangers. He is not the man he claimed to be in his letters. She is losing her husband to the vices of the city. Yet, she surrenders her life savings to feel his touch.

Nottage's characters long to experience the American dream in New York City. These characters attempt to read and digest the various codes and signs in their environments in

order to formulate and actualize their dreams. These characters accept and reject guidelines of respectability in order to fulfill their needs and desires. Consequently, they want to find a place in the city. In many cases the Black female characters like Esther accept and reject guidelines of respectability in order to find this place.

## Notes

1 Nottage received the Pulitzer Prize for her play *Sweat* in 2017. Her other plays include *Fabulation, or the Re-Education of Undine, Crumbs from the Table of Joy, POOF! By The Way, Meet Vera Stark*, and *Ruined*.
2 In the Off-Broadway production of *Intimate Apparel* at the Roundabout Theatre in New York City in 2004, Esther, played by Viola Davis, carefully examined the fabric sold by Mr. Marks, played by Corey Stoll.

## Works cited

Carlson, Shirley J. "Black Ideals of Womanhood in the Late Victorian Era." *Journal of Negro History*. vol. 77, no. 2, Spring 1992, 61–73.

Hine, Darlene Clark. *The African-American Odyssey: Combined Volume*. Pearson Education, 2003.

———, editor. *Black Women in America*, vol. 3. Oxford UP, 2005.

Homberger, Eric. *Historical Atlas of New York City: A Visual Celebration of Nearly 400 Years of New York City's History*. 2nd ed., Holt Paperbacks, 2005.

Nottage, Lynn. *Intimate Apparel*. Dramatists Play Service, 2005.

Sacks, Marcy S. *Before Harlem: The Black Experience before World War I*. U of Pennsylvania P, 2006.

Shaw, Stephanie. *What a Woman Ought to Be and to Do: Black Professional Women Workers During the Jim Crow Era*. U of Chicago P, 1996.

# 8

# EARLE HYMAN

## Scandinavian successes

*Baron Kelly*

No discussion of actors of color on the stages of Norway can exclude the career of Earle Hyman (1926–2017). Hyman was a distinguished African American actor who has been knighted by Norway for his work in *Othello* and his portrayal of Brutus Jones in Eugene O'Neill's *The Emperor Jones*. What he is best known for is his television portrayal of Grandfather Cosby on "The Cosby Show" (later 1980s–early 1990s). His love of the works of Ibsen first led him to Norway. While there, one critic wrote of him, "He loves Norway and its people, and he acts "Othello" with a vengeance" (Hyman, "Black Actor in Norway" 33).

To an earlier generation, Hyman was a "real" Black man who could lend authenticity to the Black roles he was performing. The conundrum was that he was lauded as a great actor, embraced as good friend of Norway, but the bulwark of conventional theatrical realism in Norway prevented him from performing in a non-traditional role in the work of his beloved Ibsen. Hyman began to perform in Norway speaking the two official languages of Nynorsk and Bokmål used in the theatres of that country. He appeared also on the stages of Sweden and Denmark, where he spoke Norwegian while the rest of the players spoke their native tongue. Hyman's first Norwegian performance was as Othello, for Den Nationale Scene in Bergen (1963). With Othello, Hyman created Norwegian stage history by being the first American to perform in Norwegian. In the over 50 years since Hyman first appeared onstage in Norway, issues of multiculturalism and non-traditional casting in Norway loom large.

Earle Hyman was 13 years old in 1939 when he saw a performance in a Brooklyn theatre of Henrik Ibsen's *Gjengangere* (Ghosts) with Alla Nazimova playing the role of Mrs. Alving. The play was a present from his parents. His parents had moved the family up from North Carolina to Brooklyn so he and his siblings could get a better education in the schools up north. He was too young to understand the full complexity of the characters, but the haunting quality of the story captivated him to develop a life-long interest in the drama of Henrik Ibsen. Whether or not this was because Ibsen was the first professionally produced playwright he had ever seen, as far as Hyman was concerned, "first there is Shakespeare, and then there is Ibsen" (Interview). He was a Black kid in a white world bitten by a bug named Ibsen. Hyman began to read Ibsen's translated works from *Catilina (Cataline)* (1849) to *Når vi døde vågner* (*When We Dead Awaken*) (1899), promising himself that one day he would read them in the original language. As an actor, he became aware of the complexity of Ibsen's characters and felt that some of the subtleties inherent in the scripts might have been sacrificed as a result of translation into English.

Hyman made his Broadway debut at age 18 in the now all-but-forgotten historic 1944 production of Philip Yordan's *Anna Lucasta*, about the return of a troubled, good-looking Black prostitute to her family. In the 1950s, Hyman was forging a tremendous career in New York theatrical venues with his subsequent roles on Broadway, including the title role in *Mister Johnson* and Didi in *Waiting for Godot*. His Off-Broadway roles for the Phoenix Theatre included Dunois in Bernard Shaw's *Saint Joan* and Antonio in *The Duchess of Malfi*. Hyman was the first true pioneer of non-traditional casting in the United States. In 1955, he was the first African American actor in the United States to be hired to play non-traditional roles, including Sooth Sayer (*Julius Caesar*), Melun (*King John*), Horatio (*Hamlet*), and Autolycus (*The Winter's Tale*) for the American Shakespeare Festival in Stratford, Connecticut.

In 1957, Hyman decided to take a two-week vacation and make his first visit to the land of Ibsen. Aware of Hyman's fondness for Ibsen, Romney Brent, an actor and former instructor at the American Theatre Wing, gave him a letter of introduction to Ibsen's grandson, the filmmaker Tancred Ibsen. The lineage on both sides of Tancred's family impressed Hyman. Tancred's mother was the daughter of Bjørnsterne Bjørnson, the famous Norwegian poet, playwright, and novelist. Tancred's wife, Lillebil Ibsen, was one of Norway's leading actresses. The gracious and charming Ibsens introduced Hyman to many of Norway's leading actors and directors. Hyman was completely overwhelmed by their sincere desire to learn of his background and ideas about the theatre. Hyman recalls, "It was such joy to be in an atmosphere in which theatre was discussed as an art, and not as a commercial enterprise" (Interview). One of the people he met through the Ibsens was Ellen Isefiær, a director. Little did he guess that Isefiær would direct him six years later in *Othello* at Den Nationale Scene, Norway's oldest theatre. But Norway would have to wait; Hyman had his immediate theatrical sights set on London.

In 1958, Hyman's professional career would return him to London, where ten years earlier he had been so successful in the Broadway transfer to the London stage of the American Negro Theatre's production of *Anna Lucasta*. Hyman would garner good reviews acting in productions of Errol John's *Moon on a Rainbow Shawl* at the Royal Court Theatre and, most importantly, playing Walter Lee Younger in Lorraine Hansberry's *A Raisin in the Sun*. In August of 1959, Hyman opened at the Adelphi Theatre in *Raison*. He remembered:

> We had quite a nice run although at the time London was experiencing some unusually good weather. I suppose the people wanted to enjoy it, and at first we played to meager houses. It caught on after awhile, however, and the audiences seemed to love it. Many times we could hear them crying.
>
> (Interview)

In the early summer of 1962, Hyman made another trip to Norway. Prior to his first trip in 1957, Hyman had taken Norwegian language classes in New York. While attending the Bergen Theatre Festival, Hyman met the theatre manager of Bergen's den Nationale Scene (the National Stage), Bjarne Andersen. Andersen was so impressed with Hyman's Norwegian language skills that he invited him to play the title role of Othello in Bergen in the spring of 1963. Hyman did not accept the offer immediately because he felt his language skills were not proficient enough, but he agreed to read the Larsen translation. Back in Oslo, Hyman wrote to Andersen on June 20, 1962, that he had read "Gunnar Larsen's translation of *Othello* several times," and he thought "it was a very good one." Hyman felt that Andersen "understood my feelings with regard to the preparation of the role in Norwegian." Hyman concluded with, "if there will be a performance of *Othello* in Bergen, I will give an answer the beginning of September" (Letter June 20, 1962). In the meantime, Hyman, who had previously signed to do

*Othello* at the Great Lakes Shakespeare Festival at Antioch College in Ohio, had to travel from Oslo back to the United States to begin rehearsals.

In order to better understand the difficult task that Hyman had assigned himself, perhaps it should be noted that the people of Norway have two different written forms of language but speak hundreds of dialects. Nynorsk and Bokmål are the two written languages and are mutually understandable. Hyman accomplished the unenviable task of mastering both. He commented that, "to my ears Norwegian is somewhere between English and German. What it lacks in vocabulary, it more than makes up for in the intricacy of the phrasing and inflection" (Interview). During the rehearsals of *Othello* in Ohio, he continued memorizing Gunnar Larsen's translation in Norwegian. Shortly after this, an interesting and amusing incident occurred. One night during a performance, Hyman noticed a very strange expression in Iago's eyes and unusual mutterings from the audience. Hyman suddenly realized that he was speaking Othello's lines in Norwegian (Interview). Hyman wrote back to Andersen on September 23, 1962, explaining that because of a heavy work schedule he was sending a late acceptance of the offer to play Othello in Bergen. Hyman was more confident with the script and wrote that, "there were just a few words that I find a bit difficult to pronounce" (Letter). Hyman concluded by saying, "I am still very interested to play Othello with you as Iago, and I am interested to see if terms could be met for engagement" (Letter).

When Hyman stepped off the boat in Bergen, Black people were a rare sight in Norway. If a Black person walked down Karl Johans Gate, the main street in Oslo, people would stop and stare. The Bureau of Statistics in Norway states that in the years 1961–1964, of the 3 million people in Norway, 300 were from African countries, and they were students. While it was rare to see ethnic non-whites in Norway, Norwegians were aware of the civil rights movement in the United States from newspapers, radio, and television coverage. Nevertheless, Hyman was not what Norwegians were expecting in an African American from America. Actress Karin Hox remembered:

> We all lined up at the doorway to the theatre. A buzz went around that he was coming. When he entered we saw this cultured, good-looking, light-complexioned black man in a suit, speaking Norwegian. He was strange and fascinating. It was like, Wow!!
>
> (Hox Interview)

Hyman was a tall man who had a commanding oratory that echoed that of Paul Robeson. His learning the Norwegian language because of his love of Ibsen's plays doubly impressed the Norwegians.

Det Norske Teatret's Artistic Director Tormod Skagestad traveled from Oslo to Bergen to see Hyman's performance of Othello. When Skagestad witnessed Hyman's powerful performance, he envisioned this power and intensity transferred to the character of Brutus Jones in Eugene O'Neill's *The Emperor Jones*. After the performance, Skagestad approached Hyman to inquire about the possibility of an engagement for the fall of 1964. The only catch was that the play would be performed in Nynorsk, the New Norwegian language. Den Nationale Scene's *Othello* was in Bokmål. Hyman would have a year to learn the new language. Riding on the crest of the success of *Othello*, he agreed to an engagement with Det Norske Teatret, including guest performances of *Keisar Jones* at the Bergen Theatre Festival and Sweden's Royal Theatre Dramaten.

Always with an angle eye for selling a show, Skagestad, in a 1964 *Arbeiderbladet* interview, highlighted the similarities between O'Neill's *Emperor Jones* and Ibsen's *Peer Gynt*. He said, "både Peer Gynt og Keiser Jones handler om mennesker som bygger seg opp en strålende trone,

men i begge tilfelle overtar skjebnen styringen" ("both Peer Gynt and Keiser Jones—Emperor Jones—are about people who build themselves a glorious throne, but in both cases fate takes over the control"; Gjesdahl).[1]

In 1964, America's Civil Rights Act was signed. In Norway, racist incidents in the United States were broadcast on television and radio, and many Norwegians were outraged at the treatment of Blacks by ordinary people in the United States. The performances of *Keiser Jones* (*Emperor Jones*) only added to the heated race debate already taking place in Norway. The play was described in *Aftenposten* as "et sterkt dramatisk stykke om forholdet mellom negeren og den hvite mann representert ved cockney kjøpmannen Smithers, og om negerens forhold til sitt egentilige opphav" ("a strong dramatic piece about the relationship between blacks and the white man, represented by the cockney merchant Smithers, and about the black's relationship with his real origins"; "Keisar Jones"). Skagestad knew that he would fill his theatre to capacity and also provide the Oslo theatrical debut of Hyman to Norway. Skagestad even scheduled a Racedebatt konferanse (Race Debate Conference) after one of the evening performances.

When *Keiser Jones* opened on September 14, 1964, it was a resounding success for Hyman and for Det Norske Teatret. Hyman received high praise for his Nynorsk, and Elizabeth Gording summed it up for every critic, saying, "vi fascineres av denne skuespillers imponerende sprogbruk" ("We are fascinated by this actor's impressive language skills"; Gording). Hyman's ability to take the audience on the character's journey was commented on when *Arbeiderbladet* wrote "ikke et øyeblikk får tilskueren høve til å føle seg utenfor. Han er selv med på denne flukten fra en ond og rettferdig skjebne. Så stor er skuespilleren" ("Not for one moment has the onlooker the opportunity to feel outside. He is participating in this escape from an evil and just destiny. The actor is that great"; "Keisar Jones"). Of Hyman's expression of character, Lisi Caren in *Dagbladet*, wrote "Mange vil ha meget å lære av Earle Hyman når det gjelder kroppsbeherskelse" ("Many people have a lot to learn from Earle Hyman with regard to body control").

The legacy of Earle Hyman must not be forgotten. Even though Hyman was a well-loved figure who spent a good deal of his adult life in Norway, he was still considered a visitor and not a native. The debates about migrants and (cultural) citizenship in general have led to a number of intercultural strategies and programs in the arts and education, most of which are more concerned about integration and social cohesion than about an open exchange of different values and world views. How can a country that propagates its own humanism and virtues, projects an image to the world and its people of being a tolerant, liberal, and humane society deny the development of its artists of color?

## Note

1 All translations of review quotations are by the author.

## Works cited

Caren, Lisi. "O'Neill's Keisar Jones," *Dagbladet*, Sep. 16, 1964.

Gjesdahl, Paul. "*Keiser Jones* en seier for Det Norske Teatret" ["*Emperor Jones* a Victory for Det Norske Teatret"]. *Bergens Arbeiderbladet*, Sep. 17, 1964.

Gording, Elizabeth. "Keisar Jones." *Handel og Sjøfart*, Sep. 16, 1964.

Hox, Karin. Personal Interview. Dec. 5, 2001.

Hyman, Earle. "A Black Actor in Norway." *Negro Digest*, Feb. 1964, pp. 33–36.

———. Earle Hyman letter to Bjarne Andersen. June 20, 1962. Bergen Theatre Archives. Bergen, Norway.

———. Earle Hyman letter to Bjarne Andersen. Sep. 23, 1962. Bergen Theatre Archives. Bergen, Norway.

————. Personal Interview. Apr. 19, 2000.

"Keisar Jones for første gang i Norge" ["*Emperor Jones* for the first time in Norway"]. *Aftenposten*, Sep. 12, 1964.

"Keisar Jones mer aktuelt i dag enn for 40 år siden" ["*Emperor Jones* More Topical Today than 40 Years Ago"]. *Arbeiderbladet*, Sep. 12, 1964.

Norwegian Bureau of Statistics, www.ssb.no/en.

# 9

# PITTSBURGH PIETY

## A century of symbolism

*Pedro E. Alvarado*

Critics often regard August Wilson as one of the best American playwrights of the twentieth century, perhaps of all time. His plays portray African American life unapologetically, but, unlike most other African American playwrights, Wilson's works have transcended the genre of "African American" plays. They have not only been accepted into the canon of twentieth-century mainstream American plays but also have been accorded a place of honor therein. I believe that Wilson's works broke through and found permanent residence in mainstream American theatre because he wrote plays featuring characters who wrestled, both consciously and subconsciously, with how to be African American without sacrificing the African or assimilating into the American. On one level or another, each of the plays in what Wilson called the Pittsburgh Cycle deals with African themes in an American context and/or with American ideals in an African context. Wilson's characters struggle with conflating the African heritage and history that was taken from them by slavery with the reality of living in America to form a complex African American identity. Perhaps the greatest part of this conflation, whether African theme or American context, is religion or spirituality. For the purposes of this chapter, these terms will be used synonymously and interchangeably. For Africans and peoples of the African Diaspora, spirituality is not something that is done; it is lived.

In this chapter, I parse out some of the religious symbolism and lived spirituality that I believe to be consistently present throughout the Pittsburgh Cycle. As to whether Wilson intentionally wrote his plays with these subtle religious inferences, I do not know. Nevertheless, I believe that because he was an inheritor of African spiritual heritage, his plays could not help but be influenced by this inheritance. African cultural theorist John S. Mbiti says,

> Africans are notoriously religious, and each people has its own religious system with a
> set of beliefs and practices. Religion permeates into all the departments of life so fully
> that it is not easy or possible always to isolate it.
>
> (1)

Some will inevitably argue that August Wilson also had a European heritage because his father was a white man from Germany, and those people would be correct. But I believe that in choosing to self-identify as an African American, even while acknowledging his white father, Wilson demonstrated, through the characters he created, the struggle of conflating his own

African spiritual heritage within his American context. This can be seen visibly in his play *The Piano Lesson* (1987), where the central conflict is over whether to sell the Charles family piano to raise money to buy the land their ancestors once worked as slaves.

From the text of the play, we know that the man who owned the Charles family during slavery, Mr. Sutter, traded an enslaved woman, Mama Berniece, and her son, Papa Boy Walter, to another white man in order to obtain a piano. When Mr. Sutter's wife took sick because she missed her traded slaves, and the white man with whom Mr. Sutter had made the barter refused to trade them back, Mr. Sutter ordered Mama Berniece's husband, Papa Boy Willie, to carve the images of his wife and son onto the piano. Not only did Papa Boy Willie carve those images; he also carved various other pictures, including scenes from his family's life together and his own parents. This multi-generational carving created by an enslaved diasporic African was much more than a picture of his family. It was an image with tremendous spiritual significance because African art is created "for more than decorative purposes—to serve instrumental ends—to worship, to perpetuate the memory of an ancestor, to serve as one component of a masquerade" (Hallen 237). This carving certainly helps to memorialize each subject, but what is atypical about this African carving is that it is not carved from or onto a traditional African medium. It is carved onto a piano, which originated in Europe in 1709 and but did not make its way to America until the nineteenth century (National Piano Foundation). The piano is a markedly European instrument. By having his character carve a work of African religious art onto a European medium, Wilson conflated two distinctly different cultures into one uniquely African American culture. I find *The Piano Lesson* to be the most obvious example of conflating the African with the American; however, religious art is not the only Africanism present in Wilson's plays.

Another significant Africanism frequently found in Wilson's plays is the understanding of the nature of time. Western culture tends to think of time in a linear fashion with a definite beginning, middle, and end. According to Mbiti, "the linear concept of time in western thought, with an indefinite past, present, and infinite future, is practically foreign to African thinking" (21). In African cultures, time is typically thought of cyclically. It is not exclusively thought of in terms of *when* an event occurs, as is the Western perception of time, but it is viewed as a *relationship* involving *what* happened, *where* it happened, and *with or to whom* it happened. All of these elements combine to create the African conception of time. "The African conception of time cannot be understood accurately when separated from space, history, or tradition, and the (complete) fulfillment of the individual as an ancestor" (Magesa 55).

Wilson's character Aunt Ester is an example of the African conception of time. Aunt Ester only appears in *Gem of the Ocean* (2003), but she is mentioned in *The Piano Lesson* (1990), *Two Trains Running* (1992), *King Hedley II* (1999), and *Radio Golf* (2005). Her age is a mystery but her impact as a "washer of souls" is felt throughout the Pittsburgh Cycle (Wilson, "Two Trains" 24). In *Gem of the Ocean*, Aunt Ester is said to be 285 years old, which would have made her 366 years old at the time of her death in 1985 in *King Hedley II*. Even after her death, her impact is felt in *Radio Golf* as the central conflict, which is whether or not to demolish the home she occupied while alive. I do not believe that August Wilson expected the audiences and readers of his plays to believe that an individual could really live that long, but I do believe that, with this character, Wilson was trying to demonstrate the validity of an African American identity that reaches across time and is as old as the presence of Africans in America.

Furthermore, the order in which his plays were written also provides evidence that Wilson's concept of time is more closely aligned with the traditional African conception than with the Western one. Each of the ten plays in the Pittsburgh Cycle takes place during a different decade of the twentieth century, but they were not written in chronological order. The first play of the cycle chronologically, *Gem of the Ocean*, takes place in 1904 but

was written in 2003, while the first play that was written, *Jitney*, takes place in 1977 but was written in 1982. The final play, *Radio Golf*, is last in both chronological (1997) and writing order (2005); obviously Wilson had to wait for the 1990s to end before he could write about them. Additionally, as Wilson's personification of African American identity, Aunt Ester's appearance in the first play chronologically and her former house as the object of the central conflict in the final play demonstrate the perpetual impact of African American identity and what religion theorist Laurenti Magesa called the "fulfillment of the individual as an ancestor" (112). In the Pittsburgh Cycle, Aunt Ester, or African American identity itself, is like a perpetual motion machine. It is at the end from the beginning, at the beginning from the end, and it continues moving indefinitely.

In continuing with the Aunt Ester theme, the last area of religious symbolism and African spirituality discussed in this chapter is the influence of women in African American society. One of the most consistent critiques of August Wilson's plays has to do with the way he portrays his female characters. As a matter of fact, one of my professors in undergraduate school, Dr. Shirlene Holmes, told me about a panel discussion she attended that August Wilson was on shortly before he passed, and she asked him why his female characters were not as three dimensional and fully developed as his male characters. According to Dr. Holmes, his reply to her was, "Because I'm a man and that's what I write about. I leave it to you sisters to write about women." Dr. Holmes indicated that she did not perceive Wilson as being dismissive in any way. He was merely indicating that he did not have the life experience to write women any better than he did.

Still, I believe that Wilson's female characters serve the worlds of their plays, much as women in African societies are thought to serve their families, clans, and villages. Magesa says of women in Africa, "Women play to the role of conciliators in the wider community as well, and failure to heed their advice often brings unfavorable consequences" (160). This sentiment can also be found in the African American community, particularly within the Black church. Women in the Black church, which is still largely a patriarchy, have created for themselves places between the pulpit and the pews where they can exercise influence and spiritual authority without impinging on the established order of the church (Butler 2).

In the plays of the Pittsburgh Cycle, in like manner to their African counterparts, it is primarily the women who serve as the intermediaries between opposing forces; they are sought after for wisdom and direction in life; they are looked to to bring understanding to a circumstance; and they have the principle responsibility for preserving the spiritual life in each of their plays. We see this throughout the cycle: Martha Pentecost (*Joe Turner's Come and Gone*, 1988) frees her estranged husband from his spiritual bondage; Berniece Charles (*The Piano Lesson*) exorcises a ghost by playing a piano and calling on her ancestors; and Aunt Ester (*Gem of the Ocean*) helps one man to a spiritual awakening and another man get his soul cleansed. This is not to say that the female characters have the sole responsibility for the plays' spiritual underpinnings or that none of the male characters have any connection to the unseen realm. For example, Bynum in *Joe Turner's* is a root worker who binds people together; Avery in *Piano Lesson* has a spiritual vision that leads him to start a church; and Troy Maxson in *Fences* (1986) wrestled with death. But even with these male characters' interactions with the spirit world, there was always a woman to help them.

So, from this high-level and relatively basic view of the ten plays in the Pittsburgh Cycle, we can see the tip of the religious symbolism iceberg. To cover all the religious symbolism in all of the plays would take a volume of work much more substantial than this one. Nevertheless, it is fairly safe to say that just as August Wilson used his plays to make commentary on the social and political happenings of each decade in the twentieth century, his commentary was informed by

African American spirituality, which, according to Mbiti, is ever present, even when we can't exactly put our finger on it (1).

## Works cited and further reading

Butler, A.D. *Women in the Church of God in Christ: Making a Sanctified World*. U of North Carolina P, 2007.

Hallen, B. *African Philosophy: The Analytic Approach*. Africa World Press, 2006.

Holmes, Shirlene. Personal Conversation with Author. Jan. 22, 2014.

Magesa, L. *What Is Not Sacred? African Spirituality*. Orbis Books, 2013.

Mbiti, J. S. *African Religions and Philosophy*. Anchor Books, 1970.

National Piano Foundation. *History of the Piano*. *PianoNet*, 2017, http://pianonet.com/all-about-pianos/history-of-the-piano/.

Wilson, August. *Fences*. Plume, 1986.

———. *Gem of the Ocean*. Theatre Communications Group, 2003.

———. *Jitney*. Samuel French, 1982.

———. *Joe Turner's Come and Gone*. Plume, 1988.

———. *King Hedley II*. Theatre Communications Group, 2005.

———. *Ma Rainey's Black Bottom*. Plume, 1985.

———. *The Piano Lesson*. Penguin, 1990.

———. *Radio Golf*. Theatre Communications Group, 2007.

———. *Seven Guitars*. Plume, 1996.

———. *Two Trains Running*. Plume, 1992.

# 10

# INTERVIEW WITH RON SIMONS

## Broadway producer

*Interviewed by Lisa B. Thompson*
*June 29, 2017*

Ron Simons is a four-time Tony Award-winning producer and a stage, film, and television actor (Figure 10.1). The founder and CEO of SimonSays Entertainment, he is a member of the Screen Actors Guild and the Producers Guild of America. The Detroit native's producing credits include the Broadway shows *A Gentleman's Guide to Love and Murder* (Tony Award for Best Musical), *The Gerswhin's Porgy and Bess* (Tony Award for Best Revival of a Musical), *Vanya and Sonia and Masha and Spike* (Tony Award for Best Play), and *Jitney* (Tony Award for Best Revival of a Play), as well as the critically acclaimed films *Night Catches Us*, *Gun Hill Road*, *Blue Caprice*, and *Mother of George*.

LBT: Tell me about your education.

RS: I have an undergraduate degree in English from Columbia University; most of the courses I took were in theatre arts and computer science. I have an MBA from Columbia Business School. After a few years in corporate, I got my MFA in acting at the Professional Actors Training Program at the University of Washington.

LBT: Why did you choose theatre as a form of expression?

RS: What I love about theatre is that the theatre is comprised of community. It's the community that is created when the actor meets the audience onstage. It is a medium that is never exactly the same twice. It's a medium that requires actors to be focused and in the moment when they're onstage, throughout the run of the show. I feel like it's an art form that can move you in a way that film can't, that television can't. It's an important part of our cultural legacy that we support theatre for all of the above reasons.

LBT: Tell me about your journey to becoming a Broadway producer. Did you receive formal training?

RS: My training has been on the job training exclusively. I began as a co-producer because I didn't understand enough about the business to be a lead producer, nor did I have a project I was working on. I didn't know how to raise the seed money to get the project off the ground, negotiate with talent, or obtain a theatre. Before that, I did invest in a Broadway show, and that was August Wilson's *Radio Golf*. The two people who brought me in asked that I sit in on the meetings with the co-producers because of my marketing background. That's really where my education began. I think my career really took off when I became a co-producer for my first Broadway show, *The Gershwin's Porgy and Bess*.

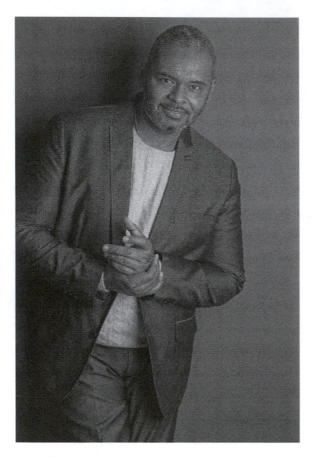

*Figure 10.1* Producer Ron Simons.
*Source*: Photographer Bobby Quillard.

LBT: If you were speaking to undergraduates how would you explain what a theatre producer does?

RS: Broadway producers, in the general sense, are the COO of the production. They make sure the infrastructure is set up. They do all the negotiations, hire the legal staff, find the theatre, all the talent, all the crew, find an ad agency, the PR agency, the social media agency, and find investors and co-producers. So, while it's true that if there were no writer there'd be no play, if there were no producer there'd be no production.

It's a money game to produce on Broadway, which is a barrier to entry for many people of color. Part of being a successful producer is developing your network of potential investors along with your skill set. You also need to know what makes good theatre good, and what makes good storytelling good, and know strategies to bring the shows you want to Broadway.

LBT: I imagine that your production company, SimonSays Entertainment, Inc., receives hundreds of script submissions annually. What factors go into your decision to select projects?

RS: The first thing is a great story. I'm a storyteller. I'm trying to change the world one show, one film, at a time. The second thing is—and it's a triad—is that it has artistic integrity, which is to say that the content is of high quality, and the people associated with it need to have artistic integrity as well. The third thing is, it must tell the story of underrepresented communities that [Broadway and] Hollywood generally tend to overlook. What separates SimonSays Entertainment from other entities is that we define underrepresented communities by a broad umbrella. It's not just African American stories, but Latino, Asian, LGBTQ, women, and the disabled—basically a very broad description that I think represents the majority of the people on the planet.

LBT: What are some of the mistakes people make when they're trying to pitch you?

RS: Some people pitch me a story and they give me the synopsis of the story. That's great but that doesn't help me understand what makes the story compelling. I need to understand three things: why you're passionate about this project, why you're the right person to tell this story, and why this story needs to be told now. Take me on a journey. Help me understand the various colors, contradictions, and extraordinary moments that make the story so compelling that I want to read it when you're done pitching it to me. Don't think of pitching as selling; think about it as sharing why you are so passionate about this project.

LBT: What are some of the major challenges in the field?

RS: Forty years ago it was a producer's business. Theatres were begging to get productions to come and play in their houses, but now the roles are reversed. Theatre houses hold the power because there's four or five plays vying for that space … Theatre is also becoming more challenging because there's so many forms of entertainment. It's no longer ABC, NBC, and CBS; now there's all the cable channels and all the streaming services. That's a hell of a lot cheaper than buying a family of four Broadway tickets!

I try to reach out past the normal demographic of Broadway because the people who buy tickets are often white women between the age of 45 and 60. Eventually that demographic will have seen your show, and then who is your show going to appeal to? Shows that are performing exceedingly well, like *Wicked, Dear Evan Hansen,* and *Hamilton,* have content that really appeals to younger audiences. The challenge is always how to bring a younger audience and people of color to Broadway.

There are also challenges around the perception about the kind of people you need to cast to attract audiences. There is an ongoing belief that if you have the right celebrity it will pack the house. Broadway plays are even more challenging than musicals. They tend to attract smaller audiences. It's a rare bird that becomes what I call a brand, a brand that goes beyond Broadway, that goes beyond theatre and is now in the vernacular of the community—*Wicked,* which is known all over the world; *Hamilton* is now all over the world. I can't think of a single play that's reached that level of branding success. So to counter the lesser interest of audiences, producers often look to add star power to the production with a big TV or film name. That in turn increases the cost of the show making it more difficult to recoup the higher budget.

LBT: How does being an actor influence your work as a producer and vice versa?

RS: Being an actor helps me understand stories so much better. I know the difference between a great script, a good script, a mediocre script, and a script that really should be used for kindling. I think that being a producer helps me as an actor to understand that sometimes it's not about your talent. Sometimes it's about stuff that you really have

71

no control over. Sometimes it's how you look against the leading man, or it may be that you're perfect for the part but there is this celebrity that wants to do it and investors will spend money on that celebrity versus someone unknown.

LBT: What advice do you have for African Americans who want to enter the business as theatre producers, particularly new college graduates?

RS: I would say make sure you investigate all of the programs that are designed to bring people of color into the industry. The Broadway League has an initiative where talented young people of color get matched up with producers, general managers. If you're interested in film, you need to know about Sundance and the Independent Film Project. I also know a bunch of people who got their start in regional theatre. I would say find a mentor, someone who will take you under their wing so you learn on the job by doing and seeing how the business operates. That probably means interning somewhere for little or no pay. Go work alongside the people you want to emulate.

So much about this is *who* you know. Projects even come to me because of who I know. Knowing who your peers are, be they senior or more junior to you, is absolutely key. You need to see and read a lot of plays; take a class in theatre appreciation or the classics so you understand good stories and what makes a good story, so when the time comes for you to assess something, you're not just responding to it because there's a great song in the middle of Act 2 but because the structure of the piece supports the story that's being told. In addition to the mentoring, you want to get to know a lot of writers because writers are the ones writing the plays today that you will be producing tomorrow. Get to know those who are writing the plays in the genre that you care about, or in the space that you value. If you really want to do African American plays, find out who the African American playwrights are, go see their work, support their work, and get to know them personally.

LBT: You've won four Tony Awards for producing. What is the most memorable accomplishment? What are you proudest of?

RS: I'm most proud of when *Turn Me Loose* opened and Dick Gregory said, "I thought I was going to die in obscurity, and this play lets me know I won't be forgotten." That was priceless. You can't buy that type of elation. Yes, I love winning Tony Awards, and I'm thankful for each and every one of them, but when I have an artist, in this case, comedian and activist Dick Gregory, whose story needs to be told, is moved alongside the audience, then I'm on the right track.

# 11

# INTERVIEW WITH PAUL TAZEWELL

## Costume designer

*Interviewed by Niiamar Felder*
*June 19, 2017*

Paul Tazewell, a native of Akron, Ohio, is a Tony and Emmy Award-winning costume designer (Figure 11.1). Having designed for regional and Broadway theatre, opera, television, and film, Tazewell has amassed an impressive list of credits that span 25 years. His most notable productions are *Hamilton, Bring in 'da Noise, Bring in 'da Funk*, and *The Color Purple*.

NF: What attracted you to costume design, or was it theatre first?

PT: Originally, it was the theatre. My mother was very artistic—she did puppet shows for our church and for the library—and my grandmother was a painter. My interest was working with my hands, such as drawing and painting and sewing, so I became very interested in that way of creating. I attended Buchtel High School, which offered a performing arts program. It was the same time that *Fame* the movie came out, *All That Jazz*, and *A Chorus Line*. The world of live performance was very popular and that was a major influence for me.

NF: Did you go to many plays growing up?

PT: My parents would take us to tours that came through Akron. I remember seeing *Jesus Christ Superstar, Godspell*, and *Ain't Misbehavin'*. We would also go to concerts at the Blossom Music Center in Cleveland. So the world of the arts was definitely a part of our lives. My brothers and I also studied violin, so we were a very artistic family.

NF: Did you have a mentor, or were you inspired by anyone?

PT: I was inspired by Patricia Zipprodt's flair and conceptual thinking, Edith Head's Hollywood allure, Willa Kim's eccentricity and originality, Irene Sharaff's powerful embrace of both theatre and film, and Geoffrey Holder's imagination and presentation. I had incredible undergraduate mentors at North Carolina School of the Arts and for my master's [work] at New York University [NYU]. I was taught by the legendary Carrie Robbins and the groundbreaking John Conklin. In addition to being an incredibly talented designer, Gregg Barnes was a peer, mentor, and wonderful friend and support system during those NYU years.

NF: What were conditions like when you entered the field?

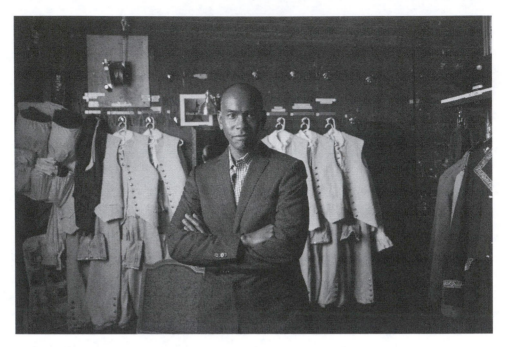

*Figure 11.1* Tony Award–winning costume designer Paul Tazewell in front of costumes for the Broadway musical *Hamilton*.

*Source*: Photographer Yvonne Albinowski.

PT: My last year at NYU, I worked with director Tazewell Thompson. At the time, he was the associate artistic director at the Arena Stage in Washington, DC. There was a production called *Stand Up Tragedy* that was being produced at the Arena and he passed my name on and they invited me to design the costumes. So, this leads into how I was seen or how it was assumed how I would use my strength as a designer because the production was about people of color, youth from inner cities. Thereafter, I started working with the Arena a lot and had tremendous creative growth that happened through the Arena. They became my artistic family, and I ended up moving to DC and became resident costume designer there until 1998.

NF: What were your major challenges?

PT: I was learning the professional world on my own, as it was happening, which was exciting, challenging, and frightening at times. I developed a way of staying open to what was next. I worked as a draper in the costume shop at Tisch School of Performing Arts with Gregg Barnes and learned so much from him on how to start to be a designer in New York, but then I had to put that into practice in my own way once I went to the Arena and as I continued to work.

NF: What do you consider your first major design and why?

PT: *Bring in 'da Noise, Bring in 'da Funk* for several reasons. First, after some years of designing for regional theatres, my reputation had finally been established enough that the prolific director and artistic director of the Public Theatre, George C. Wolfe, asked me to come to New York and work on this new show. Second, the show itself was a game-changer.

The African American experience had never been told like that through musical theatre. The show was crafted and executed with a fierce energy and voice. I see it as one of the first shows that truly helped to change the face and style of the American musical.

NF: Name one accomplishment that you are most proud of.

PT: Accolades and awards aside, the entertainment industry is not an easy one to thrive in. So the accomplishment of which I am most proud of is being a designer who has managed to navigate those waters for 25 years and work consistently. I am proud that I have done that with integrity and without spite and envy towards others. I am proud that I can do honest, creative, work and still support my family and myself and ... be respected in the field by both peers and press.

NF: Having designed in theatre, dance and opera, do you have a preference?

PT: I feel the creative expression of design has the potential of being exciting no matter which of those venues you might pursue. I love the world of musical theatre. In high school, I originally wanted to be a performer. My goal was to be the next Ben Vereen; I was going to be an actor, dancer, a triple threat. I was studying to do that when I started at the Pratt Institute. I still used all of those skills that I learned in pursuit of performing as I designed and continued to grow in some of the same direction, but it just shifted how I was approaching it.

NF: Do you have a favorite show that you have designed?

PT: I would say *Hamilton* is front and center. I love the way the story is told, the music. I love that it is a blend of modern and historic, and that it's all inclusive and very diverse. I am very proud of what I brought to the production, and stylistically it is right up my alley. *The Color Purple*, the original production, is also a huge favorite. Having the opportunity to explore and research those characters and then applying it to the piece was a great joy.

NF: Is there a Paul Tazewell style or something that distinguishes you from other costume designers?

PT: I have an honor and reverence of costume history, technique, craftsmanship, and the persons inhabiting my clothes. I think my style is that I always try to bring a freshness, a modern sensibility, an integrity, and honesty of character to the clothes I design while serving the show as a whole with equal respect. I love the exploration of researching, and I love details even more. I believe strongly that the all of the tiny unseen details on a garment give it a depth and integrity that can be felt on a molecular level by the audience. The emotional and visceral impact of color also plays a huge part for me, but that varies from show to show. I'm not wary of using any color if I think it will influence the reaction of an audience.

NF: What was it like winning the 2016 Tony for *Hamilton*?

PT: It was mind-blowing because it was my sixth nomination, and I am very grateful that I received it for *Hamilton*. It is very heartwarming and a huge honor to be acknowledged by the community of the New York theatre for work that I was really proud of and that brought joy to other people.

NF: Given the enormous popularity of *Hamilton*, has it changed your career to a large degree?

PT: Yes, it has. Because of how visible Hamilton has made me as a designer, there are more people who are now aware that I am a potential choice. It has also affected how I see myself—how I value who I am, what my creativity is, and the kind of presence that I make personally on the stage or film. It has given me more confidence about by own work.

NF: Has race or gender or both affected your opportunities?

PT: I would say race has greatly affected how I've arrived to where I am. In the world of theatre or the entertainment industry, I realized that performance parts for people who looked like me were not necessarily going to be leading men, and that was the kind of role I wanted to play. That was a deciding factor in going towards design. I wanted to avoid being typecast. I was seen for a long time as a designer for shows about people of color. That makes sense, but it also pigeonholed me in a way that didn't acknowledge my ability and love for designing period pieces. There was an element of resentment towards the entertainment industry and how I was being seen by the people that were hiring. That is starting to break down, but at least 50 percent of the offers I still receive are productions about people of color.

NF: Do you recommend young people pursuing a degree in design, as you did, or do you suggest they find a good mentor and assist?

PT: I think taking both educational and professional paths are ideal. The degree teaches a person how to think literally and abstractly, how to relate to others, how to express him or herself. Young students need to learn how to flex their muscles creatively on their own or they will only learn how to emulate others. However, assisting a talented designer is absolutely invaluable if he or she, the designer, is willing to share and impart. There is so much to be said for the experiences, resources, and access [to artisans and techniques] that assisting will expose you to. Young people will never be a lesser designer for assisting; I think it can only make you stronger.

NF: Do you feel there are a representative number of African Americans in your field? If not, what suggestions can you offer to improve situations?

PT: For most of my career, there have only been a handful of African American designers. Over the past decade, some younger designers of color have entered the field, but I can't say it is representative. This is partly because the field only supports so many designers, period. As far as improving the situation? I think that exposure to art and theatre arts for all children, but particularly children of color, needs to be vastly increased. Additionally, they need to be shown to not only admire, but be made to realize that theatre or other creative work is something you could actually do for a living. Working in the theatre arts doesn't have to stop with playing an instrument or acting; stagehands, technicians, wardrobe staff all work and thrive in the theatre environment. But how do kids find this out? This is why I love the invaluable education program connected to *Hamilton*. Teenagers are learning that there is so much more to life than the insular environment in which they grew up. More programs in this vein will help with this exposure effort.

NF: If there was one thing you feel young people today should know about your field, what would that be?

PT: Work ethic. It needs to be rock solid. This field is a team sport. If you take too many short cuts—if you don't pull your weight—people catch on, and word spreads fast.

NF: Do you serve as a mentor?

PT: Yes. Many people inspired me, helping me to realize myself. It's imperative that I give back and offer space, knowledge, and to have others carry on and realize themselves. I taught at Carnegie Mellon for three years, and see in the future that I may return to education. In the meantime, I hope that I can continue to be an inspiration for other people through my work.

# 12

# RACE ON THE OPERA STAGE

*Twila L. Perry*

Opera is a form of entertainment in which an entire story is performed in song, usually without any spoken dialogue. There are different stories about the origins of opera. One story is that opera originated in Florence, Italy, around 1600, when groups of musicians and scholars began to organize with the goal of reviving Greek musical dramas in a form that would combine drama, dance, music, and song (Abbate and Parker 36–44). Another story about the origins of opera is that it grew out of various genres of theatre that were developing across Europe prior to 1600 (37–39).

Most operas are performed in the language in which they were written, often Italian, French, or German. There are also operas in Russian, English, Czech, and other languages. In opera performances, the singers do not use microphones. They are trained to project their voices into a large auditorium over both a chorus and a large orchestra without amplification. The music of an opera is written by a composer, the words are written by a librettist. Sometimes the composer is also the librettist, but usually the composer and the librettist are not the same person.

Opera's enduring popularity is due to a number of factors. Of primary importance is the beauty and emotional intensity of the singing, combined with the beauty of the music played by the orchestra. Also, while each opera may be based in a specific historical, political, and social context, the themes in operas are the timeless themes of the human condition: love, hate, death, friendship, loyalty, jealousy, revenge, and complex family relationships. Many operas involve some kind of political intrigue that results in a lead character, who has fallen in love with the "wrong" person, being forced to choose between love and duty. The main characters in some operas are royalty or nobility or others at elite levels in a society. Other operas are the stories of common people. Many operas end in tragedy, but there are also comic operas. Regardless of a particular opera's story or setting, the themes of the human condition and the beauty and passion of the singing and the music has a way of connecting many audience members to their own life experiences and deep emotions.

The lead roles in operas are traditionally written for different voice types: soprano, mezzo-soprano, tenor, baritone, and bass. The soprano is usually the female romantic lead, while the tenor is the male romantic lead. Mezzo-soprano roles are often that of the "bad girl," the witch, the mother, or the nursemaid. Baritone roles are often fathers, brothers, best friends, or political advisers. Bass roles are usually kings, high priests, or executioners. There are some roles, but many fewer, for countertenors and contraltos.

Opera is much more popular in Europe than in the United States. Reasons for this include the fact that opera originated in and has a long history in Europe and the fact that most operas are performed in languages other than English. Unfortunately, few Americans are exposed to opera in contexts that would provide them with a meaningful opportunity to determine whether opera is an art form they might enjoy. In 2012, only 2.2 percent of Americans attended an opera performance (Cohen). Staging operas is costly, and in the United States, in contrast to Europe, there is little in the way of government subsidy for the arts (Abbate and Parker 1, 64). Opera's American musical descendent, musical theatre, often referred to as the "Broadway show," is far more popular in the United States (Cohen).

The history of the relationship between African Americans and opera is a complex one. Although opera originated in Europe and the most famous operas were written at a time when the Black presence in Europe was very small, Black people and other people of color have long had a presence in opera, sometimes even as leading characters. Examples of this are Verdi's Otello, who was the Moor of Shakespeare's play, *Othello*, and Verdi's Aida, the Ethiopian princess captured and enslaved by the Egyptians. However, the roles of Otello and Aida have usually been performed not by Black singers but by white singers in dark makeup. African Americans are still a rarity on the opera stage, not only in lead roles such Otello and Aida, but also in operas where there are no Black characters or racial themes. In opera, African Americans are rare in leading roles, in secondary roles, and in choruses.

The analysis of the relationship between African Americans and opera is complicated by the fact that while few Blacks have appeared on the opera stage, some of the few Black singers who have made it to the very top of the opera world have been cast, as far back as the 1960s, in leading roles they would not have been given in films, television, or Broadway shows during that time. Leontyne Price (1927–), Shirley Verrett (1931–2010), Grace Bumbry (1937–), and others have sung the roles of queens, princesses, and other women of nobility in many operas. George Shirley (1934–) has sung the roles of princes and dukes and has been the male romantic lead in some of the most famous and popular operas, including *La Boheme*, *Madama Butterfly*, and *Romeo and Juliet*. Despite the small number of Blacks who have had leading roles in operas, it is also the case that beginning several decades ago, opera became one of the leaders in non-racial casting for some African American opera singers at the very top level.

Matilda Sissieretta Joyner Jones (1868–1933) is often thought of as the first African American woman to achieve success singing opera. Sissieretta Jones became known as the "Black Patti," a reference to the acclaimed Italian soprano Adelina Patti, a singer to whom Jones was often compared. Jones performed in many prestigious concert venues in the United States and abroad, although she never had the opportunity to sing in a fully staged opera (Story 1–19). Camilla Williams (1919–2012) is believed to have been the first African American woman to appear in a role in a major opera company when she sang the lead role in *Madama Butterfly* with the New York City Opera in 1946 (Fox). The first African American to sing at the Metropolitan Opera (MET) was Marian Anderson (1897–1993) in 1955 as the fortuneteller Ulrica in *Un Ballo in Maschera* (Fox). Regrettably, Ms. Anderson was 55 years old at the time of her Met debut, and the role she sang, although important, was also a rather brief one. Still, her performance broke a significant racial barrier. Leontyne Price had an extraordinary career at the Metropolitan Opera and on many opera stages in Europe. Other African American women who have had extraordinary success include Shirley Verrett, Kathleen Battle, Jessye Norman, Martina Arroyo, Leona Mitchell, and Grace Bumbry.

African American men have also had some major successes on the opera stage. Baritone Todd Duncan (1903–1998) was the first African American man to sing a lead role at a prominent

opera company when he sang the role of Tonio in *Pagliacci* at New York City Opera in 1945 (Fox). Beginning in the 1960s, baritone Simon Estes and tenor George Shirley had major success both in the United States and Europe. However, the road has been more difficult for African American men because of the reluctance of some opera companies to cast African American baritones and basses as figures of leadership and authority and as romantic leads opposite white women (Cheatham 44, 159–160).

In recent years, there have been a number of African American singers who have been successful at the world's leading opera houses, including the Metropolitan Opera. Bass-baritone Eric Owens and tenor Lawrence Brownlee have been cast both as romantic leads as well as figures of authority. Black South African soprano Pretty Yende is now singing major female lead roles at the Met and other top opera houses around the world. Despite the recent success of a handful of Black singers, the question remains as to why the presence of African Americans on the opera stage continues to be small. Because opera is not a popular art form in the United States, opportunities are not plentiful for opera singers regardless of race. There are far more excellent opera singers than there are opportunities for them to sing. However, even taking this into account, the small number of African Americans appearing on the opera stage is troubling. Race continues to be a factor in casting. It is also likely that some African Americans who would make excellent opera singers choose other music genres that they believe offer greater opportunities. The decline in funding for arts education in public schools is another factor, decreasing the opportunities for African American children to be exposed to opera in that setting.

Although the most widely known and performed operas were written by Europeans, American composers have also written operas. Often the stories in these operas arise out of the American experience. *Porgy and Bess* (1935) is probably the most widely known American opera. Written by George Gershwin (1898–1937), a renowned white composer, *Porgy and Bess* is the story of Porgy, a crippled beggar in South Carolina, and his love for Bess, a beautiful but troubled woman. "Summertime," the famous aria from the opera, is popular beyond the world of opera and has been performed by singers of many genres. While the beauty of the score of *Porgy and Bess* is widely praised and the opera has provided many performance opportunities for Black opera singers, *Porgy and Bess* has also been criticized as embodying racial stereotypes (Brown). Some Black male opera singers are reluctant to sing the role of Porgy for fear that association with that role will make opera companies less willing to offer them other roles (Oby 14, 21, 87).

*Porgy and Bess* is the most performed opera about African Americans, but there are other operas about African Americans written by African American composers. Scott Joplin (c.1867–1917) is widely known and acclaimed for his ragtime piano compositions, but he is less known for his major opera composition, *Treemonisha*, composed in 1910. *Treemonisha* tells the story of a young woman, the adopted daughter of plantation laborers, who becomes a leader and a source of inspiration and enlightenment in her community soon after the Civil War. It is tragic that *Treemonisha* was never performed in Joplin's lifetime; indeed, it was not publicly performed until the 1970s. Other African American opera composers in the early twentieth century include William Grant Still (1895–1978) whose opera, *Troubled Island*, about Jean Jacques Dessalines and Haiti was, in 1949, the first opera by an African American to be performed by a major opera company, the New York City Opera (Smith 8). Harry Lawrence Freeman was a composer of many operas, the most famous of which was *Voodoo* (1914) about a love triangle on a plantation after the Civil War. He founded his own opera company, the Negro Grand Opera Company, to perform his operas in Black communities around the country (H. Lawrence). There have been other Black opera companies that have provided opportunities for Black performers and for Black audiences to see operas performed by Black singers—the National Negro Opera

Company founded in 1941 (Smith 8) and, more recently, Opera Ebony, Opera Noire, and the Harlem Opera Theater.

African American composers continue to write operas that address the African American experience. Anthony Davis has composed "*X*": *The Life and Times of Malcolm X* (1986), *Amistad* (1997), based on a famous rebellion on a slave ship, and *Five* (2016), based on the infamous case in which five Black teenagers were wrongly convicted of attacking a white jogger in New York's Central Park. There are operas by African Americans based on the lives of figures such as Frederick Douglass, Marcus Garvey, and Harriet Tubman. These kinds of operas bring the history and experiences of African Americans to audiences in another art form. They also provide important performance opportunities for African American opera singers.

Today, as access to entertainment in the home has increased as a result of the Internet and other forms of media, opera, like other forms of entertainment outside of the home, faces economic challenges (Cooper, "Metropolitan"). The question is how to maintain and promote interest in an art form that is associated with foreign histories and cultures, is performed in languages other than English, and is widely perceived as elitist. The fact that today many operas are performed with subtitles or supertitles in English that enable the audience to follow the story nearly word for word has potential to expand opera audiences. Still, in order for opera to survive and thrive in the future, other needs will have to be addressed.

Clearly, there is a need for increased funding for both arts education and community arts institutions so that more Americans can be exposed to opera. It is also clear that demographic changes in America will require opera to reach out to attract more ethnically and racially diverse audiences. In order for this to happen, there must be more racial diversity on the stage in opera performances. That diversity must be in leading roles, in secondary roles, and in the choruses. It has generally been the case that, in opera, physical appearance has been less important than vocal ability. Luciano Pavarotti, viewed by many to have been the greatest tenor of the twentieth century, was a very large man who often sang the role of the passionate young lover. Large middle-aged sopranos have often been cast in the roles of young women barely out of their teens (Cooper, "Otello"). The vocal demands of many roles in opera often require a level of suspension of disbelief on the part of the audience. The most important issue is whether the singer has the vocal ability to sing the work. While opera clearly has provided some opportunities for African Americans to be cast in non-racial roles, it is clear from interviews with some Black opera singers that they see race as a factor that affects their opportunities for work (Midgette; Maddocks).

If opera is to increase the number of African Americans on the stage and in the audience, another issue that must be addressed is ethnic and racial stereotypes in the content of some operas. *Porgy and Bess* has been criticized for this, as have some European "rescue" operas such as Rossini's *L'Italiana in Algeri* (*The Italian Girl in Algiers*) (1813) and Mozart's *Die Entführung Aus Dem Seraile* (*The Abduction from the Seraglio*) (1782). The latter two operas involve stories in which Europeans abducted by North African pirates are rescued by what is portrayed in the operas as a combination of their own ingenuity, courage, and intelligence and that of their European sweethearts. Some Asians have been critical of *Madama Butterfly* (1904) as embodying stereotypes of Asians as well as for the casting of white singers in makeup designed to make them look Asian. Not all European operas in which foreigners are part of the story engage in ethnic or racial stereotypes, but it is a concern in some of them.

In 2015, the Metropolitan Opera announced that dark makeup would no longer be applied to the faces of white singers singing the role of Otello (Cooper, "Otello"). Some saw this as a welcome rejection of the vestiges of minstrelsy, when white performers darkened their faces to perform skits in which Black people were ridiculed and degraded. Others expressed concern that failure to make it clear that Otello was not white eliminated an

important aspect of the story. The controversy over makeup also clearly highlighted the fact that few Black opera singers have been engaged by opera companies to sing the role of Otello. In 2015, there was a production of *Porgy and Bess* as a musical rather than as an opera. The production was done with a smaller cast and orchestra, and many of the leads were not traditional opera singers. This, too, was controversial (Isherwood). The producers felt that the changes brought more dignity to the characters in the story. However, while performing *Porgy and Bess* as a musical rather than an opera may have provided work for Black musical theatre performers, a group also underrepresented in their craft, it resulted in less opportunity for work for Black opera singers.

One trend in opera during the past few decades has been to move productions to different historical settings while leaving the music and the story intact. An example of this is the 2017 production of *Rigoletto* (1851) at the Metropolitan Opera; the setting of the opera was moved from the 1500s in Mantua, Italy, to Las Vegas in 1960. Despite the change in setting, the emotional themes of the opera remain strong. In 2018, the Met set its production of Mozart's *Cosi Fan Tutte* (1790) in Coney Island in the 1950s. Changing the settings of traditional operas to modern contexts where racial and ethnic diversity would more likely be present in real life may draw a wider audience to opera generally, but it does not necessarily result in increased diversity in casting. It is important for the opera world to offer opportunities for singers from diverse backgrounds to be cast in operas that take place in a wide range of historical contexts.

Opera today is operating in a world of changing demographics where there is increased sensitivity to issues involving race, ethnicity, and culture. It is important for audiences to see people who look like them included on the opera stage. It is also important for opera to find creative ways to address problems of racial and ethnic stereotypes that may be present in some operas written long ago in a world very different than the one we live in today. The ability of opera to address the challenges of a changing world will determine whether this art form, loved by so many, will thrive in future generations.

## Works cited

Abbate, Carolyn, and Roger Parker. *A History of Opera*. Norton, 2012.

Brown, Gwynne Kuhner. "Performers in Catfish Row: Porgy and Bess as Collaboration." *Blackness in Opera*, edited by Naomi Andre, et al., U of Illinois, 2014, pp. 165–186.

Cheatham, Wallace McClain, editor. *Dialogues on Opera and the African American Experience*. Scarecrow, 1997.

Cohen, Patricia. "A New Survey Finds a Drop in Arts Attendance." *New York Times*, Sep. 26, 2013, www. nytimes.com/2013/09/26/arts/a-new-survey-finds-a-drop-in-arts-attendance.html.

Cooper, Michael. "Metropolitan Opera Faces a Slide in Box-Office Revenues." *New York Times*, May 6, 2016, www.nytimes.com/2016/05/07/arts/music/metropolitan-opera-faces-a-slide-in-box-office-revenues.html.

———. "An Otello Without Blackface Highlights an Enduring Tradition in Opera." *New York Times*, Sep. 15, 2015, www.nytimes.com/2015/09/20/arts/music/an-otello-without-the-blackface-nods-to-modern-tastes.html.

Fox, Margalit. "Camilla Williams, Barrier-Breaking Opera Star Dies at 92." *New York Times*, Feb. 12, 2015, www.nytimes.com/2012/02/03/arts/music/camilla-williams-opera-singer-dies-at-92.html.

*H. Lawrence Freeman Papers, Rare Book and Manuscript Library Collection*. Columbia University Libraries, New York.

Isherwood, Charles. "A Porgy for Theatergoers Not for Fans of the Opera." *New York Times*, Jan. 20, 2012. www.nytimes.com/2012/01/21/theater/gershwins-porgy-and-bess-on-broadway-is-more-for-theater-fans.html.

Maddocks, Fiona. "Black Voices Matter: Lawrence Brownlee on Driving Change in Opera." Guardian, Jan. 6, 2018, www.theguardian.com/music/2018/jan/06/lawrence-brownlee-tenor-interview-cycles-of-my-being.

Midgette, Anne. "Talking Race and 'Blackface' in Opera: The Long Version." Washington Post, Oct. 16, 2015, www.washingtonpost.com/news/style/wp/2015/10/16/talking-race-and-blackface-in-opera-the-long-version/.

Oby, Jason. "Equity in Operatic Casting as Perceived by African American Male Singers." Dissertation, Florida State University School of Music, 1996.

Smith, Eric Ledell. *Blacks in Opera: An Encyclopedia of People and Companies, 1873–1993*. McFarland, 1995.

Story, Rosalyn M. *And So I Sing: African American Divas of Opera and Concert*. Amistad, 1990.

# 13

# *THE WIZ* AND THE AFRICAN DIASPORA MUSICAL

## Rethinking the research questions in Black musical historiography

*Sam O'Connell*

The history of American musical theatre has not been kind to *The Wiz*, the 1975 Broadway musical that was a funk-and-soul adaptation of L. Frank Baum's *The Wizard of Oz*. Though *The Wiz*, with music and lyrics by Charlie Smalls and book by William F. Brown, successfully updated Baum's tale for a 1970s Black audience and eventually went on to win seven Tony Awards, including "Best Musical," the musical struggled in its early days to win over critics.[1] Due in part to those early reviews, as well as its eventual commercial success as a crossover hit with Black and white audiences, *The Wiz*'s place in musical theatre history has minimized its politics and reception by Black audiences in favor of a history that has examined the way it affected those Black musicals that followed it and adopted its model for crossover commercial success.[2] As a result, it has had the power of its politics, in both music and narrative, defanged by musical theatre critics and historians who pigeonhole the musical into the historical narrative of "Black musicals" that are often sidelined in the master narratives of American musical history.

In his discussion of *The Wiz* and its place in musical theatre history, Allen Woll, in *Black Musical Theatre*, writes: "In its continuing attraction for both black and white audiences, *The Wiz* seemed to be an ideal nominee for a 'crossover hit'" (265). Juxtaposing *The Wiz* to its early 1970s predecessors within the category of Black musical theatre, this crossover appeal for Woll, for both Black and white audiences, comes from two sources within the musical: its story and its music. In terms of story, Woll has argued that the musical "seemingly dismissed the worries of the age. This musical found its inspiration in Frank L. Baum's tales from the turn of the century and in the succeeding plays and films that rendered the saga of Dorothy familiar to all" (263). As for its music, it has been argued that the musical's commercial, crossover success came from "incorporating a watered-down version of black music for white and black audiences" (O'Connell 171).

This crossover success, more commercial than critical, has come at a cost with respect to *The Wiz*'s place within musical theatre history. As of result of Woll's *Black Musical Theatre*, one of the first examinations of *The Wiz* and the history of Black musicals, this labeling of *The Wiz* as a "crossover hit" has had a direct impact on our understanding of the musical and its place

in musical theatre history. Since Woll's book, many historians and critics—including Woll, John Bush Jones, and, regrettably, as I realized in researching this chapter, myself—have continually positioned *The Wiz* and its success as the transition point from the socially political and activist Black musicals of the early 1970s to those musicals of the later 1970s that "with few exceptions … abandoned protest in favor of pride in black heritage, culture, and music regardless of their creator's colors" (170). Supporting this line of argument and analysis, Geoffrey Holder, in his own words, was determined to "convey the full richness of black culture" through the staging of the musical ("Wizard"). Holder, the Trinidadian director and costume designer for the show's Broadway run, took the helm after a series of semi-disastrous out of town previews and tryouts and transformed it into the smash crossover hit that it became, leading it to its seven Tony Awards. Citing this success and its aftermath, Woll details what he identifies through *The Wiz* as the transition of 1970s Black musicals:

> With the financial success of *The Wiz*, new black musicals retreated from the "problem" shows of the early 1970s. Racism, segregation, lynchings, and discrimination, issues emphasized in previous years were now avoided. Some might argue that *The Wiz* ignored contemporary black life, but it still drew on Afro-American culture in its music, choreography, design, and libretto. This seemed to be the [lesson] of *The Wiz*. Instead of addressing solely the difficult aspects of black life in America, a new musical might draw on positive aspects of black culture and history for inspiration and style. That notion became the hallmark of a string of highly successful black musicals that emerged in the late 1970s.
>
> (265–266)

Thus, following Woll's foundation, musical theatre historiography has traditionally positioned *The Wiz* as the tipping point from the socially active musicals of the early 1970s into the commercially successful, feel-good musicals of the late 1970s and early 1980s. Through this positioning, *The Wiz* has been de-politicized, under analyzed, and needs to be reconsidered from a perspective outside of an American musical theatre history.

If music and narrative are the two modes through which *The Wiz* has been hailed as a crossover success while at the same time blamed for a mis-identified transition in the politics of the Black musical, it is through those modes that a recovery and reexamination of *The Wiz*'s role in musical theatre history begins. This chapter is intended to start a conversation that looks to disrupt narrow modes of musical theatre historiography. As a research field, musical theatre historiography of the American musical has largely been characterized as a distinctly nationalist project with a focus on the relationship between musical theatre, identity construction, and musical memory. But what happens if we were to investigate *The Wiz* as an example of musical theatre as African Diaspora drama? If we reframe our research question to be one centered on diaspora as a guiding analytic, we can re-write a history of *The Wiz* and come to new understandings about the original Broadway production that might help us understand its history and significance in a new way. In so doing we can begin to chip away at American musical theatre historiography's tendency to approach musicals looking for how they fit into a national narrative of creating and expressing a sense of American identity that has "mirrored the concerns and lifestyles of middle Americans, their primary audiences" (Jones 3).

A productive entry point for analyzing *The Wiz* as a diaspora drama in order to explain the difference in its reception from Black and white audiences when it premiered on Broadway in 1975 begins with Paul Carter Harrison's contribution to the Forum on Black Theatre in *Theatre Journal* in 2005, "Performing Africa in America." Of Black theatre and Black play, he writes,

"Black, then, is perhaps an inappropriate designation of the African Diasporic performance" (589). He explains:

> In order to shift the gaze and establish a verifiable global legitimacy beyond color which is often reductively confined to reactions of oppression, burlesques of local culture or inflated portraits of dignity, and worse, exoticized nobility ... black performance irrespective of regional specificity, must be understood to be a departure from constructions of Aristotelian poetics, and more recently, the vagaries of postmodernism.
>
> (589)

Ultimately, Harrison concludes, "Black Theatre, then, should be viewed as a defining performance mode with an expressive style rooted in performance practices throughout the African Diaspora, and in essence, an expression of African Theatre" (589). This argument aligns with a history and understanding of Black music's connections to racial authenticity and diaspora. Paul Gilroy has argued that "black music is so often the principal symbol of racial authenticity" (34). Further, as others have argued, "black music *speaks* blackness, as a shared sense of collective experience, while also shaping how one hears the multiplicity of black positions, diasporic layers, and historical traces of the local or the individual" (O'Connell 160). Thinking about *The Wiz*'s music, which is the primary symbol that marks the characters of Oz, in fact, as Black, gives us a way to re-attend to the work it accomplishes as a funk-and-soul musical. As Elizabeth Wollman reminds us, for instance, *The Wiz* was left out of the early history of the rock musical due to its funk and soul score. Rock, she points out, was for white musicals, while *The Wiz*'s soul score was Black, leaving room for its erasure in musical theatre history.[3]

As for narrative, Sandra Richards continues the thread of reframing definitions and analytics for Black or African American theatre in her essay, "African Diaspora Drama," a project that defines diaspora drama and outlines its many categories. She writes:

> In summary, diaspora ... is an analytic and a practice that entails a number of seemingly contradictory moves held in productive tension, namely: (a) a "backward" glance and affective affiliation with the site of collective origin; (b) alienation from, varying degrees of accommodation to, and critical appropriation or creolization of, norms of the host nation, which is ambivalent about the presence of the diasporans within its borders; (c) subjective experience of identity as both rooted or fixed in a distinctive history, and routed or continually (re)articulated in relation to intersections of local, regional, national, and global particularities; (d) recognition of affinity with other ethno-national communities displaced from the original homeland, accomplished by privileging similarity and unity over difference; and (e) identification and nurturance of a home in the world.
>
> (232–233)

Richards then goes on to outline a narrative trajectory for diaspora dramas where diaspora is viewed, understood, and performed in narratives of "Return." Describing the narrative tropes of "Return," she writes:

> A contemporary descendant of slaves journeys to an African location ... Overwhelmed by the sights, sounds, smells, tastes, and mis-recognitions, she nonetheless perceives similarities between herself and the people who generously extended welcome. She has found "home" ... Like a long lost, but not forgotten child, she has *returned* and

can then return, self-assured, self-possessed, and properly equipped for struggle in that other home in the Americas or Europe.

(241)

As a musical theatre historian, I read through this trajectory and cannot help but think of *The Wiz* and the story of Dorothy, Scarecrow, Tin Man, and Lion: Dorothy's journey to Oz, her alienation from the different peoples of Oz, the ambivalence of Oz to her presence, the affinity between the four wandering characters that "Ease on Down the Road" bonded through similarities, and the longing for "Home." It is with this analytic that I am both proposing and in the process of beginning a historical re-examination of *The Wiz*, hoping to reposition it not as the commercially successful transition away from a politically conscious era of the Black musical but rather as a continuation of the trends of the early 1970s and a prime example of musical as diaspora drama.

Ultimately, in writing about home and return, Richards asks,

> How might home—both in its present location and elsewhere—be imagined not as the place of unchanging, family coherence, but as the ground of love and struggle, dynamic, open to difference, and responsive to the challenges of history in the present?
>
> (242)

If we as historians take our cues from Richards' description of diaspora narratives and conceptualizations of "home," we become capable of drawing connections between these ideas and *The Wiz*'s source material. After all, Dorothy in most iterations of the story, not just that of *The Wiz*, struggles with trying to understand and find a home that exists somewhere between her present and some imagined elsewhere.

Writing on the MGM's 1939 film adaptation of Baum's stories, Salman Rushdie has argued that Dorothy singing "Over the Rainbow" expresses "the human dream of *leaving*, a dream at least as powerful as its countervailing dream of roots" (24).[4] Rushdie continues, "At the heart of *The Wizard of Oz* is the tension between these two dreams" (24). For Rushdie, the story is "unarguably … about the joys of going away … of making a new life in 'a place where there isn't any trouble,'" and he sees "Over the Rainbow" as "the anthem of all the world's migrants … a celebration of Escape, a grand paean to the uprooted self, a hymn—*the hymn*—to 'Elsewhere'" (24–25). Further, in his textual analysis of the film version of the story, Rushdie demonstrates that Dorothy, upon her arrival in Oz,

> has been unhoused, and her homelessness is underlined by the fact that, after all the door-play of the transitional sequence [from black and white to color], she will not enter any interior at all until she reaches the Emerald City.
>
> (24)

At the end of the film adaptation, however, Rushdie claims that

> we understand that the real secret of the ruby slippers is not that "there's no place like home" but rather that there is no longer any such place *as* home: except, of course, for the home we make, or the homes are made for us, in Oz, which is anywhere, and everywhere, except the place from which we begin.
>
> (58)

This is the language of home as it relates to the diaspora, and so it is also the language of home in *The Wiz*. In Smalls and librettist William F. Booth's musical, under direction by Geoffrey Holder, the story's narrative maintains the parallels and allusions to the 1939 movie and references them through the language and music of Black America in 1975. Given the 1975 context for the story of Dorothy as migrant, Richards' frame of diaspora helps us revisit *The Wiz* in a more productive way. Using diaspora as our analytic changes the ways we approach Dorothy's story, her longing for home, the songs she sings, and her interactions with the citizens of Oz. As a result, we might come to a more complete understanding of the musical's relationship to musical theatre history that extends beyond its commercial success as a crossover hit.

## Notes

1 Originally, *The Wiz* was marketed simply for a Broadway audience, but, due to poor ticket sales and early poor reviews, the marketing campaign was targeted directly at Black audiences through TV commercials and African American publications, both of which at the time were non-traditional marketing strategies for Broadway shows.
2 Reviews of *The Wiz* in Black periodicals like the *New York Amsterdam News* were very enthusiastic in their praise of the show, going out of their way to identify aspects of contemporary Black life that their readership would identify with in the show. The positive reviews in Black publications stand in direct contrast to those by critics like Clive Barnes of the *New York Times*, whose initial review concluded with, "There are many things to enjoy in *The Wiz*, but, with apologies, this critic noticed them without actually enjoying them."
3 In her review of *Passing Strange* from a 2008 issue of *Theatre Journal*, Wollman writes: "Yet popular music remained segregated by an industry interested in targeting increasingly fragmented audiences, and Broadway reflected the tendency: black musicals weren't marketed as rock musicals or rock operas because 'rock' was for white people. *Jesus Christ Superstar* was a 'rock opera'; *The Wiz* was a 'soul musical'" (635).
4 Salman Rushdie, crediting *The Wizard of Oz* as his first literary influence, wrote his book about *The Wizard of Oz* for the BFI Film Classics series from Palgrave Macmillan on the occasion of the twentieth anniversary of the series.

## Works cited

Barnes, Clive. "The Wiz (of Oz)." *New York Times*, Jan. 6, 1975, p. 32.
Gilroy, Paul. *The Black Atlantic: Modernity and Double Consciousness*. Verso, 2002.
Harrison, Paul Carter. "Performing Africa in America." *Theatre Journal*, vol. 57, no. 4, Dec. 2005, pp. 587–590.
Jones, John Bush. *Our Musicals, Ourselves: A Social History of the American Musical*. Brandeis UP, 2003.
O'Connell, Samuel. "Fragmented Musicals and 1970s Soul Aesthetic." *The Cambridge Companion to African American Theatre*, edited by Harvey Young, Cambridge UP, 2012, pp. 155–173.
Richards, Sandra. "African Diaspora Drama." *The Cambridge Companion to African American Theatre*, edited by Harvey Young, Cambridge UP, 2012, pp. 230–254.
Rushdie, Salman. *The Wizard of Oz*. 2nd ed. Palgrave Macmillan, 2012.
Woll, Allen. *Black Musical Theatre: From Coontown to Dreamgirls*. Louisiana State UP, 1989.
Wollman, Elizabeth. "Passing Strange (review)." *Theatre Journal*, vol. 60, no. 4, Dec. 2008, pp. 635–637.

# 14

# BOB COLE'S "COLORED ACTOR'S DECLARATION OF INDEPENDENCE"

## The case of *The Shoo-Fly Regiment* and George C. Wolfe's *Shuffle Along*

*Paula Marie Seniors*

Bob Cole, the star of Black Patti's Troubadours, wrote the "Colored Actor's Declaration of Independence" (1898) in response to the theft of his sketch, "At Jolly Cooney Island," by white producers and his jailing for claiming ownership. He wrote,

> We are going to have our own shows … We are going to write them ourselves, we are going to have our own stage manager, our own orchestra leader and our own manager out front to count up. No divided houses—our race must be seated from the boxes back.
>
> (Foster 48–49)

This affirmation led Cole to write, produce, direct, and star in the successful Broadway show *A Trip to Coontown* (1897–1899), the first all-Black book musical. Cole joined James Weldon and J. Rosamond Johnson to write produce, direct, and star in *The Shoo-Fly Regiment* (1906), which had a storyline and the first serious love scene. Johnson wrote that 1910 marked a "term of exile" during which white writers, composers, choreographers, directors, and producers took control and produced Black theatre. African Americans lost their foothold in theatrical productions (Johnson Collection). Composers Noble Sissle and Eubie Blake and blackfaced comedians Flournoy Miller and Aubrey Lyles' broke the exile in 1921 with *Shuffle Along*. Some $1,800 in debt at the start, miraculously the show made them millions (Thompson 15–17).

In 2016, from New York's 34th Street to 45th Street, banners picturing Black flappers announced the arrival of *Shuffle Along: The Making of the Musical Sensation of 1921 and All That Followed*, based on the original play that was the first Black Broadway show written by, directed by, choreographed by, musically directed by, and starring Blacks. The media promoted the new production and its Tony Award-winning cast—Audra McDonald, Brian Stokes Mitchell, Billy Porter, and Joshua Henry. Adrienne Warren as Florence Mills and Brandon Victor Dixon would receive Tony nominations. It opened on March 15, and, on July 24, white producer Scott Rudin closed it (Thompson 97–108). Adrienne Warren expressed disappointment in a Tweet, riffing off

the Black Lives Matter movement: "Shuffle Along closes in 3 [more] days, [the play] Motown closes in 10 days. I am starting to feel as if people don't think #blackshowsmatter. #broadway."

This chapter explores how *Shuffle Along* and *Shoo-Fly Regiment* used W.E.B. Du Bois' call for theatre as sites of public protest, propaganda, and civil rights, and how Cole and Johnson used "The Declaration" and Booker T. Washington's theory of Black Economic Nationalism in *Shoo-Fly* (Seniors, 16). It looks at how white producers controlled some productions of Black theatre from 1906 to 2016. Ultimately, the chapter explores whether in 2016 white supremacy could be surmounted in *Shuffle Along* and on Broadway.

In 1906 Cole and Johnson borrowed $1,223.47 to produce *Shoo-Fly Regiment* (Johnson Collection). They used Washington's Black Economic Nationalism—Black ownership of land, property, and businesses—to maintain financial control of their musicals and music. They promoted Black theatre ownership (Seniors, 16).

How did the team use Du Bois' ideology? The show tells the story of Tuskegee graduate Ned Jackson's romance with Rose, daughter of the Lincolnville Institute's principal, who refuses to allow them to marry. Jackson joins the Spanish American War as a commissioned officer. *Shoo-Fly Regiment*'s soldiers emerge as heroes, conquering San Juan Hill and replicating Black soldiers' real heroism. Rose and Ned marry. According to Johnson, "The Love Scene Taboo" dictated that Blacks portray romance as comedic in order to appease white folks. *Shoo-Fly* broke the taboo with the couple's romance. The status and attitudes of the shows' soldiers also referenced Black revolt (Johnson Collection).

Cole's 1893 scrapbook held articles about Ethiopia's Menelek war with Italy and the *Journal* illustration, "War between the Italian Army and the Unconquerable Savages of Abyssinia" (1893). These items exposed Cole's political thought, revealing his anti-imperialist leaning and his understanding of African resistance to oppression. The illustration's title had dual meanings, reflecting both supremacist notions of Africans as barbaric while also defining Africans as unconquerable, conveying the message that they would, without a doubt, break the Italian army. The artist implanted signs and symbols. The tattered Italian flag signaled defeat. Billows of smoke encased Italian soldiers hurling rocks at Abyssinian soldiers armed with shields and daggers, countering the mischaracterization of Ethiopians as primordial since they used modern weaponry supplied by France. The illustration and articles informed *Shoo-Fly Regiment*'s stouthearted Black soldiers and Black revolt, and embodied Cole's commitment to diasporic African Liberation.

The 1990s–2000s saw a few Black Broadway shows that followed Cole's "Declaration." They included *Bring in Da Noise, Bring in Da Funk*, *It Ain't Nothing But the Blues*, and *Fela*, and multi-racial amalgamations like *The Color Purple* by white writer Marsha Norman and *The Lion King* by white and African composers Elton John, Lebo M., and Tsidii le Loka. Still, the exile continued, notwithstanding the lone Black performer in a white show. Black talent was locked out (McGrath).

In 2016 *Shuffle Along* broke this exile, costing $12 million to produce (Cox). The show was written, directed, and choreographed by Blacks George C. Wolfe, Savion Glover, and Daryl Waters, and starred an all-Black cast. In the play, we meet Adrienne Warren's effervescent Gertrude Saunders and Audra McDonald's Lottie Gee, who positions herself as diva-esque and insecure. Gee tells everyone that she used to perform with the famous performer and choreographer Aida Overton Walker. Saunders and Gee hire a white producer, who provides Mammy costumes that maintain minstrelsy. The artists reject the costumes and transform Mammy into a jazzy flapper. The composers and writers Sissle, Blake, Flournoy, and Miller bicker and run out of money. Notwithstanding these setbacks, the show opens triumphantly and runs successfully on Broadway.

Saunders leaves *Shuffle Along* in a huff, replaced by Florence Mills. Gee takes Mills, also played by Adrienne Warren, under her wing to "train" her vocally, even though all the time she is jealous of Mills' enormous talent and the career that she goes on to have. Warren's Mills is luminous and delicate, with a lovely rendering of how Mills might have performed since no recordings exist. Romantic intrigue emerges with the *very* married Eubie Blake, played by Brandon Victor Dixon, courting Gee. She rejects Blake's advances, coyly dancing around romance, and then finally succumbs by singing "Daddy." They infuse romance with whimsy, longing, and a sense of fun. Their relationship is doomed by Blake's marriage and theatrical aspirations, but Gee has sacrificed her career for their affair. Deeply disappointed by Blake's betrayals, Gee performs in Europe and suffers a mental breakdown onstage. Wolfe infused romance with fancy, adding to the joy of seeing this adulterous romance unfold. While Wolfe broke the Love Scene Taboo, he maintained it in the "staged" show by presenting slapstick as per Johnson's definition. It was a troubling choice given that the most important innovation of *Shuffle Along* was *breaking* the taboo (Seniors 171). Gee fearfully whispers her concern about the "white gaze" to her partner, played by Phillip Attmore. They combatively push and pull away from each other, and they never kiss, which elicits audience laughter.

Lottie Gee's mentor Aida Overton Walker described her home in a 1906 *Freeman* interview. A militant race woman with

> likenesses [in her home] of Booker T. Washington, Frederick Douglass, T. Coleridge Taylor … hundreds of letters … with reference to bettering the race … Every little thing we do must be thought out and arranged by Negroes, because they alone know how easy it is for a colored show to offend a white audience.

Aida Overton Walker lays bare the prohibitions set in place, echoing McDonald's concerns, who says, "In all the ten years that I have appeared and helped produce a great many plays of a musical nature there has never been even the remotest suspicion of a love story in any of them." She exposes proscriptions against Black love and illustrates the normalness of white love:

> During those same ten years I do not think there has ever been a single white company which has produced any kind of a musical play in which a love story was not the central notion. Now why is this? It is not [an] accident or because we don't want to put on plays as beautiful and as artistic in every way as do the white actors, but because there is a popular prejudice against love scenes enacted by Negroes. This is just one of the ten thousand things we must think of every time we make a step.

Considering the historic interdictions that McDonald as Lottie Gee addresses, why did Wolfe stage Black romance as comedic? Wolfe could have let Aida Overton Walkers' advocacy seep into Gee's persona with her taking a stand as did Walker in her writing.

How did George Wolfe infuse *Shuffle Along* with politics in the vein of Du Bois' ideology? We learn that the creative team struggled in theatre. Portrayed by both Billy Porter and understudy Arbender Robinson, Aubrey Lyles, who is always dressed at the height of fashion and is flamboyantly effeminate, *yet married*, he points out, is struggling mightily. Tired of laboring, he sings "Low Down Blues" with tableaus of Marcus Garveyites holding equal rights signs and promoting Garvey's Back to Africa movement. Lyles joins Garvey's movement and moves to Africa. This draws on Lyles' real-life experience of living in Liberia in 1929, and his plans for returning there (Egan 747–748).[1] In "Deserts Glamour of Broadway to Pioneer in Liberia"

(1930) published in the *Baltimore Afro American*, the writer discusses Aubrey Lyles' move to Liberia.

> Just why Mr. Lyles chose Africa as his adopted home, he does not say other than he is intently interested in his own race … Liberia in particular seemed to offer that outlet from prejudice and proscription that his rebellious soul has cried out for since boyhood.
>
> (30)

In real life, Lyles escapes the strictures of the strangulating racism that is the United States and that prevents him from reaching his full potential. He unmasks the stage Negro, removes the blackface. In *Shuffle Along* Wolfe dramatizes Lyles' politicization as a Black nationalist, exposing more than Lyles' flamboyant glamour. Lyles tells *The Baltimore Afro-American* that "while my friends thought I was wasting my money in fast living … I was looking far ahead of them all"—to Liberia (30). In *Shuffle Along*, joining the Garveyites and moving to Africa indicated Lyles' intellect and fight for racial equality.

> Born in the Southland where [Aubrey Lyles] tasted early on the bitterness that the shackles of color forced him to endure, one of his greatest longings was that someday he would visit the land of his forefathers and help in the development of a haven in the land of his nativity.
>
> (30)

Lyles condemned the colonialism brought to Liberia by African Americans, who expected Liberian children to carry their umbrellas, stealing the idea "from the Southern white planter that their children should be aristocrats … imbued with the idea that they are superior to the natives (30). He argues for equality:

> You can't go over there feeling that because you have lived in the greatest civilized country on earth that you are better than they are … You've got to come right down to earth and realize that in Africa the youngest African is your superior. He is born with instincts that we have lost by transmigration. A 12-year-old boy knows the use of every twig … He knows Africa.
>
> (30)

Lyles condemned colonialism while upraising Liberians. *Shuffle Along* whets our appetite for knowledge, *The Baltimore Afro-American* offers the lens, and Wolfe compelled us to learn.

The scene "Til Georgie Took Em Away," performed as a magnificent tap solo by Phillip Attmore as the composer William Grant Still, offered a social commentary reflecting Du Bois' call. The dance detailed George Gershwin's theft of Still's song "Afro-American Symphony," which became Gershwin's "I Got Rhythm" (1930). Still's wife in 1969 and daughter Judith Anne Still in 1987 confirmed the theft (36). Judith Anne Still says that

> My father said that Gershwin came to the Negro shows in Harlem to get his inspiration, stealing melodies wholesale from starving minority composers and then passing them off as his own. "I Got Rhythm" was my father's creation according to Eubie Blake.
>
> (Peyser 42–43)

Still's granddaughter, Celeste Headlee, asserted "that's a totally true story … listen to the third movement … and you can hear the notes that Gershwin used" (Forrest). Some attribute this

phrase to Gershwin, maintaining that Still lifted the phrase from him, as opposed to Gershwin's theft (Pollack, 75).

I found this scene fascinating, its execution mesmerizing and thought provoking. It illumined white theft of Cole's sketch, Gershwin's theft of W.C. Handy's opening notes of "St. Louis Blues," which he used in "Summertime," and Gershwin's theft of Fats Waller's "Summertime." Blake wrote that Waller gave Gershwin "Summertime" "for a bottle of gin or maybe two bottles." (Pollack, 75)

Many critics praised *Shuffle Along* while others objected to the politicized story and humanization of Blacks, preferring Blacks dancing and singing, or as Kristin Moriah notes, for audiences "to be entertained but not riled too much" (177–186). Notwithstanding objections, *Shuffle Along* excelled, winning the Drama Desk Awards, New York Drama Critics Award, Fred and Adele Astaire Award, and ACCA Award—but no Tony Awards, which sealed its fate.

When Audra McDonald announced her departure and intention to return after her pregnancy, producers hired Rhiannon Giddens, an unknown to Broadway, to replace her. Soon after, Rudin announced, "The need for Audra to take a prolonged and unexpected hiatus from the show has determined the unfortunate inevitability of our running at a loss for significantly longer than the show can responsibly absorb" (Rooney). Rudin blamed McDonald's pregnancy closed *Shuffle Along*, which mirrored the show's storyline, despite profits of $1.1 million weekly.

*Shuffle Along* exemplifies the importance of Cole's "Declaration" and call for Black theatre ownership. The Shuberts, Nederlanders, and Jujamcyn own all the theatres and produce shows. If Cole and Johnson's initiatives had been firmly in place, I believe *Shuffle Along* would have survived—that Black Broadway would survive. Catherine M. Young of the website *Howl Around* wrote that *Shuffle Along* "is a forthright commentary on the circumstance of Black performers caught in a commercial entertainment system that largely benefits white men. Rudin and the other producers' decision recalls this dynamic from nearly 100 years ago." Lloyds of London refused to cover the losses, arguing, as did the online websites *Broadway Black* and *Scary Mommy*, and others, that

> *Shuffle Along* did not need to be shut down. The show was nominated for 10 Tony Awards, and the talented cast featured several other award-winning performers … By virtue of the all-star cast, Ms. McDonald's temporary absence does not appear fatal to the show's continued success.
>
> (Hershberg)

In January 2017, Lloyds of London argued that McDonald knew she was pregnant before the opening of *Shuffle Along*, so they asked the New York court to void the contract with the producers (Bacani).

What would have happened if Blacks *had* produced *Shuffle Along*? *Forbes* Lee Seymour contended that theatre owners and producers don't "actively shun minorities, they just don't see an incentive to reach out;" they don't see Black validity, "whose spending power is over $1 trillion;" they don't prioritize racial equality and are only concerned with making money (Seymour). Seymour doesn't interrogate the racism embedded in these ideologies that exclude Black artists and theatregoers. White producers could take a lesson from Black producers like Ken Harper of *The Wiz*; Vinnette Carroll with *Don't Bother Me, I Can't Cope* and *Your Arms Too Short to Box with God*; Ashton Springer's *Bubbling Brown Sugar* and *Eubie*; and Jada Pinkett, Will Smith, Shawn Jay Z. Carter, and Questlove with *Fela*. Harper drew audiences through word of mouth and a $120,000 "advertising blitz" by Twentieth Century Fox, making *The Wiz* one

of the most popular Broadway musicals (Ken Harper Papers). They saw the viability of the Black dollar.

What does it mean to have whites produce Black musicals? It means that theatre owners can compel a show's closing to place *their show in their theatre*. *Dear Evan Hansen*, produced by the Shuberts, was performed at the Music Box Theatre where *Shuffle Along* closed. It means that there is no cast recording of *Shuffle Along*. None exists from 1921 either. Black musical theatre, stories, and creative artists are deemed unimportant because as Seymour, the *New York Times*, and Actors Equity report, Black artists make less than whites, "minority designers [and others] can be counted on a few hands," six Black stage managers work Broadway compared to 131 white stage managers, and ultimately whites hire whites (Seymour).

As a former New York City professional dancer, I was over the moon to hear about the revival of *Shuffle Along*. I loved sharing the show with my 5-year-old daughter and my 80-year-old father. I loved standing at the stage door where the dancers greeted my daughter so warmly. I felt connected to dance and the dancers. Upon hearing about the closing, I grieved for the dancers, who I know worked so hard for that coveted position on the Broadway stage. I ached for them, because the opportunities for them are so miniscule. I was angry for this lost opportunity. Everyone can't be that lone dancer in a white Broadway show.

## Note

1 Marcus Garvey's UNIA was "a mass-based global, black nationalist movement intent on redeeming Africa and establishing a homeland for the black world" (see Cruse 558).

## Works cited

@adriennelwarren. "*Shuffle Along* Closes in 3 Days, Motown Closes in 10 Days. I Am Starting to Feel as If People Don't Think #blackshowsmatter. #broadway." *Twitter*, July 21, 2016, https://twitter.com/adriennelwarren?lang=en.

Bacani, Louie. "Lloyd's Hits Back at Broadway Producers over Multimillion Lawsuit." *Insurance Business*, Jan. 5, 2017, www.insurancebusinessmag.com/uk/news/breaking-news/lloyds-hits-back-at-broadway-producers-over-multimillion-lawsuit-42265.aspx.

Cox, Gordon. "Broadway's Shuffle Along to Close When Audra McDonald Exits." *Variety*, June 23, 2016, http://variety.com/2016/legit/news/shuffle-along-closing-audra-mcdonald-1201802767/.

Cruse, Harold. *The Crisis of the Negro Intellectual*. William Morrow, 1967.

"Deserts Glamour of Broadway to Pioneer in Liberia: Aubrey Lyles to Adopt Liberia." *The Baltimore Afro-American*, Nov. 15, 1930, p. 30.

Egan, Bill. "Shuffle Along." *Encyclopedia of the Harlem Renaissance, Volume I and II*, edited by Carl Wintz and Paul Finkelman, Routledge, 2012, pp. 747–748.

Forrest, Elliott. "Did Gershwin Get His 'Rhythm' from African American Composer William Grant Still?" *WQXR Blog*. June 26, 2016, www.wqxr.org/story/did-gershwin-get-his-rhythm-african-american-composer-william-grant-still/.

Foster, William. "Pioneers of the Stage." *The Official Theatrical World of Colored Artists National Directory and Guide 1*, no. 1, Apr. 1928, Black Culture Collection Reel, UCSD Geisel Library.

Harper, Ken. "Ken Harper Papers, 1972–1988." *New York Public Library*, http://archives.nypl.org/the/21378.

Hershberg, Marc. "Audra McDonald Stars in New Lawsuit." *Forbes*, Nov. 14, 2016, www.forbes.com/sites/marchershberg/2016/11/14/audra-mcdonald-stars-in-new-lawsuit/#28e7576f54c2.

Johnson, J.W. James Weldon Johnson Collection. May 13, 1913. Box 1, Folder 3. Special Collections Department, Robert W. Woodruff Library, Emory University, Atlanta, Georgia.

McGrath, Sean. "'Nothin But the Blues' Ron Taylor Suffers a Stroke." *Playbill*, 15 June 1999, www.playbill.com/article/nothin-but-the-blues-ron-taylor-suffers-stroke-com-82594.

Moriah, Kristin. "Shuffle and Repeat: A Review of George C. Wolfe's *Shuffle Along*." *American Quarterly*, vol. 69, pp. 177–186.

Peyser, Joan. *The Memory of All That: The Life of George Gershwin*. Hal Leonard Corporation, 2006.

Pollack, Howard. *George Gershwin His Life and Work*. U of California P, 2006.

Rooney, David. "'Shuffle Along' Announces Abrupt Closing Date on Broadway." *Hollywood Reporter*. June 23, 2016, www.hollywoodreporter.com/news/shuffle-along-announces-abrupt-closing-906008.

Seniors, Paula Marie. *Beyond Lift Every Voice and Sing: The Culture of Uplift, Identity and Politics in Black Musical Theater*. Ohio State UP, 2009.

Seymour, Lee. "Why Is Broadway So White, Part I: Real Estate, Nepotism and David Mamet." *Forbes*. Apr. 7, 2016, www.forbes.com/sites/leeseymour/2016/04/07/why-broadway-is-so-white-part-1-real-estate-nepotism-and-david-mamet/#77383a1e22bb.

Thompson, David S. "Shuffling Roles: Alterations and Audiences in *Shuffle Along*." *Theatre Symposium*, vol. 20, 2012, pp. 97–108.

Walker, Aida Overton. "George Walker." *Freeman*, Oct. 6, 1906.

Young, Catherine M. "Don't Blame Pregnancy for *Shuffle Along* Closing." *HowlRound*. July 18, 2016, http://howlround.com/don-t-blame-pregnancy-for-shuffle-along-closing.

# 15

# *SHUFFLE ALONG* AND ETHNIC HUMOR

## A family story

*Sandra Seaton*

In the small Southern town where I was raised, African Americans knew how to use ethnic humor for their own purposes. Neither mere political strategy nor art, ethnic humor dexterously straddled both realms. Its complexities defy summarization, but my grandmother Emma Louish Evans, a highly respectable churchgoing mother, schoolteacher, and vaudeville practitioner, serves as an illustrative example. Grandma Emma delighted in walking for the cake, dancing the Charleston—the "real Charleston," as she called it—and putting on the cork. For church fundraisers, she created minstrel skits in which she played the "end man" to her friend Olivia's interlocutor (obviously crossing several categories in the process—from respectable citizen to entertainer; from female to male; from Black to "blacked-up"). These types of unrecorded minstrel skits performed within the Black community expressed not conformity to stereotype but rather an endlessly unraveling set of jokes and references whose allusions are still being debated. My grandmother's skits were of a piece with her life as an educated Black woman for whom "vaudeville" also meant dancing around segregation, lynching, and state-sponsored violence, but with a creativity and complexity that cannot be reduced to a declarative statement. It is precisely these aspects of Black Southern ethnic humor—irreducibility and ambiguity—that allowed it to thrive in a time of widespread anti-Black violence. Because of its lack of clear political instrumentality, minstrel performances allowed for spaces of fluidity and critique that would have been denied to more straightforwardly coded cultural forms such as overtly political protest. However, especially today, Black Southern ethnic humor of the past is sometimes read as a form of internalized oppression or bad faith. This doesn't just miss the point; it misreads the historical context and removes the agency (both literal and figurative) of the actors in one fell swoop. The often deeply problematic conversations surrounding George C. Wolfe's 2016 revival/revision of *Shuffle Along*, the 1921 musical created by African American artists, illustrate how contemporary critics truncate African American experience into a shallow narrative taken out of cultural context.

My Grandma Emma (1883–1973) was a close childhood friend of Flournoy E. Miller (1885–1971), a cousin to her husband, my Grandpa Will (see Figures 15.1 and 15.2). Miller was also a co-author and creator of *Shuffle Along*. Through a more intimate, behind-the-scenes history out of which *Shuffle Along* emerged, this chapter seeks to complicate these contexts and argue for a more subtle, informed reading as opposed to those that seem insistent on turning the makers of minstrel-style artistic material into reductive stereotypes themselves—as if they lack

*Figure 15.1*   Photo of Flournoy E. Miller (*c*.1921) signed to Sandra Seaton's grandfather Will Evans.
*Source*: Courtesy of Sandra Seaton.

*Figure 15.2*   Photo of Emma L. Evans, age 18 (*c*.1901), grandmother of Sandra Seaton.
*Source*: Courtesy of Sandra Seaton.

both self-awareness and aesthetic distance. These fragmentary recollections have been handed down to me by my Grandma Emma directly, as well as by Herbert Johnson (1919–2000), a close family friend and son of Rebecca Johnson, my grandmother's best friend and collaborator. The point of this archival material is not only to enrich the historical record but also to stand in opposition to the consolidating of this work and period into a reductive and essentializing historical gaze.[1] My hope is that these family stories will serve both as material for further analysis and as the beginning of a deeper synthesis between African American archival and primary source material and their aesthetic and historical analysis.

Grandma Emma was never formally a stage professional. For a respectable church woman and teacher, appearing onstage as a professional entertainer would have caused such an uproar in Columbia, Tennessee, that they would still be talking about it today. However, in their teens, Grandma Emma and Flournoy Miller were the co-creators of little skits for their own enjoyment.

Columbia, Tennessee, a small town 40 miles south of Nashville, was the typical segregated Southern community with its strong and vibrant middle class of Black teachers, doctors, and undertakers—educated people who did not separate themselves from the bootleggers, laborers, maids, cooks, and agricultural workers. Enjoyed by the entire Black community of Columbia, the minstrel shows in our small town ran at least from the early 1900s to the end of World War II. My grandmother and Miss Rebecca[2] are the focus of my ethnographic narrative with some sense that there must have been many similar stories from other communities around the South. However, this does not mean to imply that their experience is necessarily one that can immediately be generalized.

After my grandmother's marriage at age 18 around 1902, she and Miss Rebecca began putting on shows. The MC, Miss Rebecca, was called the interlocutor and kept the show going. Grandma Emma more often played the end man, the person at the end of the row who engaged the interlocutor. The performances were usually held at St. Paul A.M.E. Church (African Methodist Episcopal, founded in 1830) to help the church to survive and to raise money for the ongoing support of community needs. One song in particular that Grandma Emma and Miss Rebecca performed was derived from a dance that my grandma said had come out of slavery, the "Possum-a-la." As a young child sitting at her knee, I remember her jumping up in the middle of one of her stories, doing a little dance, and singing, "You do the Possum-a-la" to my laughter and applause.

*Out of Sight: The Rise of African American Popular Music, 1889–1895* points to the Possum-a-la, known among Black performers of that time as "The Difficult Dance," being performed in Kansas City, Missouri, and Louisville, Kentucky, in 1893–1895 (Abbott and Seroff 444). According to *Out of Sight*, the "Pas Ma La" as my grandmother, hand on one hip, called it, was generally acknowledged as an African American folk dance, the title "Pas Ma La" a phonetic corruption of the original French. In *Out of Sight*, music historian Isaac Goldberg speculated that it derived from the French *pas mele*, or mixed step (444). The terms "difficult dance" and "mixed step" bring to mind the role-playing and sleight of hand necessary to slip past "land mines" placed in the path of the Black community and its entertainers.

Part song and dance, part political satire, the skit created by Grandma Emma and Miss Rebecca had them wearing men's pants, "flop tail coats" with shirts, vests, and evening hats or derbys. The two would use blackface made of soot mixed with cooking grease or Vaseline. To fit the storyline, they would draw a white ring under one eye and a black one under the other. For the finishing touch, they would pull back their hair so you couldn't see it. According to Herbert S. Johnson, whenever the skit was being performed, a call would go out to the community: "the Possum a la extravaganza, needed all the young women in the town, including those that didn't even belong to a church!" The other cast members would dress in old

clothes as either the sheriff and his posse or the "naïve" Black townspeople. In this all-female skit, when the sheriff—"the law"—would come around, my grandmother and Miss Rebecca, with the aid of mother wit and great timing, would outsmart him and his men. Miss Rebecca would "play possum" until my grandma leaned over her and announced that there was no life in the body on the floor. After an inspection by the sheriff, a group would carry Miss Rebecca off the stage. In the end, after trying the usual violent tactics with his posse, even swinging a rope in the air, the sheriff would be out-strategized. As soon as he and his men left, Miss Rebecca would jump up and the cast would sing and dance the Possum-a-la.

I am a playwright, librettist, and sometime historian. The character of Emma Edwards in my play *The Bridge Party* is based on my grandmother. In the play she outwits two newly deputized white men who are going house-to-house through the Black community looking for guns. Edwards is a trickster, using sly humor as a weapon and pretending to be slow-witted and naïve as a way of dealing with the deputies, one of whom has ties to the Ku Klux Klan. Treating "the law" with extravagant courtesy that could easily be mistaken for subservience, she sends them away without the guns they were looking for. As Edwards says in the play, "I'm a performin' woman," a version of the trickster so important in African American culture who outwits superior force with laughter and guile (60). Her character in *The Bridge Party* grew out of my memories of all the times I would sit transfixed, watching Grandma Emma over and over again act out a scene in which she dealt with "the law" when they cruised by to ask her what she was up to as she sat on her own front porch.

About the time my grandmother and her friend began performing their own minstrel shows, Cousin Flournoy, addressed by his contemporaries as F.E. Miller, was attending Fisk College in Nashville, the home of the Fisk Jubilee singers. Without graduating, in 1908 he left with his stage partner and Fisk classmate, Aubrey Lyles, for vaudeville. Miller and Lyles were a hit on the vaudeville circuit—comedians Jack Benny and George Burns both insisted that Miller and Lyles were the funniest comic duo in American entertainment—but F.E. had bigger ideas. In 1921 he co-produced, wrote the book, and starred with Aubrey Lyles in the groundbreaking Broadway musical *Shuffle Along*. *Shuffle Along* was the first true musical comedy on Broadway, where operettas by Sigmund Romberg and Victor Herbert had reigned (Kimball and Bolcom 7). The musical's historical importance for African American culture is suggested by Langston Hughes' comments in his autobiography *The Big Sea*: "The 1920s were the years of Manhattan's black Renaissance … certainly it was the musical review, *Shuffle Along*, that gave a scintillating send-off to that Negro vogue in Manhattan, which reached its peak just before the crash of 1929." Hughes adds that

> to see *Shuffle Along* was the main reason I wanted to go to Columbia (University). When I saw it I was thrilled and delighted … It gave just the proper push—a pre-Charleston kick—to that Negro vogue of the '20s, that spread to books, African sculpture, music, and dancing.

(344)

*Shuffle Along* is often remembered today for the work of Noble Sissle and Eubie Blake, who wrote its wonderful songs, including "Love Will Find a Way" and the much repeated and rarely credited "I'm Just Wild about Harry." Elaborated through song, *Shuffle Along*'s love story presented something new in American theatre, a Black man and woman in a romantic relationship—lovers whose feelings for each other were as deeply felt as those of any white couple—amidst a multi-layered African American community. The show's success was due at least as

much, however, to the comedic genius of its two stars and book authors, Miller and Lyles, who portrayed a pair of outrageously crooked politicians who stole from each other as well as from the city coffers, to the chagrin of the respectable citizens. The levelheaded majority of the all-Black town Jimtown, appalled by these antics, finally succeeds in electing one of its own, Harry Walton, who wins his true love *and* the mayoralty in the show's conclusion. This rich portrayal of Black life was repeated later on the televised *Amos 'n' Andy* show, in which Andy is repeatedly fooled by Kingfish's get-rich-quick schemes, but also in which is presented a panorama of Black life that includes the commonsensical Amos as well as Black doctors, lawyers, teachers, and businesspeople, much like the Black community in Columbia and in much of segregated America. Whites leaving a performance of *Shuffle Along* realized that they had been gloriously entertained, but they may not have realized that they had been influenced to see all-Black Jimtown as a complex community made of a wide range of characters—skeptical and gullible, honest and scheming, romantic lovers and lovers of money—just as in any "white" community.

In his *New York Times* feature about the 2016 revival, though, theatre critic John Sullivan confusedly calls the original *Shuffle Along* book by Miller and Lyles "racist" (37). He uses the word "racist" to describe the Miller/Lyles line, "You ain't got no business being mayor and you knows you ain't." This line pokes complicated fun at the fact that politics was an all-white business in the American system—that's where the "racism" lies, not in the blackface all-too-serious "joke." Why, then, is Sullivan unable to parse this multivocal African American "trickster" humor?

F.E. Miller and, subsequently, Langston Hughes, as he makes clear in his autobiography, did not consider the comedy demeaning. Miller knew larcenous politicians are to be found in all ethnic groups, and he was quite willing to make use of the stereotypes associated with ethnic humor if the end result was not denigration but instead the ridiculing of prejudice through laughter. He was more than willing to make jokes about traits supposedly typifying African Americans and, by implication, about those so foolish as to accept seriously the ethnic or racist stereotypes of the time. I remember chatting with F.E.'s daughter, my cousin Olivette Miller, a prominent jazz harpist, about the misunderstanding of later generations who would condemn *Shuffle Along* as 'minstrelsy.' Her father's pose was that of a Black man making fun of the way white people make fun of Black people, Cousin Olivette casually explained (Miller and Seaton). Most of those white people encountered African Americans only as servants. Behind legally segregated veils, African Americans went to college, edited newspapers like the *Nashville Globe*,[3] and formed literary societies. Not only Madame Sissieretta Jones (aka the Black Patti) but also other divas of color, many of whose names have been forgotten, gave concerts in small communities like my hometown.

Since so much of this primary-source cultural material has been lost or devalued, what to make of what remains is still unfolding. Even terms like "respectability politics," "minstrelsy," and "the Black underclass" have complex historical antecedents that need to be rethought using people's life experiences and stories. For instance, my grandmother's multi-generationally educated African American family of teachers spans back to the late nineteenth century in a mostly unbroken line. And yet, when it came to Big Jim Ingram, Columbia's bootlegger, the respectable women of the town like my grandmother saw him as an ally and fellow community member.

During the Depression, Grandma Emma and Miss Rebecca were able to keep their shows going at St. Paul A.M.E. Church, even at 35 cents a ticket. Big Jim, an important funding source, would come to the shows carrying an axe or a sickle to announce his intention to handle any troublemakers. A well-known authority figure in our community, he did not need protection himself; his reputation preceded him. In my play *The Bridge Party*, the bootlegger is spoken of

with great reverence. Every morning my grandmother made sure to cook a pan of biscuits exclusively for Big Jim in case he stopped by her home. In return, Big Jim's men would stand out in the rain all evening selling tickets to her shows.

As Spike Lee explores so deftly in the film *Bamboozled* (2000), the line between minstrelsy as self-irony or contextually sited performance by people who, like my grandmother and Jim Ingram, actually do have both agency and, most importantly, multiplicity, seems to still befuddle. The brilliant (if pedantic) *Bamboozled*'s major thesis is that the economic and aesthetic realities of blackface still inform contemporary realities of race and representation. For instance, Lee's Black actor-protagonists are coerced into roles as "Sleep 'n' Eat" and "Man Tan." Among the differences between Lee's actors and the residents of Jimtown as written by Miller and Lyles is that Lee's characters are not self-scripted and have little aesthetic or personal autonomy in choosing their roles.

On more than one occasion, Cousin Olivette Miller, Flournoy Miller's daughter, told me in conversation that her father wrote the still-influential Abbott and Costello comedy routine, "Who's on First?" "Who's on First" relies on jokes about the relationship between a person and the person's pronoun, or given name. For Black people in Jim Crow America, names often gave way to "Boy," "You," or "Girl," regardless of age, education, or status. Turning pronoun confusion into an extended joke about mistaken identity may be a thinly disguised commentary on segregation-era Black subjectivity. And if Flournoy Miller wrote the routine for Abbott and Costello, then that of course also flips the joke's meaning again. Blackface is always comedic, but its political meaning depends on context; that is, *who* is *really* on first?

Nowadays, to "take back" or play with the very terms that define or underpin one's own social predicament is often seen as a sophisticated technique of performance artists and other counter-culture figures whose merging of aesthetics, politics, and everyday life has been validated as resistance praxis. Can this reappropriation not be attributed to *Shuffle Along* as well? Critic Wesley Morris, writing in 2016, argues yes, grouping Wolfe's *Shuffle Along* together with *Lemonade* (album by Beyoncé), *Black(ish)* (television show), and *Key & Peele* (comedy team) as part of "a new Black Power" aesthetic of cultural production. To properly reassess *Shuffle Along* means looking carefully at archives and examining its humor and effects in a layered and careful way. *Shuffle Along* continues to unsettle and even render some observers unable to distance themselves from its racially confrontational aesthetic. Is the very text of the play itself somehow "racist?" To even raise this question beautifully demonstrates how *Shuffle Along* continues to make us wonder "who" is on first.

## Notes

1 To reduce minstrel performances historically is to see (i.e. "gaze" upon) them as having essentially the same meaning, no matter the context or whether they are created by Black people or whites. Adding racial essentialism to this reductive perspective presumes that all Black people must have identical reactions to blackface.
2 As an expression of courtesy, unmarried and married Black women of that period might be referred to by other Blacks as Miss in response to the refusal by whites to give Black women the title of Miss or Mrs.
3 Flournoy Miller's father, Lee Miller, was editor of the *Nashville Globe* for several years.

## Works cited

Abbott, Lynn, and Doug Seroff. *Out of Sight: The Rise of African American Popular Music, 1889–1895*. UP of Mississippi, 2009.

Hughes, Langston. *The Big Sea: An Autobiography.* Thunder's Mouth Press, 1988.

Kimball, Robert, and William Bolcom. *Reminiscing with Sissle and Blake.* Viking Press, 1973.

Miller, Olivette, and Sandra Seaton. *The Laughmaker.* Unpublished.

Morris, Wesley. "Defining, and Proclaiming, a New Black Power." *New York Times,* June 17, 2016, www.nytimes.com/2016/06/17/arts/defining-and-proclaiming-a-new-black-power.html.

Seaton, Sandra. Audio Interview with Herbert S. Johnson. Aug. 8, 1993.

———. *The Bridge Party.* East End Press, 2016.

Sullivan, John Jeremiah. "'Shuffle Along' and the Lost History of Black Performance in America." *New York Times Sunday Magazine,* Mar. 27, 2016, p. 37.

Wolfe, George C., et al. "Shuffle Along, or, the Making of the Musical Sensation of 1921 and All That Followed." Apr. 28, 2016, New York, Music Box Theatre.

# 16

# INTERVIEW WITH EVA YAA ASANTEWAA

## Dance writer

*Interviewed by Thomas F. DeFrantz*
*April 1, 2018*

Since 1976, dance writer, curator, and community educator Eva Yaa Asantewaa (Figure 16.1) has contributed writings on dance in publications such as *Dance Magazine*, *The Village Voice*, *SoHo Weekly News*, *Gay City News*, and *Time Out New York*. She blogs on dance, theatre, and other arts at InfiniteBody.Blogspot.com. In 2017, Eva received the Bessie Award for Outstanding Service to the Field of Dance. That same year, her curated cast of 21 Black women and gender nonconforming artists for *skeleton architecture, or the future of our worlds*, an evening of collective improvisation at Danspace Project, won a Bessie Award for Outstanding Performer.

TDF: How do you describe what you do as a writer on dance?

EYA: I witness and enter into the worlds that dance artists create, seeking to connect with and learn from what I find there. I do go in with my own identity, experience, and sensibilities, but also an open mind. In my writing, I want to bring readers deep into this sensory world, to convey my empathetic feelings as well as to assess the effectiveness of what I've seen, and I strive for my writing to be accessible and persuasive to a general reader beyond dance insiders. Dance writing is a field where white publishers, editors, and writers still predominate. It needs more Black writers and writers of color to bring a wider range of experiences, knowledge, perspectives, empathy, and respect to the work—and especially when we're writing about Black artists and other artists of color. These artists have too often found that their values, ideas, creative methods, and resulting work are being defined and judged by narrow or Eurocentric values and standards.

TDF: What attracted you to writing about performance?

EYA: Well, I have been writing since I was a kid—poetry, short stories, parodies of TV shows, journaling. I was also interested in dance from very early on and took classes, although my working-class, immigrant family [from Barbados] never approved of dance as a viable or respectable career. I pursued writing in college in my Communications major at Fordham but, after graduation, I started dance classes again. That was transformative and healing. It felt natural to want to express the healing power of dance, and I sensed I could do that through writing about the art. And that's typical of me. When I find something that works well for me, I want to share it with other people. That same

*Figure 16.1*   Photo of Eva Yaa Asantewaa.
*Source*: Photographer Scott Shaw.

summer, I discovered two courses in dance criticism—one at Dance Theatre Workshop [now called New York Live Arts] and the other at The New School. I took them both and ended up doing very well at it.

TDF: Then what happened? How did you get started professionally?

EYA: First, I was recommended to *Dance Magazine*. The reviews editor at the time, Tobi Tobias, insisted that I see and write about as many different kinds of dance as possible, everything from Ailey to classical ballet to African dance to postmodern, all in full swing in the very rich environment of the New York arts scene. I remember being very shy, thrown into this conference room for meetings with mostly white writers, most of whom had years of experience in the field. If I recall, Julinda Lewis might have been the only other person of color there. How I managed it, I still don't really know, but I got to work. I was soon recommended to the *Village Voice*, where the atmosphere was a lot looser. My writing was good. So my first and wonderful *Voice* editor, Burt Supree, only needed to help me clean up or clarify things where necessary but gave me freedom to do what I wanted to do.

TDF: Your blog has been enormously influential among artists and writers. When did you start it?

EYA: I launched it in the spring of 2007, at a time when paying dance writing gigs had been going away. Publishers were retracting for economic reasons, and the dance writing field had fewer places where critics and journalists could publish. I wanted to have a

103

place where I could keep writing and do it my way. I could write about whatever interested me. I could also be as political and profane and funny and Black and queer as I wanted to be!

TDF: How has InfiniteBody grown and transformed over 11 years?

EYA: I think there's more depth and freedom in my writing. I think artists have secretly and subliminally taught me to be more like them, to be experimental and risk-taking, to value going deeper into process, to trust what I learn from moments of connection and empathy. I can be subjective and sensitive and creative in my responses. I really enjoy this work and continue to value learning from artists. Along the way, when I started to open up in my writing, I wasn't so worried about capturing every single detail of a show or fact about it. I wondered, "How can I give you a sense of the atmosphere of this world that I stepped into? How can I offer it as something that might matter to you as it mattered to me? How can I convince you that this work is important, that this artist is important, that this art form matters?"

TDF: Let's talk about conditions in the field, and challenges as a writer of color.

EYA: We have more challenges today. While it was never a lucrative profession, believe me, there were more places where you could get your work published. I had certain skills and was lucky to be discovered, if you will, and brought along by editors like Tobias and Supree. But then I had to do the work and, largely, educate myself by going, seeing, thinking, writing, and, having been edited, getting good at editing myself. I can't say that I found any kind of a formal support system as a writer among my fellow writers. I never felt that the dance writing field in New York operated quite that way. But I do feel that dance artists and dance advocates operate that way, and the more I interact with them, the more I draw my support from that sector. Some years ago, I began to convene a group of young dance artists who were also interested in writing to talk about how we could create a support system for dance writers—something just short of a union, and a little bit more formal than a collective—to work on the issues around making dance writing more of a viable, sustainable part of the field's ecosystem. I think these discussions only went so far before falling away because dance artists already have way too much to do. They're already struggling to survive while making their creative work or dancing in the work of others or going to school or teaching dance. It's hard to commit time and energy to another discipline requiring its own intense focus as well as its own advocacy. But there are some dance artists who do blog, at least.

TDF: What's an accomplishment that you're happy about or that gives you that feeling of encouragement and loving for yourself?

EYA: The fact that InfiniteBody has survived for 11 years. I remain energized about what I can accomplish with it and what I can bring to it. The other is winning the Bessie Award for *the skeleton architecture, or the future of our worlds*. I'm very proud of that project. Invited by Ishmael Houston-Jones and Will Rawls to join their curatorial team for Danspace Project's Lost and Found platform [2016], I went in with an open heart not knowing how things would work out. But I knew amazing, interesting dance artists who I enjoyed. I wanted to see how they would work together in improvisation and trusted them to figure things out—which they did, magnificently. It has been fantastic to see this group recognized by our entire field. After that performance, they formed a collective, named Skeleton Architecture, to continue mutual support and to discover new ways to connect to other artists and communities of color and share their magic.

TDF: Can we talk a bit about your work as a mentor?

EYA: I'm not sure I'd call myself a mentor, which I think of as a one-to-one guiding relationship with a particular mentee. I don't know that I necessarily have ever had that. But, at age 65, I'm a community elder. I've grown accustomed to having that word applied to me, and I've come to favor it. Individuals and organizations often call upon me for information and counsel. And I speak and teach a lot, often about dance writing, and create spaces for community discussion. It's amusing to me, on some level, because I am introverted, somewhat still shy, a fairly private person. But my community sees leadership in me and persists in drawing that out. It has made for an interesting and fun life! I find I can use this to do things of value, make things happen, open doors for others. More and more, I'm contemplating what it means to have leverage in my world and use it consciously. I feel I must remember my responsibility to the people who come after me. What can I do now to make conditions less stressful for them in the future because I acted today, I spoke up, I said something, I created something?

TDF: Is there one thing that you think young people today should know about your field?

EYA: That it's important, and that it matters. When I first started out, I would tell people that I was a dance critic, and they would look at me as if I had ten heads because they had no conception of what that meant. If I had said I was a rock music critic or a Broadway critic or a movie critic, they would probably get it, because they probably read *Rolling Stone* and paid attention to Broadway and movie reviews in the *New York Times*. But they heard the words "dance" and "critic," and the two words together didn't make any sense because dance itself, as a serious concert art form, was not on their radar. For a long time, I struggled with the feeling that what I was doing was unimportant to most people in our society, and that was difficult for me psychologically. But the rigor and contribution of dance artists must be recognized and documented. It's important to have a way to capture and talk about the phenomenon and experience of dance, to analyze, assess, and reflect on it. We have to care about these artists and care for them in this way, especially artists of color or queer-identified artists, both of whom are often neglected or poorly critiqued by mainstream journalists and critics. I've also reflected on just how enormously generous artists are, particularly in the dance field. There are intelligent, gifted people healing our society through the work they do in dance. Dance matters, and dance writing as a part of its ecosystem matters very, very much.

# 17

# BLACK FEMALE SEXUALITY IN THE DRAMA OF PEARL CLEAGE

*Beth Turner*

Merriam–Webster defines sexuality as an "expression of sexual receptivity or interest." Sociologist Judith Lorber expands on this definition, stating that sexuality involves "lustful desire, emotional involvement and fantasy" (8). But beyond individual choices about the objects of our sexual attraction, philosophical and sociological theorists have proposed that there is a strong connection between sexuality and power. Sociologist Patricia Hill Collins states: "Sexuality is not simply a biological function; rather, it is a system of ideas and social practices that is deeply implicated in shaping American social inequalities" (*Black Sexual Politics* 6). Scholar and priest Kelly Brown Douglas, paraphrasing philosopher Michel Foucault, concurs: "If one can establish that a people's sexual behavior is improper, then one can also suggest that that people is inferior" (22). By portraying Black sexuality as deviant, excessive, animalistic or in any manner non-normative, white America has tried to elevate itself while subordinating African Americans. The stereotypic depiction of Black female and male sexuality, stoked by racist erotic imaginings and given free rein of expression in American slavery, has been at the heart of some of America's most prohibitive, denigrating social practices and policies towards African Americans, especially Black women. From the mammy to Jezebel, from Sapphire to the welfare mom, from matriarch to dyke, the American imaginative has allowed Black women "no place to be somebody" (Gordone).

Among the image makers who strive to subvert the narrow, inhibiting images of Black women are talented African American women playwrights. Since the mid-twentieth century—with the depiction of Black female heterosexual desire in plays such as Alice Childress' *Wine in the Wilderness* (1969), the portrayal of the punishing consequences of interracial sexual desire in Childress' *Wedding Band* (1973) and Adrienne Kennedy's *Ohio State Murders* (1992), and the disclosure of lesbian desire in Dominique Morisseau's *Skeleton Crew* (2016) and in Shirlene Holmes' *The Lady and The Woman* (1990)—African American women playwrights have vigorously rebutted stereotypical portrayals of African American female sexuality. However, among the African American female playwrights who have lent their vast talents to the creation of fully drawn, African American female sexuality, few have paralleled the zest, determination, and sheer number of African American female characters that mark the work of playwright, novelist, and essayist Pearl Cleage. From Cleage's early dramatic work, *puppetplay* (1983), to her more recent work, *What I Learned in Paris* (2012), she has expressed her full embrace of Black female subjectivity and sexuality, a viewpoint that she also expressed clearly in her early books of essays: *Deals*

*with the Devil* and *Mad at Miles*. An overview of the female characters in Cleage's body of dramatic work quickly reveals that her women are too busy fulfilling their destinies as free women to ever conform to anybody's stereotype about Black female sexuality. Consequently, Pearl Cleage has created complex, non-stereotypic Black women characters who are, by Trudier Harris' definition, "self-sufficient without diminishing anyone else, … secure in their own identities, … [and] sexual and spiritual beings who appear to continue to live in this world instead of escaping into immortality or purgatory" (177).

While Cleage has portrayed a vast range of Black female sexuality—from the yearnings of the crack-addicted teen Rosa for her drug-pedaling boyfriend in *Chain* to the lesbian attractions of the young prostitute Ava in *Late Bus to Mecca*, this chapter will explore Cleage's depiction of the sexuality of the mature woman—Black female characters who range in age from their late thirties to their sixties. Adeptly, Cleage is able to subvert and complicate the two most prominent controlling images used to harness and suppress the power of the sexuality of Black women of this age range: the Mammy, a non-threatening, submissive figure, often portrayed, according to Collins, as "an asexual woman, a surrogate mother in blackface devoted to the development of a white family" (*Black Feminist Thought* 72); and the Matriarch, "essentially a failed mammy, a negative stigma applied to those African-American women who dared to violate the image of the submissive, hard-working servant" (74). Matriarchs are portrayed as being "aggressive" women who are "abandoned by their men, end up impoverished, and are stigmatized as being unfeminine" (75). This stereotype became particularly weaponized in the 1960s as the controversial Moynihan Report (1965) expounded "an ideology racializing female-headedness as a causal feature of Black poverty" (73).

From her earliest plays, Pearl Cleage overtly grappled with the issues of mature Black female sexuality. For instance, *Hospice* (1983) is a cross-generational two-character play about Alice Anderson, age 47, and her long-estranged daughter Jenny, age 30. After being apart for some 20 years, they both independently seek refuge at a house bequeathed to Alice by her mother. Each needs a hospice—Alice, because she is dying of cancer, and Jenny, because she is about to give birth and embark on a life of single parenthood. In the course of the play, we learn that Alice had followed the prescribed path for the respectable expression of sexuality by a young woman in the late 1950s, prior to the sexual revolution: she fell in love and married right after graduating from high school. She reveals that Jenny's father "was not just the only man I'd ever slept with, he was the only man I'd ever fantasized about." He was an older man, a charismatic civil rights activist (much like Cleage's father) who had been "out in the world longer than I [Alice] had been alive!" (*Hospice* 150). She, on the other hand, had yet to explore the world and her place in it. She wrote love poems to him, but when she expressed the desire to seek publication, he literally ate her most recent poem to express his disapproval. With her artistic expression further stifled by the demands of motherhood, by the age of 18 Alice had dutifully turned her attention to domestic life. But across the next ten years, an overwhelming inner urge that she describes as a voice screaming in her head began to intensify and finally demanded she free herself from the "little black box" of her existence (156). In the end, she abandoned her husband and her 10-year-old daughter for a life in Paris, where she became a renowned published poet and partook in her own sexual revolution. Giving in to a brief display of maternal affection hard-sought by Jenny as she leaves to deliver her baby, Alice admonishes herself upon Jenny's departure, saying, "Miss Alice, just don't fool yourself" (159). Thus, to the end, Cleage creates a character that resists not only categorization as a mammy or a matriarch but also the script of traditional motherhood.

A more recent example of non-stereotypical mature sexuality can be found in Cleage's 2010 play, *The Nacirema Society Requests the Honor of Your Presence at a Celebration of Their First One*

*Hundred Years*. Set in 1964 in Montgomery, Alabama, the play presents a story of upper-class Black traditions, multi-generational love triangles, and blackmail against the faint backdrop of the impending protest at the Edmund Pettus Bridge in Selma, only 54 miles away. Grace Dunbar, a widowed grandmother, 60 years of age, and her long-time good friend Catherine Green, are preparing to continue the tradition started 100 years earlier in which the young women and men of their upper-crust Black society are presented at a cotillion. While the relationships of the three teen-aged characters in the play are complex, at the spine of the story is an unusual love triangle from the grandparents' generation that offers the most intriguing view of Black female sexuality.

In Grace Dunbar, Cleage does depict a matriarch, but one who is indeed the female equivalent of a patriarch, a role that implies both power and respect. As a prestigious member of the Black intelligentsia and a bulwark of her community, Grace wields power with grace, femininity, intelligence, and dignity, a far cry from the stereotypic Black matriarch of Moynihan's report. Yet Cleage does not let her character become a cardboard anti-stereotype. As the story unfolds, it is revealed that Grace's venerated husband had had an affair with the family maid, who bore his child. Following this revelation, confirmed by a letter in his handwriting, Grace is circumspect. She solemnly reveals to Catherine:

> Dunbar was a good man and an amazing doctor and I always respected him, but there was never a spark between us. Not even in the beginning. *(A beat.)* I never held it against him. He kept up his end of our bargain and so did I, and that was always enough for me, so I could pretend it was enough for him. But I always knew it wasn't. *(A beat.)* Dunbar didn't fall in love with Lillie to hurt me. Dunbar just fell in love with Lillie.
>
> (90)

In their youth, perhaps Grace and her husband had acquiesced to the pressures to marry she is now placing on her granddaughter and Catherine's grandson as bloodline descendants of the Nacirema Society founders. However, in revealing Grace's life as one rich in social prestige but devoid of sensual love, Cleage also hails and debunks the stereotypic evocation of the Mammy, a figure often strongly linked with asexuality in the white imaginary. There is absolutely nothing in Grace Dunbar's majestic bearing that could ever be mistaken for that stereotype.

Another Cleage character that eschewed the expression of her sexuality for a goal she deemed more worthy is Sophie Washington, age 36, in *Flyin' West*. Born into slavery but freed by the Emancipation Proclamation, Sophie arrives on the Memphis doorsteps of pre-teen Fannie Dove and her infant sister, Minnie, who were orphaned during the yellow fever outbreak. Offering to do their laundry, Sophie quickly recognizes the dire straits facing these children. Although only 16 years old herself, Sophie stays on and they mutually grow into a new family. The play opens some 20 years later in 1898, after the "sisters" have migrated to the all-Black town of Nicodemus, Kansas, founded during the great Exodus of 1879. Taking advantage of the Homestead Act, they have obtained their own land where they live in freedom. In her Western environment, Sophie has become a rifle-toting, no nonsense woman who is hell-bent on fighting off land speculators and maintaining Nicodemus as a Black enclave. She fiercely embraces her status as a "free woman." At no point in the play is there any reference to a person, male or female, who is the object of her sexual desire. Indeed, when their 73-year-old neighbor, Miss Leah, jokes about the possibility of Sophie finding a love relationship, she retorts: "Two things I'm sure of. I don't want no white folks tellin' me what to do all day, and no man tellin'

me what to do all night" (21). Again, although outwardly asexual, there is nothing else of the Mammy stereotype in Sophie's characterization.

Finally, in *What I Learned in Paris* (2012), Cleage gives us another original portrayal of the sexuality of a mature woman—Eve Madison, 50 years of age. The time period is 1973 and Maynard Jackson has just been elected Atlanta's first Black mayor. Divorced two years earlier from Jackson's campaign advisor, J.P. Madison, Eve returns from her self-imposed exile in San Francisco on the night of the win, drawn, like a moth to the light, by the excitement of her hometown's political history-making. Even upon Eve's entrance, Cleage strongly affirms her sexuality, saying in the stage directions that she "exudes confidence, health, energy, and sensuality" (15). Indeed, Eve is a force of nature—politically and socially astute, intuitive, intelligent, and widely admired. Years earlier she had known her marriage was in jeopardy when she realized that her husband no longer had time for her, no longer made her laugh, and was no longer there to share her moments of anguish or despair. In an effort to rescue their marriage, she had planned a trip to Paris for the two of them. He forgot about the trip in the midst of a flurry of job-related demands, and she determinedly went on her own. While there, she made a revolutionary discovery:

> Once you realize there are very few things that you can't enjoy alone, you're free to decide everything on the basis of your own individual ideas of pleasure and morality … You don't have to ask permission or seek approval. You simply move through your life, guided by the magic of your own feminine mystique and the universal impulse that is the essence of your true humanity.
>
> (62)

In short, what Eve learned in Paris, as she explains to J.P. as they move toward the revival of their love at the end of the play, is, "I couldn't love a free man unless I was a free woman" (118).

For historical, political, and deep-seated psychological reasons, Black sexuality, like Black anger, is writ large in the American imaginary. It is a terrain loaded with stereotypic landmines. Cleage says:

> When you look at our history as black women in this country, you certainly can understand our reticence to talk openly about our sexuality because we were used as sexual objects and as breeders for such a long time during slavery that it's still, I think, that moment where we say to ourselves, "Can we acknowledge that we are sexual beings and that this is OK?" So that I'm very conscious of … creating characters who do have relationships with other people that are sexual—that allow them to express affection, that allow them to express emotion.
>
> (Chideya)

Indeed, in all of the plays mentioned above, Cleage also depicts the sexual desires of younger characters: Jenny in *Hospice*, the three teens in *The Nacirema Society*, the love relationships of Sophie's adopted sisters in *Flyin' West*, and J.P. Madison's new girlfriend and his colleague John in *What I Learned in Paris*. Each depiction is nuanced and complex, reflecting the reality of Black sexuality and a fierce determination by Pearl Cleage to extricate the depiction of the sexuality of her Black female (and male) characters of all ages from the morass of American racial stereotyping.

# Works cited

Chideya, Farai. "Playwright and Novelist Pearl Cleage." Interviews. NPR. Aug. 15, 2005, www.npr.org/templates/story/story.php?storyId=4800216.

Cleage, Pearl. *Flyin' West. Flyin' West and Other Plays.* Theatre Communications Group, 1999, pp. 1–86.

———. "Hospice." *Callaloo.* no. 30, Winter 1987, pp. 120–159, *JSTOR,* www.jstor.org/stable/2930641.

———. *The Nacirema Society Requests the Honor of Your Presence at a Celebration of Their First One Hundred Years.* Dramatist Play Service, 2013.

———. *What I Learned in Paris.* Unpublished playscript, 2012.

Collins, Patricia Hill. *Black Feminist Thought: Knowledge, Consciousness, and the Politics of Empowerment.* Routledge, 1991.

———. *Black Sexual Politics: African Americans, Gender, and the New Racism.* Routledge, 2005.

Douglas, Kelly Brown. *Sexuality and the Black Church.* Orbis Books, 1999.

Gordone, Charles. "No Place to Be Somebody." *Black Drama Database,* 2nd ed., Alexander Street Press, 2018.

Harris, Trudier. *Saints, Sinners, Saviors: Strong Black Women in African American Literature.* Palgrave Macmillan, 2002.

Lorber, Judith. *Gender Inequality: Feminist Theories and Politics,* 3rd ed., Roxbury, 2005.

# 18

# COMING-OF-AGE AND RITUALS OF GENDER NONCONFORMITY IN LESLIE LEE'S *THE FIRST BREEZE OF SUMMER*

*Rhone Fraser*

According to a 2014 study by the American Foundation for Suicide Prevention, transgender or gender-nonconforming individuals have a suicide rate nearly nine times the national average (Reyes). This tragic fact might encourage us all to consider the importance of understanding how gender-nonconforming Black people find their way through daily life. Leslie Lee's play *The First Breeze of Summer* (1975) includes a gender nonconforming character in Lou Edwards, who defies social and familial norms by accepting his celibacy and by refusing to follow his father into the family's plastering business. In its contemporary setting in a small city in the Northeast, the drama unfolds when "17 or 18-year-old Lou" (Lee, *Breeze* 305) discovers that the cost of freeing himself from gender conforming stereotypes is the life of his grandmother, affectionately known as Gremmar. Through a hard-won process of maturation, Lou successfully confronts oppressive stereotypes that, unfortunately, lead too many youth to suicide.

*The First Breeze of Summer* was originally produced at the Saint Mark's Playhouse on March 2, 1975, by the Negro Ensemble Company (NEC). It opened on Broadway at the Palace Theatre on June 10, 1975, where it ran for 48 performances and was later nominated for a Tony Award in the Best Play category. The NEC's Artistic Director Douglas Turner Ward directed both productions and performed in the role of Harper Edwards. In 1976 the play was produced for public television in the *PBS American Playhouse* series with the original Broadway cast and Kirk Browning co-directing. In 2008 Signature Theatre revived the play with Reuben Santiago-Hudson as director. At that time, Leslie Lee said in an interview that this play "is semi-autobiographical" in that the Gremmar character was based on his grandmother, "a good Christian woman, a good woman, a pillar of the church [who] had a right to be seen" (Lee, "Journeys"). I contend that Lee's play shows that young Black men who fight gender conforming stereotypes deserve to be seen as much as the beloved "good Christian" women like his grandmother.

Any audience member who has struggled with society's norms of gender identity might learn from Lou's coming-of-age process. The play begins with Lou not knowing how to reconcile

who society wants him to be with who he actually is. The play ends with his passage into a greater knowledge of himself when he discovers that deconstructing his perception of Gremmar as "a good Christian woman" did not require his verbal attack on her. Lou's experience follows a coming-of-age process that in this instance results in the shedding of oversexualized stereotypes that Western society places on Black men. Unlike stereotypes that present Black men as experts at sex, Leslie Lee's writing of Lou is quite the opposite. Lou struggles with being sexually inexperienced.

The play takes place over the course of four days in the home of Milton, Lou's father and Gremmar's son. It includes a series of Gremmar's flashbacks as her younger self, Lucretia, in three different relationships: first with Sam Green, second with Briton Woodward, and third with Harper Edwards. What is significant about Gremmar's flashbacks is that the audience sees them and Lou does not. These flashbacks make the audience sympathetic to Lucretia and make Lou's dramatic invective at the end of the second act tragic for the audience.

The first act presents the strong emotional bond between Lou and his Gremmar, who constantly defends him against his father's demands that he join the family's plastering business. When Lou tells her how he is teased at school for being a bookworm, Gremmar instead encourages him: "strive for the highest you can get" ("Breeze" 323). His confession triggers her first memory of a time when she, too, felt like an outcast. Briton Woodward is shown as the initiator of a love affair with Lucretia whose consent is, at best, loosely established, mainly because Briton's parents employ her. Her relationship with Briton violates miscegenation laws and produces a child who the audience learns is Aunt Edna.

From Gremmar's private memory, the play returns to the present where we see Lou struggling to fit into familial as well as social norms. After playing Scrabble, the family gathers for a prayer, and Lou delivers a boisterous prayer that affirms boldly his plan to "go to college and study medicine and … science … and biology" and "keep [his] eye on the sparrow, and pray and not and … not get tempted" (332). Older brother Nate, who presents himself as a smooth-talking lady's man, tells Lou that this effusive prayer embarrassed him. Lou first refuses to apologize but then equivocates and seeks his brother's help by saying, "I … I really think there's something wrong with me—I really do" (336). He then tells Nate that when he was alone with a girl, he got sick and wanted to vomit. Nate conversely expresses his comfort with his very active sex life, and Lou responds: "sometimes I'd … I'd like to … to … take a knife and … and just … rip this black stuff off!—just … skin myself clean" (327). Lou is not fulfilling the normative gender role that as a Black teen he should be sexually active and heterosexual. This is the first stage of Lou's coming-of-age process: an admission of his inability to reconcile who he is with the stereotype society wants him to be.

The second stage of his coming-of-age also revolves around sexual issues and shame. Hurt because she feels that Gremmar, her mother, does not visit her home as often as she visits her brother Milton's, Aunt Edna exclaims: "sometimes I think the only reason momma don't come over is because my daddy was *white!* And Milton and Sam had black ones!" Lee's stage directions read: "Lou looks up slowly at Gremmar, his face registering shock. He slowly slides his hand away from hers and glances at her" (361). Lou is disappointed that Gremmar did not tell him about her relationship with Edna's father. He sees this revelation as Gremmar's betraying their relationship. In his mind, she is a fraud because she has always presented herself as a good Christian woman who has obeyed religious norms about marriage. But he struggles to admit his emotions because he is still trying to identify as the strong man that society's gender norms say he should be. Tensions escalate when Gremmar does not deny her sexual needs but, instead, urges Lou to acknowledge his own. Her comments confirm for Lou all the negative stereotypes the dominant society has concerning Black people, but Gremmar persists in urging him

to accept his sexuality, using language that is derogatory in its assumption of heterosexuality. She contends that he talks "like some old maid, some ... some little old sissy" and accuses him of being ashamed of his race (367). Resentful and eager to wound as he has been wounded, Lou unleashes a barrage of insults about his grandmother's three relationships: "Three of them!— Three! ... Just another—another ... nigger, that's all! Didn't even marry any of them—not even—not even—one!" (369). This attack causes Gremmar's breathing to become more labored, and fairly soon thereafter, she dies. Seemingly, her death has been caused in part by Lou's inability to determine his own identity as well as Gremmar's not having the language to help him accept his identity as a Black, gender non-conforming teen.

Lou comes of age, or becomes an adult who takes responsibility for his actions, when he tells Nate: "I didn't ... I didn't ... mean to ... to ... to kill her!" (371). He realizes that his invective hastened the death of the one person who defended him against his father and against his detractors in school. His invective of "nigger!" was a result of his trying to conform to a gender stereotype instead of being himself. The audience also learns from Lou the importance of honest conversation with children about religious teachings and the inability of human beings to live up to many religious teachings because of the social construction of race, class, and gender.

Jason Dirden, who performed Lou in the 2008 Signature Theatre production (Figure 18.1), said:

> I had to have several conversations [with Lee] about whether or not this kid was gay. And I really tried not to assume that he was, but because it was 2008, and this is where we are, and where I'm from, the South, I sometimes put that on him. And he's like: "No, no. He's just different."

*Figure 18.1* The Signature Theatre Company production of *The First Breeze of Summer* (2008) with Brandon Dirden and Jason Dirden.

*Source*: Photographer Richard Termine.

Dirden in the twenty-first century was prepared to interpret Lou as gay, but Lee wanted him to see Lou as not gay or straight but simply as *uncertain* of his identity. More than gay, Lou is gender nonconforming. Dirden said:

> That first portion of *First Breeze of Summer* when we're talking about Lou is *Moonlight* [the 2016 movie]. I think Lou's journey is very much Chiron's in *Moonlight* … Struggling with who we are and what society is trying to tell us [about] who we are.

I asked Dirden what helped him to craft an unforgettable performance as Lou, and he explained:

> What I was really able to grab a hold on was the kind of house that Lou grew up in and how it was so spiritual. I can hold on to my spiritual convictions and beliefs and be okay. And people should accept that. I'll hold on to that and maybe even hide behind that. I tried my best to connect to that throughout the journey of the play, which ultimately leads to the heartbreak.

What also helped his performance was "just imagining finding out something about one of my parents that you could never imagine. That's what I tried to do nightly. Something new that I found out about my parents" (Dirden). Finally, I asked Jason what advice he would give to any future actors playing Lou. He replied:

> Lou is on a constant journey to try to understand. And I think if you live in that place as an actor … filter it through his naivete, filter it through his love for Gremmar, filter it through his religious convictions, filter it through the disdain he has for his brother and sexual prowess, then you're in the exact right place. That's where the character lives.

The character of Lou lives in a place that confirms gender nonconforming possibilities for Black life onstage and, ultimately, in the real world outside the theatre.

## Works cited

Dirden, Jason. Personal Interview. June 3, 2017.

Lee, Leslie. "The First Breeze of Summer." *Classic Plays from the Negro Ensemble Company*, edited by Gus Edwards and Paul Carter Harrison, U of Pittsburgh P, 1995, pp. 301–375.

———. "Leslie Lee Journeys into the Past: Interview with *Signature Edition*." *Signature Edition*. Fall 2008.

Reyes, Emily Alpert. "Transgender Study Looks At 'Exceptionally High' Suicide Attempt Rate." *LATimes. com*, Jan. 28, 2014, http://articles.latimes.com/2014/jan/28/local/la-me-ln-suicide-attempts-alarming-transgender-20140127.

# 19

# POMO AFRO HOMOS

## A revolutionary act

*Tabitha Jamie Mary Chester*

The emergence of the performance group Postmodern African Homosexuals (Pomo Afro Homos) signaled an important era of Black Queer Theatre and Performance history. Their work showcased the voices and experience of Black gay men. Pomo Afro Homos was created in San Francisco in the early 1990s by Brian Freeman and Djola Branner and would later include Eric Gupton. This chapter will situate their artistry within the political and social periods from which they emerged in their performances *Fierce Love: Stories from Black Gay Life* (1991) and *Dark Fruit* (1991), in which they tackled LGBT racism, AIDS, religion, sexuality, etc. in a bold and unapologetic way. *Fierce Love* continues to be produced through its current iteration, *Fierce Love (Remix)* (2011). Their subject matter challenged Black and gay communities to confront taboo subjects, and their work paved the way for other Black queer artists like the hip hop group Deep Dickollective and other images of Black queer masculinities (Wilson 120). Pomo Afro Homos was critical in defining the voices of Black queer men navigating race, gender, and sexuality during the height of the AIDS epidemic.

We live in a patriarchal world that centers hegemonic masculinity and heteronormativity—one that relegates queer voices to the margins. Pomo Afro Homos' works premiered and were workshopped in bars in the Bay Area. The venues utilized by the Pomo Afro Homos point to the outside positions these works and subjects occupied in theatre. Pomo Afro Homos' work was rooted in the intersections of their experience in the Black and gay communities and the ways patriarchy, capitalism, sexism, and misogyny affected their lives. The period of the late 1980s included many Black men who saw death and pain throughout their communities and who created platforms to deal with that pain. Writer Joseph Beam, filmmaker Marlon Riggs, and poet Essex Hemphill are just some of the many men who used their creative work to break the silence and shame associated with HIV/AIDS in Black communities. While the number of diagnoses and deaths attributed to AIDS rose, the United States government largely ignored the impact of the disease (Roman 204). The country suffered from silence and ignorance. The impetus to create Pomo Afro Homos can be seen in Marlon's Riggs *Tongues Untied*, which featured several of the original members of Pomo Afro Homos. Riggs declared that Black men loving Black men was an urgent, revolutionary act. This mantra was seen in every aspect of the political and creative work of Pomo Afro Homos. Their work examined questions like: What does love look like among and within Black men? How might Black men learn to love and accept themselves in a world that devalues so many aspects of who they are?

The friendship of two of the men who would form Pomo Afro Homos began on the set of *Tongues Untied*. Freeman was an executive producer and performer, and Branner was a dancer and performer (Brinkley). In 1990, they came together to form the performance collective that answered Riggs' call for Black men to love each other and themselves. Within a year of meeting they became one of the most sought-after experimental theatrical performance groups in the country. The group consisted of Brian Freeman, Djola Bernard Branner, and Eric Gupton, each of whom brought unique talent and perspectives to the group. Freeman's extensive theatre credits included the Negro Ensemble Company and the San Francisco Mime Troupe (Brinkley). Branner's background included work as a poet and Afro-Haitian dancer and teacher. Before Pomo Afro Homos, Gupton performed as an actor, singer, and cabaret artist. Founding member Freeman stated:

> At that moment we were reading postmodern theory. A lot of the PomoAfroHomos' performances had to do with fragmented identities, taking something fragmented and reconstituting it. Gay theater at the time was only represented as gay male, and black theater was only represented as African American. As PomoAfroHomos, we moved between gay theater and the black community, smashing identity on the ground and making it different, reconstituting it in a different way.
>
> (Wilson 120)

Their first collaboration, *Fierce Love: Stories from Black Gay Life*, debuted at Josie's Cabaret and Juice Joint in San Francisco in 1991 (Godfrey 68). Critics and audiences found the performance to be raw and edgy. As one reviewer wrote, the work contained "exceedingly graphic content," some of which was questioned for its artistic merits. Pomo Afro Homos forced audiences to deal with Black queer men's bodies onstage and take in all the complexities and discomfort this depiction stirs. This was too much for some in the Black community, where ideas of respectability politics might constrain the artistic work of those in the community. The National Black Theatre Festival banned the performance troupe from its annual festivals in 1991 and 1993 (Plum 242). They also faced criticism from white and Black gay men for their depiction of interracial relationships as unhealthy or based on perversion (Godfrey 72). The honesty in their words and the reality of their unapologetically queer bodies onstage was too much for those in power.

Unlike *Fierce Love*, *Dark Fruit* was created under the pressure of an intense touring schedule and the spotlight of newfound notoriety (Brinkley). It premiered December 14, 1991, at the Public Theatre in New York City as a work-in-progress (Godfrey 70). Freeman relinquished his previous title of director to Susan Fink in order to focus on being an ensemble member (Brinkley). The stories written in *Dark Fruit* are darker and more complicated than those of *Fierce Love*. The skits are longer, and themes seem to linger.

Pomo Afro Homos was committed to reminding Black communities the ways that queer Black men have always been an integral part of Black communities while also questioning the ways that they have been represented in mainstream culture. After the collective stopped performing, its commitment to recovering histories that have been ignored and/or forgotten continued to be a catalyst for Freeman, who went on to write the play *Civil Sex*. The play was first performed on September 16, 1997, at the Woolly Mammoth Theatre in Washington DC (Freeman 97). The play was further workshopped and various iterations performed between 1998 and 2000 in San Francisco and New York (99). *Civil Sex* dictated a quest to find a civil rights icon whose legacy should have been known in the ways that we know Reverend Martin Luther King, Jr. and Malcolm X but whose sexuality made him merely a footnote— Bayard Rustin. It was Rustin's death in August 1987 that brought him into Freeman's life. "At

that time there was no biography of Rustin, just a brief academic here, a reference there in Civil Rights-era histories" (95). The lack of information about Rustin in a movement that was well documented underscored the ways that Black queer stories have been written out of history. The writing of *Civil Sex*, almost ten years after Freeman was first introduced to Rustin, utilized much of the community collaboration that had shaped Pomo Afro Homos. This included dinners and interviews with Rustin's contemporaries, colleagues, friends, and lovers (97). Much of the work of queer artistry is creating archives that should have already been created. Most recently Freeman has produced *Fierce Love (Remix)*, an updating of Pomo Afro Homos classic piece.

Djola Branner's work with Pomo Afro Homos and his own playwriting often gestures to African Diasporas. In "The Visitation," found in *Fierce Love*, Branner brings in his background of Afro-Haitian spirituality through dance. The stage directions describe the dance that Branner choreographed:

> A loud thundercrack. An African spirit magically appears. The rain changes to drums as the spirit, using Afro-Haitian dance, takes control of RONALD's spirit, allowing RONALD a moment's break from his bourgeois obsessions to indulge in a tribal dance. When RONALD is wrecked the spirit departs.
>
> (Pomo Afro Homos 264–265)

Branner's use of diasporic dance creates the room that the character Ronald needs to break away from his performance of anti-Black white-men aesthetics. The short skit portrays him as a Black man obsessed with white characteristics (as in Blue/Green eyes) and contempt for all things Black (as in fried chicken). This use of African dance and spirituality is seen more concretely in Branner's 2013 collection of plays, *sash & trim*. In the forward to that collection, performance theorist E. Patrick Johnson commends Branner for his ability to connect "African & Latin people … [his work] underscores the fact that blackness is formed and circulated from multiple geographies and histories, which complicates narratives that suggest North American blackness is the most 'authentic'" (Branner xi). Like his work within the Pomo Afro Homos collective, Branner's plays complicate monolithic notions of identity. As there is no one way to be Black and queer, there is also no one way to be Black. By constantly questioning pre-conceived notions and hegemonic representations, Branner opens various possibilities of Black life in his pieces. In *oranges & honey*, he combines movement, text, and music to create theatrical language. The actors embody Oshun, the Yoruba goddess of love (62). In this short play, the character Rafael is reminded of his roots and goes to Oshun for healing. He calls to her in both English and Spanish, seeking her guidance.

The pieces in *sash & trim* were written and first performed between the years 1996 and 2006. The title piece of this published anthology is an autobiographical offering that reminds us of the vulnerability seen within Branner's work in Pomo Afro Homos. In *Dark Fruit*, he speaks to growing up Black in LA during the Watts riots and how his Christian mother dealt with his sexuality (Pomo Afro Homos 334). In *sash & trim* he goes further into the Branner family, chronicling life after his father Hank's death. This is the longest and most personal piece in the collection: Branner played his father in each of the initial productions, and his vulnerability highlighted the nuances and complexities of gender and sexuality in Black families.

An ever-present theme in Pomo Afro Homo's work was the impact of HIV/AIDS in Black communities. *Dark Fruit* dealt with the pain of losing loved ones to HIV/AIDS in "Last Rights," and dealt with the hypocrisy of the Black church and Black communities

in "Chocolate City, USA." The most telling reminder of the impact of HIV/AIDS on the group was the death of founding member Eric Gupton in 2003 of AIDS related complications (Hurwitt).

In 2017, *Moonlight* (2016) was awarded the Academy Award for Best Film. *Moonlight* is a story about what it means to grow up poor, Black, and queer. Written by playwright Tarell Alvin McCraney and originally conceived as a theatrical piece, the film shows the ways that Black queer people are integrated into Black communities. McCraney dedicated his award to "all those Black and Brown boys and girls and non-gender conforming who don't see themselves—we're trying to show you *you* and us … This for you." McCraney and *Moonlight* both stand in the lineage of the Pomo Afro Homos, which wrote and performed their lives onstage and challenged the media for more nuance portrayals of Black queer masculinities. They invited Black communities to see how religious dogma, politics, and intolerance contribute to the oppression of members of their communities. They reminded Black communities that Black queer folks are indeed part of Black communities. They called white gay men out on their racism and the fetishizing of Black men. In an age where the accolades of *Moonlight* and the medical developments of HIV drugs like PREP can allow some to think that Black queer folks have reached a promised land, it is important to revisit the work and legacy of our elders like Pomo Afro Homos to remind us of how far we have gone and have much we still have left to achieve.

## Works cited

Branner, Djola. *sash & trim and other plays*. Redbone Press, 2013.

Brinkley, Sidney. "Pomo Afro Homos." *Blacklight*, 2016, www.blacklightonline.com/pomoafro.html.

Freeman, Brian. "Civil Sex." *The Fire This Time: African-American Plays for the 21st Century*, edited by Harry J. Elam Jr. and Robert Alexander, Theatre Communication Group, 2003, pp. 96–141.

Godfrey, John. "Pomo Afro Homos and the Emergence of a Voice." *TheatreFurom*, Spring 1993, pp. 67–73.

Hurwitt, Robert. "Eric Gupton—Pomo Afro Homos Troupe Co-founder." *SF Gate*, May 4, 2003, www.sfgate.com/bayarea/article/Eric-Gupton-Pomo-Afro-Homos-troupe-co-founder-2650464. php.

*Moonlight*. Directed by Barry Jenkins. Performances by Mahershala Ali and Trevante Rhodes. A24 Films, 2016.

"NPN Re-Creation: Brian Freeman and Pomo Afro Homos' 'Fierce Love.'" *NPN/VAN*, Apr. 21, 2011, https://vimeo.com/22718513.

Plum, Jay. "Attending Walt Whitman High: The Lessons of Pomo Afro Homo's Dark Fruit." *African American Performance and Theatre History: A Critical Reader*, edited by Harry J. Elam and David Krasner, Oxford UP, 2001, pp. 235–248.

Pomo Afro Homos. "Dark Fruit." *Staging Gay Lives: An Anthology of Contemporary Gay Theatre*, edited by John M. Clum, Westview Press, 1996, pp. 319–343.

———. "Fierce Love." *Colored Contradictions: An Anthology of Contemporary African-American Plays*, edited by Harry J. Elam, Jr. and Robert Alexander, Plume, 1996, pp. 255–285.

Roman, David. "Fierce Love and Fierce Response: Intervening in the Cultural Politics of Race Sexuality, and AIDS." *Critical Essays: Gay and Lesbian Writers of Color*, edited by Emmanuel S. Nelson, Harrington Park Press, 1993, pp. 195–220.

*Tongues Untied*. Directed and Performed by Marlon T. Riggs. Marlon T. Riggs and Brian Freeman, 1989.

Wilson, D. Mark. "Post-Pomo Hip-Hop Homos: Hip-Hop Art, Gay Rappers, and Social Change." *Social Justice*, vol. 34, no. 1, 2017, pp. 117–140.

# PART II

# Institution building

## A space of our own

*Kathy A. Perkins*

African Americans had a difficult birth in the American Theatre. Minstrel shows, popularized by actor Thomas "Daddy" Rice during the late 1820s and other whites in blackface, created enduring stereotypes of African Americans that have been etched into the consciousness of white America. Coupled with these stereotypes, racial segregation and the perceived inferiority of Blacks by whites were among the forces that limited African American participation in mainstream theatre institutions until the 1970s.

While a limited number of theatre programs at predominantly white institutions (PWIs) admitted a paucity of African Americans prior to the 1970s, Black institutions produced the majority of talent. PWIs that admitted African Americans during the early half of the twentieth century rarely accepted students in acting degree programs, particularly men, for fear of their close proximity to white women. Many African Americans interested in acting would study elocution (the art of proper speaking) or English. Several who focused on acting often found themselves performing primarily radio drama. This meant that most African Americans seeking degrees in theatre studied playwriting, directing, history, design, or other "behind the scenes" disciplines.

Sears department store president Julius Rosenwald established the Rosenwald Foundation from 1917 to 1948, in part to provide funding for Blacks to study at PWIs. During the 1930s, oil magnate John D. Rockefeller established the General Education Board to provide scholarships for Blacks to attend northern universities with the goal of returning south to teach. Several of the beneficiaries of such awards attended Yale University's then Department of Drama. John Ross became the first African American to receive a degree in theatre from Yale in 1934. Others included Anne Cooke who became the first African American to receive the PhD in theatre from Yale (1944), while Shirley Graham (Du Bois), Owen Dodson, and Randolph Sheppard Edmonds all studied playwriting. The number of Blacks at Yale appeared to decline with the termination of these awards, as evidenced by my years of research on African Americans behind the scenes in theatre.

Starting in the late 1930s, the University of Iowa was one of the few PWIs that trained a relatively large number of African Americans in non-acting areas. Many of these alums, such as Thomas Pawley, Winona Fletcher, Carlton Molette, James Butcher, Whitney LeBlanc, and Joan Lewis, would later transfer their knowledge as professors at historically Black colleges and universities (HBCUs) (Figure PII.1). However, even in these non–acting areas of study, African Americans often faced adversity. Playwright Lorraine Hansberry (*A Raisin in the Sun*) had

119

*Figure PII.1* Early behind-the-scenes artists who graduated from white institutions and who would play a major role at HBCUs. (*Left to right*) Bertram Martin, Owen Dodson, Thomas Pawley (standing), Whitney LeBlanc, and Winona Fletcher.

*Source*: Courtesy of Winona Lee Fletcher.

aspirations to study scene design at the University of Wisconsin in 1948, "but was told by her white professor that she would be wasting her time as there were no jobs for Black designers" (Hatch 10). She left the university after two years.

The chapters, interviews, and discussions by leading African American artistic directors in this section focus on several Black institutions that promoted and continue to promote the growth of artists in all disciplines. The term institution will be used for both academic establishments and professional theatres.

Monica Ndounou (Chapter 20) provides a historical overview of Black actor training before Stanislavski and the Black Power movement, with programs dating back to the late nineteenth century. Sandra Adell (Chapter 21) shares the history of three female artistic directors who created unique institutions in New York City. Readers are informed of companies that sought to train not only actors but also artists in all areas of theatre with Susan Watson Turner's chapter (Chapter 26) on the Negro Ensemble Company (NEC), Gregory Carr (Chapter 29) on the St. Louis Black Repertory, and Shondrika Moss-Bouldin's interview with Ekundayo Bandele of Hattiloo Theatre (Chapter 36). K. Zaheerah Sultan (Chapter 34) moderates a round table discussion at the 2016 Black Theatre Network Conference with leading artistic directors on the financial fitness of African American theatres in the twenty-first century. Two interviews highlight the careers of stage manager "Femi" Sarah Heggie (Chapter 28) and lighting designer Shirley Prendergast (Chapter 27), both of whom were products of the NEC and were able to obtain union membership: Heggie in Actors Equity Association and Prendergast in United Scenic Artists (USA). USA represents designers, and Actors Equity represents stage managers and actors. Membership in one of these two unions is necessary to work on Broadway or in major regional theatres.

This section also highlights programs at HBCUs as well as Black programs housed at PWIs. Leslye Allen (Chapter 22) recognizes a giant, and often neglected, figure in education in her

chapter on Anne Cooke at Spelman College. Denise Hart and I (Chapter 23) write of the past and current legacy of the Howard Players at Howard University. Johnny Jones (Chapter 35) shares his experience as part of the hip hop generation at the University of Arkansas Pine Bluff. Nefertiti Burton (Chapter 24) acquaints us with one of the oldest African American theatre programs housed in a major white institution, the University of Louisville. In an interview, Karen Baxter of Rites and Reason Theatre at Brown University discusses another Black organization housed at a PWI as well as one of the oldest continuously operating theatres in New England (Chapter 25).

The onset of the Black Arts Movement of the 1960s saw a shift from European styles of acting to a surge of training rooted in Black cultural aesthetics. Sharrell Luckett (Chapter 33) provides a sketch of the history of three prominent artists who had an impact on Black actor training in Harlem, Elizabeth Cizmar (Chapter 32) presents a chapter on Ernie McClinton and his Jazz Acting method, and Khalid Long (Chapter 31) explores the Black feminist theatre of director Glenda Dickerson. J.K. Curry (Chapter 30) celebrates the legacy of Larry Leon Hamlin and the National Black Theatre Festival. These chapters highlight a segment of the numerous institutions that were and are still vital to the growth and development of African Americans in theatre.

While Black theatre institutions date back to the end of the nineteenth century, it was the early part of the twentieth century that saw the emergence of sizeable theatre training, primarily at HBCUs. While the Howard University Drama Club (1911) has often dominated the discussion of HBCU dramatic organizations due to its outstanding program and high caliber of faculty, it was not the first. The beginning was at Atlanta University in 1900 with Adrienne McNeil Herndon, who had studied elocution at the Boston School of Expression. Shakespearean actor Charles Winter Wood was hired during this same period of the early 1900s by Tuskegee Institute, where he taught drama, directed plays, and organized the Tuskegee Players. Other dramatic clubs that emerged include those at Florida A&M University (FAMU), North Carolina A&T, Hampton Institute, Morgan College (now Morgan State University), and Virginia Union, to name a few.

As there were few plays written by African Americans, most HBCUs during the early years performed Shakespeare along with other works by white authors. The majority of HBCUs had white presidents well into the 1950s, and these officials often determined the plays presented, even in cases where scripts by African Americans were available. Randolph Sheppard Edmonds, often referred to as the father of Black educational theatre, was concerned with the shortage of Black plays. He brought HBCUs together through such organizations as the National Association of Dramatic Speech and Art and made an effort to increase the number of plays written by Blacks and about "Negro life." Edmonds, who also wrote to increase the repertoire of Black plays, chaired and created drama programs at Morgan, Dillard University, and FAMU. HBCUs played a major role in the South, where most of them were located. According to Anne Cooke's 1945 survey, "The theatre is potentially a social force in addition to being a source of entertainment. In many Southern communities, the college affords the only opportunity for cultural experiences" (418–24).

Spurred by the momentum of the civil rights movement during the late 1960s, theatre departments at PWIs began to open up to African Americans, and Black students demanded Black faculty. A few of those pioneer scholars at PWIs were Errol Hill, Margaret Wilkerson, Vernell Lillie, and Loften Mitchell. These professors introduced African American theatre into the curriculum and nurtured a generation of Black scholars who would, in turn, cultivate another generation. There were also white scholars such as James V. Hatch and Doris Abramson who must be given credit for their role in promoting African American theatre. Credit should

also be given to Jewish acting professor Vera J. Katz who, in the Drama Department of Howard University for nearly four decades, trained a roster of actors who would gain prominence in theatre, film, and television. African Americans trained in the technical and design fields also began teaching at PWIs in an effort to create a new generation of artists who would work professionally as well as take their talents to HBCUs. With the inclusion of African American faculty at PWIs, there was a growth in the number of Black students in those institutions.

Black theatre companies also played a significant role in the training of artists, both onstage and behind the scenes. Though short lived, The African Company in New York City (1821–1824) set the stage for African Americans creating their own institutions. The first part of the twentieth century would witness a variety of companies, situated predominantly in New York City, Chicago, and Washington, DC. The Playhouse Settlement (1915) in Cleveland, founded by a Jewish couple, Rowena and Russell Jelliffe, began as a multiracial institution, but over time it became a Black company (Karamu House), which is still in existence today. Other theatres that had a lasting impact were Anita Bush and the Lafayette Players, which is highlighted in this section, and the American Negro Theatre (ANT) in Harlem. ANT (1940–1948) was committed to professional training in all areas of theatre and would produce some of the greatest actors of the period, including Ossie Davis, Ruby Dee, Fred O'Neal, Sidney Poitier, Hilda Simms, and Alvin Childress, along with playwright Alice Childress. ANT's demise was due in part to its success with the Broadway production of *Anna Lucasta* in 1944, which lured the play's amazing talent to more commercial projects. The next theatre company to have a major impact on the American theatre would not surface until the NEC in 1967. The Black Arts Movement of the 1960s ignited a nationwide growth in Black theatre companies, including Free Southern Theater, Freedom Theatre, St. Louis Black Repertory, Penumbra, National Black Theatre, DC Black Repertory, New Federal Theatre, eta Creative Arts, and Houston Ensemble. These institutions, as described in the following chapters, have developed a variety of talents in all areas of the theatre.

The last two decades of the twentieth century up to the present have presented major challenges for Black institutions. Large numbers of African Americans have begun to attend PWIs with state of the art facilities, something often lacking at many HBCUs. Various economic recessions have slashed budgets at HBCUs, reducing faculty, staff, and productions, while some programs have had to merge with other units. Although many PWIs are experiencing these same issues, the larger impact is on HBCUs. In the case of many theatre companies, major funding that would have been awarded to Black theatres is now being directed to mainstream companies that advocate "diversity and inclusion" (New York producer and director Woodie King, Jr. elaborates on this dilemma in Chapter 5). The argument continues as to whether or not there is the need for ethnic specific theatres and HBCUs, but without them there would not be the large talent pool that currently exists. For many African Americans, it is the ethnic specific institutions that keep them employed, particularly for many in the non-acting areas. Our major regional theatres are still predominately run by white artistic directors and other whites in positions of authority. Until the playing field is leveled, ethnic specific institutions are necessary.

Within the past decade, I have seen new Black theatre companies emerging and more established ones rejuvenating. As well, several HBCUs are getting a second wind with new faculty and a fresh vision for the twenty-first century. The latest proof of Black institutions on the rise are the number of festivals being held throughout the country, including the New Black Fest in New York, DC Black Theatre & Arts Festival, Atlanta Black Theatre Festival, the more recent Bull City Black Theatre Festival in Durham, NC, and many others. Not only do these festivals showcase work by artists both known and emerging, but these events also include

workshops in various areas including acting, design, playwriting, and marketing. The phenomenal success of the film *Black Panther* (2018) has also fueled excitement for Black stories being presented by Black institutions. In spite of all the limitations placed on African Americans, we have always and will continue to make a space of our own.

## Works cited and further reading

Cooke, Anne M. "The Little Theatre Movement as an Adult Education Project among Negroes." *Journal of Negro Education*, vol. 14, no. 3, Summer 1945, pp. 418–424.

Hatch, James V. "Introduction to African American Theatre History." *ONSTAGE: A Century of African American Stage Design*. New York Public Library at Lincoln Center, 1995.

Hill, Errol G., and James V. Hatch. *A History of African American Theatre*. Cambridge UP, 2003.

Hill, Lena M., and Michael D. Hill. *Invisible Hawkeyes: African Americans at the University of Iowa during the Long Civil Rights Era*. U of Iowa P, 2016.

# 20

# BEING BLACK ON STAGE AND SCREEN

## Black actor training before Black Power and the rise of Stanislavski's system

*Monica White Ndounou*

Mainstream actor training programs in the United States rarely include the contributions of Black Americans. Instead, they primarily focus on Russian actor, director, and theorist Constantin Stanislavski, whose system of acting encourages strategies for consistently engaging in more realistic performances (Moore 9). Originating in 1906, variations of the system have continued to dominate US actor training programs since the 1930s and 1940s (Carnicke 3–6). As a result, matters of race, gender, and sexuality in training received little attention until the 1970s and 1980s (Bernhard 472–473).

Even without a "national" school of actor training, Stanislavski-based curricula eclipses the various culturally distinct contributions to the development acting theories and practices throughout the 1,800 US college and university theatre departments offering Bachelor degrees in theatre arts (Bernhard 472–473). This selective focus reinforces the erroneous impression that the development of actor training in the United States is a distinctly white enterprise when that is hardly the case. Various Black theatre studies and biographies reveal a rich history of Black actor training grounded in careful study of craft, cultural expression, artistry, history, and lived experiences. Black Americans have historically participated in actor training and have influenced acting technique in the United States. This chapter introduces several of the programs that existed in the nineteenth century and through the 1940s.

The first US actor training institutions emerged in 1871. After studying with François Delsarte in France, white American actor, director, playwright, designer, and inventor Steele MacKaye established the St. James Theatre School in New York, the first known professional theatre academy in the United States. When the school dissolved after six months, at least four others emerged in New York along with three more in New England (Watson 62–63). Early Black performers like Adrienne McNeil Herndon, Alice M. Franklin, and Henrietta Vinton Davis studied at these predominantly white institutions (Peterson, "Profiles" 116; E. Hill 51–52, 65). Before the end of the century, though, around 1896–1898 and possibly earlier, Black institutions began to appear. Bob Cole, an early Black American actor, entertainer, playwright, songwriter, director, and producer of vaudeville and the musical stage, founded the All-Star Stock Company in New York City (Peterson, "Directory" 12–13). Established in residence at

Worth's Museum, the All-Star Stock Company was the first professional Black stock company and training school for African American performers (Peterson, "Profiles" 70–71).

Cole's institution challenged popular perceptions of Black performers as "natural actors" lacking intellect and artistry (Ross 239). Notable performers in the company demonstrated expertise in stage management, producing, directing, playwriting, songwriting, and musical composition. They did so while immersed in the study of voice and vocal music (i.e. opera); movement through dance (i.e. the cakewalk); comedy, including stand-up and ensemble work in specialty acts (i.e. minstrelsy), and character acting. Examples of the performance styles explored at the All-Star Stock Company include *The Creole Show* (1890–1897), the Octoroons Company (1895–1900), the Black Patti Troubadours (1896–1915), the Williams and Walker Company (1898–1909), and the Pekin Stock Company (1906–1911), which performed Black musicals and popular comedies (Peterson, "Directory" 13). Some of the Pekin's players were also involved in film, like William Foster, who is generally credited as the first Black film-maker (*The Railroad Porter*, 1912) (Robinson 168–169). The rich tradition of institutional Black actor training ushered in by the All-Star Stock Company continued in various forms, including apprenticeship/mentorships, on-the-job-training in professional jobs, theatre programs at historically Black colleges and universities (HBCUs), and the Negro Units of the Federal Theatre Project (1935–1939).

Before the All-Star Stock Company, Black American actors routinely developed voice, movement, and emotional flexibility through a variety of individual and collective processes. The all-Black African Company of the African Grove Theater, founded by William Brown, exemplifies those early processes. In 1816–1817, Brown hosted "entertainments" in his back-yard tea garden on Thomas Street in New York City, an enterprise that eventually grew into his legendary company (1821–1824). The African Company is best known for its staging of William Shakespeare's plays as well as Brown's original work, including the first Black authored play in the United States, *King Shotaway*, a story of the Carib uprising against the British on the island of St. Vincent (Hill 11–16).

The African Company's star performers were James Hewlett and Ira Aldridge. According to the New York *Star*, Hewlett's initial "histrionic education took place under those celebrated masters [George Frederick] Cooke and [ … Thomas Abthorpe] Cooper, whom he followed as a servant boy, and stole their action and attitudes in moments of recreation or recitation" (qtd. in Lindfors, "Early Years" 54). Aldridge attended the Free School in New York, where he learned reading, writing, and recitation, and then apprenticed under Hewlett (A. Hill and Barnett 11). After performing with the African Company, Aldridge made his London debut in 1825 at the age of 17, honing his skills by "performing in small venues while touring the English provinces, where he was acclaimed both as a tragedian and as a comedian" (Lindfors, "Early Years" 4). By the end of his eight-year apprenticeship, "he could perform as many as sixteen different roles in a week and a half—a range broader than that of some of his more famous [white] contemporaries" (4). In his performances, Aldridge drew upon "anti-slavery sentiments by playing long-suffering slaves in abolitionist melodramas set in the New World" (Lindfors, "Mislike Me" 181). Grounding his performances in Black culture and an awareness of the plight of Black people, Aldridge paved the way for the more natural performance style that has become the crux of US actor training (Hill 19).

Towards the end of the nineteenth century, vaudeville performers George Walker and Bert Williams formed a theatre company that incubated Black talent while developing acting processes and characters in an attempt to disrupt existing Black stereotypes (Ndounou 65). Born in the Bahamas, Williams carefully studied the "darky" stereotype in American entertainment and adapted it into a sad clown with an insightful philosophy of life. In addition to

studying mime in Europe with Pietro, the great pantomimist, Williams fused observations of Africana cultures with his lived experiences to cultivate his vocal technique in speech and song as well as in movement and improvisation. His signature sad, comic character, known as the Jonah Man, revolutionized a popular trope and provided a model for his contemporaries and successors.

Other members of the Williams and Walker Company also recognized the importance of training. Actor and choreographer Aida Overton Walker, George Walker's wife, trained with the All-Star Stock Company (Peterson, "Directory" 12). In 1905, the majority of training and experience obtained by Black performers was in musicals and comedies. Aida Walker suggested that "one of the greatest needs of the times [was] a good school in which colored actors and actresses may be properly trained for good acting" (Walker 571–575). By 1911, her dramatic productions provided Black actors access to a broader range of roles thereby expanding practical training opportunities in dramatic acting (Perkins 308). Anita Bush, a chorus member of the Williams and Walker Company, also provided training through her own theatrical group, the Lafayette Players (1915–1932). They performed serious dramas, most of which had been written by whites due to the limited number of full-length plays by Black playwrights. Clarence Muse and other members of the company sometimes performed in whiteface, thereby exploring the performing of racial and cultural identity in serious dramas through costuming, makeup, and accents (McAllister 113–114).

The Little Negro Theatre movement from the mid 1910s to late 1930s offered additional training opportunities in local community theatres, institutions of higher education, and other venues. In 1945, while advocating for the potential of this movement to promote adult education, Dr. Anne Cooke, founder of theatre programs at several Black colleges and universities, conducted a survey of some of those institutions (Cooke 418–424). Out of 36 colleges, 21 responded. Of these, 2 had no theatre programs, 6 programs were solely extracurricular, but 13 had community programs and/or played to audiences beyond their campuses.

HBCU theatre programs like those at Howard University, Tuskegee Institute, Hampton, North Carolina A&T, and several other colleges developed noteworthy curricula for the training of Black theatre professionals. In addition to developing acting theory and practice by performing in plays by white authors, Black performers also trained in "native dramas" by Black authors, including "race" or propaganda plays and folk plays. Randolph Sheppard Edmonds, known as the Dean of Black Academic Theatre, helped to organize Black theatre training programs, develop more intentional curricula, and raise production standards when he founded the Negro Intercollegiate Drama Association (NIDA) (1930–1952). He also founded the Southern Association of Dramatic and Speech Arts (SADSA) (1936–1951), later known as NADSA when it became a national association. Through these organizations, HBCUs developed theatre seasons and curricula with the central focus of training Black theatre professionals, especially in acting and playwriting.

These programs reveal the importance of accessibility of training and performance opportunities on and off college campuses. For example, in collaboration with the local rural, Black community, the student writers at Tuskegee's Bucket Theatre supplied community-inspired material for the locals to perform in off-campus shows. In this instance, actors received on-the-job training performing local stories in the community. To make the theatre truly by and about the community it served, Dr. Cooke suggested that the program employ a technique in children's theatre that would enable community members to write their own scripts or, if they were illiterate, to dictate their plays to Tuskegee student playwrights. Such acting techniques grounded in improvisation and storytelling informed the development of playwriting and vice versa.

Wiley College's Cabin Theatre demonstrated a model for sustainable training by collaborating with the community. Wiley's program sought playwrights who were encouraged to "write from the inside experiences of their various communities" and child and adult actors to perform the work (Cooke 419). A local church paid for its own director to train at the college and implemented a year-long program at the church that explored secular and spiritual approaches to acting. Atlanta University's Summer Theatre Lab, founded by Dr. Cooke, involved the study of all types of professional theatre training. The majority of the plays it produced were by white authors, many containing non-Black characters. One show per season was dedicated to a Black-authored play. This program's predominantly Black lab setting demonstrated the potential for merging mainstream, popularized techniques with culturally nuanced experimentation. Dillard University's program deviated from the little theatre model represented by the other programs by simultaneously educating the performers and the audiences through an array of community programs.

Black actor training continued during the Federal Theatre Project (FTP) (1935–1939). As part of President Franklin D. Roosevelt's Works Progress Administration, the FTP employed out-of-work actors, directors, playwrights, designers, and stage managers. The initial 16 Negro Units expanded to 23 units; out of those, only 3—in New York, Boston, and Chicago—were directed by African Americans. These three units characterized the institutional development of Black actor training at the time. The New York Unit, headed by famous actor and director Rose McClendon and later by white director John Houseman, had a classical drama unit staging African American adaptations of white dramas. The Boston Unit, headed by actor and director Ralf Coleman, produced folk plays and productions from other Negro Units. Trained musician Shirley Graham brought national recognition to the Chicago Unit with a range of successful, serious dramas and musicals. The repertoires of these units represented a variety of distinct acting styles achieved through a range of techniques. The FTP's theatre apprentice program documented various performances, like the veteran musical-comedy entertainers in the Vaudeville Unit in New York, providing rich material for studying acting in this period (Ross 231–246). After the FTP ended, Abram Hill, a HBCU alum, founded the American Negro Theatre, one of the most tangible outgrowths of the Federal Theatre Project and best-known example of Black theatre training at the time.

A variety of approaches to individual and institutional actor training by Black artists and educators emerged from the nineteenth century through the 1940s. Incorporating these contributions into today's formal training programs can correct the misperception of US actor training as an exclusively white enterprise.

## Works cited

Bernhard, Betty. "Training." *The World Encyclopedia of Contemporary Theatre: Volume 2: The Americas, Volume 2,* edited by Don Rubin and Carlos Solórzano, Routledge, 2014, pp. 472–473.

Carnicke, Sharon Marie. *Stanislavsky in Focus.* Harwood Academic, 1998.

Cooke, Anne M. "The Little Theatre Movement as an Adult Education Project Among Negroes." *Journal of Negro Education,* vol. 14, no. 3, Summer 1945, pp. 418–424.

Hill, Anthony D., and Douglas Q. Barnett. *Historical Dictionary of African American Theater.* Scarecrow Press, 2008.

Hill, Errol. *Shakespeare in Sable: A History of Black Shakespearean Actors.* U of Massachusetts P, 1986.

Lindfors, Bernth. *Ira Aldridge: The Early Years 1807–1833.* U of Rochester P, 2011.

———. "'Mislike Me Not for My Complexion … ': Ira Aldridge in Whiteface." *African American Review,* vol. 33, no. 2, Summer 1999, pp. 347–354.

McAllister, Marvin. *Whiting Up: Whiteface Minstrels and Stage Europeans in African American Performance.* U of North Carolina P, 2011.

Moore, Sonia. *The Stanislavski System: The Professional Training of an Actor.* 2nd revised ed., Penguin Books, 1984.

Ndounou, Monica White. "Early Black Americans on Broadway." *The Cambridge Companion to African American Theatre*, edited by Harvey Young, Cambridge UP, 2012, pp. 59–84.

Perkins, Kathy A. "African American Drama, 1910–45." *The Oxford Handbook of American Drama*, edited by Jeffrey H. Richards and Heather S. Nathans, Oxford UP, 2014, pp. 307–321.

Peterson, Bernard L. *The African American Theatre Directory, 1816–1960: A Comprehensive Guide to Early Black Theatre Organizations, Companies, Theatres, and Performing Groups.* Greenwood Press, 1997.

———. *Profiles of African American Stage Performers and Theatre People, 1816–1960.* Greenwood Press, 2001.

Robinson, Cedric J. *Forgeries of Memory & Meaning: Blacks & the Regimes of Race in American Theater & Film before World War II.* U of North Carolina P, 2007.

Ross, Ronald. "The Role of Blacks in the Federal Theatre, 1935–1939." *The Theatre of Black Americans: A Collection of Critical Essays*, edited by Errol Hill, Applause, 1987, pp. 231–246.

Walker, Aida Overton. "Colored Men and Women on the Stage." *The Colored American Magazine*, vol. 8, no. 9, Sept. 1905, pp. 571–575.

Watson, Ian, editor. *Performer Training: Developments Across Cultures.* Psychology Press, 2001.

# THREE VISIONARY AFRICAN AMERICAN WOMEN THEATRE ARTISTS

## Anita Bush, Barbara Ann Teer, and Ellen Stewart

*Sandra Adell*

African Americans began carving spaces for themselves in American theatre in 1821 when William Brown (*c.*1803–1884) opened the African Grove Theatre in New York City. The theatre provided an entertainment venue for the city's free Blacks who were barred from other venues because of their race. It also provided Black actors with opportunities to practice their art, making Brown the first documented African American founding artistic director of a theatre company in New York City.

Over the next century and a half other African American theatre artists attempted, with varying degrees of success, to establish theatre companies that would break down racial barriers that kept Black actors off most American stages and challenge prevailing aesthetic standards in American theatre. Most were men; opportunities for women dramatic performers were rare. Rarer still were women artistic directors of any race or ethnicity as founders of their own companies. Among the few African American women who defeated the odds, three stand out: Anita Bush, Ellen Stewart, and Barbara Ann Teer. Like William Brown, these women were visionaries. They were committed to creating a company of professional actors, building institutions to train future generations of theatre artists, and introducing audiences to new forms of artistic expression.

## Anita Bush

Anita Bush (1883–1974) was born in Washington, DC, and began her career as a young dancer with the chorus of Bert Williams and George Walker's vaudeville company. She was introduced to theatre by her father, a respected tailor whose clientele included actors. She and her sister would often help deliver costumes to her father's clients, thereby gaining access into their profession. Their contact with these and other white theatre professionals led to them being cast as maids in a Park Theater production of *Anthony and Cleopatra*. Thus began Bush's lifelong love for theatre (Thompson 211).

After a backstage accident forced her to give up dancing, Bush decided to pursue her dream of founding a professional theatre company. She called it the Anita Bush All-Colored Dramatic Stock Company to distinguish it from musical and vaudeville companies. It included Charles Gilpin; Dooley Wilson, who later gained fame as the piano player in the movie *Casablanca*; Andrew Bishop; Carlotta Freeman; Evelyn Preer, who, like Anita Bush, went on to a career in film; and Edward Thompson.

To find a home for her company, Bush convinced the manager of Harlem's Lincoln Theater to allow them to perform there. On November 15, 1915, they presented their first play, *The Girl at the Fort*, a farcical comedy by a white playwright and director, Billie Burke. A few weeks later they moved to another Harlem theatre, the Lafayette, where on December 27, 1915, they presented *Across the Footlights*. The following year, Bush sold her company to the Lafayette, and Anita Bush's All-Colored Dramatic Stock Company became the famed Lafayette Players (Thompson 215).

Bush remained with the Lafayette Players until 1920 when she left to pursue a career in film. In 1921 she appeared in her first movie, a silent film titled *The Bull Dogger* starring the African American cowboy and rodeo performer, Willie "Bill" Pickett (1870–1932). In 1922 Bush appeared in her second movie, *The Crimson Skull*, alongside the popular African American silent film actor and fellow Lafayette Player, Lawrence Chenault (1877–1943). What Bush did afterwards is lost to the history of African Americans in theatre. She died in 1974 in New York City at age 90.

## Barbara Ann Teer

Barbara Ann Teer (1937–2008) was born in East St. Louis, Illinois (Figure 21.1). Like Anita Bush, Teer began her performance career as a dancer. After earning a bachelor's degree in dance education in 1957 from the University of Illinois at Urbana-Champaign, Teer studied in Europe with modern dance pioneer Mary Wigman, took courses in pantomime with Etienne Decroux in Paris, and briefly performed with the Alvin Ailey Dance Company in Brazil before turning to acting after a knee injury brought her career as a dancer to an end. In New York Teer immersed herself in the acting techniques of Sanford Meisner. She also studied acting with Paul Mann, Lloyd Richards, and Robert Hooks at his Group Theatre Workshop.

By 1965 Teer had built a successful, if not financially rewarding, career as an actress. In addition to her award-winning performance in Rosalyn Drexler's play, *Home Movies* (1964), Teer was in the original cast of the Negro Ensemble Company's production of Douglas Turner Ward's farce, *Day of Absence*, and Ron Milner's *Who's Got His Own* (Thomas 40). She also appeared in minor roles in several feature-length films. Most notable among her film credits are *The Angel Levine* (1970) starring Harry Belafonte (who also was an un-credited co-producer), the Jewish actor Zero Mostel, and the African American actor Gloria Foster; and *Slaves* (1970), with Ossie Davis and the singer Dionne Warwick in starring roles.

By the late 1960s, Teer had grown disenchanted with the direction Black theatre was taking and the limited roles that she was being offered. She felt that Black theatre needed to be grounded in the realities of Black people and in "non-Western" performance traditions. She sought a theatre that would nourish the spirits of Black people rather than feed the commercial theatre with its emphasis on reaching the Broadway stage.

In 1968, Teer founded what would become the Harlem-based National Black Theatre. According to Lundeana Marie Thomas in her study of the National Black Theatre of Harlem, Teer lacked experience with "theatrical theory, Black Pentecostalism and Yoruba traditions" when she began working toward establishing her own theatre (46–69). However, she was

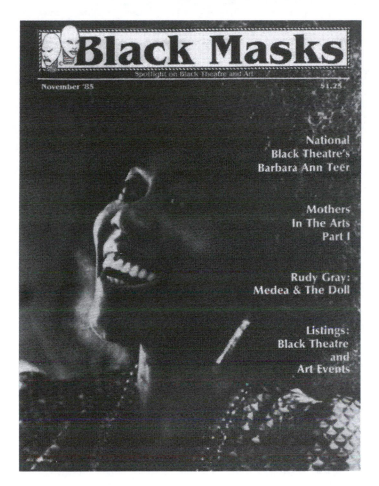

*Figure 21.1* Barbara Ann Teer on the cover of *Black Masks* magazine (November 1985).
*Source*: Courtesy of Beth Turner.

familiar enough with the rituals of the Black church to begin making connections to those of Yoruba creative expression and began offering classes to a small group of actors who shared her commitment to developing a "Black theatrical standard" based on "the Black lifestyle." To accommodate her steadily growing classes, in 1969 Teer purchased an 8,000-square foot space on East 125th Street. By this time, she and her students had formulated six goals that became the core of her process-oriented theatre training: self-affirmation, cooperation, education, spirituality, values, and liberation (Thomas 79–86).

In 1972, Teer received a Ford Foundation Fellowship to visit Africa. Although she was supposed to visit seven African countries, she spent most of her time in the village of Oshogbo in western Nigeria where she was initiated as a Yoruba priestess. The village's regularly held religious festivals confirmed for her that Black Pentecostalism retained strong connections with Yoruba rituals and that those connections could be the basis for a new Black theatre in America.

Over the next few years, Teer frequently traveled to Nigeria and to other parts of Africa and the Caribbean. The experiences, information, and knowledge that she gained during those trips helped to shape the theatre's mission and Afrocentric curriculum. The curriculum included the

Teer Technology of Soul Workshop and the Master Liberation Workshop along with courses such as Meditation and Spiritual Release and dance and movement classes based on Yoruba ritual performances (Thomas 101–108). Teer also sponsored Sunday afternoon symposiums called "Blackenings" that featured Black artists, writers, and political figures and were open to the Harlem community.

In 1983, after a fire destroyed the theatre, Teer began working on plans for a larger theatre complex. A $12 million, 64,000-square foot building at 2031 Fifth Avenue in Harlem became the new home of the National Black Theatre. It includes two theatres, classrooms, and retail spaces. The theatre's logo, exterior relief art, and interior designs were created by artists from Oshogbo, Nigeria. Their work with the National Black Theatre is one of many examples of cultural exchanges with artists from Africa and the African Diaspora that Teer initiated and sustained throughout her life and career as one of this country's most successful African American women artistic directors.

Barbara Ann Teer died in New York on July 21, 2008, at age 71. Her homegoing celebration on Monday, July 28, embodied the spirit of her accomplishments, bringing together artists, writers, politicians, and the people of Harlem in a joyful and colorful processional from the National Black Theatre to the Hudson River. Teer's organization remains New York's oldest continuously producing company devoted to Black theatre.

## Ellen Stewart

Known throughout international theatre circles as "La Mama," Ellen Stewart (1919–2011) had much in common with Barbara Ann Teer. Like Teer, Stewart founded her theatre company, La Mama Experimental Theatre Club, so that artists could have a place where their work and talent would be nurtured and valued. She also shared Teer's commitment to cross-cultural exchanges between artists. The difference between the two is that while Teer's multiculturalism was grounded in the cultures of Africa and the African Diaspora, Stewart had a different focus. Her mission was to support and present work by African American and international experimental theatre and performance artists who might not otherwise have opportunities to collaborate on innovative projects that were more suited for the theatre "fringe" than for the global main stages.

Born in Alexandria, Louisiana, and raised in Chicago and Detroit, Ellen Stewart went to New York to become a fashion designer. One of her first jobs was as a porter at Saks Fifth Avenue department store, one of the few jobs available to African Americans in the city's fashion industry. She frequently wore her own creations under the blue smock that she and the other Black employees were required to wear. According to Cindy Rosenthal, whose "Ellen Stewart, La Mama of Us All" is one of the few scholarly essays published about Stewart, after customers began asking about the outfits that the "colored model" was wearing, Stewart was hired as a designer (30–31). After leaving Saks she continued working as a freelance designer until the early1970s.

Stewart began her theatre career in 1961 as an artistic director of an experimental theatre in a basement at 321 East 9th Street in New York's East Village (Rosenthal 16). She was called "Mama" because she nurtured her artists regardless of their level of training and experience. Her only criterion for admission into her "club" was that artists be totally committed to the performing arts and to creating work that was not Broadway fare.

Between 1961 and 1969, the theatre moved four times, each time into a larger and more accommodating space. After receiving a grant for $25,000 from the Ford Foundation in 1967, the same year the theatre received its not-for-profit tax status, Stewart applied for and was

awarded other grants, which she used to purchase a building at 74A East 4th Street. La Mama Experimental Theatre currently occupies three buildings on East 4th Street. The campus includes two theatres, rehearsal space, dormitories for visiting artists, an art gallery, and an archive where the company's records are stored and are available to researchers by appointment.

In 1985 Stewart was awarded a $300,000 MacArthur Grant. She used it to purchase and renovate a fourteenth-century convent in Umbria, Italy, near Spoleto, and turned it into the internationally renowned La Mama Umbria artist retreat. Every year actors, directors, designers, and playwrights from around the world gather at Umbria for two- and three-week theatre workshops.

Despite her influence on late twentieth-century international avant-garde and experimental theatre, Ellen Stewart is not widely recognized for her contributions to Black theatre. The cast lists from her productions include names of renowned Black artists such as playwrights Adrienne Kennedy and Richard E. Wesley, and actors Andre De Shields, Beverly Atkinson, Rhodessa Jones, and Basil Wallace. For these Black artists and others who honed their skills at La Mama early in their careers, Stewart provided a space where talent and a spirit of collaboration prevailed over one's race, gender, or ethnicity.

Anita Bush, Barbara Ann Teer, and Ellen Stewart helped to open the way for African American actors in the twentieth century to define themselves as artists and to continue the legacy of dramatic performance that began when William Brown did something daring in 1821: put Black actors on a New York stage.

## Works cited

Rosenthal, Cindy. "Ellen Stewart, La Mama of Us All." *The Drama Review*, vol. 50, no. 2, Summer 2006, pp. 30–31.

Thomas, Lundeana Marie. *Barbara Ann Teer and the National Black Theatre: Transformational Forces in Harlem*. Garland, 1997.

Thompson, M. Francesca. "The Lafayette Players, 1915–1932." *The Theatre of Black Americans: A Collection of Critical Essays*, edited by Errol Hill, Applause, 1987, pp. 211–230.

# 22

# THE BIRTH OF QUEEN ANNE

## Re-discovering Anne M. Cooke
## at Spelman College

*Leslye Joy Allen*

There is no single archival collection of documents and/or photographs solely about the life of drama professor and director Anne M. Cooke. Her work and ideas are scattered among archival collections of many individuals with whom she worked, directed, taught, and mentored. Yet, Cooke's consolidation of theatre groups at Spelman College, Morehouse College, and Atlanta University and her founding of the Atlanta University Summer Theatre and School (AUST) were extremely innovative. Cooke assembled a theatre program at Spelman College that she later transplanted to Hampton Institute and Howard University, where she was nicknamed "Queen Anne" by drama students in the late 1940s due to her elegant dress and regal appearance. But in 1928, when Cooke arrived in Atlanta, Georgia, as a 20-year-old Oberlin College graduate to teach English and speech at Spelman College, no one knew that she would become the single most important theatre director and theatre educator on historically Black college and university campuses (Perkins 144–145).[1]

A sizeable portion of the analysis written here is based on correspondence between Cooke and Spelman's last white president Florence M. Read and on one letter in particular that Cooke wrote in 1933. Their letters date from 1928 through the 1950s. Cooke's letters underscored her desire to define "Black theatre" and a "Black aesthetic." In their correspondence, Read and Cooke rendered opinions about particular plays, the happenings in the locales where they traveled, the University Players, and the Atlanta University Summer Theatre and School. While Cooke respected Read's authority, she did not defer to Read in the typical manner that Blacks were expected to defer to any white person during the 1920s and beyond. On Atlanta University Center campuses, these racial mores were muted. While Read tenaciously guarded her right to the final say-so on what took place on Spelman's campus and assumed near absolute control over the repertoire of the University Players and AUST, Cooke did disagree with Read who worried about the moral content in plays. Cooke was more adventurous (Anne Cooke Employment File; Hatch 64–73).

When Cooke was around the age of 86, she shed some light on her early abilities and her decisiveness. She stated that teaching at Spelman had been her first real job and that she had arrived there one year after Read had assumed the presidency. After a couple of years she approached Atlanta University president John Hope about the possibility of creating a summer theatre.[2] She recalled: "I was twenty-two years old at the time. He [Hope] said, 'You don't mean

to tell me you are interested in doing something like that?!' Well, in a couple of years we had the summer theatre going" (Perry).

In 1929, Atlanta University, Spelman College, and Morehouse College affiliated to make up the Atlanta University Center (AUC). Cooke took a leave of absence from Spelman during the 1930–1931 school year to study in New York at the American Academy of Dramatic Arts and Columbia University. Upon her return in the fall of 1931, she created a single theatre group out of the three groups in the AUC and named it the Atlanta-Morehouse-Spelman Players, commonly called the University Players. Baldwin Burroughs, who succeeded Cooke as head of Spelman's Drama Department, has explained that Cooke consolidated the theatre groups in order to choose from among the best actors at all three schools.[3]

The following summer Cooke started the first children's theatre at Spelman. The success of the children's programs helped her to make the case for an adult summer theatre program. Although John Hope was a fan of theatre, he knew that permission for creating a summer theatre would require the permission of Spelman president Read along with his endorsement. The 22-year-old Cooke stunned Hope with her imaginative theatre program and earned his admiration, and the Atlanta University Summer Theatre and School was inaugurated in 1934 (Anne Cooke Employment File; Burroughs; Perkins 144). When Cooke's former student, playwright, and AUST alum Shauneille Perry asked her what difficulties she experienced as a Black woman, Cooke answered that women do have to "get up and fight" but that she never viewed anything she wanted to do with the expectation that being Black or female would stop her from doing it.[4]

Cooke envisioned AUST as a community repertory theatre for students, faculty, professional, and amateur actors. She designed it as a semi-professional theatre that would fill the void left by New York City's Lafayette Theatre, which had once been a training ground for many Black actors. Soon theatre luminaries such as Jasper Deeter from Hedgerow Theatre, Ethel Barrymore, José Ferrer, Paul Robeson, and Abbie Mitchell became regular visitors to Spelman's campus (Atlanta University Summer Theatre Programs).

With funds gleaned from Atlanta University's budget, AUST embodied the communal spirit that Cooke intended. Her vision for its necessity and success was realized its first year, so much so that in the fall of 1934 AUST re-staged one of its summer audience's favorites, the popular and funny *Mr. Pim Passes By*, starring for a second time Morehouse graduate and co-director John McLinn Ross in the humorous title role. Spelman senior Marian Ables wrote of the performance:

> The college community owes deep gratitude to the work of the dramatic groups in its midst ... Great trust in a gradual training of the masses to belief in the need of higher education for all may be laid before the footlights of our Little Theatre in Howe Memorial Hall.[5]
>
> (3)

Ables' comments underscored Cooke's mission: to educate and uplift those Black Atlanta citizens who did not have much access to the arts or higher education (3; Collins 3).

The Black-owned newspaper *Atlanta Daily World* wrote that the Atlanta University Summer Theatre's premier on Monday, June 18, 1934, was an amazing success. The group performed white playwright Lula Vollmer's folk drama *Sun-Up*. The audience "enthusiastically applauded the actors" at the end of every act ("Atlanta University Summer Theatre's Initial Play" 3). AUST distributed flyers advertising summer productions in the Black-populated south and west sides of Atlanta, at all of the historically Black colleges, at churches, and at the then all-white Emory

University. Enthusiasm for AUST extended beyond Atlanta. A group called the Auburn-Opelika Players traveled from Opelika, Alabama, to watch AUST's first production. Under Cooke's direction AUST's Black actors convincingly portrayed white North Carolina mountain dwellers in Vollmer's anti-government play (Hatch 144; Perkins 144; Read).

Cooke was the first known Black woman to earn a doctorate in theatre in the United States. She began studying for her PhD at Yale in 1936, a unique undertaking given that the degree was not a requirement for teaching drama on most college and university campuses. Yale provided Cooke with classmates who later became, arguably, the most talented theatre professionals ever assembled on a single historically Black college campus. Her Yale classmates, director-actor-playwrights John McLinn "Mac" Ross and Owen Dodson, followed her to Spelman. She recruited more Black artists, including actor-playwright James "Beanie" Butcher and actor-director Thomas Pawley, who eventually founded a summer theatre at Lincoln University (Well-Trained Dramatists 2).

With a backbreaking schedule of five different productions in five weeks, actors performed Mondays, Wednesdays, and Fridays while rehearsals for upcoming productions took place on Tuesdays, Thursdays, and Saturdays. During AUST's first year, the core group of actors consisted primarily of recent college graduates with a few current students and faculty. Morehouse graduate William Jennings designed and built most of the sets. Actor Frederick Maise was a Morehouse and Atlanta University alumni. Actor Frank Adair and actor-director John M. Ross were also fellow Morehouse graduates. Among Spelman's alumnae were actors Ernestine Jackson and Naomah Williams Maise. Maise also finished the Juilliard School. The first season's student actors were Morehouse's Raphael "Ray" McIver and Spelman's Eldra Monsanto and Florence Warwick. Billie Geter, an actor and drama coach at Bethune-Cookman College, regularly traveled to Atlanta to perform with AUST (Hatch 83).

Although the majority of the plays performed by the University Players and the summer theatre were written by white and European playwrights, Cooke annually produced three one-act plays by a variety of Black playwrights under the title *Three Plays of Negro Life*. AUST and the University Players performed the works of nationally known Black playwrights such as Willis Richardson's *The Broken Banjo* and Langston Hughes' *Don't You Want to Be Free?* The *Three Plays of Negro Life*, however, often featured relatively new Black (and a few white) playwrights who wrote one-act plays about different aspects of Black life. In most instances Cooke had direct access to these playwrights as many of them came to Atlanta to participate in the summer theatre (Atlanta University Summer Theatre Programs).

During its first year, AUST performed Vollmer's *Sun-Up*, George Bernard Shaw's *Candida*, A. A. Milne's *Mr. Pim Passes By*, and Oscar Wilde's *Lady Windermere's Fan*. The first season's final performances were the three one-act "Negro plays" that consisted of Erostine Coles' *Mimi LaCroix*, James Butcher's *The Seer*, and Richardson's *The Broken Banjo*. By the late 1930s, poet and actor Sterling Brown and sociologist Dr. Ira De A. Reid (whom Cooke later married) were regular actors in AUST along with local community members and faculty from AUC colleges. Although Cooke occasionally directed one or two of the one-act plays, her co-director John "Mac" Ross, who completed his master's degree at Yale in 1934, directed most of those plays. His training in directing and technical directing served AUST well.

Importantly, Cooke used the one-act plays for several purposes. They were relatively easy and inexpensive to copy; the set designers became more inventive building sets that could be quickly changed from one act to another; and an actor with little or no experience onstage had fewer lines to learn, making his or her first experience less stressful (Cooke, July 12, 1933; Perry).

Cooke had very particular ideas about what theatre and art in general could do for Black Americans. While at Spelman, and long before she directed a communications center at Hampton Institute that incorporated visual art, speech, theatre, and music as modes of communication, she conceived and drafted two programs that would later be put to greater use at Hampton. In the summer of 1933, Cooke wrote Read that she wanted to create a six- to eight-month program open to adults who were interested in learning about theatre "regardless of previous academic training" (July 12, 1933). She visualized it as a series of lectures and acting demonstrations covering eight areas related to theatre and the arts. The lectures would be provided for the wider Atlanta community, free of charge.

The program as envisioned by Cooke would consist of several categories: easy plays for community members; how to stage, costume, and direct plays; plays for children; the use of music in theatre, and pageantry and community drama. Cooke also requested that the University Players and students in her play production class give demonstrations after each lecture. "Theatre-practice is certainly one activity which needs to be met because so many agencies misuse the theatre as a means of expression," she wrote (July 13, 1933). She wanted to begin the program in the fall of 1933.

While Spelman and the other AUC colleges gave free lectures about arts and other subjects to the general public, Cooke's idea was never fully implemented as an academic extension program at Spelman. She was able, however, by the summer of 1934, to extend theatre and the arts to a broader community, in and outside of Atlanta, with the creation of the summer theatre. In 1937, AUST began a full academic summer curriculum in all areas of theatre production (Cooke, July 13, 1933).

The second program Cooke discussed with President Read in 1933 was particularly ingenious. As a child, Cooke had traveled internationally with her mother and father, who was a well-known architect. This exposure had given her some advantages. She wrote Read that she wanted to select a group of college students to take for one semester to study and observe the music, literature, and visual arts in various African countries as well as in Russia, Spain, France, and Germany in order "to discover what is unique about the expression of each country" (July 13, 1933). In her letters she stressed that the students should look for one or two aspects—what she called the "least common denominators"—about each country's art forms. She wanted to find that particular component (or components) that she believed set peoples of African descent apart from others. She wrote the following:

> I see something in Negroes, a quality, which is purely his. I would not want to prejudice the minds of others by making suggestions to them concerning my ideas. You see, after a time the group would say that with all other things removed and explained there is one *flavor* left which Mr. Negro claims and which can't be taken from him.
>
> (July 13, 1933, original emphasis)

Cooke emphasized that the next step would be to figure out how to "artistically articulate this *thing*" (Awarded 4, original emphasis).

It is not known whether Cooke was ever able to assemble a group of students in Atlanta to conduct this international study. She stressed that studies of various countries, along with the study of Blacks in the United States and in African countries, would help students scientifically determine cultural and artistic aspects of people of African descent that were "not racially American Negro, but distinctly Negro." She searched for a distinctively Black or African component in the arts of peoples of African descent regardless of where the art had been produced. By so doing, she anticipated the development of Black and African Studies

some 30+ years before such studies became distinct disciplines and in demand on college and university campuses. Students should work, she argued, as a group on the study because "the individual Negro on the whole is too subjective to create. It will be some time before he can relax enough to be real." She also made a thinly veiled argument that Black people were not comfortable enough to express themselves, artistically and otherwise, because virulent white racism often stunted their ability to say exactly what they thought (July 13, 1933).

Although she remained affiliated with AUST into the 1950s, Cooke left Spelman in 1941 and was awarded her PhD in drama from Yale in June of 1944 (Awarded 4). By the time she left as principal director of the University Players and AUST, Cooke had created a community theatre that actually reached the community. It lasted until 1977, making it the longest running summer stock theatre in the United States. Atlanta subsequently became a central training ground for Black actors throughout the nation because Cooke had created a demanding curriculum in theatre. To this day, both the University Players and AUST have very long traditions of producing many of the nation's most talented Black actors.

Cooke has been largely overlooked by scholars, perhaps because she remained primarily affiliated with college theatre. Yet, her early work in Black college theatre was the actual dawn of professional Black theatre in Atlanta. It would take another three decades before the explosive growth of Black playwrights and productions propelled the national Black Arts Movement of the 1960s and 1970s.

## Notes

1  Data about Cooke's life and work are scattered among several archival collections at Spelman College, the Atlanta University Center Woodruff Library, Emory University, and Howard University.
2  John Hope was president of Morehouse College from 1906 to 1929. In 1929 he became president of Atlanta University and oversaw the affiliation of Atlanta University and Spelman and Morehouse Colleges that made up the new Atlanta University Center.
3  Spelman, Morehouse, and Atlanta University were the first three institutions in the Atlanta University Center. More historically Black colleges and universities joined in the 1950s.
4  Shauneille Perry graduated from Howard University in 1950, but during the summer of 1948 she played the role of Anias in Alexander Dumas' *Camille*, directed by Owen Dodson, during the fifteenth season of AUST.
5  The Little Theatre in Howe Memorial Hall on Spelman's campus functioned as the primary venue for the University Players and AUST until the early 1960s.

## Works cited

Ables, Marian. "Mr. Pim Passes By." *Campus Mirror*, vol. XI, no. 2, Nov. 15, 1934, p. 3.
Anne Cooke Employment File. Manley Papers, Box 27. Spelman College Archives, Atlanta, Georgia.
Atlanta University Summer Theatre Programs 1934–1940. Department of Drama and Dance Files. Spelman College Archives, Atlanta, Georgia.
"Atlanta University Summer Theatre's Initial Play Is a Big Success." *Atlanta Daily World*, June 20, 1934, p. 3.
"Awarded Ph.D. Degree." *New York Age*, June 24, 1944, p. 4.
Burroughs, Baldwin. "Drama at Spelman, 9-20-1966." Baldwin Burroughs Employment File. Manley Papers, Box 13. Spelman College Archives, Atlanta, Georgia.
Collins, Claire. "Dramatics for Freshmen." *Campus Mirror*, vol. XI, no. 2, Nov. 15, 1934, p. 3.
Cooke, Anne M. "Letter to Florence Read." July 12, 1933. Cooke File, Manley Papers, Spelman College Archives, Atlanta, Georgia.
———. "Letter to Florence Read." July 13, 1933. Cooke File, Manley Papers, Spelman College Archives, Atlanta, Georgia.
Hatch, James V. *Sorrow Is the Only Faithful One: The Life of Owen Dodson*. U of Illinois P, 1995.

Perkins, Kathy A. "Anne Margaret Cooke." *Notable Black American Women, Book II*, edited by Jessie Carnie Smith and Shirelle Phelps, Thomas Gale, 1992.

Perry, Shauneille. Video Recording of Interview with Anne Cooke Reid. April 25, 1993. Camille Billops and James V. Hatch Archives at Emory University, Atlanta, Georgia.

Read, Florence M. "Letter to Anne M. Cooke." October 20, 1936. Cooke File, Manley Papers, Spelman College Archives.

"Well-Trained Dramatists to Take Part in New AU Summer Theatricals." *Atlanta Daily World*, June 10, 1934, p. 2.

# 23

# THE HOWARD UNIVERSITY PLAYERS

## From respectability politics to Black representation

*Denise J. Hart and Kathy A. Perkins*

The turbulence of the 1960s came to a full boil in 1968. The year that witnessed the assassinations of Dr. Martin Luther King, Jr. and Robert Kennedy, the escalation of the Vietnam War and protests against it, and a riot at the Democratic Party convention also witnessed the rise of the Black Power movement and division among the leadership of the civil rights movement.

It was time for Howard University to come to grip with these issues. The Black community in Washington, DC was primed to explode as a result of the Black nationalist ideologies thrust into the public discourse by more militant groups and leaders such as the Black Panther Party and Malcolm X. Fondly nicknamed "the Mecca," Howard University sat squarely in the middle of the growing unrest; yet, during this time, Howard, like many other historically Black colleges and universities (HBCUs), still held fast to the belief that respectability politics—the presentation of a set of Eurocentric socially acceptable standards of appearance and behavior—would protect Black people from prejudices and systemic injustices.

In March of 1968, hundreds of Howard students took over the administration building with demands for immediate change. They were fed up with the lack of responsiveness to their requests for a radical shift in the university's curriculum and desirous of a curriculum that stemmed from uniquely Black aesthetics that included a Black Nationalist ideology. Across the campus in the Department of Drama, the theatre students, known as the Howard Players, were hard at work but not completely disconnected from what was happening. They were making their own demands for plays written by Black playwrights that interrogated the confrontational truth of the Black experience in America. In an interview, Richard Wesley, a playwright and 1967 graduate of the Department of Drama, stated:

> There were several professors on campus who were very strong advocates for expanded Black studies on campus because that was not something that was integral to the curriculum. That is one of the major contradictions that people in my generation would tell you about campus in those days. Black history was not a part of the curriculum even though there were many expert historians on the campus.

This chapter examines how the "respectability" framework shaped the plays produced by the Howard Players from 1919 to the mid-1960s. It also reviews how this paradigm of respectability shifted as a result of the Black Power movement and Black Arts Movement (BAM) of the 1960s into the 1970s.

To better understand the paucity of Black authored plays by the Howard Players, it is important to examine how the respectability framework was instituted during the organization's inception. According to historian and former Professor Samuel Hay of North Carolina A&T State University in Greensboro, during the period prior to the 1950s, HBCU key college administrators (who were primarily white) did not allow much protest theatre, and professors did not resist for fear of risking their places on the faculty. They would often write their own, safe plays. Also, most theatre programs were a probationary part of the college curricula housed in other departments such as English (Hay 32).

The Howard Players began in 1911 as the Campus Dramatic Club under the leadership of Professor Ernest Just. In 1919, Professors Montgomery T. Gregory and Alain Locke renamed the club the Howard Players. Their stated purpose was: "The establishment of a National Negro Theatre where the Negro playwright, musician, actor, dancer and artist in concert shall fashion a drama that shall merit the respect and win the admiration of the world" (Historical Analysis). This statement alludes to the "respectability politics" that prevailed during that time period and appears to be heavily influenced by Locke's commitment to his beliefs and goals for the development of African American theatre.

Unlike their contemporary W.E.B. Du Bois, who held a more Black Nationalist philosophy regarding the advancement of Black people, Locke and Gregory believed that Black people would eventually gain favor and the rights of citizenship through proving that their skill capacity was just as great as whites, and they infused this belief into the operational fabric of the Howard Players. They made their philosophy clear when they published the first anthology of plays focusing on Black life, *Plays of Negro Life*, in 1927. This collection included plays by both Black and notable white playwrights such as Eugene O'Neill, Ridgely Torrence, and Paul Green, playwrights whose works were often produced by the Players.

The Howard Players also adhered to the respectability framework by steering clear of producing protest plays and plays that depicted demeaning and stereotypical portrayals of Black people that stemmed from minstrelsy. However, plays written by Black playwrights were rarely produced except those by Howard Players students such as Thelma Duncan and Helen Webb. The Howard Players produced their first play by a Black non-student playwright on March 29, 1924, with Willis Richardson's play *Mortgaged*. Richardson had achieved recognition as the first African American to have a play produced on Broadway with *The Chip Woman's Fortune* in 1923. His mainstream recognition opened the door for other unaffiliated Black playwrights to be produced at Howard with *Undertow* by Eulalie Spence and two plays by George D. Lipscomb, *Frances* and *Daniel*, in 1932. 1936 witnessed another Richardson play, *Compromise*, with a few more plays to follow. Unfortunately, the addition of Black plays did not translate into a watershed moment for Black playwrights. From 1922 to 1950 the Howard Players produced 45 plays, yet only 11 were written by Black playwrights (Historical Analysis).

In 1944, the Howard Players gained new leadership that would uphold producing plays focused on the respectability paradigm. Dr. Anne Cooke, a highly regarded administrator, director, and professor, joined Howard after successfully creating the Theatre Department at Spelman College in Atlanta. As the first Black woman to earn a PhD in theatre (at Yale), Cooke, in a 1981 interview, shared her philosophy regarding creating the Department of Drama:

I came to Howard to establish an academic department which was to train undergraduates in the basics of the theatre arts in general. It was related to the concept and philosophy of the humanities …The point of view was that theatre is a communal art, a popular art and a world art. It was important for our students to know the entire spectrum of world theatre. My thinking was to be prepared to go out and attack this world as actors, designers, playwrights and they needed to explore as interpretive artists, as creative artists—the entire spectrum … In all ways to fight the dangers of the stereotype.

(Parry)

Cooke would recruit some of the best educated talent to elevate the quality of the program not only in acting but also in design and directing. These included such professors as director/playwright Owen Dodson, actor/director James Butcher, and designer William Brown. In 1948–1949, Cooke took the Howard Players on a tremendously successful three-month tour to Norway and Germany to perform the Ibsen classic *The Wild Duck*, marking the first time any American university had been invited to perform in Europe. With this achievement, Howard recognized that the Dramatic Arts needed its own department. In 1950, the Department of Drama became official with Cooke serving as chair until 1958 (Figure 23.1).

During Cooke's tenure as chair the Theatre Department primarily produced European classics and popular plays by white American playwrights. From 1951 to 1960, 38 plays were produced with only two productions by Black playwrights (Historical Analysis). One of the Black plays, *The Amen Corner*, was by a little known writer, James Baldwin. According to theatre

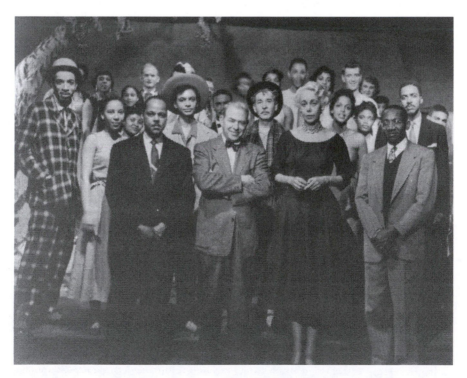

*Figure 23.1*  Dr. Anne Cooke with the cast of the Howard Player's *Finian's Rainbow* (1950s).
*Source*: Courtesy of the Moorland-Spingarn Research Center, Howard University Archives.

historian James Hatch, Cooke informed Owen Dodson that the 1954–1955 season needed a Black play and handed him a script by Baldwin. Dodson read it and directed it, and the play was a success on campus (97). The second production was *Tabernacle* by Paul Carter Harrison in 1960. Again, there was no outpouring of Black plays during this period. However, as a result of *The Amen Corner*, Dodson and Baldwin became friends, and in 1965 Dodson would premiere a second play by Baldwin, *Blues for Mr. Charlie*.

With the growing tide of Black separatist ideologies on college campuses, tensions between Howard faculty and students ran high. During the 1960s, students such as Richard Wesley, who was one of the first members in the playwriting concentration, along with his classmates remained intent upon honoring the purpose of the Howard Players (Wesley would graduate to become a prominent playwright with such works as *The Mighty Gents* and *The Talented Tenth*). At the same time, the Players were also determined to expand that purpose and evolve a new mission. Wesley shared how the integrationist versus separatist struggle played out in the Theatre Department:

> There was still a lot of internal struggle in the department around African-centered or afro-centric ideology. We lost our lighting designer because of it. Mr. Brown was not in agreement with the shifting ideological ideas. To his way of thinking nationalism was sort of like Black separatism and another form of segregation and he was standing against that. Students were placing ideology above training ... I think also that was Owens' concern. If students got too involved in the political aspect of things they would cause or allow the training they would need to fall by the wayside and take second place to ideology. It was difficult for us to understand that ... at 18 and 19 we see what's going on in the streets and we felt we needed to be talking about it. We need to be part of the conversation that's going on out in the streets right now. Why aren't we taking our training and applying it to that? Why aren't we developing our art to be the voices ... and reflectors of our people? And you sort of have this clash.

With Cooke's departure in 1958, Dodson became chair of the department and would serve as the bridge from the era of respectability to representing new as well as classic Black voices for the Howard Players. In 1964, Dodson introduced the most critical change in departmental play production with his direction of his former student Amiri Baraka's explosive and racially charged drama *The Dutchman*. The play attacks racism and assimilation head on. At the story's center is the "Eve-like" white woman who successfully seduces and then kills a middle-class, assimilating Black man. It sparked controversy in both the Black and white communities for its depiction of the primal rage that lies beneath the façade of a Black man presumed to be an assimilationist. *Dutchman* marked the beginning of a new era in the department, paving the way for young Black playwrights to tell the kinds of stories that mattered to them. It wasn't that the integrationist philosophy was negative; it was simply too limiting, especially during a time when Black discourse had moved away from a focus on being accepted by whites to celebrating and respecting blackness. Baraka (aka Leroi Jones) is hailed as the father of the Black Arts Movement (BAM) that was inspired by the Black Power movement. BAM inspired a proliferation of politically motivated works by artists, including poets, playwrights, musicians, visual artists, novelists, and dancers.

The changes occurring after 1965 would attract talented future playwriting students such as Pearl Cleage, who went on to become one of the country's leading playwrights with such works as *Flyin' West* and *Blues for an Alabama Sky*. In a 2007 interview, Cleage stated:

I went to Howard because they had a BFA department so I could major in playwriting. I could start taking classes my freshman year … I arrived in 1966 and was there for three years and left in 1969. My first year advisor and teacher was Owen Dodson; second year, Ted Shine; third year, Paul Carter Harrison. I was in playwright's heaven! I had working playwrights every time. All of their styles were very different, the three of them. Their methods of approaching the play were very different, but it was wonderful because they were all working in the theatre. They were not talking about being a Black playwright in an abstract kind of way; they were actually talking about the craft and then about the real practical side of trying to get the play over.

While tension over productions continued to exist for a few years, under Dodson's leadership new faculty, both permanent and visiting, joined the department with fresh ideas: Eleanor Traylor, Mike Malone, Vera J. Katz, and Glenda Dickerson joined playwrights Paul Carter Harrison and Ted Shine. Though Dodson shifted the paradigm in the department, he refused to give up producing Greek classics, which were dear to him. Over time, many of the Players came to appreciate Dodson's treatment of the Greek plays due to their visual and emotional impact on audiences and their connection to African culture. In the same interview, Cleage expressed her reaction to Dodson's production of *Oedipus Rex*:

> Dr. Butcher was the chair when I arrived in 1966. We were very radical and he was not impressed with all the things we were demanding … An important moment for me was my freshman year. The first play that Owen Dodson did that year was *Oedipus Rex*, so we were outraged. Here you are doing the Greeks and its 1966 … we wanted to have all Black plays. So we actually picketed the Fine Arts Department because we wanted to have all Black plays. The production that he did of *Oedipus Rex* was so wonderful and so creative and so different than anything I had ever seen. I actually went to his office after I had seen the show and apologized and said, "I don't know why I thought I knew more than you knew, but I was wrong. Please teach me!"

Glenda Dickerson, a former student of Dodson, returned to the department as faculty in the late 1960s. In 1980 she created a theatre company in New York City in honor of Dodson called the Owen Dodson Lyric Theatre. In a 1983 interview Dickerson spoke of her interest in the Greeks during a rehearsal of *The Trojan Women*:

> We are doing *The Trojan Women* because of my interest primarily in the classics. Of all of those Greek tragedies, *The Trojan Women* speaks to the African experience because it talks about slavery, oppression; it talks about war and the effects of war on a proud and noble people. So you see the Trojan women, you hear classical language being spoken, but you are looking at Black women, you're looking at African American women, and the experience therefore becomes very immediate to us as a people. And it is comparable to our own experience in being taken out of Africa and brought to this country and other places in the Diaspora as slaves.

During the 1970s, the Drama Department continued to attract prominent faculty members and visiting playwrights. Joseph Walker, the first African American to win a Tony for Best Play with *The River Niger* (1974), and others, including Clay Goss, would join the department. Henrietta Edmonds (daughter of Randolph Sheppard and Irene Edmonds, who were both playwrights)

and Kelsey Collie would also join the department during this period and create a children's theatre program focusing on plays highlighting positive images of Black children. The program attracted young audiences on weekends from around the city.

The department became a showcase for new plays by Black playwrights as well as by talented students in the department. In 1974, New York actor and playwright Garland Thompson, Sr. premiered his *Papa B on the D Train*. The year 1976 was a big year as choreographer Louis Johnson and composer Valerian Smith created the controversial musical *Niggers*. Actress and playwright Saundra Sharp premiered her play *The Sistuhs*, directed by senior Dianne Houston. Houston would become a prominent screenwriter and director for film and television. That same year, Howard Player Ajamu (Robert Crawford) won the American College Theatre Festival (ACTF) Award at the John F. Kennedy Center in Washington, DC, for his powerful play that explored Black manhood, *The Brass Medallion*. During this era, the complexity of the Black experience flowed from the pens of visiting Black playwrights as well as Howard Players at "the Mecca."

## Works cited

Cleage, Pearl. Personal Interview. February 14, 2007.

Dickerson, Glenda. Personal Interview. 1983.

Hatch, James V. *Sorrow Is the Only Faithful One*. U of Illinois P, 1993.

Hay, Samuel A. *African American Theatre: An Historical and Critical Analysis*. Cambridge UP, 1994.

"A Historical Analysis of the Howard University Players and Their Influence on Contemporary Black Theatre." Theodore G. Cooper Papers, Drama Department Howard University, Washington, DC. Howard Players Constitution, 1919.

Parry, Betty. "In the Shadow of the Capitol: Theater in Segregated Washington." *DC Digital Museum*. Accessed April 12, 1981, www.wdchumanities.org/dcdm/items/show/1190.

Wesley, Richard. Personal Interview. June 10, 2017.

# 24

# AN AFRICAN AMERICAN THEATRE PROGRAM FOR THE TWENTY-FIRST CENTURY

## *Nefertiti Burton*

The African American Theatre Program (AATP) was born at the predominantly white University of Louisville (UofL) in Kentucky in 1993. In 1996 UofL became the first institution in the nation to offer a minor in African American Theatre (Burton and Vandenbroucke). The impetus for the development of the program came out of a time of great national strife over the unwillingness of US states like Arizona, New Hampshire, and South Carolina to make Martin Luther King, Jr. Day a paid state holiday. Although Kentucky was not among the naysayers, UofL's decision to compete in the Sunkist Fiesta Bowl (January 1, 1991) in Tempe, Arizona, caused protests by leaders in Louisville's Black community and by students on UofL's campus. The university's president at the time, Donald C. Swain, stated that the $2.5 million that the university would gain from participating in the Bowl "did not enter into [his] decision at all" (Louisville 3). Institutions of higher education were beginning to recognize the "diversity imperative," and so Swain pledged to use some of the income from the event to fund "minority programs," one of which was to become the African American Theatre Program (12). Initially controversial, undervalued and under-resourced, the AATP eventually came to be lauded by the university administration and UofL's Theatre Arts Department as a key component of the institution's diversity initiatives. This chapter not only documents the history of one of the first Black theatre programs in American universities, but also highlights challenges facing Black theatres in an increasingly diverse society.

Throughout its first ten years the AATP struggled to make a place for itself within the Theatre Arts Department. Stephen Schultz, then department chair, enthusiastically supported the concept, but the program's growth was hampered by the ambivalence of other white colleagues who felt the AATP was thrust upon them and who were unsure of how and why a Black theatre program should exist in their midst and outside of their control. The AATP's development under its first co-directors, Victoria Norman Brown and Eugene Nesmith, was also hampered by the lack of a unified approach to leadership and a clear program structure. Brown and Nesmith were succeeded by a series of co-directors with less than compatible leadership styles and divergent ideas about the AATP's mission and how to achieve it. This coupled with insufficient administrative support inhibited the development of long-term goals and the strategies necessary to achieve them.

Despite these barriers, by the end of its first decade, the AATP boasted a catalogue of eight graduate and undergraduate credit-bearing courses on Black theatre in the areas of history,

theory, literature, performance, and design. It offered two main stage plays per year, one each semester. This chapter's author joined the AATP in 1999 as co-director with Dr. Lundeana Thomas. Together we crafted a mission that spoke to the AATP's commitment to "staging works by new and established African American dramatists, developing a broad audience for African American theatre, and offering an in-depth curriculum that focuses on the theory and craft of acting, directing, and designing for Black Theatre." In 2002 the AATP implemented the first and still the only Graduate Certificate in African American Theatre in the nation. The program would gain national and international attention through touring productions to the National Black Theatre Festival in Winston-Salem, North Carolina, the Grahamstown Theatre Festival in South Africa, and, in subsequent years, universities in China and Singapore. In 2004 I stepped down as co-director. While I continued to teach AATP courses and direct AATP productions, Dr. Thomas' energy and vision elevated the program to new heights. The list of prominent African American theatre artists/scholars who accepted her invitations to collaborate on AATP productions, offer classes, workshops, and lectures is too long to include here. Suffice it to say that through the AATP, the University of Louisville has become a respected venue for the production of African American classics, the development of new work by African American playwrights, and the broad study of African American theatre.

Thomas retired in 2014, and I retired in December 2017, after two years as Theatre Arts Department chair and ex-officio AATP director. Now in the midst of its third decade, the AATP is recognized by the Theatre Arts Department as "the jewel in its crown." The department also recognizes the need for renewed clarity of identity and purpose. Assistant Professor Johnny Jones was appointed AATP director in 2018. An able young African American scholar and devoted teacher, Jones is working with a committee of theatre arts faculty and staff to interrogate the discussions of the past two years and chart the program's course for the future.

Louisville, like so many US cities, has undergone significant demographic change in the past 20 years, in large part due to immigration from Africa and Latin America. Louisville's African-descended population is still majority African American, but the city and the university are becoming increasingly diverse as more Latinx, Caribbean, South and Central Americans, and Africans from all over the continent take up residence in the region. Thus, the AATP would do well to articulate a broader mission that reflects the diversity of African-descended people living and working in the United States today.

Despite the presence of LGBTQ★ people of African descent on our campus, over the past 20 years the AATP has largely overlooked the work of LGBTQ★ authors. It has rarely produced work by playwrights from the African continent or the Diaspora beyond the United States. Embracing the related but specific performance traditions, idioms, and concerns of these populations would enrich the curriculum and bring vitality and variety to AATP productions while maintaining the program's commitment to the work of African-descended artists.

The AATP could offer a wider range of scholarship, teaching, and production by expanding its own expertise and intentionally growing its program to include more faculty, students, staff, and community partners with specialties and interests in the varied performance modes of African-descended people. This should include global perspectives from Black LGBTQ★ authors as well as Black artists of different physical abilities.

Does the AATP's location in a predominantly white institution lessen its ability to tell the stories it seeks to tell to the people who can most benefit from witnessing them? At the same time that the Louisville-Metro region's African-descended population is expanding, Louisville's African American community finds itself re-living the history of its enslaved forbears. Black men and women across the nation continue to be denied their personhood as demonstrated

by the violence perpetrated against so many by those sworn to protect and serve the public. Tragically, as Black people and their allies protest the systemic denial of African descendants as human beings, in West Louisville, where the African American population is the densest, rates of gang violence and murders are the highest in recent memory. Thus, plays like Charles Fuller's *Zooman and the Sign* (1980) and Katori Hall's more recent *Hurt Village* (2013) represent precisely the kind of work that needs to be produced in Louisville at this moment in time.

Zooman, a teenager abandoned by family, community, and government, cleaves to the only form of survival he knows—gang culture and violence that brings grief and death to the guilty and the innocent. Three generations of women in *Hurt Village* struggle to overcome the physical, psychological, and economic perils that threaten their very existence. Such works expose the social/economic/political conditions that give rise to the deterioration of Black neighborhoods. They present shockingly honest and unrelenting portrayals of Black characters infected by the generational "dis-ease" that continues to consume countless Black families and communities.

Such plays can stimulate audience members to work for personal and social change. However, for the AATP, this brings up the tension that has existed in Black theatre circles since the Du Bois–Locke debate of the 1920s. The dilemma arises when producing material that will stimulate meaningful and necessary conversations for the Black community is likely to be misconstrued by those without the lived experience needed to contextualize the content (McKay 615–626). This tension must be constantly acknowledged and mediated. Producing works like *Zooman* and *Hurt Village* at white institutions can impose unwelcome burdens on Black students, faculty, and staff, who find themselves inadvertently put into the exhausting and frustrating position of interpreting the production for white classmates and colleagues. It is impossible to organize enough panels, talkbacks, symposia, etc. to ensure that every non-Black person who comes to see the production understands that Fuller's Zooman is not every young Black man, or that Katori Hall's Crank is not every impoverished Black mother.

Still, Black students, especially those on predominantly white campuses, are hungry for productions and curricula that address and validate their history and cultural aesthetic. Because of their own lived experience, most African American students are able to recognize the authentic in Black theatre even if they are not yet prepared to analyze the unique circumstances that bring specificity to individual characters and their stories. But the ugly conditions that have shaped, maimed, and even destroyed the lives of so many African Americans cannot be confined to stages in Black communities and historically Black colleges and universities (HBCUs).

In addition to housing an African American Theatre Program, the University of Louisville is also the home of a Department of Pan African Studies that celebrated its fortieth anniversary in 2013. It would be disingenuous to say that because UofL has these programs their non-Black audiences have sufficient understanding of African Americans' sojourn in the United States to appreciate the nuance reflected in our myriad stories. It would be false as well to claim that non-Black students flock to courses in these departments because of their deep interest in Black lives, past and present. UofL's undergraduate theatre major requires three courses from AATP offerings, and most undergraduate Pan African Studies courses satisfy a "diversity" requirement for general education at UofL.

In order to make certain that Black students on UofL's predominantly white campus have full access to stories that speak to all aspects of the Black experience, the AATP must enlist and develop allies in a wide variety of departments and campus units to demonstrate how its work in theatre supports the educational and professional goals of other disciplines. The dean of the College of Arts and Sciences, the provost, and the university's president must be courted to promote Theatre Arts and the AATP as quintessential resources that can support the university's thrust towards "interdisciplinarity." Only through campus-wide advocacy for its work can the

AATP ensure that it serves both its (predominantly white) university and its Black campus members and community audiences fully and fairly.

The question of what is appropriate and useful to present in the midst of a predominantly white, presumably Christian, hetero-normative environment is present in deliberations regarding not only the department's choice of AATP productions, but also its season selection in general. The question has inevitably led to discussions that have sometimes been strained but always necessary. In a time of deep anxiety over the direction of a United States of America with Donald J. Trump at its head, the responsibility of artist/educators committed to social justice has become ever more pressing. There has been understandable pressure among non-African American theatre colleagues at UofL to produce plays that address the circumstances of the other vulnerable populations in our society and in various parts of the globe. Implied, if not directly stated, is the notion that the status of the AATP in UofL's Theatre Arts Department, with its human and financial resources (limited as they may be) privileges African Americans over other oppressed and marginalized groups whose stories also deserve to be told. This is not untrue. But most UofL students and faculty are still undereducated about how colonialism, imperialism, slavery, capitalism, patriarchy, and other forms of oppression have shaped not only the lives of African descended people in this country, but also the actions and attitudes of those who are descended from our oppressors.

Sadly, as state and university funding shrink, the security of the AATP and its ability to pursue its mission are put at risk. AATP leadership will have to pursue multiple strategies to safeguard against the financial and political vagaries of the state of Kentucky to build upon the successes of the 25-year-old program. The Community Advisory Board, revived in 2016, can provide vital input about how the AATP can support community development efforts in education and public health with an emphasis on violence prevention. The Friends of the AATP should be revived as a fundraising arm. It must be nurtured and encouraged to participate in ways that increase the program's visibility among alumni, patrons and sponsors.

Efforts that began in 2015 to develop an institutional base off-campus at the Kentucky Center for African American Heritage (KCAAH) started to bear fruit in 2017 and, with continued cultivation, will enable the AATP to produce professional quality theatre that speaks directly and unapologetically to the African-descended residents of the Louisville-Metro area in the heart of Louisville's Black community. KCAAH exists to enhance the public's knowledge about the history, heritage, and cultural contributions of African Americans in Kentucky. The AATP has been designated the theatre company in residence at KCAAH. Through an on-going residency with this partner institution, students, faculty, and staff of the AATP get to make theatre with community artists for community audiences, thereby enriching the artistic and cultural experience for all involved and adhering to the tenets espoused by W.E.B. Du Bois and the Krigwa Players in 1926 (Krigwa). Thanks to successful proposals to local and national funders, the partnership has grown from touring productions and play readings at KCAAH to offering playwriting workshops for local African-descended writers that culminate in presentation of the work at KCAAH and on campus. These plays explore critical issues that many residents are unwilling to discuss in diverse public settings, and laud the successes and achievements of West Louisvillians so often ignored by the media and the larger Louisville community.

The presence of credit-bearing undergraduate and graduate programs specifically designed to present, explore, and preserve the histories of Black people through the affective power of theatrical performance is a unique feature of UofL's Theatre Department. Such a program exists nowhere else in the country. Surviving and thriving amidst state budget cuts and a devaluing of the arts in general will test the creativity and resolve of the AATP's new leadership team, but the program has the ability to call upon friends throughout the nation for advice and financial

support. It can and should expand and deepen its programming by reaching out to a broader spectrum of African descended artists and audiences in order to educate, enlighten, and entertain the next generation.

## Works cited

Burton, Nefertiti, and Russell Vandenbroucke. "Beyond Balkanization." *American Theatre*, vol. 20, no. 3, March 3003.

Krigwa Players Little Negro Theater, *c.*1926. W.E.B. Du Bois Papers (MS 312). Special Collections and University Archives, University of Massachusetts Amherst Libraries.

*Louisville Cardinal*, 15 November 1990, pp. 3, 12.

McKay, Nellie. "Black Theatre and Drama in the 1920s: Years of Growing Pains." *Massachusetts Review*, vol. 28, no. 4, 1987, pp. 615–626.

# 25

# INTERVIEW WITH KAREN ALLEN BAXTER

## Senior managing director of Rites and Reason Theatre

*Interviewed by Jasmine Johnson*
*November 27, 2017*

Karen Baxter is the senior managing director of the Department of Africana Studies/Rites and Reason Theatre at Brown University (Figure 25.1). Rites and Reason Theatre is the oldest continuously operating theatre in New England. Baxter's professional trajectory began by being surrounded by theatre at a young age. In high school she worked at the New Lafayette Theatre in Harlem. Baxter's career in theatre—with experiences spanning from Harlem to Jamaica to Providence and beyond—reflect the essential role of directors in the history and making of Black theatre.

JJ: How would you describe your work?

KAB: I'm lucky and I'm blessed because I like what I do here at Brown [University]. I produce theatre, which isn't a one-dimensional job. I work mostly with playwrights, actors, scholars, and designers. I like realizing a vision. Sometimes writers don't even know what their intent is, and so I love trying to uncover it with them.

JJ: What attracted you to your line of work?

KAB: Lack of talent. [Laughs] My father was an actor. As a little girl I saw him on Broadway in a very small part in *Anna Lucasta*. Roy Allen, my father, was a part of the American Negro Theatre [with Sidney Poitier, Harry Belafonte, Ossie Davis, and Ruby Dee]. Television was a new entity, and my dad had been a radio broadcaster in his hometown of Cambridge, Massachusetts. I believe his first opportunity in television [during the early '50s] was with CBS. He worked on their early morning show as a stage manager. He was the first Black member of the Directors Guild, and he was a company man. He worked on the *Gary Moore Show*, the *Ed Sullivan Show*, and on several soap operas. In the early '80s he had his own show on CBS called *Black Heritage*.

I was always around theatre. I loved it, but in high school I realized I couldn't remember lines, didn't like the process, and didn't really like being onstage. I wasn't the best stage manager either … I soon discovered, after high school, that somebody had to put this stuff together.

*Figure 25.1*   Karen Allen Baxter.
*Source*: Photographer Kathy Moyer.

I didn't even know there was a title for the kind of work that I did. My first paying gig in theatre was at the New Lafayette Theatre [in the late '60s]. I sold tickets in the box office. The women in the paid theatre company were expected to work in the office when they weren't in rehearsal. But the minute that something was going on in the theatre, they were gone, [they would leave] in the middle of anything. Sometimes when I wasn't selling tickets, I would sit in the office, answer the phone, count this, stack up that, or copy. I began to learn what goes on in the theatre office. What it takes, you know? So I graduated from the box office to the office assistant.

Later one of the actors in the theatre company, Whitman Mayo, who became "Grady" on *Sanford and Son*, he and I started a literary agency, the New Lafayette Theatre Literary Agency, and we managed playwrights and some actors, including Richard Wesley, Ed Bullins, and Roscoe Orman. We arranged royalty agreements for theatre companies that wanted to do the kind of work that the New Lafayette Theatre had done.

When the New Lafayette Theatre closed, we created a for-profit agency and moved to downtown Manhattan, and we had a larger roster. At that time, Jamaica was undergoing a terrible crime spat. Tourism had dropped off, and we pitched this idea [to the Jamaican Minister of Tourism] called "Holiday Jamaica," which was a three-pronged event meant to attract African American tourists.

The headliner was Stevie Wonder and, at that time, a new and relatively unknown Bob Marley and the Wailers, and Harold Melvin and the Blue Notes. Harold Melvin and the Blue Notes still owe me money because they never showed.

That's how I got to know Bob Marley and worked for him for a couple years, 1978 to 1981. I also worked for Nina Simone before Bob Marley. I didn't particularly care for the music industry but it taught me business. I worked with artists Bob Marley, Jimmy Cliff, T-Connection, and a young reggae singer/songwriter called Big Youth.

JJ: How did you get to Brown?

KAB: I was recruited for my position by George Houston Bass [1938–1990]. I was running the Frank Silvera Writers' Workshop in Harlem. My good friend, Pat White, and I, as executive director, resurrected the workshop after the founder, Garland Lee Thompson, abandoned it. One of the things that I did while I was in New York, and even after I came here, was produce the AUDELCO Awards, which honor and award excellence in Black theatre. We always had a band as part of the annual awards ceremony, and Loni Barry became the musical director for the AUDELCO Awards band. Loni Berry is a Brown alum.

I'd known about Rites and Reason [Theatre], and Loni kept saying, "There's this position up [at Brown] that you would be fabulous in." I ignored him for a year!

Loni talked me up to George, who was Loni's mentor, and George knew of me because he had come to the Frank Silvera Writers' Workshop to cast a play he was doing. One of the things that I developed at the workshop was an unofficial casting directory of the Black actors in New York City. It was a big Rolodex. George came and worked with us to cast a play he was directing. Later, I received an official invitation to come and talk about this position that had remained open for over a year. I accepted the offer and came in July 1988.

September 19, 1990, George Bass suddenly passed away. We were in the middle of taking *Mule Bone: A Comedy of Negro Life* by Langston Hughes and Zora Neale Hurston to Broadway with Lincoln Center. George was the executor of the Langston Hughes estate and had the original copy of the script. George wrote a prologue and epilogue, and I produced it here at Rites and Reason. We got the attention of Lincoln Center, and they took it to Broadway. It was a very exciting time. But then George died. One day he was here and the next day he wasn't.

At that time, Rites and Reason had three directors. We had an artistic director, George Houston Bass; a research director, Rhett S. Jones, who was a historian; and a managing director, me. When George passed, both Rhett and I believed that if I left, the university would shut Rites and Reason down, or just let it linger. We didn't trust they would replace me. There was really no plan to replace George.

I had been working with Elmo Terry-Morgan in New York for a number of years on the AUDELCO Awards. Elmo wrote the awards ceremony. Elmo is Brown alum and George's former student. It took almost two years to get Elmo appointed. When Elmo finally got here, [he] said to me, "Well, you can't leave now." We began making plans to continue the work using the Research to Performance Method (RPM) of play development that George had begun.

Rhett became very ill and passed in 2008. The vision Rhett had and work Rhett did was invaluable to the development of Rites and Reason. The university did not replace him as research director. Not replacing Rhett sent a clear signal and made me believe that if I or Elmo left, they wouldn't replace us. I felt obligated to stay and to continue the work. We used to be a three-legged stool, as George would say. We're a strong two-legged stool now.

JJ: Has race or gender or both impacted your opportunities?

KAB: Oh yeah. But I wouldn't *not* want to be female, and I wouldn't *not* want to be African American. I don't really remember it but I'm old enough to have been "Negro." I think it's one of the reasons why I'm still in the same position—new title, but in the same position at this university. I think in the twenty-first century they're, [the industry is] having to realize the assets and attributes of people of color and women of color, so there's been a big increase in seeking me out, which sometimes seems flattering but is really just more work.

The segregated world is part of the reason why I'm still here, because any other comparable position [like mine] in or outside the academy is a white space. There's no place else like Rites and Reason, I dare say, in the world. Within universities most theatres are white spaces.

JJ: Could you talk about what it means to have this theatre within an academic institution?

KAB: It means a lot of things. It means that we are one of the oldest Black theatres in the nation. We're the oldest continuously operating theatre in New England. It means that I don't have to raise brick and mortar money, which is really important. George and I had conversations about the possibility of Rites and Reason leaving the university, becoming independent, what it would mean to leave the university and be a standalone theatre. The university has never given us enough operating money for programming, but ultimately we said, "Oh, I think we're going stay here [at Brown]."

The university knows we're a jewel in the crown, but they don't know what polish to use to make us shine. We polish ourselves. We don't have enough operating money. We don't have enough staff. We're now in the process of getting another theatre faculty person and that has taken the whole time I've been here. It's not even replacing a research director who we lost, but it's adding a scholar-theatre practitioner, which is very good. The fact that we're at Brown University makes people pay attention and makes people think that we have many more resources than we do.

JJ: What accomplishment are you most proud of?

KAB: Surviving with a voice. In my position here, I still have a voice. I still have vision, and I can implement it.

# 26

# THE NEGRO ENSEMBLE COMPANY, INC.

## One moment in time?

*Susan Watson Turner*

There was a time when you could get up in the morning, go to work in a Black theatre, and pay your rent in New York City. A thriving momentum on and Off-Broadway fueled the professional employment of Black artists, and some of those artists enjoyed working with the Negro Ensemble Company (NEC). From 1970 through 1980, the NEC was at the pinnacle of its development and recognition. More than ten Black Broadway shows were produced that decade, coinciding with the peak of the NEC's classic period. In the 1980s, the NEC produced *A Soldier's Play* by Charles Fuller, winning industry accolades and receiving generous support from audiences and artists. *So, then, what happened after that?* Why didn't this professional theatre institution take its seat with its institutional contemporaries, some of whom currently own and control Broadway theatres? What went wrong?

## NEC history

The NEC was founded in 1967, when the New York City climate was fertile ground to create a professional theatre. Lorraine Hansberry's *A Raisin in the Sun* (1959) had opened the door to the Great White Way to Black performers and playwrights in the post-war era. Previous attempts to produce commercial theatre had not presented realistic views of Black American life. With *A Raisin in the Sun*, the American theatre burst wide open with opportunities for Black artists. Community-based theatre efforts were also popular as an attempt to settle the violent urban unrest of the 1960s civil rights movement.

The NEC was the dream of three men: Douglas Turner Ward, Robert Hooks, and Gerald Krone. However, the effort was spearheaded by Ward, a journalist, playwright, and actor who called for the establishment of a theatre that could be a training ground for Black artists. Ward was from Burnside, Louisiana, and studied at Wilberforce College and the University of Michigan. At the age of 19 he moved to New York to become a journalist and became involved with the Paul Mann Workshop. Ward's plays *Day of Absence* and *Happy Ending* were produced in 1965, and the working relationship between Ward, Hooks, and Krone was born. Not far into the distant future these three designed the model for the Negro Ensemble Company.

In an article in the *New York Times* on August 14, 1966, Ward issued a mandate to the established theatre structure. Appropriately aimed from the dramatists' point of view, Ward

155

insisted that the playwright be at the center of the creative incubator. "That the Negro play-wright is more or less excluded from legit boulevards is not a revelation for concern," he wrote. "More important is the fact that, even when produced within this environment, the very essence of his creative function is jeopardized" (A116).

Ward would not subject art to a socioeconomic agenda that attempted to placate political uprisings. He rejected the isolated cultural islands that had sprung up in urban communities as part of other social programs and called for a professional theatre institution that could stand alongside other professional theatre companies. He was responding to what he saw as a missing cog in the American Theatre wheel. Founding the NEC addressed not only the current landscape, but also looked forward to include those waiting in the wings.

A start-up grant from the Ford Foundation helped to develop America's first paid profes-sional Negro/Black theatre ensemble, located in the 99-seat St. Marks Playhouse in Greenwich Village. At the time, Greenwich Village offered a welcoming, nurturing ground for the avant-garde poetry, music, and theatre that was testing the waters with non-traditional art forms as well as lifestyles. Establishing the NEC at this location was Ward's way of addressing the use of his company as a political/social panacea and grounding it in a legitimate professional model and location.

Within a decade, the NEC had garnered several Tony and Obie Awards. In the 1970s, the NEC produced a string of hit plays that launched a number of actors, directors, and designers into prominent positions on Broadway and in regional theatres as well as in television and film. Though this had not been a direct goal of the NEC, its successes became the calling cards for actors Roxie Roker, Esther Rolle, Denzel Washington, and Samuel Jackson; designers Wynn Thomas and Shirley Prendergast; and playwrights Samm-Art Williams and Charles Fuller, who were first seen on stages at the NEC.

The year 1980 brought a second generation of artists affiliated with the company. The NEC moved from its first location to the Theatre Four located on West 55th Street. The new venue had 283 seats, and, by this time, the NEC had become the premiere Black theatre in the nation.

The move from the St. Marks Playhouse to Theatre Four had a great impact on the NEC and its capacities. The second generation of artists arrived inexperienced, eager, and happy to be working as the company's new paid labor force, but the institutional impact of expanded staff and budget that the move demanded was monumental for the founders. It became clear to Ward that the 1980–1981 season was about more than any one play—the company had to be recognized as a viable professional institution.

## The autonomy model

Autonomy can be defined as freedom from external control or influence—independence. The NEC's relocation was motivated by the need to move not only toward financial stability, but also toward an autonomous existence—to increase its ability to earn income to subsequently control its own destiny. The autonomy model permeated the artistic, economic, and ultimately the institutional decisions of the NEC. The question became: Is any arts organization that is beholden to its funders ever able to achieve true autonomy?

From the beginning, Ward was on the opposite side of his partners. As a journalist in Harlem, he had had the opportunity to witness the American Negro Theatre's formation and demise. So when the NEC's first commercial success, *Ceremonies in Dark Old Men* (1969), was offered a Broadway run, Ward resisted pressure from company members and his co-founders to move the production. As Krone later explained:

> The first three years we had enormous success in developing Black audiences. A serious work could command a 100% Black audience; that was unheard of at the time … Bobby [Hooks] was very keen on moving the play. Doug said if we take this great success and move it we will be saying to our company and community that we have our heads in the wrong place; that is not what we are here to do.

Ward recognized that moving *Ceremonies* would weaken the structure of the NEC and send the wrong message to its audience and supporters. The NEC had not been established to develop plays for Broadway or for their commercial appeal. The seed money from the Ford Foundation had been intended to place into the fabric of the American theatre a company that would serve Black audiences and artists.

For ten years, the NEC produced works for the main stage, provided outlets for new writers, and trained emerging artists in every theatrical discipline. At the same time, as the NEC matured as an institution, the Ford Foundation's grant model of focused theatre that was *not* geared toward commercial transfer created conflict among the NEC founders as the foundation challenged the company's artistic choices and managerial governance. Despite its artistic success, the NEC faced an impending financial crisis in 1977. Ward wrote the Ford Foundation a passionate letter requesting dissolution of their relationship due to the foundation's far-reaching violations of the autonomy model. The letter begins with a description of the context for the original relationship:

> The ferment of the sixties was stimulating a new consciousness among Blacks and a greater awareness of black aspirations throughout the country. As in other phases of life, it was clear to black theatre artists that *we had to build our own institutions* in order to provide opportunities more responsive to our needs and possibilities. For us, there was no future except the present … Our only successful answer to our critics had to be quality of work.

As major funding sources altered priorities in favor of integrating Black artists into mainstream institutions, the existence of Black theatres that served Black audiences and artists was challenged. Along with the Ford Foundation, the Lila Wallace Fund initiated guidelines that pushed larger institutions to integrate their staffs, artists, and seasons in exchange for large awards. Non-traditional casting and diversity led the theatre industry. Institutions that had not been diverse previously were rewarded with large grants to achieve this end. But companies that had answered the call of the civil rights movement of the 1960s were no longer funding priorities and were not included in the guidelines for these new funding initiatives.

Still, companies like the NEC were planting the seed for the future. Charles Fuller's first NEC production, *In the Deepest Part of Sleep*, was part of the Season-Within-a-Season in 1973–1974; Charles "OyamO" Gordon's *His First Step* (1970–1971), Samm-Art Williams' *Welcome to Black River* (1974–1975), and two plays by Don Evans, *Sugar Mouth Sam Don't Dance No More* and *Orrin* (1974–1975), were cultivated off the main stage. In the 1978–1979 season, the NEC produced *Home* to standing-room-only crowds at St. Mark's. (*Home* later had a successful Broadway run and a two-year national tour *without* the NEC at the producing helm).

In 1980, the NEC produced *Zooman and the Sign* at Theatre Four. Its success confirmed the decision to move: the size of the home venue mattered. Leon Denmark, then general manager, remarked on the situation, stating:

> With *Zooman and the Sign* … it paid for itself in Theatre Four [with 283 seats]. We didn't have to give it up [to another producer]. That's what we were looking for …

There was the proof that if we had a big enough theatre we didn't have to give up control of it.

The second season at Theatre Four produced *A Soldier's Play*, which ran for two years and subsequently toured under the guiding hand of the NEC. True autonomy had been reached. The NEC had produced a success from among its own playwrights, had managed the production, and had maintained artistic control of its work. Truly, the NEC had realized a dream.

## The price

We were receiving, in 1982, $200,000 from NEA [National Endowment for the Arts], and by 1989 we were receiving $50,000. We had produced a Pulitzer Prize winning play. We had produced a major revival at the same time, and we were cut $150,000 of support from the government.

(Denmark)

The decade that started out with a new home and two major hit plays ended with the NEC being forced to move from Theatre Four in 1990. Some called it censorship, some called it racism, and some accused funding powers of both. As Margo Jefferson stated in *Writing about Race, Walking on Eggshells* when summarizing the attitudes surrounding the Toni Morrison novel and film *Beloved*, "American writers have come up against the power of the law, but what they usually run into is the power of the dollar or the powers that make and break reputations."

The NEC tightened its belt, became a gypsy company, lost public contact with audiences, and faded from the headlines of the American theatre. More than ever before, the company was plagued with financial deficits and waning government support. The NEC continued to produce plays under Ward's leadership for only two more years. His spirit was frustrated, and, after more than two decades of struggle, the company again faced its demise. Embittered by this turn of events, especially in light of his sole commitment to the NEC, Ward left the company to pursue his own personal goals. By this time the landscape of the American theatre had changed and Black theatres found themselves on the outside of funding priorities. The industry had shifted its priority to diversity, which was now being guided by major arts institutional control.

Alumni members resuscitated the NEC's visibility through a significant voluntary effort that, along with funding from alternative sources, placed the organization on a path of modest existence. Alumni returned to teach classes in acting, and a new generation of actors, designers, and writers emerged. Through the fundraising efforts of alumni and a new staff headed by Susan Watson Turner, the NEC's accumulated deficit was all but eliminated or forgiven, including debts to vendors and federal taxes. The company instituted computerization and solid business practices and established strict adherence to budgetary guidelines. With the help of alumni, the board of directors, and young artists, the NEC enjoyed modest seasons from 1990 until 2019. The NEC resumed its practice of training artists and producing at the grassroots level, returning to the community as its primary basis of support. This approach made it possible for the NEC to continue without conforming to constantly shifting priorities and artificial demands from external sources.

## The institution

Currently, Charles Weldon has taken on the difficult task of leadership of the NEC. He has had firsthand experience in working in the lucrative regional theatre circuit and recognizes the need for Black theatre institutions to remain autonomous:

We [NEC] did something that Black theatre hadn't done—we did a whole season. We didn't do just one play; we had a season of plays. By the time we started one play, we knew whether we were going to go on the road or to rehearse another play. We would run one and then we would start rehearsal for another one. My mission statement is: I'm going to do whatever it is … I'm going, to my dying breath, give back to something that can help somebody else, especially the younger artists coming around who have no idea about the NEC.

<div style="text-align: right">(Weldon)</div>

The NEC continues to exist in New York City with offices located in the heart of the theatre district. Their plays are performed in and around the city in gypsy fashion, finding a temporary home at Theatre 80, ironically located on St. Marks Place (Figure 26.1). The Company celebrated a fiftieth anniversary in 2017. The alumni of the NEC play an active role in assisting Weldon with fundraising, production, and general "giving back" to ensure that the next generations of playwrights, actors, designers, and managers have a creative home.

The idea of autonomy was integral to the existence of the body of work produced by the Negro Ensemble Company, and fiscal responsibility is part and parcel of institutional autonomy. Certainly, the climate of New York City and America has changed over the last 50 years since the NEC was established. Still, the needs of artists have remained consistent. Artists have to be nurtured and paid. Designers, challenged to build sets using the last play's lumber, work throughout the entertainment industry. Managers, who have learned to juggle $1,000 as if it were $100,000, continue to create financial miracles. The hope is that the NEC will never again be economically beholden to the "kindness of strangers." The company merits support of a different kind.

*Figure 26.1* *A Soldier's Play* produced by the Negro Ensemble Company, Inc. and Karen Brown, executive producer. New York City, Theatre 80, directed by Charles Weldon (2017). (*Left to right*) Fulton C. Hodges, P.J. Max, Jay Ward, Jimmy Gary, Jr., Horace Glasper, Adrain Washington, and Gil Tucker.
*Source*: Photographer Tanja Maria Hayes.

## Works cited

Denmark, Leon. Personal Interview. New York, 1998.

Jefferson, Margo. "Writing about Race, Walking on Eggshells." *New York Times*, June 10, 1999.

Krone, Gerald. Personal Interview. Aaron Davis Hall, New York, 1998.

Ward, Douglas Turner. "American Theatre: For Whites Only." *New York Times*, Aug. 14, 1966.

———. Letter to the Ford Foundation. 2006. Negro Ensemble Company Archives, New York.

Weldon, Charles. Personal Interview. New York, 2004.

# 27

# INTERVIEW WITH SHIRLEY PRENDERGAST

## Lighting designer

*Interviewed by Kathy A. Perkins*
*2015, 2017*

Born in Boston, Massachusetts, Merris Shirley Prendergast became the first African American female to design lighting on Broadway in 1973 with the Negro Ensemble Company's (NEC) production, *The River Niger*. She is the recipient of numerous awards, including the 1997 Obie Award for Sustained Excellence in Lighting Design, 1998 Black Theatre Network Award, several Audelco Awards, 2009 National Black Theatre Festival Award, 2014 USITT Distinguished Achievement Award in Lighting Design, and 2016 Brooklyn College Alumni Award, and at 86 years young, Prendergast continues to design (Figure 27.1).

KAP: Do you remember the first time going to the theatre?

SP: I remember going with my uncle to the Lafayette Theatre in Harlem when I was very small. Don't remember the show, but I had a great time.

KAP: When did you become interested in dance and theatre?

SP: It was much later in life. I was a pre-med major. I got my BA degree from Brooklyn College around 1954. I went to Columbia for one semester for my master's in microbiology and became bored. I left Columbia and had to go to work because my mother became very ill. I took an exam for the City and became a junior bacteriologist for about ten years.

KAP: How did you get involved in dance?

SP: When I was at Brooklyn College, I was on the fencing team. After graduation, I started to gain weight and decided to take some dance classes. Donald McKayle, Mary Anthony, Sophie Maslow were teaching. This was the New Dance Group on 49th Street. Geoffrey Holder and Pearl Primus also taught there. Anthony's lead dancer started a modern company, and I danced around town with him while working at the same time.

KAP: How did this lead to lighting?

SP: I'm also interested in photography and was a "serious amateur." All of this was during college. The Clark Center in the 51st Street YWCA had a lighting course that I thought would help with photography. Nick Cernovich was a teacher and also the designer for the Alvin Ailey Dance Company. I would help him set up. Nick told me I had talent and that I should go to Lester Polokav Studio to study lighting design. This was in the 1960s.

*Figure 27.1*  Lighting designer Shirley Prendergast.
*Source*: Photographer Richard Finkelstein.

Ken Billington was in my class. Patrika Brown, Tom Skelton, and Peggy Clark were my teachers. I met so many great people and learned so much. The studio was located on West Street in the Village [Greenwich Village] and classes were on Saturdays. One of the prerequisites for the class was drafting, so I took a home course from LaSalle University. I was at Polokav's for about two years and learned so much.

Peggy would design lighting for outdoor summer theatre at Jones Beach, and I'd go assist. Ken Billington would drive us out. I remember going there and returning home at 3:00 am but getting up, going to work the next day. In addition, Marshall Williams was the lighting designer for the Niad Playhouse for the summer, and I would travel on the weekends and worked with him.

KAP: When did you design your first production?

SP: I was taking dance with Mary Anthony, and some of the kids in the class wanted to do a show. Mary said we could use her studio. We went around to restaurants, collected tin cans, and created lighting instruments. We strung them up, and I designed the lighting for the dance. But my very *first* play was with Negro Ensemble Company (NEC), which was *Summer of the 17th Doll* in 1967.

KAP: What was your connection to NEC?

SP: Through Marshall Williams, since he used to design for them. I assisted him and he introduced me to Douglas Turner Ward. Marshall couldn't light the show, so Doug asked me to design it. I explained to him that I had only done dance. He said, "So?" I will

always be grateful for that opportunity. It was a realistic interior play. Ed Burbridge was the set designer, and Gertha Brock designed the costumes.

KAP: What was your biggest challenge with this being your first play?

SP: Sitting in the middle of my living room with the drafting board and crying my eyes out about what I was doing. There was the concern of creating night and day. My biggest issue was dealing with the fireworks. Buddy Butler was my board operator. I had an instrument with different color gels. We took it up to full intensity on a switch and then dimmed it down. The audience was so crazy about the effect that I did it three or four times! Another challenge was trying to light the staircase, which I ended up using tin cans [for] since conventional instruments were too long. I got through it and learned a lot.

KAP: Were you one of the charter members with NEC?

SP: No, I came in about three years later. I was around when Jules Fisher was designing there. I really wanted to learn, so I became one of his assistants.

KAP: When did you decide to take the lighting exam for United Scenic Artists (USA)[1]?

SP: When Tom Skelton said I should. I passed it in 1969. It was a two-day event. Tom told me if I passed, I could be his assistant.

KAP: Were you aware that you were the first African American woman to obtain membership in the area of lighting?

SP: No, I thought there was someone before.

KAP: Louise Evans Briggs-Hall joined earlier for costumes. What was your first union contract?

SP: I think it was on *Indians* that I assisted with Tom [1969]. I assisted him on several Broadway shows. I also assisted Jennifer Tipton along with many other prominent designers.

KAP: Why do you enjoy assisting?

SP: You really learn when you assist. You have ideas about what should happen, and, when you see the person you're assisting do something and it doesn't coincide with your idea but it works, you realize that there are so many things you can do. Assisting really broadens you. I highly recommend any young designer to assist. If you keep your mind open, you can really learn.

KAP: What was it like designing *The River Niger* in 1973, your first Broadway show?

SP: I was pinching myself!

KAP: What difference did you find designing on Broadway versus Off-Broadway?

SP: There is no big difference. If you are going to do a show and going to do it well, you do the same thing if you have 75 units or if you have 175 units.

KAP: Is there a Shirley Prendergast style? Can one attend a production and say Shirley designed that?

SP: I don't know. I hope not. For a realistic show, I like to work with a palette that will give me white light, a complementary color palette. I really don't have a style. I want to use whatever fits the show.

KAP: Is there a particular way you communicate with directors?

SP: What I've found most helpful is to ask directors what do they envision. And if they envision something and we can talk about it … I can say what things can be. If I think it's right, I'll do it. If I think it's wrong, I'll try to talk them out of it. If they really insist on something … I'll do it and let them decide. It will usually be a combination of what they want and what I want.

KAP: What do you do in a case where the director can't communicate with the lighting designer or may say, "I don't know what I want?"

SP: What I do is verbally tell them what I'd like to do … As nice as directors are, many of them don't see, not really, until they get into the space.

KAP: What is your most memorable show?

SP: Whatever show I am designing at the time.

KAP: What dance companies have you worked with?

SP: I've worked with Alvin Ailey, and with Dianne McIntyre when she choreographed for Ailey. I've worked with Dance Theatre of Harlem, Leslie Martin, and Pearl Primus at one point.

KAP: Do you have a preference in terms of what you like to design—dance, musicals, drama, etc?

SP: No, as long as I like the piece when I read it. It could be a one-person show or whatever. I have no preference for intimate versus large spaces. It really doesn't matter.

KAP: Do you feel that technology has helped or hindered you as a designer?

SP: It has definitely helped! You just have to take the time to learn it. I have taught myself how to use Vectorworks. I now do everything on the computer.

KAP: Are you finding more young Black people going into design?

SP: I honestly don't know all of the young people out there but the ones I've encountered are doing great work. I really can't say what the numbers are.

KAP: Your advice to young people?

SP: Become a theatre person. If you find a vehicle that you really like, do it, regardless of pay. You can vent your creativity.

## Note

1 USA is the designer's union of which one must be a member in order to design on Broadway and in other major regional theatres.

# INTERVIEW WITH FEMI SARAH HEGGIE

## Stage manager

*Interviewed by Kathy A. Perkins*
*June 9, 2017*

Femi Sarah Heggie, one of the first African American females to receive an Equity card as stage manager, was born in Kansas City, Kansas (Figure 28.1). Her career includes resident stage manager at the Negro Ensemble Company (NEC) and Broadway productions that include *Bubbling Brown Sugar, Jelly's Last Jam, The Song of Jacob Zulu,* and *Once on This Island.* She has worked in several regional theatres and has mentored many stage managers.

KAP: How did you become interested in theatre?

FSH: Originally, I was going to be a journalist. I was attending Sarah Lawrence College. During the summers, I worked as a journalist for the *Southern Courier* newspaper in Montgomery, Alabama. The summer of 1968, I was assigned to come to New York City to interview Leontyne Price, Robert Hooks, and other artists. I saw the NEC production *The Song of the Lusitanian Bogey,* a play about apartheid in South Africa. I was so taken by the play that I decided that theatre is what I need to do. The next summer I interned at NEC and did everything from box office to backstage. This started a 20-year relationship with the company where I met and worked with great actors. The first phase of NEC was on 8th Street and 2nd Avenue. There were ensemble members that included David Downing, Rosalind Cash, Esther Rolle, Denise Nichols, Arthur French, Hattie Winston, Frances Foster, and Graham Brown. The second ensemble of NEC was at Theatre 4, [and] added such actors as Samuel L. Jackson, LaTonya Richardson, Denzel Washington, Mary Alice, S. Epatha Merkerson, and Elain Graham.

Ed Cambridge trained me as a stage manager at NEC. My mentor became Charlie Blackwell who worked on Broadway with Melvin Van Peebles. I would venture to Broadway and sit backstage next to him just to be involved. Charlie took me under his wing. I also worked in entertainment as a personal assistant for Nina Simone, Aretha Franklin, and Lena Horne.

I was one of the first people to work on the concept of the AUDELCO (Audience Development Awards) awards with Vivian Robinson, who was my boss for my day job in advertising at *The Amsterdam News* at the time. Just as AUDELCO was about to bloom, I got the first national tour of *Bubbling Brown Sugar* on the road, around

*Figure 28.1*   Stage manager Femi Sarah Heggie.

*Source*: Courtesy of Femi Sarah Heggie.

1976. I eventually became the production stage manager and assistant director of the AUDELCO awards for over 15 years.

KAP: When did you obtain your Equity[1] card?

FSH: I got my card around 1974 on *The Prodigal Sister* produced by Woodie King, Jr. at Henry Street Settlement.

KAP: You are probably one of the first African American women to get an Equity card as a stage manager.

FSH: That's true. In those days, I worked several theatres. I was fresh out of college, and New York was an intriguing place to be in the '60s through the '90s.

KAP: When starting out as a stage manager, was it difficult for you, particularly as a Black woman?

FSH: I had a passion for the theatre. I'm sure I was turned down for some Broadway shows because of my gender and the color of my skin.

KAP: Do you think the fact that you were working in Black theatre made a difference?

FSH: I hope so. Occasionally, there will be a young person of color that will come up to me and say, "You're Femi. You helped me so much!" That is very rewarding. I cared about my work and was taught to be a professional. Everything you do in preparation for the production requires focus, organization, and many hours. Douglas Ward would say if there are four characters in the play, the stage manager is the fifth. So when you called a cue, you felt you were a part of the production. You were invested. You know what the director wanted to happen and what the people onstage were doing. So opening nights

were always the best! Because all that you had done in rehearsals, you saw manifest right there in front of you. When an audience appreciates it, or laughs at the right place, it's very rewarding.

KAP: I'm aware that stage managers are sometimes undervalued. Can you explain the stage manager's role?

FSH: The stage manager [SM] is a pivotal point. All of the designers and crew for the production have to communicate with the SM, who has all the information about the production. The SM keeps a production book and organizes and schedules production meetings, rehearsals, costume fittings, focus sessions, etc. The SM spends many hours with the director to ingest his/her vision.

KAP: Do you feel that working in numerous positions at NEC made you a better stage manager?

FSH: Absolutely! I worked in the box office; I worked on the crew; helped to focus lights, and became a resident stage manager. I dealt with actor's personalities. As a stage manager, your goal is to get the show up. The show must go on. You're always [being] understanding. You never curse anyone or yell because that's not going to get your show up.

KAP: Can you share your experiences working on Broadway?

FSH: I've only done one show on Broadway where I was the production stage manager [PSM]. It was a Black show produced by Ashton Springer, *Rolling on the T.O.B.A.* However, as first assistant on several Broadway shows, I found that the work was much easier than on Off-Broadway productions. I enjoy the professionalism of working on Broadway.

KAP: Can you explain the difference between the PSM and the stage manager?

FSH: The PSM *is* the pivotal person. Equity rules and the number of people involved in the show—actors, musicians, etc.—will determine how many stage managers are on the production. You can have as many as five stage managers working on a show under the PSM. The various stage managers have different responsibilities depending on the demands of the show. One of the stage managers will call the show. The PSM doesn't call the show, unless she/he wants to, but they are keeping tabs on all aspects of the production.

KAP: What was your most memorable show?

FSH: *Porgy and Bess* in 1978 with the Houston Grand opera. It was the biggest show I had ever done. We went to Paris and other places in Europe where I called every show. I'm traveling to all these countries calling cues in different languages and meeting people. That was my best experience.

KAP: Having traveled extensively, did you feel more respected overseas?

FSH: Oh, yes. That's why there was a movement in the 1960s with [James] Baldwin and other folks going to Paris. Look how Zora Neal Hurston was treated here. Being a Black female working in the creative arts, you'd think we'd be more acceptable. We disappear somehow while we're still breathing.

KAP: Do you feel much has changed since you started? Are there many Equity Black women stage managers?

FSH: Yes, I think so. I haven't really spent a lot of time in the theatre as much as I used to. I don't really enjoy the theatre as much because I'm looking at the lights, sets, costumes, and observing cues instead of enjoying the show.

When you asked about spending years in Black theatre, it was not financially rewarding, but it was my passion. Women of color are not considered valuable. You don't realize when you're young … all the work you're doing to be the best. Don't expect to be appreciated, just do your job, get your money, and go home. But it was always more than a job for me. The '60s was an amazing time and our generation came to New York all raring to go. But as I've gotten older, you really see how things work and you wish you would have been more discerning.

KAP: Do you keep up with what's going on?

FSH: I've found that my generation is trying to survive unless they've become famous like Denzel, or Sam, or Epatha. And rarely do those of us "behind the scenes" become famous. As you get older in this business, you are facing something else. Now you're a Black woman in your sixties and hitting a wall and asking yourself, "Where do I go now?" A man can be 80 in a wheel chair, and they'll let him call cues. It's an interesting phenomenon for Black women. Jewish and Anglo Saxon women don't go through this. I think you get tired of knocking on doors. You figure that sometimes the door should be open for you. I also think Black people are very homophobic when it comes to women more than with men. They will more readily accept Black gay men, even in the church. This is why I think Black women are quiet about their lifestyle. This is something I'm writing about now in short stories.

KAP: What kind of advice would you offer a young Black person pursuing stage management?

FSH: Because our world is a capitalistic society, you've got to live, you've got to eat. I never thought I'd hear myself say this, but I really feel you should go for the gold. Don't settle for the down-the-street theatre. You are going to be "Black" wherever you go, so go to where you get the most. If you want to give like we did back in the '60s, you can still do this on the side, but join the union and go for the Broadway shows. Get to know folks who can hire you. I don't know the circuit anymore. Younger people today have a lot more at their fingertips than we did. They have websites, blogs, and Facebook, where you can put yourself out there. But don't let your personality get hooked up in all of this. You find yourself doing a lot to get the show up. Be sure not to interject your personality into all of those components and clash with others. I think young people going into stage management need to look at the whole picture. The passion is great, but the rent is more important.

## Note

1 Equity refers to membership in the union Actor's Equity Association. One must be a member in order to work on Broadway and in many major theatres in the United States.

# 29

# WEATHERING THE WINDS OF CHANGE

## The sustainability of the St. Louis Black Repertory Company

*Gregory S. Carr*

There's a saying in St. Louis, Missouri: "If you don't like the weather, wait ten minutes." St. Louis is well known for its unpredictable weather patterns. Like the weather, the arts scene in St. Louis has had its share of disparate weather patterns. Although the city has a long-standing tradition of theatre oriented toward white audiences, there was no comparable Black theatre. The landscape for a viable Black theatre was a barren desert. Fortunately, this arid condition changed for the better around 1976. One such theatre that brought about that change was the St. Louis Black Repertory Company, also known as the Black Rep. The Black Rep has become a nationally renowned theatre that provides engaging workshops and a viable internship program. It has impacted not only the local St. Louis theatre scene, but also the national theatre community through its activist inception, its entrepreneurial prowess, and its uncanny ability to develop young acting talent.

The St. Louis Black Repertory Company's key to success has been its adaptability and sustainability in producing quality theatre. Founded in 1976 by Producing Director Ron Himes when he was a business major at Washington University, the Black Rep began as a touring company of actors until it found a performance space at Greely Presbyterian Church on 23rd Street and St. Louis Avenue in 1981 (Ron Himes). Dubbed "the Miracle on 23rd Street" by local critics, the Black Rep successfully carved out a niche in the St. Louis theatre community. From 1981 to 1991, the Black Rep produced such plays as *Zooman and the Sign*, and *Dream on Monkey Mountain*, and musicals like *Ain't Misbehavin'*, *The Wiz*, and *Bubbling Brown Sugar* (Hughes 2B).

In a 2017 interview I conducted with Ron Himes, he described the evolution of the Black Rep through a series of existing Black theatre groups:

> The Black Rep was really mixed, but there was a student group prior to the Black Rep, which was called the Phoenix Theatre Troupe. It was a group of undergrads at Washington University that included Marsha Cann, Geraldine Cole, Michael Smith, and Keith Gooch. We were the main students who were in the original group. The Black Rep operated as the Phoenix Theatre for several years after that, and I incorporated it as the Black Rep in 1976.

One of the Black Rep's primary goals was to create opportunities for students on the Washington University campus. Himes emphasized that students could graduate from the Theatre Department without ever being cast in a mainstage production, acting in a Black play, or even being exposed to works by Black playwrights. Because of the lack of opportunities for Black actors, Himes and Black theatre majors took matters into their own hands, with Himes arguing that since students paid tuition, the university should give them the same opportunities to perform and produce their own plays as the white students (Himes).

The fledgling theatre company needed to find its voice within the greater St. Louis community, so it performed for Black History Month programs and Martin Luther King, Jr. and Malcolm X commemorations, and booked spaces on the Washington University campus. This programming was remarkable because St. Louis was known primarily for its conservative politics and exclusive white private societies. In fact, the larger arts community either provided little or no Black theatrical performance other than an occasional touring company for a weekend booking of the latest popular "gospel play." Therefore, there was a great demand for the kind of culturally relevant theatre that the Black Rep provided for an arts-starved Black community. As a result of these performances, the Black Rep received bookings on other campuses, which eventually led to productions within the community. These performances provided valuable acting opportunities for young Black actors (Himes).

There were other Black theatre companies operating in the St. Louis area, groups like the Vivian Womble Players, the Persona Players, the Richard B. Harrison Players, and B.A.G. (the Black Artists Group). Many of these companies were comprised of older actors. The Persona Players, for example, were mostly educators. There was, however, one important factor that separated the older companies from the novice Black Rep: the latter had the opportunity to acquire a building of its own in which to perform. Having such a building would give the Black Rep a centralized location from which to build an audience.

The Black Rep's growing audience necessitated a change in venue both figuratively and literally. The change was necessary figuratively because the young company had outgrown its rigorous touring schedule and activist roots at Washington University. The change was also necessary literally because it needed a space for its audiences to congregate and develop a sense of community. In 1980, Himes sensed that the timing was right and secured a building that would soon be dubbed "the Miracle on 23rd Street." As he explained to me:

> The difference was, in 1980 when we moved into the Greeley Presbyterian Church, the difference was having a facility. A facility gave us presence. A facility allowed us to schedule a season. The Vivian Womble Players and the Richard B. Harrison Players didn't have a space. Before we got the space, I rented the old Victory Center on Page and Union and did a production of *The Brownsville Raid*. The Guinns, who ran the Greeley Community Center, came to a performance and told me that they had this vacant church down on 23rd Street and St. Louis Avenue. They said we could basically have the space in exchange for teaching classes for kids in the neighborhood. We opened in February of 1981. We did four shows that season. It was off and running. The difference was, and the difference *is*, having a facility. Having a facility we could control.

Thanks to the philanthropic efforts of the Guinns, the Black Rep produced a prolific number of quality productions at the Greeley Community Center from 1981 to 1991. The Guinns, a white couple, saw a dual need in inviting the Black Rep to be housed in the center. The first reason was that it satisfied the need for community outreach. The Black Rep not only began teaching

acting classes to children in the low-income St. Louis Place neighborhood, but also planted the seeds for its future Summer Performing Arts and Professional Internship Programs. The second reason was that the theatre was located in the heart of the Black St. Louis community and reflected the cultural values and pride that were exhibited in the Black Rep's productions. Following an opportunity to become more financially profitable, in October 1992, the Black Rep moved to the "467-seat Grandel Theatre in downtown St. Louis [where] they produced five main-stage shows per year, attracting 175,000 people annually" (Hill and Barnett 458).

Providentially, the Grandel Theatre, like the 23rd Street Theatre, was a converted church that had formerly been known as the First Congregational Church. The theatre was more centrally located in the Grand Arts District, which gave the Black Rep the high-profile visibility that it needed. At the Grandel, the Black Rep began to produce new works by emerging playwrights such as S.M. Shephard-Massat (*Waiting to Be Invited*) and Eric Clark (*Strands*). Both of these plays achieved critical success and provided valuable stepping-stones for the development of other plays. The Black Rep also produced works by established playwright Samm-Art Williams, whose 2001 production of *The Dance on Widow's Row* proved to be a hit with St. Louis audiences.

The Black Rep has honored August Wilson's Century-Cycle by producing many plays from this canon: *Ma Rainey's Black Bottom, Fences, Seven Guitars, Jitney, The Piano Lesson*, and *Gem of the Ocean*. The company has featured a number of classic and popular works by Black playwrights such as Ntozake Shange's *for colored girls who have considered suicide/when the rainbow is enuf*, Langston Hughes' *Black Nativity*, James Baldwin's *The Amen Corner*, Shay Youngblood's *Shakin' the Mess Outta Misery*, Leslie Lee's *The Ninth Wave*, Pearl Cleage's *Blues for an Alabama Sky*, and Lynn Nottage's *Intimate Apparel* and *Ruined*. The Black Rep has also presented a healthy balance of dramatic works and high-energy musicals, and its stellar intern program has provided young actors with opportunities to gain much-needed acting roles and to tour.

In addition, the Black Rep has become a mecca for a number of directors, scenic designers, lighting designers, and costume designers. Directors such as Andrea Frye, Chris Anthony, Buddy Butler, and Ed Smith have lent their creative talents to productions like *Joe Turner's Come and Gone, Othello, The River Niger*, and *A Raisin in the Sun*. Felix Cochren's scenic design for *Dreamgirls* and Kathy Perkins' lighting design for *The Dance on Widow's Row* demonstrate the high level of technical artistry that the Black Rep has attracted (Figure 29.1). Costume designers Reggie Ray, Gregory Horton, and Felia Davenport provided brilliant costumes for *Black Nativity, Blues in the Night, Dreamgirls, Sarafina! Black Pearl Sings*, and *The Waiting Room*. Indeed, this combination of artistic programming, high-caliber design teams, and actor education has allowed the Black Rep not only to stay afloat but also to achieve national prominence.

The Black Rep's Professional Internship Program is probably the one remaining holdover that has survived the transition from Washington University's early theatre days to community theatre to professional theatre. This rigorous program gives young actors opportunities to act as well as to gain valuable technical experience. The interns are required to learn the elements of set design, lighting design, costume design, sound design, and properties along with stage management. This intense training prepares the young actors for touring shows in which they not only perform but also serve as technical support, an arrangement that is cost effective for the Black Rep.

These young actors serve as ambassadors for the theatre company in the community. In addition to exposing many children to Black culture and the arts, the touring shows are often used to market for upcoming productions where students can be bused in for Wednesday morning matinees. Study guides are provided to schools so that teachers and students can have a better understanding of the plays and effectively engage in post-show discussions with the directors and actors (St. Louis).

*Figure 29.1*   St. Louis Black Repertory's *Ain't Misbehavin'* (2006) directed by Ron Himes. (*Left to right*) Anita Jackson, Drummond Crenshaw, Teressa Renee' Williams, Julia Nixon, and J. Samuel Davis.
*Source*: Photographer Kathy A. Perkins.

Throughout the years, the Black Rep Professional Internship Program has nurtured an abundance of talent. Many of the interns have appeared in Black Rep productions as well as established successful careers on stage, television, and film. For example, Ronald L. Conner has appeared in national commercials such as the Coors Light spots during the NFL season and on television shows such as *Empire*, *Chicago P.D.*, *Sirens*, and *The Secret Santa*. Sophia Stevens has performed as Nala in the national touring company of *The Lion King* and as a backup vocalist on several appearances on *The Tonight Show with Jimmy Fallon*. Kelvin Roston, Jr., a mainstay on the Chicago theatre scene for a number of years, has appeared in *Crowns* at the Goodman Theatre, in *Detroit '67* at the Northlight Theatre, and in his own play *Twisted Melodies* at Congo Square Theatre, where he starred as the brilliant musician Donny Hathaway. Roston has also made television appearances in *Chicago Med*, *Chicago P.D.*, and the film *Princess Cyd*. Actress Rheaume Crenshaw has appeared on Broadway in *Amazing Grace* and in the Tony Award-winning *Groundhog Day: The Musical*.

As a frequent patron of and a former actor at the Black Rep, I saw the company develop corporate partnerships with Fortune 500 companies like AT&T, Enterprise Rent-A-Car, World Wide Technology, and the Centene Corporation, each of which sponsored and underwrote a number of shows. Generous grants from the Missouri Arts Council and the Regional Arts Council have provided additional financial support (St. Louis). As is typical, an active outreach program has meant that Black Greek organizations, churches, and other social groups have enthusiastically supported the Black Rep by repeatedly buying large blocks of seats. Still, when financial challenges escalated in 2013, the Black Rep moved the company to Harris-Stowe State University, where it mounted successful productions for three seasons. The Black Rep was able to maintain its patrons from the community and gained a new audience from the campus

community at-large. The sale of "Student Rush" tickets encouraged college students to see professional shows for as low as $15.00 if they purchased their tickets a half hour before show time (St. Louis). This arrangement proved to be extremely profitable for the theatre and popular with the students, who regularly attended professional shows on campus and also gained valuable experience working on shows.

For more than four decades the St. Louis Black Repertory Company has given the region entrée into the riches of Black culture. Recently, the Black Rep returned to its early roots and now produces shows in its original home at Washington University, operating out of a facility donated by the university that boasts several performance rooms, a costume design and fitting shop, and a much-needed scene shop. Productions are mounted and performed at the Edison Theatre. Of this new development, Ron Himes cheerfully observes,

> When you come to the Black Rep, you don't know who you are sitting next to— Black or white, straight or gay, rich or poor. We've been able to create a world of theatre. When the lights come up we hope to share the experience we've had in the dark.

## Works cited

Hill, Anthony, and Douglas Q. Barnett. *Historical Dictionary of African American Theater*. Scarecrow Press, 2009.

Himes, Ron. Personal Interview. July 2017.

Hughes, Cleora. "The Black Repertory is Moving Ahead." *The St. Louis Post-Dispatch*, June 23, 1984, p. 18.

"Ron Himes: Henry E. Hampton, Jr. Artist-in-Residence." Washington University in St. Louis, 2017, pad. artsci.wustl.edu/ron-himes.

The St. Louis Black Repertory Company, 2018, theblackrep.org.

# 30

# THE NATIONAL BLACK THEATRE FESTIVAL AND THE "MARVTASTIC" LEGACY OF LARRY LEON HAMLIN

*J.K. Curry*

Every two years since 1989, Black theatre companies, writers, actors, producers, and notable celebrities have gathered in Winston–Salem, North Carolina, for six days of performances, workshops, and networking known as the National Black Theatre Festival (NBTF). The biennial event was the brainchild of Larry Leon Hamlin, a man with the vision, energy, charisma, and determination to make it a reality (Figure 30.1). Though the NBTF would not have been created without Hamlin's drive, the festival grew and continues to thrive because of a strong network of support, including an army of local volunteers. A tireless promoter and organizer, Hamlin recruited several capable collaborators who helped him develop the NBTF and who have sustained the festival following Hamlin's death in 2007. Also, key players in African American theatre nationwide have helped perpetuate the NBTF because it has filled a clear need.

Born on September 25, 1948, Hamlin grew up in Reidsville, North Carolina. One of four children of a tobacco factory worker, Hamlin developed an interest in theatre at a young age, performing in school and community productions (Barksdale) with encouragement from his mother (O'Donnell). As an adult, Hamlin completed a degree in business administration at Johnson & Wales in Rhode Island before studying theatre with George H. Bass at Brown University and working with Bass' Rites and Reasons Theatre. In 1978, following the death of his older brother, Hamlin returned to North Carolina, settling in the Winston–Salem area where his mother and sisters were living. Looking for a way to work in a state with no existing professional Black theatre, Hamlin established the North Carolina Black Repertory Company (NCBRC) in 1979. Though he continued to do side jobs such as working on an occasional film project, Hamlin devoted most of his efforts as actor, director, writer, and producer to developing his fledgling theatre company.

Cultivating an audience and securing adequate financial support for the NCBRC took creativity and persistence. The company presented plays in various local auditoriums, eventually finding a permanent home at the Arts Council Theatre, and toured some productions to other parts of North Carolina. In order to reach a wide audience and develop close connections with the community, Hamlin initiated a series of "Living Room Theatre" productions, taking performances directly into people's homes (McMillan).

To enhance the artistic reputation of the company, Hamlin regularly brought in New York and California based professional actors such as Antonio Fargas, Marjorie Johnson, and Ricardo Pitts-Wiley to perform roles and conduct workshops with his local company members (Turner). In 1981 Hamlin established the NCBRC Theatre Guild, whose paying members were expected to sell tickets and otherwise support the NCBRC, and to recruit additional guild members. This active community of NCBRC supporters beyond the company's board members would prove essential when Hamlin launched the NBTF as a project of the NCBRC in 1989. Hamlin also began to secure funding from sources such as the Arts Council of Winston-Salem and the North Carolina Arts Council.

Even as Hamlin worked to keep the NCBRC afloat, he noticed that other Black theatres around the country were struggling. While conducting research for a magazine article on Black theatres in the South, Hamlin observed that "there was a terrible scream of pain" coming from the theatres (Rothstein). Extending his investigation to Black theatres around the country, Hamlin discovered that many were facing financial difficulties and limited support after having had a comparatively successful period in the 1960s and 1970s. Furthermore, the companies were isolated. Hamlin himself had not known of the existence of many of the companies before he began his research. The idea for the NBTF was born as Hamlin decided it was important to bring the companies together to share strategies for survival and to showcase the best of contemporary Black theatre. He shared his idea with the NCBRC board members and more widely with contacts in theatre companies around the country (Himes). With the NCBRC on board to host a festival, Hamlin solicited letters from numerous theatre companies in order to demonstrate interest in and need for a festival. These letters helped him to raise funds, including a grant from the National Endowment for the Arts, for the initial festival. To raise the profile of the festival and attract public interest, Hamlin enlisted the support of Dr. Maya Angelou, who had settled in Winston-Salem after being appointed Reynolds Professor of American Studies at Wake Forest University in 1982. Angelou agreed to serve as the honorary chair of the inaugural festival, and she invited celebrity friends, including Oprah Winfrey, to attend.

As detailed planning got underway for the first NBTF, theatre companies were invited to propose productions that they wanted to bring. A total of 16 companies were selected to present their work including: Crossroads Theatre (New Jersey), the National Black Theatre (New York), Carpetbag Theatre Inc. (Tennessee), the Negro Ensemble Company (New York), Penumbra Theatre (Minnesota), Jomandi Productions (Georgia), Philadelphia Freedom Theatre, Harlem Jazz Theatre, Just Us Theatre (Georgia), and the African American Drama Company (California) (1989 National Black Theatre Festival). Other theatre companies as well as independent theatre artists attended the festival, taking the opportunity to participate in workshops and seminars and to view multiple theatre productions. Hamlin labeled the festival "A Celebration and Reunion of Spirit" (expanded into an "International Celebration" in 1995) (King, "National") and offered the artists in attendance the valuable opportunity to come together as a theatre community to share advice and enjoy each other's company. As one participant noted, "Those fortunate enough to have attended came away with a renewed vigor, a stronger sense of purpose and without the sense of isolation that affects so many of our theatres as they struggle" (Coleman 23).

The wider public was also invited to the festival, where they could see many professional theatre productions and rub elbows with the stars. From the start, celebrity attendees were part of the attraction of the NBTF. Honorary chair Angelou presided over an opening gala attended by over 1,000 festivalgoers. The event began with the Otesha Creative Arts Ensemble providing African drumming and dancers to lead a procession of special celebrity guests into the gala (McMillan). One of the notable guests was August Wilson, who was presented with the Garland

Anderson Playwright Award. Following the gala banquet, the host theatre, NCBRC, performed its production of Micki Grant's *Don't Bother Me, I Can't Cope*. Festivities continued after the musical with a celebrity reception in honor of Oprah Winfrey. Throughout the festival, celebrities appeared for daily press conferences and were honored at nightly receptions. Some of those honored at the receptions were Ruby Dee, Ossie Davis, Lou Gossett, Jr., James Earl Jones, Cicely Tyson, and Roscoe Lee Browne.

Drawing an estimated 20,000 people, the inaugural National Black Theatre Festival was judged a success, and plans were announced during the event for the next festival in 1991. The budget for the inaugural festival was over $500,000, not counting in-kind support like the free use of various performance venues. NBTF events were held all over the city—at the Arts Council Theatre, the Stevens Center, and on the campuses of Winston-Salem State University, the North Carolina School of the Arts, and Wake Forest University. Having pulled off such a big, successful, and logistically complex event, Hamlin became something of a celebrity himself. During the festival he was busy around the clock supervising festival staff and volunteers, but he also enjoyed mixing with the celebrity guests and other festivalgoers. (A very capable staff including long-time technical director Artie Reese tackled the challenges of load-ins and technical rehearsals for the numerous productions.) A sharp dresser, Hamlin regularly sported sunglasses and at least one shade of purple, his favorite color. Purple and black were adopted as the official colors of the NCBRC and the NBTF. Hamlin often expressed his enthusiasm for festival events by calling them "marvtastic," a word he coined from marvelous and fantastic. This was such a signature expression that Hamlin also gained the nickname "Mr. Marvtastic" (King, "Marvtastic").

Hamlin was able to build on the good reputation of the first festival, though it continued to be challenging to raise the money needed to produce the event, select the productions, and work out all the logistics, including securing buses to shuttle participants to venues throughout Winston-Salem. In addition to the opening gala and award ceremony, the professional theatre productions, panels of scholarly papers, workshops on professional theatre topics, a vendors' market, and celebrity receptions, many other features were added to the NBTF over the years. Beginning in 1991, a Reader's Theatre series, led by Garland Thompson of the Frank Silvera Writers' Workshop until his death in 2014, provided an opportunity for many writers to get new work heard by potential producers (Heyliger). Other additions to the festival included the New Performance in Black Theatre Series, the Youth/Celebrity Project (a targeted interaction between festival celebrity guests and local disadvantaged youth), NBTF Fringe (showcasing college theatre productions), Hip Hop Theatre series, Black Film Festival, Midnight Poetry Jam, Storytelling Festival, Children's and Youth Talent Showcases, and the Larry Leon Hamlin Solo Performance Series.

The plentiful and varied offerings continue to be a noted feature of the NBTF, which serves a diverse audience including theatre makers and celebrities looking for professional advancement, national and international academics, visitors flying in for the week, locals, and busloads of ordinary people from around the region. Coming together to celebrate Black theatre and related arts, eager audiences find plenty to enjoy whether their tastes run to polished musicals and revues, gritty dramas, contemporary comedies, educational pieces exploring the lives of historical figures, or cutting-edge experimental work.

After the first year, more companies and independent producers wanted to present work at the NBTF than could be accommodated, making the selection of productions an increasingly large part of festival planning. In addition to established theatre companies sharing standout productions from their repertory, the festival began to include star vehicles and new projects, often one person shows, looking for future production opportunities (Butler). Though the length of the festival has held steady at six days, the number of performances, budget, and

number of attendees have increased, with nearly 70,000 guests attending performances in 2015 (Felder). The budget for each NBTF is now around $1.5 million, making fundraising vital to success. During the early years Hamlin sometimes thought the NBTF was not receiving enough financial support locally, and he entertained proposals from other cities interested in hosting the NBTF. However, over time Hamlin began to refer to the festival locales in Winston-Salem as "Black Theatre, Holy Ground" (officially the theme of the 2003 NBTF) and acknowledged it would be difficult to run the festival without his 1,500 dedicated local volunteers (Curry 102). The City of Winston-Salem now makes a regular contribution to the festival, reflecting growing recognition of the economic impact of the NBTF to the community. Since 2003 Winston-Salem mayor Allen Joines has demonstrated a personal commitment to the NBTF several times by serving as a fundraising co-chair (Underwood).

Following inaugural NBTF honorary chairperson Maya Angelou, one or more celebrities have been selected each year to serve as honorary chairs who promote the NBTF at press conferences, preside at the gala banquet, and generally help draw attention to the festival. The honorary chairs have been Ruby Dee and Ossie Davis (1991), Sidney Poitier (1993), Billy Dee Williams (1995), Debbie Allen (1997), Leslie Uggams (1999), André DeShields and Hattie Wilson (2001), Melba Moore and Malcolm-Jamal Warner (2003), Janet Hubert and Joseph Marcell (2005), Vanessa Bell Calloway and Hal Williams (2007), Wendy Raquel Robinson and Ted Lange (2009), T'Keyah Crystal Kayman and Lamman Rucker (2011), Tonya Pinkins and Dorien M. Wilson (2013), Debbi Morgan and Darnell Williams (2015), and Anna Maria Horsford and Obba Babatundé (2017).

*Figure 30.1*  Larry Leon Hamlin.
*Source*: Photographer Michael Cunningham.

Each festival includes the recognition of particular contributions to African American theatre through the presentation of awards to notable recipients. The Garland Anderson Playwright's Award was presented to George C. Wolfe (1991), Ron Milner (1993), and Laurence Holder (1995). In 1997 the award was renamed the August Wilson Playwright's Award and presented to Amiri Baraka. It has also been presented to Ed Bullins, John Henry Redwood, P.J. Gibson, Lynn Nottage, Leslie Lee, Celeste Bedford Walker, Charles Smith, Samm-Art Williams, Richard Wesley, and Katori Hall. In 1993 the Sidney Poitier Lifelong Achievement Award was established with Sidney Poitier as the first recipient. Since then other individuals to be recognized with the award have been Leslie Uggams, Geoffrey Holder, Carmen de Lavallade, John Amos, Ja'Net Du Bois, Ruby Dee, Ossie Davis, Cicely Tyson, Diahann Carroll, Phillip Rose, Katherine Dunham, Melvin Van Peebles, Douglas Turner Ward, Oscar Brown Jr., Micki Grant, Wole Soyinka, Woodie King, Jr., Glynn Turman, Hal Williams, and Bill Cobbs.

The inaugural Lloyd Richards Director's Award was presented to Lloyd Richards in 1993. Later recipients were Hal Scott, Shauneille Perry, Glenda Dickerson, George Faison, Rome Neal, Kenny Leon, Seret Scott, Lou Bellamy, Ed Smith, Chuck Smith, Oz Scott, and Clinton Turner Davis. The Larry Leon Hamlin Producer's Award was added in 1995 when it was awarded to Woodie King, Jr. and Ashton Springer. Later recipients of the award were Barbara Ann Teer, Ricardo Khan, Marsha Jackson-Randolph, Thomas W. Jones II, Marjorie Moon, Miguel Algarin, Curtis Black, Carl Clay, Jackie Taylor, Voza Rivers, Vy Higginsen, Eileen J. Morris, Ben Guillory, and Nate Jacobs. An Emerging Producer Award was added in 2011 and presented to Yvette Heyliger and Yvonne Farrow of Twinbiz. Later recipients of the award were Jonathan McCrory and Erich McMillan-McCall.

In keeping with Hamlin's goal of sustaining Black theatre companies, a Theatre Longevity Award has recognized the Arena Players (Baltimore), the New Federal Theatre (New York City), Karamu Playhouse (Cleveland), the Negro Ensemble Company, Berkeley Black Repertory Group Theatre, the National Black Theatre, Black Theatre Troupe (Phoenix), and the Carpetbag Theatre (Knoxville). By 2009 additional awards had also been added for outstanding achievement in costume, lighting, and scenic design and in film. Stage management was added in 2017.

Since 1991 several distinguished guests at each festival have also been honored with the designation of "living legend." The first group of living legends included Frederick O'Neal, Dick Campbell, Rosetta Le Noire, Helen Martin, Whitman Mayo, Gertrude Jeanette, Loften Mitchell, Melvin Van Peebles, Vinnette Carroll, and Ashton Springer. Living legends honored at the NBTF in later years have included Ntozake Shange, Lonne Elder, III, Vinie Burrows, Ernie McClintock, Douglas Turner Ward, Yvonne Brewster, Ed Bullins, Virginia Capers, J.e. Franklin, Louise Stubbs, Earle Hyman, Dr. Ethel Pitts Walker, Sherman Hemsley, Ben Vereen, and many others.

Because the success of the NBTF was so closely associated with its founder, Larry Leon Hamlin, his serious illness followed by his death on June 6, 2007, was a crisis period for the festival. Cheryl E. Oliver was appointed interim executive director of the NCBRC in July 2006 and helped produce the 2007 NBTF, working closely with Hamlin's spouse, Sylvia Sprinkle-Hamlin. Director of the Forsyth County Library, Sprinkle-Hamlin is an experienced administrator who married Hamlin in 1981 and has been involved with the NCBRC since its beginning. After the hurdle of hosting its first NBTF without Hamlin, the NCBRC announced long-term replacements for Hamlin in October 2007. It seemed impossible for a single person to take on all the tasks that Hamlin had handled, so the position was divided. Gerry Patton, a long-time NCBRC volunteer with professional administrative experience, was announced as the executive director. Mabel Robinson, who had had a notable Broadway career before

relocating to Winston-Salem to teach dance at the North Carolina School of the Arts and had directed and choreographed many productions for the NCBRC, was named artistic director (Jackson).

Patton retired from her position following the 2013 NBTF, and Robinson retired in December of 2015. Jackie Alexander, who previously had served as artistic director of the Billie Holiday Theatre in NYC and who had directed several productions presented at the NBTF, replaced Robinson as artistic director. T. Taylor Thierry served as executive producer for about a year following Patton's retirement. She was followed by Nigel Alston, another long-time volunteer with the NCBRC, who was initially appointed on an interim basis. Sylvia Sprinkle-Hamlin continues to serve as president of the board of directors as well as executive producer of the NBTF. Annie Hamlin Johnson, Hamlin's mother, who was present at the first NCBRC board meeting in 1979, has also continued to be a fixture at the NBTF.

The North Carolina Black Repertory Company supports the vision of founder Hamlin, and the NBTF should continue as a vital event for the foreseeable future. Fundraising is underway for a National Black Theatre Festival Hall of Fame and Museum, a project first proposed by Hamlin, which should further showcase the significance of the festival (Elliott).

## Works cited

"The 1989 National Black Theatre Festival." Black Masks (1984–1989), Aug. 31, 1989.

Barksdale, Robin. "Larry Leon Hamlin: From Footlights to Fame." Black Masks, February 2008.

Butler, Sana. "Together We Stand." Black Enterprise, vol. 38, no. 7, Feb. 2008, pp. 77–78.

Coleman, Stephen. "Bravo for First Biennial National Black Theatre Festival in N.C." *New York Amsterdam News (1962–1993)*, Sept. 2, 1989, sec. Art and Entertainment.

Curry, J.K. "The National Black Theatre Festival: A One-Stop Tour." Theatre Symposium, vol. 13, 2005, pp. 95–104.

Elliott, Frank. "Preview of a Dream: The National Black Theatre Hall of Fame & Museum." Black Masks, Spring/Summer 2015.

Felder, Lynn. "NBTF Bottom Line: A Most Popular Event." Winston—Salem Journal, Sep. 13, 2015.

Heyliger, Yvette. "Mainstage at the National Black Theatre Festival." Black Masks, Feb. 2008.

Himes, Ron. "Larry Leon Hamlin: 1948–2007," American Theatre, Sep. 2007.

Jackson, Paul M. "Two Picked to Take over for Hamlin." McClatchy—Tribune Business News, Oct. 16, 2007.

King, Woodie Jr. "A Marvtastic Life." Black Masks, Feb. 2008.

———. "National Black Theatre Festival—African Heritage and Kinship." The Impact of Race: Theatre and Culture, Applause Theatre & Cinema Books, 2003, pp. 163–170.

McMillan, Felicia Piggott, The North Carolina Black Repertory Company; 25 Marvtastic Years. Open Hand, 2005.

O'Donnell, Lisa. "Mama Marvtastic: Beneath the Glitter, a Heart of Pure Gold." Winston—Salem Journal, May 11, 2008, sec. A.

Rothstein, Mervyn. "Festival Sets Goal For Black Theater: New Togetherness," *New York Times, Late Edition (East Coast)*, Aug. 17, 1989, sec. C.

Turner, Beth. "North Carolina Black Repertory Company: Look Out N.Y." Black Masks (1984–1989), Apr. 30, 1987.

Underwood, Kim. "Joines to Help Festival." *McClatchy—Tribune Business News*, Dec. 15, 2006.

# 31

# THE BLACK FEMINIST THEATRE OF GLENDA DICKERSON

## Khalid Yaya Long

Glenda Dickerson's (1945–2012) career spanned a little over 40 years, during which she held many roles: playwright, director, folklorist, performer, adapter/conceiver, and pedagogue (Figure 31.1). Dickerson was the second Black woman to direct on Broadway with the 1980 production *Reggae, a Musical Revelation*. She also directed for prominent theatres throughout the country, including the Negro Ensemble Company, the New Federal Theatre, the Seattle Repertory Theatre, the John F. Kennedy Center for the Performing Arts, Crossroads Theatre Company, and the St. Louis Black Repertory Company. In doing so, Dickerson collaborated with many well-known performers and choreographers, including Lynn Whitfield, Lynda Gravátt, Mike Malone, and Debbie Allen.

Dickerson's dramatic works challenged the realist model for drama and centered the Black female voice. She was not only concerned with shifting the subject of theatre by bringing Black women in from the margins to the center, but she was equally concerned with discovering the methods in which to forge new aesthetic and pedagogical ground. As theatre scholar Freda Scott Giles notes,

> Though her university and professional work often called for her to direct realistic plays, Dickerson chafed under the restraint of realism. As she experimented with forms to reflect her ideas, she steadily built a body of work that tended toward the stylized and expressionistic.
>
> (35)

Dickerson was committed to her task, spending much of her lengthy career endeavoring to develop an aesthetic for a type of theatre that was not only Black, but also and most importantly woman-centered.

This chapter will chart a genealogy of Glenda Dickerson's theatrical career, illuminating some of the historical and sociocultural influences that shaped her work in the theatre. We recognize Dickerson as a Black feminist/womanist aesthetician who modeled a Black feminist theatre theory through her praxis.[1] Born February 9, 1945, in Houston, Texas, Dickerson had an early fascination with oral interpretation. In high school Dickerson participated in oratory contests performing dramatic readings from James Weldon Johnson's *The Creation* and Lorraine Hansberry's *A Raisin in the*

*Figure 31.1*   Glenda Dickerson (2002).
*Source*: Photographer Kathy A. Perkins.

*Sun* (Dickerson, "Rode a Railroad"). After contemplating attending Bowling Green State University, Dickerson decided to accept a scholarship to Howard University and enrolled in the school's theatre program.

Dickerson's professors at Howard included a roster of significant African American literary scholars and theatre professionals such as Whitney LeBlanc, Eleanor Traylor, James Butcher, Ted Shine, Anne Cooke Reid, Marian McMichael, and Owen Dodson. In an interview in January 1983, Dickerson revealed that of all these theatre luminaries, it was Dodson, a noted poet, playwright, and director, who Dickerson states had the "profoundest impact" on her life and career. Dickerson acknowledges that Dodson gave her and her classmates "an extraordinarily personal affinity for the classics. Mr. Dodson beat it into our heads in a most poetic way so that Clytemnestra, Orestes, Medea, Hamlet, all of them, Hecuba, Andromache, are like family to us." Additionally, it was Traylor, an eminent scholar of African American literature and criticism, who instilled in Dickerson adulation for African and African American history, culture, and folklore (H. Dickerson). Accordingly, because of her instructors' varying philosophies Dickerson was trained in a variety of theatre styles and traditions: from the Aristotelian model found in ancient Greek theatre to African oral traditions and African American mythology and folklore.

Dickerson graduated from Howard in 1966 with a Bachelor of Fine Arts. Prior to earning her Master of Arts in Speech and Theatre from Adelphi University in 1969, she founded a theatre company between 1967 and 1968, TOBA (Tough on Black Actors), named in honor of the 1920s–1930s vaudeville circuit for Black performers. Although short-lived, it was during her time with TOBA that she began to create works that combined oral narratives, choreographed movements, and ensemble compositions. Dickerson's aesthetic has been described as being closely akin to Ntozake Shange's choreopoem. However, according to Taquiena Boston and Vera J. Katz, Dickerson was doing this stylistically devised work prior to Shange: "Drawing on her intense training in choral and oral interpretation … Dickerson was perfecting the 'choreopoem' before the term was coined for the famed production *for colored girls*" (22). Significantly, elements of the choreopoem would become staples found in many of Dickerson's conceived works.

Dickerson returned to Howard as an assistant professor of theatre in 1969. She was instrumental in developing the Black theatre scene in Washington, DC, from the late 1960s well into the mid-1970s. The Black theatre scene in Washington was piloted by three important

institutions: Workshop for Careers in the Arts (which later merged into Western High School for the Arts in 1974 and remounted as Duke Ellington School of the Arts in 1976), the DC Black Repertory Company, and the Black American Theater Company, where Dickerson served as artistic director from 1969–1972. Believing in the notion that "black theater must play a role in helping bring about Black liberation" ("Black Women"), Dickerson forged a relationship with each of these institutions and began creating works that evidenced what theatre scholar Nadine George-Graves considers "the intersections between African American performance, activism, and civic service," where theater can "create a sense of shared community against overly oppressive and subtly hegemonic forces" (197). These works included N.R. Davidson's *El Hajj Malik* (1970, Howard University); *The Trojan Women* (1970, Howard University); *Jesus Christ, Lawd Today* (1972, Sylvan Theater, Washington, DC); *Jump at the Sun* (1972, Theater Lobby, Washington, DC); *Owen's Song* (1973, Last Colony Theatre, Washington, DC); and *Magic and Lions* (1977, Women's Interart Theatre, New York). With these works, Dickerson focused on staging the "drylongso," what she recognized as the "ordinary, plain, everyday" people ("Cult" 179). In staging the drylongso, Dickerson was bringing to the forefront what John Langston Gwaltney calls "core black culture" that is embodied by personal narratives that express the "values, systems of logic and world view" of everyday people (xxii, xxvi).

Having received an Emmy Award nomination in 1971 for her direction of the television performance of Alice Childress' play *Wine in the Wilderness*, a Peabody Award in 1972 for conceiving and directing *For My People*, and an Audelco Award for Best Director in 1977 for *Magic and Lions*, Dickerson became one of the preeminent directors of her time. Even with the accolades, however, professional theatre did not sustain Dickerson financially. For that reason, she turned to academia primarily as way to support herself and her family (A. Dickerson). Dickerson would later proclaim that academic theatre allowed her both a space and a sense of freedom to conceive and direct works that she felt were most impactful without the constraints of conventional theatre: "My vision could not be contained in a bedroom, a kitchen" ("Wearing Red" 156). After serving as the first Drama Department Head at Duke Ellington School of the Arts (1973–1976), Dickerson found herself teaching at several universities including Fordham University at Lincoln Center (1977–1981); Mason Gross School of the Arts (1981–1983); SUNY at Stony Brook (1983–1988); Rutgers University, New Brunswick, NJ (1988–1992); and Spelman College (1992–1997).

In 1978, Dickerson was hired as resident director for the Negro Ensemble Company (NEC), mounting works such as Judi-Ann Mason's *Daughters of the Mock* (1978) and Alexis De Veaux's *A Season to Unravel* (1979). With these productions, Dickerson worked with a host of distinguished actors like Michelle Shay, L. Scott Caldwell, Barbara Montgomery, and Adolph Caesar. Moreover, the NEC afforded Dickerson ample opportunities to dabble in works that, to quote Douglas Turner Ward, "provided the NEC with unique female perspectives and additional stylistic diversity" (xvii). After her time with the NEC Dickerson continued on a streak of mainly directing plays by and about Black women: *NO!* by Alexis De Veaux (1981, New Federal Theatre, NY); *The Haitian Medea*, an original adaptation (1982, Hansberry-Sands Theatre, Milwaukee); *Ma Lou's Daughter* by Gertrude Greenidge (1983, No Smoking Playhouse, NY); *Black Girl* by J.e. Franklin (1986, Second Stage, NY); *Tale of Madame Zora* by Aishah Rahman (1986, Ensemble Studio Theatre, NY); *Long Time Since Yesterday* by P.J. Gibson (1988, St. Louis Black Repertory); *Wet Carpets* by Marion Warrington (1988, Crossroads Theatre Company, New Brunswick, NJ); and *Shakin' the Mess Outta Misery* by Shay Youngblood (1988, Horizon Theatre Company, Atlanta). It is important to note that these productions heralded Dickerson's turn towards a Black feminist consciousness through artistic praxis while simultaneously evidencing the burgeoning of Black women playwrights receiving a steady stream of productions at well-established theatre companies.

In two critical essays Dickerson reflects on her choice to focus primarily on women-centered works, explicitly expressing her commitment to decentering herself and subsequently her art from "the norms of a dominant heterosexual ideology ("Wearing Red" 157). The first essay is "The Cult of True Womanhood: Toward a Womanist Attitude in African-American Theatre." Part-autobiographical, part-manifesto, Dickerson states that her mission in the arts was to resist the stereotypes of Black folk that were born out of "minstrel shows and plantation literature" (179). Accordingly, Dickerson made it her life's work to reclaim the culture and history of Black people through the use of African American folklore. Taking her cue from folklorist, anthropologist, and literary giant of the Harlem Renaissance Zora Neale Hurston, Dickerson regarded folklore as a method to connect the past with the present, to acknowledge the genealogy of cultural traditions and philosophies, and to preserve the histories of a people through storytelling. Dickerson maintained that folklore—especially for Black women—should be used as a "liberating, subversive weapon" (179). By staging the folklore of Black women Dickerson resuscitated the "silenced voice of the woman of color," providing space for her own subjective words to be heard and counted for and to not depend on an often-distorted illustration.

The second essay, "Wearing Red: When a Rowdy Band of Charismatics Learned to Say 'NO!'" details her cathartic experience of finding her "liberatory voice" when she co-conceived and directed Alexis De Veaux's *NO!* (158)." The first step was approaching Alexis De Veaux and forming a collaboration to produce a new piece based on a collage of De Veaux's poetry, plays, critical essays, and short stories. A major element within De Veaux's writing is the topic of sexuality, which Dickerson wanted to highlight because women's sexuality is typically considered "things unspoken, the taboos, the personal stuff" (158). The collaborators embraced what Black feminist poet Audre Lorde referred to as the act of transforming silence into language, thus activating the belief that what is important "must be spoken, made verbal and shared, even at the risk of having it bruised or misunderstood" (40). Dickerson's second step towards finding a "liberatory voice" was in her and De Veaux's choice to produce the work on their own rather than waiting for a theatre company to offer space and financial backing. The third step was deconstructing the rehearsal space from one of hierarchy to one of collaboration. Collaboration and ensemble-based performance were always elements within Dickerson's work; yet, in this case, she questioned her role as director. She challenged the notion that the director was the sole or lead visionary during the rehearsal process. Not wanting to sit among the "ranks of directors," Glenda Dickerson declared herself a "PraiseSinger." Her aim was "not to invent but to rediscover and to animate" and be "concerned not with acts, and scenes and curtains; but with redemption, retrieval, and reclamation" ("Cult" 187).

An example of Dickerson subverting the traditional role of the director was to not refer to the cast as actresses, but rather as divas. And the one male cast member was referred to as the count. These weighty titles suggest not only a role of importance but also a position of equal authority with regards to the creative process. As such, Dickerson reworked the notion of directorial authority as she allowed the divas' voices to dictate the material assigned. Further, Dickerson did not enter the rehearsal space with a prompt book of predetermined blocking, but rather the divas and the count were invited to co-devise blocking as their bodies moved to the rhythmic intonations of their dialogue.

Dickerson's Black feminist/womanist consciousness carried over into almost every aspect of her professional life. It was especially evident in her pedagogy. When Dickerson joined the faculty and subsequently took on the role as chairperson of the Department of Drama at Spelman College in 1994, she made it her mission to bring to the school works by and about women,

especially Black women. According to theatre scholar and Dickerson's former colleague at Spelman College, Paul Bryant-Jackson, Dickerson

> emphasized that the women of Spelman should be at the center of their own discourse and encouraged student writing and performance pieces that explored the lives and struggles of Black women. She also encouraged the production of works by Adrienne Kennedy, Lisa Jones, Kia Corthron, Ntozake Shange, Josefina Lopez, and others.

(241)

Dickerson left Spelman in 1997 and continued to create dramatic pieces that clearly fall under the rubric of a Black feminist/womanist aesthetic: *Re/membering Aunt Jemima: A Menstrual Show* (1994, co-written with Breena Clarke); *Barbara Jordan, A Texas Treasure* (2005, co-written with Lynda Gravátt); and, before her untimely death, Dickerson initiated a lengthy venture at the University of Michigan called *The Project for Transforming thru Performance: Re/placing Black Womanly Images*.

After a short illness, Glenda Dickerson died on January 12, 2012. On April 30, 2012, a host of performers, producers, former students, and theatregoers gathered to celebrate Dickerson's life and legacy at Barbara Ann Teer's National Black Theatre in Harlem, New York. Speakers included producer Woodie King, Jr., Carol Maillard of the famed a cappella group Sweet Honey in the Rock, Dickerson's former student and co-collaborator Breena Clarke, and performer Gwendolyn Hardwick. During the three-hour memorial friends and fellow artists honored Dickerson as a leading pioneer to usher in contemporary Black theatre while simultaneously praising her contribution to the intersecting roots of American theatre, community theatre, academic theatre, and feminist/womanist performance.

## Note

1 For more on Black feminist and womanist theatre theory and praxis, see Anderson.

## Works cited

Anderson, Lisa. *Black Feminism in Contemporary Drama*, U of Illinois P, 2008.

"Black Women 'Star' Behind Scenes in New York Drama: Talented Directors, Producers, Playwrights Work 'On' and "Off" Broadway." *Ebony*, April 1973, pp. 106–112.

Boston, Taquiena, and Katz, Vera J. "Witnesses to a Possibility: The Black Theater Movement in Washington, D.C., 1968–1976." *Black American Literature Forum*, vol. 17, no. 1, 1983, pp. 22–26.

Bryant-Jackson, Paul, with McCarty, Joan. "Performing Spelman: Theatre, Warrior Women, and a Dramaturgy of Liberation." *Radical Acts: Theatre and Feminist Pedagogies of Change*, edited by Ann Elizabeth Armstrong and Kathleen Juhl, Aunt Lute Books, 2007, pp. 223–246.

Dickerson, Glenda. "The Cult of True Womanhood: Toward a Womanist Attitude in African-American Theatre." *Theatre Journal*, vol. 40, no. 2, 1988, pp. 178–187.

———. Personal Interview with Kathy Perkins, New York, January 14, 1983.

———. "Rode a Railroad that Had No Track." *A Sourcebook of African-American Performance: Plays, People, Movements,* edited by Annemarie Bean, Routledge, 1999, pp. 147–149.

———. "Wearing Red: When a Rowdy Band of Charismatics Learned to Say 'NO!'" *Upstaging Big Daddy: Directing Theater as if Gender and Race Matter*, edited by Ellen Donkin and Susan Clement U of Michigan P, 1993, pp. 156–176.

Dickerson, Harvey III, Personal Interview, College Park, Maryland, April 11, 2014.

Dickerson Duncan, Anita. Personal Interview, Durham, North Carolina, November 8, 2015.

George–Graves, Nadine. "African American Performance and Community Engagement." *The Cambridge Companion to African American Theatre*, edited by Harvey Young, Cambridge UP, 2013, pp. 196–214.

Giles, Freda Scott. "Glenda Dickerson's Nu Shu: Combining Feminist Discourse/Pedagogy/Theatre." *Contemporary African American Women Playwrights: A Casebook*, edited by Philip C. Kolin, Routledge, 2007, p. 135.

Langston Gwaltney, John, editor. *Drylongso: A Self-Portrait of Black America*, Random House, 1980.

Lorde, Audre. "The Transformation of Silence into Language and Action." *Sister Outsider: Essays and Speeches*, Crossing Press, 1984, p. 40.

Turner Ward, Douglas. "Foreword." *Classic Plays from the Negro Ensemble Company*, edited by Gus Edwards and Paul Carter Harrison, U of Pittsburgh P, 1995, p. xvii.

# 32

# ERNIE MCCLINTOCK'S JAZZ ACTING

## A theatre of common sense

*Elizabeth M. Cizmar*

In 1965, after training at the Louis Gossett Academy of Acting, an integrated school in lower Manhattan, Ernie McClintock felt a burning desire to create an all-Black school in Harlem (Ernie McClintock Interview). One year later, McClintock and his partner, Ronald Walker, opened the Afro-American Studio for Acting and Speech. Subsequently in 1968, they established the 127th Street Repertory Ensemble, which served as the professional extension of the school. In 1991, the couple moved to Richmond, Virginia, and McClintock changed the name of his acting technique from Common Sense Acting to Jazz Acting.[1] Although the technique evolved over 40 years, Jazz Acting consistently infused the Black Power principles of self-determination and community in training and productions.

Through archival research and interviews with McClintock's pupils, I contend that his pedagogy mirrors jazz aesthetics by responding to the individual challenges of actors and the collective identity of the ensemble, as opposed to a "one size fits all" approach common in Stanislavsky-based training. In 1974 McClintock articulated that his technique encouraged actors to bring their lived experiences, devices, and creativity to create characters beyond naturalism to reveal important traits of the character to the audience (McClintock 82). Through the jazz aesthetic framework, McClintock's method of acting promoted healing and self-determination.

## Defining ourselves: healing through jazz technique in training and performance

Marc Primus, the first instructor of Black history at the Afro-American Studio, defined the school as a healing center to nurture the individual spirit and uplift the community. McClintock's training in the 1960s and 1970s contextualized African-inspired values and the rehabilitation of dislocation and subjugation: "Our people are longing for self-definition and learning about themselves ... That's what the definition of the studio was ...our work was about defining ourselves." Primus situated this approach of self-definition and cultural education in the Black Theatre movement's historical moment.[2] Furthermore, actor Bolanyle Edwards, who trained with McClintock in the 1970s, recalled that "[a]t that time, so many of us were trying to be somebody else and had not accepted ourselves because of what we were told for so long and for so many years." McClintock created an environment that affirmed positive self-image and progress within the African Continuum.

In initial stages of Jazz Acting training, actors were encouraged to embrace their individual identities and trust the ensemble in a class known as "Stretching Out." Al "Suavae" Mitchell explained that, "in the beginning, a part of the work was to get you to be free. Just to be relaxed, to loosen up, and not to be afraid or concerned of how people saw you." In addition to relaxing the actor's instrument and vocal warm ups, "one student at a time rolled over a line of other students lying side by side [bringing] forth a chorus of giggles and groans" (Walker). Through additional exercises, the studio created dynamic relationships among the actors who eventually physically and vocally riffed off of one another, reminiscent of jazz musicians.

This technique corresponded in performance spaces with the foundational trust and ensemble dynamic established early in Jazz Acting training. Although Jazz Acting may appear to overlap with Stanislavsky-based exercises, aspects of mainstream techniques potentially damaged actors of color by triggering cultural trauma and distorting identity formation (Ndounou).[3] This was particularly relevant in plays such as Amiri Baraka's *Slave Ship*, which chronicles the forced voyage of enslaved Africans across the Middle Passage. Baraka's play assaults audiences through evoking ancestral bodies captured by slave traders. Jazz Acting applied a rhythmic and physical approach rather than "emotional recall." During the first rehearsal, the actors turned their heads from left to right for four counts in several repetitions. McClintock then cued the ensemble to vocalize the wind and the water, instructing the actors to "sound out how you feel" (*Slave Ship*). In rhythmic chanting, the men sounded out "ah" and then the women followed suit. The process demonstrated the director's ability to create a haunting and terrifying mood simply with breath and sound. The exercise concluded with McClintock uttering, "quiet, quiet …" The ensemble eventually faded out, and McClintock instructed, "breathe" (Ernie McClintock). Jazz Acting provided actors a safe method to portray Baraka's retelling of brutal dehumanization. Perhaps more importantly, it encouraged actors to access the tenacity of the African spirit.

McClintock's theatre also established a community presence through self-authored performances in unconventional outdoor spaces throughout New York and, in the 1990s, in Richmond. In a 1970 interview, McClintock situated his African American street theatre production *Where It's At—70* in New York's politically charged environment. The production centered on materials that cast members wrote, created, and/or chose from a range of genres, including dance, poetry, and music. Audiences connected to the everyday sociopolitical concerns that the company members chose to highlight. The performances ended with cast members singing familiar folk songs that invited locals to join in, transforming the event into a spontaneous communal performance. Hence, McClintock's street theatre genre personified a traveling community center, echoing the Black Panther's commitment to civic engagement. Some 30 years after his premiere of *Where It's At—70*, McClintock continued to produce street theatre in Richmond, where actors expressed their own community concerns in, for example, *Ndangered*. The cast included young Black men confronting issues such as incarceration, father absence, sexually transmitted diseases, and racism through hip hop-themed soliloquies, African dance, and percussive accompaniment.

## Jazz acting and self-determination

Niglin Anadalou-Okur observes, "collectivity is not meant to be anti-individualistic, it is rather the ability to reach the collective consciousness of the people" (16). Similarly, McClintock challenged the traditional paradigm in theatre in which actors serve the director's vision. According to McClintock,

the most important part of the creative process is that the creative artist has his creative input, which goes beyond just interpreting what someone else wants … A lot of actors find themselves restricted by having to work in situations with directors who are interested in only their point of view being presented.

(Hilliard 12)

Moreover, a self-determined actor can activate social change by exposing the audience to Black experiences without stereotypical representation, exposure that can ameliorate everyday racisms.

The actor's agency manifested in subverting text, echoing William J. Harris' definition of Jazz Aesthetics as a procedure of converting white poetic and social ideas into Black ones. McClintock's method allowed the actors to exercise collective agency, which had the potential to subvert the meaning of Eurocentric texts. His AUDELCO-winning 1982 production of Peter Shaffer's *Equus* revised a white European story in the context of Black Queer sexuality. Shaffer's source text tells the story of Alan Strang, a white British teenager, growing up in a dysfunctional household with a religious fundamentalist mother and an atheist father. His inner turmoil surfaces in his pathological obsession with horses and his inability to explore his sexual urges with his friend Jill, culminating with the teenager blinding his horses.

In McClintock's production, actors accessed self-determination to foster community healing from a Black Queer perspective, a lived experience typically excluded from Black Power ideology. In this way, McClintock's training and productions demonstrated that perspectives outside of heteronormative standards were equally representative of the Black Arts Movement. In the original version of *Equus* and in revivals since, the actors wear masks to portray the horses. Instead of relying on a literal interpretation of the text, McClintock insisted on focusing on the horses' physicality through what he called "character observations." Actor Jerome Preston Bates, who won two AUDELCOs for best supporting actor and best choreography, and his fellow "stallions," went to Central Park, observed horses, and slept in the stables. A bare-chested, unmasked Bates astounded audiences by personifying the horse Nugget's precise gaze, soft whinny, and resounding neighs based on his character observations. In Gregory Wallace's portrayal of Alan, the adolescent gained confidence and escaped his suppression upon mounting Bates: "The wildest thing about it was six Black men in leather, incredible and unabashedly sexual and sensual … being with me completely … The show clicked—everyone's jaw dropped" (Wallace). The production, hailed by both white and Black critics, became a "must-see" production for theatre patrons to make the pilgrimage to Harlem to witness this reinterpretation of the British classic. Through Jazz Acting's character observations and ensemble dynamic, *Equus* achieved the resolve of self-determination to "call our own names and define our own terms" (Hilliard 12).

The essence of jazz includes multiple voices or, as Sharon Bridgforth and her collaborators articulate, "simultaneous truths" (Jones 6), and McClintock asserted that for "most Black people music is a significant part of existence" (84). McClintock integrated music/rhythm as part of the Jazz Acting technique as a means of helping actors access the physical expression and emotional truth of their characters, resulting in a profound connection to music that permeates the performance. Hence, a critical component of Jazz Acting requires identifying the character's cadence and the ensemble's collective rhythm. In 1971 McClintock produced N.R. Davidson's *El Hajj Malik*. Actor Woody Carter struggled to find an entry point to portray the iconic, incarcerated leader. In rehearsal, McClintock played jazz musician Archie Shepp's "Malcolm, Malcolm—Semper Malcolm" at a piercing decibel. "[The song is] very chaotic," remembered Carter. "It sounds like the guy is in an insane asylum but for that particular scene it was particularly helpful. For the scene, I measured out that space and put on Shepp's piece and thought

about what was expressing in the scene through the body language." The dissonant tones afforded Carter a dynamic embodiment of Malcolm X's physical and emotional anguish. For the ensemble, McClintock rehearsed scenes in reverse to find a collective rhythm among the actors. Notably, McClintock considered Davidson's play a "contemporary Black Classic" due to its historical significance and Afrocentric perspective, which specifies that all cast members play Malcolm X at varying stages of the slain leader's life.

## Conclusion

McClintock's legacy continues through his pupils in New York, Los Angeles, and Richmond, who apply Jazz Acting in their work. Disseminating McClintock's technique, spanning four decades, etches a path for future creative and scholarly projects. For example, acting teachers and directors often evoke the notion that actors must be "in the moment" onstage. In my teaching experience, novice actors struggle with breaking free from line readings and achieving emotional truth. Specifically, within mainstream techniques, instructors have been known to ask actors to access past traumas, resulting in an unhealthy mental state. Conversely, in Jazz Acting, actors use character observations and music as entry points to the internal life of the character. Once actors are grounded in the fundamentals and make their own choices to create character, they are able to allow the text to take on new meaning and riff in the moment with their fellow ensemble members.

## Notes

1 Walker worked as the technical director, lighting designer, and set designer, and his contribution in forming the school is significant. The scope of this article focuses on McClintock.
2 The Black Power movement was a political movement that advocated for racial pride and self-sufficiency. The Black Arts Movement, or the "spiritual sister" of Black Power, as defined by Larry Neal, emphasized the social function of art. The Black Theatre movement established professional companies to bring Black stories told and performed by Black actors in their communities.
3 The theatre is a space of identity formation through imagination and representation that "links past to present" (Eyerman 2).

## Works cited and further reading

Anadalou-Okur, Nilgun, *Contemporary African American Theater: Afrocentricity in the Works of Larry Neal, Amiri Baraka, and Charles Fuller*. Routledge, 1997.
Asante, Molefi Kete. *The Afrocentric Idea*. Temple UP, 1998.
Baraka, Amiri. "*Slave Ship*." *The Motion of History and Other Plays*. William Morrow, 1978.
Bates, Jerome Preston. Personal Interview. Aug. 31, 2015.
Carter, Woody. Personal Interview. Sep. 29, 2015.
Davidson, N. R. "*El Hajj Malik*." *New Plays from the Black Theatre*, edited by Ed Bullins, Bantam, 1968.
Edwards, Bolanyle. Personal Interview. Aug. 25, 2015.
Eyerman, Ron. *Cultural Trauma: Slavery and the Formation of African American Identity*. Cambridge UP, 2008.
Harris, William J. *The Poetry and Poetics of Amiri Baraka*. U of Missouri P, 1985.
Hilliard, David. *The Black Panther Party*. Dr. Huey P. Newton Foundation, 2008.
Jones, Omi Osun Joni L. "Making Space: Producing the Austin Project." Experiments in a Jazz Aesthetic: Art, Activism, Academia, and the Austin Project, edited by Omi Osun Joni L. Jones, Lisa L. Moore, and Sharon Bridgforth, University of Texas Press, 2010, pp. 3–11.
McClintock, Ernie. "Doris Freedman Interviews Founder and Director of the Afro American Studio for Acting & Speech," www.wnyc.org/story/ernie-mcclintock. Accessed Apr. 14, 2016.
McClintock, Ernie. Interview by Robert Wilson. Countee-Cullen Harold Jackman Memorial Collection, Archives Research Center, Atlanta University Center.

McClintock, Ernie. "Perspective on Black Acting," *Black World*, May 1974, pp. 79–85.

Mitchell, Al. Personal Interview. Aug. 24, 2015.

Ndounou, Monica White. "Acting Your Color: The Power and Paradox of Acting for Black Americans." Center for Humanities at Tufts University, Feb. 24, 2015, Medford, MA. Lecture.

Primus, Marc. Personal Interview. Aug. 25, 2015.

Shaffer, Peter. *Equus*. Scribner, 1973.

*Slave Ship* rehearsal at the 127th Street Repertory Ensemble, Tape Recording, Jan. 23, 1975, Private Collection of Geno Brantley, Richmond, Virginia.

"Studio A Series, directed by Ernie McClintock." *Style Weekly*, March 2002.

Walker, Greta. "If You Must Act, Act Now." *New York Magazine*, Sep. 1971.

Wallace, Gregory. Personal Interview. Sep. 16, 2015.

Williams, Mance. *Black Theatre in the 1960s and 1970s: A Historical-Critical Analysis of the Movement.* Greenwood Press, 1985.

# 33

# BLACK ACTING METHODS®

## Mapping the movement

*Sharrell D. Luckett*

Long before Greeks, Africans participated in festivals and religious celebrations that honored humanity and the fruits of the Earth. With this, let us imagine that there were customs and rules of engagement that the performers (actors) followed in order to successfully complete the rite or celebration. Like acting theorists of the twentieth and twenty-first centuries, actors of ancient African civilizations created processes and techniques to help the performer perfect their role. However, as acting theory began to take shape in the United States in the early 1900s, the history of African and Black American acting theories and their possible influences and contributions to acting theories of the white Western canon were largely ignored, hidden, and erased due to racism. Fortunately, in recent years many acting and directing teachers have become invested in diversifying theories and teaching materials in US acting classrooms. Still, the primary methodologies taught at many institutions are of white European lineage. Thus, this chapter contributes to the necessary work of including the methods of Black American performance theorists in the history of acting and directing pedagogy in the United States. In particular, the Black Acting Methods® movement centers the voices of acting theorists whose pedagogy is of Africanist and Black American expressive traditions.

Focusing on Black American contributions to acting and directing theory in the twentieth century, this chapter highlights three key figures in actor training: Frank Silvera, Barbara Ann Teer, and Freddie Hendricks. Silvera, Teer, and Hendricks all devoted a large part of their careers to cultivating and providing space for new, diverse, and culturally specific ways of thinking about and implementing actor training. Rather than fully detailing Silvera, Teer, and Hendricks' methodologies, this chapter provides a brief overview of the philosophical underpinnings of their teachings (see the endnotes for resources about each acting theorist). Their work, along with many other Black American acting teachers, paved the way for the 2016 release of the foundational book *Black Acting Methods: Critical Approaches*, edited by Sharrell D. Luckett and Tia M. Shaffer. This chapter concludes with a brief overview of *Black Acting Methods* and shares how the book sparked the 2017 founding of the Black Acting Methods® Studio, the nation's first certificate program and training studio in acting and directing methodologies rooted in Africanist and Black American cultural traditions and epistemologies.

# "Theatre of Being": the American Theatre of Being

## *Frank Silvera (July 24, 1914–June 11, 1970)*

Frank Silvera was an American actor and director who worked in the film and theatre industry in the early to mid-twentith century. He emigrated from Jamaica during his early childhood years. His mixed heritage of various ethnicities, including Black and Latino, provided him with a racially ambiguous look as an actor. This "look" allowed him to play many non-Black roles— roles that allowed him to show a full range of emotions.

Silvera became disheartened when he continuously saw identifiably Black actors often receiving stereotypical, detrimental, and negative roles. He was dismayed and rightfully disappointed with the racism that Blacks endured in the entertainment industry. The fact that Black actors were almost always hired to portray demeaning roles and had very few options to receive formal acting training compelled Silvera to begin coaching many Black actors and to provide a space for them and others to train.

In 1963 Silvera founded the American Theatre of Being in Los Angeles, CA. This entity operated as both a training space and an acting methodology. In his methodology, Silvera wanted the actor to experience the character rather than portray the character (Stewart 15). He wanted the actor to focus on simply being, unveiling the universality in humanity. Silvera believed that a "being" actor is "one who is able to identify as the person whose life the actor is portraying and who accepts that character's point of view—his definition and perceptions of himself" (12). Silvera also hoped that his training methodology would allow casting agents to see that Black people were actually nothing like the stereotypical and detrimental roles that they were often asked to portray.

Beah Richards (1920–2000), an indomitable actress who was nominated for both an Academy Award and a Tony Award, trained with Frank Silvera, and she is said to have been one who truly understood Silvera's methodology. In fact, she taught classes at the American Theatre of Being. In her course syllabus, Richards defined Being as "mortal existence in a complete and perfect state, lacking no essential characteristic" (11).[1] Though the American Theatre of Being was short lived, closing in 1967, the company produced highly successful plays such as *The Amen Corner* by James Baldwin, which ran for two years and six months (57). Beah Richards starred in this play and received critical acclaim for her work, including a Tony Award nomination.

In addition to working with Beah Richards, Silvera also worked with other notable African American actors such as Avery Brooks, Louis Gossett, Jr., and Tommie "Tonea" Stewart. In fact, in 1989 Dr. Stewart completed an in-depth study of Frank Silvera and the American Theatre of Being for her dissertation studies at Florida State University. Stewart offered that "Silvera's technique attempted to help the Negro shake off the shackles of stereotypes and become a visible, believable, and representative artist on stage and screen" (39–40). She also stated that "to Be meant to invest something of one's soul into and under- neath the character for universal reference in order to achieve a full dimensional experience (49). Stewart's dissertation is actually the only full-length study of Silvera's acting method- ology and company. Dr. Stewart now serves as Dean of the College of Visual and Performing Arts at Alabama State University, a HBCU in Montgomery, Alabama, where Theatre of Being is a component of the acting curriculum. The Department of Theatre Arts is chaired by Dr. Wendy R. Coleman.

## "Teer Technology of Soul": the National Black Theatre

### *Dr. Barbara Ann Teer (June 18, 1937–July 21, 2008)*

Born in East St. Louis, Illinois, Dr. Barbara Ann Teer was a successful dancer, actress, and theatre director who would go on to establish the National Black Theatre (NBT) in Harlem, NY, in 1968. As the CEO of NBT, Teer developed an acting methodology called the "Teer Technology of Soul," which was taught for over 20 years.

Teer Technology of Soul is an acting technique specifically designed with Black actors in mind. Teer understood that Black actors needed to be uplifted and honored in unique and culturally specific ways because of their lived experience in a racist and unequitable America. Therefore, her actors received holistic training that was concerned with the well-being of the entire actor as she or he worked on portraying a character. The technique consisted of actors taking several courses, including movement and dance, meditation and spiritual release, liberation theory, identity building, writing courses, and entrepreneurial courses. Actors were also asked to participate in community work, identifying and honoring the expansive diversity of Black life and personhood in Harlem as well as attend Black Pentecostal church services (Thomas 112–129). Teer believed that by attending Black worship services "students could gain further insight into the character of their own people" (109). She valued the emotional activities that occur during worship services and wanted her students "to discover the close connection between the spirit and the senses" (109). Teer's programming culminated in an uplifting, self-affirming graduation ceremony (123–125). Upon graduation, students who were trained in Teer Technology of Soul had a greater sense of self and responsibility to their community, which, in turn, made them better able to access and portray the complexities of Black American characters and life.

In 1997, Lundeana Thomas, Professor Emerita of Theatre at the University of Louisville and co-founder of the first and only graduate certificate program in African American Theatre in the United States, published an expansive study of Dr. Barbara Ann Teer's legacy, *Barbara Ann Teer and the National Black Theatre: Transformational Forces in Harlem.*

In 2018, the NBT celebrated its forty-ninth season with the theme "Black to the Future." The organization's current core mission is to produce transformational theatre that educates and informs, and that provides a safe space for artists of color to express themselves (Core Mission). Although Teer Technology of Soul classes are no longer taught (Faison), NBT still offers symposiums and various training series for Black artists such as staged readings.[2] The National Black Theatre also produces a full season of plays with Teer's daughter, Sade Lythcott, serving as the CEO. Undoubtedly, Teer's theatre remains a symbol of vitality and artistic production in the Harlem community and abroad.

## "Hendricks Method": the Freddie Hendricks Youth Ensemble of Atlanta[3]

### *Freddie Hendricks (b.1954)*

Freddie Hendricks was born in Rome, GA, in 1954. After graduating high school, he pursued acting at Lincoln Memorial University in Tennessee, earning a Bachelor of Arts degree in Theatre in 1976. In 1990, following a decade of a successful career as an actor, he and a few close friends incorporated the Freddie Hendricks Youth Ensemble of Atlanta. Based in Atlanta, GA, the teen and young adult ensemble quickly became a force to be reckoned with in the arts community as they consistently created full-length musicals about social and political issues such as teen pregnancy and HIV/AIDS.

During his 15 years of work with the ensemble, Hendricks developed the Hendricks Method. Like Teer Technology of Soul, the Hendricks Method was specifically developed with the Black actor in mind. The Hendricks Method is defined as "an amalgamation of empowered authorship, musical bravado, spirituality, ensemble building, activism, effusive reverence of Black culture, and devising, often [without a] script" (Luckett and Shaffer, "Hendricks Method" 21). Hendricks' rehearsals often began and ended with prayers and testimony, acknowledging the profound role that spirituality holds in Black cultural traditions. During rehearsals, ensemble members would be prompted to create original material by singing, dancing, acting, or even playing a musical instrument. Full scripts were not used or created, signaling the respect for oral tradition in the Black community. Hendricks operated as a sort of maestro, piecing together the students' offerings that would evolve into a full-length musical with the students often serving as the musicians in addition to acting.

After training in the Hendricks Method for several years, many students went on to have successful careers on the stage and screen. Some of Hendricks' notable protégés are Kenan Thompson (Saturday Night Live), Sahr Ngaujah (Tony nominated actor for *Fela!*), Saycon Sengbloh (Tony nominated actress for *Eclipsed*), Kandi Burruss (Real Housewives of ATL & member of Xscape), Kelly Jenrette ("Pitch" on Fox), Charity Purvis Jordan (*Selma*), Jahi Kearse (Broadway's *Baby It's You* and *Holler If Ya Hear Me*), Day Byrd (creator of pop icon Nicki Minaj's signature look), and Juel D. Lane (Camille A. Brown & Dancers, former dancer with Ronald K. Brown/EVIDENCE). In addition, those trained in the Hendricks Method have earned degrees from New York University, Carnegie Mellon University, University of North Carolina School of the Arts, Howard University, Cincinnati Conservatory of Music, Spelman College, and the University of the Arts, to name a few. They have also attended Yale University, the Juilliard School, and Cornell University.

In 2005, Freddie Hendricks resigned from the company to pursue other artistic endeavors, leaving Debi Barber and Charles Bullock to continue the important work of managing the company, now known as the Youth Ensemble of Atlanta. Having codified the method as an acting teacher and director, Sharrell D. Luckett currently conducts workshops and lectures about the Hendricks Method along with Freddie Hendricks. In fact, Luckett's research on the Hendricks Method and the success of the Freddie Hendricks Youth Ensemble of Atlanta inspired her and Tia M. Shaffer to publish the foundational book in acting theory and pedagogy, *Black Acting Methods: Critical Approaches*, which is the focus of this chapter's final section.

## *Black Acting Methods: Critical Approaches* (edited by Sharrell D. Luckett with Tia M. Shaffer)

In the fall of 2016, *Black Acting Methods: Critical Approaches* was released. Sharrell D. Luckett and Tia M. Shaffer, both acting teachers and directors, had been surprised to learn that such a collection did not already exist. So they made it their duty to highlight the work of performance theorists whose methodologies and techniques are rooted in an Africanist and Black American cultural aesthetic.

Black acting methods are defined as rituals, processes, and techniques rooted in an Afrocentric centripetal paradigm. In such a model, Black theory and modes of expression are the nucleus that informs how one interacts with various literary and embodied texts as well as how one interprets and (re)presents imaginary circumstances. The book set out with four goals in mind: (1) to rightfully identify and re-center Blacks as central co-creators of acting and directing theory; (2) to provide culturally relevant frameworks for Black people who are pursuing careers in acting; (3) to diversify teaching material in the acting classrooms, and (4) to

highlight the role of activism and social justice found within the performance methodologies (Luckett and Shaffer, *Black Acting* 2).

Endorsed by theatre luminaries Anne Bogart and Kenny Leon, the book includes ten offerings (chapters) that outline Black American cultural methods, techniques, and rituals.[4] For instance, in the second offering, actor, scholar, and founder of Progress Theatre Cristal Chanelle Truscott discusses her methodology, called SoulWork; while, in offering six, professor and actress Tawnya Pettiford-Wates espouses on her work with "Ritual Poetic Drama within the African Continuum." The book also includes two special sections where even more distinguished practitioners share their processes and provide words of wisdom to students (with special attention paid to Black students) who are pursuing careers in acting.[5] The book concludes with useful suggestions for ways that acting programs can provide equitable training for all acting students.

Soon after the book was released, Luckett and Rahbi Hines, her artistic partner and practitioner of the Hendricks Method, embarked on a very successful HBCU book tour, visiting several colleges and universities on the east coast (the HBCU Tour). The inspirational feedback and responses that they received as a result of guest lectures and master classes impelled Luckett to act upon the next phase of her vision.

In the fall of 2017, Luckett founded the Black Acting Methods® Studio with generous support from her home institution, Muhlenberg College in Allentown, Pennsylvania. The Black Acting Methods® Studio is the nation's first educational program and training studio that specifically focuses on the history and implementation of Black acting methods. Muhlenberg students are able to apply for admittance into the program, and, if accepted, they participate in reading and research sessions, workshops, and embodied practices that center Black performance theory. In addition, Luckett offers Black Acting Methods® lectures, workshops, and actor training to entities outside of Muhlenberg College.

The founding of the Black Acting Methods® Studio and the success of *Black Acting Methods: Critical Approaches* would not have been possible had it not been for the work of Frank Silvera, Barbara Ann Teer, Freddie Hendricks, and many other scholars and teachers working on Black performance in the African Diaspora. As US theatre institutions continue the necessary work of diversifying their spaces and places, the Black Acting Methods® movement is a key player in this important endeavor inside and outside of the academy.

## Notes

1  See also *BEAH: A Black Woman Speaks*. Richards offers a variation of this quote during the filming.
2  The author called the NBT to inquire about classes and courses offered. Nabii Faison informed her that Teer Technology of Soul courses were no longer offered. He stated that the courses ended around the 1990s.
3  Select portions of this section are cited from Luckett and Shaffer ("Hendricks Method" 19–36).
4  Chapter contributors include Rhodessa Jones, Cristal Chanelle Truscott, Lisa Biggs, Justin Emeka, Clinnesha Sibley, Tawnya Pettiford-Wates, Daniel Banks, Aku Kadogo, Kashi Johnson, Daphnie Sicre, Sharrell D. Luckett, and Tia M. Shaffer.
5  Distinguished practitioners include Judyie Al-Bilali, Tim Bond, Walter Dallas, Sheldon Epps, Shirley Jo Finney, Kamilah Forbes, Nataki Garrett, Anita Gonzalez, Paul Carter Harrison, Ron Himes, Robbie McCauley, Kym Moore, Seret Scott, Tommie "Tonea" Stewart, and Talvin Wilks.

## Works cited

*BEAH: A Black Woman Speaks*. Directed by Lisa Gay Hamilton. Women Make Movies, 2003.
"Core Mission." *National Black Theatre*, www.nationalblacktheatre.org/about-us.

Faison, Nabii. Phone conversation. June 2017.

"The HBCU Tour—Black Acting Methods®." *You Tube*, uploaded by S. L., June 19, 2017, https://youtu. be/JOpCkWxyO3E.

Luckett, Sharrell D., and Tia M. Shaffer, editors. *Black Acting Methods: Critical Approaches*. Routledge, 2017.

Luckett, Sharrell D., and Tia M. Shaffer. "The Hendricks Method." *Black Acting Methods: Critical Approaches*, edited by Sharrell D. Luckett and Tia M. Shaffer, Routledge, 2017, pp. 19–36.

Stewart, Tommie Harris. *The Acting Theories and Techniques of Frank Silvera in his "Theatre of Being."* 1989. Florida State University. PhD dissertation, WorldCat (28981061).

Thomas, Lundeana. *Barbara Ann Teer and the National Black Theatre: Transformational Forces in Harlem*. Garland, 1977.

# 34

# FINANCIAL FITNESS OF BLACK THEATRES

## Roundtable of artistic directors

*Moderated by K. Zaheerah Sultan*

CEO, MIND YOUR BUSINESS ART
BLACK THEATRE NETWORK CONFERENCE—"BLACK THEATRE: FUTURE FORWARD"
COLUMBIA COLLEGE, CHICAGO, ILLINOIS
AUGUST 8, 2016

### Panelists

Eileen Morris, artistic director, the Ensemble Theatre of Houston, Texas. Founded by George W. Hawkins in 1976.

Kemati J. Porter, artistic director, eta Creative Arts Foundation. In the past 45 years, eta has evolved to become a recognized cultural treasure not only in the city of Chicago but also nationally and internationally.

Jackie Taylor, founder and artistic director, Black Ensemble Theatre, Chicago. Taylor is also a writer, producer, and director at the 40-year-old institution that is committed to eradicating racism.

Phillip Thomas, former president and CEO, eta Creative Arts Foundation, and Senior Program Officer, Chicago Community Trust.

Greg Williams, founder and artistic director, New Venture Theatre, Baton Rouge, Louisiana. Founded in 1997 to enable the performing arts to be more accessible to the underserved.

Nykiiah Wright, founder, Ms. Nikki's Traveling Story Bag, Toledo, Ohio. Founded summer of 2013.

ZAHEERAH: Please share some of the challenges you saw in the grants submission process for African American theatres when applying for funding from foundations.

PHILLIP: What I would say in general is that we should never forget that the grant awarding process is a competitive process. There are always more people that want the money than there is money to be distributed. So that even in the best of circumstances when you add race, ethnicity, culture, the state of the economy, you complicate all of that. Now, what does getting this mean? It means that any grant proposal has to be the best that it could possibly be, and even that doesn't assure funding or guarantee it.

I think the broad question for any organization is, what does this grant-funding mean for me in my mix of revenue? What proportion is the grant in my budget? Is it the right proportion? Do I have other ways of getting this money? If this money went away, would we survive? You have to think about each grant opportunity as a strategic opportunity, and understand where your organization is going. And frankly speaking, most nonprofits, nonprofit theatres, and most Black theatres depend too much on foundation money. They leave most of the money on the table and that is the money that's in our community and it's our people.

Across foundations and across the fundraising realm, the biggest source of money is from individual donors. If you look at the balance sheets of nonprofits, nonprofit theatres, and Black-owned nonprofit theatres, the grants section is the smallest line item. So the "thing" that gets the biggest attention in the industry is the smallest contributor. The institution that gets the most money as a category from individuals, and the ones that get the most money period, are churches. The church raises the most money in America. Why does it raise the most money? The church receives more money because it asks for money all the time. And it asks for little denominations. We go after these huge foundation grants. But the bedrock for nonprofits is little grants, little individual gifts under $100.00. What we have to do as nonprofit Black theatres is become more sophisticated in our fundraising operations at that wholesale, retail level of getting all new folks. We need to cultivate our theatre patrons and make them donors, cultivating them up the ladder and creating something that is going to be sustainable at the time.

KEMATI: So much of grant approval has to do with your connection to the decision makers and who's sitting at the table. I've had the opportunity to serve on national and local panels, and I understand the importance of networking to improve the process of moving your organization forward. Networking is important to find out which institution is interested in terms of moving forward in the process of forming a relationship with your nonprofit. So, I think the arm wrestling and the negotiation can be an unnecessary challenge. You walk into a room and are given huge binders to read hundreds of grants. And after a few experiences and understanding how this game is played, you're either going to come to the battle or you just [don't] come in the room. I fought in enough battles to know that the ones I did fight in, I didn't want to come back to the room. I'm also a firm believer in community support for our institutions. They write the checks. Grants are necessary, we all know that, but just know that it's an uneven playing field once you sign on the dotted line and send it out.

ZAHEERAH: Thank you, Kemati. This is a question for everyone since we were talking about how challenging grants can be. How do you maintain sustainability? How do you make sure that your theatre continues to exist? Kemati's theatre is 45 years old, Jackie's is 40, Eileen's is 40, Greg's is 10, and we have a newbie in the house—Ms. Nikki's Traveling Story Bag is 4 years. How do you all manage sustainability?

GREG: I think I look at things differently because I have an MBA; I don't have an MFA. For me the main thing is I'm always looking at things from the flip side. The first thing is managing your organization so that it has at least five cash flow models, so that money is coming in from different directions. Also, finding ways for everyone to be able to give. I think too often we have this idea that getting $5 or $20 bills from someone isn't going to keep the doors open, but you will be amazed how good people feel when they give.

I put a box outside that says "365: Will you help us raise 365 $20 bills by the end of the season?" and people give to that. People give into the idea of being a part of this process.

When you're purchasing a ticket online, are you willing to donate an extra $5 to help with sustainability? I do that. I can't write you a $1,000 check, but I can give you $20, and we have far more grassroots things that we can do. We have grants and large donors, but we rely heavily on those grassroot principles to keep our doors open. Also, looking at those, knowing where your money is coming from. Too often I walk in, and I'm walking around looking for someone to buy a bag of chips from. How well developed is that? How well developed is your box office staff? Are you renting islands? What about pipe and drape? You can rent that for $200 for events.

Understand the culture of your buyers; for instance, direct deposit hits Thursday. You call your friends [on] Friday and ask if they want to see a show. We should be sending that e-blast out on Friday. Saturday, you should be calling people to buy tickets because you know [they] got that money in the bank. I would have spent it by Tuesday; that's just who we are. So understanding the story behind your budgets is really important, making sure that every single revenue model is well developed.

EILEEN: The Ensemble Theatre owns its own building at 3535 Main in Houston, Texas, and it came with a lot of talk about the Board not wanting to follow the dream of the founder, and so the founder fired the board. Three days later, we had to ask the board to come back because we didn't have the money to pay for the institution. The theatre went from paying $300 a month rent to $3,000 a month rent, and [from] a space that was one quarter the size of this room to a 30,000-square foot space. When you evaluate all of that, you realize that it takes a whole village to make everything work. We need a strong board, but we needed more members that would believe in the dream. I think that one of the things that George [Hawkins] did, much more like Jackie Taylor, was redirect that. He redirected the Board, and helped them to get on board to understand the dream that he had for the institution. Today it's based in midtown Houston where the square [footage] goes for $12 a foot. It's very expensive to be there now, and people are always knocking on the door asking us do we want to sell this space. But we build upon foundation support; corporation support; and box office, which is subscriptions and also single-ticket sales. Of course you want single-ticket sales because you can charge a little bit more for that than the subscriptions.

First of all, make sure you've got a great product that people would want to buy into. That's the first the thing. It's not just about coming to see the play, but you want people to buy into the institution. And in buying into the institution, they are going to support what it is that you are doing, whether that is through subscriptions, single-ticket sales, doing an educational piece that would go into a school or for someone to come to your play. We do student/senior matinees. We call it our intergenerational matinees that we perform for students and seniors to come together and see during the day on one of the main stage shows. We do that three to four times per show, so that we present to a new audience that [represents] different generations. But it has also earned revenue. You want your earned revenue to be anywhere between 40 and 50 percent of your entire operating budget. Also, we rent our facility out.

The one thing that really turned it around for us was, about five years ago, we did a really expensive international piece. We spent about $2,000 dollars getting this done, and all we received on our investment was $250 dollars. Then we did a more simplified piece

and this simplified piece became a founder's circle. We asked people to invest in the institution and called it our rainy-day funds. Then we started doing a smaller piece and said, "Listen, you know five people. Can you call your five people and ask them to commit to $1,000? Can you call five people and ask if they can commit to $2,500? Can you call your people and ask if they can commit to $5,000?" That became our founder's circle in memory of our founder George Hawkins. Asking people to buy into the institution to support a Black theatre that was 40 years old … we wanted to create a contingency fund. We raised over $1 million. We didn't know how to do it. We were figuring it out as we went along. We made some errors and made some mistakes, but that's one of the things we are applying now in our books—this five-year-old program. Those are the entities that we use to create our $2 million budget.

JACKIE: At the Black Ensemble Theatre, we have a $23 million facility that is five years old, and what we are doing now is creating our revenue streams outside of the theatre. I purposefully bought the spot we are in because there was nothing there, and I knew the property would be cheap. We have bought a lot of property, and we are going to build a soul food restaurant, an education center, a literary cafe, and some housing facilities. The purpose for all this is to create revenue streams that will sustain the operations of the theatre. I don't want the theatre to be in a position where it's dependent on giving. We are still going to last, none of that's going to change. We still do all the stuff that everybody else does for sure. But if the weather changes next week and nobody came out, we could still function. The theatre has revenue streams that are outside of its entity … we are not going to manage these facilities because we have partners in these facilities who are experts in these areas and they will manage. But it's our property, and we're going to have certain criteria outside of the rent that they have to give us, whether it's part of the liquor sales, whether it's part of the rents that the tenants give. There's all kinds of revenue streams, so no matter what happens we still have our operations.

ZAHEERAH: Nykiiah, please share what it was like for you to ask for money after performing free. How did you get started?

NYKIIAH: Ms. Nikki's Traveling Story Bag started out of necessity. I was working at a school as a teacher and they ran out of funding for their summer program. I had to discover a way to provide for my family, and I loved to tell stories. I made money telling stories for $20. Later, I began charging $150 for my stories, and I would take deposits if people didn't have enough money to pay it all at once. I find that if you ask for the money and they really want it, they will pay. When you begin giving your product away for free, people don't value it. Money and honor go hand in hand. It comes down to courage, coming from the need to feed my family.

ZAHEERAH: Can you share a collaboration you've had with other organizations? Eileen, can you share your collaboration?

EILEEN: We've collaborated with the Houston Grand Opera. I wanted the Ensemble to receive the benefit. We had the chance to partner with the opera, and we received their publicist and their audience. Many of our patrons would not have been able to see the program. The tickets for the show were free.

KEMATI: The Christmas Passports were one. You'd get a ticket to participate in all five or six theatre companies. We performed *If Scrooge was a Brother* alternative holiday show … and other smaller theatre companies were doing holiday plays, Star Trek Christmas plays where characters spoke Vulcan. People really like that concept. We also provide an

opportunity to give people a space to produce their works. When you own your own theatre, you have the freedom to do that.

ZAHEERAH: Greg, you are excellent at marketing. Could you share some of your expertise with us?

GREG: Great theatres don't necessarily have great marketing … Great theatre builds advocates on the ride home. Great theatre doesn't even have to put up a poster; people just come to see the show. Going back to your branding, everything must be concise. Marketing is about a tactical way of selling. You need to get people to fall in love with your mission, your vision. Too often people try to copy others, and it doesn't work because that's not your mission, it's not your brand. At Venture everything we do matches our brand. We are heavy into social media. Get people to advocate for you and what you do.

ZAHEERAH: If you can give the audience one nugget in this session, what would it be?

JACKIE: If you have a dream or a vision, don't give up. Stick with it and you can make it happen. Chicago has a lot of talented people that are nonunion, and we set aside a certain amount of money for our budget to insure they work. We had to make people equity. It's about talent and opportunity. It's important for us to hire talented people.

My first board [of directors] was my family. My next board was a real board. There were eight to ten people on it, and then I decided I wanted to build an institution. We're rebuilding the board with people who see the vision and can support my goal of creating a $50 million institution. Identify people who can support your vision.

GREG: Great talent is great talent.

EILEEN: It's not just about coming to see the play, but you want people to buy into the institution.

KEMATI: Don't talk, work. If you want these institutions to be here for the next 40 or 50 years, write the check.

PHILLIP: I love everything here because it's asserting a feeling of urgency. That is missing. Ask yourself, is there more Black theatre or less of it? It is our job to stop the bleeding, and make it part of our cultural milieu. All of you are building institutions. There is a cultural mission. There is a community mission imbedded in what we do. So there's urgency here.

JACKIE: If we are relying on someone to tell our stories, then we are in trouble. We still have healing to do in working together. Whenever you hear that someone else can tell our story better than us, you must stand up and correct them.

ZAHEERAH: Let's be about the business of art. It's the difference between being "fired up and ready to go" and "burned out and can't function."

# 35

# A REFLECTION ON THE UNIVERSITY OF ARKANSAS PINE BLUFF'S *THE HIP HOP PROJECT*

## Insight Into the Hip Hop Generation

*Johnny Jones*

On April 20, 2005, Gregg Henry, artistic director of the Kennedy Center American College Theater Festival (KCACTF) spoke these words to festival spectators in Washington, DC:

"Ladies and gentlemen, we've just seen the future." Henry was praising University of Arkansas Pine Bluff (UAPB) students and director, professor Steve Broadnax, for their production of *The Hip Hop Project: Insight to the Hip Hop Generation* (Figure 35.1). Broadnax conceived, directed, and choreographed the two-act play written and co-choreographed by students as they revived the historically Black college's theatre program in the Arkansas Delta. The ensemble dominated state and regional festivals, performed on college stages, and negotiated a summer run at the Arkansas Repertory Theater.

This chapter summarizes my personal experience as student, co-writer, performer, and media relations manager for *The Hip Hop Project* and UAPB's theatre program.[1] Following Theresa Perry's exploration of African American narratives as "counternarratives" and historically Black colleges and universities (HBCUs) as "counter-institutions" to dominant knowledge and organizations, I am transmitting cultural knowledge from personal memories.[2] Additionally, following D. Soyini Madison's "The Labor of Reflexivity" that suggests that self-reflexive writing transforms experience into narratives for social and artistic communities, I am sharing the seminal period of my theatre career in the hopes of inspiring others (129–138).

Named after the first African American to receive the Master of Fine Arts degree from Yale School of Drama, UAPB's John McLinn Ross Players Theater Program had an established legacy. However, when I arrived in 1998, the program was struggling. I majored in mass communication, which was merged with theatre. Both programs struggled, but the theatre lacked faculty and majors. During my senior year, after working as a sports journalist at a daily newspaper, I was hired as media relations manager for UAPB's Technical Services Department, which administered university Internet, radio, and television media. I co-founded an online newspaper and provided commentary for UAPB sports. As an aspiring poet, I contributed daily

*Figure 35.1*   Johnny Jones performs in *The Hip Hop Project: Insight into the Hip Hop Generation.*
*Source*: Photographer Brian T. Williams.

spoken–word poetry on UAPB's morning radio show, facilitated youth poetry workshops, and hosted bi-weekly open-mic nights with community artists and friends. Despite UAPB's mass communication and theatre program's troubles, I established a creative life and career.

The program's reestablishment began with Dr. Barbara McDaniel-Suggs, UAPB's mass communication and theatre program coordinator from 2002 to 2004. Along with reorganizing mass communication faculty and majors during her first academic year, Suggs met Webster Conservatory and Pennsylvania State University graduate Steve Broadnax, who lived and worked in New York as an actor but was home in Little Rock recovering from vocal cord surgery. Suggs convinced Broadnax to become the lone theatre instructor for the beleaguered program of two majors, and he directed three productions his first year (2003–2004). *Hip Hop Project* was a one-act play devised from Broadnax's Creative Dramatics class prompts; students wrote narratives beginning with "Hip hop is …" I watched the production in UAPB's packed 500-seat auditorium theatre and was fascinated. Afterwards, I congratulated Broadnax and explained to him that "few things work well at this university, but *this* worked." After learning that I worked for UAPB and performed open mics with his students, Broadnax encouraged me to audition for *Black Boys*, a choreopoem that he was directing in spring 2004. Despite job

demands and being long overdue for graduation, I auditioned and was cast. Theatre became a newfound challenge and Broadnax became my mentor.

During fall 2004, Broadnax learned that he possessed a budget of only $2,200. He decided to restage *Hip Hop Project* because of its minimal style and popularity. Broadnax initially cast four poets (myself included) from previous productions and added four dancers from the original production. He held open auditions and buzz about another *Hip Hop Project* revealed the bevy of talented students at UAPB. After nearly 100 students auditioned, four poets and eight dancers were added to the initial cast of eight. Rehearsals began in August 2004. Only two students were theatre majors.

Broadnax used his musical theatre, Shakespeare, and modern acting training to guide us to use our poetry and dance skills to create heightened personas. Early in the process, we transformed our green room into a rehearsal space. Broadnax and the poets—Moriah Hicks, Royce Massengill, Precious Hall, John Proctor, Rikki Nelson, Richard Lofton, Cynthia Talley, and myself—wrote and workshopped poetry. Meanwhile, the dancers worked in a campus studio with a dance captain. Each night culminated in the green room with both groups presenting rough drafts of their work. We transitioned to a performance composition phase and focused on script analysis and blocking. Broadnax also taught Stanislavsky's foundational acting techniques. We discovered objectives and beats in our poetry and articulated narratives with clarity. Instead of reproducing the habits of spoken-word performance, we made choices that informed our performance style and transformed us into stage actors building scenes. Once Broadnax fully incorporated the dancers, he orchestrated a fusion of monologues, sketches, choreography, and music focused on the sociopolitical views of an all Black cast between ages 18 and 29.

By opening night in October 2004, the show was presented in two acts preceded by a 30-minute pre-show with a DJ and a hype man onstage. As the DJ mixed songs, the hype man interacted with spectators. The set consisted of a large brick-imprinted tarp backdrop hanging upstage center and two large scaffolds set stage right and left. One of the dancers had graffitied "Hip Hop" in large letters on the tarp, and Broadnax used the same scaffolding he had rented for the set to hang lights. Spectators danced and sang together until the stage and house blacked out. My fellow poets and I walked center stage dressed in choir robes. Once the stage was lit, we sang a Gregorian chant. Then I stepped away from the group, walked downstage right, raised my right fist, and recited "Hip Hop Haiku": GOD deejayed these streets / African American / expression through beats. After two other poets and I performed "Hip Hop Genesis," Broadnax's original music reverberated throughout the theatre. We removed our robes and revealed our urban-style fashion while the dancers entered and battled. For the next 105 minutes, we spoke to the joys and struggles of living Black in America.

Our run continued for nearly two years, thanks in part to Broadnax's receiving a brochure for the American College Theater Festival (ACTF) in Fayetteville and vowing that we were "going to enter it and win it." About a month after our opening, we traveled to the state festival where a judge invited us to perform at Western Washington University. ACTF invited us to participate in its regional competition in Fayetteville, Arkansas, and after encores in Pine Bluff and Arkadelphia, Arkansas, and in Seattle and Bellingham, Washington, we arrived in Fayetteville in February 2005. Our performance sold out the Walton Arts Center's 1,200-seat theatre, and we won multiple awards, including the Respondents' Choice. The morning after we returned from Fayetteville, Broadnax called me and said he had received a phone call from Gregg Henry informing him that UAPB had been chosen to perform at the Kennedy Center.

Before the regional competition, Broadnax had retitled the production *The Hip Hop Project: Insight to the Hip Hop Generation*. Earlier in the process, I had shared with him Bakari

Kitwana's book, *Hip Hop Generation: Young Blacks and the Crisis in African-American Culture*. Kitwana's writing critiqued sociopolitical issues affecting Blacks born between 1965 and 1984. Topics included systemic racism, the gender/sex divide, materialism, and the George W. Bush administration. Broadnax said our poetry paralleled Kitwana's ideas:

> The term "hip-hop generation" is used interchangeably with Black youth culture. No other term better defines this generation of Black youth, as the entire spectrum of Black youth … has come to identify with hip-hop's cadence … It is our attempt to bring critical focus to the issues that defined our time and that went beyond simply rap music.
>
> (p. xiii)

As we related to Kitwana's message, we labored in circumstances of a scarce budget and minimal faculty. We succeeded partly because before we started theatre we had worked in media and performed at open mics. By the time Broadnax arrived at UAPB, our talents were primed for his tutelage. Consequently, we created, marketed, and produced an original production that allowed us to transform raw subjectivities into performance. By the time *The Hip Hop Project: Insight to the Hip Hop Generation* completed its KCACTF run, we had solidified a Black theatre collective. By doing this with minimal means, we embodied the resilient legacy of the HBCU, which despite being a product of segregation has been utilized by Black folks to create counter-institutions and foster counternarratives (Perry).

Weeks after Gregg Henry referred to our play as "the future," I emailed him for our press kit and asked him to elaborate on that statement. I wanted him to specify what he saw in our work. He responded: "If more theatre events can capture the energy, the honesty, the passion, and the electric showmanship of the UAPB production, then I think that the future of the art form is very secure." Although Henry was acknowledging our production's innovation of the art form, we knew our work owed respect to the tradition of hip hop theatre pioneers like Danny Hoch, Will Power, Kamilah Forbes, and others.[3] Nonetheless, we also realized what separated our work from the pioneers. From 2004 to 2006, Professor Broadnax had assembled an ensemble and a performance process focused on hip hop generational themes at an HBCU. We had created representations of Black life that not only contributed to the HBCU cultural aesthetic heritage in line with marching bands, Greek organizations, and college football, but we also distinguished ourselves from predominantly white (theatre) institutions. UAPB became the first college from Arkansas' state university system to receive a showcase at the Kennedy Center. It is still among a handful of HBCUs that have performed there. Although our cohort disbanded when Broadnax left UAPB for Penn State in 2006, and several of us graduated and/or left for the "real world," for a short period the John McLinn Ross Players created real, original, culturally distinctive work that competed in an academic theatre system largely indifferent to Black perspectives. Our labor is a testament to the dynamic African American theatrr tradition and the possibilities that continue to arise from Black arts and academic communities.

## Notes

1 All information about University of Arkansas Pine Bluff's theatre program and *The Hip Hop Project* was retrieved from my personal archive. I worked as the program's media relations manager from 2004 to 2006.
2 For further reading see Perry (11–51).
3 For further reading on hip hop theatre pioneers see Banks (1–20).

## Works cited

Banks, Daniel. "Introduction: Hip-Hop Theater's Ethic of Inclusion." *Say Word!: Voices from Hip Hop Theater: An Anthology*, U of Michigan P, 2011, pp. 1–20.

Kitwana, Bakari. "Introduction: Confronting the Crises in African American Culture." *The Hip Hop Generation: Young Black and the Crisis in African-American Culture*. Basic Civitas Books, 2002, p. xiii.

Madison, D. Soyini. "The Labor of Reflexivity." *Cultural Studies, Critical Methodologies*, vol. 11, no. 2, April 2011, pp. 129–138.

Perry, Theresa. "Freedom for Literacy and Literacy for Freedom: The African-American Philosophy of Education." *Young, Gifted, and Black: Promoting High Achievement among African-American Students*, Beacon Press, 2003, pp. 11–51.

# 36

# INTERVIEW WITH EKUNDAYO BANDELE

## Founder and CEO of Hattiloo Theatre

*Interviewed by Shondrika Moss-Bouldin*
*June 2017*

On September 22, 2006, Ekundayo Bandele gave birth to Hattiloo Theatre Company in Memphis, Tennessee. This innovative company was named after his two daughters, Hatshepsut (Hatti) and Oluremi (Loo). During the theatre's inception, Bandele found himself working as the only employee, handling production, the artistic vision, and the box office of a 66-seat storefront theatre that was operating with less than $100,000 a year. He eventually had a three-person team and now employs over 20 staff members. Bandele has transformed his theatre into a multi-million dollar, debt-free theatre with a $500,000 endowment. In addition to having two theatres in its new artistic home in the highly sought after Arts Midtown district, Hattiloo has acquired a development center, a technical center, and Hatti House, which houses guest artists and interns. In the summer of 2017, Bandele announced that he would transition from artistic director to CEO of Hattiloo. Award-winning playwright Katori Hall has taken the reigns as the new artistic director. Under their leadership, Hattiloo has been able to establish a national presence in the American Theatre.

SMB: So, you want Hattiloo to take the lead in Black theatre?

EB: (Laughing) It's an arrogant statement and I know it. And I stand by that statement. I have a really clear vision of what that looks like. We have some great theatres nationally doing some great work. What does that mean to be the leader? There are people who do great work and there are people who are great leaders. A real leader is a servant. A real leader is someone who serves. A real leader is not someone who says come follow me. A real leader is someone that says, "How can I help you be great?" That is my Garveyite mindset. What I mean is that we are going to make certain that whatever resources that we may have … we will make ourselves available nationally to the greater Black community. Here's the big one: human capital.

Everybody wants to act but no one wants to go on a [scaffold] with a monkey wrench, or put on some dungarees and paint a set, or sit at a desk and make a prop. But these are where the jobs are in theatre. Hattiloo is dedicated to being committed to technical theatre. We have a technical theatre center that used to be an old school and is in an impoverished neighborhood. I bet these kids don't know that painting a set,

hanging lights, is a job. This is a job. We need to ask, "Are you interested? Then develop that interest." If we at Hattiloo Theatre in Memphis can be responsible for an influx of Black kids going to college or getting an internship, or maybe they don't go to college. Maybe they just intern with people like Kathy [Perkins]. Then you have all these people entering these Black theatres and you see an increase in the quality. They now see they don't have to have contractors, and they can hire someone in house that is Black. So that is what I mean by leading. Another thing we want to help develop is that authentic voice of the Black South. The Black South is not really known here. My father is from Memphis, my mother was from Jackson, Mississippi, and, even though I did not grow up here, it is still important to me.

SMB: What initially drew you to theatre?

EB: What drew me to theatre initially was Dr. James Birdsong at Tennessee State University giving me the book *Five Black Playwrights* after I told him my ambitions in writing. I wanted to be a novelist but he suggested that I try playwriting. After reading the book and doing further research, I believed I could do it. I began producing, writing plays, and making a profit from my work. When I moved to Memphis, my first board chair, Michael de Caetani, told me that Memphis had been trying for many years to get a Black theatre and he thought I would be really good at it. It was his belief that I could do it that really pulled me into it.

SMB: What do you enjoy the most in theatre?

EB: I most enjoy designing and building sets, and I enjoy most when I'm by myself. I like solitude. I also love directing but I'm a morning person.

SMB: Why did you choose Katori Hall as the incoming artistic director?

EB: She is a Memphian. She knows this city, the people, and their stories. We are focused on the stories here. Most Black theatre companies are in the North and few are telling the stories of the South. Katori is really committed to the advancement of Black people and that is our mission of our theatre—to produce plays and programs that support the advancement of Black culture, and Katori embodies that. I have taken Hattiloo as far as I could artistically. I haven't been in a room with larger theatres, and I really don't know the proper processes on how to do certain things, and Katori does. She has seen and knows these processes. Memphis is known for barbeque and the blues, but now with her we will become known for great theatre, great Black theatre. She knows Memphis and she can help us grow artistically and legitimize us.

SMB: What does Hattiloo look like after Katori Hall finishes her tenure?

EB: I don't know what that looks like yet. It's my job to figure it out. Right now, I'm looking at other theatres, reading historically, daydreaming, and thinking about, what does the Memphis community need?

SMB: What were your biggest challenges in developing Hattiloo?

EB: They were many Black theatres that had started in Memphis but over the years did not stick. More than anything, I was challenged with the ghost of past Black theatres that failed in Memphis, funders saying it would not work. Another big challenge, believe it or not, was my appearance. When I opened Hattiloo I looked and dressed like an artist. At the end of the day, philanthropists and foundations are not going to trust an artist with their money. I wanted to show them that I would do right by their money, their investment.

SMB: What did you do?

EB: I cut my hair—I had dreadlocks—and went to Brooks Brothers and started dressing like a banker.

SMB: What obstacles, if any, has race/and or gender played in your success?

EB: I don't think either one has been an obstacle. I know that some people think having a Black Theatre is segregation. However, the challenge is how do you make a Black story relevant to white people? Your white audience members come and they ask themselves, why am I spending money and watching this?

Even though your likeness as a white person may not be represented onstage, you are the dominant culture of this country, which means your culture created the circumstances of that play. Most Black plays are in response to living in a white culture, not in a bad or a good way. Take *Stick Fly*. How do we as wealthy Black people live in a dominant white culture? *A Raisin in the Sun* is all about them [Black people] trying to move into a white neighborhood. *Hurt Village* is about gentrification. White people are important to make this successful. How can I make them understand that this isn't an indictment of your history? It's not an indictment of your culture. When you flap your wings, there is a tsunami that happens in Black culture. There are people very interested to learn what are the consequences, positive or negative, of historical actions. What did your great grandfather do that is now the theme of this play, even though you don't see yourself onstage?

SMB: Do you think there is a fair representation of Black theatre?

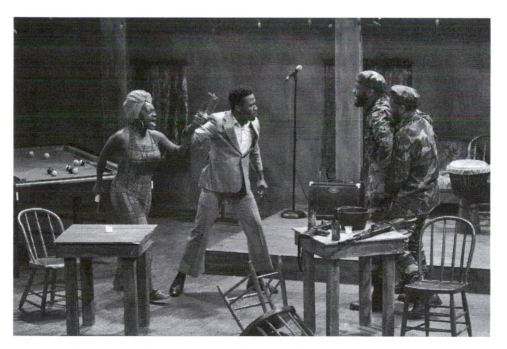

*Figure 36.1* Hattiloo Theatre Company's production of Lynn Nottage's *Ruined* (2018). Directed by Shondrika Moss-Bouldin. (*Left to right*) Maya Robinson, Bertram Williams, Jr, Courtney Robertson, and Justin Hicks.

*Source*: Courtesy Hattiloo Theatre.

EB: There is an abundance of Black individuals represented in this field. The shortage is in the investment.

SMB: What is your biggest accomplishment?

EB: My biggest accomplishment is having the bravery to name the theatre after my two daughters because even after I leave, and I will leave the theatre one day, my girls are still attached to it.

SMB: How do you serve as a mentor?

EB: I look for opportunities to pass down what I have learned. Several students have been with me since Hattiloo opened.

SMB: What words of advice do you have for young people entering the field?

EB: As a Black person, you have to be resourceful. You can't think your degree and your talent can do it alone. You have to build relationships. You have to be willing to know your place and understand what that means. Here am I, the CEO of a theatre and I was an assistant director at another theatre, taking notes because I can admit that I don't know everything. Relationships and humility are key. If you can find a way out of no way, build relationships, and be humble, you will be successful.

# PART III

# Theatre and social change

*Sandra L. Richards*

## Introduction

When we editors initially outlined the sections we imagined that our anthology would encompass, we designated one section called "Theatre and social change." Tasked now with writing an introduction, I am tempted to add the subtitle "Memory and mourning." Allow me to say a little about these terms before previewing the individual chapters.

Theatre—or the imaginative re-play/re-organization of what we have experienced in daily life—has long been thought to have the capacity to effect social change. Pre-colonial African societies considered re-enactments, through dance, music, song, and storytelling, as a fun and instructive way in which participants might see themselves otherwise—that is, as others saw them or as they might wish themselves to be seen. Societies used performance as a way to teach their younger members history and shared values; to comment upon the triumphs, failures, or foibles of their community; and to advocate, either through subtle indirection or pointed critique, for changes in individual and collective behaviors. Western theatre practice held similar views: Aristotle's theory of tragedy, church dramas or morality plays (in which the Devil seemed to have more fun than the saintly believers), Shakespeare's mirror held up to nature, or Ibsen's realism are just a few examples. As noted in these pages, some contemporary African American theatre artists draw specifically from the theories of Bertolt Brecht (1898–1956) of Germany and Augusto Boal (1931–2009) of Brazil. Brecht's "epic theatre" consciously staged events whose near-realness was designed to spark audience questioning or resistance to the dominant social order, while Boal's "theatre of the oppressed" often invited spectators to interrupt and re-direct action onstage.

Taken together, the chapters in this section encompass the twentieth century through to the contemporary moment. Beginning with scholar-activist W.E.B. Du Bois' pageants in 1913–1925, scholars have also re-visited the political activism of the 1930s and the 1960s Black Arts Movement. They have addressed understudied topics like Black youth performance, the emergence of theatre rooted at the crossroads of African and Latinx cultures, and the teaching of African American theatre texts in the Arabian Gulf. They have probed how professional actors as well as everyday folk, like formerly incarcerated women, are using theatre to prompt change. The practitioners interviewed in this section recall histories of parents, community centers, and mentors who enabled them to excel as composers, set designers, and choreographers.

So why, with this rich diversity, would I think about memory in the context of mourning? First, I am struck by how many of these scholars are researching the past. Several, like Truscott, Forsgren, Stone-Lawrence, Persley, and Sunni-Ali, seem to be remembering the past as a way of thinking about the present and future. In contrast, Gumbs contemplates a dystopian future of lawlessness and environmental degradation that seems eerily like both our present and our past. They and we are in some sense haunted by ghosts who have appeared demanding recognition and justice (Gordon xvi–xvii, 8). For example, Truscott (Chapter 38), in discussing audiences' enthusiastic responses to representations of African Muslims in the early twentieth century, notes that a similar appreciation of Islam is largely absent from current American discourses. Or in another example, Persley (Chapter 39) acknowledges that she chose to direct an anti-lynching play from that same time period as a way of enhancing audiences' knowledge of the long history of racial violence and resistance. Because her theatre is located some four hours from Ferguson, Missouri, memories of Michael Brown—and a host of other murdered young men and women—were surely present for those theatregoers.

In going back to these historical moments either in the theatre with others or in the solitary library cubicle, we need to bear in mind that memory is *not* exact recall. Imagination also plays a role. When it is coupled with the power of theatre to elicit empathy, the result is an experience in which we see and feel how the characters onstage and the past itself are both like and unlike us and our present. We mourn those who suffered; we feel a mounting fear that this past is repeating itself. And we can begin to imagine how we might use elements of that legacy to fashion responses to the crises facing us today. Our engagement with the chapters that follow and the theatre experiences they recall may help us turn memory and mourning into powerful tools for social change.

## The chapters

In 1926 social scientist and civil rights leader W.E.B. Du Bois articulated a vision for African American theatre that remains relevant today. He declared that such a theatre should be about us, by us, for us, and near us ("Krigwa" 134). Thus, it is no surprise that this section begins with two chapters about Dr. Du Bois. Though this pre-eminent scholar tended to regard his interest in theatre as secondary to political activism, Freda Scott Giles (Chapter 37) examines his output in three areas: his creation of the pageant *Star of Ethiopia*, his championing of theatre through his editorship of *The Crisis* magazine, and his playwriting. Cristal Chanelle Truscott (Chapter 38) cites Giles' observation about the popularity of early twentieth-century pageantry as an enjoyable vehicle for learning history and incorporating European immigrants into American society. Truscott argues that in countering negative representations by insisting upon Black people as a dignified and honorable race,[1] Du Bois specifically constructed that identity as Muslim. Furthermore, she demonstrates that the public did not regard such representations as unusual. Through the pages of *The Crisis* and the earlier, antebellum performances of "wrongly" enslaved African royalty, the public had already learned to associate Muslims with pride in African history and culture.

Nicole Hodges Persley (Chapter 39) describes in "Oh, my dear! What's going on?" her decision to stage Angelina Grimke's play *Rachel* at Kansas City Melting Pot Theatre in 2016. Because the play deals with a family grappling with the aftermath of the lynching of its father and son, the resonance of this 100-year-old drama was immediate for a community only four hours from Ferguson, Missouri, where Michael Brown had been shot to death by a policeman. As Persley movingly writes:

Outside of the theatre, we faced sobering statistical data. Not two miles from our theatre, Black Lives Matter organizers in Kansas City continued to fight anti-Black racism and one of the highest homicide rates in the nation … The expectation of safety that our African American audience members had in our theatre did not extend outside our doors.

Like Persley, Portia Owusu (Chapter 41) recognizes repetitions in the present of a tumul-tuous, often violent past: 50 years after men and women died seeking voting rights in Selma, Alabama, Sandra Bland died in police custody; 50 years after the March on Washington for Jobs and Freedom, protestors took to the streets denouncing the murder of Trayvon Martin and the acquittal of his killer; and 50 years after the civil rights movement, another movement was birthed, namely Black Lives Matter. Obviously, our bloody present belies the myth of American democratic progress. It also prompts Owusu to examine how violence as a means to a just end was understood by Black revolutionaries like Malcolm X, Stokely Carmichael, and Frantz Fanon. She analyzes *Dutchman* and *Slave Ship*, written by poet-playwright Amiri Baraka who is credited as the chief architect of the Black Arts Movement, dubbed the "sister" of the 1960s Black Power movement. Owusu's stated objective in returning to this past is to encourage reflection on what lessons may be relevant to today's struggles.

LaDonna Forsgren and Susan Stone-Lawrence are also remembering the 1960s, but they have different questions to pose. Their chapters insinuate that we need to recall Black theatre history differently. Forsgren (Chapter 43) focuses on four women playwrights—Sonia Sanchez, Barbara Ann Teer, Barbara Molette, and J.e. Franklin—who sought to re-define the masculinist visions of Black liberation so that it incorporated women's perspectives. In so doing, Forsgren not only recuperates women whose artistry has been overshadowed, but she also shines a spot-light on a period of gestation before the dramatic birth of Black feminism in Ntozake Shange's *for colored girls*. Stone-Lawrence (Chapter 42) focuses on the Free Southern Theater's production of Baraka's *Slave Ship*. While Black theatre history has largely focused on the North—New York and Newark in particular—as the center of revolutionary Black arts, Stone-Lawrence argues that we should remember that the founding of the Free Southern Theater in Mississippi and its coupling of theatre and political resistance occurred some two years *prior* to Baraka's articulation of what would become the Black Arts Movement.

Kimmika Williams-Witherspoon (Chapter 40) looks at another instance of African American theatre's response to state-sanctioned violence. She cautions readers that any assessment of theatre's potential to elicit social change must factor in the political economy—"interactions between the social uses of power and material resources" (Gates 971). Locating Langston Hughes' creation of the verse play *Scottsboro Limited* (1932) within the context of race riots, labor unrest, and economic collapse, Williams-Witherspoon explores how the Communist Party's politicized art appealed to impoverished Black and white workers as well as to writers like Hughes and Richard Wright. But she reminds readers that representations of a militant Black populace determined to achieve equality did not survive the federal government's implementation of the Works Progress Administration with its Negro Theatre units overseen by white administrators. The promise of a steady paycheck in a period of economic depression would guarantee that most artists returned to the norm of smiling, contented Negroes onstage.

Taking a theoretical approach, Tezeru Teshome (Chapter 51) analyzes Nambi Kelley's adap-tation of Richard Wright's 1940 novel *Native Son*, which also takes up the issue of resistance to the violence unleashed by racism. But while most authors in this section affirm theatre's power to effect social change, Teshome argues the opposite. She contends that the protagonist Bigger Thomas is haunted by slavery, which dehumanized peoples of African descent while

exalting those of European origin. Because Bigger, like all peoples of African descent, cannot escape the ontological status of Blackness, the freedom that Kelley's adaptation grants him is illusory. Furthermore, since meanings of Blackness—and whiteness as its linked opposite—are replicated in social and political structures, American theatre cannot effect desperately needed social change.

Chapters by Isaiah Matthew Wooden, Sonny Kelly, and Lori Barcliff Baptista would, seemingly, vigorously dispute Teshome's logic. Wooden (Chapter 50) recognizes in the playwriting of Robert O'Hara techniques that make the familiar strange. Plays like *Antebellum* and *Barbecue* occupy historically, geographically, or socially distinct realities simultaneously. The alleged real and media-generated real intermingle to hilarious, dizzying effect, such that audiences are pushed to re-examine "truths" related to race, gender, and family. In such provocation—as theorist and playwright Bertolt Brecht argued—lies the possibility of change. Though playwright Mike Wiley's work also derives from Brecht's techniques, he differs from O'Hara in that his plays are direct in their educational objectives and interactive in their engagement with audiences. As author Sonny Kelly (Chapter 53) notes, Wiley stages his ethnographic interviews with, for example, former Freedom Riders or post 9/11 military families in order to present little-known histories. His performances often culminate in spectators voicing opinions about how they relate to the issues raised. While O'Hara's and Wiley's plays are staffed by professional actors, the theatre that Lori Barcliff Baptista (Chapter 54) examines is predominantly grassroots. Matters of the Heart is a performance group started by formerly incarcerated women in order to de-escalate violence; interact with youth, particularly those in danger of being engulfed by the criminal justice system; and combat recidivism by enabling people to regain a sense of personal dignity. Their performances are often part of community events that may include HIV testing, a dance party, or a meal. In this instance, it appears that actors and audience members share similar socioeconomic conditions and thus similar investments in combating racism; in this instance, theatre may facilitate changes that strengthen the community as a whole.

This section also includes a number of chapters that are in one sense more personally focused. Lyricist-composer Micki Grant cites family and community experiences that equipped her to write the award-winning musicals *Don't Bother Me, I Can't Cope* and *Your Arm's Too Short to Box with God* (Chapter 44). Scholars Sandra G. Shannon and Daphnie Sicre each share a personal experience that propelled their research. Shannon (Chapter 45) remembers playwright August Wilson telling her "always keep your gloves up!" right before they were to begin a public interview. She would later come to realize that this bit of advice from the world of boxing was the perfect metaphor for analyzing Wilson's famous quarrels with critics dismissive of his Afrocentric worldviews. Sicre (Chapter 47) recalls her surprise at seeing on a New York subway an advertisement for *Platanos Y Collard Greens*, a romantic comedy that she credits with bringing visibility to AfroLatinx lives. This successful play and the many others that followed have allowed her to offer an extensive overview of drama that challenges rigid, American racial categories. Choreographer and professor Kariamu Welsh speaks of a different kind of rigidity related to the organization of knowledge (Chapter 49). Taken in tandem, her university departments generated a "double consciousness" (Du Bois, "Of Our Spiritual Strivings") because one seldom recognized the importance of race while the other tended to devalue the intellectual value of performance. Edward Haynes traces his interest in designing sets for theatre, television, film, and commercial projects back to playing with carpet samples and paint swatches as a very young boy. Poet Alexis Pauline Gumbs (Chapter 55) closes this section with what she terms an experiential archive through which she marks the deep impact of *Octavia E. Butler's Parable of the Sower: The Opera* on several generations of family members, including a not-yet-born niece.

As mentioned earlier, the Butler novel focuses on a future of extreme degradation, but through Gumbs' personal analysis, one sees how theatre, by fostering the audience's empathetic identification with characters on the stage, can trigger private grief and the hope of shared, communal rebirth.

## Note

1  The term in use at that time would have been "Negro."

## Works cited

Du Bois, W.E. B. "Krigwa Players Little Negro Theatre." *The Crisis*, vol. 32, 1926, pp. 133–134.
———. "Of Our Spiritual Strivings." *Souls of Black Folk*. Dover Publications, 1903, pp. 2–3.
Gates, Hill. "Political Economy." *Encyclopedia of Cultural Anthropology*, vol. 3, edited by David Levinson and Melvin Embers, Henry Holt & Company, 1996, pp. 971–975.
Gordon, Avery F. *Ghostly Matters: Haunting and the Sociological Imagination*. 2nd ed. U of Minnesota P, 2008.

# 37

# W.E.B. DU BOIS, DRAMATIST

*Freda Scott Giles*

The life and works of W.E.B. Du Bois (1868–1963) have been well documented. His contributions as a social and political activist and scholar cannot be overstated. His creative writing in the form of novels, short stories, and poetry has also been recognized and analyzed to some extent. However, his work in the theatre has generally been considered more as an extension of his social and political goals than as an expression of a prodigious creative imagination. This view may be partially due to statements by Du Bois himself. In critiquing Alain Locke's edited volume, *The New Negro*, and his idea that "Beauty rather than Propaganda should be the object of Negro literature and art … [Du Bois said that] if Mr. Locke's thesis is insisted upon too much it is going to turn the Negro renaissance into decadence" (Aptheker x–xi). Later, in a 1926 address to the NAACP (National Association for the Advancement of Colored People) conference, Du Bois declared that "all art is propaganda and ever must be … I do not care a damn for any art that is not used for propaganda" (Archer 65–66). Despite his love for the theatre, Du Bois could not fully embrace the plays he wrote, affectionately deeming them "illegitimate children of my thought and pen" (Du Bois "Playthings").

Du Bois viewed the arts as a powerful weapon in combating oppression, but his appreciation for the arts went much deeper. While a student at Fisk University, he discovered the beauty of spirituals, sang them, and organized a small glee club that earned money by singing in resort hotels. As a graduate student at Harvard he staged a production of Aristophanes' *The Birds* at Charles Street AME Church. Despite limited financial circumstances, Du Bois availed himself of many opportunities to attend plays, operas, and concerts during his study abroad in Germany. Through his participation in theatre, Du Bois could partially reconcile his mission as a social scientist and civil rights activist with his avocation as a creative artist. This chapter seeks to address three areas of Du Bois' theatrical pursuits: his production of the *Star of Ethiopia* pageant (1913–1925), his theatre advocacy through his editorship of *The Crisis* (1910–1933) and as producer for the Krigwa Players (1925–1927), and his efforts as a playwright.

Pageantry became extremely popular in the United States during the first quarter of the twentieth century.[1] Du Bois saw in it an opportunity:

> It seemed to me that it might be possible with such a demonstration to get people interested in this development of Negro drama to teach on the one hand the colored people themselves the meaning of their history and their rich, emotional life through

a new theatre, and on the other, to reveal the Negro to the white world as a human, feeling thing.

<div align="right">("Drama" 171)</div>

He started the first of several drafts of *The Star of Ethiopia* in 1911. At first he called the work *The Jewel of Ethiopia: A Masque in Episodes* (there were six in the first draft). Since the masque form is more allegorical than commemorative, he began with a scene in which Shango, Yoruba God of Thunder, gives the Jewel of Freedom to Ethiopia in return for her soul (Giles 87). The jewel finally reaches the United States after being lost and found several times. There, the foundation stones of Labor, Wealth, Justice, Beauty, Education, and Truth are laid, and the jewel is finally ensconced on a Pillar of Light. For the finale the entire cast forms a celebratory tableau. The 13 leading characters include the Queen of Sheba, Nat Turner, Toussaint L'Ouverture, and Mohammed Askia.

In subsequent drafts the Jewel of Freedom became the Star of Faith, and some of the allegorical elements of the masque were blended into a historical presentation. By 1913 the title had become *The People of People and Their Gifts to Men*, which was published in *The Crisis* after its presentation that year at the National Emancipation Exposition in New York on October 23, 25, 28, and 30.[2] A prelude was followed by six episodes. The setting was the Court of Freedom in front of the Egyptian-inspired Temple of Beauty, where heralds announced "the tale of the eldest and strongest of the races of mankind, whose faces be black" ("National" 339). The Gift of Iron, the Gift of Civilization in the Valley of the Nile, the Gift of Faith, the Gift of Humiliation (slavery), the Gift of the Struggle Toward Freedom, and the Gift of Freedom preceded the final episode, in which the Veiled Woman, who had appeared in several previous episodes, became the All-Mother and led the cast in a triumphant procession as she carried a bust of Abraham Lincoln. The Star of Ethiopia is not directly mentioned in the first performed text, but the Court of Freedom is shaped as a five-pointed star.

Du Bois was a member of the Board of Governors of the National Emancipation Exposition of New York, which was held at the Twelfth Regiment Armory at 62nd Street and Columbus Avenue from October 22 through October 31, 1913, to commemorate the fiftieth anniversary of the Emancipation Proclamation. A few other states planned celebrations, but New York's was by far the most elaborate. The plan was that there would be exhibits to illustrate Black progress and to indicate contemporary conditions; the pageant would provide a historical setting and lend an appropriate ceremonial feeling to the event. A portion of the $25,000 exposition budget was used to costume 350 pageant participants, hire musicians, and build the set. Du Bois handled producing responsibilities, conferring upon Charles Burroughs the position of pageant master. Burroughs, whom Du Bois had taught at Wilberforce, directed all four productions of the pageant, providing continuity between the segments and shaping the pageant into stageable form. Du Bois reported that more 30,000 people visited the Exposition; more than 14,000 viewed the pageant.

Two years later, Du Bois raised funds to restage the pageant in Washington, DC. Contributing $500 of his own money, he formed an independent producing organization, the Horizon Guild. By the time he had secured funding, the Guild had only three weeks to prepare for the performance. A citizen's committee, the National Pageant and Dramatic Association, was formed in DC to cooperate with the Horizon Guild. There were more than 700 additional costumes that had to be made since 1,200 people, including a chorus of 200 singers, would participate. The Manual Training Department of the Public Schools built the set and props, and the Superintendent of Colored Education's provision of space and manpower proved invaluable. On October 11, 13, and 15, 1915, *The Star of Ethiopia* premiered at the American League

Baseball Park. This time there was an admission fee of 25 cents. Composer and musicologist J. Rosamond Johnson served as director of music, and 53 pieces of music composed by African Americans were performed. The Colored District Militia was enlisted for the battle episodes.

Now there were five scenes: the Gift of Iron; the Relation of Mulatto Egypt with Black Africa; the Culmination of African Civilization (200 AD–1500 AD); the Valley of Humiliation; and the Triumph of the Negro over the Ghosts of Slavery. Du Bois hoped that financial success would lead to the production of the pageant in ten other cities. Though the performances were well attended, the show ended up with a deficit of over $1,200.

Du Bois thought that the presentation of *The Star of Ethiopia* in Philadelphia in 1916 would be the last. A total of 1,000 participants staged the pageant in the 15,000-seat Convention Hall on May 16, 18, and 20, as a commemoration of the 100th anniversary of the meeting of the General Conference of the African Methodist Episcopal Church. With all funds exhausted and no further hope of production in sight, Du Bois reflected on his pioneering efforts: "a new and inner demand for Negro drama has arisen ... The next step will undoubtedly be the slow growth of a new folk drama built around the actual experience of Negro American life" ("Drama" 169). Du Bois went on to comment that *The Star of Ethiopia* had inspired a Shakespeare pageant among Washington Blacks and two masques in Cincinnati, and that additional inquiries about the pageant were pouring in. He also noted that the white American Pageant Association "has been silent, if not actually contemptuous" (171).

The last production of *The Star of Ethiopia* was performed in Los Angeles with a cast of 300 at the Hollywood Bowl on June 15 and 18, 1925. Du Bois wrote, but left unproduced, a second pageant, *George Washington and Black Folk*, which he published in *The Crisis* in 1932. His collected papers include manuscripts for two other pageants, *The History of the Negro in America in Twelve Living Pictures* (n.d.) and *Nine Tales of Black Folk* (later *Ten Tales of Black Folk* dated 1941).

Du Bois wrote extensive theatre criticism, particularly in regard to the representation of Black characters by white playwrights on the commercial stage. The stage, where the stereotypes of minstrelsy had held sway since the 1840s, began in the 1920s to profess an interest in the African American character in its search for quintessential American drama. Du Bois encouraged debate on this issue in a series of articles, "The Negro in Art/How Shall He Be Portrayed/A Symposium." Many of the significant Black and white playwrights and authors of the day weighed in. In 1926 Du Bois published his now often-quoted manifesto:

> The plays of a Negro theatre must be: 1. About us. That is, they must have plots which reveal Negro life as it is. 2. By us. That is, they must be written by Negro authors who understand from birth and continued association just what it means to be a Negro today. 3. For us. That is, the theatre must cater primarily to Negro audiences and be supported and sustained by their entertainment and approval. 4. Near us. The theatre must be in a Negro neighborhood near the mass of ordinary Negro people.
>
> (Du Bois, "Krigwa" 134)

Through his institution of literary contests, sponsored by *The Crisis* magazine, and the Krigwa Players (Crisis Guild of Writers and Artists) in New York, which spawned sister companies in Washington, DC, Cleveland, and Philadelphia, Du Bois helped to discover and encourage the most produced African American playwrights of their time, such as Willis Richardson and Eulalie Spence. Ironically, the New York Krigwa Players' proudest moment led to its disbanding. Du Bois entered the company in the Fifth Annual International Little Theatre Tournament in 1927 with *Fool's Errand*, a folk comedy/drama written and directed by Eulalie Spence. The production reached the finals, which were held in a Broadway theatre. Although they did not win,

the Players garnered a $200 prize, and Spence's play gained publication by Samuel French. Du Bois refused to share the prize money and opposed the company's desire to seek more professional work. After publishing a meticulous accounting of the company's funds for the two years of its existence, Du Bois, citing artistic and ideological differences, withdrew, taking the Krigwa name, which he had copyrighted, with him.

Though the Negro Renaissance was still in progress in 1927, funding for the support of the literary contests and for "Little Negro Theatre" productions began to dry up. The economic recession that would grow into a depression struck African American communities first. Though he appears to have retreated from active producing, Du Bois never gave up his interest in drama and continued to craft plays, completing two play collection manuscripts for potential publication.

*Playthings of the Night,* a collection of five plays, was completed in 1931. In his introduction, "Negro Tabus in the American Theatre," Du Bois sought to destroy through the use of irony what he described as ten "tabus" for depicting African Americans on the stage, summarizing with the great tabu that the playwright "must not simulate ordinary intelligent people." Eugene O'Neill, author of *The Emperor Jones* and *All God's Chillun Got Wings*, and Paul Green, author of *In Abraham's Bosom*, were among those taken to task for their depictions of African American characters. Du Bois wrote that his main goal in writing his plays was not so much to break the taboos as to be truthful to the situations depicted.

The first play, *Seven Up*, is a tragic melodrama in three acts. Set in Depression-era Georgia, it tells the story of Celia, a young, beautiful Black woman who is desired carnally by two white men and who is loved by one Black man, Jim. Celia is attracted to George, one of the white suitors. He and the other suitor, Sid, drink heavily and engage in the card game "seven up" while in Celia's cabin. Sid ends up trying to rape Celia, and George ends up killing him. George flees the scene, promising Celia that he will testify on her behalf if she takes the blame and pleads self-defense—a promise he does not keep. Jim tries desperately to come to Celia's aid, but Celia, seeing that he is in danger of being lynched, kills him. The final scene takes place in the jail, where Celia is locked in an unseen cell. The sheriff and a guard play a game of "seven up." The winner gets to rape Celia.

The other four plays exhibit Du Bois' interest in modern expressionism, fable, and allegory. *Black Hercules at the Forks of the Road* not only casts the mythological hero as a Black man but also places him in a symbolic modern dilemma. He must choose a path of life. Along whatever path he chooses, Black Hercules must overcome the Wall of Prejudice and the Mountain of Segregation.

The All Mother, seen in the *Star of Ethiopia*, represents Mother Earth in the drama named for her. She is troubled by her youngest child, Europe, who raped her to beget America and treats Africa and Asia with contempt. Europe subdues the world and brings it crashing down. Fortunately, it is all a dream, though a prophetic one: in less than a decade, the entire world would be at war.

*Black Man* is an expressionist fable in which Black Man, King of the Night, fathers seven rainbow-hued children. White Man is his sinister shadow. Black Man created White Man, too, but left out his heart. When he gives White Man a heart, harmony is restored to the world.

The final play, *Christ on the Andes*, is a verse drama. The three main characters are reincarnated in different contexts through 600 years of South American history. The first act is set in sixteenth-century Peru near the moment when Pizarro and his conquistadors arrive. Set in the eighteenth century, the second act shows how the characters' paths intersect as the Catholic Church tries to cope with corruption, slavery, and plague in Chile. Act 3 is set again in Chile on the cusp of a territorial war with Argentina during the twentieth century and centers on a stone figure of

Christ of the Andes as a symbol of peace. In each act, the Black man is a figure of Christ-like suffering. In the final act, he and the Christ of the Andes become one. The recurrence of the characters signified the unending cycle of colonial exploitation and warfare.

Du Bois presented Black characters in relationships unlike those presented on the commercial stage of his time, which may have been one reason why he could not get his plays published. His expressionistic plays would have proved difficult to stage as there are often extreme events, such as worlds crashing down. There is frankness in the treatment of sexuality, and violence suffuses the action. Though he embraced modernism in dramatic structure, his dialogue often reflected a more classical/Victorian sensibility (for example, All Mother asks, "Tell me, where hast thou been?"). Du Bois was also given to lengthy poetic passages, protracted monologues, and copious stage directions, exposition, and descriptive passages that might have been acceptable for closet drama but all-but-impossible to translate into stage presentation. The contradiction between content and form may reflect contradictions and ambivalences that Du Bois may have felt toward his creative work. The idea of double consciousness that he described in his landmark work *The Souls of Black Folk* (1903), a collection of sociopolitical essays and creative writing, shows itself in his creative expression: "He lived politically but also spiritually in a dualism of mind and act forced on him by the pressure of American reality" (Rampersad 201).

Over the course of a decade, Du Bois revised and updated the scripts from *Playthings of the Night* into a new manuscript, *The Darker Wisdom: Prophecies in Tale and Play, Seeking to Pierce the Gloom of 1940*. His papers include an outline for another play, *The Prodigal Race*, based on the parable of the Prodigal Son and other Biblical imagery. After this, his playwriting appears to have ended.

From 1913 to 1940, Du Bois published *Black Reconstruction in America: An Essay Toward a History of the Part Which Black Folk Played in the Attempt to Reconstruct Democracy in America, 1860–1880* (1935) and seven other non-fiction books; two autobiographies, *Darkwater: Voices from Within the Veil* (1920), and *Dusk of Dawn: An Essay Toward an Autobiography of a Race Concept* (1940); and two novels, *The Quest of the Silver Fleece* (1911) and *Dark Princess* (1928). All the while, he continued editing and contributing to *The Crisis* magazine. Still, his "illegitimate children" were never far from his thoughts.

## Notes

1 The pageantry craze in the United States reached its zenith between 1910 and 1917 as the nation began to assert its national identity. Communities commemorated their histories as a form of public ritual through dramatic representations that featured processions and tableaux vivants. See Giles.

2 Du Bois periodically wrote about preparations for the pageant in *The Crisis*. See, for example, the November and December issues of 1913 and the September and December issues of 1915.

## Works cited

Archer, Leonard C. *Black Images in the American Theatre*. Pageant-Poseiden, 1973.

Aptheker, Herbert, editor. *Creative Writings by W.E.B. Du Bois: A Pageant, Poems, Short Stories, and Playlets*. Kraus-Thomson Organization, 1985.

"The Drama Among Black Folk." *The Crisis*, vol. 12, no. 4, August 1916, pp. 169–171.

Du Bois, W.E.B. *The Autobiography of W.E.B. Du Bois*. International Publishers, 1968.

———. "Krigwa Players Little Negro Theatre." *The Crisis*, vol. 32, no 3, 1926, pp. 133–134.

———. "The National Emancipation Exposition." *The Crisis*, vol. 6, no. 7, November 1913, pp. 339–341.

———. *Playthings of the Night*. W.E.B. Du Bois Papers, series 13, Special Collections and University Archives, University of Massachusetts Amherst Libraries.

Giles, Freda Scott. "*Star of Ethiopia* 1913." *Black Theatre USA*. Vol 1: Plays by African Americans, 1847–1938, revised and expanded, edited by James V. Hatch and Ted Shine, Free Press, 1996, pp. 87–88.

Rampersad, Arnold. *The Art and Imagination of W.E.B. Du Bois*. Harvard UP, 1976.

W.E.B. Du Bois Papers, Special Collections and University Archives, University of Massachusetts Amherst Libraries.

# 38

# THE THIRD GIFT OF THE NEGRO

## Muslim identity and Du Bois' *Star of Ethiopia*

*Cristal Chanelle Truscott*

### October 22, 1913

Imagine Columbus Avenue between 61st and 62nd streets in New York City—the current location of the globally renowned Lincoln Center—crowded with 14,000 spectators from near and far waiting in enthusiastic suspense for the cultural event of the year. Envision a cast of 350 performers (Giles 87) donning colorful regalia to take attendees on a live-action, oratorical, and musical journey through time. The artist has promised this performance as a celebration of unity and the powerful contributions of a people to the fabric of America. Halfway through the performance the full crowd remains, captivated by the spectacle. Onstage, the drums roll and the Herald proclaims: "Hear ye, hear ye, of the Third Gift of Black men to this world—a Gift of Faith in Righteousness hoped for but unknown." It's October 22, 1913, at the Twelfth Regiment Armory in New York. The event of the year is the pageant play *Star of Ethiopia* (Figure 38.1). The artist is scholar-activist W.E.B. Du Bois. "The Third Gift of the Negro to the world, being a Gift of Faith. This episode tells how the Negro race spread the faith of Mohammed over half the world and built a new culture thereon" ("*Star*" … *Black Theatre USA* 90) In the audience is a 14-year-old Duke Ellington, who leaves inspired and writes his first music composition the following summer (O'Meally 340; Tuckett 7–8). Years later at the same site, Lincoln Center will house music education programs and festivals bearing Ellington's name (Military History 17). But in 1913, Ellington is an unknown prodigy, a youth among the thousands of spectators witnessing the pageant's massive ensemble transform a Manhattan city block into a cultural celebration.

The performers move on to depict the battle of Songhai led by Askia "the Great" Muhammad, known for making the Songhai Empire the largest territory in West Africa's history. Eventually comes the procession of fourteenth-century Malian leader Mansa Musa, the wealthiest person in the world in his time. He is returning from *hajj*, the Islamic pilgrimage to Mecca, with his "entourage on horseback, followed by Black Mohammedan[1] priests and scholars" who embody the intellectual brilliance of the University of Sankore at Timbuktu.[2]

> God is God! God is God!
> There is no God but God,
> and Mohammed is his prophet!

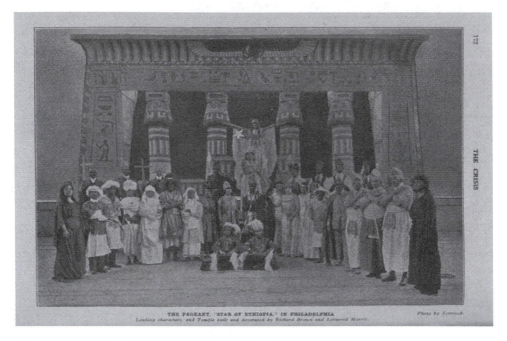

*Figure 38.1*   Members of the Philadelphia cast of *Star of Ethiopia* (1916).

*Source*: Schomburg Center for Research in Black Culture, Jean Blackwell Hutson Research and Reference Division, New York Public Library. New York Public Library Digital Collections, 1916-08. http://digitalcollections.nypl.org/items/965eae51-3242-ef51-e040-e00a180672c9.

This impressive spectacle was viewed by thousands of people at each of its four showings in New York (1913), Washington, DC (1915), Philadelphia (1916), and Los Angeles (1925). Yet, who in the audience and, indeed, who in our contemporary times would have expected the "Third Gift of the Negro," that of faith, to refer not to Christianity or the Black Church but rather to Islam?

## Pageantry and politics

As early as 1876, pageants were used to commemorate United States history through celebratory, historical reenactments that dramatized events like the Fourth of July or the signing of the Constitution in order to promote patriotism and the assimilation of immigrants (Glassberg). They were mounted primarily as episodic, large-scale, civic events that included "music, costume, dance, narration and tableaux" in a manner that was "too pictorial to be a parade, but not dramatic enough to be a play" (Giles 86). By the early twentieth century pageantry was a cultural sensation sweeping the country.

Du Bois recognized that pageantry could offer a grand stage to present Black cultural legitimacy and thereby rehabilitate the image of the American Negro that was rooted in the degradations of slavery, Jim Crow, lynchings, and blackface minstrelsy. Perhaps more importantly, he also speculated that pageantry could stimulate a pride in African heritage and a movement of self-determination. Inspired, he wrote *The Star of Ethiopia*. Six episodes portrayed the Gifts of the Negro: Iron, Civilization, Faith, Humiliation (for having survived slavery), Struggle Towards Freedom, and Freedom.

Academically, politically, and artistically, it was a bold and ambitious endeavor, one that theatre scholar Freda Scott Giles describes as "a seminal event in the development of African American drama and theatre during the Harlem Renaissance period" (88). Further, it was precisely Du Bois' use of Muslim identities in staged constructions of "the African" (and Africa itself) that provided a means for these performances to consciously transmit historical knowledge, promote themes of cultural pride, and argue for equality of citizenship for African descendants in the Americas.

## History as strategy

In constructing African identity as Muslim, Du Bois was, in fact, drawing from history.

Upwards of 15 percent of Africans transported to the Americas during the Transatlantic Slave Trade were Muslim, making this fractured, involuntary-immigrant community the first Black Muslim population in the Americas (Diouf). In *Servants of Allah: African Muslims Enslaved in the Americas*, Sylvianne Diouf writes that enslaved African Muslims "introduced a second mono-theistic religion (after the arrival of Catholicism and before Protestantism) into post-Columbian America" (1), making Islam the first revealed religion *freely* followed by the Africans who were transported to the New World, as opposed to *imposed* Christianity. Surveying a wider time frame, Robert Dannin asserts in *Black Pilgrimage to Islam* that the presence and contributions of African and African American Muslims throughout US history have been so great that it is more accurate to describe the United States as a "Judeo-Christian-*Muslim* society" (12). With the increase of contemporary scholarship that departs from typical thinking of Muslim identities solely as religious and that considers their historical and current cultural impact from Negro spirituals to hip hop, a richer picture of African American history and performance is being explored that aligns with Du Bois' work over 100 years ago.

But Du Bois' positioning of Islam as the Gift of Faith is not just factually informed; it is also deeply strategic as part of his work for equal rights. Du Bois founded *The Crisis* in 1910 as the official magazine of the NAACP (National Association for the Advancement of Colored People) and featured calls for submission of "race plays" in several issues for "the purpose of studying ways and means of utilizing the stage in the service of our cause" ("Along the Color Line"). In many ways, *The Crisis* was a precursor to the pageant, for it regularly published articles on African Islamic culture, education, and political issues. For example, Virginia Wright wrote a review in which she included information about "Moslem Spain," children learning the Qur'an in North African schools, and mosques and the university in Timbuktu in Africa ("The Congo Express"). Undoubtedly for most African American readers of the magazine, these were the first and only consistently positive depictions of Africa that they encountered. Not only could they begin to see themselves in connection to the continent, but they also had evidential proof of the reasons why they should take pride in their African heritage. *Star of Ethiopia* closely mirrored this approach.

Furthermore, at the time of *Star*'s premiere in New York, the city was already bustling with Islamic cultural nuances via an active Freemason society and burgeoning African American Muslim communities. That same year, 1913, Noble Drew Ali founded the Moorish Science Temple of America in Newark, NJ. Declaring "Moors" to include all "Negroes, Blacks, Coloreds, and Ethiopians," he became one of the first prominent community leaders to ground Black Nationalist teachings in Islamic beliefs and principles (McCloud 10–18). It would not be far-reaching to speculate that people from Ali's community were among the 14,000 who attended *Star*'s premiere in New York. Du Bois' Afro-Islamic depictions in *Star* not only served to mend African Americans' negative associations with Africa with the liberatory thread of

African Muslim legacies, but they also offered a model of inclusion and respect for spiritual diversity that our contemporary times so often lack.

## Performance as strategy

Du Bois used the historical Askia Muhammad and Mansa Musa in *Star of Ethiopia* to present the Islamic legacy and great kingdoms of West Africa. Musa is known for revolutionizing education by establishing the University of Sankore at Timbuktu, and Askia is credited with reviving Timbuktu generations later. Both were devout Muslims lauded for effectively expanding their empires through education, economic vitality, and social and political policy. By highlighting them, Du Bois cited a heritage of political, economic, diplomatic, educational, and spiritual greatness that is respected by historical record. His characterizations situate those African civilizations and, by extension, Africa as a whole, as a peer of other great empires worldwide. Du Bois did not present a utopic depiction of Africa or even of Islam as the Third Gift; rather, he presented Africa as glorious, yet complicated.

Generations before *Star*, segments of the public had been exposed to "performing" African royalty as a means of establishing pride, affirming mental and intellectual autonomy, and securing freedom. Enslaved prince Ibrahima Abdur-Rahman ibn Sori of Natchez, MS, "staged" his way to freedom, becoming during the 1820s "the most famous African in America" and the most famous Muslim in America (Austin 66). He was born the son of an *imam* (an Islamic spiritual and political leader) in Timbo, Futa Jallon, Guinea, West Africa, and educated at Timbuktu before being taken from his life of privilege as a "prince" to one of enslavement in the United States. Emancipated after 40 years of enslavement, Abdur-Rahman embarked on a speaking tour dressed in Islamic garb, performing the identity of a "Moorish Prince" to raise money for his family's freedom and return to Africa. On tour, he crossed paths with a plethora of history makers in action—the president, congressmen, abolitionists, cultural leaders, activists—inspiring hope and determination in those fighting for freedom and fear in those opposed to abolition (Austin 66–67).

Abdur-Rahman's appearances were covered meticulously by the press and met with fanfare similar to the theatrical productions of the time. He was lauded in Cincinnati, Boston, Philadelphia, New York, Baltimore, and Washington DC, with headlines such as "The Unfortunate Moor" and "The Prince of Timbuctoo" and in such proclamations as "He is entitled to the Throne!" (Alford 115) His appearances included scenic elements. One event featured a "panorama, which was said to mimic nature so well that patrons came away wet" (Alford 127). So popular was Abdur-Rahman that he sold autographs and inscriptions in Arabic to raise money (Everett 188). "For those incredulous at the thought of a literate African," he wrote in Arabic *Al-Fatihah*, the first chapter of the Qur'an (Alford 128). Abdur-Rahman played to the press and public by lending his fame to the cause of freedom beyond his own and his family's emancipation by speaking out against American slavery and the Christian justification of it while subversively promoting Islam and challenging the stereotypes of Africans.

Abdur-Rahman's quest for freedom is one of the earliest documented performances of African American Muslim identity. His tour generated a public awareness and performance record that would outlast the ephemeral nature of the tour itself. It is through Abdur-Rahman's tour that a performative foundation for African American Muslim identity is recorded and overtly tied to understanding Muslimness not only as a mark of Africanness but also as a point of entry marking Africa and iterations of African-based identity in direct resistance to mainstream American notions of Black people. A similar formulation of *performing Blackness*, *performing Muslimness* and *performing Black Muslimness* would subsequently be staged throughout the postbellum era, most accessibly in *Star*.

## The gift of *Star of Ethiopia*

Historically, Eurocentric theatre writings typically center Muslim identities as an antagonistic, ethnic Other—"Sultan," "Araby," "Orient," or "Moor" (Peterson 129). Oftentimes these representations make no significant reference to religion, except as a negative descriptor to further position these characters as dangerous, mysterious, or backward. However, Muslim characters in African American theatre and performance are predominantly represented through a kinship of heritage as precisely *African*—not Arab, Indian, or Asian. By doing so, Black theatre has not only historically positioned Muslim identity as a cultural marker of Africanness but has also anchored these depictions as a point of entry to promote more expansive, positive understandings of Africa, pride in African heritage, and rejection of white American ideologies and their notions of Blackness. Such representations also function to promote intercontinental African diasporic solidarity for equality, justice, and freedom. *Star* is not the only example, but its script is by far the most accessible to theatre students, teachers, and practitioners (Hatch and Shine 89–92). Examples of Muslim identities in Black performance significantly increase after the 1930 founding of the Nation of Islam (which has its own archive of plays); the global popularity of Malcolm X and Muhammad Ali in the 1960s; and the pioneering influences of Muslims in jazz and hip hop.

Du Bois extends a call in *Star* for those "that come to see the light and listen to the tale of the bravest and truest races of men, who faces be Black" to continue our exploration, education, and celebration of Black contributions to the world (90). The value in examining historical examples like *Star* lies in the reminder of the wealth of exploration that remains in chronicling and analyzing the multi-faceted *and multi-faith* contributions of African Americans to art, culture, and society (Krasner 39). There is a trove of information to be learned by asserting and including spiritual diversity into the analysis of Black theatre alongside constructions of race, gender, and class. In this way, perhaps, the example of *The Star of Ethiopia* in itself is one of the greatest gifts of Black theatre to the world.

## Notes

1 Western scholarship before and even up to the mid-twentieth century frequently and inaccurately refers to Muslims as "Mohammedans" and to Islam as "Mohammedism."
2 *Star* depicts the contributions of these two men out of order, showing the battle of Songhai first.

## Works cited

Alford, Terry. *Prince Among Slaves*. Oxford UP, 1977.

Austin, Allan. *African Muslims in Antebellum America: Transatlantic Stories and Spiritual Struggles*. Routledge, 2012.

Dannin, Robert. *Black Pilgrimage to Islam*. Oxford UP, 2002.

Diouf, Sylvianne A. *Servants of Allah: Africans Enslaved in the Americas*. Kindle ed., New York UP, 1998.

Du Bois, W.E.B. "Along the Color Line." *The Crisis*, vol. 9, no. 5, Mar. 1915, p. 215.

———. "*The Star of Ethiopia*." *Black Theatre USA, Vol. 1: Plays by African Americans 1847–1938*, edited by James V. Hatch and Ted Shines, revised and expanded ed., Free Press, 1996, pp. 88–92.

———. "*The Star of Ethiopia*." *The Crisis*, vol. 11, no. 2, Dec. 1915, pp. 90–94.

Everett, Edward. "Abdul Rahaman." *Orations and Speeches on Various Occasions*, vol. 3, Little Brown, & Company, 1870, pp. 186–194.

Giles, Freda Scott. "Star of Ethiopia 1913, W. E. B. Du Bois (1868–1963)." *Black Theatre USA*, edited by James H. Hatch and Ted Shine, pp. 87–88.

Glassberg, David. *American Historical Pageantry: The Uses of Tradition in the Early Twentieth Century*. U of North Carolina P, 1990.

Hatch, James V., and Ted Shine, editors. *Black Theatre USA. Vol. 1: Plays by African Americans 1847–1938.* Revised and expanded ed., Free Press, 1996.

Krasner, David. *A Beautiful Pageant: African American Theatre, Drama, and Performance, 1910–1927.* Palgrave, 2002.

McCloud, Amina. *African American Islam.* Routledge, 1995.

New York State Military Museum. "Military History." New York State Division of Military and Naval Affairs, 20 Apr. 2018, https:dmna.ny.gov/historic/armories/NewYorkCityColumbusAvenue.html.

O'Meally, Robert G., et al. *Uptown Conversation: The New Jazz Studies.* Columbia UP, 2004.

Peterson, Bernard L. "The Housley Brothers." *Profiles of African American Stage Performers and Theatre People, 1816–1960.* Greenwood, 2001, pp. 128–129.

Tuckett, Mark. *Ellington: The Early Years.* Urbana, 1991.

Wright, Virginia. "The Congo Express." *The Crisis*, vol. 2, no. 4, Aug. 1911, pp. 163–66.

# 39

# OH, MA DEAR! WHAT'S GOING ON?

## Staging Angelina W. Grimke's *Rachel* in the wake of Black Lives Matter

*Nicole Hodges Persley*

### What's going on? Black Lives Matter then

On July 28, 1917, 10,000 African Americans organized a silent march down Fifth Avenue in New York City to protest systemic racial violence against Blacks in the United States. This demonstration, the Negro Silent Protest Parade, is archived as one of the first organized protests by African Americans in the long history of the civil rights movement. The organizers wore white and marched against the rampant lynching of African American men and women. The National Association for the Advancement of Colored People (NAACP) gives the following statistics regarding lynching:

> From 1882–1968, 4,743 lynchings occurred in the United States. Of these people that were lynched 3,446 were black. Blacks accounted for 72.7% of the people lynched. These numbers seem large, but it is known that not all of the lynchings were recorded. Out of the 4,743 people lynched only 1,297 white people were lynched. That is only 27.3%. Many of the whites lynched were lynched for helping the black or being anti-lynching and even for domestic crimes.
>
> ("History")

Nearly 100 years later, I decided to stage Angelina W. Grimke's 1916 anti-lynching play *Rachel* to address the trauma of lynching that was remixed in the present wake of the Black Lives Matter movement. By connecting past protests to those in the current moment, my goal was to connect theatre audiences to the history of the (re)construction of American democracy as tied to what Christina Sharpe calls a "pervasive climate of anti-blackness" (106). As an African American female director and scholar of Black theatre, I wanted to direct a play that could connect the Black Lives Matter movement's efforts to stop anti-Black violence to an earlier, eerily relevant, history of civil rights protest that was less familiar to the general public: the anti-lynching movement.

## Oh, Ma Dear! What's going on from 1916 to 2016?

In 1915, W.E.B. Du Bois created a Drama Committee of the NAACP that published a call in *The Crisis* magazine for Black playwrights to submit works about lynching. The NAACP produced Angelina W. Grimke's *Rachel*, which became the "first black-authored, nonmusical script to enjoy stage success outside of black-only community theatre" (Mitchell, "Anti-lynching Plays" 211). The play chronicles the aftermath of lynching on the Lovings, a middle-class family living in New York. We meet Mrs. Loving, a middle-aged African American woman from the South, living with her two surviving, adult children, Tom and Rachel. Mrs. Loving (incessantly referred to as "Ma Dear" by her daughter)[1] has never revealed that their father and older brother were lynched by the Ku Klux Klan, referred to in the play as Christian "masked men" (Grimke 24). The play opens exactly ten years after their murders on the day that Mrs. Loving reveals the truth that will change the course of Rachel's and Tom's lives.

In contemporary Black families, many "Ma Dears" across the nation lose their daughters and sons to excessive police violence. Many of us ask ourselves, "What's going on?" echoing the prescient title of Marvin Gaye's 1971 soul album, which questioned hatred and injustice in America. One must ask, how is the American theatre being used today to show the nation what's going on? How does Grimke's *Rachel* allow us to see the present moment within a larger historical context of freedom pursuits?

Du Bois used Angelina W. Grimke's work to launch his anti-lynching propaganda agenda by writing the Lovings as an educated, working-class family. Grimke was dismantling stereotypical depictions onstage of African Americans as slovenly and uneducated because she understood that "white logic" used such images to undermine the humanity and suffering of Black people (Mitchell, "Sisters" 41). According to scholar Koritha A. Mitchell, Grimke shared drafts of her play with Du Bois as early as January 1915, before the Drama Committee was formed later that year. *Rachel* was staged in March 1916 in Washington, DC, and inspired many Black writers to write plays that challenged stereotypes of Black people as poor, uneducated, and subservient. The Black Lives Matter movement was created to question devaluations of Black life in American culture similar to those that Du Bois and Grimke critiqued 100 years prior.

## What's going on now? Directing and producing *Rachel* in the wake of Black Lives Matter

Black Lives Matter is an organization started by Alicia Garza, Patrisse Cullors, and Opal Tometi in 2013 to build national coalitions against the excessive force of American law enforcement and the seeming disposability of Black lives. The organization came to prominence via the social media hashtag #BlackLivesMatter, which went viral after the death of Michael Brown in Ferguson, Missouri, on August 14, 2014. In the article "A Bird's Eye View of Civilians Killed by Police in 2015," scholars Nix, et al. argue that Black men accounted for roughly 40 percent of the unarmed people fatally shot by police and were seven times as likely as unarmed white men to die from deadly police force (315). The original *Washington Post* article from which the scholars draw the data contends, "When adjusted by population, [unarmed Black men] were seven times as likely as unarmed white men to die from police gunfire" (Lowery). As a transplant to Kansas City from Los Angeles in 2009 and a professor in the Department of Theatre at the University of Kansas, I created several theatre outreach programs in the city in order to establish a connection with the African American community. I approached KC Melting Pot Theater in 2015 with the idea of creating a coalition of Black directors, actors, and technicians to produce

theatre following the Du Boisian model of theatre "about, by, for and near Negro people" (Du Bois 134). Within the context of the long history of anti-Black violence in Missouri, I explained that we had an opportunity to use theatre to educate communities about strategies of resistance against excessive police violence.

KC Melting Pot Theater (KCMPT) is the premier African American theatre company in Kansas City, Missouri. The company began in 2013 under the direction of Harvey and Linda Williams, a retired, African American husband and wife producing team. Between 2013 and 2015, the company produced original works by Harvey Williams (who is also an actor/playwright) and a select group of local playwrights. KCMPT produces shows for less than $5,000 dollars, which includes the entire production budget and payment for actors. The company relies almost exclusively on ticket sales and private donations to stay afloat. The Williams team was immediately responsive to the idea of coalition and designated me associate artistic director of the company. I pitched *Rachel* as a part of the 2016–2017 season. Our production opened November 10, 2016, and ran for ten days. For many KCMPT audience members, our production was their first experience with the history of anti-lynching plays, and it was KCMPT's first attempt to address the senseless anti-Black violence that was occurring in Missouri and the nation at large.

## All things being equal: casting Black trauma

As the director, I had a tremendous burden to present the play with honesty. I honored many of Grimke's stage directions and revered the fact that fewer than ten directors, including myself, had staged this show. My goal was to illuminate the text for the actors by framing it as a musical score that would enable them to play back experiences of African American life from the past to audiences in the present. Rachel is a naïve young woman who aspires to be a teacher and loves children. She spins fanciful stories at her mother's feet about her desire to be a mother, never recognizing how anti-Black violence will detour the possibilities of her dreams coming to fruition. Her brother, Tom, on the other hand, is aware that it is racism, not his intellect or skill, that limits his aspirations to be an engineer.

Casting 13 Black actors ranging in age from 50 to 6 years old in a city where most of the working performers are white was challenging. The principal adult characters were played by a mixture of self-taught actors and actors trained in college BFA programs in the region. All of the children's roles were cast from "Drama Time," an acting training program that KCMPT offers to children in the community. The role of Jimmy Mason, the young boy who Rachel adopts in the play after the death of his mother, was played by two young actors who alternated performances to maintain school schedules. All of the children had their "professional" stage debut with *Rachel*; in fact, this was the first time that many of the actors—adults as well as children—had ever been paid to act, design, or stage manage a theatre show. As an associate member of the Stage Director and Choreographer's Society (SDCS), I was able to work for free, thus allowing KCMPT to hire me without charge.[2]

I highlight my affiliation with SDCS to give an example of how emerging directors of color can affiliate with mainstream institutions to become eligible for work in the American theatre while simultaneously navigating how to work within the financial constraints of small theatre companies dedicated to producing Black theatre. KCMPT is the largest talent incubator for African American performers in Kansas City, yet we do not have the financial means to pay acting and directing contracts under the Equity 99-seat theatre plan. We must exist within the liminal space between professional and non-professional theatre.

After casting, we had the difficult task of producing the show on a budget of roughly $5,000 dollars within a six-week rehearsal schedule. I decided that a sparse set design that

suggested an outline of the Loving home could indicate the family's refined taste. Our set designer suspended an upstage wall from the ceiling with rope, and pieces of the baseboards of the apartment were placed in fragments downstage to indicate the fourth wall of the apartment. Projections were used to indicate a large picture window that suggested a symbolic cross that spilled across the stage during time shifts from day to night. A piece of the mantle suggested a fireplace upstage center and held a suspended clock. Rachel's piano was indicated stage right by using a small table with a carved wood block to suggest keys. We costumed the entire cast in variations of white to replicate the white clothing worn in the NAACP Negro Silent Protest March of 1915. The costume designer made simple, long skirts worn with Victorian style blouses for all of the female cast members. The male characters wore white shirts and off-white vests, jackets, and pants. The psychic and physical violence that the Loving family and the children of the community faced in the early twentieth century was symbolized by giving the performers dark coats and hats, which served as armor to battle the outside world.

## "It was the tree where they were ..." (Grimke 26)

As Mrs. Loving, the matriarch in *Rachel*, remembers the anguish of watching her husband and 17-year-old son lynched by a white mob, one cannot help but make a visceral connection to the testimonies of many African American families who have lost their loved ones over the long history of mob violence and police brutality that persists into the twenty-first century. Mrs. Loving's recollection of "The tree where they were" as she recounts the lynchings is symbolic of systemic violence against African Americans in the present. Mrs. Loving's last memory of her husband and son is chilling: "Your father was finally overpowered and dragged out. In the hall my little seventeen-year-old George tried to rescue him. Your father begged him not to interfere. He paid no attention. It ended in their dragging them both out" (Grimke 27).

On August 9, 2014, two years before we produced *Rachel* and about four hours away by car, Michael Brown's mother, Lezley McSpadden, would recall a similar memory after her son was shot and killed by Darren Wilson, a white police officer, left lying on the street for hours. Black Lives Matter protests erupted across the nation after prosecutors in nearby St. Louis announced that Wilson would not be charged for Brown's shooting. As Michael Brown's mother explained, "For the black people, Mike getting shot was like an old scab being pulled off a wound filled with racism" (McSpadden and LeFlore 187). The sheer number of present-day Black deaths due to police brutality has made international news: Jordan, Eric, Michael, Laquan, Akai, Tamir, Walter, Freddie, Sharonda, Cynthia, Susie, Ethel Lee, De Payne, Clementa, Tywanza, Daniel, Myra, Sandra, Jamar, Alton, Philando ... Following Claudia Rankine in *Citizen: An American Lyric*, I list the first names of those killed by anti-Black violence. I add to Rankine's list (134–135) two more persons, known to us through death, and add ellipses to suggest that an expectation. Staging *Rachel* in a state known for lynching Black men in the past and the site of national unrest after Michael Brown's death was not an easy task.

When Mrs. Loving reveals to Rachel and Tom that their father and brother were lynched, Rachel makes the connection that Jimmy, the young boy in her apartment building whom she later adopts, could be lynched just as her brother George had been. As Rachel grapples with her mother's trauma, she responds, "I understand, Ma Dear. Ma Dear, I am beginning to understand so much. Ten years ago, all things being equal, Jimmy might have been George. Isn't that so?" (Grimke 27). She begins to understand that Black life is devalued in the United States and that

every Black person does not have the same rights and privileges that she had assumed should be afforded to all American citizens.

## "Tell the truth and shame the devil" (McSpadden and LeFlore 187)

After we produced *Rachel* in response to Black Lives Matter in 2016, we garnered critical attention in Kansas City for our artistic excellence in mapping a historical continuum of anti-Black violence documented in American theatre. Outside of the theatre, we faced sobering statistical data. Not two miles from our theatre, Black Lives Matter organizers in Kansas City continued to fight anti-Black racism and one of the highest homicide rates in the nation. According to data compiled by the FBI's Crime Reporting Program report in 2015, Kansas City ranked number 12 in the highest murder rates in the United States, trailing St. Louis, which topped the charts at number 1 ("Thirty Cities"). The expectation of safety that our African American audience members had inside our theatre did not extend outside our doors.

One hundred years after the NAACP produced *Rachel*, mothers, fathers, daughters, and sons are being lost to anti-Black violence. Using work from the early twentieth century, we were able to connect audiences to the Black Lives Matter movement on a personal level. Not long after we staged our production, on August 2, 2017, the NAACP launched a travel ban that advised all African Americans:

> [I]ndividuals traveling in the state [of Missouri] are advised to travel with extreme CAUTION. Race, gender, and color based crimes have a long history in Missouri, home of Lloyd Gaines, Dred Scott and the dubious distinction of the Missouri Compromise and one of the last states to lose its slaveholding past, may not be safe.

As the Kansas City Melting Pot Theater continues its quest to use theatre to stage urgent conversations about African American life, we look to plays like *Rachel* and sonic reminders from artists like Marvin Gaye that ask us to think critically about what's going on in America.

## Notes

1 "Ma Dear" and "Madea" are shortened versions of Mother Dear and are used interchangeably as terms of endearment for mothers and grandmothers in many African American communities in the South. The term was revived in African American vernacular after the popularity of writer-director Tyler Perry's stage plays and his depiction of the "Madea" character. See Persley (217–236).
2 The Stage Directors and Choreographer's Society is a national union that represents professional stage directors and choreographers in the American theatre. The organization helps members at the full membership level negotiate minimum and maximum rates and contracts for services. Associate-level members gain access to institutional membership and networking opportunities but are not required to submit contracts that guarantee union rates for directing and choreography services.

## Works cited

Du Bois, W.E.B. "Krigwa Players Little Negro Theatre." *The Crisis*, vol. 32, no. 3, July 1926, pp. 134–136.
Gaye, Marvin. "What's Going On?" *What's Going On?* Tamla Records, 1971.
Grimke, Angelina Weld. *Rachel: A Play in Three Acts*. McGrath, 1969.
"History of Lynchings." 2017, www.naacp.org/history-of-lynchings/.
Lowery, Wesley. "Study Finds Police Fatally Shoot Unarmed Black Men at Disproportionate Rates." *Washington Post*, Apr. 1, 2016, www.washingtonpost.com/national/study-finds-police-fatally-shoot- unarmed-Black-men-at-disproportionate-rates/2016/04/06/e494563e-fa74-11e5-80e4-c381214de1a3_story.html?tid=sm_tw.

McSpadden, Lezley, and Lyah Beth LeFlore. *Tell the Truth & Shame the Devil: The Life, Legacy and Love of my Son Mike Brown*. Regan Arts, 2016.

Mitchell, Koritha. "Anti-lynching Plays: Angelina Weld Grimke, Alice Dunbar-Nelson, and the Evolution of African American Drama." *Post Bellum-Pre Harlem: African American Literature and Culture*, edited by B. MacCaskill and C. Gebhard, New York UP, 2006, pp. 210–230.

———. "Sisters in Motherhood (?): The Politics of Race and Gender in Lynching Drama." *Gender and Lynching the Politics of Memory*, edited by Evelyn M. Simien, Palgrave Macmillan, 2011, pp. 37–60.

"NAACP Issues 'Urgent' Travel Advisory in Missouri." 2 Aug. 2017, www.kktv.com/content/news/NAACP-issues-travel-advisory-in-Missouri-438235533.html.

Nix, Justin, et al. "A Birdseye View of Civilian Killed by Police in 2015: Further Evidence of Implicit Bias." *Criminology & Public Policy*, vol. 16, no. 1, pp. 309–340.

Persley, Nicole Hodges. "Bruised and Misunderstood: Translating Black Feminist Acts in the Works of Tyler Perry." *Palimpsest: A Journal on Women, Gender and the Black International*, vol. 1, no. 2, 2012, pp. 217–236.

Rankine, Claudia. *Citizen: An American Lyric*. Graywolf Press, 2014.

Sharpe, Christina. *In the Wake: On Blackness and Being*. Duke UP, 2016.

"Thirty Cities with the Highest Murder Rates in the US," 2017, www.bismarcktribune.com/news/national/the-cities-with-the-highest-murder-rates-in-the-us/collection_5a789407-4d43-5403-ad56-7c47880bda8e.html.

# 40

# LEANING LEFT

## Why theatre artists in the 1930s were attracted to the Red movement

*Kimmika L.H. Williams-Witherspoon*

Between 1919 and 1938, the Communist Party helped usher in a resurgence in African American arts. Published in leftist publications like *The New Masses* or performed at workers rallies, much of the drama, poetry, and art of the period examined oppression and institutional racism without the usual tropes of circumlocution, brokenness, stereotypical representations of "Blackness," song, dance, or comedy. For a time, many African American artists—poets, writers, dramatists—like Langston Hughes were both Black and Red.[1]

### Introduction

Traditional theatre criticism focuses primarily on aesthetics. However, the political economy of African American arts production often paints a more nuanced picture about the importance of the work and its performance beyond a focus on mere aesthetics. Using political economy as a method of analysis, this chapter analyzes Langston Hughes' 1931, one-act play, *Scottsboro Limited*, by examining the social and political conditions that influenced it.

A Marxist theory, *political economy* looks at "interactions between the social uses of power and material resources" (Gates 971). The same way that politics, social relations, and "the market" can affect production and distribution of material resources, cultural and aesthetic productions, like theatre, are influenced by the imposition of power in intersecting fields. "Any and every 'economic' phenomenon is at the same time always a social phenomenon" (Giddens 10).

### Contextualizing the period

In the summer of 1917 on the heels of war, two of the deadliest race riots occurred in East Saint Louis, Illinois, an industrial city. Manufacturers used African Americans migrating north to fill vacancies left by soldiers going off to war and as "strike breakers" to weaken unions that, at the same time, sought to keep African Americans out of the labor force. In May and July, racial tensions came to a head. In the resulting riots, 40 African Americans were killed and over $400,000 was lost in property damage.

Between the summer of the East Saint Louis riots in 1917 and the dismantling of the Works Progress Administration's (WPA) Federal Theatre Project and its "Negro Units" in 1938, much of African American arts production grew out of tensions between rising interest in

the Communist Party and American politicians who wanted to court the "Black vote" and then, later, to eradicate anything "Black and Red." For African Americans moving to crowded urban centers, as well as for poor, disenfranchised workers stuck in the Jim Crow/Jane Crow South, the Communist Party of the United States of America (CPUSA) was appealing precisely because of its left-wing platform on integration, fair wages, and equality (Madhubuti 2015).

Founded in 1919, CPUSA was intrinsically linked to the Union of Soviet Socialist Republics (USSR). The Party organized African Americans in demonstrations against discrimination, campaigns for political office, support for workers on the frontlines, and funding for legal fights against racism (Frazier 93). African Americans joined the CPUSA's Unemployment Councils and participated in Hunger Marches to advocate for relief, unemployment compensation, and racial parity (Grant 216). Some of the writers who supported Communist platforms privately (if not publically) included Richard Wright, Ralph Ellison, Harry Haywood, Langston Hughes, Gwendolyn Bennett, Wallace Thurman, Claude McKay, Lorraine Hansberry, Alice Childress, and Paul Robeson (Washington 123).

Communist interest in "the Negro Question" was far from altruistic. After Vladimir Lenin (1870–1924) raised "the Negro Question" in 1920, party leaders used African American and poor workers' dissatisfaction and desperation to further the Party's cause (Robinson 219–220). Aiming their appeals at the "common man," the Party fostered a renewed interest in Negro Folk culture as part of its counter hegemonic discourse on the twin perils in America of racism *and* classism (Washington 90).

"By 1933, between 15 and 17 million people were unemployed" (Bradley x). Committed to advancing its platform, the CPUSA courted and supported Blacks and poor whites as agitators on the ground. They recognized the importance of Negro art as propaganda *and* as entertainment (Richardson 362; Wilson 361–363). For the first time since emancipation, African American artists did not have to code or diffuse their examinations of race and racism within a "hidden transcript"[2] of African American theatre conventions like musicality, double-entendre, comedy, and the trope of the *African primitive* (Williams-Witherspoon, *Secret Messages* 3). With backing from the Left, one of the pieces that came out of this period was Langston Hughes' *Scottsboro Limited*.

## The play

In the spring of 1931, nine young men aged 13 to 19 were convicted on unsubstantial evidence of raping a white woman on a train in Alabama. Eight were sentenced to be executed, and one was sentenced to life in prison. The legal arm of the Communist Party, the International Labor Defense Fund, took over the appeal for the young men when it became clear that the National Association for the Advancement of Colored People (NAACP) would not (or could not) do it (Figure 40.1). Hughes, who had visited the young men at Kilby Penitentiary in Montgomery, deepened his affiliation with CPUSA during its defense of the so-called Scottsboro Boys (Duffy 436–453).

First produced in Los Angeles on May 8, 1932, the play was later produced in Paris and in Moscow. Using verse as dialogue for the nine Scottsboro characters, Hughes' play is full of Communist Party parlance—references to chains, work or the lack thereof, and terms like *comrades, workman*, and *chief*. It begins with a white audience member becoming enraged at the very appearance of the convicted Scottsboro Boys. He vehemently objects to their appearance in what is presumably a "white space," and "the Boys" take turns offering dialogue in verse about injustice and silence. The next scene offers flashbacks to the fateful train ride that hurled the young men into notoriety. On a stage with minimal scenery and props, the Boys ride atop railroad boxcars, a favored albeit illegal mode of free transportation during and following the

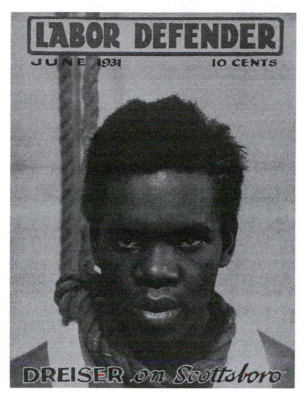

*Figure 40.1* June 1931 pamphlet published by the International Labor Defense Fund as part of its advocacy campaign for the Scottsboro Boys.

*Source*: Courtesy Merrill C. Berman collection.

Depression. Marveling at the southern countryside, they discuss the absence of jobs and the way the notion of *work* or labor has now changed for the "Negro."

> 7TH BOY: Well it's sho too bad
>     How when you ain't got no job…
> 2ND BOY: Looks like white folks is taking all the work.
> 5TH BOY: Is niggers got exclusive rights on work?
> 2ND BOY: All them little town jobs we used to do,
>     Looks like white folks is doin' 'em now, too.
> 1ST BOY: Just goes to prove there ain't no pure Black work.

Espousing Communist ideology, the Boys talk about the rich, white landowner and how he cares little for the poor white laborer, too.

> 6TH BOY: (*In wonder*) Look a-yonder you-all, at dem fields
>     bursting wid de crops they yields.
>     Who gets it all?
> 3RD BOY: White folks.

8TH BOY: You means the rich white folks.

2ND BOY: Yes, 'cause de rich ones own de land.

And they don't care nothin' 'bout de po' white man.

Hughes suggests that the poor white worker and African Americans had a common plight and needed to form ally-ship in order to wage a united fight.

3RD BOY: You's right. Crackers is just like me—

Po' whites and niggers, ain't neither one free.

(454)

More scenes of injustice follow in rapid succession. The train stops, the Sherriff spots the Boys atop the boxcar and demands they come down. Two white women are also found in a boxcar. The Sherriff berates the women until they agree to say the nine young men abused them. The Boys are taken into custody and the actor playing the Sherriff quickly becomes the Judge, thereby dramatizing the interchangeableness of "white privilege" and whiteness. As Judge, he conducts a rushed trial pushed along, like the freight train itself, by an agitating sound of drums and an ensemble of "Mob Voices" with lines like:

Kill the niggers! Keep 'em in their places!

Make an example of 'm for all the black races.

Finally convicted and awaiting execution, they hear a murmur of "Red Voices":

We'll fight! The Communists will fight for you.

Not just black—but black and white.

(456)

Addressing the fear of Communism in the Black community since the East Saint Louis riots and the Red Scare of 1919–1920, the Boys are initially suspicious.

6TH BOY: But they told us not to bother with a communist.

8TH BOY: But who else is there will help us out o' this?

(456)

When they are on death row, a white preacher comes to tell them that "If the law don't kill you then the lynchers must" (457). One of the Boys wants to pray while another, overcome by the imposition by this preacher of the same kind of *whiteness* that has condemned them, questions the very existence of a Christian God for a Black man.

3RD BOY: A prayer to a white God in a white sky?

We don't want that kind of prayer to die.

(457)

As the Mob Voices increasingly clamor for the death of the nine, the eighth Boy defiantly leaves his cell and crosses towards center stage and the ominous, symbolic electric chair. Courageously putting his own arms in the restraints, he demands to be heard and the Red Voices encourage him. He prophesizes a pan-African, united protest.

8TH BOY: All the world, listen!
  Beneath the wide sky
  In all the black lands
  Will echo this cry:
  I will not die!
  No chair!
  Too long have my hands been idle.
  Too long have my brains been dumb.
  Now out of the darkness
  The new Red Negro will come:
  That's me!
  No death in the chair!

(457)

While the Mob Voices react helplessly, the Red Voices, the 8th Boy, and then the other Scottsboro Boys become whipped into a frenzy of solidarity. As the Boys escape their cells, they chant: "No Death in the Chair," encircling and eventually destroying the electric chair as a symbol of American injustice (457). Clearly aligned with the Communist platform, the playwright's dialogue and set directions specify that the "white workers and black workers ... meet on stage" by the play's resolution (458).

Hughes' work is overtly political and shows obvious signs of defiance and resistance. While the liberal use of Ebonics, or African American Vernacular English, was an accepted convention of African American theatre during that period, Hughes' play does not rely on the usual tropes of musicality or comedy as a way to code or diffuse the politicized messages of resistance against social, political, religious, or legal structures that unjustly discriminated against or silenced the African American voice (Lippi-Green 1997).

## Conclusion

Hughes' *Scottsboro Limited* and his later play *Mulatto* (1935)[3] are just two examples of the kind of protest theatre that grew out of the Red movement. While the white producers of *Mulatto* changed parts of the first and third acts to add sensationalism for white Broadway audiences, the play's main characters still offered strong indictments against the pervasiveness of institutional racism (Turner 138).

Perhaps emboldened by their associations with CPUSA, for a brief time Hughes and others created work without the need for a hidden transcript or musical comedy. They helped to instigate a growing culture of resistance in their community and introduced a new audience to the CPUSA ideologies. But this story has an important coda that demonstrates yet again the importance of analyzing the political economy in which art occurs.

Franklin Delano Roosevelt was elected president (1933–1945), thanks primarily to 2 million votes cast by African American in the North (Bradley x). Roosevelt promised *a New Deal* (Bordelon 12). In reality it was a massive welfare and relief program (Powell 68). Under the Works Progress Administration (WPA), four arts projects were created "to employ writers, musicians, artists and actors" (Fraden 1). Harry Hopkins was appointed director of the WPA and Hallie Flanagan was named director of the Federal Theatre Project (FTP). Thanks to a suggestion by African American actress Rose McClendon, "by October 1936, seventeen [FTP] Negro Units had been established" (Fraden 3). With only one exception—Ralf Coleman, the African American director of Boston's Negro Unit—"no one in the upper echelon of the FTP

(all of whom were white) believed that a black person had the necessary clout and respect to run a Negro unit" (Fraden 96).

The formation of the Negro Units was a calculated strategy to rein in African American artists who had been leaning left. Under the WPA, for the first time in our nation's history, African American artists and the arts they produced were being validated in the public sphere and offered government funding. Artists in the Negro Units wanted to create authentic representations of themselves and give voice to a broader spectrum of the Black experience. Many, like Hughes and Theodore Ward, author of *Big White Fog*, did manage to infuse their work with a critique of racism and capitalism but unfortunately, for many others, the expectation of Blackness that white unit directors, audiences, and critics longed for encouraged a return to recognizable stereotypes and situations (Williams-Witherspoon, "On SHOT!" 178). In the end, getting approval and government funding meant writing to that expectation. By the end of 1938, so many African American writers had to retreat from the agency they had found in the Left. They had to return to the complacent center.

## Notes

1 The term *Negro* or *Negroes* is used only when referencing a text that uses that designation.
2 Used in situations of unequal power relations, a "hidden transcript" refers to "the development of multiple language strategies to communicate ideas, hidden messages, layered meaning and fluid boundaries over and beyond their well-scripted 'public transcript' in the public discourse of their performances" (Williams-Witherspoon, *Secret Messages* 3).
3 This play graphically addressed the legacy of enslavement, the sexual commodification of Black women by white men, the peculiar problem of bi-racial identity in America, and the overt oppressiveness of the Jim Crow/Jane Crow South.

## Works cited

Bradley, David. "Preface." *12 Million Black Voices*, edited by Richard Wright, Mouth Press, 1941, pp. v–xvii.

Bordelon, Pamela. "Zora Neale Hurston: A Biographical Essay." *Go Gator and Muddy the Water: Writings by Zora Neale Hurston From the Federal Writers' Project*, W.W. Norton, 1999, pp. 3–49.

Duffy, Susan. "Hughes' Move to the LEFT: *SCOTTSBORO LIMITED*." *The Routledge Anthology of U.S. Drama 1898–1949*, edited by Joshua E. Polster, Routledge, 2017, pp. 436–453.

"East St. Louis Riots," https://en.wikipedia.org/wiki/East_St._Louis_riots.

"Federal Theatre Project," http://en.wikipedia.org/wiki/Federal_Theatre_Project.

Fraden, Rena. *Blueprints for a Black Federal Theatre, 1935–1939*. Cambridge UP, 1996.

Frazier, E. Franklin. *Black Bourgeoisie*. Collier Books, 1975.

Gates, Hill. "Political Economy." *Encyclopedia of Cultural Anthropology*, vol. 3, edited by David Levinson and Melvin Embers, Henry Holt & Company, 1996, pp. 971–975.

Giddens, Anthony. *Capitalism and Modern Social Theory: An Analysis of the Writings of Marx, Durkheim and Max Weber*. Cambridge UP, 1971.

Grant, Joanne. *Black Protest: History, Documents and Analyses, 1619 to the Present*. Fawcett, 1968.

Hughes, Langston. "*Mulatto*." *Five Plays by Langston Hughes*, edited by Webster Smalley, Indiana UP, 1963, pp. 1–36.

———. "*Scottsboro Limited*." *Routledge Anthology of U.S. Drama: 1898–1949*, edited by Joshua E. Polster, Routledge, 2017, pp. 453–459.

Lippi-Green, Rosina. *English with an Accent: Language Ideology, and Discrimination in the United States*. Routledge, 1997.

Madhubuti, Haki R. "Lecture." The Charles L. Blockson Afro-American Collection. Mar. 2015, Sullivan Hall, Temple University, Philadelphia.

Powell, Richard J. *Black Art and Culture in the 20th Century*. Thames & Hudson, 1997.

"Red Scare," https://en.wikipedia.org/wiki/Red_Scare.

Richardson, Willis. "Character." *Opportunity Magazine*, June 1925.

Robinson, Cedric J. *Black Marxism: The Making of the Black Radical Tradition,* U of North Carolina P, 1983.

Turner, Darwin. "Langston Hughes as Playwright." *The Theater of Black Americans,* vol. 1, edited by Errol Hill, Prentice Hall, 1980, p. 138.

Washington, Mary Helen. *The Other Blacklist.* Columbia UP, 2014.

Williams–Witherspoon, Kimmika L.H. "On SHOT! A Rationale for Research and Dramas Depicting Violence in the 'Hood.'" *Theatre Topics,* vol. 23, no. 2, Sep. 2013.

———. *The Secret Messages in African American Theater: Hidden Meaning Embedded in Public Discourse.* Edwin Mellon Press, 2006.

Wilson, Sondra Kathryn. *The Opportunity Reader.* Random House, 1999.

# 41

# FIGHTING FIRE WITH FIRE

## Violence and the Black Liberation movement

### *Portia Owusu*

When the Black Lives Matter movement gained its momentum through social media and street protests, it was the fiftieth anniversary of various landmarks in the 1960s civil rights movement. In 2013, when thousands marched to denounce the killing of 17-year-old Trayvon Martin, it was the anniversary of the 1963 March on Washington for Jobs and Freedom. In 2014, when Michael Brown was fatally shot by police, it was the anniversary of the Civil Rights Act of 1964. And in 2015, when Sandra Bland died in police custody, Americans were commemorating Bloody Sunday, the deaths of men and women who marched in support of African American voting rights in Selma, Alabama, in 1965. The coincidence of these anniversaries and tragedies disrupts the idea of progress in American narratives of civil rights and race relations. However, the parallels between the two movements encourage reflection on the past to understand present debates and discourses such as the effectiveness of non-violent resistance in the face of deadly violence against the Black body.

In the 1960s, it was this debate that defined differences in civil rights organizations and ideologies. Whereas organizations and leaders such as the Southern Christian Leadership Conference and Martin Luther King, Jr. espoused non-violent strategies and protests, the Black Power movement, advocated by Malcolm X and Stokely Carmichael, responded to the seeming lack of change by considering violence as a means to an end. This idea is controversial and thus often silenced or was absent in the historical discourse of 1960s civil rights movements. But the similarities between contemporary political discourse and that of the 1960s allow for an examination of its effectiveness. This chapter explores revolutionary violence in 1960s political movements by examining literary works that supported the notion of "fighting fire with fire." It focuses on Amiri Baraka's *Dutchman* (1964) and *Slave Ship: A Historical Pageant* (1967), two plays written within the Black Arts Movement, an aesthetic movement inspired by Black Power ideology.

## Revolutionary violence and the Black struggle

The potentiality of violence in resistance and political movements is not a new idea, but it was Frantz Fanon who theorized and popularized the concept to apply to political struggles of colonialized and oppressed peoples in Asia, Africa, and the Americas. Fanon was a Martiniquais-French psychiatrist whose scholarship reflected his medical training and his life as a colonial

subject. In his book, *The Wretched of the Earth* (1961), Fanon analyzes the impact of colonialization on the individual by asserting that it is violence that established and maintained colonialism. Colonialism, he explains, is

> [an] encounter between two congenitally antagonistic forces ... colored by violence and their cohabitation—or rather the exploitation of the colonized by the colonizer [and] continued at the point of the bayonet and under cannon fire ... [it] reeks of red-hot cannonballs and bloody knives.
>
> (2–3)

Thus, Fanon argues that the fight for liberation cannot be non-violent because the agents of government "speak a language of pure violence" (4). To engage in violence to end oppression affords the colonized and oppressed two advantages: it forces the oppressor to listen (since demands are articulated in the language he understands the most) and it renders agency and self-respect to the oppressed. With his background in psychiatry, Fanon later argued that violence helps "the colonized subject [to] discover that his life, his breathing and his heartbeats are the same as the colonist's." Therefore, he can say to himself, "my life is worth as much as the colonist's" (10).

*The Wretched of the Earth* speaks to colonial oppression in Algeria specifically and Africa generally, but its ideas have transcended these borders. The Black Power movement in 1960s and 1970s America reflected Fanonian ideas. In *Black Power: The Politics of Liberation* (1971), Kwame Ture, one of the founders of the movement, explains the necessity of violence:

> Here is a group which realized that the "law" and law enforcement agencies would not protect people, so they had to do it themselves. ... "non-violent" approach to civil rights is an approach black people cannot afford and a luxury white people do not deserve. It is crystal clear to us—and it must become so with the white society—that there can be no social order without social justice. White people must be made to understand that they must stop messing with black people, or the blacks will fight back!
>
> (Hamilton and Ture 52)

Ture wrote this in 1967 in the shadows of at least ten years of the civil rights campaign led by Martin Luther King, Jr. By 1967, King's campaign had helped pass the Civil Rights Act 1964, but the legislation did not end racial injustice. Violence and discriminatory practices continued to mark the lives of Black Americans. The radical shift in strategies by Black Power advocates thus sought changes that would make real impact on the lived realities of Black people. They rejected Black passivity and refused to conform to the doctrine of *turn the other cheek*, which King had championed. The Black Panther Party, which was under the umbrella of the Black Power movement, expressed this clearly. The Party's "Ten-Point Program," a list of demands and tenets, held that to be armed was necessary for protection from state-sanctioned violence *and* that it was the right of the American citizen, according to the Second Amendment to the Constitution.[1]

Ideologues of the movement emphasized this in rhetoric. In the "Ballot or the Bullet" speech, Malcolm X endorses violence in the face of violence. He stresses that while he does not advocate violence for the sake of violence, it is necessary that Black people defend themselves:

> I don't mean go out and get violent; but at the same time you should never be non-violent unless you run into some nonviolence. I'm nonviolent with those who are nonviolent with me. But when you drop that violence on me, then you've made me

go insane, and I'm not responsible for what I do. And that's the way every Negro should get.

(123)

The politics and ideas of Malcolm X influenced artists within the Black Arts Movement such as Amiri Baraka. In his autobiography, Baraka writes: "[Malcolm X] reached me. His media appearances made my head tingle with anticipation and new ideas. He made me feel even more articulate, myself, just having seen him" (273). The impact of Malcolm X is evident in Baraka's work. As the cultural arm of the Black Power movement, the Black Arts Movement was a commitment to artistic representations of Black American *realities*. Like the Black Power movement, it believed in the urgency of Black American liberation and was not conservative in its approach. Baraka's poem "Black Arts" (1966) is often read as a manifesto for the movement. It begins:

> Poems are bullshit unless they are
> teeth or trees or lemons piled
> on a step
> [...]
> we want "poems that kill."
> Assassin poems, Poems that shoot
> Guns
> [...]
> We want a black poem. And a
> Black World.
>
> (219)

As argued by Maurice A. Lee, these lines constitute a "call to arms, politically and aesthetically" (85). Baraka is calling for art that is functional and purposeful to the cause of Black liberation. Violence is an inherent aspect of this because it allows for self-expression, an entry into a "Black World" where the individual can be himself. In his study of the Black Arts Movement, Larry Neal echoes this. He argues that the movement sought to ascribe *power* to Blackness and Black people because it was "radically opposed to any concept of the artist that alienates him from his community." Like the Black Power movement, it sought to realize "the Afro-American's desire for self-determination and nationhood" (29). Amiri Baraka's plays *Dutchman* (1964) and *Slave Ship: A Historical Pageant* (1967) exemplify these ideals. The two plays paint dire and violent pictures of race relations in 1960s America. Both suggest that violence is at the heart of racial oppression in America; therefore, non-violent strategies are useless because the oppressor responds only to the language of violence. Although the plays are written three years apart, this message is consistent. For this reason, the discussion that follows is not organized chronologically but thematically on the manifestations of violence and its purposes in each play. Analyzing these, we can understand how Baraka used art, and specifically theatre, to communicate Black Power ideologies to audiences.

## *Dutchman* and *Slave Ship: A Historical Pageant*

*Dutchman*, a one-act play, was first performed at the Cherry Lane Theatre in New York City on March 24, 1964. A year before the opening of the play, Dr. Martin Luther King Jr. had been arrested and jailed in Birmingham, Alabama, for participating in an anti-segregation protest, and an African American church had been bombed, killing four little girls. With these events as the

backdrop of the play, the opening scene is of a "subway heaped in modern myth." There is a "man is sitting in a subway seat, holding a magazine but looking vacantly just above its wilting pages." He is soon joined by a woman who is "tall, slender, beautiful [and] wearing only loud lipstick in somebody's idea good taste" (3). These two characters are 20-year-old Clay, a Black man, and 30-year-old Lula, a white woman. Clay and Lula engage in a flirtatious conversation, which ends in Lula killing Clay.

Physical violence in *Dutchman* is a gradual process. But in *Slave Ship*, it is recurring because it is embedded in the very essence of the story it is narrating, which is American slavery. In this play, which is also a one-act, violence—physical, emotional, and psychological—is the language of expression because it replaces coherent speech. The narrative begins with the Middle Passage. The theatre is in total darkness so the only thing that is conspicuous to the audience is the "Rocking of the slave ship" (132). A dim light eventually comes on but is accompanied with olfactory assault: "the odor of the sea … the sounds of the sea … the sounds of the ship … Pee. Shit. Death" (132). This is followed by psychological and emotional violence, which, although the audience cannot see it, is depicted by screams of men and women crying out to African deities such as Shango and Obatala to save them. Their cries are interspersed with fragmented speeches telling of physical and mental tortures, such as the rapes and infanticides that are taking place on the ship.

The function and purpose of violence in each play differ. In *Dutchman*, violence is implied from the onset but does not become physical until the end because its purpose is to show the deteriorating conditions of race relations in America. Such descriptions as "a roaring train" in the "flying underbelly of the city[,] Steaming hot, and summer on top, outside" suggest an environment that is confining and asphyxiating, a space that one cannot escape easily (3). This is realized when Lula enters the train and sits next to Clay, even though the train is empty. She places limitations on Clay's personal space, literally and metaphorically entrapping him by engaging him in a conversation that he cannot escape.

The space of their encounter thus becomes a contested one: it seemingly apolitical because they are in the "underbelly" of the city and, as such, apparently free from the complexities and politics that govern the modern society above them. Lula believes this and she convinces Clay to do the same when she asks him to "free" himself of his history as she is from hers so that they can be "anonymous beauties smashing along through the city's entrails" (21). However, this is the "modern myth" that Baraka warns against in the play's directions because it is Lula who will eventually end Clay's life.

Clay's death thus occurs because of his failure to see beyond the "modern myth" of post-emancipation America and the idea that the individual can free himself of his history. Lula represents this lie; even when she tells Clay that he can be free from his past, she proves that he cannot because she can only see him through racialized stereotypes. Clay fails to see this. When he sees Lula, a beautiful white woman, he is blinded by her external appearance and does not think about the danger she poses to him because of her history.

It is this blindness and complaisance that Baraka reinforces throughout the play. Perhaps he insists on this because in 1964, the year *Dutchman* was performed, legislative changes like the Civil Rights Act had given Black Americans false hopes about their political progress. The Act outlawed discriminatory practices on grounds such as race and religion, but, for Black Power advocates, it simply screened racism at the roots of American society. Malcolm X was cognizant of this. In "The Ballet or the Bullet," he implies that the legislation is merely symbolic. "If [President Lyndon B. Johnson is] for civil rights … Let him go in there and denounce the Southern branch of his party" (131). By referencing the South, a region with a significant population of Black people and where Blacks experienced the denial of the right to vote, Malcolm X draws attention to the disparity between legislative acts and the lived reality of Black Americans in 1960s.

Thus, the message of Malcolm X in the Black Power movement was a call to face reality rather than the dream of harmonious race relations in America. This is translated in Baraka's work through recurring themes of blindness and misconceptions on the part of Black Americans. In *Dutchman*, Lula is a stock character. With long red hair, "loud" lipstick, and apple in hand, she is the *femme fatale* and her only aim is to cause destruction. Clay cannot see the danger she represents, or chooses to ignore it, because she offers an illusion of freedom from his history. When he dies at her hands, his death proves the Fanonian idea that however friendly the inter-action between Blacks and Whites, it is underpinned by a history founded on violence and that "reek[s] of red-hot cannonballs and bloody knives" (Fanon 3).

In his 1967 essay, "The Need for a Cultural Base to Civil Rites & Bpower [*sic*] Movements," Baraka reinforces this view, stating that "to be an american, one must be a murderer. A white murderer of colored people" (119). Thus like the colonial identity, racial identity is birthed out of violence, and this violence informs interactions between the races. This is the picture that Baraka forces on the consciousness of his audience in *Slave Ship* and *Dutchman*. Particularly in *Slave Ship*, he wants his audience to understand the violent beginnings of African American identity and history. For that reason, he omits Africa from the play's historicization of slavery and emphasizes the violence of the Middle Passage. Without the possibility of returning to Africa, the Black subject, once he is in America, must fight for his survival. The agonizing screams and unpleasant smells that audiences endure as part of their theatrical experience help them to understand this and to contextualize the retaliatory violence that occurs later in the play, including the mob-killing of the Preacher who champions nonviolence. This is the last violent act of the play and it is represented as a resolution because only when the Preacher dies do the "Lights come up abruptly, and people on stage begin to dance" for having gained their freedom (145). The audience symbolizes the wider society and the abrupt transition from darkness to light reflects the realization that Black Lives Matter. The significance of this moment to the contemporary movement is the relevance of strategies that metaphorically shine light on Black realities.

## Note

1 This Amendment protects the right to keep and bear arms.

## Works cited

Baraka, Amiri (LeRoi Jones). *The Autobiography of LeRoi Jones*. Lawrence Hill Books, 1997.
———. "Black Art." *The LeRoi Jones/Amiri Baraka Reader*, edited by William J. Harris, Thunder's Mouth Press, 1999, pp. 219–220.
———. "The Black Arts Movement." *SOS—Calling All Black People: A Black Arts Movement Reader*, edited by John H. Bracey Jr., et al, U of Massachusetts P, 2014, pp. 11–22.
———. "*Dutchman*." *Dutchman and The Slave*. William Morrow, n.d., pp. 2–38.
———. "The Need for a Cultural Base to Civil Rites & Bpower [*sic*] Movements." *The Black Power Revolt: A Collection of Essays*. Collier Books, 1969, pp. 119–126.
———. "Slave Ship." *The Motion of History and Other Plays*. William Morrow, 1978, pp. 33–145.
Fanon, Frantz. "On Violence." *The Wretched of the Earth*, translated by Richard Philcox, Grove Press, 2005, pp. 1–51.
Hamilton, Charles V., and Kwame Ture. *Black Power: Politics of Liberation in America*. Vintage, 1992.
Lee, Maurice A. *The Aesthetics of LeRoi Jones/Amiri Baraka: The Rebel Poet*. Universitat de Valencia, 2004.
Neal, Larry. "The Black Arts Movement." *The Drama Review: TDR*, vol. 12, no. 4, 1968, pp. 28–39.
X, Malcolm. "The Ballot or the Bullet." *Great Speeches by African Americans: Frederick Douglass, Sojourner Truth, Dr. Martin Luther King, Jr., Barack Obama, and Others*, edited by James Daley, Dover Publications, 2006, pp. 115–132.

# 42

# "WHEN WE GONNA RISE"

## Free Southern Theater performances of *Slave Ship* and Black Power in Mississippi

### *Susan Stone-Lawrence*

Highly ranked among states historically committing the most racial terror lynchings in addition to notorious murders of civil rights activists, Mississippi has a well-earned reputation for racist oppression. Therefore, the thought of an entire Black Power salute-brandishing audience, standing and singing "When we gonna rise up!" seems incongruous with predominating images of the Magnolia State. But the April 1970 *Negro Digest* reports this scene as part of multiple near riots at Free Southern Theater (FST) performances of *Slave Ship* by Amiri Baraka (28). Is it possible that audiences in the South, especially in Mississippi, avidly engaged in the exchange of incendiary energy characteristic of revolutionary theatre? These crowd responses register as more than anomalous events transpiring in an unsophisticated South ill-prepared for the fomenting rhetoric and provocative visuals of Baraka's enraged dramaturgy. Rather, the poet-playwright's work arrived in a region already fostering an African American militancy that preceded his February 21, 1965 instigation of the Black Arts Movement.[1] Despite limiting perceptions of the South's capability to promote expanding consciousness and political progress, the Free Southern Theater and its audiences played a pivotal role in propagating cultural revolution and a Black aesthetic.

The dynamic relationship began in 1963 at Tougaloo College near Jackson, MS. Working there with the Student Nonviolent Coordinating Committee, John O'Neal and Doris Derby joined together with journalist Gilbert Moses to start the Free Southern Theater as a cultural supplement to the political cause. Originally integrationist, FST evolved to refuse repertory authored by white playwrights or intended for white audiences (O'Neal, "Motion in the Ocean" 174–175; Street 96–97). FST exhibited this separatist mentality even before working with Baraka, who wrote *Slave Ship* during the intensity of the Black Nationalist period (1965–1974) of his career.[2] Through a multi-sensory assault directed by Moses, this immersive dramatic ritual staged in explicit detail for 1969 audiences the horrors of trans-Atlantic journeys endured by enslaved Africans. The play begins in a dark cargo hold crowded with confused and frightened captives suffering sickness, separation from family, rape, and even an infanticide/suicide among their group. Then the plot transitions across eras to reveal that a race traitor from the past has metamorphosed into an assimilationist preacher of the civil rights era. The play's climax resurrects the ancestors to decapitate this "New Tom" amidst a "Boogalooyoruba" number merging traditional African movements with a Temptations-style dance line while a chorus sings the empowering anthem "When We Gonna Rise" (Baraka, *Slave Ship* 143–145).

Such dire urgency for change had grown from the christening of the Black Power movement for which the Black Arts Movement considered itself an aesthetic partner. Three years prior to the FST tour of *Slave Ship*, a pivotal event had occurred in Mississippi. Civil rights activists had become embittered by thwarted efforts at desegregation and President Johnson's 1964 compromise offer of only two at-large seats for delegates intended to represent Mississippi's entire African American population (Meier and Rudwick 12, 16). Disenchantment heightened receptivity to Malcolm X's promotion of Black self-determination "by any means necessary" in contrast to the practice of passive resistance expounded by the Reverend Martin Luther King, Jr. From reckoning with counterpoised civil rights movement strategies, the Black Power slogan emerged in Mississippi in the summer of 1966. Joining Rev. King on a march for voter registration begun by James Meredith—who had to drop out when wounded by an assassin—SNCC chair Kwame Ture (then called Stokely Carmichael) ignited "Black Power" as an idiom for the incited Mississippi crowd to chant and champion to "stop them white men from whuppin' us" (qtd. in Meier and Rudwick 19).

Considering this precedent-setting moment in Mississippi and Black Power history, one can discern an obvious echo in the reaction of a Free Southern Theater audience member to a whip-wielding *Slave Ship* slave driver: "I want to see you after the show" (qtd. in Ferdinand 29). The staged metaphor for systemic racism elicited a response of rehearsal for the real-world revolution. Poet/author/filmmaker/educator/activist Kalamu ya Salaam (then called Val Ferdinand) places this incident in West Point, MS, the same location where the previously mentioned fist-waving audience stood singing at the end of *Slave Ship* (28–29). Salaam, who spent five years as a member of Free Southern Theater and co-founded FST's "BLKARTSOUTH" workshop, also writes about an event in Greenville, MS, where the Black people "were ready to revolt after the performance" and "only reluctantly persuaded to go home" (28).

These instances do not represent isolated events. Contrary to commonly perpetuated media renderings of Southern Blacks as downtrodden and placatory subjects of white domination, African Americans in Mississippi manifested radical insurgency. As part of this history, the Deacons for Defense, a Black paramilitary organization originated in Louisiana, established a Mississippi presence in support of economic boycotts in several communities, including West Point, throughout more than a decade and a half of the 1960s–1970s (Umoja 142–143). The Deacons occasionally provided security for the FST against intimidation by the police and Ku Klux Klan (Dent et al. 87). In certain locations, simply attending an FST performance constituted an act of bravery.

Advocating social change, FST productions deliberately perforated the illusive barrier between performers and audience members. As early as the 1964 Mississippi Summer Project tour, an audience member in Greenwood walked onto the stage with the FST performers after taking as literal O'Neal's curtain speech designation of audience members as actors, a metaphor intended to incite action from a participatory audience more directly engaged than were typical Eurocentric spectators (Street 97). *Slave Ship* performances continued FST's interactive practices by literally inviting the audience to participate in vanquishing a self-identified "white Jesus God" with "long blond blow-hair," a disembodied presence demanding obedience and love from his "nigger" congregants (Baraka, *Slave Ship* 145). In the celebration that concludes the play's vision of revolt, someone throws the assimilationist preacher's head into the center of a dance floor crowded with commingling actors and audience members, and the party does not stop (Baraka, *Slave Ship* 145).[3] Most audiences of the 1969 tour were much more accustomed to attending church services than live theatre performances (Elam 112). However, their enthusiastic reception of *Slave Ship* testifies to the strength of the Black Power movement in Mississippi because firm grounding in Christian traditions did not prevent the public from appreciating

such irreverent dramatic content. This theatrical rejection of assimilation into white supremacy modeled the desired behavior for the world outside the representational space. The tactic seems to have worked because Black participation in voter registration drives drastically rose in cities visited by performances of *Slave Ship* (Elam 124).

Looking back on a tumultuous past from a not dissimilarly troubled present still punctuated by racist violence and voter suppression allows substantial insight into shared struggles. If activists and theatre practitioners of the present day succumb to a nostalgia glossing over of the intensity, immediacy, and conflict experienced in those revolutionary times, they may find themselves disconnected from their cultural inheritance and ignorant of the national and Pan-African scope that the civil rights and Black Power movements reached. Remembering the work of the Free Southern Theater and the insurrectionary impulses of its audiences provides galvanizing hope to fuel the remaining work necessary to achieve social justice and racial equality. Ten years after the FST tour of *Slave Ship*, Baraka printed the following dedication in the front of his *Selected Plays and Prose of Amiri Baraka/LeRoi Jones*: "Self-Determination for the Afro-American Nation in the Black Belt South!" Popular consciousness may not have caught up yet (then or now), but the cross-regional solidarity Baraka acknowledged remains intrinsic to the success of Black Power. "When we gonna rise up!"

## Notes

1 Baraka and most Black Arts Movement scholars recognize the assassination of Malcolm X as impetus for the definitive break that Beat poet-playwright LeRoi Jones made with his Bohemian existence in Greenwich Village to embark upon a militant separatist phase of his career and personal life. The Black Arts Repertory Theatre and School established in Harlem shortly thereafter by Baraka (the Muslim name he adopted) and his colleagues inspired a nationwide proliferation of Black Arts Movement entities.

2 Actually, O'Neal claims that the "Black-belt South" birthed the Black Arts Movement (BAM). He asserts that the Free Southern Theater "played a key role" in BAM although "much of the critical discourse on that phase of the movement has focused on events that occurred *later* in the urban north" ("A Road" 98).

3 Perceptible similarities between the unfortunate New Tom/Preacher—who attempts to hide a dead baby martyred by a church bombing—and Rev. King (assassinated just the previous year) contributed an additional element of audacity to the inflammatory act.

## Works cited

Baraka, Amiri (LeRoi Jones). *Selected Plays and Prose of Amiri Baraka/LeRoi Jones*. Morrow, 1979.
———. *Slave Ship: A Historical Pageant. The Motion of History and Other Plays*, Morrow, 1978, pp. 129–150.
Dent, Thomas C., et al. *The Free Southern Theater by The Free Southern Theater*. Bobbs-Merrill, 1969.
Elam, Harry J., Jr. *Taking It to the Streets: The Social Protest Theater of Luis Valdez and Amiri Baraka*. U of Michigan P, 1997.
Ferdinand, Val. "A Report on Black Theatre in America: New Orleans." *Negro Digest*, Apr. 1970, pp. 28–31, https://books.google.com/books?id=HDoDAAAAMBAJ&pg=PA49&dq=april+1970&hl=en&sa= X&ved=0ahUKEwjEiPukmZfZAhUKn1MKHQS_AmcQ6AEIKTAA#v=onepage&q=when%20 we%20gonna%20rise&f=false.
Meier, August, and Elliott Rudwick. "Introduction." *Black Protest in the Sixties*. Quadrangle, 1970, pp. 3–23.
O'Neal, John. "Motion in the Ocean: Some Political Dimensions of the Free Southern Theater." *The Free Southern Theater by The Free Southern Theater*, Bobbs-Merrill, 1969, pp. 171–181.
———. "A Road through the Wilderness." *A Sourcebook of African-American Performance: Plays, People, Movements*, edited by Annemarie Bean, Routledge, 1999, pp. 97–101.
Street, Joe. *The Culture War in the Civil Rights Movement*. UP of Florida, 2007.
Umoja, Akinyele Omowale. *We Will Shoot Back: Armed Resistance in the Mississippi Freedom Movement*. New York UP, 2013.

# 43

# FROM "POEMPLAYS" TO RITUALISTIC REVIVALS

## The experimental works of women dramatists of the Black Arts Movement

*La Donna L. Forsgren*

Analyzing representative works and critical responses to plays written by Sonia Sanchez, Barbara Molette, J.e. Franklin, and Barbara Ann Teer not only reveals the important artistic contributions women dramatists made to the Black Arts Movement (1965–1976) but also the continuation of Black women's activist traditions from within the Black Power milieu. These dramatists negotiated their interests as Black women while working within and outside of the tightly knit circle of Black arts compatriots who were convinced that only Black men could lead the struggle for the liberation of Black people. Yet, their art and activism demonstrate a keen awareness of the concerns that later Black feminists would also address. Their writings express Black feminist attitudes without negating the need to empower the *entire* Black community. Black feminist attitudes include an awareness of how oppressive forces contribute to the economic exploitation, social stigmatization, and political disenfranchisement of Black women as well as a desire to use experiential knowledge to create multiple visions of Black womanhood. While the innovative works of Sanchez, Molette, Franklin, and Teer vary in theatrical style and form, they all incorporate motherhood and sisterhood as galvanizing forces to unite Black men and women against racial and gender oppression. Their experimental works remain important because they placed before the public more complex representations of Black women's lives. In so doing, they not only provided the foundation for Black feminist drama to emerge but also created a counter-discourse that helped challenge western cultural hegemony.

The Black Arts Movement fostered ingenuity, creating spaces for Black women playwrights to experiment with theatrical form and style. The one-woman show *Sister Son/ji* (1969) reflects Sanchez's development of poemplays, a highly theatrical style of playwriting that privileges the performative nature of poetry.[1] She and Molette also experimented with Bertolt Brecht's *Verfremdungseffekt*, a distancing effect meant to disrupt audiences' emotional responses, but refashioned the concept to suit their own rhetorical needs. As such, both *Sister Son/ji* and Molette's *Rosalee Pritchett* (1971) incorporate violent images, sparse staging, memory monologues, direct addresses to the audience, and abrupt shifts in lighting and music to promote Black political activism. Franklin's *The Prodigal Sister* (1974) demonstrates a radical reconceptualization of the musical as a vehicle for Black liberation. *A Ritual to Regain Our Strength and Reclaim Our*

*Power* (1970) marks Teer's initial conceptualization of "ritualistic revivals," a holistic approach to art that combined elements of ritual drama, poetry, dance, revivalism, Pentecostal and Holy Roller church practices, and structured improvisation. While the theatrical innovations of Sanchez, Molette, Franklin, and Teer were not always valued by mainstream theatre critics of the time, their works were well received by Black audiences and provided the foundation for future Black feminist dramatists.

## Poemplays and *Verfremdungseffekt*

As a radical precursor to Ntozake Shange's choreopoem *for colored girls who have considered suicide/when the rainbow is enuf* (1976), Sanchez's poemplay *Sister Son/ji* disrupts Western conceptualizations of fixed literary genres. Sanchez remembers her appreciation of poetry as an oral, rather than written, form, leading her to craft dramatic works. "There were some poems I've done along the way that I would put in the margins: 'to be sung,' 'clap,' 'stamp your feet' … I wanted the person speaking out loud and I realized that this is very dramatic," recalls Sanchez (Personal Interview). These discoveries led her to craft *Sister Son/ji*, which includes visual clues as to the stylized rhythm of performance through the incorporation of slashes, phonetic spelling, blank space, and unconventional punctuation (Figure 43.1).

 *Sister Son/ji* warns audiences that true revolution will never come to fruition without strong Black families. The play recounts the lived experiences of a Mississippi woman named Son/ji. As she performs memory monologues, audiences catch glimpses of her as a naive college student, member of the nation of Islam, disillusioned young mother, and, finally, a warrior mother fully capable of defending her children and community. As a war with white America rages on, Son/ji negotiates a space for her interests as a Black woman, mother, and lover within the Black revolution. As her relationship with her partner deteriorates, she pleads with him to actualize the rhetoric of liberation by creating strong Black families. Son/ji asks, "Shouldn't we

*Figure 43.1*   Sonia Sanchez autographing her book of poetry.

*Source*: New York Public Library Digital Collections (1972). http://digitalcollections.nypl.org/items/6c8df720-49fc-5281-e040-e00a18062f9d.

be getting ourselves together—strengthening our minds, bodies and souls away from drugs, weed, whiskey, and going out on Saturday nites. alone. what is it all about or is the rhetoric apart from the actual being/doing?" (Sanchez, "Sister" 102–103) Her impassioned speech challenges fathers and leaders to cease destructive behaviors and conceptualize Black liberation in terms of bettering the entire community.

*Sister Son/ji* holds the distinction of being Sanchez's most produced and critically contested play. Following the Concept East Theatre premiere in Detroit, Joseph Papp produced *Sister Son/ji* in 1972 at the New York Shakespeare Festival's experimental theatre, Public Theatre Annex. *New York Times* critic Clive Barnes described the work as a "self-indulgent" play that merited "marginal literary interest" (37). He concluded his review by stating that "the monologue, despite the eloquence of Miss [Gloria] Foster, never becomes theater ... Had these been white visions rather than black, they might, I felt, have remained unproduced" (37). Barnes' dismissal of the poetic nature of the piece, innovative structure, and dramatic themes, coupled with his suggestion that the production was a result of tokenism, at best suggests cultural bias. The review remains important, however, because it demonstrates how constructing a narrative about the concerns of a Black woman using an original theatrical style can actually disrupt western notions of what constitutes "theatre."

At the time Sanchez wrote *Sister Son/ji*, there were very few opportunities to see the actual lives of Black women onstage. The theatre critic Clayton Riley, writing for the Black newspaper *New York Amsterdam News*, thoughtfully addressed these concerns and the challenges of producing Sanchez's innovative works. Riley writes:

> I have seen and worked with [*Sister Son/ji*] before; the impossibility of doing it satisfactorily rests ... with the fact that contemporary forms in the theater do not provide a framework for it that serve well to project what Sister Sanchez has provided—an enormously personal examination of the life and times of a Black woman, her political and social growth, the processes of her coming to be who and what she is.
>
> (D1)

Sanchez understood that mainstream critics might dismiss her work because it challenged racial, gender, and cultural constructs. Yet, she continued to use experimental forms and write about Black women's subjectivity because she believed that her art was making positive change in the lives of others.

*Rosalee Pritchett* also uses one Black woman's plight as a cautionary tale but does so in order to warn audiences about the dangers of assimilation. Barbara Molette wrote an early draft of the play as partial fulfillment for her Master of Fine Arts degree. She then collaborated with her husband, Carlton Molette, taking his advice to add a scene in which members of the National Guard introduce themselves to the audience, discuss United States racial relations in the early 1970s, and brutally rape Rosalee. At the beginning of the play Rosalee appears as a vain, idle, and pompous middle-class Black woman, intent on upholding white standards of beauty and cultural refinement. Rather than empathize or assist poor Blacks who riot outside of her neighborhood, she and fellow bridge club members criticize their efforts and encourage the white guardsmen to take swift action. When she accidently breaks the city's curfew, the soldiers remind her that they view *all* Black women as nothing more than "dark meat" and "good pussy" (Molette 16). Unable to cope with the stigma of rape, Rosalee enters an asylum where she (and spectators) relives her traumatic experience.

*Rosalee Pritchett* uses the specter of rape and dramatic irony to encourage racial solidarity. Rosalee's victimization demonstrates the fallibility of attempting to conform to white standards.

*Figure 43.2   Rosalee Pritchett* uses a minimalistic set, disjointed sound cues, juxtaposition, direct address, and visual slides to disrupt emotional responses and galvanize audiences into action. Morehouse–Spelman Players production (Spring, 1970).

*Source*: Courtesy of Carlton Molette.

Despite her claims to white beauty and class privilege, her gender and race deny her rights as a citizen and make her vulnerable to sexual assault. As the Molettes demonstrate, Black women are not safe to walk the streets of their own neighborhoods. The specter of rape, therefore, provides a catalyzing force to inspire Blacks to resist state-sanctioned violence. The fact that her friends doubt the veracity of her story and continue to support the guardsmen suggest that they, too, may suffer a similar fate if they do not support each other. The guardsmen, after all, do not suffer any consequence for their actions and will likely continue to exercise unchecked authority over the Black community. The play suggests that Black men and women of all classes, therefore, must actively participate in social change.

*Rosalee Pritchett* uses emotional distancing to galvanize Black audiences into action. The play uses a minimalistic set, disjointed sound cues, juxtaposition, direct address, and visual slides to disrupt emotional responses from audiences (Figure 43.2). *Rosalee Pritchett* requires only a bridge table, four chairs, a few props, and a screen to play slides. The minimal set highlights the stark tone of the piece, forcing audiences to critically engage with the rich dialogue and themes. Four pre-recorded songs create a sense of disjointure during tense moments in the play. The most pronounced example of this technique occurs during the climax of the play. The opening fanfare to "The Star-Spangled Banner" plays while audiences witness four members of the National Guard beat and rape Rosalee. Afterwards, the guardsmen directly address the audience and use the rhetoric of democracy to justify their actions. In this moment, the Molettes invite the audience to reflect upon Rosalee's rape as representative of Black women's continued exploitation and as a symbol of Black political marginalization in the United States.

As with *Sister Son/ji*, *New York Times* critics misinterpreted the purpose behind the experimental staging of *Rosalee Pritchett*, finding particular fault with the Molettes' depiction of

Rosalee's rape. The Negro Ensemble Theatre's 1971 production included experimental staging of sexualized violence. Actress Frances Foster (as Rosalee) delivered her lines behind a screen while sitting on a stool in a padded cell. The guardsmen, played by Black actors in whiteface, mimed beating and raping her as a slide projected the American flag "intersperse[d] with 'Americana,' e.g. garbage, billboards, coke signs" (21). The theatre critic Mel Gussow described the Molettes as "new and promising" playwrights, yet questioned their depiction of sexualized violence. He concluded that "[t]he rape, without a victim, loses impact. The play, already sketchy, seems disembodied" (19). Gussow fails to recognize the cultural memory associated with Black women's historical victimization that the Molettes' artistic choices likely triggered. Since chattel slavery, white men have exploited their position of power to rape and commodify the Black female body. This known history, coupled with the guardsmen's actions, implies a violent act. Directly representing the rape onstage would not only have been unnecessary but also counterproductive to the artistic choice of emotional distance.

## Problem musicals

In contrast to her peers, J.e. Franklin used musicals to express her concerns and experiential knowledge of growing up in the South. Deeply concerned about the legacy of Jim Crow, she developed liberation-themed musicals that combine elements of blues, doo-wop, and gospel music to teach, entertain, and edify Black audiences. Sexism often forced her to work on the fringes of experimental and commercial theatres. Despite these challenges, she emerged as one of the most prolific female dramatists of the 1960s and 1970s, garnering numerous awards, including the New York Drama Desk Award for Most Promising Playwright for her play *Black Girl* (1969).

Franklin's first major musical, *The Prodigal Sister*, re-envisions the Prodigal Son parable for modern Black audiences. Franklin originally wrote the book and lyrics for the musical but collaborated with Broadway songwriter Micki Grant to provide new music and additional lyrics for the 1974 premiere at the New Federal Theatre in New York City. *Prodigal* uses rhymed couplets to tell the story of a teen named Jackie who chooses to run away from home rather than tell her father about her unplanned pregnancy. She finds work in a casket factory and narrowly avoids becoming a victim of the dangers of urban living (i.e. prostitution, drugs, jail, murder). As with any standard musical, *Prodigal* ends happily. With the help of her co-worker, Lucille, Jackie returns home, and the entire cast praises the Lord in a spirited musical number. Despite the upbeat ending, *Prodigal* displays depth, using song to disrupt controlling images of Black womanhood.

*Prodigal* predates Michele Wallace's Black feminist critique, *Black Macho and the Myth of the Superwoman* (1978), yet addresses these concerns through Lucille's plight. Lucille resents the fact that she had to leave her children in Georgia, only to find employment as an underpaid washerwoman who will "probably have to screw her [mistress'] man" (Franklin 29). While she initially appears confident, strong, and street-savvy, she reveals her innermost thoughts in the song "Superwoman," through which the audience learns that Lucille witnessed the death of her father at an early age and most recently lost her newborn. Although she wants to express her grief, she has to remain "a tower of strength" for her other children "to lean on" (36). Her song concludes: "I'm no longer / Implacable, not unmovable, nor / undaunted. / I'm just a woman / who needs / A tower of strength to lean on" (36). Lucille's desire for companionship and love directly contradicts superwoman mythology that denies Black women's experiences of suffering and alienation. The theatre critic Jessica B. Harris heralded Saundra McClain's performance as

Lucille, noting that the actress "almost single-handedly destroys the myth of the strong Black woman" (D4). Indeed, this small glimpse into Lucille's life reveals the depth of Black women's humanity as well as a need to build strong Black families.

## Ritualistic revivals

In contrast to Sanchez, Molette, and Franklin, Barbara Ann Teer founded her own theatre in order to maintain complete artistic control over the creation and execution of her innovative work. Her desire to teach African aesthetics and to cleanse and unite the Harlem community led to the creation of ritualistic revivals, all of which she wrote, directed, choreographed, and starred in at her National Black Theatre (1968–present). She eschewed Western notions of performance, reconceptualizing her dramatic events as a means to channel the African spirit inside both "liberators" and "participants" (i.e. performer and audience) (Forsgren 17–18, 28–30).

Teer's first ritualistic revival, *A Ritual to Regain Our Strength and Reclaim Our Power*, demonstrates how the concerns of adolescent women impact the entire Black community. In contrast to her later works, *A Ritual* privileges the experiences of a poor Black child named Young Girl. She represents both the Harlem community and the millions of Black girls who are so preoccupied with survival that they neglect their minds and spirit. In the filmed recording of the play, Young Girl wears worn, ill-fitting attire that alludes to her utter neglect while the "liberators" sport afros and striking red, black, and green ankle-length robes. As representatives of a Pan-Africanist vision, the liberators encourage Young Girl to resist drugs and other harmful behaviors. They also appeal to cultural memory and prompt her to remember that Blacks are "kings and queens" who must help build the "nation" (*The Ritual*). Noting that their pupil remains unconvinced, the female liberators take on the rhythms of Black preachers to welcome a lost soul into the embrace of a loving community. They also testify to Black women's strength and resiliency during slavery and conclude by bearing witness that "we need a loving black woman revolution" (*The Ritual*). By saying "we," the female liberators extend the call to the entire Black community to include loving one another—especially Black women—within the framework of Black empowerment. *A Ritual* received positive responses from audiences and Black critics, which led to its broadcast on local television and an international tour. Mainstream presses ignored the production altogether, thus continuing the practice of dismissing Black women's works.

## Conclusion

Sonia Sanchez, Barbara Molette, J.e. Franklin, and Barbara Ann Teer contributed greatly to the cultural flowering known as the Black Arts Movement, but they were not alone in their efforts to include the concerns of women and families within a Black revolutionary framework. Dramatists Aduke Aremu, Hazel Bryant, Martie Evans-Charles, P.J. (Patricia Joann) Gibson, Gertrude Greenidge, Elaine Jackson, Josephine Jackson, Judi Ann Mason, Salamu, Jackie Taylor, and countless others also resisted Black women's social, economic, and political marginalization and have yet to receive sustained critical attention. Let this chapter serve as a foundation for further inquiry.

## Note

1  "Poemplays" is a term coined by Elizabeth Brown-Guillory in her article, "Sonia Sanchez (1934–)."

# Works cited

Barnes, Clive. "Theatre: 'Black Visions.'" *New York Times*, Apr. 5, 1972, p. 37.

Brown-Guillory, Elizabeth. "Sonia Sanchez (1934–)." *Black Women in America: An Historical Encyclopedia*, edited by Darlene Clark Hine, et al., Carlson, 1993, pp. 1003–1005.

Forsgren, La Donna L. *In Search of Our Warrior Mothers: Women Dramatists of the Black Arts Movement*. Northwestern UP, 2018.

Franklin, J.e. *The Prodigal Sister: A New Black Musical*. Samuel French, 1974.

Gussow, Mel. "Theater: Condemning the Insidious Form of Racism." *New York Times*, Jan. 22, 1971, p. 19.

Harris, Jessica B. "'Prodigal Sister' Rises Above its Weaknesses." *New York Amsterdam News*, Dec. 7, 1974, p. D4.

Molette, Carlton W., and Barbara J. Molette. *Rosalee Pritchett*. Dramatists Play Service, 1972.

Riley, Clayton. "'Black Visions' Is a Supershow." *New York Times*, Apr. 15, 1972, p. D1.

*The Ritual*. By Barbara Ann Teer. New York City Public Broadcasting Company, Feb. 2, 1970. Television.

Sanchez, Sonia. Personal Interview. June 30, 2010.

———. "Sister Son/ji." *New Plays from the Black Theatre: An Anthology*, edited by Ed Bullins. Bantam, 1969. pp. 9–107.

Wallace, Michele. *Black Macho and the Myth of the Superwoman*. Dial Press, 1978.

# 44

# INTERVIEW WITH MICKI GRANT

## Actor, singer, composer, lyricist

*Interviewed by Kathy A. Perkins*
*2016 and 2017*

In 1973, Micki Grant became the first woman to win a Grammy for Best Musical Score Album for the Broadway production *Don't Bother Me, I Can't Cope*, conceived and directed by Vinnette Carroll. For the same show, she received a Drama Desk Award for most promising lyricist as well as for outstanding performance. Ms. Grant's other Broadway productions as lyricist or composer include *Your Arms Too Short to Box with God*, *Working*, and *It's So Nice to Be Civilized*. She has received three Tony nominations for writing and an Obie for acting. She was the first African American woman to have a contract on a soap opera, *Another World*. She has received lifetime achievement awards from the Dramatists Guild and the League of Professional Theatre Women.

KAP: How did you choose art as a form of expression?

MG: Art chose me. I was brought up in the church, and I think it started there. We also had a community house where they had free dance and drama classes. At 8 or 9, I was cast as the Spirit of Spring, and I was hooked. As for music, we had a piano in the house and my father was a blues pianist, and I would sit on the stool beside him and try to imitate him. My sister took piano lessons and my dad, who was a barber by trade, played the blues by ear.

KAP: So your father was your first influence when it came to music?

MG: Yes, for piano, but we also had music appreciation in school. I was about 9 when I started studying violin and later became a member of the elementary school orchestra. Ms. Davis, who was the conductor of the orchestra and the violin teacher, needed a double bass player so I volunteered. And of course this little kid—I was … skinny as a rail—probably didn't weigh 90 pounds. My mother almost went into hysterics: "Oh, why do you want to play that thing? It's bigger than you are!" Later, when I became proficient, my parents actually bought me a second hand double bass. My parents always knew that I was talented and always encouraged me. They expected great things from me.

While at Englewood High, I was invited to attend the Chicago School of Music to study with Nathan Zimberoff, who was one of the members of the Chicago Symphony Orchestra. I became a member of the concert orchestra at the school. I attended University of Illinois at Chicago, where I'm in the hall of fame there. I didn't major in music, but I played in both the university symphony orchestra and jazz ensemble.

As I was serious about theatre, I joined the Center Aisle Players, a community group, but soon discovered Chicago was not a place for a serious actress of any complexion. I decided to go to Los Angeles because my grandmother and other relatives were there, and I had no one in New York. I had a famous cousin in LA, Jeni Le Gon, a tap dancer and actress who was in several movies, including one featuring Bill "Bojangles" Robinson. Jeni introduced me to Nick Stewart, producer of the Ebony Showcase Theatre, and that's when I also met playwright and scholar James Hatch. He and C. Bernard Jackson, the composer, were staging *Fly Blackbird*, and I got the ingénue lead. When the show was later produced Off-Broadway at the Mayfair Theatre in 1962, I came to New York hoping I would get my old role. The role was already casted, but I was hired for the chorus and as an understudy for my original role. We won an Obie, which was like the Off-Broadway Tony. *Fly Blackbird* was my first Equity production.

KAP: Tell me about Langston Hughes' *Tambourines to Glory*.

MG: Langston, who I knew personally, had seen *Blackbird*. In fact, he once said he was going to write a show for me and my friend Thelma Oliver as a result of seeing our performance in *Blackbird*. So when I auditioned for the ingénue role in *Tambourines*, it was almost a slam dunk, and everything just segued after that. *Tambourines* was my first Broadway show.

After that, I did my first soap opera, *The Edge of Night*, for about a year. *Another World*, for which I was under contract, came later. I played the role of Peggy Nolan for about seven years. As a contract player, you're on salary, and you are a regular member of the cast.

KAP: How did your relationship with Vinnette Carroll begin?

MG: That's a great story. Vinnette was directing Oscar Brown's *Kicks & Co.*, and she came to California for auditions when I was doing *Blackbird*. I auditioned and didn't get a role. That was the first time I met Vinnette Carroll. She later came to see Roscoe Lee Browne Off-Broadway in *Brecht on Brecht*, in which I also had a prominent role. She was looking for someone to do a musical version of Irwin Shaw's *Bury the Dead*, which was about these corpses that refused to be buried. Glory Van Scott, who was in *Blackbird* with me, knew I was writing music as well as playing the guitar. Glory told Vinnette, "You should hear some of Micki's music," and Vinnette said, "Micki Grant is an actress," and Glory said," she also writes and you should hear some of her music." So, I took my guitar and went up to Vinnette's studio to sing some of my songs. One was an anti-war song "Step Lively, Boy!" and another, "Human Feeling," and that was the beginning! *Bury the Dead*, which was changed to *Step Lively, Boy!* was our first project. She thought I was a great lyricist. She said, "Nobody writes like you." Vinnette never wanted to change anything I ever did—lyric, nothing. However, she might change the rhythm and do it a different way.

KAP: Is there a Micki Grant style of music?

MG: I didn't realize it until people started referring to my style, and that's one of the ways I got *Working*. It's very political, a lot of irony. Like somebody told me, I always come with something you didn't expect. I am very motivated by what happens in the world at large.

KAP: When you're composing, do you start with the melody and then the words or is it words first and then the melody?

MG: They come together. The only time I write separately is if I'm collaborating. Or if I know certain things must be said, I will maybe jot down what has to be said. But almost invariably the melody and the lines arrive together.

KAP: So in the case of *Don't Bother Me, I Can't Cope*, Ms. Carroll conceived the idea and you did the music and lyrics. What was the process?

MG: Because Vinnette had heard so much of my music, she said, "People have got to hear these songs," and she came up with a formula to put them onstage. There's a church scene, and we were doing the songs and she said, "No, it needs something in between here. You need a break between "Good Vibrations" and "Fighting for Pharaoh"; there has to be something in here." Who ever heard of a church service without a sermon? So I wrote a prayer and a sermon, "One Day Every Day's Gonna be Sunday" is a standard line in so many churches.

Vinnette loved titles. She thought of titles. I remember sitting in her kitchen up in Connecticut, and she came up with *Don't Bother Me, I Can't Cope*. Glory shared an experience about a woman who had been stopped by the police and threw her head over the steering wheel yelling, "Don't bother me. I can't cope!" All that afternoon we were discussing the show, which had no name at that time. Every now and then, somebody would say, "Yeah, don't bother me 'cause I can't cope." So the next day, Vinnette called and said, "Well, I think we should call it *Don't Bother Me, I Can't Cope*." I said, "You've got to be kidding. You mean I have to write a title song called 'I Can't Cope?'"

We opened at Ford's Theatre in Washington, DC [1971]. The show opened to rave reviews. I was sitting there in producer Frankie Hewitt's house where she had given the cast a party. We were watching TV when the reviews came in. When I heard the news I just started boo-hooing. I had never thought about reviews. I was just doing the work. I don't know why; I guess I was crying from joy, from relief, from shock! I remember it as if it was yesterday. I just remember sobbing like a crazy person. I was shaking! The show moved to Broadway in 1972 where it ran for two and a half years. I was in the show the entire run. It ran for 14 months in Chicago, and about 9 months in LA. So that's when I said, at one time Vinnette and I must have had most of the Black people in theatre working in our shows.

KAP: And you won a Grammy!

MG: Yes, and I wasn't even there to accept it. I was at Carnegie Hall doing a benefit for the Congress of Racial Equality. They sent the news backstage and announced it to the audience at Carnegie Hall that I had just won the Grammy.

KAP: So you're the first woman to win for a musical score?

MG: For the score, for Broadway. Original cast album.

KAP: What is your role during orchestration?

MG: The arranger takes over, but I work with the arranger, who subsequently may become the orchestrator.

KAP: Do you decide if you want to hear certain instruments?

MG: No, I don't usually do that, but there are times when I hear certain instrumentation. There may be times because I play bass I'll hear a certain bass line that I'll give to the arranger. I usually have a sense of what I want to hear. All that comes from being an actress as well as a writer, composer, lyricist. So you know what the feel of the scene and the moment are.

KAP: So if you had to pick one show or the highlight of your career …

MG: Has to be *Cope*. Another one I'm very proud of, where I had three songs in it, was *Working* (Broadway 1978).

*Figure 44.1*  Choreographer Talley Beatty (*lower left*), director Vinnette Carroll (*middle*), and Micki Grant (*top*), collaborators on *Your Arms Too Short to Box with God*.

*Source*: Courtesy of Micki Grant.

KAP: There have been recent productions of *Cope*, which is viewed as politically timely. Would you change any of the lyrics if there was a revival?

MG: I would change names that I referred to at the time for more current names. For the most part, I wouldn't change much as there is so much history in *Cope*.

KAP: How many shows did you collaborate on with Ms. Carroll?

MG: At least six: *Croesus and the Witch*, *Step Lively, Boy*! or *Bury the Dead*, *Your Arms Too Short to Box with God*, *Cope*, *I'm Laughing but I Ain't Tickled*, *Alice*. Yeah, that's six there. *Your Arms Too Short* was produced three times on Broadway [1976, 1980 and 1982; Figure 44.1]. The first production featured Delores Hall, who won the Tony. The second time had Jennifer Holliday, which catapulted her into *Dreamgirls*. Patti LaBelle did the National Tour, and when it returned to New York, Al Green joined her in the production.

KAP: So Vinnette was your greatest collaborator.

MG: Vinnette was such a workaholic. Before you finished one thing, she already had her mind on where she was next. She was a great motivator. It was fortunate that Glory brought the two of us together. Her Urban Arts Corps gave me a place to work and with a person who was also an extraordinary Black woman. We thought a lot alike.

KAP: What do you consider as your greatest accomplishment?

MG: Not starving to death!

KAP: Do you consider yourself a mentor, and what advice would you offer a young composer/lyricist trying to make it in the business?

MG: Learn something about the craft. It's not just about pushing buttons. I know that playing the violin, guitar, piano, and double bass really helped me as an artist. I want to see younger and more producers of color. There is a young woman who was in a recent presentation of *Cope*. She became so enamored of it that she wants to be a producer, and I have given her my blessing. I would love her to be successful.

# 45

# KEEPING HIS GLOVES UP

## August Wilson and his critics

*Sandra G. Shannon*

In September 1995, August Wilson and I lingered for a few moments backstage at Howard University's historic Ira Aldridge Theater where I was set to interview him as part of an event marking the publication of my book, *The Dramatic Vision of August Wilson*. I remember asking Wilson whether he would like a dry run of my list of questions. Surprisingly, he refused and instead imparted a bit of advice that emanated from the world of boxing: "You've got to keep your gloves up! Don't drop your guard!" Years later, as I immersed myself in the details of his biography, I came to realize that the playwright was at his best when forced to think on his feet in pressured situations or when he perceived incoming jabs from his critics. I also understood that, to Wilson, the game of boxing, like baseball, provided clear rules of engagement by which he could outmaneuver his opponent, sometimes in their own ring. Ultimately, the game of boxing became his philosophy of living. In the relatively short space of this chapter, I revisit several such episodes that forced Wilson to come out swinging.

Wilson apparently developed this fighting reflex because of the influence wielded by his boyhood role model Charley Burley, a boxing legend from 1940s and 1950s America who was also highly respected among boxing authorities. According to the *Daily Beast* reporter Ronald Fried, "Burley was denied his shot at fame in segregated America, and ended up as a sanitation worker. But his dignity and character would end up inspiring one of the best plays about sports [*Fences*]." Wilson revealed the source of his special connection with Burley in an interview with Fried:

> I grew up without a father, and the male image that was in my life … was Charley Burley. And that's what being a man meant to me, to be like him. I wanted to grow up and dress like him. He wore those Stetson hats and things of that sort, and I couldn't wait until I got to be a man to be like Charley Burley. Though Burley was a garbage man … everybody always called him Champ. And for a long while I was growing up, I thought he was the champion.

In stark contrast to Wilson's infrequent contacts with his biological father, Frederick Kittel, Burley was a more stable influence. That the boxer lived directly across the street from young Wilson was an added advantage to fostering an obviously impactful paternal relationship.

Just as Burley, a natural middleweight, fought and defeated much larger men, Wilson took on powerful critics when under threat of attack (Fried). This boxing metaphor, then, also appropriately describes Wilson's stance during some of his most contentious relationships with his greatest adversaries. Never one to back down from a good debate—whether on paper or face to face with an opponent—Wilson gained a reputation for standing his ground against blatant cultural insensitivity, ignorance, and sheer racism aimed at him personally, his ideology, or his plays. He was a man who saw no distinctions between such public stands and his private vision. He was just as adamant in defense of his boldly Afrocentric views with friends seated at a bar or in front of an interviewer as he was with reporters at a press conference or with attendees at a national conference.

"Staying woke" (as the term is now used to describe sociopolitical vigilance) was a byproduct of this activist playwright who often admitted to having been "fired in the kiln of the Black Arts Movement."[1] Wilson's playwriting career was punctuated by several well-rehearsed, contentious episodes during which he unabashedly defended his Black aesthetics and, by extension, argued against the sorry state of Black theatre. Resistance was a guiding principle of Wilson's life as well as a subtle or spoken refrain that he often struck in various manifestos, plays, essays, interviews, speeches, op-eds, and lectures. The aesthetic ground on which he stood often became the subject of intense backlash from his most vocal critics. In several instances, what began as differences of opinion among those who challenged his African and Black cultural nationalist aesthetics turned into full-blown, media feeding frenzies or irreparable relationships.[2]

Always one for a good fight, August Wilson may also be remembered for being at the center of two celebrated causes that fomented ire from his shrewdest critics and support from his most fervent allies. One such clash involved a standoff between officials at Paramount Pictures, which had secured from Wilson movie rights to *Fences* to the tune of $500,000, and Wilson, who had also placed a condition that Paramount had to hire a Black director in order to translate the cultural nuances of the play. Paramount instead selected white director Barry Levinson for the job, apparently without giving serious consideration to equally qualified African Americans. The two parties dug in their heels to create an impasse that would last over a decade.

Wilson sought public support for his position by publishing an extremely provocative statement titled "I Want a Black Director":

> Someone who does not share the specifics of a culture remains an outsider, no matter how astute a student they are or how well-meaning their intentions. I declined a white director not based on race but on the basis of culture. White directors are not qualified for the job.

("May All Your Fences" 201)

His proclamation struck a nerve with theatre critics and other members of the arts community, cultural activists, pseudo philosophers, and lay audiences. Pushback was swift. For example, *New York Times* op-ed writer Steven Dante counter-punched with familiar appeals for universality: "Great art transcends culture … The genius of Euripides and the artistic vision of the director made the cultural barriers immaterial."

While Wilson was roundly reprimanded by his critics for his uncompromising demand that *Fences* be placed in the hands of a Black director, he would not be deterred. Fortunately, 26 years after his essay, the two warring parties finally came to a resolution. In December 2016, the movie *Fences* premiered to much acclaim, with Denzel Washington as its "Black director." According to one *New York Times* film critic, "What is most remarkable about this film is how thoroughly—how painfully, how honestly, how beautifully—it answers that question 'What about my life?'" (Smith 13). Washington apparently had the right stuff (see Figures 45.1, 45.2, and 45.3).

*Figure 45.1*   Preliminary scenic hand sketch for *Fences*.
*Source*: Edward Haynes.

*Figure 45.2*   Black and white computer rendering of *Fences*.
*Source*: Edward Haynes.

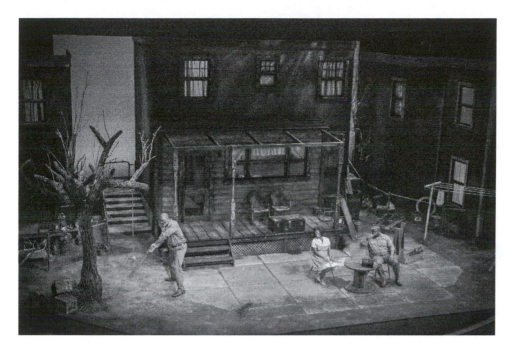

*Figure 45.3*   Edward Haynes' realized set design of *Fences* at the Lone Tree Arts Center in Colorado (April 2018).

*Source*: Photographer Jen Kiser.

In April 1996, August Wilson accepted an invitation from organizers of the annual Theater Communications Group (TCG) conference to give the keynote address. Who knew that he would use this venue as a platform to launch an all-out attack on unfair funding practices that have decimated Black theatres nationwide, and to underscore his cultural nationalist aesthetic? Before a largely white audience from predominantly white educational institutions and mainstream theatres, Wilson landed a series of blows that jolted the crowd.

The first was to affirm his identity:

> I am what is known, at least among the followers and supporters of the ideas of Marcus Garvey, as a "race man." That is simply that I believe that race matters—that is the largest, most identifiable and most important part of our personality.
>
> ("The Ground" 13–14)

The second was to state unequivocally that Black theatre suffered from a lack of institutional and financial support: "If you do not know, I will tell you," he proclaimed. "Black theatre in America is alive, it is vibrant, it is vital ... it just isn't funded" (17). He took a third swing at what he believed to be a troublesome practice of colorblind casting:

> Colorblind casting is an aberrant idea that has never had any validity other than as a tool of the Cultural Imperialists who view their American culture, rooted in the icons of European culture, as beyond reproach in its perfection. It is inconceivable to them that life could be lived and enriched without knowing Shakespeare or Mozart.
>
> (29)

Wilson's speech, "The Ground on Which I Stand," was a "shot heard around the world." It was met with shocked disbelief and boos, on one hand, and cheers of support on the other. These vastly different sentiments would soon be echoed in major news outlets and in several print publications. For all the eyebrows it raised and rhetoric that it inspired, it also forced critics both for and against his position to stretch their thinking to grapple with Wilson's challenge:

> Critics have an informed opinion … Sometimes it may be necessary for them to gather more information to become more informed. As playwrights grow and develop, as the theatre changes, the critic has an important responsibility to guide and encourage that growth.
>
> (43)

To be sure, not all of the criticism levied against Wilson is without merit, yet research reveals that more than a few theatre reviews appeared to be laced with bias—indeed, contempt—for the playwright, his unabashed project of recovering narratives of the African American experience, and his insistence upon preserving its culture. Note, for example, successive negative reviews by *New York Post* critic John Simon, who, in an October 1984 review titled "'Black Bottom,' Black Sheep," downplayed the attention that Ma *Rainey's Black Bottom* had received by referring to Wilson, who had already been writing for several years, as a "new black playwright … whose promise and provocation bode well, even if what he delivers is only intermittently drama" (95). When one fast-forwards 20 years past Wilson's two Pulitzer Prizes, a Presidential Medal of Freedom, and multiple Drama Circle Critic's awards, one finds that Simon's reviews of Wilson's work are no less dismissive. In his December 2004 review Simon throws a mean punch:

> Every talented author is entitled to the occasional clinker. August Wilson's *Gem of the Ocean* is a big, bustling mess, supposed to represent the 1900s in Wilson's decade-by-decade chronicle of African-American life in the past century. Here he crowds too much into 1904: the aftermath of slavery and the Civil War, crossing the ocean in slave ships, the Underground Railroad, a kind of Christian-voodoo exorcism ritual, and a somewhat Oz-like City of Bones.

Similar dismissals followed, such as a thinly veiled mockery in the title of Richard Day's review of Yale Repertory Theatre's revival of *Joe Turner's Come and Gone*: "A Coupla Black Folks Sitting Around Talking."

But punches were not aimed solely at the playwright. Wilson's long-time director Lloyd Richards also came under attack. Interestingly, attacks on Richards' directorial skills also raised critical questions launched by some of the playwright's closest allies. One surprisingly soured member of Wilson's inner circle was actor Charles Dutton, for whom Wilson had created several characters best suited for his acting skills. In fact, the actor's nascent career had been given a boost by the major roles in *Ma Rainey's Black Bottom* and *The Piano Lesson* that Wilson wrote specifically for Dutton. Unfortunately, the relationship between the playwright and his one-time staunch supporter began to sour with Wilson's exponential rise in popularity and increased skill at writing and staging his works. Theatre critics such as Samuel Freedman concurred with Dutton in speculating that Wilson's own hubris had begun to take its toll and threaten the Wilson-Richards mystique, evident in their successful collaborations on *Ma Rainey's Black Bottom, Joe Turner's Come and Gone, The Piano Lesson*, and *Fences*. Wilson seemed to be orchestrating his own downfall. Dutton voiced what many had willfully or innocently ignored: August Wilson had unceremoniously sidelined his longtime director, mentor, and friend Lloyd Richards.

On more than one occasion, Dutton's raw emotions surfaced as he shared his version of what had led to this dissolved relationship. As a featured speaker in the 2015 American Masters documentary, "August Wilson: The Ground on Which I Stand," the usually jovial Dutton appeared sullen as he recalled witnessing the deteriorating relationship play out before him:

> Things started to change during the Hallmark Hall of Fame production of *The Piano Lesson*. I think [among] Lloyd, August, and myself, there were moments when I actually witnessed August kind of directing a scene. And I could look at Lloyd and see that Lloyd was not necessarily enjoying it. And, after that, whatever bonds that remained started to shred.

Dutton's most stinging rebuke of Wilson came in charges concerning the playwright's seeming hypocrisy in selecting production venues not in keeping with W.E.B. Du Bois' mandate that Black theatre remain "for us, by us, about us and *near* us." Dutton asked, "When did August ever open one of his plays in Harlem? All of his plays were opened on the Great White Way. He never said, 'No. I'm not going to open on Broadway. I'm going to open at the Apollo on 125th Street'" (The Ground documentary). Dutton's accusatory tone confused many viewers who could recall the actor's one-time close relationship with Wilson.

Many continued to watch for signs that Wilson's split with Richards would impact negatively upon the quality of his work. Yet during the post-Richards phase, Wilson went on to receive a string of awards before completing his monumental American Century Cycle. He did so, however, with only a few months to spare before his death. The so-called bookend plays *Gem of the Ocean* (2006) and *Radio Golf* (2008) represent his push toward the finish line even as cancer ravaged his body and caused him to rely heavily upon his assistant, Todd Kriedler, and director Kenny Leon to bring his magnum opus to fruition.

*Radio Golf*, completed in 2005, has the distinction of being the very last play in Wilson's American Century Cycle. Theatre critics knew *then* just as they know *now* that Wilson's illness most assuredly played a role in his final product. Knowing this, some tempered their critiques then and now with just such an acknowledgment, while others remain unfazed by these external factors (Shteir). One genuinely moved critic, Peter Marks, wrote, "*Radio Golf* ... is far from Wilson's best play, but nonetheless stands as a bracing and prescient pinpointing of a next phase of African American life: the flowering of black American aspiration."

Evidence that today's critics have begun to take Wilson's "dramatic vision" seriously comes through clearly in a 2017 article, "What August Means Now," in which Ben Brantley and Wesley Morris celebrate "the power of language and representation in the full sweep of his writing." As Morris notes,

> You're listening for two things with Wilson, as well as with lots of lyrical playwrights. First, there's the handsomeness of the language itself, the way he insists that black vernacular is its own grammar. Then, you're listening to hear what characters are saying to each other. It's funny with "Fences," because so much of it feels earthbound—and not because Troy Maxson (Mr. Washington) and his friend and co-worker Bono (Mr. Henderson) are riding on the back of a garbage truck.

August Wilson and his critics have had a long-standing, interdependent affair. He delighted in good reviews and took the bad ones on the chin. Ultimately, one can argue, August Wilson kept his gloves up in the face of incoming criticism. He stood his ground and left the ring a champion.

# Notes

1 The often-cited phrase, "Fired in the kiln of Black nationalism" or slight variations thereof, was used by Wilson to characterize the origins of his activism. See Preface to *August Wilson: Three Plays* (ix), and *The Ground on Which I Stand* (12–13).
2 See Wilson's "I Want a Black Director" in *Spin* or the *New York Times*. Also, follow the subsequent fallout from his demands in letters published in the *New York Times* article, "So You Want a Black Director for Your Movie?" For more information on repercussions from Wilson's controversial 1996 keynote speech, see the October 1996 and December 1996 issues of *American Theatre*.

# Works cited

"August Wilson: The Ground on Which I Stand." Charles Dutton, Interviewee. *American Masters*. Thirteen Productions, Feb. 2015.

Brantley, Ben, and Wesley Morris. "What August Wilson Means Now." *New York Times*, Jan. 11, 2017, www.nytimes.com/2017/01/11/theater/what-august-wilson-means-now.html. Accessed May 8, 2018.

Dante, Steven. "So You Want a Black Director for Your Movie?" *New York Times*, Oct. 12, 1990.

Day, Richard. "A Coupla Black Folks Sitting Around Talking." *New England Newsclip*, May 8, 1986.

Du Bois, W. E. B. "Krigwa Players' Little Theatre Movement," *The Crisis*, vol. 22, no. 3, July 1926.

Freedman, Samuel G. "The Mother of an Era: August Wilson's." *SiteMap/The New York Times*, Feb. 2, 2003, www.racematters.org/motherofaneraaugustwilsons.htm.

Fried, Ronald K., "The Black Boxing Legend Who Inspired *Fences*." *Daily Beast*, Dec. 24, 2016, www.thedailybeast.com/articles/2016/12/24/the-black-boxing-legend-who-inspired-fences.

Marks, Peter. "Theatre Review: PM on August Wilson's *Radio Golf* @Studio Theatre." *Washington Post*, May 26, 2009, www.washingtonpost.com/wp-dyn/content/article/2009/05/25/AR2009052502109.html. Accessed May 8, 2018.

Shannon, Sandra. *The Dramatic Vision of August Wilson*. Howard UP, 1995.

Shteir, Rachel. "August Wilson: What Is His Legacy, Really?" *Slate*. Dec. 6, 2005.

Simon, John. "Black Bottom,' Black Sheep." *New York Post*, Oct. 22, 1984, p. 95.

———. "Review of *Gem of the Ocean*." *New York Theatre Magazine*, Dec. 20, 2004.

Smith, A. O. "Beneath the Bombast, *Fences* Has an Aching Poetry." *New York Times*, Dec. 15, 2016, p. 13.

Wilson, August. *August Wilson: Three Plays*. Pittsburgh UP, 1984.

———. *The Ground on Which I Stand*. Theatre Communications Group, 2001.

———. "I Want a Black Director." *May All Your Fences Have Gates*, edited by Alan Nadel, Iowa UP, 1994, pp. 200–204.

———. "I Want a Black Director." *New York Times*, Sep. 26, 1990.

———. "I Want a Black Director." *Spin*, Oct. 1990.

# 46

# INTERVIEW WITH EDWARD EVERETT HAYNES, JR.

## Designer

*Interviewed by Kathy A. Perkins*
*June 19, 2017*

Edward E. Haynes, Jr. is a Los Angeles based set designer trained in theatre but has conquered multiple areas of the entertainment industry as a designer for stage, TV, film, and events, to name a few. A recipient of an NAACP Image Award and many others, Ed comes from a family of designers. For 18 years he was resident designer at the Mark Taper Forum and is owner of Ed Haynes Design.

KAP: Why did you choose theatre as a form of expression and particularly set design?

EEH: My father was an interior designer and photographer, so my earliest toys were carpet samples and paint swatches. Growing up around Hollywood, my father had a few celebrity clients, and he introduced me to the actor Geoffrey Holder, who was also one of the first Black set, light, and costume designers. Both parents were avid theatregoers and season ticket holders for the Mark Taper Forum, where we witnessed groundbreaking plays such as *for colored girls who have considered suicide/when the rainbow is enuf* and *Zoot Suit*.

As a regular theatregoer with my parents, set design seemed like the natural starting point, the most creative and expressive outlet. I had a job with the Ebony Showcase as a teenager as a sound tech. Also, it was the only entertainment design firm that had actual structured academic training programs, BA/BFA, during that time. My family felt better that Don Winton, the one-time production manager at the Mark Taper, recommended that course of action when I was 14 years old.

KAP: Did you have a mentor(s) or were you inspired by anyone?

EEH: I was initially inspired by my father and Geoffrey Holder as a child. Later I interned with and assisted Eugene Lee, John Lee Beatty, and Tony Walton.

KAP: Did you receive formal training?

EEH: The training I received was with the BFA program at the University of Southern California School of Drama. I also received an MFA from the theatre program at the University of Connecticut, Storrs.

KAP: What were conditions like when you entered the field? What were the major challenges?

EEH: The late '80s was a boom period for the regional theatre movement. After interning at Hartford Stage Company, I started working as the resident assistant designer at the Mark

Taper right out of grad school. The Taper was a special theatrical learning experience for me. I was often able to design interesting projects that reflected the artistic impulses of Los Angeles. That led to assisting at the Ahmanson Theatre as well and eventually becoming the resident scenic designer for Center Theatre Group [CTG]. I worked with some of the world's greatest designers where I would observe their process. I worked on several groundbreaking productions such as *Angels in America, Kentucky Cycle, Twilight Los Angeles 1992*, and *Jelly's Last Jam*. I also designed a few main stage productions in addition to second stage shows. I enjoyed 18 years working with CTG.

There were, and still are, two challenges that were difficult to overcome. Los Angeles, and most regional theatre, was often perceived by entertainment business people as inferior to New York theatre. Despite the preponderance of trained designers in LA, disproportionate amounts of resources were spent hiring New York designers to design LA productions. Additionally, although regional theatres prided themselves on their liberal perspectives, Black designers were usually only offered to design "Black plays." Often, my big breaks came when a New York designer cancelled at the last minute or a production only had the budget to hire locally.

I also found that being a "theatre purist" as a designer in Los Angeles is not financially feasible. I freelanced between shows at CTG and numerous LA "Equity Waiver" theatres. In addition to Los Angeles and regional theatre work, I do theatre consulting and television design. Later, I transitioned into designing for television, events, trade shows, restaurants, and nightclubs.

KAP: What do you consider your first major design and why?

EEH: A regional tour of *Having Our Say*. The production opened at the Taper, and it went on to the Alley Theatre in Houston and Berkeley Repertory.

KAP: Name one accomplishment that you are most proud of.

EEH: Since the age of 16, I have only worked in the entertainment industry. I am also gratified to have been recognized by the NAACP Theatre Image Awards for my set designs for the Taper's *Having Our Say*, and for LA's Ebony Repertory's August Wilson's *Two Trains Running*.

KAP: Having designed for a variety of areas in entertainment, do you have a preference?

EEH: Each area has its unique merits. Trade shows are a combination of display, altars, and patron flow—it's part museum and part environmental theatre. Interiors have the freedom to shape human interactions and intersection. Television is designing for a single eye (the camera). There is limited collaboration in TV, and that can be good at times. Events are like environmental theatre except all of the audience get to touch the props. Theatre is the opportunity for maximum collaboration, the chance to truly shape an environment through all the senses and collaborate with a team of artists toward a common vision.

KAP: Do you have a favorite design?

EEH: In the theatre, it is impossible to pick a favorite. In TV, *Culture Clash*. I was the production designer for their sketch-based comedy show on FOX TV. In event design, the Fallout 4 launch event 2015—a themed, immersive, post-apocalyptic party for 2,000 guests.

KAP: Is there an Ed Haynes style or something that distinguishes you from other designers?

EEH: I have a design process. I've found that no matter the size of the project, I have to follow that process to be happy with the design. Consequently, the little projects can end up taking just as much time as the big projects.

All designs start with a human figure. Everything is scaled to that first. I believe in designing from the "actor outward." This approach allows me to design shows of varying scope and scale by concentrating on the most important aspects and conceptually and artistically embellishing "outward" from them as the circumstances allow.

KAP: Has race or gender or both affected your opportunities?

EEH: Yes. At first producers were shocked to find out I was Black upon our first meeting. Then they were shocked that I was young. Occasionally they were shocked to find out I was straight. I know I've been passed over for any of these reasons a few times, but I've never allowed others' lack of imagination to affect my work.

KAP: Have the challenges changed much since you entered the field? If so, in what way?

EEH: Yes. When I started in this field, the Internet and email was a new concept, and CAD drafting for entertainment was unheard of. Now there is less preparation and lead-time for projects. Theatre is the last hold-out for advanced planning, probably because they have the smallest budgets. I believe in the Golden Triangle theory of design: "Fast, good, and inexpensive. Pick two." But in the event and industrial world, we now have clients to which money is no object. They want everything with little to no prep time.

KAP: Do you recommend young people pursue a degree, as you did, or suggest they find a mentor and assist?

EEH: Why not both? The solid foundation of a design education is key. Design history and periods and styles are invaluable knowledge. Dramatic analysis and theatre history knowledge is indispensable. Also, the skills of doing research. The next important thing is to learn how to communicate your design, first to the producers and directors and then to the craftsmen and crews. Drafting and drawing skills are a must. Finding a good mentor is the next step, creating artistic relationships and contacts and navigating the design sphere you are most attuned to.

KAP: Do you feel there are a representative number of African Americans in your field? If not, what suggestions can you offer to increase the numbers?

EEH: No, not nearly enough. There are not enough arts training outlets at the community and school level that let Black youth know these careers exist. For every actor on stage or screen, there are at least five people behind the scenes creating that experience. I was trained by actual theatre artists starting from middle school to high school. Such programs are few and far between now. Returning comprehensive arts to the primary education system is the best way to fix this. Also, technical training in skills like drafting and 3D design should be part of core education offerings. That coupled with career education that understands and promotes the commercial potential of design for young designers.

KAP: If there was one thing you think young people today should know about your field, what would that be?

EEH: That there are few opportunities to be a purist; one needs to diversify their design sphere. Theatre, film, TV, and events are all offshoots of the same skill set. Each one leads to a broader understanding of entertainment design. You never know where your next opportunity will come from, so be open and ask a lot of questions, and listen for unique and unusual answers coming from the most interesting places. I've gotten valuable advice from artistic directors to stage doormen, Tony Award-winning designers to scene shop Janitors.

KAP: Do you serve as a mentor?

EEH: Not as often as I would like to.

# 47
# AFRO-LATINX THEMES IN THEATRE TODAY

*Daphnie Sicre*

According to scholars Miriam Jiménez Román and Juan Flores, Afro-Latinx[1] is a burgeoning hybrid identity marker that applies to "people of African descent in Mexico, Central and South America, and the Spanish-speaking Caribbean, and by extension those of African descent in the United States whose origins are in Latin America and the Caribbean" (1). Though the term itself is relatively new, Afro-Latinx have been in existence since Africans explored the Americas and were later forcefully imported during the Trans-Atlantic slave trade. They are a large part of the mixed-race Latinx constituency with their own ethnic and racial experiences of Latinidad, a term used to invoke solidarity among Latinx. But because a global, institutionalized racism privileges whiteness and denigrates the complex, mixed heritage of Indigenous, European, and/ or African peoples, identification as Afro-Latinx can be contentious. Not all Afro-Latinx self-identify as such. In fact, a 2016 Pew Research Center study found that "one-quarter of all US Latinx self-identify as Afro-Latinx, Afro-Caribbean, or of African descent with roots in Latin America." Many others use even more culturally specific terminology to signal their racial, ethnic, or national background. Yet, Afro-Latinx artists have emerged and are embracing their multidimensional identity. This chapter offers an overview of the themes these artists have proudly explored, with an emphasis on Afro-Latinas. Because bodies onstage subtly project particular histories and thereby complicate or enlarge spectators' definitions of racial or ethnic belonging, it also notes occasions where Afro-Latinx actors have been cast in roles not specifically written for them.

While studying Afro-Latinidad, I came across a play call *Platanos y Collard Greens* (2003). I was sitting on the New York City subway, where I saw an advertisement. There it was, right in front of me: a play that explored the intersectionality of being both Black and Latinx! The play is a romantic comedy that tells the story of two college students: Freeman, an African American, who falls in love with Angelita, an Afro-Latina born in New York to a mother originally from the Dominican Republic. Together they have to confront cultural and racial prejudices. For example, Angelita from the Dominican Republic. Angelita's mother prohibits her from dating Freeman, simply because he is Black. Together, Angelita and Freeman fight discrimination that both Latinx and African-Americans experience while learning about Afro-Latinidad.

*Platanos* was written by David Lamb, an African American. It was originally directed by Summer Hill Seven, also African American, and is currently staged by Doni Comas, an Afro-Latinx. It debuted to sold-out audiences in 2003 at a small theatre in Manhattan and began a

collegiate tour, opening to a standing-room-only crowd at the University of Illinois at Urbana-Champaign. To date, *Platanos* is still touring college campuses dramatizing such themes as the historical erasure of Black culture in Latin America and the struggle to overcome cultural/racial prejudices. *Platanos* not only addressed the complexity of Afro-Latinx identity but also inspired others to write and produce new work that often explores similar themes. It marks the beginning of an era in which Afro-Latinx are no longer non-existent or invisible in theatre.

## Solo shows

Given the cost of fully mounting and producing plays with many characters, sets, and costumes, solo performances pose less financial and reputational risk to performers and producers. For that reason many Afro-Latinx have chosen solo performance. Puerto Rican Nilaja Sun is perhaps mostly known for her play *No Child …* (2006), in which she examines the experience of a theatre-teaching artist in the New York City public schools through the vivid portrayal of 16 characters. She previously wrote *La nubia latina* (1999) where she explores the concept of race and the challenges she faced her as an Afro-Latinx artist. Dominican Josefina Baez has toured *Dominicanish* (1999), an autobiographical play incorporating music, movement, and personal narratives that reflect her Afro-Latinidad identity and struggles against hostility toward Black people in the Dominican Republic.

New York Theatre Workshop supported Afro-Latina April Yvette Thompson in developing *The Miami Trilogy*. The first play, *Liberty City* (2008), tells April's coming-of-age story with her Bahamian-Cuban father and African American mother in Miami during the 1970s. Her second play, *Good Bread Alley* (2014), focuses on families and the power of love transmitted through Afro-Cuban and Gullah music, dance, and myth. Her third play has yet to be produced. While working on *Good Bread Alley*, vocalist Jadele McPherson was inspired to create Lukumi Arts, an Afro-Cuban Arts Collective that premiered her own show, *La sirene: Rutas de azuca* (2016). The play maps the routes that sugar, enslaved Africans, and other commodities traveled through the ports of the American South, the Caribbean, and Latin America. Music conveys both the trauma and resilience the captives bequeathed.

Eva Cristina Vasquez has written and performed a series of one-person shows dealing with identity and race. Her *Amor perdido* was produced by Teatro Círculo at the Blue Heron Arts Center in 2002–2003; it was followed by *Lágrimas negras: Tribulaciones de una negrita acompleja*, which premiered in 2005 and was later published by El Instituto de Arte Teatral International in 2008. Vazquez is also in the process of writing a book about Puerto Rican solo performers, some of whom are also Afro-Latinx. In 2016, she wrote *Carmen Loisaida*, an adaptation of Bizet's famous opera that also draws from Prosper Merimee's novel. Instead of Spain, *Carmen Loisaida* takes place in New York City's Lower East Side and focuses on Latinx undocumented and documented immigrants struggling to find love. Bizet's music is rearranged into salsa, meringue, and other Latinx beats.

Another Afro-Latina solo performer is Liza Colón-Zayas who wrote *Sistah Supreme* (2005) about growing up in New York during the 1970s and 1980s. The play was directed/developed by Aldy Guirgis and included in the first Hip Hop Theatre Festival produced by Danny Hoch. Other unpublished plays include Maria Costa's *Macho Men and the Women They Love* (2010). Costa was born in Detroit to a Hungarian mother and Cuban father, and she uses humor to explore identity. Comedian Jenny Saldae chose not to write about her Afro-Latinidad background; she focused instead on her battle with breast cancer in *Hooray for Boobies!* (2007). Afro-Latina Florinda Bryant wrote *Half Breed, Southern Fried* (2006) for the "Performing Blackness" series at the University of Texas at Austin. Her play also uses humor to look at her identity, but

what makes it different from the others is her exploration of Afro-Latinidad in Texas. Tanya Perez, finding it hard to be cast as a lead in shows, wrote *Honor and Fidelity* (2017), a work that occasionally uses humor to address one woman's journey towards healing her heart.

A subtopic of identity within the Afro-Latinx community is colorism.[2] Both Krysta Gonzales and Alicia Anabel Santos wrote solo shows dramatizing their experiences as light-skin Afro-Latinas. Gonzales wrote *Mas clara* (2016). Santos authored *I Was Born* (2010), and she also wrote and co-produced the documentary *Afrolatinos: La historia que nunca nos contaron/Afrolatinos: The Untaught Story.*

These themes are not just evident in Afro-Latinx solo shows; they are also very popular in literature. The American Place Theatre staged two well-known Afro-Latinx novels as solo plays. In 2001, they produced *The Brief Wondrous Life of Oscar Wao* by Junot Diaz and *Down These Mean Streets* by Piri Thomas. Afro-Latino Elvis Nolasco became the lead in *The Brief Wondrous Life of Oscar Wao*, while Afro-Latino Jamil Mena told the story of Piri Thomas.

## Biographical plays

Solo shows have paved the way for biographical plays that not only teach Afro-Latinx history but also confront racism and cultural/racial prejudice. For example, Carmen Rivera authored three plays about well-known Afro-Latinas: *La Lupe: My Life, My Destiny* (2001), *Julia de Burgos: Child of Water* (2004), and the musical *Celia: The Life and Music of Celia Cruz* (2007). *La Lupe* is about Cuban singer Guadalupe Victoria Yoli ("La Lupe") who is known as the Queen of Latin Soul for her gift in transcending various Latin music genres. *Julia de Burgos* centers on Puerto Rican Julia de Burgos who is famous for her poetry and advocacy for Puerto Rican independence. Rivera's *Celia* is about the infamous and legendary Cuban salsa singer Celia Cruz. Before it toured the world, *Celia* was produced Off-Broadway at New World Stages and received a HOLA[3] Award for outstanding achievement in playwriting.

In addition to Celia Cruz, the former baseball player Roberto Clemente is another popular Afro-Latinx who appears in several plays. New York City based SEA[4] premiered *DC-7: The Roberto Clemente Story* (2012), a bilingual musical written and directed by Luis Caballero. It earned six ACE awards (from the Association of Latin Entertainment Critics of New York) and several ATI (Artistas de Teatro Independiente) awards. Afro-Latinx actors included Modesto Lacen as Clemente, Keren Lugo as Clemente's wife, and Ricardo Puente as Clemente's guardian angel. Later, SEA produced *My Superhero Roberto Clemente* (2015). This Theatre for Young Audiences play contains puppetry and comes to life as a bilingual musical about a young boy named Bobby and his friends discovering that they all have super powers. Bobby chooses to channel Clemente as his super hero. The Alianza Dominicana Cultural Center in New York premiered Haffe Serulle's *La danza de Mingo* (2015) about Florinda Soriano ("Mamá Tingó"), a well-known Dominican activist and defender of rural farming rights (Figure 47.1).

## Self-produced companies

Similar to mounting solo productions, creating one's own production company can lower costs and allow more creative freedom. For example, the New York based entertainment company Odd Girl in Entertainment, created by Linda Nieves Powell, helped to write, direct, and produce plays such as *21* about Clemente, *Yo soy latina* (2005), and *Soledad Speaks* (2013). Similar to *Platanos*, *Yo soy latina* continues to tour college circuits. It has been applauded for dramatizing multiple axes of difference—"skin color, dress, language, age, education, social class and personal experiences" that challenge audiences to re-think how categories like Latina or Afro-Latina

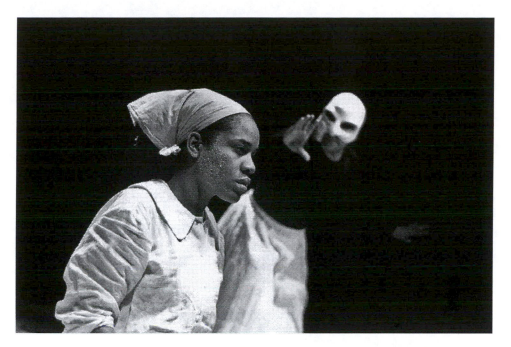

*Figure 47.1* Angie Regina (left) and Maite Bonilla (in mask) in *La Danza de Mingo* produced by Otroteatrony, New York City (September 2015). Director Billy Martin Mejia, assistant director/trainer Arturo Lopez.

*Source*: Photographer Wendy Mella.

encompass a wide range of experiences (Saborio xi). With *Soledad Speaks*, Nieves Powell crafted a different approach. A choreo-play with Afro-Latinx dance and an Afro-Latina character called *La negrita*,[5] this play is a tribute to her homeland of Puerto Rico. It begins in seventeenth-century Puerto Rico and ends in modern-day New York City. Centered on women, it explores colonization and struggles for freedom.

In 2008 Afro-Latinas Crystal Shaniece Roman and Apryl G. Lopez created *The Black Latina Movement*. Working in theatre, film, and on the web, this company has produced such pieces as *Black Latina* (2010), *The Colors of Love* (2011), *Of Mothers and Men* (2015), and *Cecelia the Celibate* (2018). In 2013, Gitana Productions, headed by Cecilia Nadal, worked with the Missouri History Museum to address the lack of stories about Afro-Latinx in Missouri. The result was *Soy yo! (I Am Me!): An Afro-Latina Suite* that traces one family's history from 1700 to 2013. Finally, Afro-Latina Jessica Carmona created Si Se Puede Productions to produce her play *Elvira* (2014) about Mexican immigration. She also wrote and stars in *Millie & the Lords* (2015), a film about a young woman who finds in the history of the Young Lords—a Latinx human rights group—inspiration to change her life.

## Full productions

In the last decade, we start to see New York theatres producing plays that explore common-alities between Latinx, Afro-Latinx, and African Americans. For example, New World Stages produced *La barberia* (2011) by David Maldonado and Ari Manuel Cruz. Set in a barbershop in New York's Washington Heights, the play intertwines the lives of Black, Latinx, and Afro-Latinx

customers. In 2015, Pregones Theatre PRTT produced "Plataforma Festival, a Bronx-Broadway Showcase for Latinx Theatre," which promoted more than ten shows with various Afro-Latinx artists. Plays such as *Teatro de las estaciones*, *I Like It Like That*, *Remojo*, *The Marchers*★★★, *La esquinita*, and *A Nation's Beat* all included Afro-Latinx actors, directors, and playwrights and looked at a multitude of Afro-Latinx themes.

Pulitzer Prize-winning playwright Quiara Alegria Hudes' first play, *Yemaya's Belly* (2005), told a Caribbean coming-of-age story centered on a young boy who wants to migrate to the United States. Though Hudes is not Afro-Latina, her plays have often been cast with Afro-Latinx actors, thereby challenging audiences' assumptions about what constitutes Latinx and/or Black identity. For example, *Daphne's Dive* (2016), produced by the Signature Theatre, starred Daphne Rubin Vega, an Afro-Latina who does not identify as such. Rubin Vega plays a character who is affectionately nicknamed "Negra" by her friends. Interestingly, African American Samira Wiley, known for her role in the Netflix series *Orange Is the New Black*, was cast in *Daphne's Dive* as the abandoned child who is embraced by Negra's informal family. Other venues like Atlantic Theatre Company, LAByrinth, the Public Theatre, and Second Stage have also explored Afro-Latinx themes and employed Afro-Latinx actors.

Outside the New York area, Austin, Texas, has become a very popular place to explore Afro-Latinidad. Teatro Vivo, a small bilingual theatre, produced *The Story of Us* (2015) written by African American Jelisa Jay Robinson. The piece explores histories behind relationships among Afro-Latinx, Latinx, and African Americans. It was Teatro Vivo's first attempt at acknowledging Latinx Blackness within the Mexican community.

## Online and onstage

In order to take advantage of online technologies and expand opportunities for those whose theatre-making has been undervalued, HowlRound started as an online journal in 2011.[6] In 2012, it collaborated with Latinx artists, scholars, and educators to produce the Latinx Theatre Commons (LTC), which in 2013 began sponsoring a series of festivals known as *Carnaval* in Boston, New York, Los Angeles, Dallas, Chicago, and Seattle. In addition to publishing the online magazine *Café Onda* in conjunction with HowlRound, LTC sponsors *Encuentros* or meetings to network, read selected plays before an audience, and curate workshops. Striving to enlarge the scope of Latinx and American theatre, the Commons has included Afro-Latinx playwright Guadalis Del Carmen at Carnaval and taken guests to see Afro-Latina Kristiana Rae Colon's play Tiikum about police brutality. As an outgrowth of *Carnaval* and the *Encuentros*, initiatives like the Sol Project were devised in order to increase the visibility of Latinx playwrights by partnering with Off-Broadway companies.

Jelisa Jay Robinson, mentioned above in relation to Afro-Latinx in Texan Mexican communities, started *The AfroLatinx Theatre Series* on HowlRound.com.

## The future

Clearly, there is a wealth of Afro-Latinx writers, actors, designers, and producers who have come to prominence, particularly within the last 15 years. Equally, the histories and personal stories of Afro-Latinx have gained visibility. This chapter has offered an introduction to the rich diversity of themes and practitioners. Furthermore, it demonstrates the need for a reconfiguration of the canon: Afro-Latinx theatre is crucial for the survival of Black theatre and its intersectionalities between Latinx and African Americans.

## Notes

1　A discussion of the changing meanings of terms such as Hispanics, Latinos, Latino/a, Latin@, and Latinx is beyond the scope of this chapter. I use the term Latinx or Afro-Latinx as a corrective to the gender specific character of the Spanish language. The term Latina or Afro-Latina will be used specifically to reference self-identifying female performers.
2　Colorism is the prejudicial or preferential treatment accorded members of one's own racial or ethnic group based upon the proximity or distance of one's skin color from whiteness. See Tharps.
3　HOLA is the Hispanic Organization of Latin Actors.
4　SEA stands for the Society of the Educational Arts, a bilingual theatre company for young audiences.
5　Much like the N-word, *negrita* or *negra*, meaning Black woman, can have positive or negative connotations depending on the context.
6　See http://howlround.com/about.

## Works cited

Jimenez Roman, Miriam, and Juan Flores, editors. *The Afro-Latin@ Reader: History and Culture in the United States*. Duke UP, 2010.

López, Gustavo, and Ana Gonzalez-Barrera. "Afro-Latino: A Deeply Rooted Identity among U.S. Hispanics." Pew Research Center, Mar. 1, 2016, www.pewresearch.org/fact-tank/2016/03/01/afro-latino-a-deeply-rooted-identity-among-u-s-hispanics/

Saborio, Linda. *Embodying Difference: Scripting Social Images of the Female Body in Latina Theatre*. Fairleigh Dickinson UP, 2012.

Tharps, Lori L. *Same Family, Different Colors: Confronting Colorism in America's Diverse Families*. Beacon Press: 2016.

# 48

# TO BE YOUNG, PERFORMING, AND BLACK

## Situating youth in African American theatre and performance history

*Asantewa Fulani Sunni-Ali*

From the 1820s when Ira Aldridge gave his first performance at the African Grove Theatre in New York to contemporary theatre productions, African American youth have engaged performance in innovative and liberating ways. These performances include yet are not limited to stage plays, dance, oral recitation, poetry, and protest. While some African American theatre and performance texts make mention of theatre performed by and taught to students at historically Black colleges and universities (HBCUs), they make little to no mention of theatrical performances, events, or activities with, by, or for youth between the ages of 5 and 18. This chapter seeks to address those gaps by highlighting historical precedents of contemporary African American youth theatre formations, linking them to a historical African/African American theatre and performance continuum. It examines ways in which African American youth create, enact, and transmute theatrical performance. I contend that considerations of the history and contemporary state of African American theatre and performance must include young people, as young people have always been participants, whether onstage, backstage, or in the audience. Furthermore, historicizing young people's engagement provides a more inclusive and nuanced understanding of the field's historical and current state, while also offering insight into where the field is headed.

Since the days of chattel enslavement, generations of African American youth have lived within a "death-affirming climate of oppression" that dehumanizes them, reducing them to objects (Freire 15). "Due to their Africanness and their status as dependent, wild, and uncontrollable," African American youth are bearers of a dual otherness (Nunn 706). They are consumed with government-sanctioned racism as well as popular media images and narratives that do not reflect and honor their lives. As such, African American youth are in perpetual need of spaces where they are affirmed and can make sense of their lived experiences. For people of African descent, theatre and performance have historically been avenues through which such space is cultivated. Contemporary formations of African American youth theatre and performance owe much of their style and subject matter to traditions from precolonial Africa to the 1960s Black Arts and Black Power movements, which I briefly outline below.

Scholar L. Dale Byam notes that "pre-colonial African performances were always communal" (xiii) taking place at festivals, rites of passage ceremonies, as well as arenas where "there was a constant exchange between those performing at the center of the arena and those watching at the edges" (xiii). These performances included pantomime, song, "rituals, and incantations told through storytelling or dance-drama" (Kennedy 73). It was "a meeting ground for ideas and sharing community culture through performance" (Byam 231). Young people and adults alike participated in these communal exchanges, as it was an opportunity for children to learn about and pay homage to their culture. "Drama, like any other art form, is created and executed within a specific physical environment. It naturally interacts with that environment: It is influenced by it, influences that environment in turn and acts together with the environment in the larger and far more complex history of society" (Soyinka 134). As such, colonialism, Western imperialist capitalism, and the Trans-Atlantic slave trade inevitably changed theatre and performance for Africans on the continent and throughout the Diaspora.

While many traditional African performance and cultural practices could not be sustained during slavery, there were spaces such as the African Grove, the first African American theatre in the United States (founded in 1821), which played to predominantly African American audiences in New York City (Hatch and Shine 14). William Alexander Brown, playwright, founding producer, and artistic director of the African Grove, sought to entertain and empower African Americans by telling their stories as well as honing and showcasing their talent. Born July 24, 1807 in New York City, Ira Aldridge attended the African Free School as a teen and was the first professional African American youth actor in the United States. As a principal actor in the African Grove Theatre Company, Aldridge creatively and intellectually engaged mixed-race audiences, shattering stereotypes about the psychological and innovative capacities of African American people and African American youth in particular. In his late teens, Aldridge made his acting debut in Europe. While he received mixed reviews, his performances were impressive enough for him to be prominently featured on European theatrical bills and dubbed the "African Tragedian" for his compelling portrayals of Shakespearean characters (Lindfors). Prior to the abolition of slavery in British colonies, Aldridge used the stage as a site of protest, a practice he undoubtedly engaged in at the African Grove. He would directly address audiences at the close of theatre productions and speak out against the institution of slavery and for the liberation of the enslaved (Nelson 9). Aldridge's renowned popularity and financial prosperity in the United States and abroad laid a foundation that set the trajectory of African American youth engagement in theatre and performance from that moment to the present day. Aldridge's lived experiences and success offer insight into the potentiality of African American youth to continue consuming, creating, enacting, and transmuting theatrical performance.

Throughout chattel slavery, Jim Crow, and even the current Trump era, African American theatre, much like African American life, has revealed itself "as largely a history of cultural resistance and survival" (Soyinka 134). Teachers, parents, and community organizers have used theatre and performance to teach, engage, and empower African American youth in this effort. In the early 1900s African American educators like Anna Julia Cooper used drama to educate African American secondary and post-secondary school students. In 1915, social worker turned theatre practitioner and activist Rowena Jelliffe co-founded Karamu House (now the oldest Black theatre in the United States) and produced children's plays with interracial casting (Karamu House). In 1920, W.E.B. Du Bois published *The Brownies' Book*, a magazine for African American youth and children between the ages of 6 and 16 (Joyce 92). Goals of the publication included teaching young people how to transform adversity into triumph, dispelling stereotypes about Africa, familiarizing young people with the history and achievements of Black people,

and teaching young people a code of honor, action, and sacrifice as it related to their membership within "the Negro Race" (Du Bois 285).

By the mid 1960s, Black Power and Black Arts Movement (BAM) leaders were organizing and directing African American youth groups with similar aims, addressing social issues as well as instilling Black pride and a sense of community commitment. These efforts, in many ways, were an embodied practice of *Sankofa*, as they represented a return to the communal rituals of traditional African theatre and performance.[1] In 1965, BAM pioneer Amiri Baraka (then Leroi Jones) felt "that a Black theater should be about Black people, with Black people, for Black people and only Black people" (Cruse 536) and as a result launched the Black Arts Repertory Theatre and School (BARTS) in Harlem. While BARTS' students were predominantly adults, Baraka often worked with youth and established the Leroi Jones Young Spirit House Movers and Players. The group is most widely known for the 1968 primetime television broadcast of one of their provocative spoken-word performances. These Bedford-Stuyvesant and Brownsville Brooklyn youth performed monologues, poetry, and collective pieces that criticized the overrepresentation of white narratives in popular children's books, nursery rhymes, and public school curricula (Hobson).

Since the late 1960s, there have been numerous theatre and performance programs, troupes, and organizations that critically and creatively engage young people of African descent (Figure 48.1). One such group is Impact Repertory Theatre in Harlem, founded in 1997 by Jamal Joseph, Voza Rivers, and Raymond Johnson. In a 2010 case study, I examined the effect of theatre and performance participation on marginalized African American youth. Impact Repertory provided "a meeting ground" for participants to ask questions, discuss ideas, and become active participants in the shaping of their lives. In creating performances that drew from their everyday lived experiences, participants explored, learned, and honed their craft while also engaging in self-discovery and, thus, positive individual and collective transformation. The performance space enabled "the moment in which the human being recognizes that s/he can

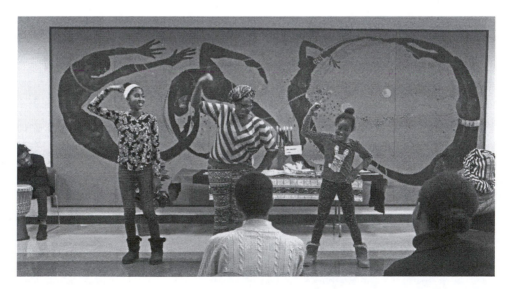

*Figure 48.1* Youth performing for a 2017 pre-Kwanzaa ceremony at the Center of Pan-African Culture at Kent State University.

*Source*: Photographer Joy Yala.

see himself or herself," when "s/he recognizes who s/he is and is not" and "imagines who s/he could become" (Schutzman and Cohen-Cruz 27). The space thus became a vehicle to bring about catharsis or the purging of what harms so that liberation is possible. Participants revealed that the Impact environment helped them to develop discipline and self-control. They felt renewed, safe, happy, free, and important (Sunni-Ali 69–70).

The Impact Repertory Theatre and my 2010 study findings are examples of a growing number of African American theatre companies, arts programs, and productions. Like Impact, these companies are invested in both celebrating youth *and* addressing the personal and social issues that impact them, like low self-esteem, family discord, white supremacy, poverty, homophobia, and ageism. Impact is also representative of contemporary formations of African American youth theatre and performance that are not traditional plays with a linear narrative but collectively devised performances that employ various performance elements including but not limited to dance, protest, spoken word, hip hop, singing, and acting. Companies like the African American Children's Theatre in Milwaukee, Wisconsin; the African American Children's Theatre in Charlotte, North Carolina; the Urban Youth Theatre of New York; the Youth Ensemble of Atlanta; and the Atlanta African American Theatre Festival Children's PlayFest carry forward African theatre and performance traditions of fostering community, celebrating history and culture, documenting and sharing marginalized stories, and empowering youth performers and audiences to take active roles in the transformation of their lives.

The history and contemporary formations of African American youth theatre and performance reveal that there is a cultural continuum at play. This continuum points toward a future of African American theatre and performance that synthesizes its cultural roots of community empowerment and innovative performance elements. Just as young people have spearheaded political and social change throughout history, young people are positively transforming the field of African American theatre and performance by grounding themselves within it. They honor processes and products of theatre and performance as equally empowering instruments of change. Through their critical consumption and unapologetically revolutionary creations, young people will sustain the existent power and magic of the field while gradually shifting from the margins into the center.

## Note

1 *Sankofa* refers to the notion of returning to one's roots, taking what is good from them and applying it to one's present life. It is a word and concept from the Twi language and an Adinkra symbol of Ghana, West Africa.

## Works cited

Byam, L. Dale. *Community in Motion: Theatre for Development in Africa*. Bergin & Garvey, 1999.

Cruse, Harold. *The Crisis of the Negro Intellectual*. William Morrow, 1967.

Du Bois, W.E.B. "The True Brownies." *The Crisis*. National Association for the Advancement of Colored People, vol. 18, pp. 285–286.

Freire, Paulo. *Pedagogy of the Oppressed*. Continuum Books, 1993.

Hatch, James, and Ted Shine. *Black Theatre USA: Plays by African Americans: The Early Period, 1847–1938*. Free, 1996.

Hobson, Charles. "Leroi Jones Young Spirit House Movers and Players, from Inside Bed-Stuy, 1968." *Thirteen*, www.thirteen.org/broadcastingwhileblack/uncategorized/leroi-jones-young-spirit-house-movers-and-playersfrom-inside-bed-stuy-1968.

Joyce, Donald Franklin. *Black Book Publishers in the United States: A Historical Dictionary of the Presses, 1817–1990*. Greenwood, 1991.

"Karamu House and Theatre." *The Cleveland Memory Project*, www.clevelandmemory.org/karamu/index.html.

Kennedy, Scott. *In Search of African Theatre*. Berne Convention, 1973.

Lindfors, Bernth. "Aldridge in Europe: How Aldridge Controlled His Identity as the 'African Roscius.'" *Shakespeare in American Life*, Folger Shakespeare Theatre. Accessed Oct. 15, 2010, www.folger.edu/shakespeare-unlimited/african-americans-shakespeare.

Nelson, Emmanuel S. *African American Dramatists: An A-to-Z Guide*. Greenwood, 2004.

Nunn, Kenneth B. "The Child as Other: Race and Differential Treatment in the Juvenile Justice System." *De Paul Law Review*, vol. 51, 2002, pp. 679–714.

Schutzman, Mady, and Jan Cohen-Cruz. *Playing Boal: Theatre, Therapy, Activism*. Routledge, 1994.

Soyinka, Wole. "Theatre in African Traditional Cultures: Survival Patterns." *Art, Dialogue and Outrage: Essays on Literature and Culture*. Random House, 1995.

Sunni-Ali, Asantewa F. *Impact Repertory Theatre as a Tool of Empowerment: African American Youth Describe their Experiences and Perceptions*. Thesis, Georgia State University, 2010, http://scholarworks.gsu.edu/aas_theses/3.

# 49

# INTERVIEW WITH DR. KARIAMU WELSH

## Professor and choreographer

*Interviewed by Amoaba Gooden*
*May 31 and July 12, 2017*

Dr. Kariamu Welsh, known affectionately as Mama Kariamu, is an internationally renowned scholar, "artivist," and choreographer (Figure 49.1). She is the creator of Umfundalai (pronounced ma foon da lah), a 46-year-old "contemporary African dance technique, which draws upon key movements from different African ethnic groups and cultures in Africa and the [African] Diaspora" (http://mamakariamu.com). Mama Kariamu is the founding Director of Kariamu & Company: Traditions and serves as full professor of dance at Temple University's Boyer College of Music and Dance. She is the author of eight books and has choreographed 100+ works, including "Raaaahmona" (1990) and "Taking Flight" (2006).

A G: What attracted you to dance?

K W: I loved seeing dance, [but] I didn't have the standard training that many dancers have. I wasn't introduced formally to dance until I was at Franklin K. Lane High School in Brooklyn. I was very athletic, and so I loved the physicality of it. I was also exposed to dance through some free performances at the Brooklyn Academy of Music. When I was 16, I joined the Ron Davis Jazz Dance Company. At that time, in the late '60s and early '70s, Black dancers were just coming to the forefront, and seeing Black bodies onstage motivated me.

A G: Discuss your role as professor and as a choreographer. Explain what one does in your capacity.

K W: I am an artist who is also a scholar. To use Du Bois' phrase, I have a double-consciousness. I will go into modes when I am working on a dance, or dances, or on a concert. Then I have modes in which I am working on a paper or research. I have compartmentalized them because it is difficult to be an artist in academia; you don't have the freedom just to do your art.

A G: Did you have any mentors or were you inspired by anyone?

K W: Pearl Reynolds! Pearl was in Katherine Dunham's first and then second company. She was this extraordinary woman who was an incredible dancer. She was constantly

*Figure 49.1*   Dr. Kariamu Welsh.
*Source*: Photographer Sandra Andrino.

telling me, "You can do it." She encouraged me, took me under her wings and treated me like a daughter.

A G: What year did you start at Temple University in African American studies and in dance?

K W: I started in African American studies in January 1985 and dance in January 2000.

A G: What were the major challenges you faced?

K W: There was a lack of appreciation for the academic or intellectual value of dance. I had no access to studio space or to the theatre because I was in African American studies. I was shut out of the very resources I needed in order to do my work. Dance was thought of as frivolous. But dance literally facilitated all phenomena in traditional Africa, and it continues to facilitate many phenomena in the Diaspora. If people can shift their thinking about dance, that would help them reevaluate dance's role. It's been very much an agent of change.

A G: Were there any notable differences between African American studies and dance?

K W: Yes. It was a two-edged sword. On one hand, I do have the resources. I do have the studio space. I do have a theatre to use. On the other hand, they [in the Dance Department] knew little about African American dance or African dance in the Diaspora. In African American studies, I dialogued around any issue. I found in the Dance Department, although I had resources, the intellectual stimulation was stymied.

A G: How do gender and race impact opportunities in your field?

K W: In African American studies gender is an understated issue. The program is male-dominated. Males ran most of the departments and [were] the people who were leading or in charge, and the same thing was happening in the civil rights movement. Although women were very much a part of it, they were not given credit. So I felt there was a

muting of the female voice. Now, dance is dominated in academia by females, so you don't have that dynamic. But as the only Black female on the faculty, I had to be all things to all people. Anything that came up on race, I was the go-to person, which put a tremendous amount of pressure on me. At the same time, I could not come off as the angry Black woman. I definitely felt the racism, and I also saw racism being enacted against the students of color. I had to come to their defense.

AG: Have you worked with the Dance Department to improve the situation around race?

KW: Well, they promised me that when I retire, they'll hire someone like me, but you know, having said that, it is very revealing. Why not hire two or three African American people? Why does my position have to be the [only] one? So that promise says, there's only room for one.

AG: How do you mentor students?

KW: I believe in empowering students. I have white males, white females, white gay males, lesbians, and some transgender students. I believe in telling them to have a voice, to stake their claims. It's not just about my African American students. But you'd be surprised that, in the academy that is supposed to encourage free thought and free speech, there are many limitations. I find myself giving them courage to either write a letter, to speak on something, to defend themselves, to take a position, because right now people are afraid to take a position.

AG: Where did your sense of social justice come from?

KW: I think growing up poor in Brooklyn, seeing the injustices between people, there were very clear lines of division. My first night at my dorm at the State University of New York at Buffalo, I had a roommate who was from Long Island. Her parents came in, they took one look at me and turned around. They did not want their daughter to be rooming with a Black girl. [Also], the Attica riot of 1971 had a profound effect on me. Seeing these men shot down in the courtyard, I could not believe it.

AG: Umfundalai creates a space for empowerment. In what ways can people take this up, regardless of their ethnicity, gender, or sexuality?

KW: Umfundalai is inclusive. That means that we accept you not only in terms of gender and sexuality but in terms of size, in terms of wherever you are. You don't come into class to be told that you are too heavy to take this class, or you're white or you're gay. That's ridiculous. I think it's empowering because even if you don't become a dancer, which most of my students don't, it gives you the power to walk strong, to be proud of yourself.

AG: I've also noted that your choreography speaks to the political and cultural climate of the time.

KW: That is a new tradition. Coming up as a young girl at the end of the '60s and in the early '70s, I was struck by all these events that happened in my lifetime, particularly the Attica Rising, [and] the dropping of the bomb on MOVE (a Black liberation group) in Philadelphia. For me, African dances are ways of telling those stories. I leave them with "who is Ramona Africa?" You may not agree with MOVE's philosophy, because I certainly don't, but I had to admire the woman who stood up to the entire city and said, "I would rather go to jail than do what you want me to do." [The dance] "Taking Flight" [is] this whole idea of wanting freedom, longing for freedom; it's always there. My grandson [stands] on the corner shooting a video for YouTube, and they're singing and dancing, [but there are] too many Black boys, unfortunately. They should be able

to congregate but they cannot, not in these United States of America. So along comes another group of young Black boys. They have a gun, and they shoot. We can't really say that we are free. I am an activist, and I don't believe in just art for art's sake. The dances may look good, but it is not just for the beauty. I am making a statement about life in these United States of America.

AG: Name one accomplishment that you are most proud of.

KW: I think that it's creating the Umfundalai technique. That's something that is a part of present-day African and African Diaspora movement vocabulary. It will live on after me.

AG: If there was one thing you think young people today should know about your field, what would that be?

KW: I think they should not put dance in a hierarchy. They cannot say that ballet is at the top. If ballet is your thing, that's fantastic, but don't take this superiority attitude that everyone should take ballet. I take umbrage [with the idea] that it's superior to any other art form in dance.

# 50

# ROBERT O'HARA'S DEFAMILIARIZING DRAMATURGY

*Isaiah Matthew Wooden*

Playwright-director Robert O'Hara has demonstrated a flair for crafting irreverent and formally inventive theatrical events since presenting *Insurrection: Holding History* at the Public Theatre in 1996. Correspondingly, he has made some of the most compelling contributions to the canon of post-civil rights African American drama. Central to O'Hara's playwriting practice is the incisive deployment of what German director, playwright, and theatre theorist Bertolt Brecht refers to as estranging techniques or the alienation effect (101–112). Like Brecht, O'Hara often renders the familiar strange in his plays in order to provoke critical thinking and unsettle the hegemony of certain perceptions, perspectives, and ideologies. This chapter uses *Insurrection: Holding History* as a point of departure to provide analytic overviews of three of O'Hara's most potent, though under-examined, plays, *Antebellum*, *Bootycandy*, and *Barbecue*. It draws particular attention to the ways the playwright employs what I call "defamiliarizing dramaturgical strategies" in each to activate critical debate and elicit fresh insights about matters of race, sex, sexuality, family, history, and Black queer identity.

Reflecting on his approach to playwriting, O'Hara remarks, "Every play to me is an experiment. When people ask me how I write, I go: 'Everyone is welcome and no one is safe.' That is something that I try and carry into my work" (O'Bryan). *Antebellum*, *Bootycandy*, and *Barbecue* certainly evidence the experimentation, generosity, and risk-taking that have become hallmarks of O'Hara's dramaturgy. They also betray the investments he first displayed in *Insurrection: Holding History* through turning the "ordinary, familiar, immediately accessible, into something peculiar, striking, and unexpected [...] in order that it may then be made all the easier to comprehend" (Brecht 108). In *Insurrection: Holding History*, O'Hara places a contemporary gay African American graduate student named Ron onstage with his 189-year-old, time-traveling great-grandfather T.J. and insurrectionist Nat Turner, among other characters. The fantastical drama interpolates and remixes popular narratives about the 1831 slave rebellion that Turner led in Southampton, Virginia, to trouble notions of a singular, authoritative history and to highlight the perennial erasure of queer, Black subjects from the official record. Though radically diverse in content and form, *Antebellum*, *Bootycandy*, and *Barbecue* see O'Hara further experimenting with the techniques and strategies that he introduced in his earlier play so as to excite new understandings of past events and present realities.

O'Hara shuttles between 1930s Germany and the United States in *Antebellum* to re-present parallels between the traumatic legacies of the Holocaust and the dehumanizing violence of

the Jim Crow era. He centers the play on a complicated love story that rivals and revises the romantic plots featured in epic films like *Gone with the Wind*. A surprise encounter between two ostensible strangers—Sarah Roca, a Jewish woman who lives on an old Georgia plantation with her husband Ariel, and Edna Black Rock, an African American woman who travels to the couple's home hoping to meet with Sarah's husband on the night of *Gone with the Wind's* Atlanta premiere—sets the action in motion. Subsequent scenes crisscross between the Georgia plantation, the library of a Nazi Commandant, and the cabarets of Weimar Germany to reveal that Edna's and Ariel's former lovers are one in the same: Gabriel, a Black jazz singer who was arrested and forced to undergo various experiments, including gender reassignment procedures, by an obsessed Nazi officer. In spinning its tale of impossible desire in the midst of brutal atro-cities, *Antebellum* highlights the ways that queerness can serve as a potent site through which to reexamine certain widely held norms, narratives, and beliefs. Simultaneously, the play actively intervenes in and emends traditional representations of the complicated histories it intertwines.

O'Hara's defamiliarizing of time, place, race, gender, sexuality, and history in the play also prompts considerations of the persistence and perniciousness of the projects of white supremacy and heteronormativity. Through its dramatizations of Ariel and Gabriel/Edna's transcontinental love affair, it lays bare just how seductive the power and privileges afforded by these projects can be. O'Hara embeds several clarion calls for contemporary audiences to remain cognizant of and, indeed, resistant efforts to reify and propagate these toxic ideologies. Thus, even as its defamil-iarizing dramaturgy looks backward, *Antebellum* remains very much concerned with exposing and interrogating the reverberations of the traumatic histories it dramatizes in the present tense.

Unveiling and critiquing some of the erroneous beliefs about race, sex, desire, and iden-tity that continue to circulate in the post-civil rights period is a chief concern of *Bootycandy*. Composed of a series of vignettes tied loosely together by a central character named Sutter, the play moves between the 1970s childhood abode of its young, precocious protagonist in the opening scene to the 1980s nursing home of his grandmother in its final sequence. The vignettes in between flout linearity to satirize contemporary societal attitudes towards diffe-rence while creating space to grapple with what it means to claim Black and gay as identities in the twenty-first century. *Bootycandy* disabuses its audiences of any misguided ideas about the incongruities of those categories. Indeed, in tracing Sutter's stutters and stumbles as he comes of age across scenes that are at once sassy and racy, the play spotlights and relishes in the possi-bilities of Black, queer sexuality.

Notably, it is the play's occasional departures from Sutter's life that provide *Bootycandy* with some of its most scathing commentary. The play's second vignette, "Dreamin in Church," is par-ticularly exemplary of this point. The scene features a minister, Reverend Benson, delivering a spirited sermon about the dangers of spreading rumors, especially those concerning another's gender expression or sexuality. After allowing details about his own predilections for sequins, stilettos, and RuPaul's "sashay chantes" to slip into his call-and-response, Benson ends his address by spectacularly flaunting the beautiful heels he is wearing, adorning his head with a glamorous wig, and painting his face with lipstick and rouge. The deliciously camp vignette repeats and revises tropes associated with African American church traditions to rebuke respect-ability politics and oppressive gender norms, particularly those propped up and proliferated by hypocritical theologies. A later vignette, "Ceremony," extends these critiques and challenges the logics of homonormativity by staging the return of a lesbian couple to the tropical site of their destination wedding to undo their vows. Throughout *Bootycandy*, O'Hara compels audiences to imagine a world capable of recognizing and accommodating experiences and expressions of difference. He also invites us to bear witness to the immense range of his defamiliarizing strategies.

That range is on further display in *Barbecue*, a dysfunctional family drama that exploits humor to zero in on the gaps between reality and the fictions we create to mediate its peculiarities. O'Hara initially centers the play on four white siblings, James T., Lillie Anne, Aldean, and Marie. They are hosting a barbecue somewhere in Middle America as a ploy to force their crack-addicted sister Barbara (or, as they teasingly call her, Zippity Boom) to attend a drug treatment facility in Alaska. As the gathering unfolds amidst various accusations about the siblings' own chemical dependencies, O'Hara uses various estranging techniques, including shifting the racial makeup of the performers portraying the family from white to Black several times, to complicate narratives about addiction made popular by television shows like A&E's *Intervention*. The barbecue ultimately climaxes at the end of the first act with the revelation that the siblings are, in fact, cast mates shooting a scene for a forthcoming movie. This dramaturgical choice endows an already unpredictable plot with an impressive element of surprise. It also provokes important questions about how we distinguish truth from fantasy in a hyper-mediated world obsessed with collapsing any distinctions between the two.

In *Barbecue*'s second act, O'Hara more pointedly confronts the lies we continue to tell and believe about race. Jumping back in time to the previous year, the act depicts a conversation between the Black and white performers who portray Barbara (now distinguished by the descriptive, facetious names, "Black Movie Star Barbara" and "White Barbara") about the former's desire to option the rights to produce a movie of the latter's successful memoir chronicling her addiction and recovery. The pair agrees that making Barbara Black for the big screen will require altering some of the details of her life story, including changing her drug of choice from methamphetamines to crack cocaine. As "Black Movie Star Barbara" puts it, "Black folks in movies don't smoke meth. Black folks in movies smoke weed. And crack" (80). Full of derogatory stereotypes, the exchange illuminates the ways that trite, harmful clichés continue to delimit representations of race—Blackness, in particular—in the purported age of colorblindness and post racialism. O'Hara's defamiliarizing dramaturgy in *Barbecue* serves to emphasize the ways that such problematic representations continue to distort our everyday perceptions of race.

*Barbecue*, like *Antebellum* and *Bootycandy* before it, notably synthesizes and integrates the aesthetic practices of what O'Hara refers to as the "Theatre of Choke." When asked to describe what he hopes audiences will take away from his plays, the theatre maker often replies that he wants them to choke. "I don't want them to easily digest the play and then go home and forget it. I want them to remember the sensation of the play just how everyone knows what it feels like to choke," he explains (Van Duzer). *Antebellum*, *Bootycandy*, and *Barbecue* no doubt provide audiences with many sensations on which to fixate and asphyxiate. More significantly, they each also bid us to confront and reckon with some of the ways we help to maintain the dominance of certain dangerous and injurious norms, practices, and ideologies. O'Hara's shrewd engagements of defamiliarizing dramaturgical strategies in the texts are no doubt central to this work. They are also what distinguish him as one of the most important theatre makers and cultural provocateurs of his generation.

## Works cited

Brecht, Bertolt. "Short Description of a New Technique of Acting Which Produces an Alienation Effect." *The Twentieth Century Performance Reader*, edited by Teresa Brayshaw and Noel Witts, 3rd ed., Routledge, 2014, pp. 101–112.

O'Bryan, William. "The Ringleader." *MetroWeekly*, June 2, 2011, www.metroweekly.com/2011/06/the-ringleader/.

O'Hara, Robert. "Antebellum." *The Methuen Drama Book of Post-Black Plays*, edited by Harry J. Elam, Jr. and Douglas A. Jones, Jr., Bloomsbury Methuen Drama, 2013, pp. 413–495.

———. *Barbecue* and *Bootycandy*. Theatre Communications Group, 2016.

———. *Insurrection: Holding History*. Theatre Communications Group, 1999.

Van Duzer, Michael. "Choking on Satire: Playwright Robert O'Hara Talks Barbecue at the Geffen." @ *This Stage Magazine*, Oct. 6, 2016, https://thisstage.la/2016/10/choking-on-satire-playwright-robert-ohara-talks-barbecue-at-the-geffen/.

# 51

# BLACK PLIGHT IN FLIGHT

*Tezeru Teshome*

Some 76 years after Richard Wright wrote *Native Son* (1940), playwright/actress Nambi E. Kelley adapted the novel into a swift, non-linear, visceral theatrical script that concludes with protagonist Bigger Thomas not on his way to the electric chair, as in the original, but in flight after he has been thrown down a trapdoor by police.

Bigger Thomas is a 21-year-old Black man who lives in a single-mother household with two younger siblings on the south side of Chicago. It is winter 1939, and the family is barely surviving in dilapidated housing owned by the Daltons, who hire Bigger as their chauffeur. On his first night of work, Bigger is to drive daughter and University of Chicago student Mary Dalton to campus, but she re-directs him to pick up her Communist boyfriend for a night out on the town, particularly at Black eateries with strong liquor and Black music. By the end of the night, Mary is so inebriated that Bigger has to assist her to her bedroom. Mary gropes and kisses Bigger who "instinctually" reciprocates not long before her blind mother enters the room (Kelley, *Native Son* 9). In panic, Bigger smothers Mary in fear that she will announce his presence and her mother will accuse him of rape. By the time Mrs. Dalton leaves the bedroom, her daughter is dead, and the rest of the play entails how Bigger tries to discard Mary's body and escape murder charges and accusations of rape. Bigger confides in his girlfriend, Bessie, but ends up raping and killing her, believing that she would betray his trust.

When Bigger is caught and found guilty in a fantastical court scene where Mary and Bessie testify from the dead, he is hosed down with water until he is naked and thrown down a trapdoor. The stage directions read: "**BIGGER's** *body suspends midair … He flies*" (115). Because flight is typically associated with freedom, redemption, resistance, or joy, Bigger's last action is likely to be read positively, despite the fateful incrimination of Blackness in America and globally. This chapter explores Bigger's flight as a restoration of his human-cargo or criminal/property status. It confronts these questions: What if the systemic, anti-Black violence that held him captive or "walking dead," as Kelley characterized him in an interview for this project, follows him in flight and after death? What if we read the ending of the play as a restoration of the violence that precedes and exceeds Bigger? In reading Bigger's flight as an extension of his life on earth, we see the paradox of Black agency haunted or hounded by slavery, which suspends Blackness into an eternal, terrorized state of subhuman property or fungible matter.

*Table 51.1* Opening and closing movements of Kelly

| Scene: *"FEAR : A Biggerlogue"* | Scene: *"Fly"* |
| --- | --- |
| (Lights rise on **BIGGER THOMAS**, alone.) / (He stands naked, dripping wet, and shivering. / (Unidentifiable onlookers onlook.) / (A voice in the dark speaks **BIGGER'**s thoughts.) (7) | (They turn on the water hose. **BIGGER** rises to his feet against the pressure.) ... / (**BIGGER'**s clothes tear from his body under the pressure of the water, but he does not fall.) (114) |

These questions may sound skeptical, but consider the adaptation's repetitive usage of water, that which encaptures and delivers Bigger to life or from death (see Table 51.1).

These scenes are placed at opposite ends of the play, but they remind me of the Middle Passage and visual representations of the Atlantic Ocean that, given its flooding of the bottom quarters of slave ships and recurrent consuming of thrown-overboard or suicidal captives, was critical in (re)creating the Other or Almost Human. The significance of water in "The Biggerlogue" is the birth of Bigger because, in the literal sense, water (the placenta) plays an important part in the physical labor of birth. The significance of water in "Fly" is the death of the Black slave fated by a captive rebirth (the Middle Passage/Atlantic Triangular Slave Trade). Water thus signifies the birth/death, or captivity of Blackness arrested under the repetitive, psychic, and physical violence of white terror. It reads as a continuous ebb and flow of the violent, political regime of slavery, and Bigger's attempt to escape is drowned and restored by its enigmatic powers.

Although I do not propose to speculate on the ultimate truth of what happens following death, this chapter is an expression, a mere reverberation, of the Black feminist thought that "nothing ever dies" (Morrison 36).[1] Consequently, it probes the proposition that the legacy of slavery may merely take on a different form of Black captivity after death. Furthermore, because one's existence is constructed from violence, how does this reading against Black redemption complicate understandings of narrativity, character arc(s), and performance in seeking theatre for social change? Is this adaptation an example of the failure of theatre to stimulate social change? Or, is it an example of theatre's capacity to inspire social change?

## Questions of freedom and choice

Tantamount to Richard Wright, Nambi E. Kelley argues that Bigger gains freedom and personhood after he murders Mary because he is able to choose. She explains:

> After Bigger kills Mary, it is the first time he feels free because it is the first time in his life that he feels like he did something, like he actually created the grounds for himself to have choice in a world that did not allow him options and choice.
>
> (Kelley, Interview)

Let us examine this claim first on the theoretical level and then in terms of the actual narratives. Taking a position against the conflation of freedom and choice, I argue first that because Bigger exists within a system that equates humanity with freedom and whiteness, he is non-human. As the Absolute Other, he can have no relationship with the Daltons based on mutual interest and consent. Bigger is property, and the world is set up so that the Daltons are entitled to own/possess him in a way that Bigger cannot reciprocate. Thus, he lacks the capacity to exercise freedom and

Table 51.2 Black choice: the changing same?[2]

| Novel | Dramatic adaptation |
|---|---|
| "How could he go to his death with white faces looking on and saying that only death would cure him for having flung into their faces his feelings of being black? How could death be victory now?" (Wright 311) | Like somebody step in my skin, start acting for me. Like my mind ain't my mind, like … my body is their body. (Kelley, *Native Son* 112) |

choice. But at the same time, in this liminal state of property that is alleged to possess citizenship or national belonging, Bigger is essential to the reproduction of white life because his negated status *guarantees* the exalted status of whiteness. Therefore, after murdering Mary, Bigger does not gain a sense of coherent personhood, choice, or freedom. Though he may gain a sense of escape, written as a flight, he will return to the changing-same state of Black suffering.

Now let us examine Kelley's provocative connection between freedom, choice, and personhood by analyzing the narrative. Consider the nature of Bigger's "choice" after he murders Mary: In which abandoned building should he seek refuge? What should he do with Mary's and Bessie's bodies? These are the choices Bigger acquires in the name of freedom. They are specious when one reflects upon the substance of Bigger's choices before Mary's death: What job can he obtain that will allow him to sustain himself? How can he protect his family from the rats that infest their tenement apartment? Moreover, in both Wright's and Kelley's versions of *Native Son*, Bigger realizes that he does not have the capacity to claim his death for himself. He realizes his death does not belong to him but to the whites from whom he was constructed and by whom he is haunted (see Table 51.2).

Both Biggers admit to being possessed or haunted by the historical and the concurrent, namely the ongoing, violent terror initiated in slavery. Therefore, both Biggers will continue to suffer from it in their next lives.

As the author of the dramatic adaptation, Kelley equates Bigger's flight to a self-determined freedom:

> I was interested in whether or not he decides to be free, not in whether or not society allows him to be free. In my mind, that is a conversation for a previous time. NOW, the question for me is, how do we as people of color decide to be free within the constructs that we are living in? My freedom does not come from a white person saying I am free. It comes from me deciding it. Even if I am physically not free, I can choose to be free in my mind, and that is the highest form of freedom to me.
>
> (Interview)

But, as I have just demonstrated, while there is indeed flight (in that Bigger flees from the authorities), there is no freedom in his flight, just a temporary escape from the over-determined, violent political regime of chattel slavery. Kelley's reflection on self-determined freedom leads me to the concluding section of this chapter in which I consider the potential of theatre as an agent for social change.

## Conclusion: theatre for social change

How can a system that perpetuates anti-Black violence, through how we see and what we value, be used to actualize a social change that does not reinstate its hegemonic power? At the

1996 Theatre for Communications Group (TCG) conference, playwright August Wilson posed a similar question. He reminded conferees that only 1 out of the 66 theatres represented was Black. White supremacy is evident not only in who can afford to go the theatre but also in which theatres receive sustainable funding. Therefore, is American theatre, with its expensive tickets and largely white audiences and artistic administration, another institution of slavery, based, in this instance, on an unconscious obsession with and consumption of captive performance? Is it possible to see a Black actor on stage or screen without the gaze of historical sexual objectification?

This chapter does not function to discredit Black people who have consistently asserted their humanity and forged communities of fortifying kinship and institutional change. Nor does it forbid my love for theatre. Buoyed by the fervor of slave rebellions, hidden messages in slave spirituals, Black resistance, love and joy and beauty, this chapter moves from a *politics of culture* to a *culture of politics* in its reading of freedom, escape, and death. To understand Bigger's flight as redemptive and reciprocal is to look at violence from a *politics of culture* perspective in which common, or hegemonic, connotations of flight prevail. Reading this adaptation from a *culture of politics* perspective allows us to focus on how anti-Black violence is a structural paradigm that precedes and exceeds Black life. It questions the political powers and structures that have designed Bigger in the first place. I don't believe in theatre for social change, but I do believe that theatre can spark ideas, conversations, and struggles that desire a social change beyond white people owning, deciding, and making everything.

## Notes

1 Toni Morrison makes this assertion in *Beloved*, a novel based on the true story of Margaret Garner, reimagined as Sethe, who was captured under the Fugitive Slave Law and then kills her 2-year-old baby girl in order to protect her from slavery. Sethe's deceased daughter, Beloved, returns as a ghost and haunts the family while restoring a spiteful peace.
2 "The changing same" is a phrase popularized by Amiri Baraka and Deborah E. McDowell to describe, in part, a sense of black time.

## Works cited

Baraka, Amiri. "The Changing Same (R&B and the New Black Music." LeRoiJones/Amiri Baraka Reader. Edited by William J. Harris. Thunder's Mouth, 1991, pp. 186–209.
Kelley, Nambi E. *Native Son*. Samuel French, 2016.
———. Personal Interview. June 16, 2017.
McDowell, Deborah E. *The Changing Same: Black Women's Literature, Criticism, and Theory*. Indiana UP, 1995.
Morrison, Toni. *Beloved*. Alfred A. Knoph. 1987.
Wright, Richard. *Native Son*. 1940. Harper Perennial Modern Classics, 2005.

# 52

# CREATIVELY CENSORING AFRICAN AMERICAN DRAMA WHILE TEACHING IN THE ARAB GULF REGION

*Phyllisa Smith Deroze*

I developed an interest in comparing Arab and African American feminisms after reading *Woman at Point Zero* by the prominent Egyptian feminist Nawal El Saadawi and noticing a resemblance in texts written by African American women such as Harriet Jacobs, Ann Petry, and many others. In 2013, I moved to the Middle East as a Fulbright Scholar with the aspiration of expanding my knowledge of Arab women's feminist writings and obtaining a personal understanding of the social, economic, and environmental conditions in the region. During that time, I learned that many countries outside of the United States operate under different formulations of academic freedom and permissible discourse in public spaces like classrooms. Thus, within the United Arab Emirates, classroom discussions of politics, sex, religion, homosexuality, and vulgarity are inappropriate. These regulations are a direct reflection of a society that maintains strict laws prohibiting male–female cohabitation, proselytizing, and disrespect toward Islam or the Prophet Mohammad, Peace Be Upon Him (PBUH). Even imported films are often censored for depicting sexual relations between unwed couples and extreme violence. Therefore, it was paramount that I identified potentially offensive aspects of my research and pedagogical methods. As a visitor, I relied upon course material given to me by other professors who had already vetted their selections for suitability.

Following the Fulbright, I remained in the UAE as an assistant professor of American literature and drama. I encountered the cultural differences head on and had to develop creative ways to navigate within the lines of censorship in order to build a successful career abroad. Originally, I thought it impossible to avoid taboo topics, given that feminism is about making the personal political and that many contemporary American texts represent a society that pushes the limits of sexual freedom and freedom of speech. In this chapter, I share some of the problems that I encountered teaching American drama and strategies I developed to circumvent those issues in order to give students an enriching encounter with African American plays.

For my first semester I contemplated teaching classical texts like Amiri Baraka's *Dutchman*, Ntozake Shange's *for colored girls who have considered suicide/when the rainbow is enuf*, and August Wilson's *The Piano Lesson*. However, each of these texts presented unavoidable challenges that caused me to omit them from my syllabi. The three most recurrent issues were profanity and

explicit language, religious differences, and use of the word "nigger." Although *Dutchman* offers amazing insight into the consciousness of the 1960s Black Nationalist movement, the play gets sexually explicit 13 lines into the first scene. After blotting out sexual references and 16 words of profanity, I did not feel the edited version was an adequate representation of the play because there were significant portions missing and each page showed evidence of heavy censorship. The play *for colored girls* is a preeminent feminist drama because Shange explicates American women's experiences with abortion, sexual assault, physical and emotional abuse, and homosexuality. These subjects were taboo in America during the 1970s and remain taboo in the United Arab Emirates. Perhaps one of the most avant-garde aspects of the play is the ending when the seven characters invite the audience to reconsider their views of God. The Lady in Red says, "i found god in myself / & i loved her/ i loved her fiercely" (63). This communion of women recognizing god in the likeness of their own images teeters on blasphemy, as images of God and the Prophet Mohammed (PBUH) are forbidden in Islam. Because the resolution of *for colored girls* can be perceived as blasphemous at worst or insensitive at the least, I excluded it from my repertoire.

Naturally, students enrolled in a contemporary American drama course should discover at least one of August Wilson's Pulitzer Prize winning plays. I added *The Piano Lesson* to the syllabus, remembering that it evades profanity, sex, politics, and religious aspects that could be perceived as Islamophobic. However, this family drama about a feud between siblings over their father's piano and the continuation of their family's legacy raises an entirely different issue— the use of the word "nigger." The character Boy Willie is well versed in the complexity of the term, and throughout *The Piano Lesson* the word is used 40 times. This makes teaching the play complicated because "nigger" is used in esoteric ways that are difficult to translate outside of the cultural context that Wilson evokes. As the prominent linguist Geneva Smitherman explains in *Word to the Mother: Language and African Americans*, there are roughly eight uses of the word within some African American linguistic communities (52). When analyzing *The Piano Lesson*'s 40 usages, I observed 19 that correspond to Smitherman's definition of "Close friend, someone who got yo back," and 11 that represent a "Generic, neutral reference to African Americans" (52). There are also six examples of the word as a derogatory racial slur used to dehumanize African Americans. The latter definition is the easiest to explain to non-African Americans. Because the word is used in nuanced ways throughout *The Piano Lesson*, teaching the script requires ample time to unpack the different forms and that include discussions around tonal inflection. Indeed, one could dedicate an entire semester to dismantling the multiple uses of the word and its historical and cultural contexts. Given my time constraints within a semester, I selected the 1995 film version in lieu of requiring the script because the word is completely omitted from the movie.

The aforementioned examples highlight some of the cultural hurdles I encounter and reasons why I have had to develop creative ways to censor in order to successfully teach African American plays. I primarily teach Arab Muslim women who range in age between 18 and 23. Some are married with children, they are all bi- or multi-lingual, and they have varying degrees of background knowledge about American literature. Thus, one-act plays like Lynn Nottage's *Poof!* and Georgia Douglas Johnson's *Blue Blood, Blue-Eyed Black Boy, Safe,* and *Starting Point* are optimal introductions to African American drama because students can complete the plays quickly, the language is accessible, the violence is usually offstage, and they are essentially women-centered dramas.

Written to have crossover appeal to women globally, Lynn Nottage's play *Poof!* is about domestic violence. The play transfers easily because the race and culture of the characters are absent: it has a cast of two women onstage and a male offstage voice, and the kitchen setting

is a domestic space universally defined as women's space. *Poof!*, then, is familiar even as the characters discuss the silence around domestic violence and the refusal of police intervention. My students are able to relate to the women in *Poof!* because they too are deciding what information about their private lives is permissible to discuss beyond the home. Teaching *Poof!* establishes an opportunity to discuss women's silence by choice and by force, the benefit of friendships between women, and the importance of having sacred spaces where women can feel safe and understood. Not only do these themes crossover easily, but also, because it is a one-act play, we are able to finish it within a week, thus providing space to include more selections in the semester.

In my search for plays that were written in accessible and appropriate language, I decided to introduce Georgia Douglas Johnson's plays. When comparing early twentieth-century American literature to contemporary American literature, the earlier texts rely on abstract language and the latter is increasingly more explicit. For example, both Suzan-Lori Parks' *In the Blood* (2000) and Georgia Douglas Johnson's *Blue Blood* (1926) discuss the sexual exploitation of African American women, but the language varies vastly between them. I encounter more areas that require censorship in contemporary plays than with earlier ones.

After teaching Georgia Johnson, I discovered that students were fond of her fight to end lynching, and they were able to connect our conversations of lynching to the Black Lives Matter movement. One class even asked if they could perform Johnson's *Safe* (1929) in front of a small audience of their peers. The play is about a mother's decision to commit infanticide after a lynch mob passes her home. At first, I was apprehensive because the audience had not received my supplemental lectures about lynching; but the class reassured me that they had the ability to convey the historical context in a powerful, persuasive manner. And they were successful!

This same group of students was asked on a mid-term exam to answer the following question: "If Liza were on trial and you represented her in a court of law, explain to the jury why she should be acquitted of murder." Here is a paraphrased response:

> During this time in American history, white people were lynching innocent Black people as a form of terror. Liza is worried about her unborn child's future. Shortly after she hears Sam (a young Black man from the neighborhood) screaming for his mother moments before he is lynched, Liza goes into labor. When the doctor informs her that she delivered a healthy boy, she kills him. Liza commits a merciful act and she should be pardoned because she gave her son peace instead of a life of trepidation.

This student's writing elucidates her understanding of the historical context of lynching in America. Through classroom discourse, I learned that social media keep these students vividly aware that racial injustices remain present in America.

Lastly, Lorraine Hansberry's *A Raisin in the Sun* is the most successful full-length play I have taught for the following reasons: it has universal themes, only one use of the word "nigger" (which is used as a derogatory racial slur), and comprehensible language for students whose second (or third) language is English. Additionally, the award-winning play about an African American family's struggles to integrate the white suburb of Clybourne Park has two popular film versions that allow students to compare performances and understand how words on the page can shift in meaning when embodied by an actor or overlaid by sound. I often provide an abridged version (to facilitate students' reading), and I omit Ruth's contemplation of abortion since abortions are illegal in the United Arab Emirates as they were in America during the time when Ruth explored that option. I also omit Walter's inappropriate behavior when he is drunk, as alcohol is forbidden for Muslims. The characters that

students most admire are Mama and Beneatha. Mama is respected because she is the family's pillar and the religious center, while Beneatha represents a change in tradition that many of my students recognize within themselves. Beneatha's desire for a husband who maintains respect and appreciates her educational pursuits is an aspiration for young women that spans across cultures.

In the end, developing a pedagogical balance for African American drama within a context that demands censorship around specific topics is a challenging and rewarding process. I garner the best results from students when I emphasize early African American drama because many of the themes expressed in those plays remain relevant, and I can circumvent potential conflicts. Nevertheless, each semester when preparing for new courses, I wonder whether it is better to avoid teaching contemporary drama altogether or to censor heavily. For now, I choose the former and remind myself that by teaching Johnson or Hansberry, students are learning about some of the most influential and foundational playwrights within the canon of African American drama.

## Works cited

Baraka, Amiri (Leroi Jones). *Dutchman & The Slave*. Harper Perennial, 2001.

Hansberry, Lorraine. *A Raisin in the Sun*. Vintage, 2004.

Johnson, Georgia Douglas. *The Plays of Georgia Douglas Johnson: From the New Negro Renaissance to the Civil Rights Movement*. Edited by Judith Stephens, U of Illinois P, 2006.

Notttage, Lynn. *Poof!* Broadway Play Publishing, 1995.

Parks, Suzan-Lori. *In the Blood*. Dramatists Play Service, 2000.

Shange, Ntozake. *for colored girls who have considered suicide/when the rainbow is enuf*. Scribner, 2010.

Smitherman, Geneva. *Word from the Mother: Language and African Americans*. Routledge, 2006.

Wilson, August. *The Piano Lesson*. Theatre Communications Group, 2007.

# 53

# MIKE WILEY

## A multi-faceted artist on a mission for social change

### *Sonny Kelly*

Combine the critical cultural perspective and wily wordsmithing of renowned African American playwright August Wilson, the rigorous research and academic acumen of revered African American writer, folklorist and anthropologist Zora Neale Hurston, and the commitment to mobilizing performance for social change of Brazilian theatre scholar Augusto Boal, and you can begin to imagine the body of Mike Wiley's theatrical repertoire. I do not suggest parity between Wiley, the young contemporary artist, and these highly renowned twentieth-century arts practitioners. Rather, I want to incite in the reader an appreciation for the innovative approach that Wiley applies to his creative process and performance style. He consistently applies what performance studies scholar Dwight Conquergood describes as the three crucial aspects of performance: artistry, analysis, and activism (Conquergood and Johnson 40). Today, Wiley's body of performance work includes nine published plays, three films, over 180 characters, and hundreds of thousands of hearts and minds reached.

Mike Wiley is a North Carolina-based actor and playwright with an MFA from UNC Chapel Hill. He has been writing, directing, teaching, and performing documentary theatre for live audiences, educational institutions, film, and television since 2000. Perhaps best known for his one-person docudramas that dramatize the stories and struggles of historical figures like Henry "Box" Brown, Jackie Robinson, and Emmett Till; Wiley has a gift for bringing history to life. Emblazoned on his homepage is a quote from American historian John Hope Franklin: "If the house is to be set in order, one cannot begin with the present, he must begin with the past" (Wiley). Through multi-media presentations that blend live performance, music, photographic projections, and poignant props, Wiley activates moments and figures in history while preparing his audiences for what Brazilian critical pedagogy theorist Paulo Freire calls *conscientização*, a raising of critical consciousness. In many ways, Wiley's work is what dramatist and theorist Bertolt Brecht refers to as "epic theatre," which aims to "teach the spectator a quite definite practical attitude, aimed toward changing the world" (57). Every scene is deliberately designed and played to draw the audience toward a deeper, more critical understanding of social justice issues. In turn, Wiley's participatory and engaging direct-address style enlists audience members to do something about the new understanding they have gained.

Wiley began this work in 2000 when he wrote and performed a one-person docudrama called *One Noble Journey* at schools in the American Southeast. It tells the story of Henry

"Box" Brown, a Virginia slave who mailed himself to freedom in Philadelphia, Pennsylvania. The ingredients of this piece include one man, one large wooden box, and willing audience participants. Wiley continues to bring Henry "Box" Brown's story to classrooms, stages, and now to the screen with his soon-to-be released film, *Box Brown*. Wiley's most popular play to date, *Dar He: The Story of Emmett Till*, has traveled around the United States, and its film adaptation (*Dar He: The Lynching of Emmett Till*) has garnered awards from New York to Sidney, Australia. In this harrowing docudrama, Wiley portrays some 36 characters of different genders, races, classes, and geographies as he seeks to reckon with the painful truths surrounding the murder of 14-year-old Emmett Till in Mississippi in 1955 and the subsequent trial of his killers.

My first encounter with Wiley's work occurred when he directed the Cape Fear Regional Theatre's Fayetteville, NC, production of his play *The Parchman Hour* in 2012. *The Parchman Hour* celebrates the brave determination of over 300 volunteers, called Freedom Riders, who endured violence and incarceration because of their efforts to desegregate interstate public transportation in the United States during the summer of 1961. Cast as Stokely Carmichael in the play, I learned that the majority of my lines were direct excerpts from Carmichael's speeches and interviews. I also learned that this play began with a conversation that Wiley had with a friend who happened to be a Freedom Rider. That conversation turned into a series of interviews and a deep dive into the archive where Wiley spent several years spelunking the public and private record for stories. The actors in this ensemble played real people like John Lewis (who would become a congressman) and then Alabama governor George Wallace. It was here that I learned the power of performance ethnography, defined as the artistic practice of formulating a staged public performance based upon archived documents, interviews, and oral histories.

Even the set design was intimately tied to the experiences of the actual Freedom Riders. It included a facade that extended from either side of the proscenium stage all the way to the rear of the auditorium, decorated to effectively transform the entire theatre into one big bus. Audience members became riders. They were encouraged to sing along and react openly to the performance. They also were invited to engage with Wiley and cast members in post-performance discussions structured to challenge everyone to grapple with such questions as: "What should we be 'riding' for today? How might we be similarly brave in confronting present-day injustices?" *The Parchman Hour* continues to inspire audiences in theatres across the nation, expanding the concept of performance beyond the aesthetic and placing it in the realm of activism.

One reason for the growing popularity of Mike Wiley's work is his knack for artfully exploring the many nuances of deep-seated social challenges. Consider the time in 2014 when Wiley was commissioned to develop a live performance piece about the literary relevance of Ralph Ellison's novel *Invisible Man*. The book had been recently banned from Asheboro, NC, schools before community outcry reversed the ban. To help the community to digest this experience, civic leaders commissioned Wiley to write and produce an original piece entitled *Black, Blue and Invisible*. In it Wiley performs as the narrator, recalling his childhood years attending Virginia schools where he struggled to discover his purpose in the face of poverty, racism, and his own awkward disposition. He brought in several actors to enact the interviews that he had spent months conducting in the community. He also seamlessly tied in an interpretation of Ellison's work performed by the brilliant performance scholar Dr. Kashif Powell. Dancer and storyteller Aya Shabu laced Powell's interpretation with exquisite movement. This beautiful synergy of academic study, art, and activism rose from the ashes of an otherwise contentious event. Wiley used this project to address the pervasive cycle of invisibility that so many humans feel in this age of appropriated cultural identities and social marginalization. He closed by directly asking audience members, "Where do *you* belong?"

At times, Wiley regards the fourth wall of the theatre with deep respect as he morphs seamlessly between characters, as if there is no audience in the room at all. He artfully draws audience members into the web he weaves by dramatizing difficult stories of our painful past. At other times, he strategically penetrates that fourth wall, engaging audiences directly as the griot, the storyteller, who leads them through the unchartered land laid out by each tale. Still at other times he brashly obliterates that fourth wall as an educator and performance activist who directly asks audience members tough questions that make them squirm in their seats, wishing this style of engagement were merely a dramatic rhetorical device to which they need not respond. Perhaps the most endearing element of Wiley's insistence upon the plasticity of the fourth wall is his refusal to leave the most painful and difficult issues on the table without giving audience members and himself a chance to come together and consider how they might enact positive change in their own communities.

For example, in *Blood Done Sign My Name*, Wiley dramatizes author Tim Tyson's book about the 1970 mutilation and lynching of Henry "Dickie" Marrow in Oxford, NC. Wiley collaborated with Mary D. Williams, a gospel singer and scholar, to accent his solo acting performance with a live sound track of spirituals such as "Oh, Freedom" and "The Blood Done Signed My Name." The performance ends with Wiley walking the aisles and touching audience members as they all sing "We Shall Overcome." This moment is not the typical theatrical denouement where audience members experience a catharsis that releases each of them from individual responsibility for the causes, effects, or solutions to the tragedy presented. Instead, this ending challenges audience members to reckon with the unresolved problems of our past and to commit to a communal effort toward resolving them.

Wiley's work elicits audience commitment by presenting struggle and hurt in a way that is tender even as it is unrelentingly honest. In his 2016 play *Downrange: Voices from the Homefront*, Wiley collaborated with Hidden Voices, a non-profit in Chapel Hill that seeks creative avenues to build networks that unify communities in efforts toward justice and peace. For this project Wiley conducted hours of interviews and focus group sessions with military members and their families. With this insight and his own extensive research on the psycho-social impacts of military deployments, he reconstructed the "new normal" inhabited by post-9/11 military families. During a post-show talkback, I witnessed audience members assert that, between military and civilian families, *Downrange* had prompted generative conversations that had long been buried under misunderstanding and fear. Shortly after the play's initial success, the Shakespeare Theatre Company's Forum at Sidney Harman Hall in Washington, DC requested a special performance of *Downrange* for military families and their communities (Mullen).

Mike Wiley's most recent project, *Leaving Eden*, is a genre-bending and blending musical that addresses parallels between the struggles of post-Reconstruction Blacks and contemporary Latino immigrant workers in the United States. Its repertoire of original music is a blend of hip hop, bluegrass, and rock and roll. *Leaving Eden* takes audiences on a journey between two worlds of people who are seeking belonging in a new land. Wiley employs a narrator to connect the two worlds, artfully juxtaposing the challenges American Blacks faced after Reconstruction with the experiences of migrant Latinos today.

The search for belonging that marked Mike Wiley's childhood has become the abiding theme of his expanding body of work. Wiley has weaponized the genres of docudrama and performance ethnography with the voices of people whose stories don't appear to belong in the dominant narrative. His work launches an arsenal of untold and under-told stories onto stages, screens, and spaces for learning. He continues to perform his one-person documentary theatre at hundreds of schools across the nation each year. Unlike the catchy chorus of rap artist Drake's 2013 hit song, "Started from the bottom, now we're here," Wiley can't

quite say that he "started from the bottom" or that his current "here" is much different than where he began his career back in 2000. He came from the classroom and that is a place where his work and industry continue to thrive. The major change that success has brought Wiley is that, while he continues to open minds in classrooms across the country, he is also turning world-renowned auditoriums and theatres into classrooms and audience members into students who learn that they indeed belong in the struggle for truth, human justice, and the reconciliation of this nation's sordid past and unsettled present. In the movement to mobilize performance toward social change, Mike Wiley's brand of "epic theatre" belongs at the forefront.

## Works cited

Boal, Augusto. *Theatre of the Oppressed*. Theatre Communications Group, 1985.

Brecht, Bertolt. "The Indirect Impact of the Epic Theatre." *Brecht on Theatre*, edited and translated by John Willett, Hill & Wang, 1957, pp. 57–64.

Conquergood, Lorne Dwight, and E. Johnson. *Cultural Struggles: Performance, Ethnography, Praxis*. U of Michigan P, 2013.

Drake. "Started from the Bottom." *Nothing was the Same*. Cash Money Records, 2013.

Freire, Paulo. *Pedagogy of the Oppressed*. Continuum, 2000.

Hidden Voices. "Our Vision." *Hiddenvoices.org*, June 20, 2017, http://hiddenvoices.org/who-we-are/mission/.

Mullen, Rodger. "CFRT Play about Pain of Deployments Earns Special D.C. Performance." *Fayetteville Observer*, June 14, 2016, www.fayobserver.com/9c41fb29-31c1-599e-88a3-d6fa73b401a4.html.

Tyson, Timothy B. *Blood Done Sign My Name: A True Story*. Crown, 2004.

Wiley, Mike. "Performances." *Mikewileyproductions.com*, June 20, 2017, http://mikewileyproductions.com/#s-performances.

# 54

# "LOCKED AWAY BUT NOT DEFEATED"

## African American women performing resilience

*Lori D. Barcliff Baptista*

On April 1, 2009, shortly after her release from prison, Rozen Burrage was brutally murdered by an acquaintance in her Englewood neighborhood on Chicago's southwest side. Jarred by the circumstances of her passing, an extended community of formerly incarcerated women and men organized a memorial picnic to commemorate her efforts to turn her life around. Inspired by the picnic, Chicago natives Mica V. Battle, Erma Hollingsworth, and Cynthia Rush, who collectively had served more than 50 years in the Illinois state prison system for violent crimes, formed Matters of the Heart to de-escalate violence in their communities, assist and train young people at risk of being involved in the criminal justice system, and contribute to "reducing recidivism and hushing the mouths of the critics that believe that rehabilitation does not exist when it does" (Matters 2).

A formerly incarcerated friend, Danny Franklin, introduced the women to attorney James Chapman, president of the Illinois Institute for Community Law and Affairs. Chapman asserts that negative public perception and media portrayals of incarcerated and formerly incarcerated persons create insurmountable obstacles for them when they are released from prison. He argues that when they are treated as less than human and excluded from fully participating in the greater society as a result of their incarceration, they are vulnerable to recidivism. Chapman attempts to counter these effects of "social death" (Patterson) through his advocacy work, which he characterizes as

> an undertaking, long range in nature, to deal with the negative attitude that most citizens ... hold regarding persons who have been *convicted* of serious crimes and released from prison ... no matter how they may have matured and how well they have readjusted back into the community... The [Changing Minds Campaign] is designed to show those people who have open minds on the subject the truth about almost all formerly incarcerated: that they are human beings who deserve to be treated as human beings.
>
> ("Introduction" 1, original emphasis)

Some of the Campaign's most effective tactics are public readings of plays or short "skits" such as "A Day in Stateville" written by participants from Chapman's writing class at the men's maximum-security Stateville Correctional Facility. The readings are staged much like readers' theatre: performers seated on barstools or folding chairs, in a circle or at a table, hold and read

from printed copies of their scripts. There are no props, sets, costumes, cues, or special lighting. With Chapman's support, Matters of the Heart wrote "Locked Away But Not Defeated," a script adapted from Battle, Hollingsworth, and Rush's auto-ethnographic accounts of life in a women's prison. Much like morality plays, the ensemble's writings are concerned with choices and consequences. Ensemble or group-authored writings lay bare the vigilance and tenacity of formerly incarcerated women in the face of threats to their very existence. Unlike supporting characters who personify good and evil in traditional morality plays, "Locked Away" is anchored by complex and multi-dimensional protagonists. The script includes a brief prologue, five short scenes—"The Library," "The Yard," "Lock Down," "Coming off of Lock Down/Commissary Day," "Chow Hall"—and an epilogue.

On the evening of Friday November 13, 2009, Matters of the Heart performed its first reading for a group of 80 youth and community advocates in the storefront office of Chicago's Greater Roseland Community Committee, a safe space for supervised recreation, youth mentoring, and support. The performance was part of a program that included announcements regarding HIV testing and a dance party. Presented at a time when Roseland was thrust into the national spotlight for the brutal beating death of Christian Fenger Academy High School student Derrion Albert, "Locked Away" prompted a frank, intergenerational dialogue between African American youth living in a neighborhood seemingly plagued by violent crime and women who had served time for serious crimes. Seated in folding chairs facing the youth, the three women listened attentively as Gwen Baxter, who founded a youth empowerment organization[1] after losing her son to gun violence, introduced them. Mica Battle then opened the performance with these words:

> Thank you in advance. This play was written to inspire, uplift, educate and open all minds to advancement in your life. The moral is to forbid by empowering ourselves from the wicked mind and to fulfill all long-term dreams and not be defeated by everyday struggles. The women in this skit are in some shape or fashion where you are in your life now or have been. We have all served ten or more years behind prison walls and want to share with you the story of our journey and trials to freedom.
>
> (1)

In Scene 2, "The Yard," Mica shared a fellow inmate's reaction to learning about the death of her child and the web of circumstances that prohibits inmates from being able to attend the funerals of their loved ones:

MICA: Did you hear about Joanne, she got a call that her son had got killed. We heard her screaming over the whole place. Then I heard that they are not letting her go to the funeral due to it was a gang related shooting.

ERMA: So how is she holding up?

MICA: How would you feel girl if somebody snuffed out your child while you were locked up behind these bars and then you need permission to go look over your son's body and say goodbye to them in their casket[?]

CYNTHIA: I can relate to that, my brother at the age of 13 died from an accidental gun shooting while I was locked up. The administration gave me the permission to go but I did not have the money.

MICA: What you mean did not have the money?

CYNTHIA: You have to have money to pay the state for transportation and officers to escort you to the funeral to view the body for 20 minutes. (4)

Later in that same scene, Erma reflects upon how individual choices set in motion a chain of consequences that diminished the amount of control they had over certain aspects of their lives: "The choices we make put us in the position for others to make [a] decision that we really should have been able to make ourselves" (3–4).

As the women learned from the post-performance discussion, their encounters with violence, loss, and confinement profoundly resonated with many of the young people as well as with Pulitzer Prize-winning journalist Don Terry, who covered the event for the *Chicago Sun Times*. One young man asked, "Do you think it's crazier in jail or out here?" to which Hollingsworth replied, "It's more crazy out here." DaAngela Shepard, age 15, responded to the play, saying, "I was scared before, but I got really spooked listening to them" (Terry). Battle, Hollingsworth, and Rush did not approach the project with the intention of normalizing, sensationalizing, or trivializing the circumstances of their incarceration. As Rush explained, "We're not trying to intimidate or be a scare tactic … we're just trying to share our experiences so that these youth don't make the same mistakes we did. I was their age when I went to prison. I was 17" (Terry).

African Americans are disproportionately represented in the US prison industrial complex, and Black women are its fastest growing population. A 2010 study conducted by Hart Research Associates on behalf of the Children's Defense Fund found that Black youth and adults palpably experience the inequities of the criminal justice system as an excess of punitive consequences for mistakes. Black adults and children have a very clear sense that the rules of the game are different for young Blacks; that, in essence, Black youth are not allowed to make mistakes, and, if they do, the consequences are harsh and often life-altering (Baptista; Baptista et al.; Kaba).

In April 2010, I assisted in script development workshops and rehearsals with Matters of the Heart as they prepared a 15–20 minute excerpt from "Locked Away" for a May showcase event. The program would also feature workshops, a roundtable, creative art auctions, video and audio screenings, a dance party, and meal intended to convene performers and funders invested in creative approaches to addressing social justice issues (Waggoner). Mica Battle was not available for the upcoming booking, so Chapman and Matters of the Heart reached out to the not-for-profit Stillpoint Theatre Collective to help identify an additional reader. Stillpoint affirms art-making as a basic human right and a contributing factor in creating a more progressive and connected society.[2] Both Chapman and Stillpoint deploy theatre practices to counter the effects of stigma by building community among and between stigmatized people. They also partner with and support incarcerated and formerly incarcerated men and women's efforts to communicate their resilience and capacity for change to broader publics. While I worked closely with Hollingsworth and Rush on script revisions, Stillpoint founding director Lisa Waggoner worked to identify a storyteller with the capacity to sincerely embody the text scripted by the original ensemble.

Our most noteworthy revision involved clarifying and replacing the roles designated as Narrator, Cynthia, Mica, and Erma with the designations "formerly incarcerated woman #1, #2, #3." This shift not only served the practical purpose of assigning roles when Battle, Hollingsworth, and Rush were not available but also created space for new storytellers to inhabit, develop empathy for, and share the ensemble's stories with other audiences. We took great care to preserve Battle, Hollingsworth, and Rush's voices, experiences, and presence in the script. These revisions were important to the women as a strategy for overcoming the estrangement of social death. As Hollingsworth and Rush asserted throughout our collaborative work process, "Locked Away" was scripted to withstand the scrutiny of the young people whose lives they hoped to positively influence and the skeptics whose minds they hoped to change. Unlike protagonists in traditional morality plays who attempt to secure their fates in the afterlife, the

women in "Locked Away" persist in the face of adversity to transform themselves and others in the earthly realm.

## Notes

1  Youth Voices Against Violence.
2  Stillpoint produces original professional plays and provides arts outreach programs to marginalized communities. Its arts outreach programs include the *Imagination Workshop* for adults with developmental disabilities; the *Persephone Project*, theatre workshops, performances, and community-building activities for currently and formerly incarcerated women; and the *Sage Theatre Workshop*, classes and performance opportunities for senior citizens.

## Works cited

Baptista, Lori Barcliff. "Black/Inside." *African-American Cultural Center.* June 30, 2017, https://aacc.uic.edu/aacc-exhibitions/blackinside/.

Baptista, Lori Barcliff, et al. Notes for *Black/Inside: A History of Captivity and Confinement in the U.S.: A Community Curated Exhibition.* Oct. 23–Nov. 21, 2012, African American Cultural Center, University of Illinois-Chicago.

Battle, Mica V., et al. "Locked Away But Not Defeated: Second Version." Unpublished script. Nov. 10, 2009.

———. "Locked Away But Not Defeated: rev Apr. 30 doc," edited by Lori Barcliff Baptista. Unpublished script. Apr. 30, 2010.

Chapman, James P. "Introduction to the Nature of Campaign Apr 12 2010." Unpublished document. Apr. 16, 2010.

———. "Re: Matters of the Heart (formerly Cluster of Rozes) reading and other matters." Received by Lori Barcliff Baptista. Apr. 16, 2010.

Kaba, Mariame, and Project NIA. "Black/Inside: A History of Captivity and Confinement in the U.S.: A Community Curated Exhibition." https://blackinside2012.wordpress.com/. June 30, 2017.

*Matters of the Heart presents: Locked Up But Not Defeated.* Performance program designed by Toosheyah Chapman, photography by Danny Franklin. Greater Roseland Community Committee, Chicago. Nov. 13, 2009.

Patterson, Orlando. *Slavery and Social Death: A Comparative Study.* Harvard UP, 1982.

Terry, Don. "Ex-Offenders Try to Save Kids from Same Fate." *Chicago Sun-Times*, 19 Nov. 2009, n.p.

Waggoner, Lisa. "Fwd: Performance Details Sought for THE GREAT COLLABORATION on May 8." Received by Lori Barcliff Baptista. 20 Apr. 2010.

# 55

# A HUNDREDFOLD

## An experiential archive of *Octavia E. Butler's Parable of the Sower: The Opera*

*Alexis Pauline Gumbs*

### Prelude

*Parable of the Sower: The Opera*, is based on a novel by Octavia E. Butler adapted by daughter/ mother team Toshi Reagon and Bernice Johnson Reagon. Butler's novel consists of journal entries from protagonist Lauren Olamina, who is charting her journey and her development of a new spirituality in apocalyptic times. The opera brings these journal entries and the characters mentioned within them to life through Black congregational sound. This chapter, in the form of journal entries, examines the impact of the opera on one family from the perspective of sister, niece, daughter, and author Alexis Pauline Gumbs, who is charting her journey and developing a spiritual center through which to survive these changing times.

### Part I

#### *Dedicated to Una Christine Gumbs*

My Aunt Una, the retired opera singer, arrived from tempest tossed Anguilla tonight with one small carry-on bag. Two weeks before her seventieth birthday, she arrived bruised from falling down the airport escalator. I applied ice at consistent intervals and listened. The pain is actually far beneath the surface.

"You wouldn't recognize it," she says of Rendezvous Bay, the small hotel and residential enclave that my family built in the 1950s. Hurricane Irma has changed everything. Even the graves are underwater. "The flooding was so bad that we couldn't get back for days. And when we got back …"

Everything is under-insured. They don't know how they can afford to rebuild. So Aunt Una is here, with us and with other family in the states. There is nowhere to return to yet. Aunt Una, who usually watches a lot of cable TV, especially Turner Classic Movies, shared that with the cable out and the power down she had started to read my books outloud, even to sing them. I imagine her singing *Spill: Scenes of Black Feminist Fugitivity* in her air-breaking soprano, facing the sea that has taken everything.

We are in a packed room of community members, visitors and friends on the campus of UNC Chapel Hill. Many people are in the room because they feel that the first year of Trump's presidency is evidence of the dystopia. Some people have traveled across the country to be

at tomorrow's US premiere of *Parable of the Sower: The Opera* [POS]. Some local community members have been participating in SpiritHouse's community reads groups for months reading Octavia Butler's novel to prepare. There are scholars in the room from multiple disciplines whom Toshi Reagon, central force behind POS, has consulted about the environmental and social components of the apocalypse we are experiencing. Bernice Johnson Reagon, Toshi's mother and the other composer of the opera, is here, Toshi's other mother is here, and so is her aunt who was one of the Black students to desegregate the University of North Carolina decades ago. My Aunt Una is here, with her stylish and necessary cane, sitting next to my partner.

Toshi and I are in a public conversation moderated by Danielle Spurlock leading up to tomorrow's event. I have a surprise for Toshi under my chair, a one of a kind print of a collage I made inspired by Octavia Butler. This is the third in a series of conversations that have taken place in independent bookstores and Black-owned coffee shops this month. Toshi recounts a UNC scholar's comments to her a few months ago during her residency here. He told her that one way to know your power is to live without something. Try living without running water for three days. Then you'll know how much power you put into running water every day without thinking about it.

Toshi also acknowledges her mother. She describes what it was like to be a baby in her mother's arms, fully enveloped in her song. Memories of another kind of water running between them. I think if we can feel just a fraction of that at the opera tomorrow, everyone's work will have been worthwhile. I lock eyes with my partner who is looking at my Aunt who must know so much about her power, after living without running water, electricity, and so much else.

"I want to acknowledge my Aunt Una." I say. "She just came from Anguilla because of the hurricane, and she's an opera singer. She has the type of voice that can cause people to go into labor, when they aren't even pregnant."

We are sitting in the first act of POS. The proscenium is full and there are rows of audience members seated on the sides of the stage. Toshi has told us that we are not the audience. We are a community. Onstage the Olamina family and their community are in the midst of an argument in an ongoing church service. Lauren Olamina, the teenage daughter, wants the community to know about her dreams that change is coming. "Lauren sit down!" says her father, the pastor.

From somewhere in the theatre comes a familiar voice. One of our community mothers who has come out to see the opera. "Naw baby, you go ahead. Tell him!" she says. I recognize her voice. I recognize that I live in a community of Black women who support young people over and over again to speak out against established traditions. We really are part of this congregation. Karma Mayet Johnson, a friend my own age, playing the role of Lauren's stepmother begins gently to sing "I Won't Crumble With You if You Fall," and from the congregation I hear Bernice Johnson Reagon, author and composer of that song, seated near me encouraging her, "Sing child!" she says.

By the end of the opera the community has in fact crumbled and had to find itself again in another form. The ensemble is on the move, most of Lauren's family of origin is presumed dead. Someone in our congregation has literally been taken out of Memorial Hall on a stretcher. My partner and I flank my Aunt and watch as Bankole, the oldest member of the community of survivors who find each other on the road, pushes a cart too small for groceries around in circles and walks in slow motion. A mother holds her baby and a backpack and a water bottle, which she shows us is perpetually empty.

The post-doc who is helping to organize the event gets me out of my chair to head backstage. I will be facilitating the talkback tonight with Toshi, and so I don't quite hear and see

the end of the show. I know the cast is back in a circle singing the song of the sower and how eventually her seeds were able to make something grow.

Aunt Una is leaving today to visit some other relatives in Florida, and then New York. She said that she loved the POS opera. My Aunt who once toured the world with Harry Belafonte and *Porgy and Bess* said the congregational opera experience made her rethink the legacy of opera, her own work and the spirit of Toshi and Bernice's Albany, GA ancestors living through all kinds of apocalypse through the power of congregational sound. Aunt Una, on the eve of 70, is thinking about her own role as an artist.

So today, in the living room, my partner Julia has set up microphones, cameras, and a music stand. The whole neighborhood can hear Aunt Una singing the invocation of *Spill* as an operatic aria. And the doors and windows are closed. She has Octavia Butler's *Parable* series on her kindle for the plane.

# Part II

## *Dedicated to Ariana Christine Good*

My sister is six months pregnant and driving a Range Rover. My 1½-year-old niece's car seat is in the backseat, empty. On NPR, TED Radio Hour is talking about how easy it would be to end all severe poverty with just 1 percent of the annual GDP. We are on our way to the sold-out NYC run of POS at the Public Theater's *Under the Radar Festival*.

As soon as we get to the closest parking garage, we start to see the congregation. An elder Black lesbian couple I know, friends of our college professors, activists we admire, friends of our family, people who I saw in North Carolina a few months ago at the US premiere, and my sister comrades, Manju Rajendran and Adrienne Maree Brown, who have all converged because we learned that Octavia Butler's family would be attending today's show.

I am so excited to introduce everyone to my sister and my niece-on-the-way. Right now, we just call her "peanut." "Baby's first opera!" I say at least 12 times to 12 different people. Everyone showered their congratulations. We smiled so big. We took selfies. The people in the theatre didn't know that before my first niece, who is back home with her father, was born, my sister had multiple pregnancies that did not make it to term, all while my father was dying of prostate cancer.

The man sitting next to me tells me that Toshi Reagon is "the soul of the Public Theater." Her band Big Lovely has been performing at Joe's Pub, a bar connected to the theatre, for many years. This is one of Toshi's homes. A place where she is known, loved, and embraced.

This time, the theatre is smaller but there are still two rows of community members onstage, including my sister's godfather's girlfriend. There is the sense that everyone is interconnected. And while no one shouts instructions or interrupts the arguments onstage, there are more people singing along. My sister and I sing and hum. As Toshi reminds us, the songs usually repeat lyrics at least three times so we can catch on. I think about Toshi in her mother's arms and her womb before that. I think about my niece enveloped in song.

When Shayna Small, playing Lauren Olamina, sings at the top of the second act "Has Anybody Seen My Father?" my sister and I, one year and a half after my father's death, are not singing. No one is. We are still. Shayna is throwing her voice high as if the heavens can catch it. I am not breathing. I am listening. Is my sister breathing? Is the baby moving? Every age of my spirit calls out for my father with no reply. What does my sister hear?

Later my sister will go back to New Jersey to make dinner, to make bed and bathtime happen for my niece McKenzie who is getting ready to become a big sister by putting her ear

up to my sister's belly, kissing "peanut" and whispering bellybutton secrets. Later, we will stand in the hall outside the theatre and watch Toshi cry as Octavia Butler's family thank her for this opera from the depths of their heart. Later Toshi, Adrienne, Manju, and I will travel up to Harlem to talk with another loving interconnected congregation about *The Parables in Iteration*. During that conversation Shayna will share that this process has not only impacted her career and her singing style, it has changed who she is in community.

But right now, I don't have to go anywhere. So after the second act when the community gathers to sing the song of the sower I can watch Toshi's conducting hands as they sing out towards us and back to the musicians behind her. For four verses there is no good ground, no air, no safe place, no room for any of the seeds to grow. But [by] the time we get to the last verse I can sing loud enough for my sister and the baby and the future to hear.

> A sower went out to sow her seed 4X
> And as she sowed
> Some fell on good ground
> Some fell on good ground
> From it the plants did grow
> From it the flowers bloom
> And in due time
> Came forth bearing fruit
> A hundred fold
> A hundred fold
> A hundred fold.

## Further reading/viewing/listening

Brown, Adrienne Maree. "Parable: An Ecstatic Review," Jan. 15, 2018, http://adriennemareebrown.net/2018/01/15/the-parables-an-ecstatic-review/.

Butler, Octavia. *Parable of the Sower*. Grand Central, 2000.

"A Conversation with Toshi Reagon and Alexis Pauline Gumbs." Unreleased video, Nov. 15, 2017, Carolina Performing Arts Center.

Gumbs, Alexis Pauline. "When Goddesses Change." *The Hooded Utilitarian*, July 7, 2014, www.hoodedutilitarian.com/2014/07/when-goddesses-change/.

Nekola, Anna, and Tom Wagner. *Congregational Music-Making and Community in a Mediated Age*. Routledge, 2015.

"Parables in Iteration: A Closer Look at Octavia Butler." *YouTube*, uploaded by National Black Theatre, Feb. 6, 2018, www.youtube.com/watch?v=hmrDkKZeC7U.

Reagon, Toshi. "There's a New World Comin'." *How to Survive the End of the World*, Mar. 13, 2018, www.endoftheworldshow.org/blog/2018/3/13/theres-a-new-world-comin-with-toshi-reagon.

SpiritHouse. "Mission," www.spirithouse-nc.org/mission-vision-what-we-believe/.

Young, Ivy. "Spotlight: Sweet Honey in the Rock," *Essence*, Apr. 1987, pp. 92–94, 158, 161.

# PART IV

# Expanding the traditional stage

*Renée Alexander Craft*

Several decades ago, I fell in love with Ruth Forman's poem "Poetry Should Ride the Bus." Two of my favorite stanzas are the first and the title stanza. Forman writes:

> poetry should hopscotch in a polka dot dress
> wheel cartwheels
> n hold your hand
> when you walk past the yellow crack house
> [...]
> poetry should ride the bus
> in a fat woman's Safeway bag
> between the greens n chicken wings
> to be served with Tuesday's dinner
>
> (10)

These excerpts point to the work I hope this section does in extending our relationship to Black performance beyond conventional conceptions of "the stage" and its relationship to both performer and audience. Part IV examines the spaces and forms of Black theatrical performance in ways that broaden "the stage" to include the circus tent, club, movie theatre lobby, street, field, fashion runway, office, and classroom. Performance most certainly can stand in the middle of a polished wooden stage framed by black velour draperies and do its important work in front of backdrops made of muslin, canvas, or scrim; but it can also occupy a polyester space that smells like cigarettes, beer, and sweat. It can take over the street with drumming and feathers or bid you to unpack your grandmother's stories from your memory and put them on your body in a classroom filled with people that neither of you know. Like poetry, performance should ride the bus. Sometimes it gets off on Broadway. Other times, it dings the bell between the corner store and my mama's house.

The chapters in this section engage variously with the following questions: How do Black performers anticipate and shape perceptions of their/our Blackness? How do performance agencies package and market Blackness within Black communities? How do Black performers draw from experiences and ways of knowing rooted in discrete Black histories and cultures to do the work of social justice, resist domination, celebrate the bonds of community, and mobilize imagination in the service of liberation?

## From Black solo to Black choreo: the politics of Black performance

Organized into six parts, the first part of this section focuses on the ways that Black solo and small ensemble performers have sought to give voice to a diversity African American experiences from the late nineteenth century to the present. Beginning with performances like Bert Williams and George Walker and ending with those like Anna Deavere Smith and Daniel Beaty, E. Patrick Johnson (Chapter 56) tracks how the genre of solo Black performance has changed over the past century. The scope of the chapter offers readers an opportunity to engage with the range of content and performative choices solo Black performers have made to have their solitary bodies reflect multiple experiences and voices onstage.

In Chapter 57, Katelyn Hale Wood charts three generations of Black feminist stand-up comics in the United States. She begins her analysis in the 1960s with Jackie "Moms" Mabley, whose performances are also highlighted in Johnson's chapter. Wood continues with Mo'Nique, whose stand-up career began in 1980, and concludes with the millennial creative duo of Jessica Williams and Phoebe Robinson, hosts of the podcast turned HBO-comedy special *2 Dope Queens*. Wood argues that "despite the diverse range in styles and formats, Black feminist stand-up comedy challenges dominant ideologies around Blackness, sexuality, and gender all while defying and reinventing conventions of the stand-up form."

Chapter 58 presents Howard L. Craft's personal reflection on the comedian Richard Pryor's impact on Craft's work as a playwright. The chapter pays particular attention to three performative techniques Pryor used in his stand-up comedy routines: his use of dialogue as a method of creating believable characters, his invocation of "the trickster" and "the bad man"—two key tropes in African American storytelling—and his use of humor and sarcasm to stage poignant political commentary that represented central themes of the African American experience.

Finally, Nicole M. Morris Johnson (Chapter 59) explores the sociopolitical influences and contexts that gave rise to the dramatic and expressive form for which the Black feminist playwright and poet Ntozake Shange is best known. In doing so, Johnson tracks the ways that Shange's experiences with the Black Arts Movement, the Gullah Renaissance, and the women's movement influenced the *for colored girls who have considered suicide/when the rainbow is enuf* author and the collective of women with whom she worked to create the choreopoem.

## Connecting with Black audiences

Whereas Chapters 56–59 concentrate on the performer's role in developing stories and styles of telling that reflect a diversity of Black sociopolitical and cultural experiences, Chapter 60 focuses on the role of arts organizations in telling compelling stories about the work they produce and about the urgency of building meaningful community relationships in order to cultivate and grow Black audiences. In Chapter 60, Kathy A. Perkins talks with the author of *Invitation to the Party: Building Bridges to Arts, Culture, and Community* and founder of Walker International Communications Group, Inc. Donna Walker-Kuhne about her pioneering career in arts marketing, audience development, and community engagement. Their conversation illuminates how Walker-Kuhne leveraged her background as a dancer, experience as a lawyer, and love of the arts to develop a successful multimillion-dollar business that works to connect arts organizations like Dance Theatre of Harlem and Broadway musicals like *Bring in 'da Noise, Bring in 'da Funk* with Black audiences who are poised to receive them.

## The politics of representation and performing real people's lives

The third constellation of chapters in Part IV attends to the politics of representing others through oral history interviews and ethnographic research that might be adapted into public staged performances. In Chapter 61, D. Soyini Madison has coined the title phrase to differentiate between staging research within the communities of our fieldwork as a part of a research process (performance ethnography) and adapting the work for audiences with no immediate connection to the original research (perform*ed* ethnography). The stakes of performance shift given changes in intent, audience, and context. In both cases, however, Madison charges those who seek to place another's voice, story, or worldview in our mouths and on our bodies to "understand representation as first and foremost an act of responsibility." Within one's research community, flattened or skewed representations can show a lack of genuine interest, commitment, and respect on the part of the researcher. Outside of one's research community, such representations can do violence to the people and cultures that the researcher purports to represent because those versions of another's reality might be the only ones to which an external audience is exposed.

Chapter 62 by Mario LaMothe is a devised oral history performance that uplifts the author's intergenerational Haitian-American family's memories of their matriarch, LaMothe's grand-mother, Lucia Hilaire (1908–1995). Created as nine interconnected invocations, LaMothe's script "evoke[s] a novena." He writes, "in the Catholic tradition, and Haitian Vodou and other Africanist faiths, this is a rite of nine successive days of prayers and mourning to commemorate a kin's death." Aligned with Madison's theory of perform*ED* ethnography, LaMothe's chapter gives us an opportunity to engage with performance-centered theories of memory, forgetting, ritual, and commemoration as he engages with "sense memories" that "indicate how Black migrants in America mythologize, re-imagine, and silence features of their border-crossing practices."

## Promoting Black performers/marketing Blackness

The next chapters in Part IV explore how cultural organizations market Black performers. Chapters 63 and 65 attend to the complexities Black performers face when US cultural organizations promote them as "US cultural ambassadors" to international audiences that attempt to interpret their performances of Blackness alongside their performances of Americanness. Performers face the re-orienting shift from being viewed as Black American to being viewed as American Black. Chapter 64 explicitly engages with the business of marketing Black performers to ensure their placement on key domestic and international stages.

In Chapter 63 Rikki Byrd examines the 1973 Battle of Versailles fashion show within the context of Black performance. At its core, Byrd's chapter puzzles through the question, "How did the Black models at the Battle of Versailles fashion show use the materiality of their Black female bodies as 'canvases of representation' that served the performative desires of American designers?" Further, it uses textual analysis to understand how fashion critics, event planners, and journalists interpreted Black models' methods of runway performance through a lens of exoticized Blackness.

Shifting from the politics of representing Black perspectives and positionalities onstage to the pragmatics and economics of representing Black artists' careers, Melanie Greene's interview with Pam Green in Chapter 64 introduces us to the business of procuring a place onstage for Black performers. As founder and president of PMG Arts Management, LLC, Green provides booking, management, and consulting services to performing artists, companies, and organizations throughout the country. Like Donna Walker-Kuhne, Green's early exposure to the arts, including Black performance artists and arts presenters, inspired her to

grow her passion for the arts into a career in arts administration. Although Walker-Kuhne's focus is on developing audiences to receive Black performance and Green's is on getting her slate of performers in front of those audiences, both cite relationship-building as a key strategies of their success.

Engaging with the types of advertisement that booking agencies use to secure work for Black performers, in Chapter 65 Katherine Zien examines publicity portraits of US Black female opera singers who toured internationally during the Cold War. Specifically, she engages with a group of photographs from the collection of George W. Westerman—the late West Indian Panamanian journalist, sociologist, historian, diplomat, activist, and concert impresario—which she discovered while doing archival research for a broader project. Like Byrd, Zien engages in a performance-sensitive analysis of the photographs within the sociopolitical context of their performers' lives. Her chapter seeks to understand what their aesthetics, body positioning, and gaze might tell us about the ambivalence they may have felt as Black opera performers framed as US cultural ambassadors at a time when their Blackness was used to exclude them from performing on the US stage.

## Cultural performance, ritual performance, and Black Diaspora carnival

The next chapters in the section explore Black Diaspora carnival traditions (or those framed as such) as community-centered repositories of Black history animated through distinct aesthetic practices and embodied performances. Sascha Just (Chapter 66) and Loyce L. Arthur (Chapter 67) introduce readers to the history, artistry, and practice of a New Orleans-based, US annual carnival tradition that honors Native Americans who helped enslaved Africans escape. "Every year on Mardi Gras Day," Just writes,

> African American groups, collectively called the Black Indian tribes of New Orleans, parade down the streets in feathered and beaded suits and reenact Native American warfare to honor those Native Americans who aided their enslaved African ancestors escape from bondage.
>
> (Chapter 66, this volume)

Chapter 66 details how practitioners artfully and ritualistically design their suits (carnival costumes), engage in carnival preparations, and celebrate their community's history of resistance to white oppression through their Mardi Gras Day performances and presentations.

Whereas Just introduces us to the tradition of the Black Indians and grounds us in its key practices, Loyce L. Arthur's interview with Chief Darryl Montana in Chapter 67 gives us an opportunity to take an intimate look at the contributions and legacy of one of its most influential contemporary practitioners, Big Chief of the New Orleans Black Indian tribe, Yellow Pocahontas. At the time of his retirement in 2016, Big Chief Montana had made and presented Black Indian suits for more than 50 years. Arthur's interview with him reveals the personal and cultural significance of this type of community-centered ritualistic performance.

Pivoting temporal and geographic focus, Chapter 68 by Margit Edwards examines the histories and traditions bound up in a contemporary Brazilian carnival tradition that has performative as well as cultural roots in the former Kongo Kingdom of Africa, of which Angola was a part. Carnival traditions are cultural and ritual performances that reflect the inter-cultural aesthetics and sociohistorical context from which they were created. Using descriptions of the seventeenth-century Angolan celebration found in a Jesuit chronicle as her

primary source material, Edwards connects "dramaturgical elements of the procession of the Feast of St. Francis Xavier in Luanda in 1620" to elements of a contemporary carnival tradition called "Maracatú," which is practiced in the Pernambuco State in the northeast of Brazil to "illustrate the processes of transculturation that began on the continent of Africa during the transatlantic period."

Whereas the previous three chapters explore the histories and practices of long-standing Black carnival traditions in the Americas, Chapter 69 by Renée Alexander Craft analyzes Black Diaspora audiences' pre-and post- *Black Panther* #WakandaForever pageantry, costuming, and imaginative play within the interpretive frameworks of Afrofuturism, cultural performance, ritual performances, and Black Diaspora carnival. Examined within the sociopolitical context of the kinds of resurgent anti–Black racism that sparked #BlackLivesMatter, Chapter 69 contends that experiencing the film during its debut weekend, which occurred in the middle of Black History Month and at the end of carnival season, gave Black audiences a new collective space to celebrate Black culture and renew bonds of community amid ongoing struggles for full civil and human rights.

## Teaching performance-centered pedagogy

Part IV concludes with a focus on one of our most sacred "stages" for the development of new theatre practitioners, actors, arts managers, theorists, and engaged audience members—the classroom. This is a vulnerable and lively space where new ideas about theatre, performance, and praxis first take shape and where new leaders in the field begin to nurture and rehearse their unique creative voices. In Chapter 70, Kashi Johnson outlines her method of introducing hip hop aesthetics to the theatre classroom for the purpose of helping students co–create original theatre performances that reflect their unique positionalities and perspectives. Johnson asserts that engaging in hip hop theatre through a set of performance-centered prompts and exercises helps students to mobilize the "creative self-expression inherent in the hip hop aesthetic." Johnson details exercises that students reading this text might use as a productive classroom resource as well as to inspire new creative work within the various theatre and performance communities in which they participate.

In Chapter 71, Eric Ruffin introduces those who have not had the benefit of participating in one of theatre professor Shirley Basfield Dunlap's classrooms to this dynamic teacher and established director. With a university teaching career that began in the 1980s, Dunlap's experiences span from those teaching at historically Black colleges and universities (HBCUs) (Central State and Morgan State) to predominantly white institutions (PWIs) (University of Cincinnati, Towson University, and Lesley University). Throughout her career, she has consistently advocated for the use of theatre arts as a method of teaching core curriculum. Dunlap's perspective on the value of exposing students across disciplines to performance-centered work holds significant relevance:

> I think that the humaneness of theatre is the reason that everybody, whether you want to be in pre-law or medicine, should take an intro or at least an Acting 1 class. It's an opportunity to understand what it means to communicate, actively listen and respond; what it means to be ethical; and what it means to be empathetic of others. Making theatre arts your vocation is a contribution to humanity.
>
> (Chapter 71, this volume)

Each of the chapters in this section engage with the politics of representation, the power of creating and nurturing spaces that honor Black cultural histories and cultures, and the necessity to bear witness to the range of traditional and non-traditional "stages" where Black ways of knowing, showing, and *being* stand at the center.

## Work cited

Forman, Ruth. *We Are the Young Magicians*. Beacon Press, 1993, p. 10

# 56

# MANY STORIES/ONE BODY

## Black solo performance from vaudeville to spoken word

*E. Patrick Johnson*

While there have always been solo components in Black performance traditions—e.g. a singer engaging in call and response with a group of singers or a musician improvising while playing with a group of other musicians—Black solo performance was not codified as a genre with its own aesthetic until the late nineteenth century with the emergence of vaudeville. A showcase for popular entertainments such as singing, dancing, comedy, acrobatics, magic tricks, etc., vaudeville shows became one of a few outlets where Black people could be paid to perform, especially those who were willing to perform in blackface as minstrels. Many performers, even those who got their start while performing with others, developed their craft as solo artists while working on vaudeville shows. For the purposes of this chapter, solo performance includes shows by a single artist onstage who engages an audience through some form of storytelling via monologues, comedy, singing, dancing, or a combination of these. I do not include in this genre what might be referred to as performance art or shows that involve a high level of abstraction or art at the conceptual level because those forms draw on more formalistic and, arguably, European aesthetics.

In what follows, I trace the emergence of Black solo performance as it begins to be codified as a genre at the turn of the twentieth century. Notably, the performers of this early period would not have thought of themselves as "solo" artists since many of them were in and out of the vaudeville circuit performing in duos or groups of other performers. Nonetheless, those who were afforded the opportunity to get work as stand-alone artists unwittingly established aesthetic tenets of what would become the genre of Black solo performance. Below is a sketch of just a few key Black solo performers over the past 100 years.

One of the most famous and successful Black minstrel acts on the vaudeville circuit was Bert Williams and George Walker. Williams and Walker became a performing duo in 1893 when they met in San Francisco. Their act consisted of songs, comedic skits, and dance for which they drew on racist stereotypes about Blacks, such as the "coon," for comedic effect. Over time, however, the performers sought ways in their act to undermine such stereotypes by calling attention to the irony of Black men using burnt cork to appear Black. Nonetheless, their act remained controversial among some factions of Blacks during a period when many felt that minstrelsy in general, and Blacks engaging in minstrelsy in particular, only further denigrated Black people in the eyes of whites.

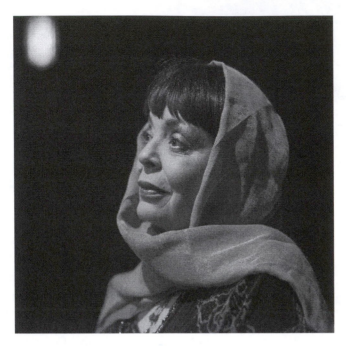

*Figure 56.1* "The Boat Scene" with Nancy Cheryll Davis as Clare (and Irene) in *Passing Solo*, produced by the Towne Street Theatre at Stella Adler Theatre, Hollywood, CA (October 2016).

*Source*: Photographer Kristina Roth.

Williams and Walker remained a duo for 16 years, creating the first Black musical on Broadway, *In Dahomey*, in 1903, and another theatre piece called *Bandanna Land* in 1908. Due to Walker's illness in 1909, Williams began a solo performance career that would build the foundation for Black solo performers who came after. Importantly, Williams' solo show also codified the aesthetic components of Black solo performance. Williams was a talented singer, dancer, actor, and physical comedian, and all of these aspects of performance came to be expected as a part of any solo act. In other words, a solo artist had to incorporate more than one genre of performance in order to be successful. Williams honed his craft as a performer as part of a team with Walker. Once he was on his own, he continued to draw on those skills, which made him even more impressive as a solo artist. One of his most famous sketches was a pantomime poker game in which he acted out a hand of poker in total silence, using only facial expressions and body language to reflect the dealer's emotions. In addition to his physical sketch comedy acts, Williams included singing as a part of his routine, thus boosting his recording career and leading to his becoming one of the highest paid recording artists in the world in the early 1920s.

Williams' career was cut short by his premature death in 1922 at the age of 47. His death was at the dawn of the Harlem Renaissance, a movement sparked by racial uplift through the arts in Harlem, New York, from the mid 1920s through the mid 1930s. Unlike Williams, however, those within the Harlem Renaissance rejected minstrelsy and other forms of Black stereotype in favor of more respectable forms of representation of the race. Influenced by a flourishing race consciousness promulgated by intellectuals and political leaders such as W.E.B. DuBois, Alain Locke, and Marcus Garvey, these artists used their work to critique racism and instantiate Black humanity. Most artists of the Harlem Renaissance were poets, fiction writers, playwrights, and

musicians, but there were a few solo performers who, while not formally a part of the Harlem Renaissance, were heavily influenced by the politics of the movement. One of the most famous of these artists was Josephine Baker.

Born in 1906 in St. Louis, Missouri, Baker spent most of her career in Paris, where she became one of the most iconic performers of her generation. Like Bert Williams before her, Baker was multitalented and incorporated all of these talents in her act. Baker performed as a chorus girl on the vaudeville circuit from the age of 15 to 19 and was particularly known for her dancing. Unlike Williams, however, she refused to play for segregated audiences, which is why she expatriated to Paris to begin her solo career. As a solo artist, Baker developed her own aesthetic, often incorporating physical comedy along with erotic dancing and singing. One of her trademark gestures was crossing her eyes. Her most iconic performance, however, was her "Danse Sauvage" (Savage Dance) in which she wore a skirt of fake bananas on a g-string and very little else while swinging on a trapeze. Baker would oftentimes have her pet Cheetah named "Chiquita" accompany her onstage during the dance.

While the spectacle of her scantily clad and swinging from a trapeze seems, on the surface, to reinforce the notion of Blacks as savages, Baker's intent in the performance was actually to upend such images of Blacks by reflecting back to the white European audiences their racist image of Blacks as savages (Caravantes; Jules-Rusette). Indeed, Baker was committed to racial justice, becoming a member of the French resistance in 1940 and volunteering for the Red Cross to assist refugees arriving in France to escape the Nazis, all the while performing for troops in North Africa. Later in her career, she returned to the United States to become involved in the civil rights movement and actually spoke at the 1963 March on Washington.

Though Baker's talent as an artist did not receive the critical acclaim in the United States as it did in Paris and in Europe more broadly—mainly due to racism and American conservatism—her legacy as a performer in the United States and within the African American performance canon still persists today. Her unique aesthetic that combined exotic dance, physical comedy, and singing, coupled with her commitment to social justice, created a blueprint for artists who followed in her footsteps.

While Josephine Baker was making a solo career in Europe, a female performer using the stage name Jackie "Moms" Mabley was having an impact in the United States during the 1920s. Born Loretta Mary Aiken in 1894 in North Carolina, Mabley's aesthetic and performance circle was quite different from Baker's. Like many other Black performers at the turn of the twentieth century, Mabley got her start as a singer and sketch comedian in minstrel shows. By the time she was 30, she had become a successful performing artist through the Theater Owners Booking Association, sometimes euphemistically called "Tough on Black Asses" or the "Chitlin' Circuit" because it was the circuit of Black-owned theatres where Black performers could get booked during the era of US racial segregation. Mabley's routine consisted mostly of stand-up comedy peppered with satirical songs. Her costume was also a part of her shtick: a housedress, floppy hat, and toothless smile. Because Mabley's audiences were all Black, especially in the earlier years of her career on the Chitlin' Circuit, she tackled controversial topics such as racism. Her routine was also characterized as "blue comedy," which contains off-color jokes, typically about sex. Though one of her signature sketches involved her romantic interests in young men, she was open about being a lesbian and came out in her late twenties. Mabley's career blossomed in the later years of her life, as she performed until she was well into her late seventies. She appeared in movies, often as an androgynous character, as well as on television. She also recorded over 20 albums, making history as one of the oldest living artists to have a US Top 40 hit at the age of 75.

Mabley's legacy influenced other, mostly female, solo artists in the years before and after her death in 1975. Among the most notable solo performance artists who emerged during the

civil rights movement era through the 1990s are Robbie McCauley, Whoopi Goldberg, and Anna Deavere Smith. McCauley began her career in New York in the 1960s as a member of the Negro Ensemble Company but rose to fame after appearing in the original 1976 Broadway production of Ntozake Shange's play, *for colored girls who have considered suicide/when the rainbow is enuf*. After her run in *for colored girls*, McCauley continued to work as an actress, playwright, and director, creating a trilogy of plays about race relations in the 1960s: *Mississippi Freedom*, *Turf: A Conversational Concert in Black and White*, and *The Other Weapon*. But perhaps more than her playwriting career, McCauley became known for her solo performance works, all of which are autobiographical. The first of these was *Indian Blood*, which debuted in 1987, followed by *Sally's Rape*, a piece based on the rape of her great-great grandmother and for which she won an Obie Award. Continuing a focus on her personal life and health issues that are prevalent in African American communities, McCauley developed a show called *Sugar* in 2010 that deals with her life as a diabetic and the connections between sugar and slavery. McCauley's work has also been heavily influenced by the theatrical jazz aesthetic, a non-Western form of theatre that emphasizes nonlinearity, simultaneous truths, and juxtapositions, among other non-Western tenets of theatre.

Unlike McCauley, Whoopi Goldberg's solo performance work has been character driven rather than autobiographical. This is partly due to her having been a student of the renowned German actor trainer, Uta Hagen. In 1983 Goldberg created her first one-woman show called *The Spook Show*. This was the basis of her most famous solo piece, simply titled *Whoopi Goldberg*, which premiered on Broadway in 1984. In this particular performance, Goldberg's deft embodiment of five characters—a junkie who flies to Amsterdam to see Anne Frank's house, a Valley girl surfer who gives herself an abortion, a little girl who doesn't want to be Black, a Jamaican woman who takes care of and falls in love with a man she refers to as the "Old Raisin," and a disabled woman—garnered critical acclaim. It also launched her film career after director Stephen Spielberg saw the show and cast her in the starring role of "Celie" in the film adaptation of Alice Walker's *The Color Purple*. Goldberg abandoned her solo career after 1985, focusing mostly on comedic and dramatic feature film roles. In 2004, she returned to Broadway in a special twentieth-anniversary revival of her one-woman show titled *Whoopi: Back to Broadway*.

Perhaps no other Black performer has had a greater impact on contemporary Black solo performance than Anna Deavere Smith. Trained at the American Conservatory Theater, Smith is a pioneer of verbatim theatre (also more broadly known as documentary theatre), a style of theatre based on journalistic or ethnographic interviews in which the performer constructs a play out of the interviews around a specific topic. Smith's gift is her ability to mimic the people she interviews with uncanny accuracy, reflecting their verbal ticks, stutters, and dialects. The two one-person shows that catapulted Smith's career are *Fires in the Mirror*, based on the 1991 riot in the Crown Heights neighborhood in Brooklyn, New York, and *Twilight: Los Angeles, 1992*, based on the 1992 riots that erupted after a "not guilty" verdict was delivered in the case against four Los Angeles police officers who were accused of brutally beating motorist Rodney King. Both of these plays were developed to reflect the multiple perspectives of those who were victims or perpetrators of violence. Since those two plays, Smith has used this method of theatre to address living in the White House (*House Arrest*), death and dying (*Let Me Down Easy*), women's relationship to justice and law (*The Arizona Project*), compassion and hope in the face of adversity (*Reclaiming Grace in the Face of Adversity*), and the school to prison pipeline for people of color (*Notes from the Field: Doing Time in Education*). All of these plays have the common thread of taking a contemporaneous social issue and reflecting it back to an audience through the perspective of multiple living people whom Smith interviews and embodies. The monologues,

therefore, are put in dialogue with each other such that the issue at hand is rendered in nuanced ways by placing the words of ideologically opposed people next to one another.

Smith's influence on solo performance is immeasurable and provided a space for other performers to produce solo work comprised of multiple characters, although not necessarily based on real people. Three actor/playwrights who actually write solo pieces with multiple characters and whose plays often go on to be produced with multiple cast members are Dael Orlandersmith, Daniel Beaty, and Sarah Jones, all of whom are also spoken word poets. Orlandersmith's one-woman shows have been produced Off-Broadway and at the McCarter Theatre, most notably her first play, *Beauty's Daughter*, which follows the life of a young Black girl from puberty to her early thirties. Other noteworthy one-woman shows by Orlandersmith include *Stoop Stories*, a semi-autobiographical piece about growing up in New York, and *Black and Blue Boys/Broken Men*, a play about men who have been sexually abused or are the perpetrators of sexual abuse. Orlandersmith's performance style is less invested in precision of voice and more in capturing the essence of the character. In other words, because her characters are not based on the narratives of real people, verisimilitude is not as much a priority as is the character's motivation for his or her actions.

Playwright, actor, singer, and poet Daniel Beaty represents a new generation of performers who came of age during hip hop and were heavily influenced by spoken word poetry. His play, *Emergency*, is a tour de force one-person show in which Beaty portrays an astonishing 43 different characters. The play recounts the perspective of various Black people when a slave ship emerges out of the Hudson River in present-day New York Harbor. In addition to portrayals of individual characters, Beaty intersperses the play with spoken word poems and song. In his follow-up show, *Through the Night*, he takes on the topic of what it means to be a Black man in the United States from the perspective of Black male characters ranging in age from 10 to 70. Similar to *Emergency*, Beaty draws on the lyricism of poetry to render some of the monologues in *Through the Night*. Both plays premiered Off-Broadway in 2006 and 2010, respectively.

Of the same generation as Beaty and also an alumna of the Nuyurican Poet's Café, Sarah Jones is an award-winning playwright and performer who is also known for her virtuosic portrayal of multiple characters. She was heavily influenced by Whoopi Goldberg and comedians like Richard Pryor. Getting her start initially as a slam poet, Jones was interested in bringing attention to global disparities related to race, gender, and economics. This desire led her to become a UNICEF Goodwill Ambassador for which she traveled around the world performing to bring awareness to these issues. Her breakthrough performance was her show *Bridge & Tunnel*, which was commissioned by the National Immigration Forum and the Ford Foundation. In the play, Jones plays immigrants from various backgrounds who gather for an annual poetry reading. The show debuted Off-Broadway in 2004 and on Broadway in 2006. Jones' use of multiple characters to address a current issue—in this instance, immigration—is similar to Anna Deavere Smith's work with the exception that Jones' characters are fictional composites, characters that she has carefully drawn from meeting people from around the world. Her work also differs from Smith's in that, in addition to taking on their vocal characteristics, she fully embodies her characters, from a young, bombastic African American rapper to a shrunken elderly Jewish woman. And unlike Beaty, whose characters sometimes have conversations with one another, Jones' characters stay within the monologue form even though they often share the same space. Because of Jones' own multiracial heritage and the multiethnic community in which she grew up, she is invested in finding the humanity of people through their differences.

Black solo performers have proliferated and thrived since the days of the vaudeville stage. The few surveyed above are a mere sample of the plethora of artists working within this genre. Contemporary artists include Sharon Bridgforth, Stacyanne Chin, Stacey Robinson, Edris

Cooper-Anifowoshe, Nancy Cheryll Davis-Bellamy (Figure 56.1), Misty DeBerry, E. Patrick Johnson, Daniel Alexander Jones, Rhodessa Jones, Calvin Levels, Lenelle Moïse, Paul Outlaw, Nilaja Sun, Mike Wiley, and a host of others. The tradition is rich and continues to inspire conversations about how one voice can reflect that of many.

## Works cited and further reading

Beaty, Daniel. *Emergency & Through the Night*. Samuel French, 2011.

Caravantes, Peggy. *The Many Faces of Josephine Baker: Dancer, Singer, Activist, Spy*. Chicago Review Press, 2015.

Chude-Sokei, Louis. *The Last "Darky": Bert Williams, Black-on-Black Minstrelsy, and the African Diaspora*. Duke UP, 2006.

Forbes, Camille. *Introducing Bert Williams: Burnt Cork, Broadway, and the Story of America's First Black Star*. Basic Books, 2008.

Jones, Sarah. *Bridge and Tunnel: A Trip through American Identity in Eight Voices*. Three Rivers Press, 2004.

Jules-Rosette, Bennetta. *Josephine Baker in Art and Life: The Icon and the Image*. U of Illinois P, 2007.

Parrish, James Robert. *Whoopi Goldberg: Her Journey from Poverty to Mega-Stardom*. Birch Lane, 1997.

Smith, Anna Deavere. *Fires in the Mirror*. Anchor Books, 1993.

———. *House Arrest and Piano: Two Plays*. Anchor Books, 2004.

———. *Twilight Approaches*. Anchor Books, 1994.

Smith, Cherise. *Enacting Others: Politics of Identity in Eleanor Antin, Nikki S. Lee, Adrian Piper, and Anna Deavere Smith*. Duke UP, 2011.

Williams, Elsie A. *The Humor of Jackie Moms Mabley: An African American Comedic Tradition*. Routledge, 1995.

# 57

# STANDING UP

## Black feminist comedy in the twentieth and twenty-first centuries

### *Katelyn Hale Wood*

With such deep and diverse roots as Black vaudeville touring troupes of the Chitlin' Circuit, West African trickster tales, and pouring tea, Black stand-up comedy in the United States has been a key modality of Black joy and political dissent.[1] Stand-up comics such as Richard Pryor and Dave Chappelle often represent the bold work of Black comedy in the United States, but Black women comedians have been widely left out of anthologies and histories of Black performance and popular culture. This chapter charts a rich genealogy of Black feminist stand-up comedy in the United States through three case studies. I argue that despite the diverse range in styles and formats, Black feminist stand-up comedy challenges dominant ideologies around Blackness, sexuality, and gender while defying and reinventing conventions of the stand-up form. From the civil-rights rhetoric of Jackie "Moms" Mabley in the 1960s to the body and sex-positive performances of Mo'Nique in the 1990s to the contemporary comedy podcast *2 Dope Queens*, Black feminist stand-up comics have played imperative roles in shaping Black political thought and are vital figures in the history of Black performance in the United States.

## The cultural labor of Black feminist stand-up comedy

The origins of stand-up comedy, like many forms of performance, are varied and complicated. From minstrel show stump speeches to vaudeville stages, stand-up comedy is a uniquely American form of performance and firmly grounded in the creation of cultural alliances and identity formation through joke telling. Media scholar Bambi Haggins calls the Black stand-up artist the "organic intellectual" (243). Similarly, in her study on humor, slavery, and redress, Black literature scholar Glenda Carpio expands on this description to include the seriousness and importance of joke-telling: "far from being *only* a coping mechanism, or a means of 'redress,' African American humor has been and continues to be more a bountiful source of creativity and pleasure and an energetic mode of social and political critique" (7). Undoubtedly, stand-up comedy deeply relies on its audience and their subsequent laughter, jeers, or silence. The audience "is not simply a body, collective or individual, waiting to be amused, but an after-effect of the new perception" that arises in the presence of performance (Rayner 33). The comic and audience, in turn, co-create an experience through call and response.

Black feminist comedy, as studies have shown on Black humor more generally, combines and navigates the seemingly opposite terrains of trauma and humor. The Black feminist stand-up

comic takes up the political and cultural specificities of Blackness, gender, and sexuality, and articulates the power of these intersecting identities through live performance. As artist, public intellectual, and cultural worker, the Black feminist comic uses the mic to "talk back" to dominant narratives that caricaturize Black culture and Black women, and to express how systemic racism, sexism, and heterosexism are imposed on the everyday lives of Black women. Further, the Black feminist comic also takes the stage to articulate the intertwined nature of struggle and joy. She understands and demonstrates the joke as a powerful way to resist and insist on the vital presence of Black feminist action and community.

## From Jackie "Moms" Mabley to Mo'Nique

With a career that spanned 60 years, Jackie "Moms" Mabley can easily be cited as the original queen of comedy. From the first solo comedic performance by a woman on the Chitlin' Circuit to more sold-out performances at the Apollo than anyone of her time, Mabley was a ground-breaking pioneer of Black and Black feminist comedy. However, the stand-up style of Mabley would seem unrecognizable to contemporary audiences. Twenty-first-century comedians often create personas that mimic, or at least appear to be, their "authentic" selves, but Mabley's on-stage persona was highly stylized and differed from the real-life Mabley. She performed under the stage name "Moms," a hip grandmother who spit cultural truths around sexuality, race, patriarchy, and politics. While "Moms" dressed in floral housecoats, floppy hats, and, in her later years, with no teeth, Mabley often dressed in menswear. "Moms" flaunted her sexuality by hitting on younger men in the audience. Mabley was an out butch lesbian. The routines Mabley created as "Moms" were filled with mixtures of sexually explicit one-liners, revisions of fairy tales, fictional stories of her advising world leaders, and spiritual hymns evoking the power of nonviolent protest. Despite its dated style, however, the content of Mabley's work still resonates as socially conscious—filled with affirmations of Black culture and life as well as feminist and queer assertions of sexual freedom.

Mabley credited her penchant for humor, truth-telling, and pleasure to her grandmother. On her 1964 album, *The Funny Sides of Moms Mabley*, Moms tells the story of how her grand-mother, Harriet Smith from Brevard, North Carolina, taught her to be "hip." Moms exclaims into the microphone,

> This is the truth. She lived to be 118 years old. And you wonder why Mom is hip today? Granny hip me. She said, I done lied to the rest of 'em but I'm not gonna let you be dumb; I'm gonna tell you the truth.

Blending Mabley's actual biography with the creation of "Moms," Mabley paid homage to her matriarchal lineage as the origin point for her future success and outlook on life. In a gruff, low tone and a Black Southern dialect with sometimes slurred speech, Mabley's voice was as distinct as her comedic material. In recounting a conversation between her and Granny, she recalled:

> One day, she sitting out on the porch and I said, "Granny, how old does a woman get before she don't want no boyfriend?" She was around 106 then. She said, "I don't know, honey. You have to ask somebody older than me!" She said, "A woman is a woman as long as she lives. But at a certain place in time, a man has to go to a place they call Over the Hill. And when you got to go son, go like a man … And you don't have to be old because your head bald. You don't have to be old 'cause your hair is gray. But when your mind start makin' dates that your body can't fill? Over the Hill, brother!"

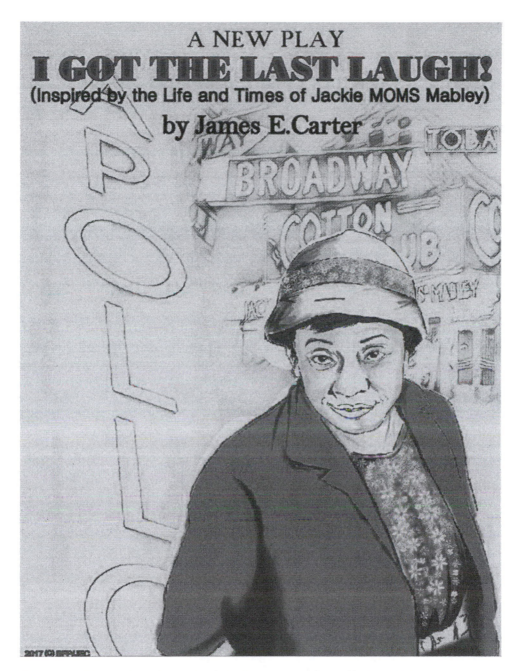

*Figure 57.1* Poster of *I Got the Last Laugh* (2018) written and directed by James E. Carter.

*Source:* Courtesy of James E. Carter.

Blurring the lines between storytelling and one-liners, as well as between fact and fiction, this particular bit reflects Mabley's complex, yet personable humor. The porch becomes a site of Black Southern communal gathering and feminist empowerment. As Granny explains to

Mabley, women have agency over their bodies and minds their entire lives, but men's power and desirability has an expiration date. This philosophy carried over into the ethos of Mabley's "Moms" persona, who found old men deplorable, yet flaunted her own sexual prowess regardless of age. Revising the misogynist traditions of making women the object of the joke, Mabley creates a world in which women's desires and sexual appeal not only exist but also are to be celebrated.

By the 1960s, Mabley had become a household name, famous for her live performances in mostly northern US cities and album recordings. Blending the personal and political, her work engaged deeply in the Black civil rights movement. Onstage, Moms preached the rhetoric of Martin Luther King, Jr. and Bobby Kennedy in hopeful tones, while also using comedy to articulate the ever-looming threat of violence that Black populations in the United States experienced, particularly in the Jim Crow South. In one of her "operas," a musical number that usually closed out her performance, Mabley raps along with a jazz piano accompaniment:

> Well, son, I was Alabamee bound. You see, baby, I had a little piece of land down in one of them little old towns. And I know I had the backing of the NAACP, also Mr. Kennedy. But what I needed was immortality. I even got a letter from Martin Luther King. Yes I did. He said that the Klu Klux Klan don't mean a thing. But, you know, I know better than that. To tell you the truth, I'm scared as a son of a gun. And baby, you know I'm too old to run. So, I ain't Alabamee bound. Not this evening. 'Cause I'm not gonna let the Greyhound take me down there and the bloodhound run me back. You know Moms too hip for that.

She ends the bit in a short chuckle, and sings in a high note, "New York!" Light in tone but serious in content, Moms created communal space for herself and audiences to bond through laughter as well as pain.

A pioneer for Black feminist comics, Mabley was a virtuosic, self-possessed performer who employed the strategic "Moms" persona to further her own career and political agenda amidst various anti-Black and anti-woman cultural climates. Through comedy and the persona of a grandmotherly figure, Mabley was able to speak truths about white supremacy, gender inequity, and sexuality, in blunt, confrontational ways that otherwise would have been dangerous for a Black American queer woman to do in the public sphere. Mabley worked until her death in 1975 and paved the way for comics such as LaWanda Page and Whoopi Goldberg.

With television widely available in American households by the latter third of the twentieth century, stand-up comedy became an even more accessible and popular form of entertainment. The cable network *Comedy Central*, the first network devoted to comedy programming, premiered in 1990 and produced many stand-up specials. The 1990s saw a resurgence in Black comedy with the premier of *Def Comedy Jam* in 1992 showcasing comedians who refused assimilation and displayed "an unabashed disregard for the politics of respectability" (Hunt 837).

Following a lineage of Black feminist comics like Mabley and garnering the spirit of Black radical comedy in the late 1980s and 1990s, the early and mid-career stand-up of Mo'Nique engaged in sexually explicit material and continued affirmation of Black female joy. Mabley and Mo'Nique both offer important moments in Black feminist comedy as a defiant and transformative form of performance. From the late 1900s and through the early 2000s, Mo'Nique's comedic material took on body- and sex-positive versions of Black feminist thought using the power of the microphone to preach the importance of solidarity among Black women and of physical pleasure.

Mo'Nique was born Monique Imes on December 11, 1967, in Baltimore, Maryland. Shortly after graduating from the Broadcasting Institute of Maryland in 1987, Mo'Nique performed at her first open mic at the Comedy Factory Outlet in downtown Baltimore. Her stand-up career soon took off. She became the first female host on *Showtime at the Apollo* in 1989 and participated in the all-female comedy special *Queens of Comedy* in 2001. While Mo'Nique is now most widely recognized for her Oscar-winning performance in *Precious: Based on the Novel Push by Sapphire*, her career has spanned three decades and was firmly established in the world of stand-up comedy when she took on the dramatic movie role.

Donning a comedic persona rooted in Black female empowerment and pride, Mo'Nique often entered the stage of her comedy specials on a throne carried by shirtless, physically fit Black men. Strutting the stage in high heels and colorful, figure-hugging outfits, Mo'Nique told jokes that preached the importance of self-love and sexual freedom for Black women, particularly Black women who identify as fat. In the 2001 special *Queens of Comedy*, Mo'Nique yells loudly into the microphone:

> All you fat bitches, stand up and take a muthafuckin' bow. Big girl, you better represent! … It's a new time. I got news for you. It's a new muthafuckin' day. And once you go fat, you never go back!

Uniting all Black women in the audience, Mo'Nique continues after the laughter dies down, "I don't give a fuck what size we are. Just bein' a sister, we are some special muthafuckas."

Some critics of her work may say that Mo'Nique evokes and thus perpetuates the stereotype of a hypersexual Black woman, but Mo'Nique's comedy can also be read as a form of redress. For Black women comics of Mo'Nique's generation, "exploiting hardcore sexuality through joking was a means to celebrate control over their immediate environment," as well as erotic control and celebration of their desires and desirability (Finley 782). Resisting cultural expectations of Black containment, Mo'Nique's comedy employs her body and sexuality to unapologetically claim space often denied to Black subjects. Mo'Nique's rejection of sexual propriety becomes a collective invitation to expect and accept pleasure.

## (R)evolutionary Black feminist comedy

The WNYC Studios Podcast *2 Dope Queens* exemplifies how contemporary Black feminist comedians are finding innovative methods to blend live performance with digital media and significantly contribute to discourses around Black Lives Matter, gender performativity, and Black feminist activism in the twenty-first century. Hosted by comics Jessica Williams and Phoebe Robinson, *2 Dope Queens* is a weekly podcast (and now four-part comedy special on HBO) that showcases the work of Williams and Robinson as well as diverse comedians whose comedy aligns with anti-racist, queer, and feminist ethos. In their onstage conversations, the co-hosts lament struggles related to being Black women in the entertainment business, their dating lives, and everyday micro-aggressions that demonstrate larger implications of being a Black woman in the United States. In the first season of the podcast, Jessica Williams describes going out with two of her white girlfriends who defend her when a white man tries to touch her hair. She explains to Phoebe and the audience:

> And I was about to say something, but my two white girlfriends were like [yelling] "Oh my god, are you fucking kidding me?'"… I was just sitting back and I was like, yaaaaas … we did it Black ladies. We *kinda* did it!

Williams refers to "it" as the momentary success in raising the consciousness of white women allies. Yet, her skeptical emphasis on "kinda" highlights that structural payoffs to such labor have yet to come.

The comedy showcased on *2 Dope Queens* cultivates space for artists to claim both live and mediated expressions of Black feminist identities and political practices. De-centering one comedian as the central authority onstage, Williams and Robinson opt to curate programs that privilege Black feminist aesthetic practices and politics while building cross-cultural community. Sam Jay, a butch lesbian, joked in a 2016 episode of the program that she loves making people uncomfortable with her presence as a gender nonconforming Black person. She proclaimed, "I'm a Black dyke and old white ladies cross the street when I'm walking down [the sidewalk], but I like that. I like that power." Jay's work sits among a genealogy of Black feminist comedy that insists on Black sexual freedom. While the experience of offending or scaring white women on the street could be degrading (no matter how mundane), Jay flips the scenario to position herself a proud and powerful Black dyke.

Or, in a special episode after the 2017 Women's March on Washington, comedian Michelle Buteau tackled the racial politics of the march, pointing out its lack of diversity and inclusion by joking,

> Today was so magical … Took the Amtrak in from Brooklyn this morning … I had my sign, "Yes We Can." Went out; saw, like, a gang of Meryl Streeps. Just a gang of old white bitches. I was like, "Were you my teacher?" Like it was so … "Is your name Esther?"

Buteau renders the white women that crowded the march endearing yet ignorant in their understanding of what sustained struggle and resistance look like for women of color. Both Jay and Buteau exemplify the complexity of Black feminist power and agency within spaces that are built to sustain and privilege white heteronormativity.

Under varying social, temporal, and cultural contexts, Black feminist comedy resists and exposes structures of marginalization and oppression that attempt to silence Black women and Black queer people. Both visceral and epistemological, Black feminist comedy and laughter hold space for the pleasures, communities, and spiritual experiences that thrive in the face of, and in spite of, legacies of racialized grief. While performance archives may characterize their work as marginal, Black women have been integral in the trajectory of stand-up comedy from the early twentieth century through present-day comedy platforms, using comedic performance to express the interconnectedness of race, gender, sexuality, citizenship, and class. As each of these examples show, Black feminist comedic performance "stands up" against oppression and "stands up" for joyful expression.

## Note

1 Informally called the "Chitlin' Circuit," the Theatre Owners Booking Association was the Black-owned and operated vaudeville circuit. It began in 1920, and helped to develop Black talent, particularly comedians and musicians of that time. In West African trickster tales (an oral tradition meant to teach a lesson), the storyteller holds particular clout in the community as a skilled solo performer. Pouring tea or spilling tea is a colloquialism employed by queer communities meant to describe gossiping among friends.

## Works cited

Carpio, Glenda. *Laughing Fit to Kill: Black Humor in the Fictions of Slavery.* Oxford UP, 2008.

Finley, Jessyka. "Raunch and Redress: Interrogating Pleasure in Black Women's Stand-Up Comedy." *Journal of Popular Culture*, vol. 49, no. 4, 2016, pp. 780–798.

Haggins, Bambi. *Laughing Mad: The Black Comic Persona in Post-Soul America*. Rutgers UP, 2007.

Hunt, Kara. "Off the Record: A Critical Perspective on Def Comedy Jam." *Journal of Popular Culture* vol. 48, no. 5, 2015, pp. 836–858.

Jay, Sam. "Billy Joel Has the Softest Hands." *WNYC Studios*, Apr. 7, 2016, www.wnycstudios.org/story/2-dope-queens-podcast-episode-2-billy-joel/.

Mabley, Jackie. *The Funny Sides of Moms Mabley*. Jewel Records, 1964.

———. "Moms." *Moms Mabley at the Playboy Club*. Chess Records, 1961.

Mo'Nique. *Queens of Comedy*, directed by Steve Purcell, Paramount Pictures, 2001.

Rayner, Alice. "Creating the Audience: It's All in the Timing." *The Laughing Stalk: Live Comedy and Its Audiences*, edited by Judith Batalion. Parlor Press, 2012, pp. 28–39.

Williams, Jessica, and Phoebe Robinson. "You Can't Touch My Fanny Pack." *WNYC Studios*, May 3, 2016, www.wnycstudios.org/story/2-dope-queens-podcast-episode-6-you-cant-touch-my-fanny-pack/.

# 58

# MY NAME MUDBONE

## What I learned about playwriting from Richard Pryor

*Howard L. Craft*

I discovered Richard Pryor on a cassette tape in the bottom of my father's "stay-the-hell-out-of draw" when I was 10 years old. I didn't know who Richard Pryor was, but the mere fact that his tape was in that draw meant that as soon as the coast was clear, my mission was to take it straight to the basement, pull out the new Pioneer boom box I got for Christmas, and listen to every word. I nearly had his … *Is It Something I Said?* comedy album memorized in its entirety before my father discovered my crime. Needless to say, thanks to Pryor I had my cussing down to a science and spent many school bus rides home amazing my friends with my proficient use of Pryor's colorful adjectives as I retold the stories I'd listened to on my father's cassette tapes. I had no interest in being a playwright or anything that had to do with words at the time. Like most little Black boys in my town in the early '80s, my goal was to be the next Tony Dorsett or Walter Payton and carry a football to work, not a pen.

I also had no clue how much impact listening to and studying Richard Pryor would have on my own craft when I did decide to become a writer. With regard to style, subject matter, and approach, there was no better teacher for me. To study Richard Pryor is to study the genius of the African American storytelling tradition, a tradition steeped in brutal honesty, humor, joy, pain, and fearlessness. Pryor questioned the justness of the American system by telling stories and creating characters that lived on its margins, from the Junkie to the Wino to my favorite of all of Pryor's characters, Mudbone.

The stories that Richard Pryor brought to the stage were about people that many African Americans recognized from their own communities. Mudbone begins one of his epic monologues by explaining that "the first person I met when I came up was Stony. Owned the barbershop. Use to give bootleg haircuts." And indeed, in the small eastern North Carolina town where I grew up, I encountered Mudbone-esque characters every two weeks when I went to the barbershop to get a haircut. They were the older Black men who sat at the checker or chess board telling lies, signifying, and breaking down philosophy and world politics with a clarity and perspective I never received from the national news. These were wily, unbroken men. Pryor captured their beauty and their ugliness. As Mudbone said, "You don't get to be old being no fool. A lot of smart wise men, they dead as a muthafucka" (Pryor).

I based the first play I ever wrote, *The House of George*, on the lives of the wily, unbroken men I knew, some of whom reminded me of Mudbone and Stony. Before I ever heard the phrase "write what you know" in a creative writing class, I learned it from Richard Pryor. I set *The*

*House of George* in an African American barbershop in Durham, NC, because hearing Pryor all those years before inspired me to explore characters based on people from my own community.

Pryor structured his stories in a way that harkens back to the tales of Br'er Rabbit, the trickster who gets the last laugh in the worst situations—the unapologetic, marginalized African American who pulls out the rug from under a racist system or, as Mudbone relates it in his tale about Cockeyed-Junior's fiancée, the one who cuts out the bottom of the outhouse. In the story, which is set in the early 1900s, Mudbone goes to pick up his boss' fiancée from the train depot with a horse and buggy. The boss and his fiancée are white. Upon meeting Mudbone, the woman slaps him and tells him to pick up the bags. When he helps her into the buggy, she slaps him again. Mudbone plays along as the happy, docile Negro until later in the evening when he waits for the woman to go to the outhouse. He follows her, cuts out the bottom of the outhouse, and states, "When I heard the splash, I got on my tractor and came up here. I wasn't mad no more either" (Pryor). In Pryor's work, I found power in the use of humor as a tool to engage how African Americans resist and survive racism.

As thought-provoking as Pryor's characters' monologues are, the dialogue between his characters goes even deeper into the psyche of the marginalized. There's no better example of this than the scene Pryor creates in his stand-up routine between a wino and a junkie. In it, the psychiatrist's couch is the street corner, the psychiatrist is the wino, and the junkie is the patient seeking help. "Tell me some of them old lies of yours," the junkie tasks the wino in Pryor's 1974 *That Nigger's Crazy.* "Make me stop thinking about the truth." The wino responds,

> I'ma help you out 'cause I believe you got potential. That's right; your problem is you don't know how to deal with the white man. I know how to deal with him. That's right. That's why I'm in the position I'm in today.

Pryor uses two seemingly unsympathetic characters that we think we know to show us, through humor, the pain these characters have endured and how that pain has led them to their current situations. The wino tells the junkie that he's ashamed to see the junkie in such a sorry state and admonishes him for not having employment. We expect the junkie to respond defensively and point back at the condition of the wino. Pryor, however, uses this opportunity to do the unexpected and allows the junkie, who is also an ex-con, to critique the criminal justice system and how that system ill prepares ex-cons for re-entry into society. "Get a job?" the junkie asks the wino. "Where I am going to get a job pressing license plates?" He then relates a story about an encounter with an unemployment counselor who asked him if he had a criminal record, to which he responded, "I'ma criminal. Just tell me where I'ma get a job" (Pryor). By the end of the comedy routine, the audience's disdain is not so much for the wino and the junkie as it is for the systems that created them.

Pryor had the ability to have his audience doubled over in laughter and then, at just the right moment, to hit them with an upper cut of truth that made them question that very laughter. The poet Lucille Clifton describes this best in her poem titled "The Wisdom of Sister Brown," where she compares Pryor's humor to Eddie Murphy's (Bates). She writes:

> Eddie, he a young blood
> He think everything funny
> Ol' Rich
> Been around a long time
> He know ain't nothing
> Really funny

Along with the study of Pryor's seemingly simple yet extremely complex characters, I've also learned a great deal from his ability to use timing, silence, and space in dialogue and monologue. In 2015, I wrote a solo actor play titled *Freight: The Five Incarnations of Abel Green*. In it, I explore the African American male experience over the last century through one character. In writing this script, I leaned heavily on what I'd learned from Pryor's ability to tell a story with multiple characters using just one character to create a dialogue with other characters. Another useful technique I learned from Pryor was how to write a monologue in a way that gives the audience the sense of dialogue by helping them imagine the other characters' responses without the actor ever changing voice to assume the role of the secondary character or characters in the story.

For example, I can't count the number of times I've listened to Pryor's routine about the wino's encounter with Dracula. Dracula never speaks a word, yet the wino has a complete and full conversation with him, and the audience knows every response Dracula gives even though Dracula never speaks. The play opens with, "Hey, fool, you with the cape, what you doing peeping in them people's window." The stage is set for a hilarious scene in which the spaces where Dracula says nothing become as important in propelling the conflict as when the wino speaks. "You want to suck what?" asks the wino. "Suck some blood? Suck your ass away from around here is what you better do!" (Pryor).

The greatest message Pryor has for the artist, the playwright, is to be fearless. To be fearless as an artist is to allow oneself to be vulnerable and to explore that vulnerability through one's art, regardless of critics or judgment from the public. Pryor's mother was a prostitute who worked in a brothel that his grandmother owned and where his father worked. He suffered from drug addiction. He set himself on fire while attempting to freebase cocaine. He survived and used these experiences in his comedy. He showed us his pain, his longing, his mistakes, and his failures. Oftentimes, he would use his characters to psychoanalyze himself. In his 1981 stand-up *Live on the Sunset Strip*, for example, Pryor, as Mudbone, says, "I felt for the boy so I went over and talked to him. And he's ignorant … Don't let him get any of that powder in his nose. That's like trying to talk to a baboon's ass."

From the technical aspects of creating character and dialogue to understanding the elements of story, Richard Pryor has been my writing professor. I learned what it means to be fearless as an artist from countless hours of listening to his stand-up. Simply put, my Chekhov[1] was a skinny brother from Peoria, Illinois, who grew up in a whore house, got his education on the street, and whose heart was so big that he took it onstage and held it up so this country could see itself. His daring presence gave permission for people who look like me to tell their stories boldly and unapologetically. In this regard, he was an inspiring and masterful teacher. Richard Pryor ladies and gentleman, the greatest to ever do it.

## Note

1  Anton Chekhov was a Russian playwright and short story writer.

## Works cited

Bates, Robin. "Murphy: Something Funny in Everything." *Better Living through Beowulf*, Feb. 19, 2015, http://betterlivingthroughbeowulf.com/murphy-something-funny-in-everything.

Craft, Howard. *Howard L. Craft: Author and Playwright. For the Love of Words*. http://howardcraft.com.

Pryor, Richard. *… And It's Deep, Too! The Complete Warner Bros. Recordings (1968–1992)*, Warner Archives/Rhino/Atlantic Records, 2000.

# 59

# NTOZAKE SHANGE AND THE CHOREOPOEM

*Nicole M. Morris Johnson*

i presented myself with the problem of having my person/body, voice, & language/
address the space as if i were a band/a dance company, & a theater group all at once,
cuz a poet shd do that/create an emotional environment/felt architecture.

<div align="right">(Shange cited in Olaniyan, 126)</div>

The choreopoem, Ntozake Shange's innovative performance form, was born in 1974 at a women's bar near Berkeley, California, called the Bacchanal. This was when Shange and a group of women that included musicians, dancers, and poets began presenting the earliest versions of what would become *for colored girls who have considered suicide/when the rainbow is enuf*. Shaped in large part by the emerging explosion of creative energy focused on women in the Bay Area, "five women[1] proceeded to dance, make poems, make music, make a woman's theater" (Shange 7). The social justice oriented artistic community with which Shange associated included women's collectives such as Third World Communications, Shameless Hussy Press, Halifu Osumare's the Spirit of Dance troupe, and the Oakland Women's Press Collective. It also included artists who focused on various other aspects of the Black experience such as renowned dancers and choreographers Raymond Sawyer and Ed Mock.

Born Paulette L. Williams in Trenton, New Jersey in 1948, Shange moved to a racially segregated St. Louis during her youth. The racism that Shange experienced when she was bused to an almost all-white school counterbalanced with her experiences of engaging with the illustrious company that her parents kept, including the likes of W.E.B. Du Bois and Dizzy Gillespie, and greatly influenced her work. Black pain and artistic excellence are recurring themes in her work.

In 1966, Shange enrolled at Barnard College in New York City, where she graduated with a degree in American Studies before relocating to southern California, a space she felt was more amenable to an independent woman's voice. While in graduate school at the University of Southern California, Paulette Williams renamed herself Ntozake, a Zulu name that means "she who comes with her own things," and Shange, meaning "she who walks like a lion."[2] In a 1991 interview with activist scholar Serena Anderlini, she explained that the name speaks to her belief that "people 'take' their space. They do things, but nobody 'gives' an opportunity. I just don't believe that. You do things" (93).[3] While in the Bay Area, Shange joined the bustling woman-centered arts scene.

Shange credits her immersion in women's studies, dance, and poetry as the building blocks upon which she created the choreopoem. The courses that she taught at Sonoma State College were "inextricably bound to the development of [her] sense of the world, [her]self, & the women's language" (7). Her dance training with Sawyer, Mock, and Halifu allowed her to intimately discover her body and, simultaneously, her poetic voice.[4] Driven by this inspiration, Shange began drafting a series of poems during the summer of 1974 while working alongside choreographer Paula Moss. These became the basis of the choreopoem. As she explains in *Lost in Language and Sound*, "as opposed to viewing the pieces as poems, I came to understand these twenty-odd poems as a single statement, a choreopoem" (11).

In Neal A. Lester's *Ntozake Shange: A Critical Study of the Plays*, choreographer Dianne McIntyre states: "Choreopoem is an ancient [African] form—words and movement happening simultaneously … Zaki made a name for it … Her words," she continues, "have the music and the dance in it and the words also have space that is open for the dance (like abstract music) whereas some other poetry may be so explicit that movement with it is redundant" (4). This suggests that, although the art form has African roots, Shange presents something unique (4).

Shange was also heavily influenced by and often discusses being heavily indebted to the leading artists of the Black Arts Movement. The late 1960s was "a signal moment in the movement, when black women were beginning to rethink themes of black dispossession, racial politics, and hegemony, while responding to patriarchy and masculinism within the Black Arts Movement and in theories of the Black Aesthetic" that were put forth by giants of the movement such as Larry Neal and Amiri Baraka (Jarrett 1249). Shange's choreopoems, often understood as an off-shoot of the Black Arts Movement, was born of this literary and cultural moment. It provided a form through which the complexities of the Black woman's experiences could be expressed and explored in a layered, nuanced manner. In many respects, Shange's choreopoems, like other Black woman-authored texts of this period, are understood to be "corrective texts, deflating racist stereotypes, refraining and revising history, and creating new mythologies" (Clarke 54).

Shange's choreopoems also serve as correctives for what she views as the shortcomings of Black theatre. In her essay "unrecovered losses/black theater traditions," Shange criticizes what she views as "the weakest arena in american art/the american theater," and implores Black American artists to discontinue the use of the current structural standards of the play, which she considers "a truly european framework for european psychology" (Shange 14, 13). She continues:

> The fact that we are an interdisciplinary culture/that we understand more than verbal communication/lays a weight on afro-american writers that few others are lucky enough to have been born into. we can use with some skill virtually all our physical senses/as writers committed to bringing the world as we remember it/imagine it/& know it to be on the stage/we must use everything we've got.
>
> (16)

Like many Black Arts Movement artists, Shange is a fan of the innovation found in improvisation and finds inspiration in the genius displayed by Black jazz musicians.[5] With this in mind, she stated, "i am interested solely in the poetry of a moment … i wd suggest that: we demolish the notion of straight theater for a decade or so, refuse to allow playwrights to work without dancers & musicians" (15).

In interviews, Shange expresses a preference for performance art to traditional forms of poetry or theatre because she appreciates the value in its ephemeral qualities and is more comfortable creating in an environment amenable to improvisation. She argues that poems do not

exist simply written on a page. The abstract and material must come together; they must be heard on the breath and animated by movement to truly exist. She believes that her responsibility, then, is not simply to create written work but also to create work that embraces the dynamic possibilities that the fusion between the moment, the audience, and the performance make available.[6]

Following *for colored girls*, Shange continued to experiment with the choreopoetic form in her work, including *boogie woogie landscapes* (1977), *From Okra to Greens/A Different Kinda Love Story: A Play/With Music & Dance* (1978), *spell #7* (1979), and *a photograph: lovers in motion* (1979). Other artists such as frequent collaborator Dianne McIntyre have also innovated within and beyond the form. With the choreopoem as inspiration, McIntyre created the choreodrama with her 1986 work, *Their Eyes Were Watching God: A Dance Adventure in Southern Blues (A Choreodrama).*[7]

Shange's innovative form and meditations on women and Black Atlantic experiences continue to resonate, as evinced by a 2014 special issue of *Scholar & Feminist Online, The Worlds of Ntozake Shange*, one of many publications or performances dedicated solely to her work and legacy.[8] Further, recent scholarship such as Mecca Jamilah Sullivan's "'walkin on the edges of the galaxy': Queer Choreopoetic Thought in the African Diaspora" (2014) attests that the choreopoem continues to provide a framework well suited to the exploration and expression of nuanced experiences of marginalized peoples.

## Notes

1 In her collection of essays titled *Lost in Language and Sound*, Shange identifies the five women as Paula Moss, Elvia Marta, Nashira Ntosha, Jessica Hagedorn, and Joanna Griffin (6).

2 As Neal A. Lester points out, Shange was given these names by friends from the Xhosa tribe in South Africa (11).

3 Here, Shange is responding to Anderlini's suggestion that opportunity existed for women in the arts in the United States during the 1920s.

4 In her essay "a history: *for colored girls who have considered suicide/when the rainbow is enuf*," Shange states, "just as Women's Studies had rooted me to an articulated female heritage & imperative, so dance as explicated by Raymond Sawyer & Ed Mock insisted that everything African, everything halfway colloquial, a grimace, a strut, an arched back over a yawn, waz mine. I moved what waz my unconscious knowledge of being in a colored woman's body to my known everydayness" (8).

5 For more on the influence Black jazz musicians had on the Black Arts Movement, see Mullen.

6 See Anderlini on Shange's views on the importance of ephemerality and embodiment in her art.

7 According to Lester, Shange points out that a difference between McIntyre's choreodrama and her own choreopoem is that "the choreodrama begins with a verbal line whereas the choreopoem begins with nonverbal expression (i.e., dance)" (16, n. 2).

8 I use the term Black Atlantic similarly to Paul Gilroy, which he explains is a "transcultural, international formation" (4). Gilroy provides a heuristic for exploring the dynamic, ever-changing "structures of feeling, producing, communicating, and remembering" such as those captured in Shange's art (3).

## Works cited

Anderlini, Serena. "Drama or Performance Art? An Interview with Ntozake Shange." *Journal of Dramatic Theory and Criticism*, vol. 6, no. 1, 1991, pp. 85–97.

Clarke, Cheryl. *"After Mecca": Women Poets and the Black Arts Movement*. Rutgers UP, 2005.

Gilroy, Paul. *The Black Atlantic: Modernity and Double Consciousness*. Harvard UP, 1992.

Jarrett, Gene. "The Black Arts Movement and Its Scholars." *American Quarterly*, vol. 57, no. 4, Dec. 2005, pp. 1243–1251.

Lester, Neal A. *Ntozake Shange: A Critical Study of the Plays*. Garland, 1995.

Mullen, Harryette. "'Artistic Expression Was Flowing Everywhere': Alison Mills and Ntozake Shange, Black Bohemian Feminists in the 1970s." *Meridians*, vol. 4, no. 2, 2004, pp. 205–235.

Olaniyan, Tejumola. "Ntozake Shange: The Vengeance of Difference, or The Gender of Black Cultural Identity." *Scars of Conquest/Masks of Resistance: The Invention of Cultural Identities In African, African-American, and Caribbean Drama*, Oxford UP, 1995, pp. 116–138

Shange, Ntozake. *Lost in Language & Sound: Or How I Found My Way To The Arts*. St. Martin's Press, 2011.

Sullivan, Mecca Jamilah. "'walkin on the edges of the galaxy': Queer Choreopoetic Thought in the African Diaspora." *S & F Online*, Summer 2014/Fall 2014, http://sfonline.barnard.edu/worlds-of-ntozake-shange/walkin-on-the-edges-of-the-galaxy-queer-choreopoetic-thought-in-the-african-diaspora/.

# 60

# INTERVIEW WITH DONNA WALKER-KUHNE

## Audience development

*Interviewed by Kathy A. Perkins*
*June 11, 2017*

Listed by the Arts and Business Council as the nation's foremost expert on audience development involving America's growing multicultural population, Donna Walker-Kuhne has provided marketing and community engagement for over 20 Broadway productions, including *Bring in 'da Noise, Bring in 'da Funk, A Raisin in the Sun*, and *Once on this Island*, as well as for Alvin Ailey American Dance Theater and Dance Theatre of Harlem. As founder of Walker International Communications Group, Inc., she specializes in multicultural marketing, group sales, and promotional events. She has raised over $20 million in earned income throughout her career. A recipient of numerous awards and author of the book *Invitation to the Party: Building Bridges to Arts, Culture, and Community*, Walker-Kuhne is recognized as a pioneer in the field of arts marketing, audience development, and community engagement (Figure 60.1).

KAP: Where did it all begin and how did you get into the arts?

DWK: I was born and raised on the south side of Chicago. When I was very young, my mother took me to see the Bolshoi Ballet with prima ballerina Maya Plisetskaya, who performed *Swan Lake*. I said to my mom, "I want to do that." I was so inspired, she enrolled me in dance classes, and I started performing. I didn't know anyone who was making a living as a professional dancer. I didn't have those role models. Around the age of 14, attorney Kermit Coleman came to my class and spoke about the legal profession. Because my goal was to change the world, I decided to become a lawyer. Dance then became more of my hobby and passion. I went to Howard University Law School, and I danced all through school.

After Howard, I married and moved to New York where I began prosecuting juveniles in family court. Though still taking dance classes, I wanted to be connected to the arts. Across the street from my job, Larry Phillips was the executive director of the Thelma Hill Performing Arts Center and a brilliant producer. I became a volunteer for a year, reading proposals, press releases, and taught myself how to become an arts administrator. That began my interest in viewing this as a profession and a career. So I resigned from Family Court, wrote a grant to become managing director, and began working at Thelma Hill around 1982.

*Figure 60.1*   Donna Walker-Kuhne.
*Source*: Courtesy of Donna Walker-Kuhne.

In 1984, I realized I really wanted to focus on dance, so I contacted Arthur Mitchell and said, "I'm a lawyer, dancer, and I know how to research, analyze, and I love selling art." I began working in audience development and marketing with the Dance Theatre of Harlem, and over the course of nine years I was able to help translate Mr. Mitchell's vision: to engage an African American audience [to] enjoy ballet.

In 1993, I received a phone call from director and producer George C. Wolfe. Mikki Shepard, a mutual colleague and a mentor, had shared with him that I was someone he should speak to about expanding audiences at the Public Theatre. George said, "I'd like this place to look like a subway stop. How would you do it?" So I shared what I did with Black folks, and I knew I could do that with other demographics. I became director of community affairs. From 1993 to 2002, I had the privilege of working with George translating that "subway stop" vision.

Because of the success of *Bring in 'da Noise, Bring in 'da Funk* at the Public, George decided to bring the show to Broadway. That's when I became immersed in the Broadway marketing world. The show ran two years at the Ambassador Theatre and two years on national tour, and I did the marketing for both. I took the cast everywhere. I took them to the community, to people's homes, libraries, and I showed videos of the performers. I took my artists to Harlem, where we did talkbacks. You have to demystify the product. I had so much content that I could really talk about the show in different ways, and that's how we started to build group sales for it. I brought in lots of group sales, so it was a real robust campaign.

KAP: Can you explain the difference between public relations (PR), marketing, and audience development? Also, at what point did you decide to branch out on your own?

DWK: Public relations is when you are engaged in talking to people from the media or people in key positions in your community who can help advance your work and talk about who you are. The public relations evolve into publicity, which is the end product. That's when you read the review, an editorial, or an article. Today it's all on social media, Instagram, and Facebook. Public relations puts you in the arena to start talking about it; publicity gives you the end product where there's conversations about who you are and what you do that hopefully will drive people to purchase a ticket.

Publicity doesn't work in our community to engage new audiences unless you have marketing support. Marketing is the development of the campaign that is going to get people to pay attention. PR is a part of the marketing as well. In many institutions the public relations person is within the Marketing Department; they don't work separately. That's brochures, postcards, ads on the radio and television. Part of marketing is community engagement, which allows the community to experience these art forms where they live. We also work with colleges in developing curriculum-based initiatives for classes that are studying Black history, literature, sociology—any topics we can connect theatre and dance to. Community engagement works when you have a narrative that goes with it, and the narrative is provided by publicity. That's how it all links together. When you put that recipe together, that's when you have a success—engagement.

I left the Public in 2002 to begin my company, Walker International Communications Group. My first client was Alvin Ailey American Dance Theater and the second client was *Hairspray* on Broadway. *Hairspray* had ten African Americans in the cast, but nobody really knew that because the ads highlighted the white lead, so they created a whole ad campaign for me to use to target the African American community. We featured the ten cast members, had them in different ads [and] created CDs with them on it, providing me with tools that clearly personified, "This is the Black participation in this show." My company is international because I love to travel, and it's very important that we think on a global level. From the beginning, I was involved in traveling to exchange my strategies. Last year I was in Scotland, South Africa, and Australia.

KAP: What were the conditions like when you entered the field? Was this a new field?

DWK: Completely. It didn't even have a name! Mikki Shepard was the first Black arts administrator I met, around 1981 when she was at BAM [Brooklyn Academy of Music]. Marketing really came to life in the 1990s when we started to see associations formed, conferences. I spoke at the first national Arts Marketing Conference in 2001.

KAP: So you're a pioneer.

DWK: Absolutely. Not only a pioneer in arts marketing, but definitely in audience development and community engagement.

KAP: Do you feel that race or gender has hindered your opportunities?

DWK: Not at all. 'Cause if it tried to, I didn't hear it. I don't believe in "no." No obstacles.

KAP: Are there many other Black women doing what you're doing?

DWK: Yes! There's certainly a few. We have Marcia Pendleton, Irene Gandy, and Linda Stewart. Irene is the only African American member of APAM, which is the union for publicists. She has pioneered many shows and produced Broadway shows.

When I started in the '90s, nobody was marketing cultural art product to the Black community in a substantial way, so my work was in demand. I've taught many people

to do this, which is why I'm in the classroom: I believe in mentoring. I now have a mentee that's marketing director of Jazz at Lincoln Center, one is marketing director at Disney. They're all over the country. I make sure that I am helping to build the field.

KAP: So what makes you at the top of your game?

DWK: For success, this is where my legal background comes in. In law school, we learned how to be strategic, how to synthesize information, and how to be organized. I know how to map out the campaign, and, because I'm a marketer, I also understand those alliances and tools. It's the complement of building relations with the community. We know a lot of people. From my Dance Theatre of Harlem days, I brought those groups with me to the Public Theatre, to the business I do now. So that's why I have a newsletter, and my blog, so I have ways to consistently speak to my constituents.

KAP: For a young person starting out, what do you recommend?

DWK: I think an internship is always great. I also think understanding the basis of marketing and communications is extremely helpful. I don't know if you need a master's but there are so many courses or workshops you can take. There's nothing like being in the trenches; there's nothing like that kind of experience. It's not theory; it's practical.

KAP: Your book, *Invitation to the Party: Building Bridges to Arts, Culture, and Community*, was this something people encouraged you to write?

DWK: I felt I had to do it because right after *Noise, Funk* closed I was being sought after by Broadway producers: "How did you do it? How did you bring young Black audiences to Broadway?" I just thought, "Let me write this down so I don't have to answer 50 phone calls." This is for producers, writers, directors. This is for people to understand how to galvanize audiences. The book just wrote itself because I had done this. It wasn't something that I had to think about. This had been my life for 20 years and I had been teaching this. I had my notes from my classes so I could start to use those in a systematic way. I wrote the book in three weeks.

KAP: So now you are in the seat as a producer.

DWK: Yes, my first time producing a Broadway show. Erin Craig is the lead producer for *Mr. Rickey Calls a Meeting*, which is a play about Jackie Robinson being invited to join the Brooklyn Dodgers. Sheldon Epps is the director. The play is amazing, and when Erin talked to me about the play and wanting to engage the Black community, because the play is all male she wanted to surround the play with Black women who would be producers. How often do Black people get invited to be a producer on a Broadway show? I thought, here again, I can have an impact.

# 61

# PERFORM*ED* ETHNOGRAPHY[1]

*D. Soyini Madison*

Performances of fieldwork data are referred to by many names. They include, among others, documentary theatre, ethno-drama, verbatim theatre, reality theatre, and performance ethnography. For the purpose of this chapter, I focus on the distinction between performance ethnography as a praxis of field research and what I have coined perform*ed* ethnography as the adaptation of field research and oral histories into staged performance projects that anticipate broader audiences than those associated with the original fieldwork or research.

I make a distinction between performances in the field—performance ethnography—and the transference of those performances to a *theatrically framed re-presentation*—perform*ed* ethnography—to acknowledge the shift from field site to staged adaptation not only in time, space, intent, technique, ethics, bodies, history, affect, power, audience, access, and so forth, but also because too often we collapse *performance* ethnography and *performed* ethnography into one overarching category and thereby ignore their profoundly different contexts, implications, and ethical responsibilities. Performance ethnography is focused more on theories and practices of local performances and its resonances within the domain of fieldwork. The researcher may not necessarily have the intention of transforming local field performances into a staged performance or performance event. When performance in the field or *performance* ethnography is adapted for the stage or communicated through modes of performance it becomes *performed* ethnography.

I have taught graduate and undergraduate seminars in ethnographic theory and method for many years. Some of the most cherished, influential, and moving texts are performance ethnographies that do not enter the terrain of a performance practice or staged event. Students across the campus from anthropology, English, sociology, education, communication studies, women's studies, comparative literature, and more become members of the seminar out of a need to understand ontologies of performance inherent in their disciplines and research methods. Most of these students have not and will not stage their performance ethnographies. In contrast, my students and I also have learned and been inspired from being audience to many performed ethnographies where the adapter, director, performers, and crew were not necessarily field researchers or involved in the original fieldwork data. Yet, the production was a beautiful and powerful ethnographic representation that expanded our understanding of fieldwork theory, methods, and ethics. I encourage my students to attend performed ethnographies to become better field researchers whether they intend to stage their own research or not.

In summary, by delineating "perform*ed*" and "performance" ethnography, I am resituating the more popularly held notion that performance ethnography is the deliberate staging of field notes and turning instead to an emphasis on local and symbolic enactments of performances in the field and on the ground of social life and processes. This is done to establish and honor the existence of local performances as vibrant and urgent and to mark the significantly different implications that undergird local performances in the field from those that are staged re-enactments of field notes.

Now, we will turn to the aim of this chapter: why and how do we do performed ethnography? What are the theories and what are the methods and techniques to create it?

## Staging qualitative research data: subjectivity, belonging, and the other

In bringing your oral histories, ethnographic research, and experiences to the stage; you may choose from a range of materials in various forms and combinations: interview transcripts, field notes, email correspondences, personal memories, diaries, blogs, television broadcasts, newspaper articles, court proceedings, historic documents, music, sound, digital imagery, visual archives, dance, symbolic movement, poetic texts, literary fiction, and non-fiction, as well the improvisations and devised scenes developed in rehearsals and workshops (Alexander; Denzin; Madison; Saldaña). Performed ethnography holds endless possibilities for inter-textual performance. Performed ethnography creates a multilayered "script" as an act of bricolage—gathering up a diversity of whatever can be imagined, available or found.

Performed ethnography raises several questions: By what describable and material means will the subjects and interlocutors themselves be affected by the performance? Can or should the performance contribute to a more active and involved citizenship? Does performed ethnography have a responsibility to disturb systems and processes that limit freedoms and possibilities on the ground? In what ways will the performers themselves probe questions of otherness, belonging, and materiality to reflect upon their own subjectivity, cultural politics, and art? Another question we should ask ourselves is: Should we assume the performed ethnography is always a good idea? What are its failures?

In addressing the challenges and pitfalls of staging ethnographic data, we also shift our focus to the audience: Who is the audience we are performing before, and what do we intend for them to experience? Remembering the long history of live performances in the staging of contested identities, Jose Estaban Muñoz reminded us of the "burden of liveness" in colonial entertainment intended for the pleasure and gaze of an elite or dominant bloc, the purpose of which sustained hierarchies, thereby erasing alternative histories, futures, and yearnings. The burden of liveness for Munoz "structures temporality" in that the "the minoritarian subject" is constrained and circumscribed with a temporality that only adheres to the present, and "to be only in the live means one is denied history and futurity," For Munoz, when the minoritarian subject only exists in the present moment, "the privilege or the pleasure of being a historical subject" is denied as well as the "luxury of thinking about a future" (189).

Fixed time becomes one of the greatest challenges in staging qualitative research data. Charlotte Aull Davis states,

> The ethnographer moves on [but] temporally, spatially, and developmentally, the people he or she studied are presented as if suspended in an unchanging and virtually timeless state … as if the ethnographer's description provides all that is important or possible to know about their past and future.

(156)

As performance makers entrusted with the materials of real people's lives, we are constantly teasing the edges between flat surfaces or mockery of stereotypes on one end and embellished felicitation or romanticizing on the other. How do we ensure that subjects are not suspended in a present that stagnates and denies their humanity of origins, histories, and contexts and, therefore, makes them invisible as living, ongoing agents of change and alternative possibilities? How do we avoid the static and unchanging story while performing in present time, where presence is all there is to experience and witness in this live performance?

We may begin through the tensive and complicated trinity of subjectivity, belonging, and otherness. I focus on this trinity because it is quintessentially created and sustained through dialogues about how subjectivity, belongings, and otherness are revealed and sustained within infinitely changing demands across life forces of time and space. This is a move against the burden of liveness and stick figures as forever stagnant to that of enlivening formations and ongoing contestations.

Ethnography is always a meeting of multiple sides in an encounter with and among others, one that requires presence, listening, and dialogue toward a possible new thing—an insight, knowledge, experience, or a relationship, a different reality—yet there is the expectation of something more and sometimes unknown. It is through the realms of belonging and dialogue that the Other ceases to be suspended in time and whose subjectivity is realized. This is the hope of performed ethnography and where one beginning point is to ask the question: By what means do local people themselves benefit from the performance?

We may start with the notion of voice. By voice, I do not simply mean the representation of an utterance, but the embodiment of a material self, a full presence that is in and of a particular world. We are not content with "being heard and included" as its focus; that is the starting point. The notion of voice is an embodied, historical self that constructs and is constructed by a matrix of social, affective, and political processes. The aim is to embody and re-present subjects as made by and makers of lifeworlds and history in their full sensory, social, and political dimensions. The performed Others are embodied subjects constituted in the substance of who they are, where they are, and how they do what they do. We are inspired and compelled to enter, albeit symbolically and temporarily, into their locations. Through performance, we are placed, subject to subject, in that contested space while, as the feminist critic bell hooks describes, oppressed "people resist by identifying themselves as subjects by defining their reality, shaping new identity, naming their history, telling their story" (43). Performed ethnographies are voices wedded to emotions and histories that are unfolding. Local people themselves may benefit from these performance unfoldings through the creation of space that gives evidence not only that "I am here in the world among you," but, more importantly, that "I am in the world under particular conditions that are constructed and that can be deconstructed and reconstructed through collective will."

Human desire implores that we each be listened to, apprehended, engaged, and free to imagine in and with worlds of Others, and that we are all historical beings where others necessarily constitute the making of a self. This idea of the self through the other reflects Mikhail Bakhtin's (1981) words, "Nothing is more frightening than the absence of an answer" (111). Here, I am substituting what it means to answer for *response*, as in call and response. More than a general notion of answer as a rejoinder or resolution that might shut down dialogue, the answer begins the conversation and sets the call on its dialogical path or on a divergent one. The answer as a response is a profound giving back, a form of reciprocity that affirms we are not alone. It is akin to a West African ontology of belonging: "I am because we are, and we are because I am."

Aimee Carrillo Rowe states, "there is no subject prior to infinitely shifting and contingent relations of 'belonging.'" Indeed, what we call "subjectivity" may be thought of as an "effect of belonging—of the affective passionate and political ties that bind us to others" (17). Performed

ethnography requires that we delve more deeply into the desires resonating within the locations of others. It demands that we move beyond the acknowledgment of voice within experience to that of embodied engagement. Therefore, subjectivity linked to performance becomes a poetic and polemic admixture of competing, comparative, and contingent bodies in time and space.

Turning to enactments of dialogue as both inspiring and enriching belonging, we come to realize that dialogue as constituted by performance emphasizes the living communion of a felt-sensing, embodied interplay, and engagement among multiple beings and expressive forms. The dialogical stance is situated in multiple expressions that transgress, collide, and embellish realms of encounters. Dialogue is both difference and unity, both agreement and disagreement, both a separation and a coming together. It is intensely committed to keeping the insights between and the conversation with the researcher and others open and ongoing. It is a reciprocal giving and receiving, a timeless resolve without history or futurity. For Dwight Conquergood, ethnographic, performative dialogue is more like a hyphen than a period (Conquergood). Dialogue is therefore the quintessential encounter with others and becomes a performed pathway to belonging. If we labor toward the deep and abiding enactments of subjectivity that are reciprocally constituted by dialogue to inspire belonging, then we recognize this labor as a responsibility.

Performed ethnography assumes responsibility for political effectiveness and communicates the principle that we are all part of a larger whole and are therefore radically responsible to each other for all our individual selves. It invites the audience to travel empathically to other worlds and to feel and know some of what others feel and know. Two lifeworlds meet and the domain of outsider and insider are both and simultaneously demarcated and fused. I have an identity separate from the subject, and the performance clearly illuminates our differences. In the performance space, I am outsider in this particular world. While I see that I am an outsider to the subject's experience, the performance does its work to pull me inside. I am now in the midst of a profound meeting. Do I remain here at the margins of the meeting, or is the performance beautiful enough and political enough to compel me to travel more deeply inside the mind, heart, and world of the subject?

Maria Lugones describes this process of world-traveling and intersubjectivity:

> The reason why I think that traveling to someone's "world" is a way of identifying with them is because by traveling to their "world" we can understand what it is to be them and what it is to be ourselves in their eyes. Only when we have traveled to each other's "worlds" are we fully subjects to each other.
>
> (Lugones in Madison 637)

Performance becomes the vehicle by which we travel to the worlds of subjects and enter domains of intersubjectivity that problematize how we categorize who is us and who is them. It also allows us to see ourselves with other and different eyes. As I argue that action beyond the performance space is of essential benefit to the subjects, so it is to audience members as well. Ideally, as an audience member consciously reenters the web of human connectedness and then travels into the lifeworld of the subject, where rigid categories of insider and outsider transfigure into an intersubjective experience, a path for action is set.

Action, particularly new action, requires new energy and new insight. In performed ethnography, when audience members begin to feel the affective tension and incongruity between the subject's yearnings and those macro processes and systems that challenge and undermine their lives and futures, there is the potential for something more and new to be learned about alterity and what might come next under the workings of power. We understand that audiences, as involved citizens, can be both disturbed and inspired to act upon or contemplate this alterity long after the final curtain. Whether one likes the performance or not, one can hardly undo

or (un)know the image and imprint of performative voices upon their own consciousness. Performing subversive and subaltern voices proclaims existence within locales and discourses that are being witnessed. This collaborative witnessing has implications and possibilities.

When we stage oral histories and ethnographic data that unsettle representations of subjects as fixed in time, we hold open the possibility for disturbances, inspirations, and actions. We invent something new. In this merging of data and performance, this new creation is not just a merging of two grand entities—performance and data—but a merging of constellations, of circulations and economies, of bodies in motion and in world-making. It is reminiscent of Henri Lefebvre's grey area of third space as an other-than space that is always hovering beyond what is being offered or presented. It is where two phenomena will always necessitate a third where "a critical 'other-than' choice" becomes an embodied performative that speaks and critiques through its otherness. This alterity, which constitutes the "other-than," does not imply or derive "from an additive combination of [its] binary antecedents but rather from a disordering, deconstruction, and tentative reconstruction of their presumed tantalization producing an open alternative" (Bhabha in Soja 86). This open alternative is not an "everything" and "anything goes" for "tantalizing" meanderings. It is a tactical intervention that recognizes political economies of geography and space as both fixed and fluid, deepened and contested, by historical subjects and their emboldened actions made more known, public, and contested through the social justice agenda of performed ethnography. Edward W. Soja invites us to think about "third space as an-Other way of understanding and acting to change the very spatiality of human life" (82–83).

## Reflections on oral history and performed ethnography

In thinking about oral history in the act of performance, one of the initial challenges for the performer is entering the selfhood to be embodied. How is selfhood performed, and what constitutes it? How can performance adhere to the ways in which identity changes, transforms itself, and multiplies? Because the performers are transported slowly, deliberately, and incrementally at each rehearsal or each encounter, crossing a threshold to the knowledge and lifeworlds of the subjects, and because they encounter partial maps of consciousness, affect, and contexts, the performers must enter a realm of receptiveness. As a performer, this receptiveness that is required will change you. You are not the same person you were before you experienced this encounter or after the performance demand to be receptive. We understand that this receptiveness is never devoid of the generative filter of the performer's own knowledge, body, and history. It is this merging when the magic happens in a transference and a reciprocity of selves in the performance of oral history.

Narrative evokes performance choices and performance choices evoke narrative. The subject's story and lifeworld guides me—what I do and who I become. My story and life are enfleshed in this narrative unfolding; both constitute the other. I have argued that, for the performer, this is an endeavor to encounter an individual consciousness shaped by a social world that also affects what our bodies do and become. The performer may research all the crucial elements that encompass a cognitive map of the social, economic, cultural, and political practices that constitute the subject's world. Moreover, the performer may be committed—doing what must be done or going where one must go—to experience the felt-sensing dynamic of that world, its tone-color—the sights, sounds, smells, tastes, textures, rhythms, the visceral ethos of that world. I have argued that in personal narrative performances, particularly for performed ethnography, performers are not only performing the words of subjects, they are performing the subjects' political, social, and economic landscapes. Cultural studies scholar Lawrence Grossberg calls this "spatial territorialization." He writes:

345

Places and spaces, of people, practices, and commodities, describes this political land-scape. It is in this sense that discourse is always placed, because people are always anchored or invested in specific sites. Hence, it matters how and where practices and people are placed, since the place determines from and to where one can speak.

(20)

Selfhood particularly in performed ethnography is then constituted by identification with spe-cific cultural and social practices, forms of empowerment, and modes of belonging. At the same time, this zeitgeist is also contingent upon how these practices within locales change over time. Identity can be definable but, because performed ethnography is also multiple, contested, and constructed, it represents how subjectivity and identity are both a matter of difference and a matter of identification. As the performer enters domains of spatial territorialization and narrative consciousness, performance becomes the vehicle by which a representation is manifest and through which living moments are embodied.

Representation is mediated through the performer's body—what it does in the performance space. Therefore, in performed ethnography and documentary performances, we understand representation as first and foremost an act of responsibility. We are responsible for the creation of what and who is being represented; our representations carry with them political, material, ideological, and political ramifications far beyond the reach of the performance. As Stuart Hall argues, "how a people are represented is how they are treated"; the act of representation is consequential (27).

In the examples of virtuosic performances like those of Anna Deavere Smith and E. Patrick Johnson, it was "transformation through imitation" that enabled the actors to represent or embody each of their characters (Kemp 138). In rehearsal and character preparation, it was a matter of "mirroring" their characters' words and actions that created the felt-sensing embodi-ment required to enact them and represent them authentically and persuasively. In other words, Johnson and Smith engaged in processes of *imitation* to build their performances. As cogni-tive evidence supports, imitation as a "tool in extending an actor's range in the creation of characters" is a method of creating and representing a character (139). Moreover, this process of imitation is now passed from the actor's body to the spectator. A double mirror is formed: As the actor mirrors a character, the spectator mirrors the actor mirroring the character. This means that the spectator mirrors the character through the actor's representation. What the body *witnesses* through *representations* also creates sensations, emotion, and thought in the witness. "We experience the action and emotion of others as we watch them" (141).

In performed ethnography and documentary performance, we understand that the burden of representation centers on factors of responsibility, ethics, and artistic labor, and how these factors culminate in a conscious effort to break through unfair closures of iden-tity and unsettle caricatures of subjectivity toward alternative identities as well as more and different representations—more and different ways of re-presenting subjects and their ways of speaking. In addition, the claim is not that performed ethnography is exclusively giving voice to the voiceless. It is understood that local subjects and interlocutors can speak and have been speaking in spaces and places often foreign to us, long before we arrive in the field. Nor do we assume that performed ethnography is the ultimate or final opportunity to enable people to name themselves, act upon their histories, or imagine their futures. We understand in performing the life histories of others that their history of speaking before, during, and after our arrival requires research. This is another layer of ethics informed by researching the history and contexts of interlocutors' personal narratives and tellings. It is a dramaturgy of voices from the field.

How we come to embody other territories of subjectivity and discourse, how we invent and inherit techniques of performance, how we conjoin the meetings of history and imagination—the performer's and the subject's—is the continuing work of oral history performance.

## Note

1 This chapter is an edited excerpt from Madison, D. Soyini. "Introduction: Performance and What It Does to Ethnography." *Performed Ethnography and Communication: Improvisation and Embodied Experience.* Routledge, 2018, pp. xvii–xxxi.

## Works cited

Alexander, B. *Performing Black Masculinity: Race, Culture, and Queer Identity.* Alta Mira Press, 2006.

Bakhtin, M.M. *The Dialogic Imagination: Four Essays.* Edited by Michael Holquist. Translated by Caryl Emerson and Michael Holquist. U of Texas P, 1981.

Conquergood, Dwight. "Performance as a Moral Act: Ethical Dimensions of the Ethnography of Performance." *Literature in Performance*, vol. 5, no. 2, pp. 1–13."

Davies, Charlotte Aull. *Reflexive Ethnography : A Guide to Researching Selves and Others.* Routledge, 1999

Denzin, N. *Performance Ethnography: Critical Pedagogy and the Politics of Culture.* Sage, 2003.

Grossberg, Lawrence. "Bringing It All Back Home: Pedagogy and Cultural Studies." Between Borders: Pedagogy and the Politics of Cultural Studies, edited by Henry A. Giroux and Peter McLaren, Routledge, 1994, pp. 1–25.

Hall, Stuart. *Representation: Cultural Representation and Signifying Practices.* Sage, 1997.

hooks, bell. "Homeplace (a Site of Resistance)." *Yearning: Race, Gender, and Cultural Politics.* South End Press, 1990, pp. 41–49.

Kemp, Rick. *Embodied Acting: What Neuroscience Tells Us about Performance.* Routledge, 2012.

Madison, D. Soyini. *Critical Ethnography: Method, Ethics, and Performance.* Sage, 2012.

Lefebvre, Henri. *La Présence et l'absence.* Casterman, 1980.

Muñoz, José Esteban. *Disidentifications: Queers of Color and the Performance of Politics.* U of Minnesota P, 1999.

Rowe, N. *Playing the Other: Dramatizing Personal Narratives in Playback Theatre.* Jessica Kingsley Publishers, 2007.

Saldaña, Johnny. *Ethnotheatre: Research from Page to Stage.* Left Coast, 2011.

Soja, Edward W. *Thirdspace: Journeys to Los Angeles and Other Real-and-Imagined Places.* Wiley-Blackwell, 1996.

# 62

# THE UNITED STATES OF LUCIA

## Three generations of Haitian-Americans reconfigure ancestry, home, and host lands through storytelling

*Mario LaMothe*

## Prelude

My intergenerational Haitian family grows in the United States since 1968. Our gatherings tell stories of how Haitian we are, stories that orient us toward our matriarch Lucia Hilaire (1908–1995), born in Léogane, Haiti. Three multiracial and multi-ethnic generations repeat, united:

> To hear the moniker "Man (mother) Louce" is to know that Yanick (my sister) renamed her grandmother so. She intentionally differentiated Lucia from her mother who left Yanick and Lucienne (our sister) in the matriarch's care to go to New York in 1968. Lucienne now possesses Man Louce's cooking hands. Their food tastes alike. Aunt Jeannette's Boston house smells spicy like Lucia's cabin in Port-au-Prince. Seeing Cousin Laurie always makes mama's boy uncle Ducoste weep because his niece is his mother's doppelgänger. It makes sense that Lucia haunts Mario's dream, as he is her first American descendant. He's the vessel through which Man Louce reminds us that we've come this far because we inherited her "fòs," the amalgam of strength, endurance, and grace that powers Haitians.

Nine interconnected invocations compose this performance script devised from an oral history project about Lucia. They evoke a novena: in the Catholic tradition, and Haitian Vodou and other Africanist faiths, this is a rite of nine successive days of prayers and mourning to commemorate a kin's death. The nine scenes herein simulate how my family stumbles through and recovers from our sense memories of our ancestor. They build upon theories of remembering as a performance steeped in the present that inherently reconfigures time, space, and ideals. I not only map out how my family maintains its connection to Lucia, their personification of Haiti, but also I indicate how Black migrants in America mythologize, re-imagine, and silence features of their border-crossing practices. Ultimately, this chapter provides a unique opportunity for readers to examine issues of Black ethnicities, class, gender, sexuality, religion, migration, and power from a personal and critical position.

## Salutations

MARIO (*with a professorial tone*): Stories about our matriarch Lucia that I collected from our interviews can be re-arranged, with various inflections and speech mannerisms fairly intact, into nine invocations about sense memories of Lucia. These memories are constructed and follow a "presentist agenda" any way. Theatre and performance scholar Sandra L. Richards would assert that our common and disparate experiences mediate what it is to remember Lucia through "processes of selecting, repeating, forgetting—willfully as well as unconsciously—and re-assembling narratives" (617).

What, how, and to what end do we remember? What memories of Lucia and Haiti do we selectively or unconsciously nurture and bury the more we become acculturated in the United States?

JEANNETTE (*speaks her facts without hesitation*): I remember my elders. I was born in Port-au-Prince, Haiti, in the 1940s. I first visited New York City in 1978. I stayed permanently in Boston in 1981. I made a family here. I am here now.

YANICK (*pensive and mournful*): God! My memories bring me pain. I was born in Port-au-Prince in the mid 1960s. Apparently, I first called her Man Louce, as in Manman or Mother Lucia, to differentiate her from Manman Mayotte, Phita, the biological mother in Brooklyn, New York, we saw during Christmas and summer breaks. I was a toddler when she and my father left us with Man Louce. I got my green card after Mario was born. American citizenship came later. I was 17 when I moved here for good.

LUCIENNE (*a touch of impatience and suspicion permeates her speech*): I don't remember anything. You know this already! To me, Man Louce gave me everything I needed. You understand? I'm the middle child. Same green card and citizenship experience as Yanick. Before I left Haiti after high school studies, Man Louce told me about her favorite songs and prayers for her funeral and novena, for some reason. Is that good enough?

MARIO (*his professorial tone is mixed with a hint of mischief and playfulness*): Then, to honor our Invisible Lucia and her wish for a novena, we will participate in nine moments that express our need to learn how the past can instruct our present and future. We are in America because my father Jacques, Lucia's first born, was also the first of his family to journey abroad to Montréal in 1968. He left behind his girlfriend Phita with their daughters Yanick and Lucienne. My mother was granted a fiancée visa and joined him in Canada. The girls stayed with Man Louce. Somehow my parents crossed the border and headed to Brooklyn, New York, where they were married. I was born a year later, the first American of the family. Because of me, my parents were granted green cards, and petitioned for the girls to have theirs.[1] My sisters remained in Haiti, yet visited frequently to maintain their residency status. I was 5 when I was sent to live with them and Man Louce.

LAURIE (*laughter textures her speech*): American-born in the mid 1980s with a Haitian soul. Am I second generation Haitian-American? I am. But I get lumped with the third one. I'm in between, I suppose. A question: Is an "Invisible" Haitian Vodou for an ancestor or beloved who has transitioned? (*All nod*). I see. Novena and presentism: Catholic education taught me that the Christian novena consists of nine successive days of vigil and prayers for one's deceased to usher the soul into the beyond, and that "presentism" also deals with apocalyptic prophecies' fulfillment. In conjuring memories of Lucia, don't we inevitably lose a little bit of Lucia and Haiti with every telling?

But when many of you are together, the conversations fall into re-creating her impressions on you. You go back to Man Louce's house. To hear that every afternoon you guys watched processions of funerals like theatre shows because you lived on the road to the national cemetery? That takes me aback a little. Just the little nuances of what you did … I feel that I missed out.

MARIO: Indeed remembering is a dynamic process of simultaneously letting go and mending gaps of knowledge. As cultural theorist Laurence Kirmayer reminds me, if the process of remembering is akin to traveling down "a roadway full of potholes, badly in need of repair, worked on day and night by revisionist crews" (2), what motions and emotions do we enact as we recycle an Invisible's impressions on us?

YANICK: In Vodou, death is a part of a cycle of renewal. For the nine days, we use Christian prayers, and add libations, candlelight vigils, songs, and dances. This is how we usher the person's immortal soul-spirit to *Ginen*, a cosmic Africa under the water, beneath the earth. From there, Man Louce will intercede between God, the spirits, and us. We reclaim her when we remember her.

MARIO: To reclaim an ancestor's energy demands sensory effort, to slow down our reality for a moment, avail us to their traces, and then re-synchronize. Let us close our eyes, breathe slowly, relax our shoulders and body, and ground our feet. Let us begin.

*(With each sequence, each storyteller lights a white candle until nine are lit. Performers should dare to add other elements that further enliven the narratives.)*

## The novena

### 1. The aural/oral

JEANNETTE: My mother was Lucia Hilaire. She was born in Léogane, Haiti, in 1908 and died in 1995. Her remains are in Port-au-Prince's National Cemetery. Her mother was Estimable Gustave. Her father Hilaire; Hilaire's last name was also his first name. Sylvia was the oldest child. My mother was second. Locacia and Irène were the other sisters. I don't remember the name of the sister who died young. There is a brother, Murat. At age 12, Lucia came to Port-au-Prince to live with a relative. I don't remember who. She met my father, Victor LaMothe, who was born in Aquin. They weren't married but they lived together like a married couple. And they had us. Like this: Jacques, Philippe, Virginie (she didn't live to see a year), Ducoste, Irma, me, and Hortensia is last. We married Haitians. And then came your generation, 16 of you. And you had spouses from Haiti, Jamaica, Puerto Rico, Barbados, the Democratic Republic of Congo, Ethiopia, Black America, and White America. And then came the younger generation of Lucia's with roots in Haiti and elsewhere. We live in Illinois, Massachusetts, Maryland, New York, and Florida.

### 2. Sight

MARIO: Our septuagenarian uncle Ducoste constantly declares with deep melan-choly: "Laurie looks so much like my mother!" Laurie vaguely remembers her maternal grandmother who she visited as a toddler, in Haiti. At the first LaMothe family reunion, in southern Florida, decades ago, my father whipped out a black and white photograph of Lucia that was considered lost (Figure 62.1). Stout, diminutive, with a round face and set jaw, and sporting a wig, glasses, and a long coat, an amused middle-aged Lucia

*Figure 62.1*   Lucia Hilaire (*c.*1974).
*Source*: Courtesy of Mario Lamothe Personal Archives.

stared at us. When the photograph landed in Uncle Ducoste's hands, he burst into tears and wailed: "Manman!" This moment would have been extraordinary if only Uncle Ducoste hadn't executed less effusive versions of that scene before.

### 3. *Scent*

YANICK: I think Jeannette (Laurie's mother) is more like Man Louce. They have the same habits. Man Louce was always busy in the kitchen, and so is Jeannette. Man Louce always made sure that people ate. Feeding us all the time was probably her way to show us that she loved us. The smell of rice with red beans, garlic, peppers, and other spices that lingers at Jeannette's house here clings to our clothes. This brings me back to Man Louce's kitchen on Burial Road in Port-au-Prince.

### 4. *Touch*

LUCIENNE: You say I have her cooking hands. But would it surprise you to know that Man Louce never taught me how to cook? I learned on my own by watching and

helping her. Actually, I remember something. I was a child. I remember for some reason, I wasn't on speaking terms with her for a long time. By that, I mean a week, not even two. When we started talking again, I remember she gave me a little bit of *swif*, an ointment to rub on her knees. I looked at her and she loved me so much and I loved her so much. And then to this day, Man Louce is gone; *I wish* I remembered what it was that caused me not to talk to her.

## 5. *Taste*

LUCIENNE: I remember something else. When you first came to Haiti, Mario, you were so small in your gray school uniform and your black Buster Brown shoes. When you came home from school, you snuck into the side corridor first because you were always *SO* grimy and dusty. Your Afro was always full of sand. You had to clean up, and combed your hair before greeting Man Louce.

MARIO: What I enjoyed most, coming home from school, was to kiss Man Louce on the forehead. She sat in her kitchen, on a low wicker chair, facing three or four wrought iron stoves. She tended to several pots with a variety of food because we were all picky eaters. I leaned over, careful of her set-up, to kiss her forehead beaded with salty sweat. I always think of Man Louce when very salty food touches my lips.

## 6. *Being*

LAURIE: I like hearing those stories. You guys had this intense, separate world and livelihood. I feel as though I should have grown up in Haiti. I certainly have an upper hand on other Haitian contemporaries in my community because I speak Haitian Kreyòl well. I'm glad for that. But there's a certain legitimacy that you guys definitely have over our heads, without question, because it seems that there are gradations of Haitianness in the United States. For instance, there are a lot of Haitian people at my school. Mostly guys, in my college, if they're Black, they're likely to be Haitian or Caribbean. When we get into a conversation, in terms of criteria of how Haitian you are, you hear: "You don't look Haitian." "You don't sound Haitian." "Do you speak Kreyòl?" "Can you cook Haitian food?" and "Oh you're probably a little bit more Haitian than her." I definitely get those remarks. Sometimes it's not said but it's understood. So, it's so sweet when Tonton Ducoste gushes over me because I look like Man Louce. I feel I belong more.

## 7. *Longing*

YANICK: When our parents attempted to return to Haiti in 1979, and we moved in with them? I was in my teens. God. Leaving Man Louce and the people you trust? It was very hard. I became rebellious. I made Manman Mayotte angry. She took me out of what I knew to be a very safe place. And then, you move to the United States from Haiti. That was challenging. You spoke English growing up. You were exposed to Americans living in Haiti. The three of us came here three times a year to visit our parents. So. We were more or less familiar with the environment. But you actually live here *permanently*, and,

you start going through those changes, that you're like: "Well, I have been here before. What's happening?" You don't have anybody to talk to about your pain. You're lonely. I missed you and Man Louce.

## 8. *The invisible*

LUCIENNE: The day Man Louce died, they must have called my husband at work. So. When he came at 11 pm, he sat on the bed. Then he kneeled down. He said, "How are you?" He was very anxious. Then he kept pacing. "Lord, I don't know how I'm gonna tell you. I'm don't know how I'm gonna tell you this." I said, "What is it?" And he kneeled next to me again: "Well, it seems that your grandmother was ill, and she's at the hospital and they don't think she'll make it." But I was so positive. "Of course she's gonna make it." I slept well that night. Then the next day, as I'm driving to work, *for some reason*, it HIT me. And. I started crying. By the time I got to work, I was distraught. I shouldn't have gone to work. It's funny now. Man Louce is not gone. She's always with me.

## 9. *Last novena: balance*

JEANNETTE: A woman from Léogane, Haiti, who had very little sent all her children to school. She visited New York once, to briefly experience her progenies' host land.

LAURIE: We are three generations of "*dyaspora*," diasporic Haitians living outside of territorial Haiti. Some of us are Haitian-born, most are American-born, some visit Haiti frequently, and others have never been. We live between the cultures of Haiti and the United States, and Kreyòl, English and French languages. Who among Lucia's progeny are able or willing and even feels authorized to invoke, register and tell her stories?

YANICK: We are individuals with different experiences, but we're able to come together to link the past to our present and future. Memories of Lucia gain vibrancy and power with the full participation of all her children. That's how we get closer to Man Louce, wherever she is.

LUCIENNE: I truly sense I have her in me. Or maybe she possesses me. I don't know. I feel her.

MARIO: Lucia, "graceful light,"[2] is the cultural sediment that urges us to ask: What are the contributing factors of transculturation in our recuperative practices? How do we forward Man Louce's legacy?

## Notes

1 For more information on the US residency process and individual situations, see www.uscis.gov/greencard.
2 Italian meaning of the name Lucia.

## Works cited

Kirmayer, Laurence J. "Landscapes of Memory: Trauma, Narrative and Dissociation." *Tense Past: Cultural Essays on Memory and Trauma*, edited by P. Antze and M. Lambek, Routledge, 1996, pp. 173–198.

Labissière, Jeannette. Personal Interview. 2006.
Labissière, Laurie. Personal Interview. 2006.
LaMothe, Lucienne. Personal Interview. 2006.
LaMothe, Yanick. Personal Interview. 2006.
Richards, Sandra L. "What Is to Be Remembered? Tourism to Ghana's Slave Castle-Dungeons." *Theatre Journal*, vol. 57, no. 4, Dec. 2005, pp. 617–637.

# 63

# "WE WERE WHAT NO ONE ELSE HAD"

## How Black fashion models constructed a new wave of performance and visibility

*Rikki Byrd*

### Introduction

In 1973, five American fashion designers—Bill Blass, Anne Klein, Oscar de la Renta, Halston, and Stephen Burrows—visited France for a fashion show that was billed as a "battle" against French designers Yves Saint Laurent, Hubert de Givenchy, Pierre Cardin, Emanuel Ungaro, and Marc Bohan of Christian Dior. Accompanying the American designers were 36 models, 10 of whom were Black. In an industry where Black models were still a rarity, the show was markedly one of the first times such a large number of Black models walked an international runway. Originally organized by New York-based fashion publicist Eleanor Lambert as a fundraiser to restore the Palace of Versailles, the Battle of Versailles Fashion Show became fundamental in propelling the American fashion industry forward. While designers in France had long carried the torch as the authority of fashion design and haute couture, on the evening of November 28, 1973, American designers claimed their place in the international fashion industry. Designers, journalists, and authors have credited much of the event's success to the performances of the Black models—Billie Blair, Alva Chinn, Pat Cleveland, Bethann Hardison, Jennifer Brice, Norma Jean Darden, Charlene Dash, Barbara Jackson, China Machado, Ramona Saunders, and Amina Warsuma.

Individually, each model gave memorable performances that were noted in the press and recollections of the show. Collectively, they functioned as ten Black female models engaged in scripted and unscripted performances that framed their Black female bodies within the context of their virtuosic runway performances. While models such as Donyale Luna (1966), Naomi Sims (1968), and Beverly Johnson (1974) were becoming the first Black women to appear as static images on the cover of mainstream publications such as British *Vogue*, *Ladies' Home Journal*, and American *Vogue*, respectively, the Black models at Versailles expanded the visibility of the Black female body as beautiful through live, embodied performance.

This chapter examines the Battle of Versailles Fashion Show within the context of Black performance. Specifically, I use textual analysis to understand how those who worked closely with the show's production as well as those in the popular press interpreted the Black models'

performances through a lens of exoticized Blackness. The chapter focuses primarily on footage and commentary from the documentary *Versailles '73: American Runway Revolution* and the book *The Battle of Versailles* written by Pulitzer Prize-winning fashion critic Robin Givhan. Following late cultural theorist Stuart Hall, I argue that Black people "have used the body—as if it were, and it often was, the only cultural capital we had. We have worked on ourselves as the canvases of representation" (109). He posits that, in being excluded from the cultural main-stream, Black people have found a way to innovate in spite of exclusion. How did the Black models at the Battle of Versailles Fashion Show use the materiality of their Black female bodies as "canvases of representation" that served the performative desires of American designers? How can their runway performances be read as performances of Blackness?

In the documentary *Versailles '73: American Runway Revolution*, model Pat Cleveland states that the presence that she and the other Black models had was "what no one else had … so the thing that may have been thought a flaw became the pearl." The flaw and pearl that she refers to is their Blackness. More specifically, it is their Black femininity, which historically has been categorized to reflect the alterity of the Black female body. According to Cleveland, the Black models' presence was a curiosity to white guests: "How did they get here? What are they doing here?" Cleveland says in the documentary. Former Ford model and late fashion historian Barbara Summers drew on the historical weight that the Black models carried that night, stating that for the women "who were possibly descendants of slaves to be the stars in this magnificent, shielded chateau" was a feat not only for American fashion but also for Black women (*Versailles*). Their bodies had been read as deviant and their beauty, historically, not fitting enough to be included in mainstream fashion publications and advertisements (Rooks). Stephen Burrows, the only Black designer selected to participate in the show, stated that the guests that evening had "never seen Black models so beautiful" (*Versailles*).[1] Perhaps that is because they had never witnessed Black women's bodies framed as beautiful in such a public forum.

Sociologist and Black feminist theorist Patricia Hill Collins discusses mainstream representations of Black women via the mammy, the Black matriarch, the welfare mother, the Black lady, and the jezebel (69–96). In her foundational text, *Black Feminist Thought: Knowledge, Consciousness, and the Politics of Empowerment*, she argues that these controlling images are connected to the experiences of Black women from chattel slavery to present day. On the stage, the Black models' performances were perhaps read as embodying Collins' ancillary subjects such as the Black lady and the jezebel in the ways that their movements were described by journalists who witnessed the show as well as by those interpreting it years later.

## "The core of who we were"

In 1969, in the midst of the Black Power and Black Is Beautiful movements, an article titled "Black Look in Beauty" ran in *Time* magazine discussing the influx of Black models who were appearing in mainstream fashion. When interviewed, Eleanor Lambert claimed that "this is the moment for the Negro girl … this is the look of now" (72–74), which acted as a barometer for fashion's sudden embrace of Black women who had become particularly desirable and commoditized for marketing purposes. Fashion theorists have argued that fashion is sustained by temporality—the constant changes of fashionable items, with clothing being used as a delin-eator of class and reserved for specific seasons (Simmel). Expanding this theory further, I con-sider the "temporality of Blackness"—the going in and out of style of Blackness and Black bodies in mainstream fashion, which often is back-dropped by moments and movements of racial solidarity. The Black Power and Black Is Beautiful movements relied heavily on visual and

bodily cues to express racial pride and solidarity (for example, the Afro and dashikis), and the appearance of Black models in the fashion industry for the very first time was not happenstance. Instead, it was a marketing effort to commoditize these movements to attract Black customers and readers who had been ignored.

Likewise, journalists writing about the Black models' performances in the Battle of Versailles did not neglect discussing their racial identity in relation to their beauty and performance. Journalist Phyllis Feldkamp, for example, wrote that "some of the girls—like Billie Blair, the reed-slim, dark-skinned beauty who moves like quicksilver—are superstars who hold their audience with disciplined performances on the runway" (cited in Givhan 251). Feldkamp, like Lambert, highlights not only the model's physique, which isn't uncommon in discussions about models of any race, but also describes the color of her skin. Is Blair's race being used as a qualifier to delineate her performance from that of other models?

Givhan writes that those involved with or attending the Battle of Versailles Fashion Show did not see the models as merely American models. Instead, they were described as "light-skinned blacks," the "black model," "categorically, uniquely and exotically black" (250). In addition, Givhan argues that it was not their beauty alone that made them stand out; it was also their racial identity alongside their performance. Throughout her text, she takes on the task of describing individual performances of some of the Black models in an effort to expound upon the contributions their performances made to the American designers' victory.[2] She writes of Pat Cleveland, modeling for Stephen Burrows:

> She emerged into the light, she was spinning like a top. She kept going, faster and faster, with the fabric of her dress fanning out around her tiny frame. As she got closer to the edge of the stage, the entire audience held its breath. She was twirling so fast it seemed as though she might spin right off the stage. She came to the very edge. And stopped. A perfect landing.
>
> (210)

Of Billie Blair, modeling for Oscar de la Renta, she writes:

> And out walked Blair in a filmy green gown, a kind of glamorous caftan, to play fashion's mesmerizing magician. She dramatically pulled a pink scarf out of her palm and five models emerged wearing pink chiffon gowns. She produced a lilac scarf and five models swanned across the stage cloaked in lilac.
>
> (213)

She describes Bethann Hardison, modeling for Stephen Burrows:

> Hardison came out onstage, her androgynous figure rocking from side to side in a proud swagger. She arrived downstage and fixed the audience with a death stare. And then she swiveled, the train swirling out behind her, and walked away.
>
> (210)

In addition to the ways in which observers discussed the performances, Black models also discussed their performances in relation to their Blackness. In *Versailles '73*, Cleveland states that the Black models' performances were the core of who they were. Their core, arguably, was their identity as Black women—their attitude, their movements, and the performative way they carried themselves onstage, which Givhan refers to as "swagger." It was as if the performative

core of their identity as Black women became both activated and authenticated during their performance on the stage. As E. Patrick Johnson argues in *Appropriating Blackness: Performance and the Politics of Authenticity*,

> Blackness does not only reside in the theatrical fantasy of the white imaginary that is then projected onto black bodies, nor is it always consciously acted out; rather it is also the inexpressible yet undeniable racial experience of black people—the ways in which the "living of blackness" becomes a material way of knowing.
>
> (8)

I contend that the Battle of Versailles Fashion Show capitalized on the models' abilities to stage essentialized notions of Blackness and the audiences' ability to interpret the Black models' performances within exoticized notions of Black Otherness. However, the show was also a space where the Black models operated within a both/and binary. While their performances might have perpetuated notions of the racialized Other, they were also subversive. As Johnson argues, "blackness has no essence," but "there are ways in which authenticating discourse enables marginalized people to counter oppressive representations of themselves" (3). While observers may have perceived the models as perpetuating controlling images that marked their bodies as Others, their performances were autonomous in the ways in which they scripted their own bodies, allowing them to demand power and reverse the gaze. As Pat Cleveland's body might have seemed out of control as she swirled furiously near the end of the stage, her awareness of the space she inhabited and her aptitude allowed her to deliver a performance of power that stunned both the audience, white models, and other participants in the show. As Billie Blair commanded models both Black and white with her scarf, her performance presented both a racial Other in possessing a sort of mesmerizing hypersexualized magic similar to that of the jezebel and a performance in which she is in control. Lastly, Bethann Hardison's death stare reverses the gaze. Hardison's stare is subversive in that as much as she is aware that her body is on display to model the clothes of Stephen Burrows, she is in command of her vision. She sees you, too.

## Conclusion

Johnson asks, "how are the stakes changed when a 'white' body performs blackness?" (2). If, for example, we interpret the bold "death stare" that Bethann Hardison reportedly gave audiences as a part of a performance that relied on Hardison's phenotypic and performative Blackness, how might the performance read differently if a white model did it? Would it seem to be appropriating Black performatives, or would it be read as doing something else entirely? In *The Battle of Versailles*, Givhan quotes Nicole Fischelis, who was dressing models during the show. Fischelis said that Billie Blair was moving with so much grace, "she was different from the French way" (213). Similarly, American designer Oscar de la Renta said the French models "were next to the black girls who knew how to walk [...] and they [the French] were flat" (212).

In *Versailles '73*, Oscar de la Renta is rumored to have stated that "the Black models ... made a difference" in the Americans' victory. As the American designers introduced the French fashion elite to the possibility of ready-to-wear designs, the Black models added movement to the clothing and the runway that, prior to their performance, had been relatively predictable in how models were to walk and appear in clothing. They introduced a possibility and confidence in movement that shifted the way models could embody clothing on runways, adding their personality to make each performance their own.

Despite their impact, the appearance of Black models on runways and on the covers of magazines soon declined. Perhaps it was due to the decline of the Black Power and Black Is Beautiful movements, causing Black models to no longer be in style as desirable tools for marketing. To counter this decline, a conversation on the lack of racial diversity in the fashion industry began to gain momentum in 2013. It was spearheaded by a host of working and retired Black models, including one from the Versailles show, Bethann Hardison. That year, Hardison sent letters to international fashion councils in New York, Paris, London, and Milan arguing that they were racist for their lack of inclusion of models of color on the runways. She wrote: "Not accepting another based on the color of their skin is clearly beyond 'aesthetic' when it is consistent with the designer's brand" (Phelan).

Givhan writes that after 1974 there was no longer a need for models to display their individuality, which meant that there was no longer a need for Black models "who had always been connected to personal showmanship" (258). She writes that during the time of the Battle of Versailles Fashion Show, "race was a dilemma that needed to be confronted … Blackness was topical … it inspired new aesthetics" (258) and, thus, the Black models present that evening presented a step in the right direction.

The Black model's presence and performances in the Battle of Versailles Fashion Show helped to propel American designers to victory and expanded notions of Black feminine beauty in the fashion industry. Designers used performances of Blackness on highly disciplined, beautiful Black models to sell a new aesthetic. However, as history has shown us, acceptance of Black beauty and celebration of performances linked to Black cultural identity do not necessarily translate into greater sustained inclusion or prolonged social justice. Clearly, there is much more progress to be made.

## Notes

1  This quote is from the documentary and wasn't contextualized. I interpret it as an assumption made by Burrows and a nod to the impact the models had on the predominantly white guests that evening.
2  In some cases, the American designers communicated their own ideas of how they wanted the models to walk. In others, the models performed based on their own ideas and experiences. Documented recollections of the event are not generally explicit about which portions of the models' performances were scripted and which were improvised.

## Works cited

"Black Look in Beauty." *Time*, vol. 93, no. 15, Apr. 11, 1969, pp. 72–74.

Collins, Patricia Hill. *Black Feminist Thought: Knowledge, Consciousness, and the Politics of Empowerment.* Unwin Hyman, 1990.

Givhan, Robin. *The Battle of Versailles: The Night American Fashion Stumbled Into the Spotlight and Made History.* Flatiron Books, 2015.

Hall, Stuart. "What Is this 'Black' in Black Popular Culture?" *Social Justice*, vol. 20, no. 1, 1993, p. 104.

Johnson, E. Patrick. *Appropriating Blackness: Performance and the Politics of Authenticity.* Duke UP, 2003.

Phelan, Hayley. "Racism on the Runway: How Bethann Hardison's Diversity Coalition is Changing Fashion," *Fashionista*, Sept. 2009, https://fashionista.com/2013/09/racism-on-the-runway-how-bethann-hardisons-diversity-coalition-is-changing-fashion.

Rooks, Noliwe. *Ladies Pages: African American Women's Magazines and the Culture that Made Them.* Rutgers UP, 2004.

Simmel, Georg. "Fashion." *Journal of Sociology*, vol. 62, no. 6, May 1957, pp. 541–58.

*Versailles '73: American Runway Revolution.* Directed by Deborah Riley Draper. American Runway Revolution Films, 2014.

# 64

# INTERVIEW WITH PAM GREEN

## Artist management and consulting

*Interviewed by Melanie Greene*
*October 5, 2017*

Pam Green is founder and president of PMG Arts Management, LLC, which provides booking, management, and consulting services to performing artists, companies, and organizations throughout the country (Figure 64.1). Learn more at pmgartsmgt.com.

MG: What attracted you to the field of arts management?

PG: I grew up in Boston where the Elma Lewis School of Fine Arts was a thriving insti-tution run by an African American woman training students to go into performing arts careers. She started a series called "Playhouse in the Park," which happened in Franklin Park, walking distance from my house. Duke Ellington would come and play every Fourth of July, and Olatunji, the amazing African drummer, would come and perform, and at [age] 4 or 5, I think, I had my first exposure to Chuck Davis, who would dance with Olatunji. That exposure planted the seed. I was always really curious: how do you put someone onstage and sell tickets, and how does that become an enterprise? What is a business model for that?

There was a Black concert producer named Al Haymon back in those days—"Al Haymon Productions presents Natalie Cole …" He went to Harvard business school and produced concerts in the Boston area back in the '70s and '80s. And so I would go to concerts and I would hear his name and wonder how that all worked as a business model. When I went to college at Duke I started working with Dance Black, the Black dance company on campus, and Karamu, the Black theatre company on campus, and decided to minor in theatre. I was a public policy major at the time, and the major had an arts administration track. So I pursued that while I was at Duke, from 1981 to 1985.

MG: Are there other mentors who inspired you once you got in arts administration?

PG: The American Dance Festival [ADF] was headquartered at Duke. I came out of class one day and I saw African dancers on the quad and I was curious. So a guy that I was dating at the time, who is now my husband, Isaac Green, wanted me to stay in North Carolina because he was in North Carolina. He was kind of interested in me being here so he could continue his pursuits. So he said, "What about that American Dance Festival? Why don't you apply there?" I called, and they said, "We want you to come be

*Figure 64.1*   Pam Green.
*Source*: Courtesy of Pam Green.

the space and equipment coordinator." So that's what I ended up doing. That introduced me to Charles and Stephanie Reinhart, who became lifelong friends and mentors. My boss there was also a woman named Nancy Trovillion who was, at the time, the managing director for the American Dance Festival.

Later in my career there were other people. Neil Barclay, Ron Brown, of course, who I have worked with for almost 20 years now. I consider him to be a role model because of his perseverance and his generosity to the field. Maurine Knighton, Mikki Shepard, Baraka Sele—those are all my mid-career mentors and people who continue to be my friends. Camille Brown and Joan Myers Brown are clients I've taken on in the last five years who continue to inspire me and be mentors to me, as well as me working for them.

MG: What is a typical day for you in your role as an administrator/arts manager?

PG: My primary goal is to help secure bookings and engagements for artists so that they can perform works that they have created. I help artists form strategic partnerships to secure funding for the development and creation of new work. And I also work very hard to create and connect communities to the artists' work, both onstage and off. So I spend a lot of time on the phone, talking in depth about what the artists are creating and doing, to try to help them contextualize the work. I'm not interested in just putting artists onstage to entertain. I'm really more interested in putting artists onstage who deliver a message or a story, primarily but not exclusively African American art and culture and history because I do have artists who are not African American on my roster. The majority of my time is spent talking to presenters and to the artists themselves, just

about what they're doing, how they're doing it, what the themes are, and how I can connect them thematically and to eventually get on those stages and get paid for it.

MG: Do you have cycles in the day when you work best?

PG: I work out in the morning and I get to the office around 10. I have a part-time assistant. We connect and talk about the business of the day—what got done the day before or what needs to get done that day—and prioritize. Has someone sent their contract back or not? What calls we have for the day? Then I dive into doing my follow-ups with the presenters that I've been working with to secure engagements, or trying to make phone calls to new presenters, or I end up having a lot of phone calls to schedule to be able to clarify what we are doing on upcoming tours or to provide greater clarity to people that I'm trying to talk to about the artist coming soon. We create budgets for artists to help them create work, and plan strategic partnerships. I talk to presenters about what the technical aspects of the creative work might be. That's how the days flow: managing paperwork, managing phone calls, and then trying to follow up on folks to secure opportunities that are in the pipeline.

MG: When you entered the field of arts management, what were the conditions like? What were the major challenges?

PG: When I entered it was a good time. ADF was my first formal job. ADF hired me, and paid me, and did not ask me to do an unpaid internship, which I think is a big hindrance to people of color getting into our field. I was given a lot of responsibility and independence in that job, but the field was still new. So the path to how you make it a career was still a little bit unknown. You had to rely on mentors and people who liked you and thought you were smart and deserving to help you move forward, and, most of the time early in my career, those were not people of color. Figuring out your path to an arts administration career is a little challenging. But I had opportunities to learn by being given a lot of independence and a lot of support as an employee.

MG: Are there additional challenges that you see since you've entered the field that affect you now?

PG: I made a very conscious choice to work for myself. I wasn't sure I wanted to go into an institution where somebody could potentially decide, because I was African American or because I wasn't something that they wanted me to be, could impact how I would move through my path in my career. So I avoided some of those institutional challenges. I think the 501(c)(3) business model for arts organizations does a lot to inhibit the ability of African Americans and other people of color to get into the performing arts field because [that model] is beholden to wealth, and we don't have the same kind of wealth that these institutions are accessing, so we're not at the table for hiring decisions or to push for diversity. The model also makes the institutions rely heavily on volunteers and people who can afford to be unpaid interns or ushers, and we don't have that flexibility as much.

MG: How have race and gender affected you in this field?

PG: When I first came to Duke, I went to the office that actually has the presenting program. It was all classical music and Broadway and not super diverse, but I saw that as sort of the equivalent to the Al Haymon and the Elma Lewis experiences. I asked for an interview to talk with the person who was running the program and was basically told to go away. I don't know why that happened, I'm not going to call that person a racist, but I think that might have had something to do with it. I really don't feel that

gender has been an issue for me. I'm a pretty strong person. A lot of our field is run by women. I'm a member of Women of Color in the Arts. I look around and see who all my mentors are; a lot of them are women who have succeeded in this business. A lot of arts administrators are women, especially the ones who run small arts councils and things like that. So I think our field is kind of fair to women until you get to the higher levels in some of these institutions and then gender challenges and differences might come into more focus.

MG: Name one accomplishment that you are most proud of.

PG: I am celebrating the twenty-fifth year of my company. I helped a lot of artists create and [I] experience all this work at the highest levels and in deep connective ways. I've maintained work-life balance. I've been married for 28 years to a terrific and supportive spouse. His name is Isaac. And I have two great kids; their names are Isaac II and Anica. They've allowed me to travel. I recently earned my master's degree in arts administration from Drexel just this past June. That was a five-year, really difficult journey because I had to do it at night and on weekends so that I could balance still working, taking one class a semester. So I think that's probably the thing I'm most proud of. I also recently won the 2017 NAPAMA [National Association of Performing Arts Managers and Agents] Liz Silverstein Agent-Manager of the Year Award. It was presented during the 2018 APAP [Association of Performing Arts Professionals] awards banquet in front of over a thousand people. It was simply incredible and one of the highlights of my life and career.

MG: If there was one thing that you would want to tell young people today, that they should know about your field, what would it be?

PG: It's a lot of fun. It's about relationship building, and it's really great to work with artists, that there is a career in working with artists, that you don't always have to be the rapper or the dancer, that you can also work behind the scenes and have a very satisfying career being connected to the arts but not necessarily always being the performer. It's very satisfying.

# 65

# SIDELONG GLANCES

## Black divas in transit, 1945–1955

*Katherine Zien*

In 2009, while researching at the Schomburg Center for Research in Black Culture in New York, I opened a box from the collection of West Indian Panamanian concert impresario George W. Westerman. Inside were publicity materials for Black performing artists whom Westerman had brought to Panama from across the Diaspora in the 1940s and later. For over a decade, Westerman organized concerts primarily for African American artists performing classical repertoires, including many Black opera singers. The Westerman divas, as I came to call them, were a heterogeneous group of accomplished Black women and some men, most hailing from the United States, who traveled to Panama to give concerts. Westerman's concerts began with lyric soprano June McMechen (1949), followed by operatic soprano Camilla Williams (1949), pianist Emily Butcher (1949), jazz singer and pianist Hazel Scott (1949), lyric soprano Dorothy Maynor (1950), operatic contralto Carol Brice (1950), operatic contralto Marian Anderson (1951), operatic soprano Ellabelle Davis (1951), classical pianist Philippa Duke Schuyler (1952), and operatic baritone William Warfield (1953). These artists had diverse backgrounds but shared a few traits: all were professionally trained at the most prestigious music institutions in the United States; with the exception of Scott, all performed classical music; with the exception of Warfield, all were female; and all were Black. In their repertoire, training, and comportment, the Westerman divas performed racial uplift and a gendered "politics of respectability:" a demure, domesticated upper-class womanhood (Gray, Rhodes). Their concerts featured programs modeled after that of Black tenor Roland Hayes: operas, *lieder*, art music, and a concluding suite of Negro spirituals presented as art song by "New Negro" composers and arrangers like H.T. Burleigh and Nathaniel Dett. These programs evinced the goal, articulated by Alain Locke, to apply European techniques to African American "mood and spirit" exemplified in the spirituals (Spencer 25–26).

The Westerman archive presented, albeit unintentionally, the divas as a cohort, an effect further aided by cross-references in their publicity materials. What does this archive tell me? What am I reading into (and over) it? In my book, *Sovereign Acts: Performing Race, Space, and Belonging in Panama and the Canal Zone* (2017), I discuss the myriad impacts of Westerman's concerts in and for Panama. In this chapter, I want to think about how the artists' publicity portraits represented them as globe-trotting performers when in fact one of their primary reasons for taking to international concert stages was their exclusion from the domestic US opera stage. Considering this group in its international and domestic circulation, I ask: how do the international tours of the

traveling Black divas reveal a *national* politics of race and gender in the United States? And what can their publicity portraits tell me about this national politics?

This query arose when I considered the divas' historical context, a time when representations of race, specifically US Blackness, confronted the Cold War (Dudziak, Plummer). Their performance style and content bridged the techniques of the New Negro movement and the postwar context, their singing bodies circulating (perhaps unintentionally) as "racial icons" and symbols of US capitalist democracy abroad. The divas' travels coincided with an increase in US diplomatic uses of Black artists to improve the international reputation of US race relations in the Soviet Union and those countries in Latin America, Asia, and Africa considered part of the "non-aligned world," neither communist nor capitalist. They performed at a time suffused with the imperative for the United States to export its culture to international venues.

The divas' concerts in Panama were privately sponsored, but as performers the divas were often conflated with US Black "cultural ambassadors" tasked with representing the United States abroad during the Cold War. Several (including Anderson, Schuyler, Scott, Warfield, and Davis) did perform on behalf of the US government, entertaining troops during World War II or traveling with the State Department's Cultural Presentations Program after 1956 (Croft 12–15). Both US and international audiences and critics cited Cold War discourses of race and nationality in describing the divas' concerts. Many audiences 'read' the divas as cheerful conduits of US national culture, individuals who triumphed over daunting racial and social odds, or, on the other hand, as focal points through which to critique US civil rights struggles. In my research for my book, I found that audiences in Latin America often cited US racism in their appreciation of the Black divas, as if to say that outside the United States there existed a cosmopolitan utopia of antiracist, appreciative publics. In this sense, the divas sometimes became pawns in inter-American ideological conflicts during the Cold War.

It is likely that the divas represented the United States to the world ambivalently at best. They vindicated Black communities quietly and did not take provocative stances. Famed baritone Paul Robeson, punished by the US government for his vocal political views, was an exception (Carby; Perucci, "Paul Robeson" and "Red Mask"; Zien, "Race"). Because the divas adhered to rigid behavioral rules on tour, including near-silence on matters of race relations despite the queries of international journalists, we are left to speculate about how they dealt with their symbolic roles. Most of these interpretations are not of the divas' making and ignore concrete reasons for their overseas tours—their desire to be financially stable, successful artists with high-caliber careers despite the absence of mainstream US support (Baldwin; Fosler-Lussier). Their stardom and international acclaim obscured their exclusion from institutions of high culture in the United States, a condition that many of the divas ultimately helped dismantle (Eidsheim 660–662; Guzman 90; Ingraham et al. 41).

Upon researching the divas' biographies, I found that many of them had taken to the international concert circuit because, as Black performers, they were shut out of US opera venues. This injustice—talented elites receiving praise for their skills abroad while shunned at home—resounds in the tragedy of Roland Hayes, a pioneering Black performer who came home to Mississippi from an illustrious international career only to be beaten by a white mob at a gas station (Brooks and Sims 242–256). While the opera divas whom I researched did not share such a violent fate, they confronted racism and exclusion about which their formal, conservative careers did not often allow them to speak openly. Although these divas were elites, their class status did not protect them from the racist interpretations of audiences, critics, and lynch mobs back "home" in the States. Marian Anderson is a famous exemplar. Framed as an artist-diplomat and a symbol of racial uplift, Anderson was often pressed to speak about the race and

class challenges that she transcended in the United States. She rarely voiced criticism, although these aggressions must have been unbearable. Her public face depended on her stoicism.

While I mused upon this charged context, the divas' celebrity portraits held my attention. The irony of their performances of restrained humility on tour, even despite their phenomenal achievements, resonates in their portraits. While some of the portraits presented the divas locking eyes with the viewer, a notable portion featured their subjects gazing to the side, averting their eyes and seemingly refusing to meet the viewer's stare (see Figures 65.1 and 65.2). I was compelled by this repeated pose, both a generic, familiar image created in the Hollywood studio and strikingly nuanced. The portraits feature broad smiles or no smile, dreamy or implacable eyes, and sharp visual vectors. Initially I saw the divas' refusal to look at me as a passive and submissive deferral. But I began to find something empowering in the divas' aversion of their gazes—what historian Darlene Clark Hine might call their "dissemblance," protecting inner lives despite an "appearance of disclosure" (915). Although the portraits were posed, and likely *imposed* by the studios or record label, the divas' sidelong glances created subversive inroads into a sense of self

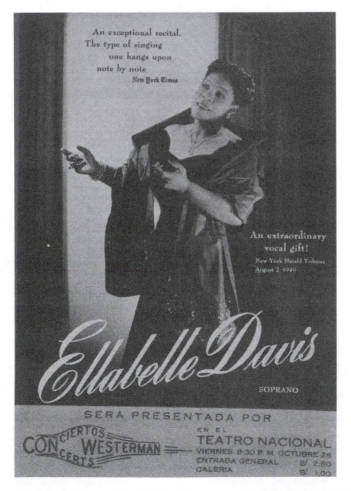

*Figure 65.1* Concert handbill depicting soprano Ellabelle Davis (*c*.1949).

*Source*: Manuscript, Archives and Rare Books Division, Schomburg Center for Research in Black Culture, New York Public Library. Astor, Lenox, and Tilden Foundations.

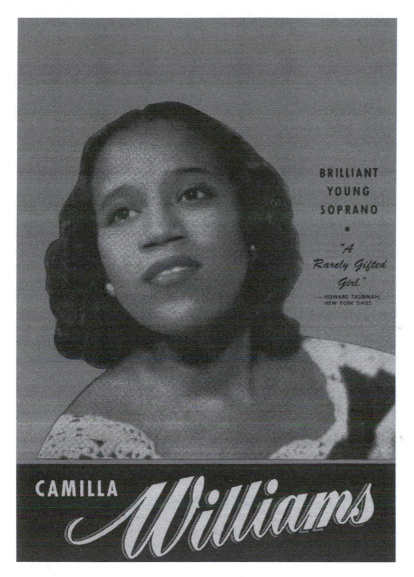

*Figure 65.2*  Camilla Williams, brilliant young soprano (1949).

*Source*: Manuscripts, Archives and Rare Books Division, Schomburg Center for Research in Black Culture, New York Public Library.

kept separate, or sheltered, from voyeuristic gazes. The portraits provide insights into possible techniques of escape through that which cultural theorist Kevin Quashie calls "quiet," or "the expressiveness of the interior" (21).

In my view, the portraits also allow the divas to distance themselves from the racist assumptions of both domestic and international concert audiences and critics. Because classical music was (and is) canonically Western and implicitly white, many audience members assumed that nonwhite singers could not perform such repertoire without somehow impinging on its supposedly "unmarked" form and content. This repertory politics is researched by sound studies

scholars Nina Eidsheim and Jennifer Stoever. Stoever and Eidsheim document extensive public scrutiny of Black female opera singers, ironically almost more so than their counterparts in popular entertainment (Eidsheim 648–653; Stoever 79–88). Images and sounds co-circulated in opera singers' tours as publicity materials surrounded the performances. In this sense, the portraits form valuable intertexts, announcing the divas' gender and race even as they frame their stardom and "high" art.

The portraits stage modernity in race, class, and gender not only as respectability politics but also as a body desiring autonomy, grandiosity, and agency. Performance scholars Shane Vogel and Deborah Paredez describe Lena Horne and, implicitly, other Black divas, as "racialized women who … have dared to publicly perform their desires [and who] taught [marginalized groups] how to claim … subjectivity" against histories of derision, objectification, and over-determination (Paredez 107). Vogel highlights Horne's withholding of expressivity, which he calls a performance of "impersona:" a "psychic distance and aloofness from her audience" (20). This distancing resounds in the portraits. Photographs exist in "the tension between definitiveness and uncapturability, how what cannot be captured is and then, as one looks beyond the frame and image, is not" (20).

The portraits utilize the respectability politics of photography to do this work. Photography, and specifically portraiture, has played an important role in the history of Black respectability. During the New Negro movement, the medium became an integral means of "reconstructing" images of blackness, and literally (re)presenting a new face (Gates 129–135). Against the onslaught of minstrel caricatures that assaulted US citizens on billboards, household items, and insignias of every kind for over a century, photography was seen as an objective marker of racial uplift. New Negro portraits showcased their subjects' bourgeois, upstanding personhood in all its facticity. Movement leaders W.E.B. Du Bois and Booker T. Washington both created portrait anthologies as visual antidotes to the minstrel logic that suffused the US signscape (Gates 136–146; Stephens 193–95). As cultural theorist Michelle Stephens notes, "the portrait photograph … far from being a more authentic representation of the black ex-slave at the dawn of the new century, is the very medium through which the modern black subject was turned further into a sign" (194). The portrait's *characteristics*, specifically of heads and faces, came to stand in for inner *character* (Gates 143). For instance, portrait sitters often closed their mouths in contrast to the min-strel caricature's slack-jawed, gaping grin. "It was in the New Negro movement … that black … performers in the United States first claimed the power to frame their own faces, deploying portraiture to capture their vision of a social self" (Stephens 194). Performance scholar Harvey Young observes that "the performance of the photographic subjects … demonstrate[d] the efforts of black folk to rehabilitate and, indeed, refashion societal images of the black body" (29). Portraits also contested insidious uses of photography for ethnographic displays of Black bodies, as in images of naked captives forcibly posed for a scientific gaze.

Young, like performance theorists Amelia Jones, Rebecca Schneider, and Laura Levin, places photography "between stillness and motion," "life and death" (45; Jones 973). In the perform-ance of portraiture—even publicity shots—the subject "poses as an object *in order to be a subject*" animated through the pose into a dance of liveness with the viewer (Jones 959). This liveness means that we spectators co-create the photograph's meaning, rendering it an event, an inter-subjective duet, and thus allowing new interpretations to arise apart from the intentionality of the portraits' sitters and production team (Levin 330).

If "divas are always more than the gesture which has become their trademark," then the portraits of Westerman's divas strike between gesture and pose (Henson 153–154, 157). And their bodies, struck (and stuck) between movement and stillness, strike at something within me, the viewer. Their portraits stage complicity and agency in creating an impression of Black passivity.

It's a forceful engagement with passivity, a sense of repose, of drawing back and away from the viewer, a quiet refusal. I am purposefully reading into the photographs, of course, creating meanings through my reception that may or may not have been present during their production. The aesthetics of their medium collide with my desire for that which is unknowable—the off-frame space—and their performance of that which is inscrutable: a raced, gendered, and classed interiority held away from my gaze (Metz 87). This gesture of breaking the chain of looking and being looked at by looking away allows the divas to retain an interiority that is apart from their public face as performers and sometime cultural ambassadors. It allows for a certain kind of privacy, a sovereignty of quiet. Alongside the multiple symbolisms that the divas performed on tour, we must learn to locate the *quiet* in their song: a means of signaling their humanity, individuality, and interiority, away from the representational trap of serving as racial icons at midcentury (Vogel 21).

# Works cited

Baldwin, Kate A. *Beyond the Color Line and the Iron Curtain: Reading Encounters between Black and Red, 1922–1963*. Duke UP, 2002.

Brooks, Christopher Antonio, and Robert Sims. *Roland Hayes: The Legacy of an American Tenor*. Indiana UP, 2015.

Carby, Hazel V. *Race Men*. Harvard UP, 1998.

Croft, Clare. *Dancers as Diplomats: American Choreography in Cultural Exchange*. Oxford UP, 2015.

Dudziak, Mary L. *Cold War Civil Rights: Race and the Image of American Democracy*. Princeton UP, 2000.

Eidsheim, Nina Sun. "Marian Anderson and 'Sonic Blackness' in American Opera." *American Quarterly*, vol. 63, no. 3, 2011, pp. 641–671.

Fosler-Lussier, Danielle. *Music in America's Cold War Diplomacy*. U of California P, 2015.

Gates, Henry Louis. "The Trope of a New Negro and the Reconstruction of the Image of the Black." *Representations*, vol. 24, 1988, pp. 129–155.

Gray, Herman. "Introduction: Subject to Respectability." *Souls: A Critical Journal of Black Politics, Culture, and Society*, vol. 18, nos. 2–4, 2016, pp. 192–200.

Guzman, Jessie P. "Conserving and Enriching the Social Heritage." *Negro History Bulletin*, Jan. 1, 1948.

Henson, Karen. *Technology and the Diva*. Cambridge UP, 2016.

Hine, Darlene Clark. "Rape and the Inner Lives of Black Women in the Middle West." *Signs: Journal of Women in Culture and Society*, vol. 14, no. 4, 1989, pp. 912–920.

Ingraham, Mary I., et al. *Opera in a Multicultural World: Coloniality, Culture, Performance*. Routledge, 2016.

Jones, Amelia. "The 'Eternal Return': Self-Portrait Photography as a Technology of Embodiment." *Signs: Journal of Women in Culture and Society*, vol. 27, no. 4, 2002, pp. 947–978.

Levin, Laura. "The Performative Force of Photography." *Photography and Culture*, vol. 2, no. 3, 2009, pp. 327–336.

Metz, Christian. "Photography and Fetish." *October*, vol. 34, 1985, pp. 81–90.

Paredez, Deborah. "Lena Horne and Judy Garland: Divas, Desire, and Discipline in the Civil Rights Era." *TDR/The Drama Review*, vol. 58, no. 4, 2014, pp. 105–119.

Perucci, Tony. *Paul Robeson and the Cold War Performance Complex: Race, Madness, Activism*. U of Michigan P, 2012.

———. "The Red Mask of Sanity: Paul Robeson, HUAC, and the Sound of Cold War Performance." *TDR/The Drama Review*, vol. 53, no. 4, 2009, pp. 18–48.

Plummer, Brenda Gayle. "'Below the Level of Men': African Americans, Race, and the History of US Foreign Relations." *Diplomatic History*, vol. 20, no. 4, 1996, pp. 639–650.

Quashie, Kevin Everod. *The Sovereignty of Quiet: Beyond Resistance in Black Culture*. Rutgers UP, 2012.

Rhodes, Jane. "Pedagogies of Respectability: Race, Media, and Black Womanhood in the Early 20th Century." *Souls: A Critical Journal of Black Politics, Culture, and Society*, vol. 18, nos. 2–4, 2016, pp. 201–214.

Spencer, Jon Michael. *The New Negroes and Their Music: The Success of the Harlem Renaissance*. U of Tennessee P, 1997.

Stephens, Michelle Ann. *Skin Acts: Race, Psychoanalysis, and the Black Male Performer*. Duke UP, 2014.

Stoever, Jennifer Lynn. *The Sonic Color Line: Race and the Cultural Politics of Listening.* New York UP, 2016.

Vogel, Shane. "Lena Horne's Impersona." *Camera Obscura*, vol. 23, no. 1, 2008, pp. 11–45.

Young, Harvey. *Embodying Black Experience: Stillness, Critical Memory, and the Black Body.* U of Michigan P, 2010.

Zien, Katherine. "Race and Politics in Concert: Paul Robeson and William Warfield in Panama, 1947–1953." *The Global South*, vol. 6, no. 2, 2013, pp. 107–129.

———. *Sovereign Acts: Performing Race, Space, and Belonging in Panama and the Canal Zone.* Rutgers UP, 2017.

# 66

# BLACK INDIANS OF NEW ORLEANS

## Performing resistance and remembrance

*Sascha Just*

New Orleans is famous for its carnival festivities. Following the Christian calendar, carnival season begins on January 6, also known as Twelfth Night, and concludes on Mardi Gras Day or Fat Tuesday. Every year during those weeks, the main streets are filled with parades, street dancers, brass bands, and costumed revelers on floats and trucks, throwing beads and trinkets to eager tourists while carnival organizations ("krewes") celebrate at lavish private costume balls behind closed doors. On Ash Wednesday, many of those who partied into the early morning can be found in church or wearing palm branch ashes in the shape of a cross on their forehead to signify penance. This is the familiar picture.

A not so familiar picture emerges in neighborhoods traditionally populated by African Americans, such as the Tremé, the Seventh Ward, and the Ninth Ward. Here, carnival is celebrated very differently and with a different purpose. Every year on Mardi Gras Day, African American groups, collectively called the Black Indian tribes of New Orleans, parade down the streets in feathered and beaded suits and reenact Native American warfare to honor those Native Americans who aided their enslaved African ancestors escape from bondage. While paying tribute to their ancestors' battles against white colonizers and slaveholders with their performances, Black Indians also express their opposition to racism in today's society. Thus, their Mardi Gras performances are a form of political theatre.

Completely self-sufficient in their carnival festivities, Indians[1] perform within and, most importantly, for their communities. As the annual highpoint of a social system that exists parallel to New Orleans society, Indians' Mardi Gras performances hold an importance for their community that exceeds the meaning most mainstream carnival participants attribute to their parties and festivities.

### The tribes

Each year, as part of the mainstream carnival tradition, Rex, New Orleans' King of Carnival, is chosen to play his role at select events, as are King Zulu of the Zulu Social Aid and Pleasure Club and other kings, queens, and courts of carnival organizations. In contrast, membership in Indian tribes commonly lasts for many years, if not for life, and requires absolute dedication to the chief and, in some cases, to a queen. The tribes are hierarchically structured and centered on a big chief. Vital positions in the tribe are: wildman, whose

371

typical attire, a cap with sharp horns, signifies his responsibility to defend the chief; spyboy, whose suit is the lightest so that he can run and stake out other tribes; the flagboy, who carries the tribe's emblem (a sturdy flag made of beads and feathers); and the trail chief, who closes the procession. Most tribes include a queen and a second queen. Traditionally, the queens' role is to augment the chief's beauty. Over time, however, gender roles have shifted. Some women have started their own tribes, and others have gained attention for their spirited presentations and beautiful costumes.

## Suits and masking

Black Indians refer to their garb as suits rather than as costumes, and the term "masking" (the process of wearing an Indian suit and performing in it) means showing themselves rather than acting a part. Instead of temporarily assuming a fake persona as a costume would suggest, Black Indians reveal their identities as Indians by wearing an intricately designed suit. Traditionally, Indians mask only on Mardi Gras Day, St. Joseph's Night, and Super Sunday.[2] Throughout the year, they dedicate a large portion of their time to designing and sewing their suits with the aim to produce a more impressive one each year. Many Indians begin working on a new suit right after Mardi Gras. In particular, beading ornaments is time-consuming and physically taxing. Frequently, they receive support from spouses, friends, or relatives to sew the suit worn under the decorative suit. This "undersuit" is usually made of silk or a similar material in the dominant color of the exterior suit. While the exterior suit is created manually, the undersuit is sewn on a machine.

While each suit expresses the wearer's taste, he or she is usually expected broadly to follow the style of the tribe's Chief in order to signify unity. Tribes identify with their neighborhoods, and local distinctions are conveyed with specific sewing and beading styles; yet, all suit styles reference Black Indians' Native American and African heritages. The suits' rich ornamentation and monumentalism present Indians as heroic and celebrate Black beauty, in particular Black masculinity. For example, tribes that like the Golden Eagles, led by Chief Monk Boudreaux, that reside in New Orleans' uptown area typically use plume feathers to decorate their crowns. The beaded patches on their suits are flat, featuring narrative scenes from Native American and African American history. Battle scenes between white colonizers and Native American warriors or African Americans struggling with enslavement or lynching are very popular.

Suits by downtown tribes, such as the Yellow Pocahontas, typically feature abstract beaded ornaments evocative of West African design patterns that protrude from the suit. Their crowns echo the headdresses of some Prairie Native Americans with long, slim feathers. Instead of two strands of feathers extending to the right and the left, theirs are connected, forming a large oval. A crown can weigh up to 60 pounds, reach 5½ feet in width, and extend close to 6 feet in length.

Indians from all neighborhoods sew images of deceased family members onto their suits. Beyond commemorating loved ones and their courageous deeds, such effigies contribute to creating a legacy and remembering their history of struggle. Consequently, the suits function as visual, political statements, defying white standards and ideals. They also serve to counter stereotypical roles often assigned to people of color while commemorating the courageous battles their ancestors have fought.

## History and heritage

Although some historians have argued that African American visitors to the Buffalo Bill Wild West Show in New Orleans in 1884 or 1885 may have witnessed dramas or exhibitions that

inspired Black Indian performance traditions, the history that Indians share within their communities does not support this claim. Reliant on stories and information passed from one generation to another within families and communities, Black Indians privilege the archival resource of their collective memories and the authority of their community's knowledge-production over the information available about them in sparse written documents created primarily by those outside of the tradition. According to Black Indian oral accounts of their history, the tribes began parading in New Orleans on Mardi Gras Day in the late nineteenth century at the end of Reconstruction when the city was segregated by Jim Crow laws. The timing of their inception suggests a response to or at least a correlation with the political shifts and tensions of the period.

This broader history is supported by genealogical history shared by community leaders like Big Chief Darryl Montana, head of the Yellow Pocahontas tribe. According to Montana, the first official tribe of Black Indians was founded in 1879 by his great-great-uncle, Becate Batiste, the son of a Native American and a formerly enslaved African. It was called the Creole Wild West. The Yellow Pocahontas emerged from that original group and was led for many years by Montana's father (Becate Batiste's great-nephew), late Chief Allison "Tootie" Montana (1922–2005). Whereas several other tribes such as the Guardians of the Flame, the Golden Eagles, the Creole Osceolas, and the Wild Magnolias have earned renown in the city for their impressive suits and inspiring presentations, Chief, Tootie Montana is credited not only as a master designer of suits and crowns but also as the leader who worked for 50 years to change the violent tribal confrontations of his youth into the artistic competitions we witness today.[3] Following Big Chief Montana's family history, then, Becate Batiste founded the first Black Indian group to honor the cultural influences of both sides of this family and as a means of intervening in the regressive Reconstruction era politics of his time.

## Rehearsal

As a way to rehearse, create unity, and uplift the spirit, Indians practice their songs and dances at neighborhood bars every Sunday from November to Mardi Gras Day. They are led by the chief, and no drums are played at these so-called drum practices. Instead, members of the tribes gather in a circle and use tambourines to accompany their singing and dancing. Through these folk songs, like "Shallow Water, Oh Mama," "I Sew, Sew, Sew," and "My Big Chief Got a Golden Crown," practitioners share feats of heroic Indian ancestors and how their tribes have entered into legendary status in New Orleans' Black communities. Several of these songs have entered pop culture through interpretations and adaptations by bands like the Meters, the Neville Brothers, and the Dixie Cups. Because of the repetitive patterns, each song can last between 30 minutes to an hour, and the total practice can last between three and four hours. Practices end with the Indian hymn "Indian Red." During the singing of "Indian Red," members of the tribe dance toward the Chief, demonstrating with a series of codified martial movements and gestures that they will defend him by any means necessary. The lyrics include:

> We are the Indians,
> The Indians of the nation.
> The whole wide creation.
> And we won't bow down,
> Down on that ground.[4]

The anthem affirms Indians' sense of connection with Native Americans as well as their determination to resist oppression.

## Mardi Gras Day

On Mardi Gras Day, each tribe observes its own rituals but many generally follow this pattern: The chief, in full garb, steps out in front of his house and presents himself to his community with a song evoking the past year of hard work preparing his suit and the ancestors that helped him on his path. He then greets the members of his tribe. One after the other, cheered on by the crowd and accompanied by the steady beat of drums, spyboy, flagboy, queen, and wildman dance toward their chief, freeze in a dramatic pose, and are embraced by the chief. The singing, dancing, and one-on-one greetings continue until finally, to the ecstatic shouts of the crowd, the crown bearer ceremonially places the crown on the chief's head. After the crowning, a growing second line of friends, family, and fans accompany the tribe as it parades through the neighborhood streets crowded with Mardi Gras celebrants, spectators, and other Indian tribes.

Usually, the spyboy runs ahead to alert of friendly or rivaling tribes. Flagboy follows him, carrying the tribe's flag. Protected by the wildman and with the queen by his side, the chief guides the procession. The second chief and the second queen follow directly behind them. Often children and grandchildren walk in the middle of the processions while a trail chief completes the group and walks at the end. Along the way, they stop to greet other tribes or to confront them in so-called mock battles. These confrontations vary, yet frequently they are highly theatricalized with large gestures and exaggerated poses.

Typically, the flagboy pounds his staff on the ground and loudly announces his tribe's name to the other tribe's flagboy. Then, the chiefs greet each other. The dances and poses that follow emulate actions from battles and allow them to show off their suits to each other. Indian festivities are driven by fierce competition over which tribe's chief is the "prettiest"— which chief designed the most awe-inspiring suit. There is no jury to decide other than the vocal approval of the onlookers and the size of the crowd that stays with a tribe throughout its procession. Before the tribes part ways, the chiefs usually embrace, complimenting each other as "pretty." At the end of a long day of parading, the tribes meet and celebrate into the night.

## Community theatre

Since the first group of Indians reenacted the obstacles that their African and Native American ancestors had to overcome, Indian culture has faced many challenges. From their very inception, performing their stories and experiences was a tool to survive, to express their viewpoints, and to give meaning to their struggle. To persist on their path, Indians have drawn strength from their heritage and their belief in those people who initiated and passed on these traditions. The essence of Black Indian carnival traditions is theatrical. It relies on using precise costuming, characters, staging, and a rehearsed script to reenact their ancestors' battles to oppose marginalization and oppression. Strictly local, Black Indian performance traditions are communal. They tie individual Indian artists and their tribes to their neighborhoods, enriching their communities all year round.

## Notes

1 The name preferred by the tribes.

2 St. Joseph's Day, March 19, is a Christian (Ca... *Orleans* of the Virgin Mary. Super Sunday is the closest... Sunday during the day and on St. Joseph's day at ...

3 In earlier phases of the tradition, intertribal m...al) holida... altercations. As suits grew in size, weight, complexity, Joseph's D... fighting ceased or vanished altogether.

4 Recorded by the author, February 19, 2012.

# INTERVIEW WITH DARRYL MONTANA

## Black Indian chief and master artisan

*Interviewed by Loyce L. Arthur*
*March 2015, September 2017, and January 2018*

Chief Darryl Montana of the New Orleans Black Indian tribe Yellow Pocahontas has made Black Indian suits for 50+ years. He learned the techniques and practices from his father legendary Big Chief Allison "Tootie Montana." There is a familial line of chiefs that goes back to the first appearance of the Indians in the 1880s. Black Indians prefer the term suit[1] rather than costume. To them the word "suit" signifies the ritualistic process of creating and presenting the suits in the aesthetic mock battles that take place on carnival days. A suit is a statement of Black pride and represents a test of skill, strength, fortitude, and endurance. Chief Montana brought out his last suit in February 2016 and has since retired, except for special projects (Figure 67.1).

LA: How old were you when you made your first suit?"

DM: I started sewing when I was 6. And I made my first suit at 9. (He made his last at 62) When I first started, I will never forget it. I was in white and most of my stuff was flat pieces and back then we used to make it sit up, we used to take and put tissue paper behind it […] That particular suit I was in white and my Daddy was in white swans, [feathers], so I had a three-dimensional white swan. Everything else was flat and I made [the swan] sit up by stuffing it with paper. I can remember that suit like it was yesterday. This was in 1964.

LA: You had a passion for it? What happened in the next years?

DM: The next year I started sewing more and I started making my own suits—more detailed suits. It took me awhile to get from that to where I am now but I can remember those suits. But now to look at them, those suits are kinda like a joke! (Laughs) But as time went on I got a little more serious with it and I kept adding and adding and before you know it my suits just blew up.

LA: Do you remember the point when you went from copying your father's methods to doing your own designs?

DM: I remember I would just create stuff, but early on my Daddy had patterns that were stencils and I would go and dig through them to see what I might want to have. But then after a while it got to a point that I really wasn't feeling what I was doing because

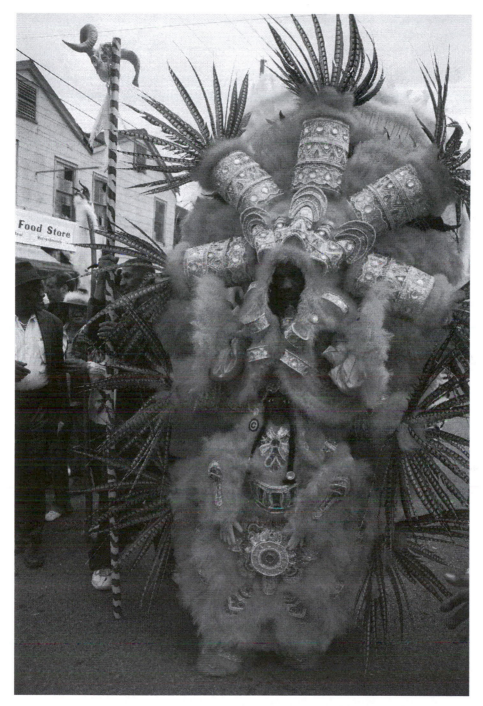

*Figure 67.1* Big Chief Darryl Montana of the Yellow Pocahontas, Mardi Gras (2007).
*Source*: Photograph by Cynthia Becker.

I was just copying what we had and I wasn't putting any creativity in it of my own. So I started experimenting … When you start creating then you start to separate—you want to separate yourself from the rest.

LA: What is the difference between your father's suits and yours?

DM: Most of the design work—my daddy was more abstract. A lot of times I would have themes. He wouldn't have themes. He did abstract pieces.

One time, I did the theme of King Tut. I had the pyramids, the scarabs, the sphinx—I had that in the suit. I even had the building—the tomb of King Tut—King Tut was lying in the tomb on my apron! I was coming up with some stuff! I would always try to come up with a conversation piece because long after this—a lot of years after King Tut—I met a guy that I know and he would say "Man I've seen a lot of your stuff but the prettiest suit you made to me was King Tut." And I used to hate hearing people tell me that. I mean I appreciated that they said that about my work but I kind of hated it too because I felt that from King Tut I wanted to grow more. I was always trying to see what I could do to get out of that King Tut thing. So I started dealing with the crowns.

LA: Making them bigger and more elaborate?

DM: Different. One year I missed and I helped this guy with his suit and I did his crown and everybody that saw him on the street said, "That's a nice crown but I know whose hands was in it." You know what I'm saying? […] That's probably going to be my legacy. And I always wanted that. I did not want to be my Daddy, I wanted to be me. And I believe that I'm the undisputed champion when it comes to the crown because I've set that standard. You know?

LA: How many beads and sequins are in a suit?

DM: I tried to estimate it one time, but it's hard to say how many … (pause) 100,000? Each sequin has a bead to hold it on. There are 500 sequins on a string. You may use 25 strings, 4 colors … (pause), so maybe 100 strings? I use 6 mm sequins, about the diameter of a pencil eraser. That's 16 sequins per inch and the crown alone can be 3 x 3 feet in diameter. With feathers the crown can be 72 inches wide and 12 feet tall.

LA: Where do you get your materials?

DM: There are a few family places around. I used to go to them when I was 7 years old. Later, I ordered from places in New York. On the packages you'd see that things came from all over the world—Japan, China, the Czech Republic. You could see from the labels. Ordering direct saves money. It's always a matter of saving money or losing time. Things can happen. You may need to send (feathers) back to re-dye, losing time. Guys used to laugh at me cause I say "I'm on a budget!" If I think ahead—before Thanksgiving, I can get what I need. If I'm using pearls—12 strings for $20. I'd need 180 strings. At a local store it could be $6 a string! If I don't plan it could be $700 or more!

LA: Each chief pays for their suits? You have a "day job?"

DM: Yes, it's all my money. The last years I did speaking engagements to pay for them. I'd do a gig, [a performance wearing the suits] but that's a lot of wear and tear on the suits. In the early years I worked for a printing company and in a hospital emergency room for 7–8 years. I used to do lawn care and landscaping but not anymore.

LA: What else goes into making a suit?

DM: If this was a year ago, this date and time (September), I couldn't sit down and talk with you because I would have to be working on my suit. Your life is centered around that. And it's a lot of pressure especially when you're in a chief position where you got all

these other members depending on you to make it and you have the most work to do. For you not to complete your task, then, you've let all these people that's in your tribe, that's coming up with you, you've let them down—not even thinking about the community, you know, and it's like you feed off of them […] But you gotta keep pushing yourself cause you don't want to let these guys [down], that want to make the sacrifice— because it is a sacrifice and I believe you really, really, have to give them respect. You make a sacrifice because your community is counting on you … (pause) and that's a big thing to carry!

I'm just so, so, appreciative that the times I came up in it [the tradition], it was like the last of the good old days, you know what I'm saying? I came up around the true soldiers […] And these were guys we looked up to that were in it and they're no longer here. But at least I was there, you know what I'm saying? It's really not easy.

LA: It was important to you, to keep the tradition going?

DM: Let me say this—I'm gonna speak to me cause I believe everybody go through their own thing. I remember my Daddy said "Sometimes you could be in it, in the house working on your stuff and the house is quiet and you just kind of thinking about—because the whole while you're working you kind of basically—your mind is going through some kind of transformation to get to that point where you put your suit on." So it's constantly in your head, you know, you're just thinking about it and dwelling on it and then when you get to the point where you put your suit on, you go through a whole lot of feelings. Like with me, I look at a lot of the sacrifices that I know I've made. Cause a lot of times when you make the journey of making these suits there's no guarantee you're going to finish it … (pause), I tell people this, you put in time preparing and working on this suit—it's so much feelings involved in it, you know, I mean it consumes your life! And you find yourself at a point where you have no life. And people say, "Oh you have a life—this is your life!" But a lot of times you feel like you want to just be able to sit down and not have to do that and do other things cause life is short, you know? […] Basically I have given it my all. And the rest is for me now, you know? Like you get your life back again cause, you know, that was my life.

LA: What's your view of the tradition today?

DM: I kind of feel today that the majestic side of what I've done, what I've given—I kind of feel that I've played a role in this effort in this tradition […] I have hope. I just want them (younger chiefs), to keep it going. So that my neighborhood the Seventh Ward, never again (becomes) a dead zone, you know?[2] […] I just want to watch it. I just wanna see, you know?

## Notes

1 A suit consists of a crown, a chest piece, an apron, and arm and leg cuffs.
2 The Seventh Ward was devastated by hurricane Katrina. Many of Montana's father's suits were lost.

# 68

# AFRICAN PERFORMANCE IN THE FEAST OF ST. FRANCIS XAVIER IN SEVENTEENTH-CENTURY LUANDA, ANGOLA

*Margit N. Edwards*

**"Princesa Dona Isabel"**[1]
Princesa Dona Isabel, a onde vai vou passear
Eu vou para Luanda, vou quebrar saramuná
Eu vou, eu vou, eu vou para marchar
Eu vou para Luanda, vou quebrar saramuná.
(repetir)

Princesa Dona Isabel, where am I going,
I am going to Luanda, I am going to break into a dance
I am going, I am going, I am going to march
I am going to Luanda, I am going to break into a dance
(repeat)

The song lyrics above belong to a repertoire of Afro Brazilian *Maracatú* songs expressing long held desires for a return to the colonial city of Luanda, Angola, the enslaved Africans' last connection with an African homeland. A carnival tradition from Pernambuco State in the northeast of Brazil, *Maracatú* is most popular in the cities of Recife and Olinda and has its origins in the crowning of the King of Kongo ceremonies held by the enslaved Africans on the plantations. Some scholars suggest, though, that clear lines of retention can be drawn from the Feast of St. Francis Xavier in seventeenth-century Luanda to modern-day carnival traditions in Angola and Brazil (Birmingham; Fromont). I would suggest that the Jesuit chronicle *Documento No. 77*[2] serves as an illustration of a society in the earliest stages of transculturation as demonstrated by intercultural performance exchanges between the Portuguese and the Africans, and that many of the captured Africans who landed on the shores of the Americas were already participants in that process. These intercultural exchanges that occurred in west central Africa lay the foundation for these traditions to develop in the Americas and locally in Angola and São Tomé e Príncipe today.

On September 27, 1620, the city of Luanda began an eight-day festival celebrating the beatification of Padre Francis Xavier, a Jesuit priest renowned for his missionary work in

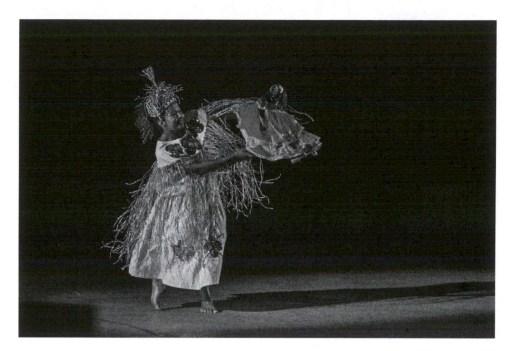

*Figure 68.1*   Contemporary theatrical Maracatu dancer, Jameelah Silva, Viver Brasil Dance Company (2007).
*Source*: Photographer Jorge Vismara.

India, Japan, China, and the east coast of Africa during the sixteenth century. The festival in Luanda, though, was part of the process of beatification prior to canonization, as he was not canonized until 1622. The purpose of the festival procession was to ceremonially install the Padre's holy relics, or bones, at the Jesuit college in the heart of the city. After two months of citywide preparations that included redesigning the city streets to more resemble Portuguese aesthetics, the city leaders launched an elaborate multi-float procession, each depicting an aspect of the Padre's life and accomplishments, as well as commemorations from the surrounding African Kingdoms, including the Kongo, the Mbundo, and the subjugated Ndongo. Each of the performances highlighted in this article illustrate different aspects of the economic and political relationships among the Portuguese royal court, the west central African Kingdoms, and the Roman Catholic Church. This includes the intricate networks circulating among the interior (Kingdom of Kongo), the metropolis (Luanda), and the off-shore creolized islands (São Tomé).

These performances reflect Luso-African activity in the process of intercultural exchange and cultural appropriation driven by religious devotion and supported by commercial efficacy and political savvy. It is important to note that the King of Kongo was a devotee of the Catholic faith. Yet, by the time the Feast of St. Francis Xavier wound its way through the streets of Luanda in 1620, a Kongolese Christianity had developed that troubled the Roman Catholic Church. Thus, one must consider the role of Christianity and its political and economic import in west central Africa during this period.

Beginning with an embrace of Christianity by the Kings of Kongo in the fifteenth century, religious transculturation was in process for almost 200 years. Transculturation refers to processes of intercultural exchange and transformation driven by relationships to power. Cultural exchange between equals becomes cultural appropriation when one group creates a new cultural product

with traces of its origin from both cultures. For transculturation to occur, a foundation of cultural exchange and appropriation must have already been established. Therefore, at least in terms of the relationship between Europe and Africa, intercultural exchange had been occurring in earnest in west central Africa since the earliest trading between the two kingdoms, forming an Atlantic Creole community in Africa prior to arrival in the Americas. The complex social, political, and cultural negotiations of these exchanges are evident in the performances at the Feast of St. Francis Xavier.

Organized around a series of themed floats, the procession honoring St. Francis Xavier in the fall of 1620 began with the entrance of three giant white female figures known as *Gigantes*. These papier-mâché puppets were approximately 18 feet tall and, with a pre-Christian history from Spain and Portugal, represented local characters or cultural figures who were honored or lampooned by the community. These three giant figures were accompanied by an African man, referred to in the chronicle as a dwarf, who performed as the "father" of the three puppets. The chronicler of the procession wrote: "First in the procession are three giants with their father dressed in the Lisbon manner, who gave much happiness to all [the Portuguese], and amazement to the negroes" (Felner 532).[3] The description goes on to say that the African was a prisoner of war from the Ndongo Wars (*negro anão de tres palmos que se apanhou na Guerra de Dongo*). Dressed in European fashion—red velvet vest, white boots, and multicolored cap—he stood only three feet high in contrast to the puppets that were approximately six times his height. The short dramatic sketch had the "father" chase and chastise his "children" to no avail. This scene was repeated again and again until the procession terminated at the Jesuit college (532).

This opening performance illustrates a process of transculturation in that this European performance included an African character in its company performing within a contested space. The characterization by our chronicler hints at European *Commedia Del'Arte* traditions performed by an African rather than an African performance of ridicule within a European performance frame (Irobi 268–282). These types of comedic acts, carnivalesque performances in which positions of status are reversed, are often referred to as performances of ridicule, an equalizer that cures or purges the effects of social ills and trauma (Birmingham 96). However, while this can certainly be seen as a performance that makes the Ndongo look ridiculous, rather than purging social ills and trauma, the effect of placing a captured Ndongo man in the position of the ineffectual "father" futilely herding his giant white children reinforces the subjugated position of the Ndongo people. The Feast of St. Francis Xavier occurred just after a series of intense battles between the Kingdom of the Congo and the Ndongo that was instigated by the Portuguese. The Ndongo people were badly beaten and kept in corrals within earshot of the festivities while awaiting embarkation to Brazil and New Spain as slaves. The forced performance by their countryman, therefore, served to reinforce not only their subjugation to the Portuguese but also to the Kongo Kingdom and the Mbundo elite of Luanda who were in alliance with the Portuguese (Heywood and Thornton 119).

In contrast to the representative performance of the Ndongo people, three floats representing three African kingdoms were in the procession: one float carried the King of Angola; another, the King of Kongo; and the third, a person representing "the rest of Imperial Africa." While their floats are described in detail and remarked on as being very elaborate, no mention is made of dancers or singers in their retinues. However, our chronicler did describe both kings and the one symbolic "king" as singing praise songs to the soon-to-be saint. These songs are quoted in detail in the chronicle and are in European poetic language and form. The performances represent not only fealty to the faith by the surrounding African kingdoms but also significant political and social alliances through a Portuguese interpretation of Africa within a theatrical/

religious performance. Taken together, the performances of the captured Ndongo warrior along with the praise singing of the Kongo and Angolan allies demonstrate a dramaturgical arc of what can, and eventually, does happen to African allies of the Portuguese.

Following the play of the unruly "children" and ineffectual "father" came dancers from the island of São Tomé (now São Tomé e Príncipe). While the chronicle provides only minimal description of the dancers from São Tomé, commenting on their "lightness," their very presence exemplifies an early stage in the transculturation process occurring on the off-shore islands. São Tomé, an uninhabited island off the northern coast of Luanda, was settled by the Portuguese almost 150 years before. Originally used as a strategic landing site for commercial ventures with the Kongo/Angola region, the Portuguese populated the island with Jews expelled from Portugal during the Inquisition and African slaves from the mainland. Encouraged by the crown to mix socially, eventually this miscegenated class became the dominant cultural group in São Tomé (Eyzaguirre 1989). As São Tomé had been uninhabited prior to Portuguese arrival, the cultural practices on the island resulted in a neoculture consisting of African traditions from the Kongo kingdom and the changing traditions of Portuguese Jewish converts to Catholicism. Today, carnival festivities on the island include *Dança Kongo*, a folkloric dance form linked directly to its Kongolese ancestry. It is possible that an earlier form of this dance was presented at the 1620 procession. At the very least, the presence of the São Tomé performers in the procession contributed to the formation of an Atlantic Creole identity for the Luso-African elites of seventeenth-century Luanda.

The descriptions of the procession offered by the chronicler point to a variety of intercultural performance practices that can later be seen in performances such as the Mardi Gras Krewes in New Orleans, Louisiana, and many other carnival parade traditions throughout the African Diaspora. The connection to the *Maracatú* of Brazil is especially strong. The seventeenth-century religious procession and the modern-day *Maracatú* performances share several dramaturgical elements, beginning with the processional structure with themed floats, or rolling stages, which tell different parts of a story. For the Feast of St. Francis, there was the story of the Padre's accomplishments and his relationship with the people of the region, specifically his role in the conversion of China, India, and Africa to Christianity. In *Maracatú*, we have a story of African Brazilian identity that includes many layers of intercultural practices: central African Kongo/Angola (Mbundo)/Ndongo traditions (with the addition of West African Yoruba Orixa traditions), the dominant European Portuguese culture, and the practices of indigenous people of the Americas.

Direct evidence in the dramaturgy of *Maracatú* that could link to a seventeenth-century Luanda can be seen in the costumes of the king, queen, and courtiers. The costumes reflect the fashions of the sixteenth- and seventeenth-century Baroque era rather than those of the late nineteenth century when modern-day *Maracatú* begins. The style of dress is duplicated on the *Calunga* doll, an important and spiritually endowed prop that links to pre-colonial African traditions and, perhaps, to the *Gigantes* from Portugal in the Feast of St. Francis. A dark brown female figure, 16 to 24 inches tall, the *Calunga* retains its African significance in the *Maracatú* tradition yet is dressed to approximate a sixteenth- or seventeenth-century lady of the European court. Considering the spiritual content of the *Calunga*, a connection can also be made with the holy relics, or the bones, of St. Francis Xavier that were carried throughout the procession and installed in the church at the end.[4]

The characters in the *Maracatú* include a king, queen, a character called the *Dama do Paços* (a lady-in-waiting), and a special lead female dancer who carries the *Calunga*. Alongside the *Dama do Paços* are the *Baianas* and *Catirinas*, court ladies at a lower status than the *Dama do Paços*. Additionally, there can be soldier characters dancing with swords, a section that can be associated with the performance of the *Nsanga*, a military dance from the interior that was

eventually called *sangamento* in Portuguese and was performed by members of the Luandan elite at the 1620 procession (Felner 533).

All together, the dramaturgical elements of the procession of the Feast of St. Francis Xavier in Luanda in 1620 and modern-day carnival traditions illustrate the processes of transculturation that began on the continent of Africa during the transatlantic period. In other words, many of the Africans who were enslaved in Angola and brought to Brazil were not entirely isolated from or unfamiliar with European culture before their enslavement. In fact, many of them were already Christian and had Portuguese/African names, spoke a mixture of Kimbundu[5] and Portuguese, and were familiar with Portuguese performance traditions and artifacts prior to arrival on the shores of Brazil. While *Maracatú* is not the only practice in the Afro-Brazilian repertoire with visible links to African traditions, it serves as a useful example. Not only does the structure of Maracatú performance harken back to the religious and political life in the city of Luanda in 1620 but also the city of Luanda persists in the Afro-Brazilian imagination. As these songs are performed by the Africans who were sent to the new world, they memorialize the city of Luanda and act as a rallying cry to return home, reminding us of the ongoing process of transculturation as the Atlantic world continues to transform itself through its cultural practices.

## Notes

1 Collected from the parading group Maracatú Nação Leão, Baque de Imalé. Maracatú. www.maracatuny. com/lyrics2.
2 The description of this event and all subsequent references to the Feast come from the transcription of "Documento No. 77: Relação das Festas que a Residênçia de Angolla fez na Beatificação do Beato Padre Franco de Xavier da Companhia de Jezus," in *Apontamentos sôbre a ocupação e inicio do estabelecimento dos portugueses no Kongo, Angola e Benguela; extraídos de documentos históricos* by Alfredo de Albequerque Felner. While Felner acknowledges the various libraries and archives in which he sourced the documents in his historical compilation, he does not specify which document came from which archive or library. Dr. Regina Castro-McGowan, who helped in translating this material, specializes in seventeenth-century Portuguese chroniclers and believes this document can be found in the Biblioteca Nacional de Portugal.
3 "Davão prencipio a procissão tres gigantes com seu pais como se costuma fazer em Lizboa, e derão muita mateia de alegria a todos espanto aos negros."
4 While beyond the scope of this chapter, according to dance ethnologist Linda Yudin, the spiritual underpinnings of the contemporary *Calunga* doll lie in the Yoruba cosmology of *Candomoblé*, pointing to another layer of transculturation among the African cultures that come together in Brazil. Yudin, Linda. Personal Interview. February 2018.
5 This is a Bantu language of the Mbundu.

## Works cited

Birmingham, David. "Carnival at Luanda." *Journal of African History*, vol. 29, no. 1, 1988, pp. 93–103.
Eyzaguirre, P. "The Independence of Sao Tome E Principe and Agrarian Reform." *Journal of Modern African Studies*, vol. 27, no. 4, Dec., 1989, pp. 671–678.
Felner, Alfredo de Albuquerque. "Angola: Apontamentos sobre a ocupação e início do estabelecimento dos Portugueses no Congo, Angola e Benguela." *Coimbra: Imprensa da Universidade*, 1933.
Fromont, Cécile. "Dance, Image, Myth, and Conversion in the Kingdom of Kongo, 1500–1800." *African Arts*, vol. 44, no. 4, Winter, 2011, pp. 52–63.
Heywood, Linda M., and John K. Thornton. *Central Africans, Atlantic Creoles, and the Foundation of the Americas, 1585–1660*. Cambridge UP, 2007.
Irobi, Esiaba. "A Theatre for Cannibals: Images of Europe in Indigenous African Theatre of the Colonial Period." *New Theatre Quarterly*, vol. 22, no. 3, 2006, pp. 268–282.

# 69

# AFROFUTURISM AND THE 2018 WAKANDA DIASPORA CARNIVAL

*Renée Alexander Craft*

Once our imagination is unshackled, liberation is limitless.

(Imarisha 4)

In 1988, *Coming to America*—a film that ranks alongside the original *Star Wars* trilogy (1977, 1980, 1983), *Roots* (1977), and *The Wiz* (1978) as cinematic and televisual icons of my youth—debuted on the big screen. In it, Prince Akeem (Eddie Murphy) travels from the fictional African kingdom of Zamunda in search of his future queen in, where else but, Queens, NY. Zamunda is represented as a small but prosperous fairytale land where Blackness is ubiquitous, joyous, and beautiful. The movie celebrates Black material culture while poking fun at subversive Black sampling and appropriation. King Jaffe Joffer (James Earl Jones), for example, flaunts a Western suit adorned with a jewel-eyed, lion-headed sash, and an ensemble of female flower bearers that toss rose pedals at his feet. His future in-law, Cleo McDowell (James Amos), is a restaurateur who appropriates McDonald's iconography and menu to form McDowell's. As Cleo explains, "They got the Golden Arches, mine is the Golden Arcs. They got the Big Mac, I got the Big Mick" (*Coming to America*). The pageantry of the Zamundan wedding looked like an African-centered utopia with celebrants decked out in African-inspired Black-world fancy clothes drinking champagne with their pinkies in the air representing Black wealth, dignity, privilege, and power. In one of the final scenes, we see King Joffer witness the ceremony from his throne with his queen at his right and his daughter's new African American father-in-law at his left—a trauma-free, history-absent African/Diaspora re/union. Why would a chapter focused on the 2018 release of the film *Black Panther* begin with *Coming to America*? Because, 30 years earlier, my generation of wanna-be-Wakandans were wanna-be-Zamundans first.

When US Black audiences saw trailers of the *Black Panther* Challenge Day waterfall scene, which featured Wakandans in an exquisite array of Pan-African fabrics, styles, and aesthetics, many saw Zamunda multiplied to the nth degree with significantly better gender politics. The Wakandan king was not only wealthy, well-educated, handsome, and kind like Prince Akeem; but he was also a bad-ass superhero supported by an elite guard of warrior women that honored many a Black girl's fantasy to get to have Wonder Woman look like her. The anticipation of seeing a mythical, uncolonized, Afrofuturistic kingdom as a major motion picture meant that even those Black audiences with no prior knowledge of the comic book character or participation in Marvel's cinematic universe approached the premiere week with great pride and

excitement. Across the country and around the world, Black individuals and organizations bought out theatres, hosted watch parties, sponsored cosplay strolls, played the djembe in movie theatre lobbies, engaged in West African dance, and greeted each other at the movie's end with fists closed and arms crossed over the chest exclaiming, "Wakanda Forever!"

This chapter focuses on the community-centered #WakandaForever pageantry, festivities, costuming, and play that marked *Black Panther*'s opening throughout the Black Diaspora. Paying particular attention to the movie's February 16 US debut, I use theories of Afrofuturism, cultural performance, and ritual performance to argue that Black Diaspora audiences' pre- and post-movie #WakandaForever embodied performances represented a unique "Wakanda Diaspora" carnival. Connecting Victor Turner's (1982) theory of communitas with Benedict Anderson's (1991) theory of imagined community, I use "Wakanda Diaspora" to point to the feelings of communion that *Black Panther* generated for Black audiences that allowed us to experience a heightened sense of our Black Diaspora sociocultural connectedness. According to Turner, communitas represents a feeling of communion that cuts across social divisions such as ethnicity, gender, class, age, and nationality. He explains that "When even two people believe that they experience unity, all people are felt by those two, even if only for a flash, to be one" (47). Discussing his use of "imagined community" in relationship to various nationalisms, Anderson argues that "It is imagined because the members of even the smallest nation will never know most of their fellow-members, meet them, of even hear of them yet in the minds of each lives the image of their communion" (6). Significantly, *Black Panther*'s US debut weekend not only took place in the midst of Black History Month commemorations but also at the end of carnival celebrations, which Black Diaspora communities use to honor their unique histories of heroism and struggle within discrete nation states.

I contend that Black-world audiences staged a spontaneous "Wakanda Diaspora" carnival that gave celebrants a joyous, communal experience of Black cultural nationalism. As a big-budget sci-fi super-hero movie that took place during Black history month, *Black Panther* also gave artists, academics, and activists a conduit through which to reflect on the power of history, innovation, and imagination in the ongoing struggle against anti-Black racism and for expanding Black experiences of freedom. How might one analyze #WakandaForever pageantry and play within the interpretive frameworks of Afrofuturism and carnival? How does performance-centered scholarship contribute to our understanding of Black audiences' embodied responses to *Black Panther*? How do #WakandaForever performances function as Black cultural performances? What is the relationship between #WakandaForever and #BlackLivesMatter? How does analyzing #WakandaForever as a cultural performance help us to better interpret the phenomenon in the broader political context of #BlackLivesMatter? I have chosen to represent the relationship between these terms and phrases using hashtags as a performative gesture aligned with the function of the symbol on social media. Although they lack the dynamism of social media hashtags, which serve as interactive archival tools to code and track them within larger sociopolitical discourses, I use them here as a performative means to point to their participation with those broader public discourses.

## Afrofuturism and #WakandaForever pageantry and play

As Ytasha Womack states in *Afrofuturism: The World of Black Sci-Fi and Fantasy Culture* (2013), "Afrofuturism is an intersection of imagination, technology, the future, and liberation." She continues, "Both an artistic aesthetic and a framework for critical theory, Afrofuturism combines elements of science fiction, historical fiction, speculative fiction, fantasy, Afrocentricity, and magic realism with non-Western beliefs" (9). Coined by cultural critic Mark Dery in a 1994 interview

titled "Black to the Future" and expanded by an interdisciplinary collective of students, artists, scholars, and science fiction fans through an online discussions group facilitated by Alondra Nelson in the late 1990s, the term provides a convenient container to thinking and praxis that preceded it by centuries (Womack). As *Guardian* columnist Steven W. Thrasher contends,

> Racism can give black Americans the impression that in the past we were only slaves who did not rebel; that in the present, we are a passive people beaten by police who cannot fight back; and that in the future, we simply do not exist.

Afrofuturism resists the intellectual and psychological domestication of such thinking by examining racism itself as a technology; amplifying stories of Black powerfulness, spaciousness, and mobility; centering stories of Black innovation and inspiration; and viewing successful Black futurity as both normative and inevitable.

That both the comic and film *Black Panther* fit into an Afrofuturistic framework is easy enough to discern, but how might we analyze Black audience's #WakandaForever pageantry within such a framework? One approach would be to analyze #WakandaForever opening weekend pageantry within Afrofuturistic aesthetics that have been popularized by innovators like Sun Ra, Parliament and George Clinton, Missy Elliot, Janelle Monáe, and a host of others across multiple generations and genres. Another is to attend to how #WakandaForever pageantry gave intergenerational Black audiences a creative means of transport between a real-life colonized space that ever seeks to dominate and discipline Blackness and an uncolonized space where Blackness is dominant, free, self-actualized, and powerful. I have chosen to use this chapter to focus on the latter.

*Figure 69.1* Black Panther Takeover at the Vault, Durham, NC Dora Milaje. (*Left to right*) Nia Wilson, Mya Hunter, and Omisade Burney-Scott.

I argue that #WakandaForever pageantry allowed Black audiences not only the experience of being temporarily transported "there" but also that imaginatively entering Wakanda, dressed (in all our creative glory) as Wakandans surrounded by compatriots, facilitated our desires to transport #WakandaForever consciousness "here." As performance theorist Richard Schechner would argue, this was not dress up as a form of "make believe" or pretend but costuming as a method of "make belief" that blurs the boundaries between the "real" and "not real" and has the potential to create something new (42).

*Black Panther* opened five years into the millennial-led civil and human rights movement known as #BlackLivesMatter. As its website recounts, "In 2013, three radical Black organizers— Alicia Garza, Patrisse Cullors, and Opal Tometi—created a Black-centered political will and movement building project called #BlackLivesMatter. It was in response to the acquittal of Trayvon Martin's murderer, George Zimmerman" (Herstory). Trayvon Martin was the 17-year-old boy whom Zimmerman fatally shot on February 26, 2012. Zimmerman, a member of his neighborhood watch program, interpreted the teen's presence in his neighborhood as suspicious and began a series of actions that led him to kill the teen and later sell the weapon he used to do so for $250,000. Martin's murder and Zimmerman's acquittal are recent touchstones in a painful cascade of white vigilante- and police-led killings of unarmed Black people.

This was part of the material reality of racism shaping the consciousness of US Black audiences at the time of *Black Panther*'s debut. Others included the resurgence of US white supremacist and white nationalists groups like the Ku Klux Klan and the rise of the "Alt-Right," which the Southern Poverty Law Center (SPLC) defines as, "a set of far-right ideologies, groups, and individuals whose core belief is that 'white identity' is under attack by multicultural forces using 'political correctness' and 'social justice' to undermine white people and 'their' civilization" (Alt-Right). Members of the Alt-Right, Neo Nazis, and other white supremacist groups used tiki torches, swastikas, and confederate flags as part of their symbolic arsenal at the August 13, 2017, "Unite the Right" protest in Charlottesville, VA, which ended in the death of counter-protester Heather D. Heyer. Described by the SPLC as "the largest by the radical right in a decade," the demonstration was in opposition to progressive plans to remove Confederate General Robert E. Lee's statue from the city's Emancipation Park. Protester James Alex Fields, Jr. killed Heyer when he intentionally drove his car into a group of pedestrians. Following the incident, #BlackLivesMatter issued a statement demanding removal of all confederate symbols. In a tweet cited by Harriet Sinclair in her August 15, 2017, *Newsweek* article, the group asserted that "After WWII, Germany outlawed the Nazis, their symbols, salutes & their flags. All confederate flags & statue, & groups should be illegal." By the time of *Black Panther*'s US premiere, months of protests were still underway across the nation to have such monuments removed. In the wake of Charlottesville, many state and local governments as well as college campuses chose to do so. In other places, like my adopted city of Durham, NC, monuments were taken down by impassioned citizens, who put their individual bodies and freedoms on the line to rid their locality of the divisive anti-American (as well as anti-Black) symbols.

#WakandaForever pageantry and play gave Black communities the necessary space to renew our psychological and spiritual stores amidst these recent battles in the ongoing struggle for full civil and human rights. An Afrofuturistic framework allowed us to engage #WakandaForever as an opportunity to celebrate #BlackJoy, #BlackExcellence, and Black expansiveness in a period that aggressively seeks to constrict our mobility through revivals of anti-Black terrorism. To be clear, #WakandaForever, as I am using it here, is not an alternative utopic spot apart from #BlackLivesMatter. Quite the contrary, it represents the imaginative potential required to fuel liberatory movements. As Walidah Imarisha writes in *Octavia's Brood: Science Fiction Stories from Social Justice Movements*:

Because all organizing is science fiction, we are dreaming new worlds every time we think about the changes we want to make in the world ... And for those of us from communities with historic collective trauma, we must understand that each of us is already science fiction walking around on two legs. Our ancestors dreamed us up and then bent reality to create us.

(4–5)

*Figure 69.2* The Bass family in African Attire to view the *Black Panther* in Jacksonville, FL (2018). (*Left to right*) Lester Bass, Micah Webster-Bass, Trinity Webster-Bass and Selena Webster-Bass.
*Source*: Courtesy Bass Family.

*Figure 69.3*   Zamunda + Wakanda, Ervin Truitt and Howard Craft.
*Source*: Photographer Renée Alexander Craft.

The 2018 #WakandaForever pageantry and play offered Black audiences an opportunity not only to participate in a rejuvenating communal ritual that reaffirmed our shared beauty, humanity, creativity, and hopefulness but also to collectively witnesses ourselves doing so again and again in-person as well as through the amplification of our lives on social media. These shared experiences of self-care and renewal help support and sustain the work of social justice.

My husband and I saw *Black Panther* during its first showing on Thursday, February 16, a day before its official debut. We had purchased tickets a month prior and had been anxiously

awaiting the date. I wore the top to a purple West African skirt set, which was embroidered in gold along with Fulani earrings, black leggings, and knee boots, while my husband wore dark jeans, sneakers, and a black Harriet Tubman t-shirt that featured the abolitionist's photo above the quote, "We Out." We both love sci-fi, well-done superhero movies, and Black culture. So, *Black Panther* was sure to be a winner. Among the groups of other Wakanda-ready Black folks, Marvel Universe fans, and comic book enthusiasts, we spotted a local theatre professor and actor dressed in a gorgeous white and gold West African tunic with matching pants. The accessory that elevated the ensemble from stylish formal wear to Zamunda-inspired costume was a stuffed lion-headed sash, which harkened back to King Jaffe Joffer's. The jovial pre-performance environment reached an even higher pitch post-performance as theatres in the multi-cinema emptied and newly minted Wakandans entered the lobby talking excitedly about the film, sharing #WakandaForever salutes with incoming audiences, and pausing to take photos in front of *Black Panther* posters and cutouts. Like many, that was my first of several viewings of the film. By the weekend's conclusion, I had seen it three times. The second time, I took my mom.

I had initially planned to take my mother to see a friend perform the lead role in Lorraine Hansberry's *A Raisin in the Sun*. We were not scheduled to see *Black Panther* together until the following week. When I reached her home, however, I immediately understood that we needed to adjust our plan. Two days before the movie opened, Nikolas Cruz murdered 17 high school students at Marjory Stoneman Douglas High School in Parkland, FL, in an abhorrent act that would galvanize survivors to initiate a #MarchForOurLives demonstration in support of stronger gun control a month later in Washington, DC. In collaboration with #BlackLivesMatter, the demonstration would connect gun violence against Black unarmed teens like Trayvon Martin, Michael Brown, and Tamir Rice with gun violence against teens in mass school shootings. On the Saturday of my visit, three days after the Parkland shooting, my mother was sullen. She has always paid acute attention to both print and televised news. In an era of 24-hour news, such intense exposure to the repeated details of a tragedy can be damaging. In her adult life, my mother has seen the trajectory of the US civil rights movement thus far, including its thrilling gains and devastating losses. Witnessing the Valentine's Day Marjory Stoneman Douglas High School shooting of children educated in a post-Columbine America where these types of mass shootings have become all too common was heartbreaking. With the preponderance of events that threatened to cement the country's racism and capitalist greed in our consciousness as unavoidable, ever-present, and inevitable—a stance that can weaken one's resolve to imagine the world otherwise—I decided to delay our viewing of the brilliantly written *A Raisin in the Sun* for an experience that might allow us to intervene in our felt-sense of devaluation and disposability.

My mother allowed me to share with her the purple and gold top I had donned days earlier and take us both to Wakanda. Like most that weekend, she entered the theatre lobby with a sense of curious wonder as she took in the overwhelmingly Black audience, many dressed in African fabrics or engaged in cosplay. When she exited the theatre, she playfully crossed her arms over her chest in the #WakandaForever salute, talking excitedly about the strength and wisdom of the female characters including the king's elite all-female guard, the Dora Milaje. One particular line rang true for us that day—General Akoya's dismissive estimation of guns as "primitive."

Approaching #WakandaForever pageantry through an Afrofuturistic framework aimed at considering the stakes of such performative play for US Black audiences necessitates viewing such performances within the sociopolitical context of #BlackLivesMatter, discourses surrounding Confederate monuments in public spaces, struggles against anti-Black and anti-immigrant violence, and urgent demands for gun reform. To understand the liberatory space

*Black Panther* held open for Black audiences to engage in this type of revitalizing communitas requires an engagement with the histories that helped structure the moment.

## Wakanda Diaspora carnival as Black cultural performance

For the past 18 years, the majority of my research and creative projects have centered on an Afro-Latin carnival tradition called "Congo" as it is practiced in Portobelo, Panama. Located on the Caribbean coast of the Republic, Portobelo is a Spanish-speaking, rural community founded during the Spanish colonial period whose history and culture reflect its African and Spanish cultural heritage. Congo carnival emerged as a performative response to enslavement in Panama and celebrates the resistance of Cimarrones, formerly enslaved Africans who liberated themselves from bondage during the Spanish colonial period and established independent communities in the hills and rainforests. Cimarrones assisted English privateers like Francis Drake and pirates like Henry Morgan to successfully sabotage Spanish colonial trade practices. Using these partnerships as leverage, they were able to negotiate with the Spanish to gain their freedom. Once successful, they were no longer "Cimarrones," meaning "wild" or "runaways." They were free Blacks, free "Congos" (Craft 3).

The Congos of Portobelo, like other Congo communities along the Caribbean coast of Panama, use both cultural and ritual performance to celebrate and share their history and traditions during carnival season. Such performances generally include embodied storytelling enacted through costumed dancing, singing, and drumming. The main drama of the tradition begins on January 20 and peaks on the Tuesday and Wednesday before the beginning of Lent, the 40 days from Ash Wednesday until Easter (3).

When *Black Panther*'s February 16 release date was announced, I knew I would miss the 2018 carnival season in Portobelo. I wanted to participate in the opening weekend ritual of *Black Panther* within my local community of family, friends, and Black Speculative Arts enthusiasts—artists, scholars, activists, and cultural critics whose work is routed through commitments articulated by Afrofuturism, Afro-surrealism, science fiction, folklore, and magical realism. I did not realize yet that I would get to experience a carnival after all.

By Christmas 2017, what I refer to as Wakanda Carnival was already taking shape. Black promotors, party planners, and collectives of Black cultural event planners were renting out movie theatres for the opening weekend and creating experiential packages that included chartered buses, costumed collective viewings, panel discussions, and dance parties. One such event in my local community was the February 16 "Black Panther Takeover at the Vault" (Figure 69.1). Promoted primarily through social media, the event's Facebook page announced:

> Wakanda, officially known as the Kingdom of Wakanda, is an isolationist country located in Africa. It is ruled by King T'Challa, the heir of the mantle of Black Panther, and is the only known source of the metal vibranium.
> WE ARE BRINGING WAKANDA TO DURHAM!
> Presented by The Vault DURM, First Class Lifestyle and BaD Arts Consulting
> THE BLACK PANTHER TAKEOVER AT THE VAULT
> Kings, Queens, Blerds, and Nerds, get ready! [...]
> We are giving you the ultimate Wakandan experience!
> Join us at the Vault for a VIBRANIUM PRE-GAME before we board up on the shuttle to
> AMC Southpoint for a PRIVATE VIEWING,
> then return to the Vault for a WAKANDA TURN UP!

The "Wakanda Turn Up" was advertised as a stand-alone experience as well, which served as an option for those with alternative movie-viewing plans but who wanted to participate in the communal post-movie festivities. As a stand-alone experience, it was billed as "Coming to ~~America~~ Wakanda: The BLK Panther After Party." In the weeks that followed the movie's debut, cultural organizations were flush with Wakanda-themed programming that gave participants opportunities to delve deeper into the imagined- and real-world histories and aesthetic practices on which the film relied. I suspect that future academic conference cycles will extend Black Panther/Wakanda analysis even further.

As with Congo carnival, #WakandaForever opening weekend cultural performances functioned as Wakanda Diaspora carnival celebrations in that they afforded African-descended participants communal opportunities to celebrate our diverse real-world histories, renew our bonds of community, and experience a sense of solidarity with festivities marked by dance, costumed pageantry, and play. According to Turner, cultural performances are set-apart "staged" moments that include, but are not limited to "ritual, ceremony, carnival, theatre, and poetry" (13). Set-apart, in this sense, points to Wakanda Diaspora carnival as a series of planned events that occurred in discrete spaces and within specific timeframes. These cultural performances were built around the ritual performance of *Black Panther* film viewings during opening weekend.

#WakandaForever pageantry and play gave Black audiences an opportunity to take a needed breath from the constrictive structures of Blackness as primarily bound to histories of enslavement and colonization. Considering Wakanda as an imaginary uncolonized alternative filled with real-world Pan-African and Afro-Diasporic actors, accents, aesthetics, and histories gave Black audiences a space to imagine: "What if" enslavement and colonization had never happened? What might still be possible if we are able to reimagine their structures and progress otherwise? Engaging in #WakandaForever pageantry and cosplay helped slip the knot of racism's intellectual and psychological domestication, at least temporarily. That the movie's production team rooted so much of the fictional world of Wakanda in real-world African histories, styles, and societies gave audiences a mechanism to increase our feelings of spaciousness and mobility beyond the theatre's lobby. It also helped fortify audience members' resilience to re-enter the structures that awaited us beyond the lobby's doors.

## Works cited

"2017 Police Violence Report." *Mapping Police Violence*, policeviolencereport.org. Accessed May 18, 2018.

"2017 The Year in Hate and Extremism." *Southern Poverty Law Center*, splcenter.org/fighting-hate/extremist-files/ideology/alt-right. Accessed May 5, 2018.

"Alt-Right." *Southern Poverty Law Center*, www.splcenter.org/fighting-hate/extremist-files/ideology/alt-right. Accessed May 5, 2018.

Anderson, Benedict R. *Imagined Communities: Reflections of the Origin and Spread of Nationalism*. Verso, 1991.

*Black Panther*. Directed by Ryan Coogler. Marvel Studios and Walt Disney Pictures, 2018.

"Black Panther Takeover at The Vault." *Facebook*, Jan. 13, 2018, www.facebook.com/events/2426746674218031.

*Coming to America*. Directed by John Landis. Paramount Pictures, 1988.

Craft, Renée Alexander. *When the Devil Knocks: The Congo Tradition and the Politics of Blackness in Twentieth Century Panama*. Ohio UP, 2015.

Dery, Mark. "Black to the Future: Interviews with Samuel R. Delany, Greg Tate, and Tricia Rose." Flame Wars: The Discourse of Cyberculture, edited by Mark Dery. Duke UP, 1994, pp. 179–222.

"Herstory." *Black Lives Matter*, https://blacklivesmatter.com/about/herstory. Accessed May 5, 2017.

Imarisha, Walidah. "Intro." *Octavia's Brood: Science Fiction Stories from Social Justice Movements*, edited by Adrienne M. Brown, et al. AK Press, 2015, pp. 3–6.

*Roots*. Created by Alex Haley, directed by Marvin J. Chomsky, John Erman, David Greene, and Gilbert Moses. David L. Wolper Productions and Warner Bros., 1977.

Schechner, Richard. *Performance Studies: An Introduction.* Routledge, 2002.

Sinclair, Harriet. "Black Lives Matter Calls for U.S. to Ban Confederate Symbols after Charlottesville Violence." *Newsweek,* Aug. 15, 2017, www.newsweek.com/black-lives-matter-ban-confederate-symbols-charlottesville-violence-651106.

*Star Wars: Episode IV—A New Hope.* Directed by George Lucas. Lucasfilm and Twentieth Century Fox, 1977.

*Star Wars: Episode V—The Empire Strikes Back.* Directed by George Lucas. Lucasfilm and Twentieth Century Fox, 1980.

*Star Wars: Episode VI—Return of the Jedi.* Directed by George Lucas. Lucasfilm and Twentieth Century Fox, 1983.

*The Wiz.* Directed by Sidney Lumet. Universal Pictures and Motown Productions, 1978.

Thrasher, Steven W. "Afrofuturism: Reimagining Science and the Future from a Black Perspective." *Guardian,* Dec. 7, 2015, www.theguardian.com/culture/2015/dec/07/afrofuturism-black-identity-future-science-technology.

Turner, Victor W. *From Ritual to Theatre: The Human Seriousness of Play.* Performing Arts Journal Publications, 1982.

Womack, Ytasha L. *Afrofuturism: The World of Black Sci-Fi and Fantasy Culture.* Chicago Review Press, 2013.

# 70

# A BEGINNER'S GUIDE TO IMPLEMENTING HIP HOP THEATRE

*Kashi Johnson*

For over 40 years, Hip Hop[1] culture has grown out of and sustained a profound influence among young people and their cultural realities. The transnational force of Hip Hop culture has, in unprecedented ways, impacted the vernacular, style, embodiment, and cultural worldview of almost every sector of life around the globe. This impact extends beyond those who engage it as consumers or practitioners. It has also shaped and challenged institutions of higher learning to not only accommodate it, but also to reckon with it. As rapper KRS-One ("9 Elements") once rhymed, "rap is something you do, hip hop is something you live," and, indeed, so many of our students today bring an unapologetic Hip Hop sensibility into the classroom.

While serving as a theatre professor at Lehigh University, my love of Hip Hop and Hip Hop theatre and my students' desire to be seen and heard in unique ways compelled me to create a course called "Act Like You Know." In existence for over 10 years now, "Act Like You Know" is a non-traditional, semester-long college performance course where social justice issues and identity exploration are remixed with Hip Hop-inspired performance techniques. By engaging students in Hip Hop theatre exercises, activities, and performance projects, I have witnessed many find their voices in this space I created for creative self-expression. Hence, my research and pedagogical passion lie in developing Hip Hop theatre curricula that positively affects and inspires students. In this chapter I demonstrate how Hip Hop theatre can build a bridge of understanding between student and educator by offering proven acting exercises and techniques, remixed within the Hip Hop aesthetic for live theatrical performance.

Hip hop originated in New York City's South Bronx in the 1970s and remains one of the most influential cultural forces shaping contemporary global youth culture today. I grew up in Queens, New York, and witnessed Hip Hop surface as a powerful megaphone for inner-city youth like me. Young Black and Latinx voices, once relegated to the margins, were now center stage proudly declaring their identities and truthfully telling their stories as they challenged the status quo. I watched Hip Hop change the world. Not only was it a transformational culture of music, dance, and creative self-expression; Hip Hop was also an art form that raised social consciousness, promoted cultural awareness, and paved the way for people to protest against poverty, drugs, and violence in their communities. In the world of dramatic literature, Hip Hop ushered in a new form of performance, aptly known as Hip Hop theatre.

Danny Hoch, founder of the Hip Hop Theater Festival, defines Hip Hop theatre as being "*by, about and for* the hip hop generation, participants in hip hop culture, or both," while scholar

Daniel Banks offers that Hip Hop theatre "is a theatre of issues that confronts not just young people but the whole world." While I agree with both Hoch and Banks, in the context of Hip Hop theatre, I will add that Hip Hop theatre is a platform for creative self-expression, where participants are empowered to celebrate their identities and speak truth to power.

Other cultural indicators of Hip Hop such as spoken word poetry and beatboxing can also fall under the umbrella of Hip Hop theatre. Whatever the style of performance, a hallmark of all Hip Hop theatre is that it courageously explores the intersection of art, culture, politics, and community. Within this framework, acclaimed Hip Hop theatre artists like Will Power, Psalmayene 24, Danny Hoch, and Universes,[2] have created and performed plays that push back on society's cultural, social, and political acceptance of the status quo, challenging audiences to see and hear voices from the Hip Hop generation in a new light.

Over the years, I have created several assignments and performance projects that invite students to access the material at a comfortable entry point. In my Hip Hop theatre classroom, students are uniquely empowered to become critical change agents able to recognize, appropriate, and transform how dominant power works on and through them as they creatively express themselves. In this way, the classroom is a "safe space" where many students develop lasting friendships. Whether I'm challenging them to reclaim their identity by writing and performing spoken word poetry, guiding them past perceived limitations by asking them to perform Hip Hop dance choreography, or by inviting them to embrace their identity by writing and "spitting" (delivering) an original rhyme; my students learn by doing.

## Step 1: keep it 100

Before you teach Hip Hop theatre, it is important to identify where you fit in the matrix of Hip Hop. Are you a card-carrying member of the Hip Hop generation? An artist? A stranger to the culture? Are you a practitioner? A student who wants to learn more? Whatever your identification, it is imperative that you recognize who *you* are in this process because Hip Hop is rooted in authenticity. If you're "not about that life," you shouldn't "front" and act like you are. Students, like audiences, instantly know if you're "keeping it 100." As the instructor, if you are unfamiliar with Hip Hop, I encourage you to do the same work that you will ask your students to do: be courageous, honest, allow yourself to be vulnerable, and trust the process.

## Step 2: identify what kind of experience you want your students to have

Are you planning to explore Hip Hop theatre for one class? A unit? A full semester? Identifying the level of engagement you want your students to have will be critical to your success. For instance, every time I teach "Act Like You Know," I do so with the goal of a performance at the end of the semester, so I design the course with this objective in mind. Each performance project is rehearsed and presented with the understanding that it may end up in the final show. This level of expectation reinforces the importance of rehearsal and keeps the bar high throughout the semester.

## Step 3: chart a curriculum for success

How will you introduce Hip Hop theatre into your curriculum? Depending on your desired level of exposure, choose exercises and activities that challenge and stimulate students. Familiarize yourself with Hip Hop-inspired exercises, games, activities, and performance assignments that feed those interests, and challenge your students to step outside of their comfort zones.

## Step 4: everything is a remix

As an experienced acting teacher, I decided to devise new ways to engage my students in Hip Hop theatre; drawing inspiration from the documentary series *Everything Is a Remix*, by Kirby Ferguson, in which he proposes that everything we create takes inspiration from something that has come before. Thus, I was empowered to remix traditional acting approaches with Hip Hop sensibilities, I was empowered to remix traditional acting approaches with Hip Hop, resulting in a collection of new Hip Hop-inspired warm-ups, games, and assignments, several of which are detailed below.

### *Vocal warm-up: beatbox drills*

Beatboxing is the art of making music using one's mouth, lips, tongue, and voice to imitate musical instruments. These drills introduce students to the fun and simplicity of beatboxing while simultaneously providing a vigorous vocal warm up. Ask students to repeat the following words and expressions in call and response fashion.

| | |
|---|---|
| Leader : Boots | Group: Boots |
| Leader: Cats | Group: Cats |
| Leader: Boots an' cats | Group: Boots an' cats |

Now ask them to beatbox by dropping the vowel sounds. Ask them to say "boots" with no vowels. It should sound like "bts." Ask them to repeat a couple of times, testing out how loud they can make the sound: *bts—BTS—**BTS***.

Ask them to try "cats" with no vowel sounds: *cts—CTS—**CTS***.

Again, ask them to repeat the word, exploring volume and articulation.

Next, ask them to say "boots an' cats," no vowel: *bts n cts—BTS N CTS—**BTS N CTS***.

Through exploration you can introduce different musical sounds, like a kick-snare drum with a closed hi-hat: *btt ctt, btt ctt.*

Then pluralize it with an 's' to open the hi-hat: *btts ctts, btst ctts.*

Then add 'n' to bring in the bass line: *btts n ctts n.*

Other words and phrases from which you can drop the vowels and explore the art of beatboxing include:

Boots n' skirts

Boots n' pants boots n' sippin' cats n' puppets

Bites n' keys

Two-two chicken-a-two, two-chicken

### *Ice breaker: step up, step back*

Instead of the traditional name game, try this remixed introduction. Gather everyone into a circle and choose the first student to go:

GROUP: Step up/step back/introduce yourself!
   Step up/step back/introduce yourself!
STUDENT: My name is *Tony!* (*insert name*)
ALL: Yeah!

STUDENT: And I like to *eat!* *(choose an action)*
ALL: Yeah!
STUDENT: If you don't like it,
ALL: Yeah!
STUDENT: Then *have a seat!* *(choose a phrase that rhymes with your action)*
ALL: Oh yeah!

The activity continues until everyone introduces who he or she is, including the teacher.

## Assignment: ol' skool

Walking in the shoes of the Hip Hop legends who came before, this assignment is a great way to merge Hip Hop and performance. Make a list of ol' skool Hip Hop artists and their popular songs. Assign an artist, song, and verse to each student. Focus rehearsals on lyric memorization, rhythm, and breath control. For the final performance, ask students to dress as their artist.

## Assignment: class anthem

Select a rap song with a meaningful message. Ask the class to memorize it. Until the song is completely learned, you can quiz students on their level of memorization. Once the class has strong command of the lyrics, break up the song and assign parts. Envision a concept for staging the song, and direct students in that performance.

Quality performance of any kind requires exploration and observation of the human condition, listening, generosity, and discipline. By remixing traditional acting exercises and assignments through a Hip Hop-inspired lens, students are empowered to creatively communicate their lived experiences by using Hip Hop theatre to confront social justice issues and claim their identity. In the name of Hip Hop, I ask my students to be courageous and recognize that by being brave enough to truthfully share, they invite the audience to make connections to their own personal experiences and access the universal through the personal. Once they absorb this idea—that their work is in many ways bigger than themselves—fears of being judged and criticized are often replaced with feelings of pride, responsibility, and empowerment. If we want the arts to survive and thrive, we need the next generation to see themselves and their stories live onstage. Hip Hop theatre has proven it can do exactly that.

## Notes

1  I have elected to capitalize the letter 'h' in all references to "Hip Hop" in this chapter, in recognition of the genre's influence and cultural significance.
2  Will Power has written several unpublished plays including *Stagger Lee, Fetch Clay, Make Man, The Seven, Five Fingers of Funk! Honey Bo and The Goldmine, The Gathering, Flow*. He also co-wrote *Steel Hammer*, with Kia Corthron, Carl Hancock Rux, and Regina Taylor, published in *Humana Festival 2014: The Complete Plays*, Playscripts, 2015. Psalmayene 24 has written several unpublished plays including *Cinderella: The Remix, P.Nokio, The Freshest Snow Whyte, Undiscovered Genius of the Concrete Jungle, Unscheduled Track Maintenance*, and *Zomo the Rabbit: A Hip-Hop Creation Myth*. The play *Free Jujube Brown!* is published in *Plays from the Boom Box Galaxy: Theater from the Hip-hop Generation*. Theatre Communications Group, 2009. Danny Hoch has written and performed several unpublished plays including *Taking Over, Till The Break of Dawn, Up Against The Wall, Clinic Con Class*, and *Pot Melting. Jails, Hospitals & Hip Hop and Some People* is published in a book by the same title by Villard in 1998. The ensemble Universes has written and performed the following unpublished plays *UniSon, Party People, Spring Training (Igor Stravinsky), Ameriville, Blue Suite, Rhytmicity: Flipping*

*The Script, The Denver Project, The Last Word, One Shot in Lotus Position, Blue Suite (Eyewitness Blues), Slanguage, Live From the Edge,* and *The Ride.*

## Works cited

Banks, Daniel. *Say Word! Voices from Hip Hop Theater.* U of Michigan P, 2011.

Hoch, Danny. "Towards A Hip-Hop Aesthetic: A Manifesto for the Hip Hop Arts Movement." *Hemisphericinstitute.org,* Hemispheric Institute of Performance and Politics. May 1, 2018, http://hemisphericinstitute.org/hemi/modules/item/2188-dhoch-manifesto.

Kirby, Furguson. *Everything Is a Remix,* Kirby Ferguson, May 18, 2016, www.everythingisaremix.info/watch-the-series.

KRS One. "9 Elements." *Kristyles.* Koch Records. 2003. CD

# 71

# INTERVIEW WITH SHIRLEY BASFIELD DUNLAP

## Educator and director

*Interviewed by Eric Ruffin*
*August 1, 2017*

Shirley Basfield Dunlap has been a university theatre professor since 1980 (Figure 71.1). Her teaching career has spanned from historically Black colleges and universities (HBCUs) (Central State and Morgan State) to predominantly white institutions (PWIs) (University of Cincinnati, Towson University, Lesley University) where she has been an advocate for using theatre arts as a means of teaching core curriculum. Dunlap finds it necessary to continue her professional work while teaching in order to offer students the opportunity to study with a member of the Stage Directors and Choreographers Society (SDC).

ER: How did you end up on a path in education?

SBD: I loved teaching. Kids were playing house and I was playing school. I graduated with a BA from Morgan, went to the University of Cincinnati for my MFA, then taught at Central State University (in Wilberforce, Ohio) and later at the University of Cincinnati. I started my professional career while teaching at Morgan State University in Baltimore, Maryland, when playwright Dr. Endesha Ida Mae Holland saw my production of her play *From the Mississippi Delta* (FTMD) and recommended that I direct it at the Hippodrome Theatre in Florida with Melba Moore.

ER: What was your undergraduate degree in?

SBD: Theatre arts. My MFA is in directing [with] a theatre management emphasis because I wanted to know how the business of it worked. I actually also wanted to make sure I understood that marketing and advertising aspect.

ER: Have you found any challenges to having a professional career as a director and being an administrator while at Morgan?

SBD: Yes, I found challenges being a director because many times a university doesn't know what to do when you tell them you're going to be gone for three weeks, and you have a full load, and you are also heading up the administrative work for your program—especially when they come to you for everything. The other part of it is being a Black woman. When I look at what's on Broadway now I think there is a challenge in being a Black person and a woman.

*Figure 71.1*   Shirley Basfield Dunlap.
*Source*: Courtesy of Shirley Basfield Dunlap.

I remember when I was interviewing to hopefully direct Lynn Nottage's *Crumbs from the Table of Joy*. She had a piece about a 15-year-old girl who was under the care of her father and a German woman. I remember the interviewer saying, "Well, Lynn Nottage likes to work with white directors anyway;" and I said to myself, "Really?!" I mean, how did I present myself that would allow a white person in a professional position to talk to me that way?

ER: What attracted you to directing?

SBD: I like directing because I like being a storyteller. I like guiding the audience to a place that has an idea that I think they should know or that they should experience. I never wanted to be an actor. I've always wanted to be a director. Someone once said, "You just love the idea because you like power," and that's not true. I like the idea of touching a lot of people in that one go-round. For people to come out thinking about the possibilities.

ER: Have you had a moment as a director that was the most satisfying?

SBD: When I did FTMD it was the first time that I had done a show in which there were only three actors, and they are doing a multitude of roles—different ages, different cultures, different genders. On top of that, I was doing it in the round. It was the most awesome experience. But I directed it again, and an African man commented that he was moved by the direction in which he saw an African presence, home. The next time was directing *Having Our Say: The Delany Sisters' First 100 Years*. Telling their story of educated, professional Black women in America during the turbulence of the turn of the [twentieth] century was most gratifying. The show went from Milwaukee Rep to Buffalo Studio Arena and to Dallas Theatre Center.

ER: So why theatre as opposed to film, television, or anything else?

SBD: The cathartic moment, the emotion, the instant gratification you get when you see someone onstage and you have an immediate relationship. It doesn't happen in film. Also, I think it was my upbringing. I'm from South Bronx, New York. I went to a private school, and their fundraisers were to rent out Carnegie Hall and do huge musicals. That was a beautiful experience. Then I went to a church where you had the Christmas show, the Easter show, the youth show. But, what was most important was that my high school [Morris HS] had Lincoln Center for the Performing Arts do in-school programming, and I was able to see these professionals perform. Plus, my family often went to the theatre.

ER: How has the field of directing changed from when you first entered it?

SBD: There was an article about a decade ago saying that it used to be all about talent, but now directors are looking to see what your degree is in because they don't want to teach you in the rehearsal hall. I'm noticing that more and more people are coming to the rehearsal hall more educated in techniques and their own personal styles. Actors I see now have a learned technique but seem to be relying more on an innate feeling of their impression of the script and their character without doing any research. So I'm not teaching in the rehearsal hall about character development, style, or technique, but I'm teaching about where we are in this world of the play and this is what's going on in it. So now dramaturgy has entered.

ER: You're a member of SDC. Has that benefited your work?

SBD: I come from a union family: my dad was a Teamster; my mom was a member of the National Association of Black Social Workers, so I understand that whole concept of being in a union. I pay union dues for times when I don't do a show. The benefit is that I can say to someone, "You might want to call up SDC to see if that is where you can start my contract for the size house you have." I have had to say that because I know the white male who directed just before me with less experience received more than my offer.

ER: Have you mentored anyone?

SBD: I want to be mentored! You know Hal [Harold Scott] was really good about that. I asked him to mentor me and he was really good at giving me clarity. Hal helped me to understand the dynamics of working with different types of people. My dad said to me when I was young that I had two strikes against me, I'm Black and I'm a woman, so I've always got to be on my toes. I am proud to have students who I have mentored who head up theatre programs and are Equity card holders.

ER: If there were one thing you think young people today should know about your field, what would it be?

SBD: That it's hard work. That it's not easy. That even though many people told you that you've got a knack for it, it's still a learning process every single minute of the day. I just finished directing *The Wiz*. People can direct that with their eyes closed. But I still did my research on L. Frank Baum; I still did my research on what this play really means when the theme is internalized. We were crying around the rehearsal table just understanding what that meant.

ER: You work both as a director and as an administrator. How do they feed each other?

SBD: The beauty of being an administrator is that I can choose with whom I want the students to work. I can also say this is the amount of money that we have, so make it rain! I have to also be the producing artistic director of the program. Like now, Morgan

is doing *Home* and the scenic designer wants to do it in the round, but we have a semi–thrust stage and I had to say, "Well, let's just build the set out into the audience." Professionally as a director, it's not my job to deal with a budget; it's the theatre's job to be creative and think that the designers will make this work.

ER: Finally, why should anyone study theatre?

SBD: I think that the humaneness of theatre is the reason that everybody, whether you want to be in pre–law or medicine, should take an intro or at least an Acting 1 class. It's an opportunity to understand what it means to communicate, actively listen, and respond; what it means to be ethical; and what it means to be empathetic of others. Making theatre arts your vocation is a contribution to humanity.

# INDEX